il Modo Italiano

il Modo Italiano

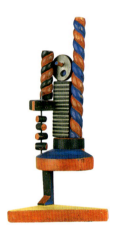

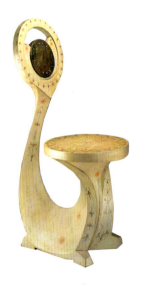

Italian Design and Avant-garde in the 20th Century

SKIRA

THE MONTREAL MUSEUM
OF FINE ARTS
Jean-Noël Desmarais Pavilion

Edited by Giampiero Bosoni

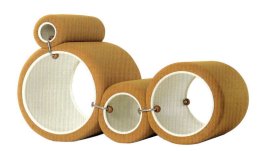

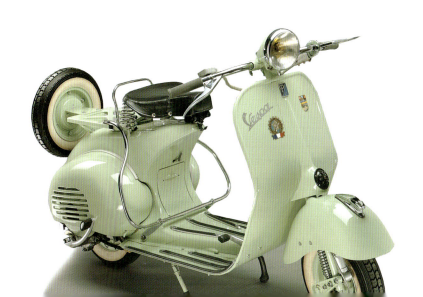

Skira editore

Art Director
Marcello Francone

Editorial Coordination
Vincenza Russo

Editing
Emanuela Di Lallo
Timothy Stroud

Layout
Luigi Fiore

Translations
Christopher "Shanti" Evans (from
Italian and French to English), Robert
Burns and Leslie Ray (from Italian to
English) for Language Consulting
Congressi srl, Milano

Iconographical Research
Alessandra Mion

The Montreal Museum of Fine Arts

Publisher
Francine Lavoie

Revision and editing
Clara Gabriel

Research and documentation
Maryse Ménard

Copyrights and photo credits
Linda-Anne D'Anjou

Technical assistance
Majella Beauregard
Jasmine Landry
Micheline Poulin

Cover
Alessandro Mendini
La poltrona di Proust
"Bau.Haus" Collection
1978, example of 2001
(cat. 208)
Lucio Fontana
Concetto spaziale. Attese
1959
(cat. 142)

Back cover and pages 2-3
Piero Manzoni
Merda d'artista, No. 68
1961
(cat. 176)
Joe Colombo
Tube Chair
1969–70
(cat. 95)
Fortunato Depero
Costruzione di bambina
1917
(cat. 117)
Enzo Mari
Atollo Fruit Bowl
1965
(cat. 182)

Aldo Rossi
Tea & Coffee Service
1983
(cat. 285)
Giuseppe Terragni
Casa del Fascio, Como
(1932–36). Perspective
of the Back Facade
1933
(cat. 332)
Dante Giacosa
Fiat *Nuova 500*
1957
(cat. 152)
Bruno Munari
Giallo-rosso
From the series
"Negativo-positivo"
1951
(cat. 225)
Carlo Bugatti
Chair
1902
(cat. 52)

First published in Italy
in 2006 by
Skira Editore S.p.A.
Palazzo Casati Stampa
via Torino 61
20123 Milano
Italy
www.skira.net

© 2006 The Montreal
Museum of Fine Arts
© 2006 Skira editore for the
publication
© 2006 Fondazione Alberto
Burri, Città di Castello
© 2006 Fondazione Lucio
Fontana, Milan
© 2006 Eredi Archivio Ugo
Mulas - All rights reserved
Sandro Chia © VAGA (New
York) / SODART (Montreal)
2006
© SODRAC (2006):
Giacomo Balla, Alighiero
Boetti, Carlo Bugatti, Duilio
Cambellotti, Massimo
Campigli, Francesco
Cangiullo, Giuseppe
Capogrossi, Carlo Carrà,
Felice Casorati, Giorgio De
Chirico, Fortunato Depero,

Marcello Dudovich, Renato
Guttuso, Osvaldo Licini,
Piero Manzoni, Filippo
Tommaso Marinetti, Marino
Marini, Ubaldo Oppi,
Mimmo Rotella, Alberto
Savinio, Mario Sironi

All rights reserved under
international copyright
conventions.
No part of this book may be
reproduced or utilized in
any form or by any means,
electronic or mechanical,
including photocopying,
recording, or any
information storage and
retrieval system, without
permission in writing from
the publisher.

Printed and bound in Italy.
First edition

Skira editore (softcover):
ISBN: 88-7624-875-7
Skira editore (hardcover):
ISBN-13: 978-88-7624-537-4
ISBN-10: 88-7624-537-5

ISBN The Montreal
Museum of Fine Arts
(English softcover):
2-89192-297-0
ISBN The Montreal
Museum of Fine Arts
(English hardcover):
2-89192-298-0
Également publié en
français sous le titre :
*il Modo Italiano. Design et
avant-garde en Italie au XXe
siècle*
ISBN The Montreal
Museum of Fine Arts
(French softcover):
2-89192-295-6
ISBN The Montreal
Museum of Fine Arts
(French hardcover):
2-89192-296-4

Legal deposit – 2nd quarter
2006
Bibliothèque et Archives
nationales du Québec
National Library of Canada
All rights reserved.
The reproduction of any
part of this book without
the prior consent of the
publisher is an
infringement of the
Copyright Act, Chapter C-
42, R.S.C., 1985.

Distributed in North
America by Rizzoli
International Publications,
Inc., 300 Park Avenue
South, New York, NY
10010.
Distributed elsewhere in
the world by Thames and
Hudson Ltd., 181a High
Holborn, London WC1V
7QX, United Kingdom.

This catalogue is published in conjunction with *Il modo italiano. Italian Design and Avant-garde in the 20th Century*, an exhibition produced by the Montreal Museum of Fine Arts in collaboration with the Royal Ontario Museum, Toronto, and the Mart – Museo di Arte Moderna e Contemporanea di Trento e Rovereto.

Exhibition venues

Canada
The Montreal Museum of Fine Arts
Jean-Noël Desmarais Pavilion
May 4 to August 27, 2006
Royal Ontario Museum, Toronto
October 21, 2006 to January 7, 2007

Italy
Mart – Museo di Arte Moderna
e Contemporanea di Trento e Rovereto
March 3 to June 3, 2007

General Curators

Giampiero Bosoni
Professor, Faculty of Design, Politecnico, Milan

Guy Cogeval
Director, The Montreal Museum of Fine Arts

Curatorial Committee

Diane Charbonneau
Curator, Non-Canadian Decorative Arts after 1960, The Montreal Museum of Fine Arts, and coordinator of the exhibition

Rosalind Pepall
Senior Curator, Decorative Arts, The Montreal Museum of Fine Arts

Irene de Guttry
Archivi Arti Applicate Italiane del XX secolo, Rome

Maria Paola Maino
Archivi Arti Applicate Italiane del XX secolo, Rome

Renata Ghiazza
Curator, Casa Museo Boschi Di Stefano, Civiche Raccolte d'Arte, Milan

Assistant Curatorial

Anna Dacci

The Montreal Museum of Fine Arts wishes to thank Quebec's Ministère de la Culture et des Communications and the Conseil des arts de Montréal for their ongoing support. Its gratitude goes also to the Volunteer Association of the Montreal Museum of Fine Arts as well as all its Friends and the many corporations, foundations and individuals for their contribution.

The Montreal Museum of Fine Arts international exhibition program receives financial support from the Exhibition Fund of the Montreal Museum of Fine Arts Foundation and the Paul G. Desmarais Fund.

The Montreal Museum of Fine Arts
P.O. Box 3000, Station H
Montreal, Quebec
Canada
H3G 2T9
www.mmfa.qc.ca

Senior Management
Director: Guy Cogeval
Chief Curator: Nathalie Bondil
Director of Administration: Paul Lavallée
Director of Communication:
Danielle Champagne

Acknowledgements

We are extremely grateful to all those who contributed to bringing this exhibition to fruition, especially:

Jane Adlin
Angelo Antenucci
Paola Antonelli
Nur Bahal
Francesco Baragiola
Antoine Baudin
Pierre Bergé
Laura Bianchi
Gentucca Bini
Shannon Bell Price
Kim Bergen
Jean-François Bourque
Ilaria Calgaro
Silvia Casagrande
Laura Castagno
Irma Castiglioni
Sarah Coffin
Anna-Maria Consadori
Bruno Danese
Louise Désy
Lory Drusian
Fulvio and Napoleone Ferrari
Matteo Fochessati
Chrystel Garipuy
Claudia Gian Ferrari
Renata Guttman
Barry Harwood
Marianne Lamonaca
Robert Little
Christine W. Lockett

Ian Lumsden
Giovanna Mori
Celeste Morozzi
Leonardo Mosso
Daniel Noiseux
Rosalia Pasqualino di Marineo
Eleonora Pecorella
Franca Pellegrini
Mariacarlotta Rinaldini
Simona Riva
Olivia Ruccelai
Davide Sandrini
Clare Sauro
Kevin Stayton
Gary Tinterow
Cynthia Trope
Marcella Turchetti
Massimo Vitta Zelman
Concetta Voltolina Kosseim
Barbara Vernocchi
Renata Wirz
Queenie Wong
Mirko Zardini
Henry Zimet
Martin Zimet

Lenders to the exhibition

Canada
Pierre Bouvrette
Canadian Centre for Architecture, Montreal
Jean-François Gratton
Robert and Alice Landau
The Montreal Museum of Fine Arts
Roberto Navarro
Richard Petit
Royal Ontario Museum, Toronto

France
Galerie Cazeau-Béraudière, Paris
Collection Yves Saint Laurent–Pierre Bergé
Anne and Wolfgang Titze

Italy
Archivio Cambellotti, Rome
Archivio Storico Fiat, Turin
Archivio Fotografico Fondazione 3M, Milan
Archivio di disegni e documenti dell'architetto
Pietro Lingeri, Milan
Archivio Opera Piero Manzoni, Milan
Archivio Marucelli, Milan
Archivio Ugo Mulas, Milan
Archivio Muzio, Milan
Archivio Storico Olivetti, Ivrea, Turin
Archivio Centro Studi Giuseppe Terragni,
Como
Banca Intesa, Vicenza
Bardelli Casa Srl, Bottegone, Pistoia
Gentucca Bini
Casa Museo Boschi Di Stefano, Milan
Davide Campari Milano SpA, Milan
Campeggi Srl, Anzano del Parco, Como
Cristina Cappa Legora
Chiara and Francesco Carraro
Centro di Alti Studi sulle Arti Visive, Comune
di Milano
Centro Studi e Archivio della Comunicazione,
Università degli Studi di Parma
Civica Raccolta delle Stampe A. Bertarelli –
Castello Sforzesco, Milan
Collection Cosmit SpA, Milan
Collection Pizzigoni
Collezione De Vecchi Milano 1935
Mario De Biasi
Agnese De Donato
Giovanni and Evelina De Poli

Claudia Gian Ferrari
Olga Finzi Baldi
Nicoletta Fiorucci
Flos SpA., Bovezzo, Brescia
Fondazione ADI per il design italiano, Milan
Fondazione Biagiotti Cigna
Fondazione Casa Museo Boschi Di Stefano,
Milan
Fondazione Cavallini Sgarbi, Ro Ferrarese,
Ferrara
Fondazione Lucio Fontana, Milan
Fondo Jacqueline Vodoz e Bruno Danese,
Milan
Fondo Paolo-Gioli
FontanaArte SpA., Corsico, Milan
Barnaba Fornasetti
Galleria d'Arte Moderna e Contemporanea,
Turin
Galleria d'Arte Moderna, Udine
Galleria Daniela Balzaretti, Milan
Galleria Marina Barovier, Venice
Galleria Colombari, Milan
Galleria dello Scudo, Verona
Galleria Christian Stein, Milan
Paolo Curti / Annamaria Gambuzzi & Co.,
Milan
Grazia and Luigi Gilli
The Kartell Foundation Museum
Miroslava Hajek – Antonio Zucconi, Novara
Mimmo Jodice
Enzo Mari
Memphis Srl., Pregnana Milanese, Milan
Rosanna Monzini
Musei Civici di Como, Palazzo Volpi
Musei Civici, Museo d'Arte Medievale e
Moderna, Padua
Museo Alessi, Crusinallo di Omegna, Verbano
Museo Alfa Romeo, Arese, Milan
Museo d'Arte Moderna e Contemporanea
di Trento e Rovereto
Museo di Fotografia Contemporanea, Cinisello
Balsamo, Milan
Museo Richard-Ginori della Manifattura
di Doccia, Sesto Fiorentino, Florence
Museo Casa Mollino, Turin
Museo Nazionale degli Strumenti Musicali,
Rome
Ugo Nespolo
Alessandro Pedretti
Pinacoteca Comunale, Macerata

Lisa Licitra Ponti
Franco Maria Ricci
Andrea Rosetti
Ferdinando Scianna
Studio Albini Associati, Milan
Triennale di Milano
Giancorrado Ulrich
Università degli Studi di Palermo, Facoltà
di Architettura, Dotazione Basile
Vatican Museums – Pinacoteca
Venini SpA, Murano, Venezia
The Mitchell Wolfson Jr. Collection –
Fondazione Regionale C. Colombo, Genoa

Switzerland
Archives de la construction moderne EPFL,
Fonds Alberto Sartoris, Lausanne

United States
Brooklyn Museum, New York
Carnegie Museum of Art, Pittsburgh
Massimo e Sonia Cirulli Archive, New York
Cooper-Hewitt, National Design Museum,
Smithsonian Institution
Deitch Projects, New York
The Museum at the Fashion Institute
of Technology, New York
French & Company, New York
The Metropolitan Museum of Art, New York
The Museum of Modern Art, New York
Sonnabend Gallery, New York
The Mitchell Wolfson Jr. Collection – The
Wolfsonian-Florida International University,
Miami Beach, Florida

An exhibition project does not leap booted and spurred from the curators' heads. It often progresses in an underground clandestine manner, liable as it is to disappear and reappear at the mercy of changing tides, and of debates between, in general, the different experts in the field and the organizers of the project, who know what appeals to the general public. When I came to Montreal almost nine years ago I hoped, sooner or later, to pay tribute to Italian art of the early twentieth century. In terms of themes, I envisaged an exhibition that would bring together Symbolism, Divisionism and Italian Futurism, from Segantini, Pellizza da Volpedo and Previati to Carrà, Panaggi and Prampolini, thus presenting a *different* Modernity that did not necessarily derive from the avant-garde experiments of Paris, Berlin or Vienna. The presence in Montreal of the remarkable collection of objects of Italian design built up by Liliane Stewart, which was given to the Montreal Museum of Fine Arts in 2000, led to the project's change of focus and widened scope.

The Museum's collection of Italian design from 1945 to the present is one of our strong points and made it possible to offer a very precise picture of the work of Giò Ponti, Ettore Sottsass, Achille Castiglioni and Gaetano Pesce. Should we settle for an exhibition of its masterworks and dress it up with a fancy title? Or should the collection be looked at afresh in light of the past, over a longer timeline? The MMFA's recent exhibitions have often tried to provide a historical viewpoint on modern phenomena; thus we included Joseph Vernet and Émile Loubon to partially explain where Cézanne's Provençal landscapes originated. Similarly, in the Alfred Hitchcock show we demonstrated how part of the filmmaker's inner drama had its origins in the nineteenth century, somewhere between Edgar Allan Poe and the pre-Raphaelites. Indeed, recent exhibitions at the Montreal Museum of Fine Arts have sought to go back in time, to create archaeologies of the image, in order to explain artistic phenomena whose exclusively contemporary nature may blind us. Design will be no exception to the rule, at the risk of disappointing the proponents of the here-and-now, at the additional risk of presenting two exhibitions in one: one will focus on the latest blossomings of an artisan tradition of unique, splendid and distant artworks, while the other will display the ambivalent glamour of industrial design and demonstrate the triumph of the endless duplication of the object. So a number of seemingly straightforward questions arose as the project took shape: is a designer an artist properly speaking, or a pattern-maker for furniture, fabrics, vases, kitchenware and washstands? Was Italian design the exclusive driving force of the avant-garde, or was it above all an indication of the unbelievable economic prosperity the peninsula enjoyed in the postwar period?

Was the permeating melancholy of the long-prevalent *Metafisica* checked by the prolific inventions of the Rationalism from the same period? These are but some of the questions that this exhibition attempts to tackle.

Our title recalls that of an exhibition held at the Los Angeles Institute of Contemporary Art in 1984. Entitled *Il Modo Italiano: The Italian Manner* and directed by Germano Celant, the show was designed to introduce the public to contemporary Italian art, which was little known in California at that time. Ours is based on research and testimonials that shed light on the synergy between art and design.

When we approached Professor Giampiero Bosoni to ask him to be chief curator of this exhibition, it was initially in his capacity as a professor and architect. But it was as a curator that he helped us to conceive this original idea. He brought us face to face with remarkable people and places, enabling us to re-experience forgotten emotions and discover new collections.

I thank him warmly for his unwavering commitment, and wish also to thank his research assistant Anna Dacci, whose tact and charm won over a number of prospective lenders. I am very grateful to Diane Charbonneau, the Museum's Curator of Non-Canadian Contemporary Decorative Arts after 1960, for mounting the exhibition with her usual meticulous concern for detail. My gratitude also goes to Rosalind Pepall, Senior Curator of Decorative Arts at the Museum, for the enthusiasm and professionalism of her contribution throughout the project. Sincere thanks also go to the other members of the advisory committee, Irene de Guttry, Maria Paola Maino and Renata Ghiazza. The entire Museum staff has my deepfelt gratitude for their wholehearted dedication. Finally, I must acknowledge the special contribution of Skira in publishing the exhibition catalogue.

This project would never have come to fruition without the many individuals and institutions who agreed to lend us major works from their collections. In organizing this exhibition, the Montreal Museum of Fine Arts has had the advantage of drawing from its own holdings in Italian decorative arts and design, most of them from the Liliane and David M. Stewart Collection. We have also been privileged to work closely with the Museo di Arte Moderna e Contemporanea di Trento e Rovereto, an institution famous for its collections encompassing Futurist works and Pop art as well as Arte Povera and realism. And lastly, I wish to acknowledge the generosity of all the lenders, public and private, who helped to create this celebration of Italian know-how.

I am delighted that after Montreal the exhibition will travel first to the Art Gallery of Ontario, Toronto, where it will appear in the new architectural setting designed by Daniel Libeskind, and then to the Museo di Arte Moderna e Contemporanea di Trento e Rovereto. Let me conclude by expressing my admiration and thanks to the directors of these two institutions, William Thorsell and Gabriella Belli, for their part in promoting this unusual and delightful exhibition.

Guy Cogeval
Director of the Montreal Museum of Fine Arts

Italian Arts and Design: The 20th Century, celebrates the astonishing achievements of Italian artists, architects, designers and artisans during the course of the twentieth century. The exhibition examines not only the intellectual and formal relationships that existed among Italian artists, but interconnections in the various productions of individual artists themselves. We experience the paintings, along with the revolutionary furniture and clothing designs, of Futurist artist Giacomo Balla, the textiles and glassware of Vittorio Zecchin, the furniture designs of Novecento painter Mario Sironi, and the multi-faceted genius of extraordinary individuals such as Gio Ponti and Ettore Sottsass.

It is appropriate that the Royal Ontario Museum celebrates the contributions of *Italian Arts and Design: The 20th Century* as part of its current expansion project: Renaissance ROM. This exhibition inaugurates the ROM's new Garfield Weston Exhibition Hall, a central focus of the new Michael Lee-Chin Crystal, designed by architect Daniel Libeskind. Its presentation underscores the ROM's commitment to the innovative in architecture, art and design, as well as scholarship and research.

The exhibition also celebrates the long-standing spirit of collaboration that has long existed between two of Canada's major cultural institutions, the Montreal Museum of Fine Arts and the ROM. This collaboration extends back as early as 1913 when the ROM's Dr. Charles Trick Currelly advised Montreal collector F. Cleveland Morgan, later Curator and then President of the Montreal Museum of Fine Arts, on the purchase of Egyptian artifacts. This collaboration over the years has led to the presentations in both cities of noted exhibitions, including most recently, Eternal Egypt, in 2003 04. Both institutions are known internationally for their collections of European Decorative Arts and Design. A new gallery devoted exclusively to the ROM's own collection of 20th Century Design is planned as part of Renaissance ROM.

Toronto is indeed a most fortunate city, for amongst its diverse population is the largest Italian community outside of Italy. Their contributions to urban life over the last century have been a source of continual enrichment.

The Royal Ontario Museum welcomes the opportunity to collaborate with the Montreal Museum of Fine Arts in bringing to the communities of Montreal and Toronto *Italian Arts and Design: The 20th Century—the Italian way!*

William Thorsell
Director and Chief Executive Officer
Royal Ontario Museum

The MART has been an enthusiastic collaborator on the exhibition *Modo Italiano*, which provides "new insights" into the history of the relationship between design and the figurative arts in twentieth-century Italy.

The innovative aspect of this project lies in the demonstration of a "contiguity" of the arts that has fostered the growth and development of a seam of unique creativity consistent with, though sometimes running ahead of, the directions taken by design elsewhere in Europe. Indeed, it is the MART's philosophy to present exhibitions that reveal the exchange that takes place between different forms of art, in the knowledge that there is no single major path followed by culture and artistic expression.

Modo Italiano does not just focus on design or painting, but is an attempt to reconstruct the complex creative climate that existed in Italy during the twentieth century.

All the arts have been called upon to provide evidence of how Italy opened itself to modernity, thereby awakening very powerful flows of creativity. This is particularly true for design, the sector in which postwar Italy took one of the leading roles worldwide.

In *Modo Italiano* artworks are presented in relation to objects of everyday use, such that they enhance each other's qualities and reveal how the creative vein has very often not been the exclusive prerogative of art in the proper sense of the word, but has also played a significant part in the design of utilitarian articles. Design of this nature has been one of the highest expressions of Italian creativity during a historical period in which industrial production has driven the economic and social development of the country in a sort of postwar "rebirth."

The MART will stage *Modo Italiano* from March 3 to June 3, 2007—after the exhibition has been presented at the Montreal Museum of Fine Arts and the Royal Ontario Museum in Toronto—and thus devote a substantial part of its 2007 program to the study of design.

Gabriella Belli
Director of the Museo di Arte Moderna e Contemporanea di Trento e Rovereto

Contents

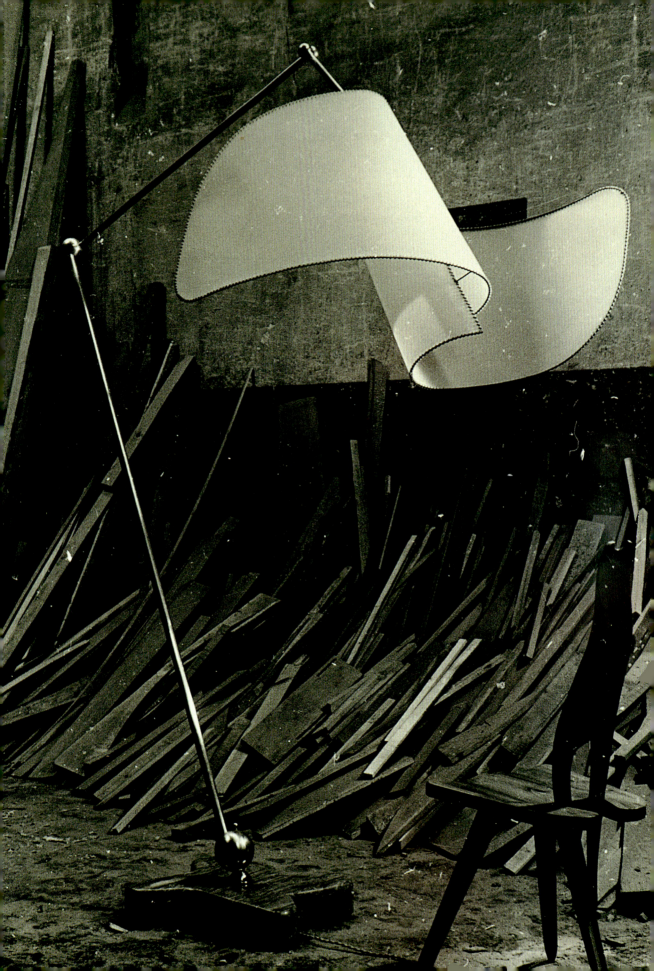

Giampiero Bosoni

Of the *Modo Italiano* and Its Ways

History of the "Things,"
Expressions and Symbols of Italian Creativity

On page 14:
Carlo Mollino
Adjustable Floor Lamp
Brass with a marble base
on rubber-coated rollers
1947
Produced by Cadma
The chair (1946) for his
apartment is in the
foreground.

Paradoxically man's capacity for aesthetic enjoyment may have been his most practical characteristic, for it is at the root of his discovery of the world about him, and makes him want to live.[1]

This illuminating observation was not made by an artist locked up in his own poetic vision of the world, but by a historian of science, Cyril Stanley Smith (an expert on material sciences at MIT who worked on the Manhattan Project), whose scientific research led him to the conclusion that aesthetic curiosity has been central to both genetic and cultural evolution.[2] Stanley Smith held that discovery requires aesthetically motivated curiosity, not logic, for new things can acquire validity only by interaction in an environment that has yet to be.[3]

Recently, the American sociologist Harvey Molotch has taken up Stanley Smith's ideas and used them as a basis for many interesting considerations, supported by the latest studies in the cognitive sciences. He asserts that when the characteristics of an object are established, aesthetics and practicality merge, to the point of shaping the very nature of the thing.[4]

This premise brings us to the title here, the *Modo Italiano*, a study that sets out to investigate the question of the history and development of Italian design from a particular point of view.

The expression *Modo Italiano* is intended to stress right from the start what could be called an anthropological or, better still, a "behavioural" aspect of conceiving and making "things" in Italy. These terms with elastic boundaries, "way" and "things," are deliberately employed not to lighten the tone of the discussion but to get closer to an aspect that concerns a very broad range of values and expressions that are in turn the characteristic traits of a *Modo Italiano* of "creating" and making things. It is a way inclined, by its historically complex nature, to continually mix up the sacred and the profane, as the saying goes, producing that special amalgam that has to some extent been inherited by what is known today as Italian design.

In this we can turn for help to the art historian George Kubler, who in his book *The Shape of Time* offers a new perspective from which to observe the complete range of forms, languages and expressions devised and produced by

Glassworks in
Murano, Venezia
Late 19th century

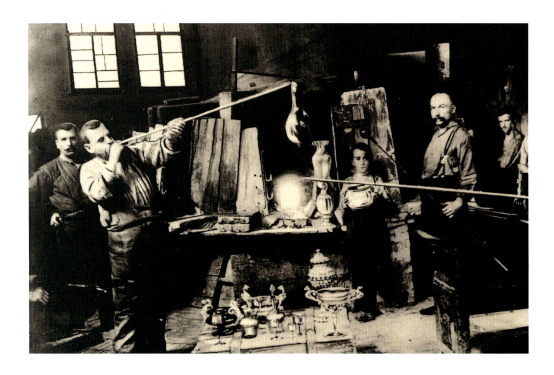

Giacomo Balla
Drawing of Futurist
Furnishings
From the magazine
Rassegna dell'arte e del lavoro, March 25, 1922

Giacomo Balla
Studio rosso
in *Casa Balla*
Rome
1920s

humanity, placing them on the same level but with all the necessary gradations. Kubler suggests that the purpose of the history of things is to reunite ideas and objects under the rubric of visual forms, including both artefacts and works of art, replicas and one-of-a-kind articles, tools and expressions: in other words, all materials worked by human hands under the guidance of connected ideas developed in temporal sequence. He implies that from all these things a shape in time emerges, a visible portrait of the collective identity, whether a tribe, class, or nation.[5] In this sense, to speak of the *Modo Italiano* of design and art in the twentieth century is to open a new window on the "shape of time" of an entire century, still so close to us today but also, in some ways, so distant. Hence, *modo*, or "way" in the sense of approach, attitude, vision, instinctive adaptive strategy, which comes before the design, which comes before the project, and which has its deepest roots in a rich and complex heritage of expressions and languages, built up over the centuries in continual dialectical and rhetorical

collisions, where thinking on the one hand and experimentation on the other have moulded the ideal figure of a "philosopher-artisan." This figure was once present in the prince's study as well as in the workshop of the master craftsman, but he could, with the passing of time, still be found among a group of enlightened entrepreneurs (unfortunately increasingly rare), true prototypes of the designer, as well as in the studio-workshops of many architect-designers or artist-designers, and again in the studio-testing grounds of a long history of craftsmen-entrepreneurs. This model has been defined by some as humanistic, where thinking (the chosen field of the Platonic *artes liberales*) always pervades the product of doing, whether we are talking about the so-called major arts or the reviled, so-called minor arts, both of which, it should be remembered, were for a long time considered inferior to the liberal arts, in that they were *artes mechanicae*. It may well be that for many centuries in Italy this separation between liberal arts and mechanical arts placed the studio of the sculptor on the same

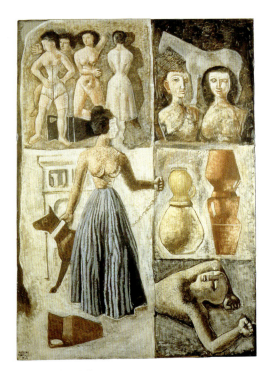

Massimo Campigli
*Market of the Women
and the Amphorae*
1929

Franco Albini
Veliero Suspension
Bookcase
1938
One-of-a-kind piece

level as the workshop of the stonecutter, and that of the painter on a par with that of the decorator or miniaturist. What is certain is that, while a rupture did take place in a given period, for a long time the major and minor arts worked together to rise to higher levels. Their aim was an improvement not just in technique, but also and above all in the expressive and symbolic value of their products, a value that was long related to the precepts of religion, but later on came to be seen in terms of those of humanistic philosophy or the exact sciences. This amalgam is the essence of a certain *Modo Italiano* of approaching and handling "things" and often excels in "making virtue out of necessity."[6]

It can be seen in all its vitality if we look at the very broad area in Italy in which the design of the objects of everyday use has been interwoven, during the belated and hesitant industrial era of the country, with many and varied aspects of the conception and making of "things." In particular, it has been connected with the experiences of the artistic avant-gardes, which on several occasions have suggested new ways of expressing the form of their own time, something that has always been accompanied, even if on another plane, by continual creative experimentation in the rich culture of the handicrafts.

The intention here is also to bring in new elements in an attempt to correct a distorted cultural vision that has for a long time led people to see Italian design as a mere appendage of the architectural culture of the Modern Movement. Yet it has certainly never assumed the connotation of community service and artistic education in the Anglo-Saxon and northern European mould, still less the methodological implications of the German model. As far as industry in Italy is concerned, historically backward and superficial with respect to other industrialized countries until about 1910

(although it went through a phase of rapid development, with some contradictions, after World War II, displaying a great capacity for innovation and production), the goal here is not to go into the extremely important matter of design in technical and manufacturing terms, which has already been extensively covered elsewhere.[7] The intention instead is to re-examine this history from the aesthetic-symbolic or aesthetic-communicative point of view, following the thread that runs through the evolution of the forms of objects of everyday use, from the arts and crafts of the late-nineteenth century to a production linked to current expressions of design in what can today be defined as the third industrial revolution. The intention is not to propose a new vision of the history of Italian design, but rather to offer interesting new perspectives of the intricate web of relationships that make up the history of Italian design. This is true whether discussion centres on the design of the industrial product only; on the "culture of design" as an expression of a limited circle of designers, chiefly architects and artists; or instead takes a more general look at the design of objects of everyday use, be they pieces produced individually or in series by craft methods or prototypes or mass-produced articles of the industrial type. At this point it might be interesting to recall that the terms design, machine, technology and art are closely connected: in his essay about the word *design*, the philosopher Vilém Flusser even considers that each of these terms is unthinkable without the others, and that they all derive from the same existential view of the world.[8]

The Latin equivalent of the Greek *techné*, from which the words "technique" and "technology" are derived, is *ars*, which would become "art" in English. In Greek the word *techné* is related to *tekton*, which signifies "builder" or "carpenter." The basic idea here, explains Flusser again, is that

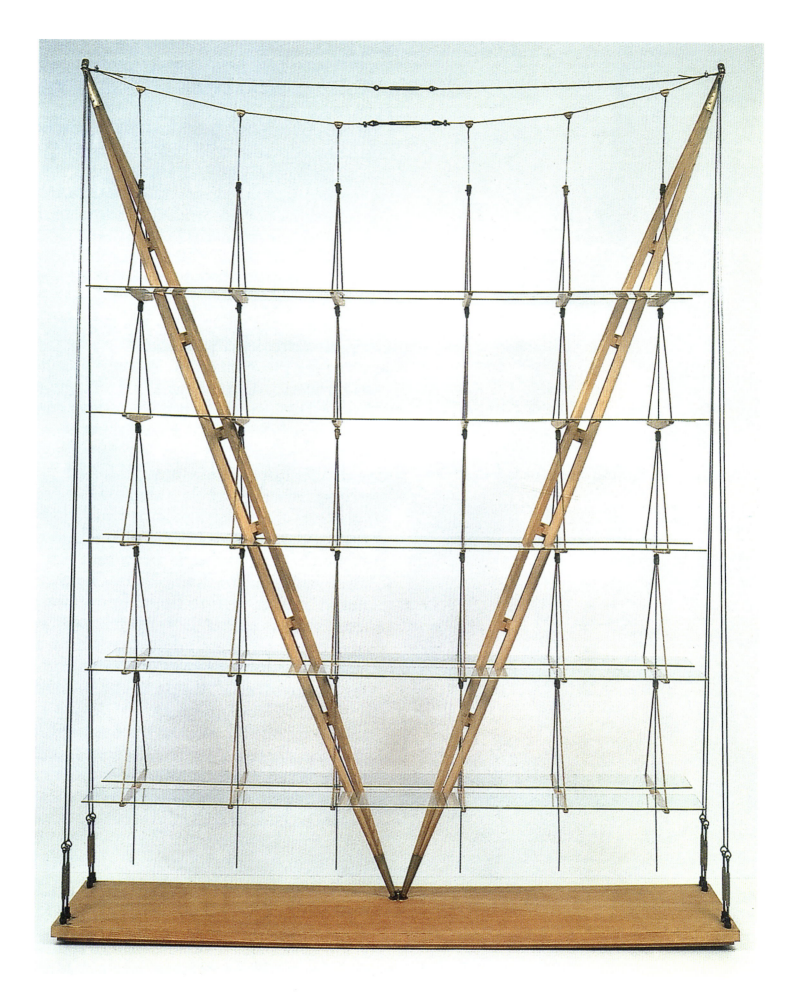

Roberto Gabetti and
Aimaro Isola
Armchair for the Turin
Stock Exchange
1952–56
Produced by Colli, Turin

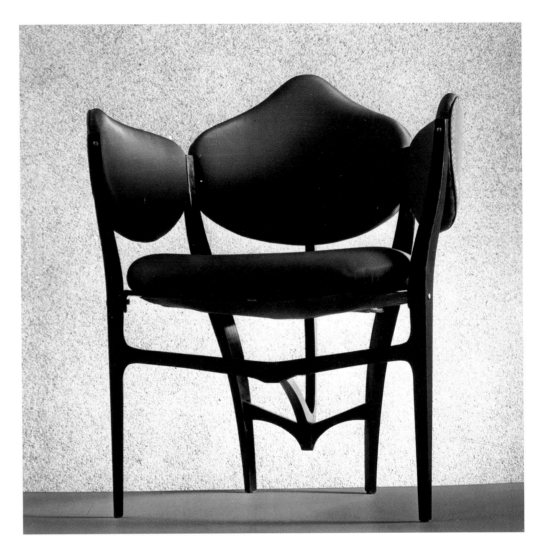

wood (*hyle* in Greek) is a shapeless material to which the artist, the technician [*artifex* for the Romans, *artefice* in Italian, meaning shrewd, clever and experienced in his work, *author's note*], gives form, thereby causing the form to appear in the first place. Plato's basic objection to art and technology was that they betray and distort theoretically intelligible forms (Ideas) when they transfer these into the material world. For him, artists and technicians were traitors to Ideas, and tricksters because they cunningly seduced people into perceiving distorted ideas.[9] Out of this Platonic vision was born the distinction between liberal arts and mechanical arts.

In this sense it is interesting to note that the Greek root *mêchos*, from which "mechanics" derives (through the late Latin *mechanica*, from the Greek *mêkhanikê* [*tekhnê*], "art of the machine"), refers to a contrivance intended to deceive, such as a trap. It is no coincidence that Ulysses is described as *polymêkhanikos*, which can be translated as "crafty," as his devising of the Trojan Horse clearly shows.[10] To conclude this etymological survey and return to the relationship between what is called *progetto* in Italian, design in English, and art in its various expressions, it is worth remembering that the Italian word *disegno*, now reduced to just the single meaning of drawing, derives from the Latin *designare* (from the word *signum*, i.e. "sign"), which corresponded principally to the meaning of its English equivalent "designate," to indicate, define, trace. From the fourteenth century onwards *designo* appeared in the first treatises of Renaissance artistic culture, in which

it was used primarily in the sense of *progetto*, planning. This explains the fact that "the [English] term design made its way into our vocabulary [Italian] as a semantically innovative backward borrowing; the history of this took place within the recesses of polysemy under the impetus of the prestige of the Italian artistic literature of the Renaissance and the prestige of the Anglo-Saxon industrial culture of the 1900s."[11]

So, if etymology provides support for this rapprochement of the products of the major arts to those of applied art (in the full range of this category that the twentieth century has taught us to recognize), the interest of this parallelism in relation to the particular case of the *Modo Italiano* is confirmed by the liveliness and wealth of exchanges and stimuli that has characterized much

of Italian exploration in art and design. This has occurred through a continuous dialectical interplay of ways of seeing, thinking and representing, first in proto-industrial society and then in industrial and now post-industrial society.

In Italy the history of design has been written by a relatively small group of "designers" and "entrepreneurs" whose paths have most often crossed in craft workshops, as well as at literary salons, in small- and medium-sized enterprises and even at art galleries, but hardly ever in the design departments and only rarely in the *Centri Stile* of major manufacturers. Their work, in the best cases, has always been independent of the internal logic of industry or the market (and in some cases and periods actually in open conflict with it), and for the most part stemmed from the need to come up with responses to

Gino Colombini
KS 1068 Dustpan
with Handle
1958
Produced by Kartell-Samco

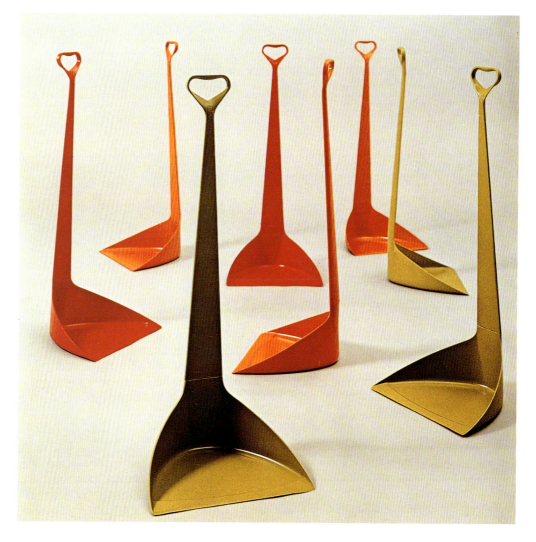

demands that had not yet been expressed: a new way of inhabiting, a new way of getting around, a new way of life.

This may explain why almost all Italian designers come from either the world of architecture or the world of art, although there has also been a number of technicians and engineers whose sensitivities have been shaped by a certain "humanistic" culture that has allowed them to look first at the meaning of things rather than just at their technical function.

The Italian peninsula was not united politically until 1861, barely a century and a half ago. This too explains the variety of languages and expressions cultivated for centuries in this country of a "thousand bell towers,"[12] which have been kept alive by a strong sense of regionalism that goes as far as to glorify individualism. One should bear in mind not only the complexity of forms and cultural trends found in the different corners of this country, but also the other something that was a constant in almost every decade of

the last century: a dichotomy, a painful and deeply felt rift with respect to the advent of modernity, which grips this land. Italy is decidedly old and mature as a result of the important experiences that history has stamped on it, but from the viewpoint of its political unification it is young and to some extent castrated by its own history. Italy has metabolized modernity in its own way through its complex history, and for this reason has never fully gone along with the modes and times laid down by countries better adapted to the needs of industry, such as Great Britain, France, Germany and the United States. In this sense modernity has developed in Italy in what could be described as an uncertain, imperfect and incomplete way,[13] with an eternal sword of Damocles hanging over its head, always caught between the desire to shrug off the burden of history and the difficult but intense attempt to hold a dialogue with it. These are two profound impulses that are continually drawn to and repelled by the allures of modernity, diverting its most

Franco Albini
and Franca Helg
Orion Television Set
1962
Produced by Brionvega

Achille and Pier Giacomo
Castiglioni
Spalter Vacuum Cleaner
1956
Produced by REM

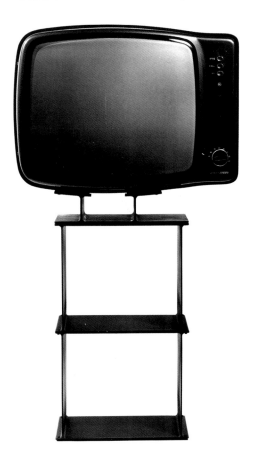

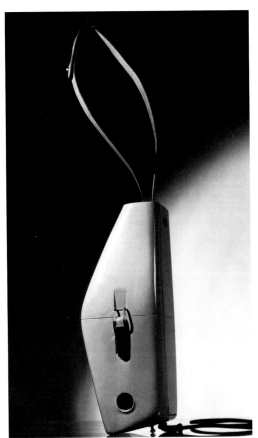

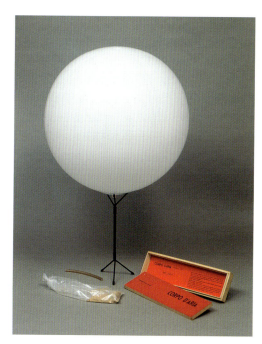

Piero Manzoni
Corpo d'aria
1960

Superstudio
Quaderna Table
1971
Produced by Zanotta

consolidated effects into unusual, hybrid solutions of an original and unpredictable character. It is well known that in Italy there has always been a passion for rival factions (Montagues and Capulets, Guelphs and Ghibellines), antagonisms and opposing fronts. It is no accident that the history of design too has seen, decade after decade and reflecting that insoluble dichotomy, a succession of strong dualisms expressed by new "philosophies" accompanied by new "aesthetics," bearers in turn of new signs that have left deep marks on the debate over the arts and design.

Many of the achievements of Italian design cannot be explained without recognizing, for better or worse, the philosophical and aesthetic legacies of Italian humanistic culture. Since the early years of the twentieth century these legacies have been reinterpreted and to some extent rejected or remoulded, first by the Futurism of Marinetti, Boccioni and Balla, which soon found its natural antithesis in the Metaphysical art of De Chirico, Carrà and Morandi. Later the same themes were reinterpreted once more in a "modernist" vision by the Rationalism of Terragni, Baldessari and Albini, which in turn was opposed by the call for a "return to order"[14] from the Novecento movement[15] of Sironi, Muzio and Ponti. After the war, the clash was between Neorealism and Concrete art, followed shortly afterwards by the confrontation at a distance between the experiments of Arte Informale and Arte Programmata. In the mid-1960s the criticism of consumer society made by Radical Design and Arte Povera was countered by the conservatism of a new and fossilized classicism of the "modern." And in the late 1970s an attempt to overcome the crisis in Modernity (which would play a more or less direct part in the emergence of the Postmodern phenomenon) was made by the Memphis group led by Sottsass in the field of design and by the group of artists who called themselves the Transavanguardia in the field of art, while a Minimalist and

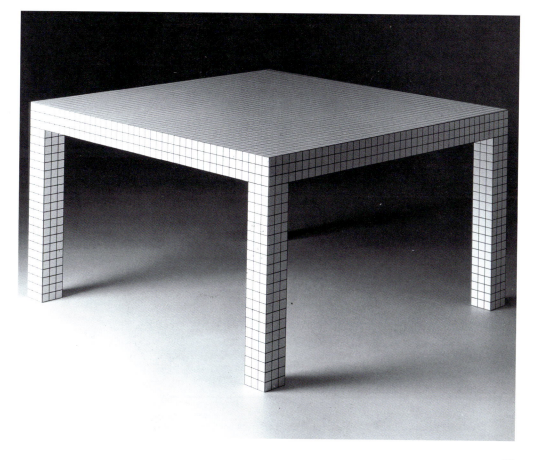

pragmatic approach, to some extent a revitalization of an aesthetic root of the "modern," took a stand against this revolutionary "return to order."

This dualistic trail had already been in crisis since the 1950s, and broke up into a multitude of freely expressed positions from the late 1980s onwards, when the more "lasting" effects of the much-heralded Postmodern condition became apparent with the collapse of all the strong values expressed by modern thought and culture. Naturally, summed up in these terms alone, this reading would be too schematic if it failed to take account of the fact that—while a certain historical propensity has always incited this two-way clash, where positions sometimes remote from one another found themselves united even if only by a minimal common denominator—the richness of the Italian model has always lain in its almost individualistic

heterodoxy of thought and investigation, where it is possible in some cases to recognize, even in a positive sense, that highly Italian art of political and cultural opportunism. This condition has seen the eventual success of authors who have chosen to go down not very well-trodden paths that have only revealed their vigour and prescience over time. Although weak and incomplete—as Branzi has pointed out[16]—the *Modo Italiano* of modernity seems to draw from its own anomaly the energy for continual adjustment, and for uninterrupted experimental investigation. Starting out from these observations, and bearing in mind the fact that no history has yet been written that tackles the close relationship between artistic experimentation and design investigation within the Italian industrial culture of the twentieth century in its full complexity, this investigation aims to make a contribution of its own towards that goal.

Gino De Dominicis
*L'immortale, l'invisibile
e il luogo*
1989
Guntis Brands Collection

Paolo Deganello
Regina Chair
1991
Produced by Zanotta

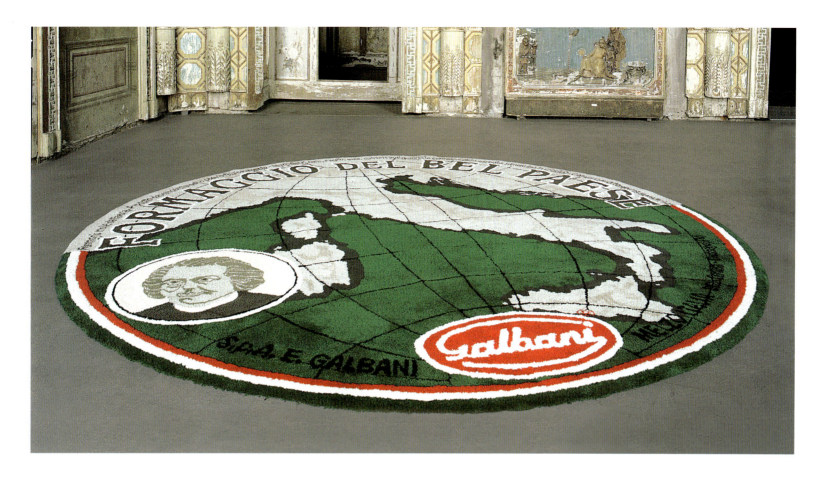

Maurizio Cattelan
Bel Paese
1994
Museo d'arte
contemporanea del
Castello di Rivoli, Turin

[1] Cyril Stanley Smith, "Art, Technology and Science: Notes on their Historical Intersection," in Duane H. D. Roller (ed.), *Perspectives in the History of Science and Technology* (Norman: University of Technology Press, 1971), quoted by V. Postrel, *The Future and Its Enemies. The Growing Conflict over Creativity, Enterprise and Progress* (New York: Free Press, 1998), p. 134.

[2] Cyril Stanley Smith, *A Search for Structure: Selected Essays on Science, Art and History* (Cambridge: MIT Press, 1981), p. 329.

[3] Ibid., p. 43.

[4] Harvey Molotch, *Fenomenologia del tostapane. Come gli oggetti quotidiani diventano quello che sono* (Milan: Raffaello Cortna Editore, 2005), p. 95; English ed. *Where Stuff Comes From. How Toasters, Toilets, Cars, Computers and Many Other Things Come To Be as They Are* (Rotledge, Taylor & Francis Group, 2003).

[5] George Kubler, *The Shape of Time: Remarks on the History of Things* (New Haven; London: Yale University Press, 1972).

[6] Ibid.

[7] See Vittorio Gregotti (with Giampiero Bosoni, Manolo De Giorgi and Andrea Nulli), *Il disegno del prodotto industriale italiano 1860–1980* (Milan: Electa, 1981); *Storia del disegno industriale 1750–1990*, 3 vols. (Milan: Electa, 1990).

[8] Vilém Flusser, *Vom Stand der Dinge. Eine kleine Philosophie des Design*, Fabian Wurm (ed.) (Göttingen: Steidl, 1993).

[9] Ibid.

[10] Ibid.

[11] Gabriella Cartago, "design, disegno," in *Studi di lessicografia italiana*, 3 vols. (Florence: Accademia della Crusca, 1981).

[12] A typical way of defining Italy as a country where provincialism is strong, reflected by the large number of bell towers that in turn represent the number of communities (villages, towns and cities) scattered over the country.

[13] The main theorist of this historical interpretation of a lively and prolific "weak" culture of design in Italy is Andrea Branzi, in his book, *Introduzione al design italiano – Una modernità incompleta* (Milan: Baldini & Castoldi, 1999).

[14] An expression derived from Giorgio De Chirico's essay "Il ritorno al mestiere," in *Valori Plastici*, nos. XI–XII, 1919.

[15] A label that comprises a variety of cultural and artistic aspects derived from the tendency expressed by the artistic group Novecento Italiano, which exhibited for the first time at the Galleria Pesaro in Milan on March 26, 1923.

[16] Branzi 1999.

Vittorio Gregotti

Architectural Culture and Industrial Design in Italy

Giovanni Muzio and
Mario Sironi
Detail of the Graphic Arts
Gallery at the IV Monza
Triennale (1930)

Giuseppe Terragni
Gallery X at the Exhibition
for the Tenth Anniversary
of the Fascist Revolution,
Rome (1932)

On page 26:
Luigi Figini and Gino Pollini
Axonometric Drawing of
the Villa-Studio for an Artist
at the V Milan Triennale
(1933)

Il disegno del prodotto industriale, Italia 1860-1980[1] is the title of the book I edited in 1982 with Bosoni, De Giorgi, and Nulli. It represented a first attempt to reassemble the history of Italian product design in that period. The work focused on the characteristically Italian application of industrial culture to the design of everyday objects, highlighting its limitations, misinterpretations, and lag with respect to the rest of Europe.

It also sought to illustrate Italy's considerable inventive and adaptive capacity and its lively artisanal tradition through its relationship with the international culture of the Modern Movement emerging in the 1920s.

This all took place within the context of imbalance in industrial development between northern and southern Italy in the twentieth century—the north being particularly advantaged in this respect—and a growing awareness of the professional autonomy of designers. This latter trend began to emerge rather late in Italy, achieving institutional and pedagogical affirmation only after mid-century. It is no wonder then that the theoretical and methodological bases of the Modern Movement were only assimilated after 1920 and that it was the architects who undertook the task of highlighting through design the values of an industrial and material culture that had enjoyed little consideration up to then.

With only rare exceptions—as found in certain writings of Carlo Cattaneo, or even earlier in the writings of Gaetano Filangeri, or Pietro Selvatico in his 1888 *Storia delle arti del disegno in Italia*— the culture of Italian industrial design had not responded to the artistic debate in eighteenth-century England, as described by Donald Klingender,[2] which culminated in the mid-nineteenth century with Henry Cole and the Crystal Palace Exhibition in London. Early twentieth-century Italy did not have

personalities such as Gottfried Semper or Hermann Muthesius, nor associations such as the Deutsche Werkbund.

In the 1930s it did not have schools such as the Bauhaus, nor the ideas of Walter Benjamin. The contradictions posed by industrial culture (the famous "Kultur-Zivilisation" dichotomy) were not described and discussed in Italy as dramatically as in other European countries.

After the era of the textile industries, it was essentially military, naval, and railway production that drove nineteenth-century Italian industrial development, marked by the rise of companies such as Ansaldo, Terni, Breda, and Falck. After the turn of the century, this role was assumed by the automotive industry (Fiat, Lancia, Alfa Romeo), motorcycles (Bianchi), the first airplanes (Caproni), typewriters (Olivetti), and telephone cables and tires (Pirelli). Models from the decorative arts were used predominantly in the production of household objects, and these models moved only sluggishly from Eclecticism towards the stylistic liberation sweeping the world at the end of the nineteenth century. Of course these were not the only sources of design in the period of industrial development. Others came from Italy's widespread and variegated artisan culture. Alongside the world famous Venetian glass tradition, this included cabinetmaking (Quarti, Bugatti, Valabrega), ironworking (Mazzucotelli), ceramics (Ginori, Florio), textiles, and metals, as well as the tradition of arts and crafts schools (and associated museums), culminating in 1906 in Milan with the foundation of the Umanitaria school.

The ferment in industrial design during the first half of the twentieth century strongly reflected the internationalism of late-nineteenth and early-twentieth century artistic culture

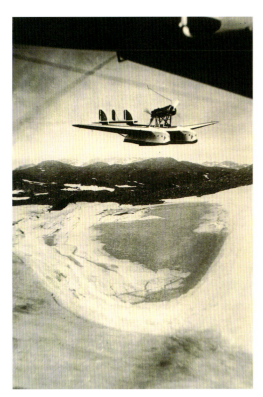

Alessandro Marchetti
S.I.A.I. S55 Seaplane
1922

(Art Nouveau, a.k.a. Stile Liberty, a.k.a. Jugendstil), which triumphed at the Turin Esposizione in 1902 and was promoted in the magazines *Emporium* and *Arte decorativa moderna* by the globalist outburst of the Futurist reconstruction of the universe, and, after 1919, by the "return to order" of the Novecento movement. These three movements, along with Fascist neo-monumentalism, were the dominant currents in the period with Rationalism being relegated to a minor role, at least up to the mid-twentieth century.

In the years between the two world wars, at least until 1938, the Monza Biennale exhibition of decorative arts, which in 1930 became the Triennale and in 1933 shifted to Milan, was an unquestionably important national and international showcase for design.

This was the arena for confrontations between the two protagonists of the period: the nationalist Novecento movement (which considered Futurism a romantic prewar movement) and the growing Italian Rationalist movement, which emerged in 1927. The thrust of Fascism, which had for many years been ambiguous in its aesthetics (at least until 1937), was directed at monumental architectural representations and therefore very indirectly at questions of object design within material culture, although the sympathies of the ruling class lay with decorative objects of Novecento-esque inspiration. The main terrain of the cultural clash was therefore architecture, which seemed to conserve its age-old pre-eminence with respect to the "minor arts" in spite of the methodological principles preached by the international Modern Movement.

The first attempts at a concrete relationship between industrial design and architecture took place towards the end of the 1930s (the exhibition of Pagano's standard took place in 1939)

and also embraced semi-finished construction materials. However, starting in the late 1920s attention was mainly dedicated to furnishings. Figini and Pollini, Pagano, Albini, Mucchi, Terragni, BBPR, Bottoni, painters such as Casorati, and a few others—that is, virtually all the leading members of the first generation of Italian Rationalism (particularly in northern Italy)—designed "modern" furniture items, often of high quality, that were sometimes produced industrially more than half a century later. They were produced in small quantities and their models were those of European Rationalism, while decorative objects and household utensils were almost always the outcome of a moderate and decorative modernization of traditional objects.

Magazines held a special status, at least among the small social group interested in the arts. The progressive decline of *Emporium* and the Novecento taste in furnishings opened the way in 1928 for the magazines *Casabella* (edited by Giuseppe Pagano and by the most lucid Italian critic of the period between the wars, Edoardo Persico), *Domus* and later, *Quadrante*. *Domus* was the most successful in terms of readership and the most eclectic, reflecting the personality of its editor, Gio Ponti.

In the 1940s proposals began to emerge that embodied criticism of the Modern Movement. These included the surrealist works of Carlo Mollino, and those of others caught up in concerns about historical tradition such as Caccia Dominioni, Gardella, and the BBPR group.

A very special and important (even if indirect) place was occupied by temporary exhibitions, which represented a field for experimentation in and convergence between architecture, graphics, object design, and the figurative arts. There was the Fascist revolution

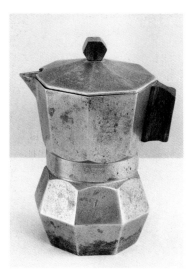

Alfonso Bialetti
Moka Coffee Maker
1930–33
First model
Produced by Bialetti

exhibition of 1932, where Futurism, Rationalism, and Novecento were brought together with the collaboration of Giuseppe Terragni and the painter Mario Sironi. At the other extreme there were the exhibitions by Persico, Nizzoli, Albini, and BBPR, close cousins to the group of Italian abstractionists (Rho, Radice, Melotti and Licini), which were full-blown and highly poetic manifestos of the Italian Modern Movement.

It may be said that industrial design became modernized (driven partly by Fascist economic policies) in the twenty years between the two wars in a manner largely independent of the cultural debate described above. A leading role was played of course by the development of the car, the most significant and popular sign of modernization. However, the country remained substantially agricultural—especially the South, but also Veneto—with significant pockets of poverty. There was, even if in a rhetorical sense, an impetus towards urban renewal and a new dynamism, marked by a characteristically Italian streamlined design.

Even the most interesting industrial products of those years—and there was certainly no shortage of them—often live on in a sort of posthumous attribution of meaning and recognition. Large and small automobile manufacturers (Fiat, Alfa Romeo, Lancia), pioneers in aircraft (Caproni, Savoia-Marchetti, and others), and also small businesses designed successful modern objects (the Moka Express is from 1933). Other examples include the radio (Allocchio Bacchini), where we note the experimental models designed by Franco Albini and Gino Pollini, or the ceramics of Pozzi. This was also a period when product designers began to make high-profile names for themselves. One revolutionary creation was the Phonola radio in 1939, designed by the Castiglioni brothers, who were to play an important role in

the history of Italian design after the war. Then there was Mario Revelli di Beaumont for cars, Celestino Rosatelli and Mario Castaldi for hydroplanes, Carlo Guzzi for motorcycles, Vincenzo Lancia with the Lambda car, Giuseppe Bianchi for electric locomotives, and many others. Cars such as the Lancia Aprilia with its self-supporting body, the aerodynamic Fiat 1500, and the Fiat Balilla 508 were to enjoy great popularity in the mid-1930s, not to mention the international success of the great ocean liners, such as the famous *Rex* of 1932. There were also the aeronautical experiments of Corradino d'Ascanio that led to the construction of the first helicopters in 1931 and the jet aeroplanes of Secondo Campini.

Separate mention must be made of the Olivetti industrial group, the most passionate adherent of Rationalism in architecture and industrial design. The engineer Aldo Magnelli (brother of abstract painter Alberto), was joined by the graphic artists Giovanni Pintori and Xanti Shawinsky (from Bauhaus), and later Marcello Nizzoli in 1940 to become the four protagonists of industrial design in the theoretical and methodological wake of the Modern Movement.

The postwar and post-Fascism years affirmed the connection between culture and politics, also in industrial product design, a connection that had crept into awareness during the last three terrible years of the conflict and the war of liberation. In the progressive camp an exemplary case was the clash in leftist culture between the inheritance of the internationalist avant-garde and the various forms of Socialist Realism. But first and foremost there was the need for reconstruction of the country. This was the driving force behind a disordered, imbalanced, but very vital renewal that also touched on the culture of design. The VIII and IX Triennali concentrated on the theme of popular housing and

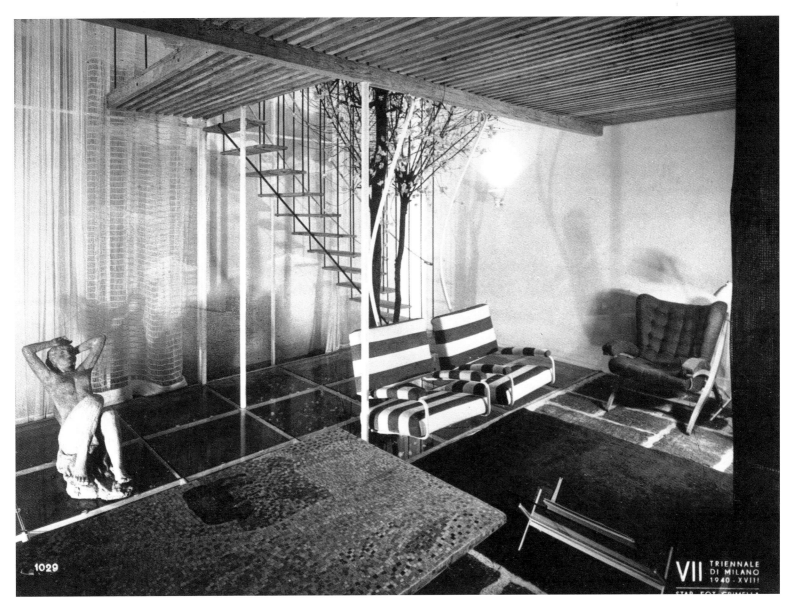

Franco Albini
Living Room of a Villa
at the VII Milan Triennale
(1940)

furnishings. *Domus* magazine was, if only for a brief period under the editorship of Ernesto Rogers, an important tool in forging new connections with the international culture of the Modern Movement, and a great critic, Giulio Carlo Argan, was the leading theoretical thinker.

In 1952 *Casabella* was reborn, and in 1954 the magazine *Stile Industria* was created, devoted entirely to product design. In the same year, La Rinascente department stores organized the Compasso d'Oro prize, which for half a century has been awarded to the designers of the best Italian objects.

In 1956 the Associazioni per il Disegno Industriale (ADI) was founded with the aim of recognizing and honouring the independent profession of the designer.

Large- and medium-scale industries produced items (formally wholly independent of the tradition of the decorative arts) such as scooters (Corradino d'Ascanio's Vespa in 1946, Pallavicino's Lambretta of 1947, and Torre's of 1950), the Isetta bubble-car in 1953, and the minitaxi by Pio Manzù in 1968. In the automobile field, the car-body designers Pininfarina, Bertone, and Zagato became internationally famous, but the most important individual was Dante Giocosa, who between 1955 and 1957 designed the affordable Fiats 600 and 500, which became incredibly popular in Italy.

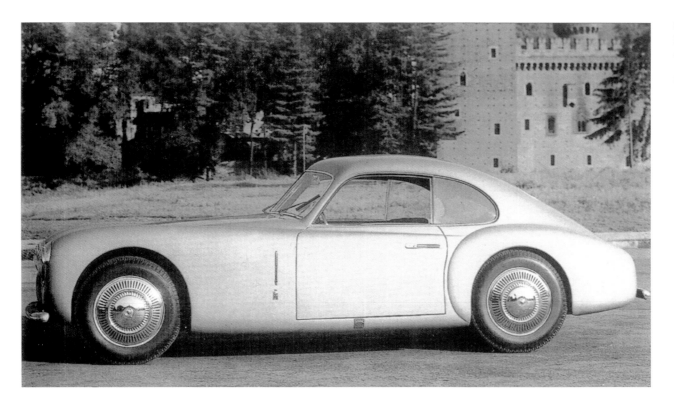

Carrozzeria Pininfarina,
Dante Giacosa, eng.
*Berlinetta Cisitalia
Tipo 202*
Produced by Cisitalia

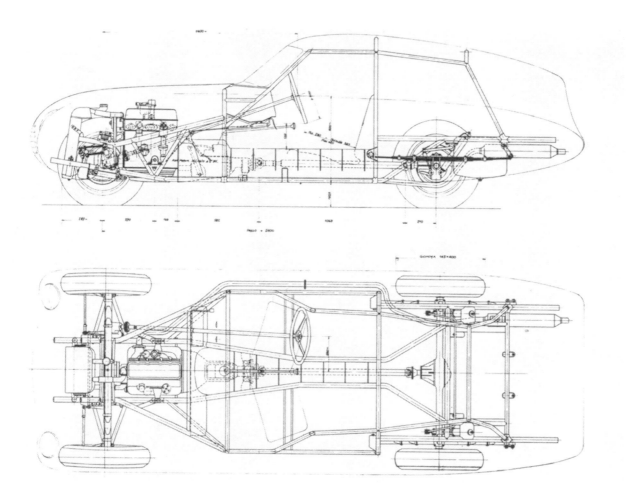

Dante Giacosa with
Bosattino
Assembly Drawing of the
Chassis and Tubular Body
of the Cisitalia Coupe
July 1945
Produced by Cisitalia

Pier Luigi Torre
Lambretta Scooter
1949
Produced by Innocenti

Corradino d'Ascanio
Assembly Drawing of the
Body of the Vespa 125
1953
Produced by Piaggio

In 1954 Fiat Aviation built the G91 light fighter, designed by Gabrielli in a very Modern tradition. Olivetti consolidated its tradition starting with the collaboration with Marcello Nizzoli (Lexicon 80 and Lettera 22 in 1948 and 1950, respectively), then with the famous items by Ettore Sottsass, and finally with Mario Bellini in the years of electronics.

In the late 1950s and early 1960s, a series of medium-sized companies emerged whose philosophy was to combine production with the work of designers: Kartell for plastic materials, Olivetti (as well as Fantoni and Castelli) for office systems, Artemide and Arteluce for lighting, Cassina, Busnelli, and Zanotta for furnishings, Pirelli for foam rubber in furnishings, and many others. Some later produced restyled versions of classic pieces from the early years of the Modern Movement, midway between revival and a genuine interest in modern culture.

Production processes remained a source of formal inspiration for many. A representative example is the creative vigour of Marco Zanuso, one of the leading figures in the aesthetic debate, and throughout the 1980s the most significant designer and innovator of production-process-oriented objects. During this period architects remained the most important designers of objects for the home.

In the 1950s Franco Albini designed some extraordinary pieces of furniture for the home, reinventing the tradition of handicrafts. It was in those years that Gio Ponti designed his best piece, the superlight *Chiavari* chair, and a number of designers from the next generation, led by Magistretti, began their brilliant careers. The architects Caccia Dominioni and Gardella constituted a special current, reinterpreting the Milanese Neoclassical tradition through the Azucena trade name. The subsequent

generation (Gregotti, Gabetti and Isola, Aulenti, Rossi, Portoghesi, and others) followed a similar path in the late 1950s with their reinterpretation of *fin de siècle* tradition, raising the issue of the relationship of design with memory and tradition.

A particularly important place was occupied by the Castiglioni brothers, whose products were manufactured in large numbers until the 1990s. They produced a highly acute and original interpretation that resembled the modern self-assembly furniture tradition, with radical inventions and references to Italian Futurism.

The choice of the year 1964 as representing the passage to the subsequent phase is, I realize, entirely conventional. The move to mass culture has its roots in the second half of the 1950s, due to increases in living standards, consumption, and car ownership, and extended beyond the crisis of 1968. The VIII Milan Triennale of 1964, a critical exploration of leisure time, was the outcome of a rich and variegated collaboration among men of letters (Umberto Eco), musicians (Luciano Berio), architects (Gregotti, Aulenti, Aymonino, Rossi), painters (Fontana, Baj, Mari, Colombo), and movie people (Brass, Munari-Piccardo). The show aptly represented the shift to mass culture and its contradictions, as well as the advancing notion of total environment.

The exhibition marked the apex of the boom in consumption and mechanization of the home, but also that of the theoretical debates on models of development and the role of design.

In 1964 the first stretch of the Milan subway was built based on designs by Franco Albini and Bob Noorda (an example of the positive link between architecture, design and graphics).

It also marked the beginning of a significant architect-designer

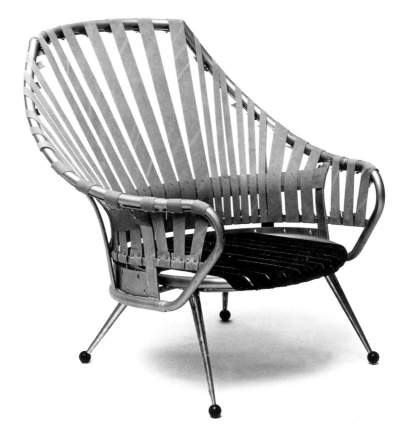

Marco Zanuso
Martingala Armchair
1954
Produced by Arflex
The same armchair is
shown below broken
down into its structural
elements and upholstery.

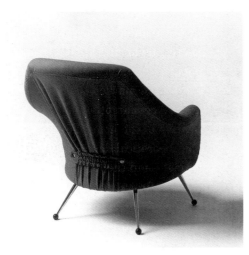

collaboration with Valle and Mangiarotti's work in semi-finished and prefabricated construction materials. From 1960 to 1980, Italian design flourished and gained widespread international success. Its leading figures were well known and had considerable professional training. Those who had made their names prior to the political crisis of 1968 came through it without serious consequences.

Small- and large-scale industrial companies also had solid relations with the culture of design: in 1977 Giugiaro and Mantovani's Italdesign (founded in 1968) designed the Fiat Panda and some taxi prototypes for Alfa Romeo, while also receiving contracts from many foreign car manufacturers. Rodolfo Bonetto was involved in the (ergonomic) design of machine tools, the Piaggio company produced a new type of moped and designs for public transport, while Olivetti continued to produce calculators, typewriters and electronic goods.

The design world responded to the political crisis of 1968 in two different ways. On the one hand there was a focus on participatory, do-it-yourself products (Dalisi), and simple technologies, but also on radical political commitment (Enzo Mari) through objects with an absolutely rigorous raison d'être. On the other, it moved towards a freedom from rules, with decoration becoming the realm of imagination and desires, a utopia of libertarian aesthetic radicalism, as seen in the various visual art movements that converged into one great stream of generalized aestheticization of commonplace objects.

The most extensive and comprehensive overview of this phase of Italian design is the catalogue of the exhibition on Italian design at the MoMA of New York in 1972. The exhibition explored both the various "movements" and also the way in which Italian "designers" had encapsulated and neutralized the crisis of 1968 through a process of aestheticization. The exhibition at the MoMA also testified to the international success of Italian design across the board, celebrating

Danese with Enzo Mari and Bruno Munari, Marco Zanuso, Vico Magistretti, and many others who developed as designers in the early 1960s. Others were involved in a kind of "democratic" design (school supplies, babycare goods, urban fixtures, and so on), in which utility prevailed over market image.

There was of course no shortage of figurative influence from Pop art (De Pas, Pesce, Gruppo Strum, Gilardi, Archizoom, UFO, and many others), as seen in the use of bright colours, formal techniques, enlargement, and the introduction of "soft" objects and "weak design" as we might define it now.

Joe Colombo, Mario Bellini, Gae Aulenti, Cini Boeri, Giotto Stoppino, and Paolo Deganello also offered a wide range of products whose inventiveness however did not go so far as to transgress the design principles of the modern tradition or upset the equilibrium between functionality, even of innovative materials, and figurative creativity. This was also the period of more mature projects by names we have already mentioned: Achille Castiglioni, Enzo Mari and Marco Zanuso, and most importantly Ettore Sottsass.

About 1980 the concept of industrial design shifted radically and became simply "design," and made a clean break from the culture—and also the profession—of architecture. Conversely, the gap narrowed between design and the visual arts, and a general process of aestheticization of manufactured articles took place, in keeping with the principle advanced in the United States in the late 1950s: form was to respond to the ideology of the market, and not to the requisite of function, which was relegated to an accessory role. In some ways the design of manufactured articles returned to being "decorative art," with all its associated symbolic and anti-modern baggage. This also implied an expanded and independent responsibility to foster and describe political and anthropological connections with all their polycentrism and uncertainty. Also involved was an abandonment of the forms deriving from the avant-garde Constructivist tradition in search of other softer, more overloaded morphological fields: hence Metaphysical art or Surrealism, Pop art or Conceptualism, rather than the Rationalist tradition. Industrial

Gino Valle
Airport Flight and Time
Indicator
1962
Produced by Solari,
Udine

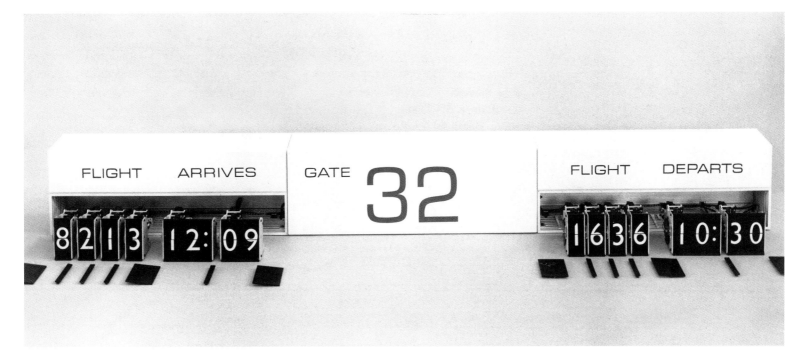

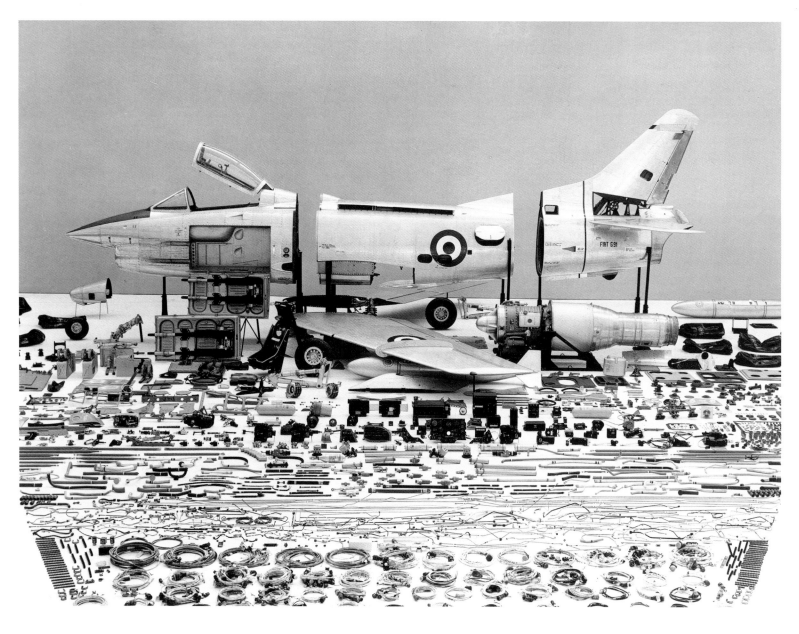

Giuseppe Gabrielli
and Fiat Technical Office
The components
of the *Fiat G91*
light tactical fighter
1954
Produced by Fiat Aviazione

production generally entered a
deepening crisis in Italy while at the
same time introducing a great number
of variants into its production (made
possible by electronically controlled
machines) in an anti-Fordist but also
anti-egalitarian polemic. Many
industrial resources were shifted from
innovation into advertising, with the
thrust being oriented towards
a continual updating of the physical
appearance of products coupled with
the creation of a need for it, generally
via the mass media.

Furthermore, the early 1980s marked
the overtaking of industry by the
commercial and service sectors and the

success of the small-scale industry of the
"third Italies": Veneto and Le Marche.
Italy's economy improved in this period,
partly due to the international success
of Italian products, heralding the
emergence of design as a marketable
asset. This imbued the design process
with a strong creative stimulus, one
no longer grounded in method and
principles but inspired by the value
of freedom conceived as an absence
of limits (hence, anything goes) rather
than as a plan. It also created within
it a desire for independence from the
rationale of industrial production.

The Memphis group (preceded by the
Archizoom group, Studio Alchimia and

Ettore Sottsass
with H. von Klier
and A. van Houck
Elea 9003 Computer
1959
Produced by Olivetti

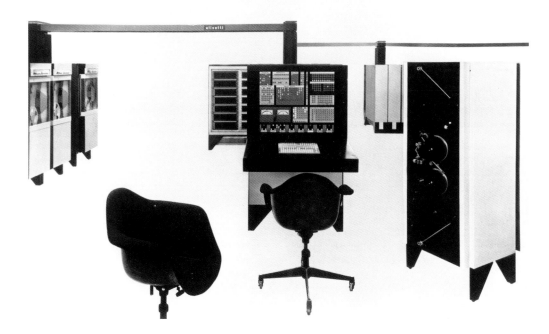

others) grew out of the initial impetus in this direction, embodying an attempt to tap directly and uncritically into the new reality of incessant change characterizing the countries that were richest in both services and industry.

It was a neo-avant-garde movement constructed out of pieces of everyday empirical reality: comic strips, pop culture, decoration, advertising, audiovisuals, fashion, and some mementos of Art Deco. Its members openly advocated the representation of the ephemeral, of consumer goods, and also of the feelings and complexes of the younger generations, of their rebellion and its sublimation into luxury. Ettore Sottsass, by far the group's most creative and original progenitor, brought with him his experience in the design of Olivetti typewriters, early computers (the Elea 9003), and even the company's first PCs in 1984. He was well versed in the sentiments of the Unites States beat generation, and, in a moment of existential crisis, had gained much from his encounter with Indian spiritual and morphological culture.

The community of designers began to burgeon. At the close of the millennium, every department of architecture had its own well-attended design course. There were also specialist schools, courses at the arts academies, and a large number of dilettantes who moved from fashion or advertising to design, a trend that gradually spread also to southern Italy.

In the history of Italian design covering the last twenty years, instruments of communication have played a particularly important role: the medium, as we know, has become the message, which can become the vehicle for any content or desire.

The aesthetic quest took a great many different forms in this period: from attention to new materials to the aesthetics of recycled items, from "ecological design" to virtual reality, from stimuli prompted by miniaturization to the non-material, from stylistic revivals to the rhythm of seasonal fashions, and from the total-decor house to responses to the need for luxury and retrospective neo-decorativism. Thus the number of

designers (including those who came to design from other disciplines) increased, resulting in the extension and dilution of the very notion of creativity.

The progressive slowdown (with obvious exceptions) of industrial research translated into a decrease in the variety of products in the last decade of the century. To make matters worse, products only appeared when highlighted via advertising, selected for this stage on the basis of their economy or singular image. But this all took place within the context of the host of new products with entirely analogous characteristics, principles, and objectives arriving freely from all over the world—in the name of the globalism of the developed countries.

Starting particularly in the last decade of the century, the instruments of non-material communication, the whole range of computers and the ever more numerous combinations among their functions have obviously occupied a prominent place, displacing entire categories of products from the market. However, this is an area where "Italian design" seems to have contributed very little.

The upheaval of meaning in recent years has taken the form of a reduction of every visual, material, and non-material aspect to "design." The same trend has occurred in the figurative arts and even architecture, which now produces enlarged design objects deployed in a raging spirit of competition.

The globalization of markets and of communications media with its dizzying speed of transformation has replaced European culture's critical internationalism as an ideology. If this is an adequate description of the shift in the arts from a critical and utopian attitude—marked by a constant questioning of their role and their instruments, which characterized their development in the first thirty years of the twentieth century—to a form of faithful representation, and profit-minded, non-critical adhesion to the post-social condition in which we live, then design is the sole art (if this word still has any meaning) of the twenty-first century, in which everything is represented in lockstep with a 'certified' reality in a manner that we have not witnessed for at least five centuries.

Enzo Mari
Flores Box
1992
Produced by Danese

Achille and Pier Giacomo
Castiglioni
Light Switch
1968
Produced by VLM

This makes it very hard among the overwhelming quantity of products to find processes, methods, rules, and rationales that might provide a basis for sound judgments within a constantly mutating perimeter of perception, especially when infractions are so rife that they are no longer a cause for scandal; indeed the only scandal would be the re-establishment of the rule itself. This all lies within an unresolved contradiction between the aspiration to absolute subjectivization and a desire for total homogeneity of behaviours and induced desires confined within a strictly limited range: between the absolute positivity of market ideology and the rigid cement limits of technological progress (containing within it the environmental issue).

Even if we cannot help being impressed by the enduring success of Italian design in the world, the questions posed above no longer regard exclusively an isolated Italian case. They have become globalized in the limited, so-called "advanced" portion of the world gazing beneficently on the other half. It is difficult to envisage how and when we will emerge from this condition and what role may be played by the great wealth of experience in "design" when design at last regains its full, Renaissance sense.

[1] Vittorio Gregotti (ed.) with G. Bosoni, M. de Giorgi, A. Nulli, *Il disegno del prodotto industriale*, *Italia 1860-1980* (Milan: Electa edizioni, 1981).
[2] Francis Donald Klingender, *Art and the Industrial Revolution* (London: Adams and Mackay Ltd, 1968).

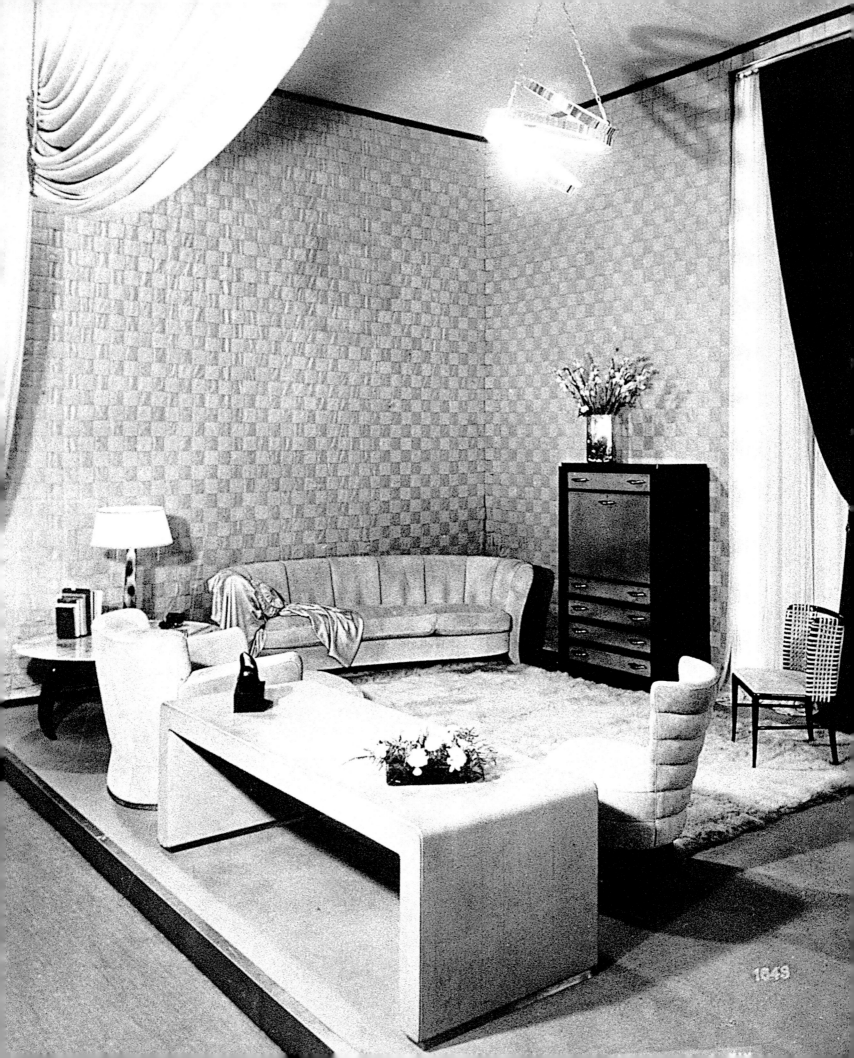

Irene de Guttry
Maria Paola Maino

From Artist-artisans
to Architect-designers

On page 40:
Guglielmo Ulrich
Living Room at
the VI Milan Triennale (1936)

The wealth of art in Italy is unmatched: all ages since antiquity have contributed directly to the creation of its immeasurable heritage. Such continuity has meant that the applied arts have benefited from the handing down from generation to generation of a unique knowledge of craft and a manual dexterity nurtured over the centuries by the power and ambitions of princes and popes.

In the early decades of the twentieth century the role of craftsmen was still fundamental: it was through their virtuosity that the creativity of designers found expression. It was the norm for objects to be handmade, and every sector of the applied arts had its own sublime interpreters. Moreover, the artisan was not a mere anonymous executor; in some cases, if creative and enterprising, he could become the leading actor.

In Italy at that time it was mostly the painters and sculptors, influenced by William Morris, who devoted themselves to the decorative arts. Although Morris' example was propagated all over the Western world, in Italy this influence cannot be considered a reaction to industrialization, given the still substantially agricultural state of the country at the time. With the industrial developments of the 1930s, artists were replaced by architects and the country gradually entered the age of industrial design.

The works in this exhibition are a selection extrapolated from a highly complex history. The story woven together here was inspired by careful study of the works themselves.

Towards modernity
In Italy, the turning point came in the final years of the nineteenth century as a reaction to academic conservatism and historicist eclecticism.

The weight of historical styles was particularly oppressive in Italy compared to other countries, on account of the country's "glorious" past. The reunification of Italy was still recent so a national culture as such did not exist[1]; on the contrary, there were many regional cultures in which ancient homegrown traditions and contributions inherited from various foreign rulers intermingled. The artistic elite was divided into small groups and operated at the local level. The young State, struggling to commence its process of modernization through the creation of schools,[2] roads, railways and infrastructures, was aiming at industrial development. While the south, the land of large estates, remained inexorably backward, in the north, particularly in the Piedmont–Liguria–Lombardy triangle, the first industrial manufacturers were appearing. The transformations that followed led to the creation of a social and political awareness that also involved artists.[3]

Sympathizing with the urban and rural proletariat, the Divisionist painters in Lombardy—Giovanni Segantini, Angelo Morbelli, Gaetano Previati and Giuseppe Pellizza da Volpedo—were the first artists to denounce the inhuman living conditions the poor were forced to endure. To contrast with the sentimental current of Verismo, they adopted a new formal language based on the decomposition of light and colour; meanwhile, in Rome also Balla and Boccioni started their own explorations into Divisionism.

Bugatti the star
The first representative of Italian excellence in the decorative arts was Carlo Bugatti.

It has often been said that Bugatti was the extraordinary artist who succeeded in passing through historicist eclecticism and transforming it into Art Nouveau. The Milanese artist, whose works were and are still immediately recognizable, was a child of artistic parents, and his sculptor father studied perpetual motion: technical and artistic

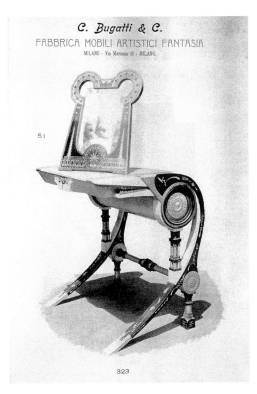

A page from the sales
catalogue of C. Bugatti & C.,
about 1902.

invention were the Bugatti family's prerogative. Carlo experimented with special glues and invented bicycles and musical instruments. As a boy he attended the Accademia in Brera where he became closely associated with Giovanni Segantini and his entourage, subsequently becoming the painter's brother-in-law. He also painted and served an apprenticeship with an elderly, very capable cabinetmaker, Mentasti. Bugatti's furniture, which at the time was linked to the popular fashion of Orientalism, was a disquieting mixture of architectural styles, asymmetrical exotic decorations and materials of animal, vegetable and mineral origin. Parchment, his preferred material, covered the flat surfaces and was hand-painted by him, Milanese painters and his children, who were precocious apprentices. The style evolved over twenty years of work devoted to cabinetmaking, reaching its apex at the international exhibition in Turin in 1902, where the anthropomorphic, white and almost science-fiction-like room *della chiocciola* [the "Snail Room"] left critics and the public speechless (cat. 52). It was clear that Bugatti was too far ahead of his time and bound to be misunderstood. Original and avant-garde, by about 1890 he had patented his models and assigned them for construction and sale to the company Meroni e Fossati. His custom of designing complete environments using plaster models was highly unusual. His furniture adorned the houses of Puccini, Marinetti and Segantini and was a status symbol in the houses of rich eccentric aristocrats.

After his move to France (1904), where for some years he created silver household furnishings for the Hébrard foundry, he was forgotten in Italy and his name was overshadowed by the great success of his son Ettore, the famous designer of futuristic cars and engines. The career of his other son Rembrandt, an Animalier sculptor (cat. 54), followed its own short, not altogether successful but extraordinary path.

Art Nouveau: Stile Liberty or Stile Floreale
The great exhibitions that were so much in vogue in the nineteenth century, such as the Great Exhibition at the Crystal Palace in England in 1851, conveyed modernity. As an expression of commercial and industrial development, scientific research and artistic experimentation, they provided an opportunity for comparisons to be made between cultures and were an effective way of circulating ideas and stimulating economic growth. If the contemporary theories of Art Nouveau entered Italy, this was due not so much to its promotion by art critics in the magazines *Arte Italiana Decorativa e Industriale* and *Emporium* as to the considerable involvement of artists, craftsmen and entrepreneurs in these international shows.[4]

At the 1900 Exposition Universelle in Paris, leading members of the Italian decorative arts showed that they had by this time taken up the new art, which in Italy went by the name of Stile Floreale or Stile Liberty.[5]

The Florentine factory Arte della Ceramica won the Grand Prix at the exhibition for the quality and originality of its works. The company was founded in 1896 by its artistic director Galileo Chini, with some of his fellow students at the Accademia di Belle Arti in Florence. An early interpreter of the Modern style, Chini—a painter, decorator, poster designer, illustrator, set designer and the creator of memorable mural decorations— was the first important Italian ceramicist to turn to industrial production. He designed plates, vases, tiles and small sculptures with decorative flowers, volutes and female faces, which initially showed traces of the Renaissance decorative culture prevalent in Tuscany, but later moved towards free

The Casa dell'Arte in
Florence, a shop founded
by Galileo Chini with
artists Salvino Tofanari
and Ugo Fioravanti.
The display case
is by Chini
From the magazine
L'Ambiente moderno,
no. 1, pl. 69, Milan,
undated [1910]

interpretations of nature. The small
workshop enjoyed tremendous success
and soon grew into a busy industrial
factory with a catalogue of hundreds of
models, some of which were produced for
the building trade. Chini's dynamic
creativity found an outlet not only in the
continuous invention of different forms
and new, increasingly stylized
decorations, but also in experimenting
with firing techniques, coloration and
texture (cat. 86).

One of the first to appreciate Chini
was Federico Tesio, who inserted pieces
of his multicoloured majolica disks into
items of furniture. Tesio's involvement in
the history of Italian furniture was
limited to a single episode. He was in fact
neither a cabinetmaker nor a designer,
but an avant-garde dandy. In 1898 he
moved to a villa in Dormelletto in
northern Piedmont where he built a
stable in order to breed thoroughbred
racehorses: the champions Ribot and
Varenne were born in his stable. An
advocate of modernity, he designed a
series of highly original pieces of
furniture for his house (cat. 334). He
undoubtedly drew inspiration from what
he had seen abroad, learning from the
Arts and Crafts movement a taste for
simplicity. But the audacity of his forms
and their functionality combined with a
structural solidity revealed an
independent and unique creative talent.
His was a case of Italian individualistic
excellence: even though few of his works
remain, Tesio has his place in the "Italian
way" because of his daring design.

The Grand Prix at the 1900 Exposition
in Paris was won by Eugenio Quarti. The
son of a carpenter, Quarti was a typical
product of the enlightened proletariat
who achieved success through the
mystical practice of labour. He began to
work when still just a boy, at the same
time attending evening art classes. At the
age of twenty-one, having spent a few
months in Carlo Bugatti's studio, he

opened his own workshop in Milan,
employing three workers. He was among
the first to join the progressive surge,
promote the new art, and design pieces
with elaborate stylized floral decorations
with carvings and inlays (cat. 282).
His mastery of execution and exquisite
workmanship made Quarti the heir to
Lombard cabinetmakers like Maggiolini
and Pogliani who, for the inlay work of
their furniture, combined woods, selected
for their natural colour, with ivory,
mother-of-pearl and various metals.
Quarti only made furniture designed by
himself. In just a few years, he became
the cabinetmaker most sought after by
architects and a wealthy clientele alike.
In 1904 he opened a new workshop with
more than fifty employees, transforming
his firm of artisans into an industrial
enterprise. In an ongoing search for
modernity, he created entire, expensive
interiors for which he also designed the
fabrics, lamps, stained glass windows and
carpets. In the 1930s the Quarti name
remained a mark of excellence under the
direction of his son Mario.

In Milan Quarti's competitor was
Carlo Zen whose furniture factory had
been operating since 1881. The company
distinguished itself with the high quality
of its work, but Zen had commercial
goals and combined extensive production
of furniture copied from various styles
with a modern section that followed the
various contemporary trends. In Zen's
work the abundant use of mother-of-
pearl and metal filaments (derived from
Bugatti and Quarti) as decoration was
cleverly incorporated into Art Nouveau
and Secessionist forms; pictorial inserts
of Orientalist taste stood out against a
dark wood ground in pretentious living-
room furniture. However, some pieces
remain significant due to their original
interpretation of contemporary taste and
the artistic and technical skill with
which they were made (cats. 360,
361, 362).

Another central figure of the period—who was at the same time creator, manufacturer and entrepreneur on a par with Eugenio Quarti—was the blacksmith Alessandro Mazzucotelli. Since his participation in the Exposition Universelle in Paris in 1900, he had been an interpreter of the new art like Quarti, his friend and companion in many enterprises. Mazzucotelli collaborated closely with architects (Giuseppe Sommaruga, Ernesto Pirovano, Ulisse Stacchini), creating gates, handrails and balusters for their buildings, but also furnishing accessories, lamps (cat. 199), frames, torch holders, stools and small sculptures. Gradually the Stile Liberty forms Mazzucotelli produced evolved towards more abstract and geometric designs. His workshop, which had become the biggest and most famous in Italy, also received large orders from abroad. Both Quarti and Mazzucotelli belonged to the Milanese art world: Quarti was supported by Vittore Grubicy, the promoter of the Divisionist painters, and Mazzucotelli was associated with Bugatti, who fitted out his stand at the Esposizione Internazionale delle Arti Decorative in Turin in 1902. In 1903 they were called upon to teach at the Società Umanitaria, one to run the metalwork department, the other the cabinetmaking department at the new workshop-schools. The Umanitaria was a lay and Socialist association founded in 1893, thanks to a philanthropic legacy, which had the mission, as the articles of association stated, of "putting the disinherited, without discrimination, in a position to stand up for themselves, providing them with accommodation, work and education." In the avant-garde in every field, the Umanitaria enabled students to develop their talent freely in light of contemporary theories. In order for Quarti and Mazzucotelli to experience the international artistic climate directly before they began teaching, which they

considered a social service, the Umanitaria financed them to take a cultural trip to Northern Europe. Both were active therefore on two fronts: they devoted themselves on the one hand to the cause of humanitarian Socialism, and on the other to producing goods for the very rich. The contradiction whereby art, understood as "for all," was in reality "for the few," was to emerge clearly: the manufactured articles made by them were valuable and expensive and therefore destined only for wealthy buyers.

In the first decade of the twentieth century, under the reformist Liberal-Democratic government of Giovanni Giolitti,[6] Italy also lived through its *belle époque*, a time of prosperity and economic and social progress.

In 1901 the political and financial establishment promoted a large international exhibition of exclusively modern decorative art to stimulate industrial companies and the purchasing power of the emerging middle class. The exhibition was opened in Turin in the spring of 1902 in the presence of King Victor Emmanuel III and was intended to celebrate the official recognition of the new art in all its aspects, encompassing graphics, furniture, ceramics, glass and fabrics, laying claim to a specific Italian primacy in all these areas. It was no coincidence that the only criticism made of the beautiful Stile Liberty pavilions designed by Raimondo D'Aronco was that they showed the influence of the Viennese Secession. It emerged that the vast majority of the 250 Italian exhibitors came almost exclusively from northern Italy;[7] the economic, social and industrial divide between north and south, already dramatically evident during the Risorgimento, was now taken to the extreme.

The only rooms representing southern Italy were devised by Sicilians Vittorio Ducrot, a furniture manufacturer, and Ernesto Basile, an architect. The

association between Ducrot, a young and dynamic entrepreneur with initiative and organizational ability (he transformed the artisanal workshop of his stepfather Golia into a large industrial complex), and Basile, the established professional and professor, as his father had been, of Architecture at the University of Palermo, lasted for ten years: the first job to bring them together was the furnishing of the reception room at the Grand Hotel Villa Igiea in Palermo in 1898, an astonishing masterpiece in the latest fashion (commissioned by the Florio family, patrons of art, shipowners, industrialists and large estate owners who fostered a dynamic cultural period in Sicily that was to last a generation); the final piece in the mosaic of their collaboration was the enlargement of Palazzo Montecitorio in Rome with the new wing of the Parliament.

Of the three rooms they presented in Turin, two exemplified luxury Art Nouveau production with Arabian-Norman influences typical of Basile's style. The third, the Work Room, was more functional and reasonably priced, and consisted of undecorated furniture in which the most notable feature was the wood joints. Produced by Ducrot in hundreds of models, they are a milestone in the history of Italian furniture as a prime example of industrial design. The twin approach—the exclusive item of furniture sometimes decorated by painters and sculptors, and the very popular and affordable piece—was to remain a favourite theme of the Basile–Ducrot team, as shown by the rooms presented at the subsequent exhibitions, at the Biennali in Venice and the Exposition that in Milan in 1906 celebrated a major public work, the Sempione Tunnel, which connects Piedmont with Switzerland (cat. 215). In the Milan exhibition it was once again Quarti, Mazzucotelli, Ducrot and Zen who excelled in the decorative arts pavilion frescoed by Chini. Whereas the 1902

Ernesto Basi (designer)
and Ducrot (builder),
the Chamber of the Italian
Parliament in Palazzo
Montecitorio, Rome
(1904–18)
Visible are the frieze
painted by Giulio Aristide
Sartorio and the bronze
high relief by Davide
Calandra.

Esposizione in Turin had confirmed the triumph of Art Nouveau, this one announced its decline, anticipating an involution that would once again look back to historical styles.

Cambellotti the interpreter of Modernism in Rome
The driving force in Rome, the capital of the new kingdom, was politics and all the bureaucratic apparatus surrounding it. Industrial companies were prohibited there in order to avoid social conflict, and power was in the hands of the landed aristocracy and the new class of builders riding the turmoil of the city's expansion. The traditional destination of artists, the city was the centre of cultural debate and society life. At the turn of the century, Gabriele

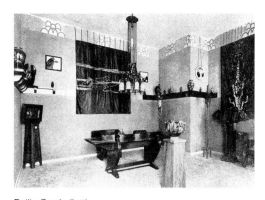

Duilio Cambellotti
Study at the
Prima Esposizione
Internazionale delle Arti
Decorative Moderne,
Monza (1923)

D'Annunzio, who played an influential role, involved the young talents of his generation (Sartorio, De Carolis, among others) in avant-garde publishing enterprises. Duilio Cambellotti, taken on by D'Annunzio in 1907 as a set and costume designer for the drama *La nave*, won his first public success.

The son of a craftsman, Cambellotti almost naturally promoted Morris' cause of equating the minor and major arts. A gifted and versatile artist, set designer, graphic designer, illustrator and sculptor, he designed furniture (cats. 59 and 61), tapestries and embroidery and made glass windows, pottery and jewellery, which were almost always unique because of the lack of industrial manufacturers in the capital. After an initial period devoted to Stile Liberty, he developed his own modern style, drawing inspiration from the archaic world of the Roman countryside, of which he offered a symbolist, mythical and substantially anti-naturalistic interpretation.

Cambellotti was an artist with progressive ideas. He contributed to the Socialist newspaper *L'Avanti della Domenica* and the periodical *Il Divenire Sociale*; he also read Tolstoy and had met Maxim Gorky. When he became aware of the awful living conditions of the inhabitants of the Roman countryside, denied education, exploited by their landowning bosses and whose lives were decimated by malaria in the early years of the new century, he became a member of the committee for the creation of free schools founded by a group of philanthropists with the intention of rescuing rural communities from illiteracy. With the painter Vittorio Grassi and other artist friends, he promoted the foundation in 1908 of the magazine *La Casa*, a bi-weekly illustrated publication of "aesthetics, decoration and modern housekeeping," which popularized the theoretical principles of central European modernism. Aimed at a wide readership drawn from every social class, inexpensive and printed on low-quality paper, the magazine illustrated bright interiors, simple lines and the use of plain materials. Some examples of furniture were illustrated: those by Duilio Cambellotti were austere, sculptural, solid, vibrant with energy, whereas Grassi's were simple and functional, easy to take apart, and built in parts for assembly through interlocking joints.

Cambellotti devoted some of his time to producing ideologically inspired graphics (illustrations, advertisements and posters) that directly communicated messages to the broadest possible public. The strong, black lines and aesthetic symbolism of his wood-engraving designs formed a style that he kept the rest of his life. A modern but not revolutionary pacifist, he kept away from the Futurist current that would sweep up his friend Giacomo Balla.

At the first two Biennali delle Arti Decorative in Monza in the 1920s, Cambellotti was in charge of the Lazio section. He himself designed the Study in 1923 and the Earth Room in 1925, employing simple, furniture rustic in form but decorated with inlay and ivory, bronze, copper and iron elements.

Other lines of investigation between past and future
In Venice, a centre of the arts since its first Esposizione Internazionale d'Arte in 1895, the young painter Mariano Fortuny gained a reputation as a couturier and fabric designer with great flair.

He lived in Venice from the age of eighteen with his mother, a collector of Renaissance textiles. Having studied early dyeing and decorating techniques, in 1906 Fortuny began producing his own fabrics, inventing a silkscreen printing process for decorative motifs. He had a dual working method: the invention of modern techniques on the one hand, and

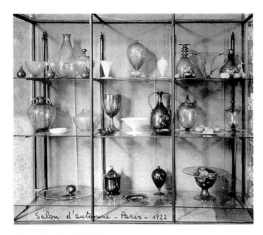

Cappellin, Venini & C.
Glass items by
Vittorio Zecchin
Salon d'Automne,
Paris (1922)

the revival of craftsmanship and the adoption of models from the past on the other. He devoted himself to both the decoration of materials and the creation of gowns—silks and velvets printed in gold and silver, with designs taken from the Renaissance or inspired by the Arab world. These were sumptuous versions of traditional models that he took from the cultures of the Middle and Far East. The year 1907 saw the famous *Delphos* dresses inspired by the Charioteer of Delphi (cats. 150 and 151), with simple pleated tunics and hemmed with glass beads specially manufactured in Murano. Though looking to the past, Fortuny had a modern awareness of the commercial value of his inventions and patented all the objects he created.

At the 1914 Biennale in Venice the painter Vittorio Zecchin, a Venetian son of a glassworker, presented a number of Murrina glasses. Trained at the Accademia di Belle Arti, he was to be one of the main architects of the revival of the arts of glass- and lace-making that had for centuries been the prerogative and the boast of the islands of Murano and Burano respectively. The Biennale was of fundamental importance in that it introduced him to the painting of artists belonging to other cultures: he was influenced by the mystical symbolism of Toorop and the mosaic-like decorativism of Klimt. The slender, wide-eyed maidens in his paintings who emerge from a dense pattern of arabesques, wrapped in long, splendid mantles, lend themselves to enamel and gold decoration on glass and transposition onto silk- and wool-embroidered tapestries. Foremost an artist-artisan and creator of one-of-a-kind pieces, in the 1920s and 1930s Zecchin devoted himself above all to the art of glassmaking, and became a designer for Venini and later for other glassworks. He used his talent to create new forms that expert craftsmen then repeated in hundreds of copies.

Futurism
The first Italian avant-garde movement, Futurism was founded by Marinetti in 1909 (its manifesto was published in Paris in *Le Figaro* on February 20) and progressively took root in every part of Italy. It was founded on the declared congenial affinity of its members, who developed a strong sense of group affiliation, as though they were a caste extolling an outrageous lifestyle. In their disdain for convention and their worship of the machine and progress, the Futurists practised art as action and developed radically new themes and artistic languages inspired by the industrial city and the myth of speed. Initially the movement revolved around painting and sculpture but it then opened up to every sphere, including literature, theatre, music, film, architecture, the applied arts and even politics. In architecture they limited themselves to projects that remained on paper, partly because Antonio Sant'Elia, its leading member, who designed extremely beautiful, futuristic and provocative buildings, was killed at the front in 1916, having enlisted as a volunteer—the Futurists were war enthusiasts and praised Italy's joining the war.

In 1919 the silversmith Arrigo Finzi, Sant'Elia's close friend, executed the silver "navette" entitled *Futurismo* (cat. 138), which they had designed together. Subsequently, Finzi became the owner of one of the most important Milanese companies producing gold and silver, and he branded his range of modern products "Sant'Elia" to honour his friend's memory.

Futurist ideology, based on speed and the dynamism of action, was optimistic in nature and, in the case of Balla and Depero, the most important designers of Futurist furniture, also decidedly playful. In 1915 the two, referring to themselves as "Futurist Abstractionists," published a manifesto with the title *Futurist*

Reconstruction of the Universe, which stated their intention of completely renewing the surrounding reality. They reinterpreted the "global design" postulated by Art Nouveau, but in a radically different manner. The reconstruction in question concerned not only the design of environments, but also behaviour and clothing: their suits—"*aggressive*, able to multiply courage, *dynamic* in their patterns and colours"[8]—communicated the provocative message publicly. Aware of the influence that the environment exercises on our moods, in their designs for furniture, furnishings and objects of everyday use, Balla and Depero adopted eccentric forms and covered every surface with colourful abstract paintings. Diaghilev's Ballets Russes offered a concrete outlet for their exuberant creativity: Balla made the scenery for Stravinsky's *Feu d'artifice*, which was staged in Rome in 1917, and Depero designed both scenery and costumes for *Le chant du rossignol*. Their playful vein made them the ideal designers of interiors for entertainment: Balla decorated and furnished the Bal Tik Tak cabaret in Rome in 1921, and a year later Depero fitted out the Cabaret del Diavolo, also in Rome.

The painter Enrico Prampolini became associated with Futurism when very young. He developed a particular interest in theatre and in 1915 expressed his revolutionary ideas on the subject in the manifesto *Futurist Scenography and Choreography*; following the example of Balla and Depero, he too devoted himself to applied art (cat. 276).

The furniture and furnishings of the Futurists were handmade from humble, perishable materials with the idea that they should be continuously replaced, a dynamic notion that was an early forerunner of the "throwaway" concept (cat. 22). Ironically, time has worked in a wholly opposite direction: today those "humble" materials are on display in international museums. The fact that functionality was not taken into consideration and comfort was even disdained as bourgeois further reduced the commercial appeal of their pieces, yet the Futurists wanted to sell their manufactured articles.

This is seen in the proliferation of the Case d'Arte, literally art-houses, galleries where their creations were sold.[9] Prampolini opened one in Rome in 1918 with a solo exhibition of painted fabrics, lamps, ceramics, carpets and cushions that were dynamic, geometric and proto-Rationalist in design. In 1919 Balla advertised his Casa Futurista (his own home)—where everything was reinvented and painted, including furniture and objects of everyday use—and invited visitors to it as though it were a collection of models. During the same year the Casa d'Arte Depero was founded in Rovereto; it was the only one to have any real success with the public and to last over time. In his workshop, which was also an exhibition space, Depero designed sets and manifestos whose concise, forceful character was to have a modernizing influence on advertising graphics. Assisted by his wife and a few workers, he produced wooden toys and furniture, carpets, tapestries (cat. 127), cushions, cloth waistcoats and even windows. The technique of collages or inlays of coloured geometric forms, characteristic of his unmistakable style, was also applied to furniture: for veneer Depero used boxwood, the new wood substitute, which lent itself to aniline dyeing in vivid colours.

The second wave of Futurism, in the 1920s and 1930s, swelled the ranks with new members, even though some of the founding fathers of the movement had moved away. Either challenging or engaging in dialogue with other European avant-garde movements (Cubism, Surrealism, Cubo-Futurism, Constructivism, Neoplasticism, Vorticism, Expressionism, Dadaism and Bauhaus),

Futurism acquired great renown abroad, and in Italy gained institutional recognition. The Futurist artists were invited to and given awards at the Biennali d'Arte Decorativa in Monza, the Biennali in Venice, and at the Paris Exhibition of 1925. Although they were enthusiastic supporters of revolutionary Fascism and celebrated Mussolini in their works—for instance, Bertelli in the ceramic representing the *Testa di Mussolini* in "continuous profile" (cat. 38), Cagli with the vase *La Marcia su Roma* (cat. 56), Tullio D'Albisola and Nino Strada with the panel *Le forze fasciste* (cat. 102)—the public response to their work was limited, and private commissions were scarce. Futurist creations were amusing, they were discussed in the newspapers and magazines because extravagance is news—it was entertaining to see Marinetti and Depero wearing their provocative waistcoats on top of the Eiffel Tower—but they were too eccentric to be desirable. And yet, amid the geometric and chromatic fury, they had an impact on customs and contributed decisively to the formation of a new aesthetic, influencing not only contemporary Rationalism but also, some time later, Italian design choices after World War II.

The twenty years of Fascism
Although Italy was on the winning side in World War I, the ensuing confusion and political uncertainty as well as the country's fragile democratic tradition led it towards the Fascist dictatorship. With regard to cultural policies and art, particularly at the beginning, Fascism allowed a pluralism of approaches. Its promotion of art competitions and exhibitions was exploited for propaganda purposes and to extol its triumphalist image. Free of the heavy-handed censorship that limited the freedom of expression of writers, intellectuals and journalists, artists and architects contended with each other for the regime's patronage, accepting without scruple membership in the Fascist trade-union organizations, an obligation for those who wished to participate in any public event or employment. And it was only after the adoption of the racial laws in 1938 that some degree of opposition was manifested. Taking part in the preparation of the 1932 *Mostra della Rivoluzione Fascista* [Fascist Revolution Exhibition], which commemorated the tenth anniversary of the March on Rome,[10] were exponents of all the modern currents: Futurist artists such as Prampolini and Dottori, Rationalist architects like Terragni, Libera and De Renzi, and the Novecento painters Sironi and Funi. The exhibition was held at the Palazzo delle Esposizioni in Rome, with large mural decorations, panels with montages and *fasci*[11] used as decorative elements. It marked a major change in iconography in all art forms.

Soon afterwards, with the conquest of Ethiopia and the foundation of the Empire,[12] the Fascist regime aimed at a particular stylistic image, and state architecture became Neo-Roman, grandiloquent and commemorative. Thus the crucial *Ventennio*,[13] the "twenty years" that were so decisive for the history of the arts, unfolded under the aegis of Fascism and, because the period was identified with the party, was for a long time repudiated after the end of World War II.

Since the early 1920s, a period when rapid and radical changes were taking place, the relationship between industry and craftsmanship in the sphere of the applied arts lay at the heart of the debate on modernity. Gaining ground was the idea of using mass production to influence tastes and educate the public, since only industrialized production could guarantee products of a high aesthetic quality that were affordable and accessible to almost everyone. Nevertheless exclusively handcrafted work, an expression of luxury for the privileged few, continued to have its supporters. While cases of mass-produced industrial designs began to increase in number, certain one-of-a-kind pieces, examples of original creativity, still marked the evolution of taste like milestones on the road to modernity.

The figure of the artist/craftsman was replaced by that of the architect/designer, a change that was endorsed by their common membership in the middle and upper-middle classes. Indeed, at that time it was still a privilege to study at university. Graduating from the Politecnico in Milan, which had an average of no more than fifty students a year, were Muzio, Ponti, Lancia and Marelli, and later the younger Buzzi, Bottoni, Albini, Pica, Portaluppi, Pizzigoni, Ulrich, Terragni, Figini, Pollini and Baldessari, all of whom were leading figures of modernization. The rise of Milan to become the capital of Italian industrial design was due not only to the contribution made by these names, but also to the fact that the Milanese hinterland had more manufacturing companies than anywhere else. It was an ideal terrain for the development of the bond between designer and industrialist that was to bear much fruit after World War II.

One event that was crucial to the history of Italian design was the inauguration in Monza in 1923 of the Prima Biennale Internazionale di Arti Decorative. The exhibition was the result of the effort and determination of Lombardy's cultural and social elites (first and foremost the Società Umanitaria and that defender of the decorative arts, Guido Marangoni, both coming from Humanitarian Socialism), and it put an end to Italy's cultural isolation on account of the war and made Italian artists and industrialists comparable to their foreign counterparts once more.

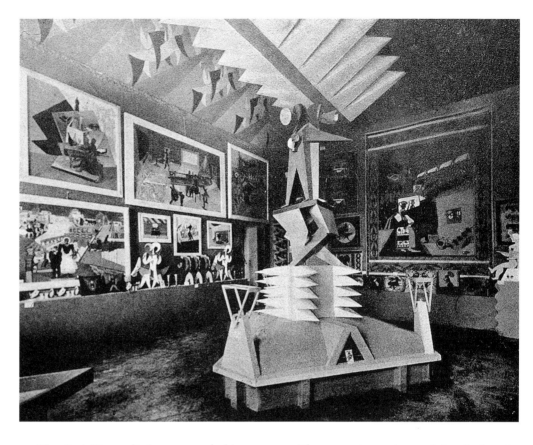

The first Biennali shows were held under the aegis of the founders and continued to represent the talents of the artist-artisans and their faith in decoration; however from 1930 onwards a new generation of individuals linked with Fascism took the helm and decided to transfer the event to Milan, where they commissioned a new building from Giovanni Muzio. Having become the Triennale, the institution, a showcase of modernity, became an up-to-date and qualified review of artistic and industrial products and launched new talents through spectacular presentations. Despite the numerous political setbacks it has encountered and its profound transformation, the Triennale still performs a universally recognized role for art and design today. Numerous studies, exhibitions and volumes have been devoted to its glorious history.

The return to Classicism
In Monza in 1923 two key figures in Italian decorative arts made their debuts: Gio Ponti and Paolo Venini.

The ceramics and porcelains designed by Ponti for the Richard-Ginori company and the Cappellin-Venini glass created in Murano in the glassworks acquired by Venini were the most obvious signs of the change that was spreading through the international art world: the revival of Classicism that Giorgio De Chirico had heralded with his call for a "return to order." Ponti and Venini were close friends and were important personalities among the more cultured and enlightened Milanese middle class. One was endowed with inexhaustible creativity, the other with an exceptional entrepreneurial talent, and together they represented the two faces of artistic production. The principal instigator of the rebirth of the art of glassmaking, Venini understood that the contribution of a skilled designer was crucial to the industrial manufacture of artistic products, so in 1921 he entrusted the artistic direction of his glassworks to Vittorio Zecchin. Needless to say, Murano glassmaking is unique: it is an industry in terms of the organization of the work, but the glass is

blown and shaped by a craftsman, and every model, even though it may be repeated in large numbers, is created by hand. For Venini, Zecchin created not only the *Veronese* vase, taken from the painting *The Annunciation* by Paolo Veronese, the famous Venetian sixteenth-century painter, but also a series of very thin, undecorated blown glasses with purely classical lines, made from colourless transparent glass or with subtle colorations (cat. 359), which were immediately successful with both the public and critics. From 1925 until 1932 the artistic direction of the Venini company was in the hands of sculptor Napoleone Martinuzzi, also the son of a glassworker. Martinuzzi had a preference for more full-bodied forms and sharp colours, and he invented a type of glass, the *pulegoso* (cat. 196), made from thick paste and full of air bubbles. In the 1930s, when the company was expanding its sales throughout Europe and in the United States, the architect Carlo Scarpa worked with Venini and designed the *corrosi* (cats. 302 and 303) and *sommersi* series of products in thick, opaque and primarily monochrome glass. And late in the decade he produced vases from the *tessuti* (cat. 304) series using thin rods in contrasting colours and goblets and plates with very colourful Murrine glass, anticipating the taste of the 1950s.

For architect Gio Ponti the collaboration with the most important Italian porcelain manufacturer, Richard-Ginori, as its artistic director from 1923 to 1930, provided him with his first opportunity for solid achievement. Not a ceramicist, his contribution consisted in providing designs, and over a period of less than ten years he made more than a thousand. He reworked models from the past, the urn and the cista, which, together with goblets, bowls, vases, dishes, dinner sets, statuettes and small ornaments, served as the basis for a myriad sophisticated decorations, grouped together thematically (cats. 261 and 262). His subjects were drawn from Classical, Etruscan, Greek, Roman and Renaissance mythology and interpreted in a modern and quirky vein. Success was immediate and lasting: Ginori still reproduces some of his models today and original specimens from the period are to be found in important collections and museums. Ponti's creativity was expressed in every field, from architectural planning, the design of furniture, lighting and clothing, to every kind of furnishing and everyday object. Ponti moved easily between promoting mass production and arguing for the safeguarding of craftsmanship, apparently antithetical concerns, to which his support gave force and credibility. He also continued to grasp the spirit of the time—the neo-classical architecture of his early career was associated with Palladio, while his furniture was linked to the Lombard neo-classicism of the early nineteenth century, or was inspired by ancient Greek and Roman models. The one-of-a-kind luxury pieces he designed for the Labyrinth Room[14] at the 1927 Biennale in Monza were light and graceful, and meticulously made from high-quality woods. Around the same time and following the same modern neo-classical inspiration, Ponti and Emilio Lancia, the partner at his studio, experimented with the mass production of furniture for complete interiors that were aimed at the general public and distributed by the largest Italian department store, La Rinascente. This range of products was named Domus Nova.

Domus is also the name of the magazine dedicated to the "architecture and furnishing of the modern home in the city and the country" that Ponti founded in 1928 and that has guided and educated public taste ever since, informing readers on everything occurring in Italy and abroad that is new and of aesthetic value. More open than others to working with artists, craftsmen and architects, Ponti encouraged young people in their early careers and discovered new talent. He put his name to prestigious pieces of furniture with Tomaso Buzzi; together with Pietro Chiesa, an artist and glassworker, he took on the artistic direction of the Fontana factory, and in 1932 founded FontanaArte, creating furniture, lights and glass or mirror objects of unsurpassed elegance. At the end of the decade he began his association with Piero Fornasetti, who used a special printing technique to decorate fabrics, paper, glass and porcelains. Ponti involved Fornasetti in a number of projects and applied his decorations to furniture (cats. 268, 269, 270).

It is hard to say whether Ponti is better known for his architecture, his writings or as a designer. It is certainly true that his work in promoting Italian artistic industries in his own country and abroad, particularly in the United States, which he conducted with enthusiasm and impartial generosity, contributed decisively to the success of "made in Italy" products.

In the contemporary viewpoint of Italian decorative art, works are praised that stand out as icons of the important developments that have taken place in design, works that in their time were not in exhibitions or were hidden away in private homes. The furniture designed by Felice Casorati is an example. For the great painter from Turin the years 1925 to 1928 were a brief period dedicated to applied art, during which he produced furniture designs, cartoons for mosaics and glass windows, and decorative sculptures. In those years Turin was a very lively and active cultural centre, partly due to the industrialist Riccardo Gualino, who was also a patron of the arts. For his own home (cats. 69, 70, 71) and for Gualino's house, which he also equipped with a small theatre (cat. 298),[15] Casorati designed furniture of simple volumes, which he lacquered black. Its proportions gave it

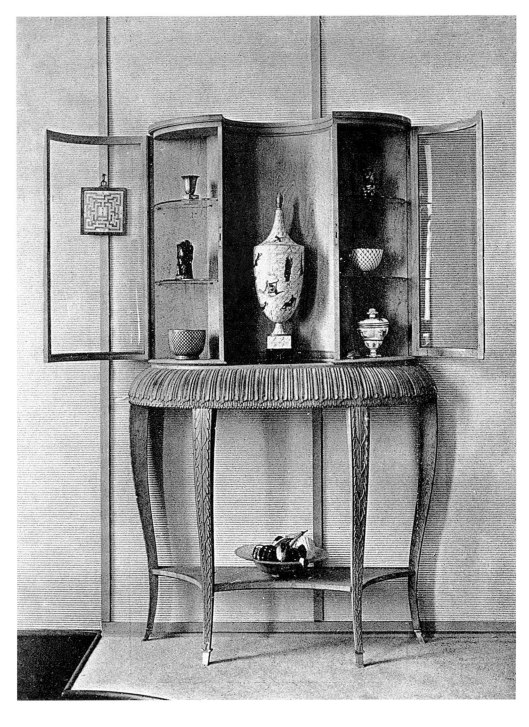

an elegant sobriety like that of the unprecedented metaphysical atmosphere in painting. At the same time that Casorati was producing his highly original pieces, Giuseppe Pizzigoni and Giancarlo Maroni were also creating polished, black furniture, Pizzigoni (cat. 258) for his father's house in Bergamo and Maroni for D'Annunzio's Vittoriale.[16] Their designs, however, were interpretations of the refined neo-classicism typical of the taste of the time.

Casorati's Butcher's Room, all white marble and shining metal tools, which he designed for the 1927 Monza Biennale, fascinated Gio Ponti so much on account of its purism that he selected it to represent the *crème de la crème* of Italy's offering at the exhibition of European decorative art held at Macy's in New York in 1928.

Novecento and Rationalism
Towards the late 1920s the decade's very diverse and wide-ranging forms of revived

Classical styles—Archaic and Renaissance, nineteenth-century Lombard and Greco-Roman or Etruscan—began to lose the decorative affectation that had made them successful. Consequently they were transformed into the Novecento style, which took its name from the painting movement promoted by the art critic Margherita Sarfatti.[17] Novecento was a simplified and bold version of neo-classicism. In the applied arts it made use of strong colours, solid volumes, and pure, rigid geometric forms arranged in symmetrical compositions. In furniture, plastic forms and high-quality materials replaced decoration, as seen in the "artistic" works made in limited editions or as one-of-a-kind pieces: for example, the "ceremonial" armchairs (cat. 233) in the Marble Room at the 1930 Triennale in Monza, designed by architect Giovanni Muzio, the founder of the Novecento style in architecture, the decor designed in 1934 by architect Piero Portaluppi for Casa Corbellini in Milan, and the furniture (cat. 312) designed by painter Mario Sironi for the dining room of Casa Aimetti and displayed at the Milan Triennale in 1936. There are also the truly amazing pieces designed in 1933 by Marcello Piacentini for the home of Fiammetta Sarfatti, daughter of the famous friend Margherita. They are lacquered red-orange (cat. 255), Novecento in form but almost Futurist in their lively colours. Piacentini felt free to experiment for private commissions like this where his personal relationship with artists blurred with his professional work. In his capacity as the all-powerful spokesman of the political regime and the architect of public buildings, he adopted the particular neo-Roman Classicism that makes use of forms that are grandiloquent yet elementary and unadorned. His final and exemplary design statement was the EUR, the new district in Rome that in 1942 was intended to celebrate twenty years of the Fascist regime with a Universal Exhibition.[18]

By the early 1930s industrial production had become very well established.[19] It publicized the new style but often did so with questionable results, occasionally combining it with other styles, so much so that by the end of the decade Novecento had become synonymous with "bad taste." "Good taste," on the other hand, was represented by the Milanese Guglielmo Ulrich and Gaetano Borsani, two sophisticated interpreters of luxury goods destined for the upper-middle class, who created interiors complete with every accessory and household item. Behind them they had solid companies with capable craftsmen: Ulrich's company was Ar.Ca., which he founded with Renato Wildt, and Borsani's Atelier di Varedo.

The Ente Nazionale Artigianato e Piccole Industrie (ENAPI, the National Organization for Crafts and Small Industries) founded by the Ministry of Industry in 1925, deserves praise for its modernization and promotion of Italian industrial manufacturers of artistic objects. Through competitions, the organization stimulated new products, supervised their execution and promoted their marketing. By establishing the connection between the designer and manufacturer, it laid the foundations for industrial design by prizing the skills of the craftsmen. This modernization also consisted in suggesting new manufacturing techniques and employing modern materials. For example, in 1933 the Matteucci workshop in Faenza, which was traditionally known for working wrought iron, was commissioned to make a gate designed in the fashion of the moment by architect Ernesto Puppo. It was to be made of aluminum, a home-produced metal that was then becoming widely used.

Much of what was produced by important designers and companies in any field of the applied arts between the late 1920s and the 1960s came about as a result of the patronage of ENAPI. Among the many names of the organization's collaborators was that of architect Franco Albini, who in 1933 participated in the ENAPI section at the fifth Triennale in Milan. Albini, then at the start of his long professional career, had already become known for decorating certain prestigious interiors, including the furniture he designed in 1932 for Casa Ferrarin in Milan. Imagination and rigour, a knowledge of the materials and construction techniques, attention to detail and a taste for experimentation governed his work. The projects by Albini "represent a kind of 'artistic Rationalism' in which the most important thing is the object, well designed and well made,"[20] wrote Edoardo Persico, editor of *Casabella*, the architecture magazine that supported Rationalist theories, in 1932. Such theories were introduced in Italy by Gruppo 7, founded in 1926 by seven architects, Frette, Rava, Larco, Terragni, Figini, Pollini and Castagnoli (the latter soon replaced by Libera). Enthused by the writings of Le Corbusier and Gropius, Gruppo 7 became their interpreters and promoters. Aligned with the international avant-garde and in opposition to the "moderate" Moderns who were continuing the tradition of the Novecentists, Gruppo 7 rejected all decorative superstructures, claiming that beauty was the result of the correspondence between a piece and its function. The battle for a radical renewal begun by these young professionals—they were all little more than twenty years old—met with the approval of the architects of their generation. As expected, their new conception of architecture involved interiors. They designed furniture and furnishing accessories starting from principles of sanitation, affordability and reproducibility; they saw these as tools,

rethinking their proportions to make them human in scale. Even if in principle the Rationalists accepted anonymity as going hand-in-hand with low-cost mass-production, in practice they did not give up the search for strongly characteristic innovative forms. Yet few models met with the favour of industry. Between 1932 and 1936 Giuseppe Terragni, the most talented of the Rationalist architects, built the Casa del Fascio in Como (cat. 332), a work so famous as to become the symbol of the Modern movement in Italy. He also designed the furnishings for it, including the powerful *Benita* armchair (cat. 333), with a dynamic, slender tubular metal structure. Originally made by Palini, it was eventually recognized as a classic of the Modern Movement and was mass produced by the firm Zanotta thirty years later, when the seeds of Italian design had borne their extraordinary fruit.

[1] National unification took place in 1861 and Victor Emmanuel II of Savoy was made King of Italy. Until then the country was divided into seven states of different size and importance, including the Lombardo-Veneto kingdom under Austro-Hungarian rule and the Kingdom of the Two Sicilies under Bourbon rule.

[2] At the time of reunification 75% of the population (25 million people) was to some degree illiterate. In 1879 elementary education was made obligatory by law but at the beginning of the twentieth century, 40% of the population was still illiterate.

[3] The Socialist Party was founded in 1892; laws were passed to limit exploitation of the working classes.

[4] *Arte Italiana Decorativa e Industriale*, a monthly magazine published under the patronage of the Ministry of Agriculture, Industry and Commerce, was founded in 1890. It was distributed in the Institutes and in the Scuola d'Arte Applicata. *Emporium*, a monthly modelled on the English *The Studio*, was founded in 1895.

[5] The name Stile Liberty was taken from the huge department store in London belonging to Arthur Lasenby Liberty, where the Italian furniture makers and designers bought their fabrics with modern designs.

[6] A statesman from Piedmont, Giovanni Giolitti (Minister of the Interior, 1901–03; Prime Minister, 1903–14) implemented a series of broad-minded social policies.

[7] In addition to Chini, Zen, Quarti and Mazzucotelli, the following all stood out: the Bolognese company Aemilia Ars, Cometti and Valabrega from Turin, Issel from Genoa, Cadorin and Jesurum from Venice, and the Florentine company Ginori.

[8] From the *Manifesto futurista del vestito da uomo* by Giacomo Balla, 1914.

[9] In addition to those opened by Balla, Prampolini and Recchi, Rome was also regaled with the Casa d'Arte di Ugo Giannattasio and the Casa d'Arte Bragaglia. Case d'Arte were created by Pippo Rizzo in Palermo, Tato in Bologna, M. G. Dal Monte in Imola, Pippo Oriani and Nikolaj Diulgheroff in Turin, and Thayaht in Florence.

[10] On October 28, 1922, when the Fascist Party had swollen to 300,000 members, Mussolini made his "blackshirts" converge on Rome. As a result of the "march," King Victor Emmanuel III surrendered power to the Fascists. As head of the government, Mussolini put an end to the liberal state and established a dictatorship. In 1924, following the murder of Socialist deputy Giacomo Matteotti, a crisis arose, and in early 1925 Mussolini abolished Parliament and established the Fascist State.

[11] Meaning "bundle," from which the word "Fascist" derives (*translator's note*).

[12] In October 1935 Italy invaded Ethiopia and in 1936 took Addis Ababa, whereupon Mussolini proclaimed the birth of a new Roman and Fascist Empire. The sanctions imposed by the League of Nations led to a program of autarchy and the imposition of the use of national products.

[13] The twenty-five-year Fascist period (*translator's note*).

[14] Il Labirinto was an association founded by architects Gio Ponti, Emilio Lancia, Michele Marelli and Tomaso Buzzi, the industrial glassmaker Paolo Venini, the glass and stained glass window artist Pietro Chiesa, the fabric designer Carla Visconti di Modrone, and some of their industrialist friends, such as Roby Lepetit, Carla and Cici Borletti, and Carlo Vimercati.

[15] Casorati was aided by the young Alberto Sartoris in drawing up the plans for the "teatrino di Casa Gualino Casorati."

[16] The poet's residence on the banks of Lake Garda (*translator's note*).

[17] In March 1923 Margherita Grassini Sarfatti (who was in various ways tied to Mussolini), editor of the newspaper *Il Popolo d'Italia*, curated the first exhibition of the Novecento artists, which was held at the Galleria Pesaro in Milan.

[18] Although the buildings planned to host it were under construction, the exhibition did not take place because of the war.

[19] By the late 1920s furniture production was mostly mass produced. In Lombardy the industrialized companies—those with more than five employees were considered as such—were more than 300, in Veneto around 230, in Tuscany and Piedmont 170.

[20] "Nuovi ambienti dell'arch. Albini," in *La Casa Bella*, no. 54 (June 1932), p. 40.

Renata Ghiazza

From Abstract-Concrete to Concrete

The Postwar Period to the Economic Miracle

The Postwar Period and Abstract-Concrete

The year 1945 marked the end of World War II, after the popular insurrection of the Resistance had reunited northern Italy with the rest of the country, which had been liberated by the British and Americans.

It was not until 1948, however, that the postwar period can be said to have come to an end. Over this time work began on the reconstruction of the country, where free political elections were held for the first time after twenty years of Fascist rule through a plebiscite based on universal suffrage. On June 2, 1946 the first Italian Republic was founded, with a government in which all the democratic parties of the anti-Fascist coalition that was heir to the Resistance took part.

The free elections placed the running of the country in the hands of the moderate clerical party, while the Marxist-oriented and pro-Soviet Left formed the opposition in the government.

Europe was then living through the years of the Cold War and was divided into two opposing spheres of influence: those of the United States and the Soviet Union. Italy, though internally divided, fell within the United States sphere of influence, the Western Bloc.

Shortly after, in 1948, the Fronte Nuovo delle Arti was officially consecrated at the XIV Venice Biennale. This "New Front of the Arts" was a grouping of artists, mostly painters, whom the critic Giuseppe Marchiori presented as a renewal of Italian art at the Biennale, which had opened its doors again after the interruption of the war under the auspices of an extraordinary commissioner, Christian Democrat parliamentarian Giovanni Ponti; the art historian Rodolfo Pallucchini served as general secretary.

The Biennale of 1948 was extraordinary, not so much because it saw the involvement of major Italian critics such as Giulio Carlo Argan, Nino Barbantini, Roberto Longhi and Lionello Venturi in a review of the great masters of twentieth-century Italian art (Casorati, Carrà, Modigliani and others), but for one exceptional fact: after years of Fascist autarchy, visitors were finally able to admire great European painters (Rouault, Ensor, Picasso, Magritte, Permeke) alongside the Guggenheim collection, recently arrived in Venice, and a dozen New York artists (including Baziotes, Gorky, Motherwell, Pollock and Still), who had all been influenced by European culture but were taking things in a different direction.[1] At the same Biennale the presentation written by Argan was to have a considerable influence on future developments in Italian art: introducing the theme of abstractionism, he wrote: "Following the crisis in figurative culture brought about by Cubism and Expressionism, all artistic currents that consider the work of art no longer a simple representation of reality and objects but a reality in itself can be described as abstract."

This was a very far-sighted assertion if compared with the results achieved by the Fronte Nuovo delle Arti, which consisted of the work of eleven artists shown in the Italian pavilion and lumped together under the label "Abstract-Concrete," according to a formula that had been contrived more for the purposes of the exhibition than out of any attempt to reflect shared intents and programs, as was proven by subsequent events. Nevertheless, the presence of the Fronte in the Italian pavilion was a real innovation after the years of Novecento naturalism.

Presenting the artists of the Fronte Nuovo delle Arti, Marchiori wrote: "In the months following the end of the war,

Atanasio Soldati
La città
1935
Oil on panel
70 x 54 cm
Boschi Di Stefano
collection

a consequence of the winning of freedom had been the search for new relations between men that went beyond divisions and suspicions; it was as if everyone had begun to live without a past and to find a *raison d'être* for themselves and their work in a sense of human solidarity that had been denied and betrayed for too many years . . ."[2]

The critic then went on to summarize briefly the history of the group, which had initially been called Nuova Secessione Artistica – Fronte Nuovo delle Arti [New Artistic Secession – New Front of the Arts], and only a little while later Fronte Nuovo delle Arti, and to relate how the first proposal to break the isolation had come from the painter Renato Birolli. It had then been taken up by Giuseppe Santomaso, Armando Pizzinato and Emilio Vedova and debated, first in Rome and then in Milan. Finally it had been given concrete form in a manifesto that was signed in Venice on October 1, 1946 in one of the rooms of Palazzo Volpi. The signatories were the painters Renato Birolli, Bruno Cassinari, Renato Guttuso, Ennio Morlotti, Armando Pizzinato, Giuseppe Santomaso and Emilio Vedova, and the sculptors Leonardo Leoncillo and Alberto Viani.

On the occasion of the first exhibition by the group, which in the meantime had become the Fronte Nuovo delle Arti, at the Galleria della Spiga in Milan on June 12, 1947, it was joined by the painters Antonio Corpora and Giulio Turcato and the sculptors Pericle Fazzini and Nino Franchina, while Bruno Cassinari chose to leave.[3]

In his introductory text, Marchiori set out to open up the Italian situation for renewal, putting artists on their guard against the illustration of current events, according to the dictates of a party-based aesthetics. This was a problem that had already been raised by Roger Garaudy in an article

published in *Art de France* in October 1946 and then reproduced by Elio Vittorini under the title "Non esiste un'estetica del partito comunista" [There Is No Aesthetics of the Communist Party] in the December issue of *Politecnico* the same year.[4]

Soon after, the Fronte Nuovo split into two extreme wings: the Abstractionists and the Realists. The cause of the division was the *diktat* of the secretary of the Italian Communist Party, who, on the occasion of the group's participation in the annual exhibition of the Alleanza della Cultura in Bologna (1948), had expressed his disapproval of their works, which were not in line with the stereotyped products of Soviet art.

Although the realist wing did meet with some success at the following Venice Biennale (1950), where Guttuso's *Occupazione delle terre in Sicilia* [Land Occupation in Sicily] was shown, it was only rarely capable of maintaining this level. Instead it often lapsed into a descriptive naturalism that was analogous to Neorealism, to use a term borrowed from the cinema, the new art that was soon to enter its golden age under the impetus of that very movement.

From Abstract-Concrete to Concrete
As for the abstract wing, it soon formed into the Gruppo degli Otto, made up of the eight painters Afro, Birolli, Corpora, Morlotti, Moreni, Santomaso, Turcato and Vedova, who simplified the geometry of Picasso and rounded off the corners of the Abstract-Concrete, adapting it to the ideas of Art Informel. They were presented by Lionello Venturi at the XXVI Venice Biennale (1952) and then, after a few exhibitions abroad, the group was disbanded.

The reasons? Their language, derived from Picasso's post-Cubist work, suffered from an endemic crisis, which

Renato Birolli
Natura morta
1947
Oil on canvas
49.5 x 67 cm
Boschi Di Stefano
collection

was not the false dilemma of having to choose between the abstract and the figurative, a problem only taken seriously by the illustrated magazines. It was deeper than that, and stemmed from within abstractionism itself, the abstractionism that descended from Kandinsky, Mondrian, Malevich, Klee and the abstract painters of the Galleria del Milione, and which would attract the artists who were most open, free and indifferent to political alignments.

The term Abstract-Concrete, coined in 1946 by the critic Lionello Venturi on his return to Italy from the United States, showed by its very ambiguity that changes were underway, that something was on the move at a time when the political and economic balance of power was shifting from Europe to America. The first sign of this had come the year before the Fronte Nuovo was formed, with the publication of the manifesto *Oltre Guernica* [Beyond Guernica].[5] Endorsed by the artists Giuseppe Aimone, Aldo Bergolli, E. Bonfante, Gianni Dova, Ennio Morlotti, Giovanni Paganini, Cesare Peverelli, Vittorio Tavernari, Giovanni Testori and Emilio Vedova,[6] it was an explicit invitation to go beyond Picasso's post-Cubism, which had influenced painting in Italy for ten years.

The exhibition of Concrete art held at the Galleria Bergamini in Milan in 1945 was a real innovation. Organized by Pompeo Borra, it presented works by Bruno Munari,[7] Mario Radici, Mauro Reggiani, Manlio Rho, Atanasio Soldati and Luigi Veronesi, artists who had worked alongside Rationalist architects in the 1930s[8] and who had also constituted the strongest opposition to the Fascist Novecento movement.

In the years 1946–47 *Domus* magazine[9] helped clarify the position of Concrete art, with two articles published a few months apart, one

by Max Bill and the other by Gillo Dorfles, that set the current of Concrete art within the perspective of the abstract tendency as a whole.

The Swiss artist Max Bill summed up the difference between abstract art and Concrete art with an example: "take a painting consisting of a white surface with a red dot; if it had been painted by an abstract artist, he would have entitled it *Snowy Landscape with Sun*, whereas if a Concrete artist had painted it, the title would have been *White Surface with Red Dot*. Yet the obviousness of the latter title should not deceive us, because Concrete art is in reality a representation of abstract and invisible thoughts." And he went on to say: "If Concrete art was initially defined as abstract, this is due to the fact that this is what it appeared to be, if compared with a model taken from nature."[10]

Underlining the difference between the Concrete and Abstract approaches, the article by Dorfles[11] contradicted the claim made by Venturi when he had written a few months earlier, also in *Domus*: "Every work of art should be considered abstract and concrete at the same time. Concrete because based on sensations, abstract because it is pervaded by the universal values that are proper to representation."[12] In the same article, Venturi asserted that the origin of abstractionism was Cubism. Dorfles held a different view, declaring that abstractionism was derived from Kandinsky and passed through Van Doesburg before being taken up by the abstractionists of Il Milione.

In January 1947 further clarifications regarding Concrete art, not just in Italy but in the rest of Europe as well, emerged from the major exhibition *Arte astratto-concreta* that was staged by the association L'Altana at the Palazzo Reale in Milan. Reviewing it, again in the pages

Aldo Bergolli
Paesaggio
1947
Oil on canvas
43 x 67 cm
Boschi Di Stefano
collection

of *Domus*, Dorfles wrote: "Here we are today in the realm of the abstract, or rather of the concrete," and went on to make an appeal to Concrete artists "not to be too tied to mathematical schemes, too concerned about algebraic relationships, which should instead spring by spontaneous generation out of the inner fabric of the painting."

In April of the same year (1947) the manifesto of the Forma group, signed by Carla Accardi, Ugo Attardi, Pietro Consagra, Piero Dorazio, Mino Guerrini, Achille Perilli, Antonio Sanfilippo and Giulio Turcato, was published in Rome in the magazine of the same name. It is reproduced in full below:
We hereby proclaim ourselves formalists *and* marxists, *convinced as we are that the terms Marxism and formalism are not* irreconcilable, *especially today, when the progressive elements of our society must maintain a* revolutionary *and* avant-garde *position instead of settling into the mistake of a spent and conformist realism that in its most recent experiences in painting and*

sculpture has shown what a limited and narrow road it really is.
The need to bring Italian art to the level of the current European language forces us to take a clear-cut position against every silly and biased nationalist ambition and against the gossipy and useless province that present-day Italian culture is today.
For these reasons, we assert that:
1) In art the traditional, inventive reality of pure form is all that exists.
2) We recognize formalism as the only means to avoid decadent, psychological, and expressionistic influences.
3) The picture, the sculpture, have as their means of expression colour, draftsmanship, plastic masses, and as their goal a harmony of pure forms.
4) Form is means and an end; the painting must also be able to function as a decorative complement to a bare wall, and the sculpture as a furnishing in a room—the goal of a work of art is usefulness, harmonious beauty, weightlessness.
5) In our work we use the forms of

61

objective reality as means to attain objective abstract forms; we are interested in the form of the lemon, and not the lemon.
We reject:
1) Every tendency aimed at inserting human details in the free creation of art, by the use of deformations, psychologisms, and other contrivances; the human is determined through the form created by man-as-artist and not by his a posteriori preoccupation with contact with other men. Our humanity is realized through the act of life and not through the act of art.
2) Artistic creation that posits nature, sentimentally intended, as the starting point.
3) Everything not of interest to the goals of our work. Every assertion of ours originates from the need to divide artists into two categories: those of interest to us, who are positive, and those not of interest to us, who are negative.
4) The arbitrary, the apparent, the approximative, sensibility, false emotionality, psychologism, spurious elements that compromise free creation.

Rome, March 15, 1947
Accardi, Attardi, Consagra, Dorazio, Guerrini, Perilli, Sanfilippo, Turcato[13]

Glancing through the various points of the manifesto, the main concern of its signatories stands out clearly: first of all, to distance themselves from the Realists and then to distinguish themselves from the Concrete artists, in spite of their affinities, by declaring: "we are interested in the form of the lemon and not the lemon." In these terms, the Concrete artists would not even have been interested in the form of the lemon, since they took nothing from what existed, but started out from zero. For them it was a matter of inventing, of following an intuition, in an extreme freedom that was to lead them in a number of directions. The artists of the Gruppo Origine immediately understood what direction to take.

The Gruppo Origine
Formed in 1949 on the initiative of Mario Ballocco, along with Alberto Burri, Ettore Colla and Giuseppe Capogrossi, the group was rooted in an unusually cultivated milieu, in which the traditional materials of painting could be abandoned in favour of experimentation with new techniques, with the aim of returning to the primary impulse in artistic action.[14]

The group exhibited only once, in the Roman gallery of the same name, in 1951.[15] Staged at the behest of Colla, the exhibition was immediately followed by one of the works by Giacomo Balla dating from between 1913 and 1929. The birth of the group was announced by Ballocco himself in the magazine that he edited, *AZ*.[16] The manifesto of the Gruppo Origine was published in the issue of November 1950, and its key elements are:
Far from being an arbitrary and delayed resurrection of positions that have already been reached, the new non-figurative art is the sense of a new energy that, emerging with features all of its own, is the most characteristic and widespread phenomenon of recent times on account of its spontaneous and synchronized appearance (1945) in almost every country. After the latest experiments, which have brought the appearance of physical reality into art, culminating in neo-Cubism, painting and sculpture, following an inevitable line of development, have entered the realm of non-figurative art, establishing a connection with the first abstract experiences of the beginning of the century . . . Origin, therefore, as point of departure for the inner principle, as the need to draw on the most innocent, free, primordial nature . . . Origin, therefore,

Enzo Mari
Interno
1952
Oil on Masonite
98.5 x 67 cm
Boschi Di Stefano
collection

as freedom from multiple superstructures and as identification with the truth contained in ourselves.

In keeping with the program they had set themselves, the four artists did not have a common language. In fact, Ballocco adopted a strictly geometric mode of expression to which he would remain faithful his whole life. Burri, returning from the United States in 1945, developed his first organic compositions called *Muffe* [Moulds] and *Neri* [Blacks]. Colla used materials salvaged from the mechanical engineering industry, which he assembled into a variety of compositions. Capogrossi entered the Gruppo Origine with strong motivations. For someone who had already attained international success as a figurative artist, adopting that mysterious alphabet of his was a real choice of sides. A not entirely fortuitous development in view of the fact that as far back as 1933, at the Galleria del Milione, he had signed the manifesto of Plastic Primordialism with Cavalli and Melli. Although this was the product of a short-lived association, it bears witness to the consistency of his desire to investigate the primeval—an interest that would subsequently lead him to come up with his inscrutable alphabet. Recollecting an episode way back in his childhood, he commented: "I must have been about ten years old when my mother took me with her to visit an institution for the blind. This was in Rome where I was born. In a large room we came upon two children assiduously drawing. Their sheets of paper were jammed with little black signs like a mysterious alphabet, so vibrant and alive that I felt deeply moved, even though at that age I was not interested in art. Somehow, right then, I understood that drawings do not stand necessarily for something *seen* but can also express something within

ourselves, perhaps the tension of a human being plunged into reality.

At that precise moment, I think, I felt the call to art, nor was it extinguished by the classical studies my family forced me to undertake for reasons of convention and tradition; in fact my formal education only came to an end when I became a full-fledged doctor of law. At last I could give myself up to painting. For years I was a realistic or representational painter, actually a rather successful one; so much so that many amateurs still mourn my lost talent while some few of the most lenient politely marvel at my conversion to abstract painting.

I, however, am convinced that my painting has not substantially changed; it has only become clearer. From my earliest beginnings I have tried to go beyond the outward appearance of nature; I have always felt that space is a reality within our sentient beings and I have tried to define it. At first I found myself using natural images, comparisons or affinities drawn from the visible world; later I tried to express directly and personally the sense of space I inwardly perceived and came to understand through my everyday actions.

I could not forget the blind boy who sought out with his minute and dashing 'marks' the form of space which his eyes could not apprehend but which he, nevertheless, intensely felt and lived."[17]

This invaluable declaration of poetics has been reproduced in full because it may offer some insight into not just the artist Capogrossi, but also and above all the complex history of Italian art from the postwar period to the end of the 1950s. This was a period that saw the birth of new forms of aesthetics as a consequence of the expansion of the artistic experience and of art understood as cognitive activity, within a broader horizon than the familiar one

bounded by the traditional system of the visual arts. "It must immediately be said that the most obvious manifestation of this changing artistic experience lies in the abandonment of traditional techniques and materials, the bearers of traditional codes to which the realists and most of the abstractionists were all strictly faithful, in favour of other techniques, other materials and other procedures. As a consequence the object of art itself was modified. In this sphere, with the theme of the primitive championed by Origine, the problem of modernity, the debate that had bedevilled the realists and abstractionists, crumbled away. What also crumbled was the idea of style, bound to those codes, which were rejected to make room for new artistic objects."[18]

So to go back to Capogrossi, his alphabetical sign is a script that writes itself and is no longer a medium, it is a reality and not a means of representing it, as painting had hitherto been used. The surface on which it is now set is no longer that of the traditional picture, but a portion of a continuum, of an infinity understood not just in a spatial but also a "temporal" sense. On several occasions in the 1950s and 1960s, various Italian groups set out to investigate the same dimensions of space and time, referring to their experiments as "interventions." These were the Gruppo T, the Gruppo N and Azimut, which saw the participation of artists like Gianni Colombo, Piero Manzoni, Piero Dorazio, Grazia Varisco and others.

The MAC, or Concrete Art Movement
A contribution to spreading an awareness of Concrete art was made not only by the various magazines but also and above all by a series of public and private initiatives, sometimes both at once as in the case of the major

exhibition entitled *Arte astratta e concreta in Italia*. Held in February 1951 at the Galleria Nazionale d'Arte Moderna in Rome, it comprised works by artists from all over Italy, including Munari, Radice, De Fusco, Berti, Nativi, Tatafiore and Guerrini. The exhibition was staged under the patronage of the Art Club, an association formed in Rome in 1945 and open to cultural innovation, which took an active interest in Concrete art for a period of about five years under the direction of Enrico Prampolini.[19] Meanwhile, the MAC (Movimento Arte Concreta) was born in late 1948. The main historical point of reference for the MAC in Italy was the geometric abstraction of the 1930s by Atanasio Soldati, Luigi Veronesi, Mauro Reggiani, Manlio Rho and Mario Radice. Despite this precedent, the line of the new group was in fact neither especially geometrical nor neoplastic. Indeed, the deliberate vagueness allowed each of its members to realize linguistically different works, for example, an approach that was organic (Soldati), lyrical-oneiric (Dorfles), graphic-synthetist (Monnet) or else open to all possible forms of visual expression (Munari).[20]

The initiative had been launched by Gillo Dorfles, Gianni Monnet, Bruno Munari and Atanasio Soldati. After a first joint exhibition at the Salto bookshop in Milan, in 1948, where twelve hand prints by its members were shown,[21] the manifesto of the MAC was published in 1951 on the occasion of a joint exhibition by its members at the Galleria Bompiani. The manifesto, entitled *Dal concretismo classico all'astrattismo romantico* [From Classical Concretism to Romantic Abstractionism], was drafted by Dorfles, who developed some of the premises already contained in the article that appeared in *Domus*,

Alberto Burri
Muffa
1952
Mixed media on canvas
40.5 x 46 cm
Milan, Civiche Raccolte
d'Arte Antica e Moderna

mentioned earlier. With his usual clarity, the artist-critic from Trieste added: "The error of many critics and treatise writers was to mix up and confuse the two fundamentally distinct, indeed initially opposing groups, the abstractionists and the Concrete artists, often seeking to give Cubism the credit for having been the first germ of abstract painting." In fact the aim behind the creation of the MAC was not just to combine the forces of Concrete art in Italy, but above all to clarify matters at a time when the public, as well as many painters, saw all forms of avant-garde art that were not classically figurative as "abstract."

Dorfles made a further clarification with reference to the current of Concrete art by stating that it was not attempting to create works inspired by the external world, taking already familiar objects and then abstracting a pictorial image from them, but looking for pure, primordial forms, in which any eventual resemblance to something from nature had not the slightest importance. The exponents of this current, Dorfles went on to say, were the international founders of Concrete art: Theo van Doesburg, Jean Arp, Piet Mondrian and Wassily Kandinsky. He concluded by claiming a new creative freedom for the artist (in common with the Gruppo Origine manifesto) and attempting to show how a Concrete work of art was born, stressing that it never sought "to penetrate its inner mechanism of formation . . . The prime mover in the creation of a picture," argued Dorfles, "is a graphic module rather than a coloured image, but more often still it is the precise and lucid search for a given form that guides the pencil or brush, and not a copy of a naturalistic object."[22]

The MAC did not forget the contribution made to Concrete art by the founding fathers of Futurism, first and foremost Giacomo Balla, to whom the Concrete artists themselves dedicated their first significant anthological exhibition in 1951, held at the Amici della Francia association in Milan. The task of promoting Concrete art was entrusted to a large extent to articles in the press, chiefly through the *Bollettino del MAC*, which came out monthly. Subsequently the bulletin was replaced by another periodical, *Documenti d'arte oggi*. Ballocco's magazine *AZ* also devoted many articles to the MAC.

But it was largely through the exhibitions it staged that the MAC was able to attract attention and grow. The shows in Milan were followed by others in Florence, Genoa, Rome and Turin, as well as in the south of Italy, at Catania and Naples. It was at the Galleria Medea in this last city that the exhibition *Perché arte concreta?* [Why Concrete art?] was held in 1954,[23] accompanied by the publication of the manifesto of the same name. This presented abstract art as a mode of perception, while viewing Concrete art as a direct participation in the world of production.

The MAC and the "Synthesis of the Arts"
In the meantime something had changed inside the MAC, following the merger with the French Groupe Espace of André Bloc in 1953. The new MAC Espace movement showed less interest in art and "pure" painting and focused instead on the newly emerging field of industrial design and on experiments with the "synthesis of the arts" in collaboration with a number of architects, such as those of Studio B24. The expression "Synthesis of the Arts," frequently used in MAC circles in the postwar period, in fact runs like a subterranean current through the

history of twentieth-century art in Europe. Branching out in various directions from Art Nouveau, it resurfaced from time to time with De Stijl and the Bauhaus and a little later, outside Germany, with the French Esprit Nouveau and Léger's murals.[24] Around the same time, it appeared in Terragni's Casa del Fascio in Como (1932–36), a building that translated the aesthetic aspirations of the abstractionists of the Galleria del Milione and the theories put forward by Carlo Belli in *Kn* into a structural and spatial language.

However, it was with the MAC that the synthesis of the arts achieved its most complete expression, when it

extended the functions of the traditional artist to include what was to become the specific task of the visual designer. In 1952, at a time when the MAC was widely known in Italy and abroad (especially in Austria and Argentina), the Synthesis of the Arts current emerged within the movement with the aim of fusing painting and sculpture with architecture, and thus abolishing the objective value of the work of visual art. So objects of "total art" were presented to the public at the Galleria Annunciata in Milan, in the Saletta dell'Elicottero. These included a machine-made picture by Veronesi, Munari's useless machines, the organic works of Joe Colombo, the mechanistic

works of Baj and Dangelo, a metal object by Nino Di Salvatore and the disintegrated works of Monnet.

Yet it was only after the death in 1953 of Atanasio Soldati, who had been at the head of the MAC since its birth, and his replacement by Bruno Munari, that the movement took a more marked shift in the direction of design. At this time architects began to join the MAC, along with painters who had devoted themselves to industrial design. When the MAC broke up in 1958—following the death of Gianni Monnet, who had been one of its most lively and active proponents—it had about seventy members, including many architects and engineers. Among the more significant exponents, it is worth mentioning: Ettore Colla (1896–1968), Nino Di Salvatore (1924–2001), Piero Dorazio (1927), Nino Franchina (1912–1987), Albino Galvano (1907–1990), Paola Levi Montalcini (1909–2000), Enzo Mari (1931), Mario Nigro (1917–1992), Achille Perilli (1927), Enrico Prampolini (1894–1956), Carol Rama (1918), Pierluigi Nervi (1891–1979) and Vittoriano Viganò (1919–1998).[25]

But that's another story, one is tempted to add, and concerns the world of design and its codes, in direct connection with industry and the world of production during the years of the economic miracle.

As for "pure" art, it is necessary to point out its growing dependence on industrial technologies, from which it drew the materials that were increasingly to characterize it, as in the case of the neon adopted by Lucio Fontana in his spatial environment at the Galleria Il Naviglio in 1949, as well as the Combustions (1953) by Alberto Burri, where the material subjected to the violent effect of fire was plastic, or more simply the glass wool used in Piero Manzoni's Achromes (1959).

[1] G. De Marchis, "Il Novecento," in Storia dell'arte italiana (Turin: Einaudi, 1982), vol. VII, p. 567.
[2] G. Cortenova, F. Menna, Astratta (Milan: Mazzotta, 1988), p. 42.
[3] Ibid.
[4] Politecnico, a periodical founded in 1945 in Milan by Elio Vittorini.
[5] Otherwise known as Realismo.
[6] T. Sauvage, Pittura italiana del dopoguerra (1945-1957) (Milan: Schwarz, 1957), p. 233.
[7] Bruno Munari, future chairman of the Movimento Arte Concreta (MAC).
[8] G. Belli, M. Garberi, Il mondo di Carlo Belli (Milan: Electa, 1981), p. 207.
[9] The Milanese magazine Domus was first edited by Gio Ponti (1928–1941), subsequently by Giuseppe Pagano, Massimo Bontempelli and Melchiorre Bega, then by E. N. Rogers in the period 1946–47 and then by Ponti again.
[10] M. Bill, "Pittura concreta," in Domus, no. 206, 1946, p. 39.
[11] G. Dorfles, "Arti plastiche," in Domus, no. 217, 1947, p. 36.
[12] L. Venturi, "Considerazioni sull'arte astratta," in Domus, no. 205, 1946.
[13] First appeared in Forma I. Mensile di arti figurative, Rome, April 1947; translation in The Italian Metamorphosis, 1943–1968, exhib. cat. (New York: Guggenheim Museum, 1994), pp. 712–13.
[14] Cortenova, Menna 1988, p. 48.
[15] The Fondazione Origine was set up by Colla, Burri and Capogrossi in 1952 on Via Aurona in Rome. The aim of the foundation was to encourage the new generation of artists to carry out research into abstract art. It also published the magazine Arti Visive, which was issued uninterruptedly until 1956.
[16] The periodical AZ was founded by Ballocco and edited by him from 1949 to April 1952: twelve issues appeared in all. See A. Vattese, M. Ballocco dal 1949 (Milan: Fondazione J. Vodoz e B. Danese, 2002), p. 9.
[17] Giuseppe Capogrossi, in The New Decade: 22 European Painters and Sculptors, Andrew Caraduff Ritchie (ed.) (New York: The Museum of Modern Art, in collaboration with the Minneapolis Institute of Arts, Los Angeles County Museum, and San Francisco Museum of Art, 1955), pp. 87–88.
[18] De Marchis 1982, p. 576.
[19] Prampolini's book Arte Polimaterica had been published by Del Secolo in 1944.
[20] M. Corgnati, F. Poli, Dizionario dell'Arte del Novecento (Milan: Mondadori, 2001), p. 346.
[21] The artists invited to take part in the exhibition at the Salto bookshop were Dorfles, Dorazio, Fontana, Garau, Guerrini, Mazzon, Monnet, Munari, Perilli, Soldati, Sottsass and Veronesi.
[22] Sauvage 1957, p. 96.
[23] Among the artists who exhibited at the Galleria Medea it is worth mentioning Barisani, Tatafiore, De Fusco and Venditti.
[24] Fernand Léger had formulated an ambitious prospect of "synthesis" with architecture through the construction of murals, mosaics and installations taking up whole rooms. The artist felt the need for this approach was so urgent that he was prepared to give up signing his work to favour the uniformity of the overall effect. See Corgnati, Poli 2001, p. 581.
[25] Ibid., p. 357.

Rosalind Pepall

"Good Design is Good Business": Promoting Postwar Italian Design in America

After the devastation of World War II, Italy was a country defeated; however, in the ensuing decade, the country was able to turn from austerity and deprivation to creativity and invention. The reasons varied from low labour costs to cheap energy, but the economic help and investment provided by the United States played a major role in its industrial and social development. After the war, Americans were sympathetic to the idea of helping rebuild Italy, the country that had been the historical centre of Western art. With this in mind, Americans began to take notice of the vitality that marked the country's recovery in the areas of architecture and design. In the early 1950s, through exhibitions of Italian architecture, painting and applied arts, through commercial marketing of Italian goods, and through reviews of Italian design in American magazines such as *Interiors*, *Arts & Architecture* and *Art Digest*, Americans gradually turned their attention not only to the recognized specialities of Italian craftsmanship, such as leather goods and glass, but also to Italian furniture, ceramics, lighting fixtures, and industrial products, as Italian design began to move to the top of the international market.

As early as July 1948, the New York magazine *Interiors*, one of the first American reviews to show Italy's post-war developments in design, devoted a whole issue to the furniture and interiors of the country's leading architects.[1] The noted American architect and industrial designer, George Nelson, wrote the introduction to this "first comprehensive American presentation of postwar Italian design." At the time, Nelson was design director of Herman Miller Furniture Co., and he was particularly impressed by the flexibility of the Italian furnishings, which emphasized lightness and mobility. He noted works by, among others, the office of BBPR (Banfi, Belgiojoso,

Peressutti and Rogers), Carlo De Carli, Carlo Mollino and Franco Albini who, according to *Interiors*, was the best-known Italian designer to its readers. Two years later, in June 1950, *Interiors* reported on the steadily increasing demand for Italian furnishings.[2]

J. G. Furniture Company was the first American manufacturer to produce an Italian designed model in the United States: a canvas armchair with steel frame by Paolo Chessa, which was a great success. However, the major turning point in America's awareness of Italian design was an exhibition entitled *Italy at Work* that travelled to museums across the country from 1951 to 1953.

Italy at Work *exhibition*
The exhibition was sponsored by the Compagnia Nazionale Artigiana (CNA), a company supported by the Italian Ministry of Foreign Trade and which, with American funds, assisted promising craftsmen to obtain adequate working facilities and to find markets for their work. The CNA had opened a marketing outlet in New York in 1948 called House of Italian Handicrafts. It was through contacts with this company that Meyric Rogers, the curator of decorative and industrial arts at the Art Institute of Chicago, launched the idea of an exhibition of Italian crafts. He sold the project to eleven other American museums, and enlisted Charles Nagel, director of the Brooklyn Museum of Art, to be a member of the organizing committee. Rogers and Nagel selected the works along with the respected industrial designer, Walter Dorwin Teague, and the Vice-President of the CNA, Ramy Alexander, who was the point man in Italy. The honorary committee was made up of Italian and American politicians and diplomats eager to promote Italian trade with the United States.

In Spring 1950 the selection committee took on what would be a curator's dream project, travelling 3,000 miles by car in just two months and exploring studios, showrooms and exhibitions of about 250 Italian craftsmen with a mandate to select the final items of original and contemporary work for this ambitious exhibition. Walter Dorwin Teague wrote about the group's "Italian Shopping Trip" for *Interiors* in November 1950.[3] As Teague explained, few of the artists they met were prosperous or well known beyond their small circle in Italy. Teague was especially struck by the great freedom and inventiveness of the Italian designers who, unlike American industrial designers, worked for small specialized markets and were not controlled by a large commercial market and the demands of mass production. Teague was prescient in concluding that this dynamic revival of Italian craftsmanship was a movement "merely hitting its stride" and still had far to go.[4]

The exhibition was presented at the Brooklyn Museum of Art from November 29, 1950 until January 31, 1951 (the installation having been designed by Teague). Afterwards it went to the Art Institute of Chicago and then travelled to ten other museums across the United States for three years.[5] A huge undertaking, the show numbered 2,500 works at the Brooklyn presentation, though it had to be reduced for other museums. In the introductory essay to the exhibition catalogue, Meyric Rogers wrote of a "contemporary renaissance" of the craft arts in Italy, rising out of the traditional roots of Italian craftsmanship.[6] Rogers noted especially the lack of distinction between the fine arts and the applied arts in Italy, so that architects, painters and sculptors might design anything from furniture to ceramics and glass.

The range and quality of the exhibits, chosen mostly from northern and central Italy, varied considerably. Moved by the romance of the Italian surroundings, the personalities of the artists and the commercial concerns of this venture, the selection committee chose works of uneven interest, and sometimes in great

quantity; for example, there were straw hats and baskets, lace, textiles, puppets, toys, costume jewellery, mosaics, and objects of *pietra dura*, the traditional hardstone inlay work. At the same time, some of Italy's most original and inventive contemporary designers, such as Franco Albini, Carlo Mollino, Gio Ponti, Lucio Fontana and Gino Sarfatti were well represented in the show, as well as companies like Arte Luce and FontanaArte.

Meyric Rogers marvelled at the way Italian designers, working under economic restraints and often in tiny, rundown shops, made inventive use of materials that were cheap and readily available. As a result, ceramics and textiles made up the largest number of exhibits, and silver objects were few, though one of the most impressive metalworks was a silver swan centrepiece created by Argenteria Finzi, Milan.[7] The ceramics ranged from small marketable dish services and ashtrays to major sculptural works by such artists as Fausto Melotti, Leoncillo Leonardi, Antonia Campi and Guido Gambone,

whose work was popular in the United States. Great masters of Murano glass, such as Archimede Seguso and Paolo Venini, were represented, as well as leather goods, including fifty pairs of Ferragamo shoes, which were sent to a welcoming market in the United States.

The highlight of the *Italy at Work* exhibition was five interior ensembles commissioned from major architects. Carlo Mollino's living–dining room for a moderate-income family received the most acclaim and was featured on the cover of the *Magazine of Art*.[8] Mollino's sculptural tea table, made from plywood and glass, was included in another part of the exhibition (cat. 220), as was his astonishing dining table consisting of a glass top supported by a skeletal ribbed structure of curved plywood held together with metal rods and clearly visible brass bolts. It was accompanied by six moulded plywood chairs with metal frames and legs (p. 68). The Gio Ponti dining room was much more flamboyant, featuring furniture and door panels decorated with Fornasetti prints and shelves filled with white ceramics

(p. 71). Ponti himself claimed that the room was a deliberate showpiece, and the public reacted to it with some wonder. A private chapel by Roberto Menghi, a foyer for a marionette theatre by Fabrizio Clerici, and a summer terrace room by Luigi Cosenza completed the rooms.

The majority of works in the exhibition were one-of-a-kind or serially produced crafted items, but there was a small section devoted to industrial design products such as Olivetti *Lexicon 80* typewriters and calculators, a Robbiati espresso home coffee-machine, and a *Lambretta* scooter by Innocenti, Milan. As Meyric Rogers wrote: "Given the right conditions, it is here that the universally recognized scientific and mechanical skills of the Italian people combine most effectively with their ingenuity and sense of form." He concludes that the mechanized business and office equipment produced by Olivetti of Ivrea "ranks with the best of its kind in world production."[9]

The exhibition was a major event in the American design world, and it was covered by newspapers and magazines as it travelled around the country.[10] Writers applauded the exhibition and emphasized the need to help Italy towards prosperity and democracy. This had been one of the main goals of the exhibition, as is evident in the Brooklyn Museum's press release about the exhibition, in which they said Italy "Shows Resurgence of Nation Freed of Dictatorship and Aided by Marshall Plan."[11] To respond to the many requests for information on the availability of merchandise in the show, the host museums even allowed the CNA to have a representative travel with the exhibition to each of the venues.

One of the most discerning reviews of the exhibition and of Italy's postwar design was by the curator of the Museum of Modern Art, Edgar Kaufmann, in the *Magazine of Art*, January 1951.

He particularly noted the dominance of architects in the field of interior design and the way designers were able to skilfully blend the past with the present. Kaufmann also admired the individualism of the Italian works, stating: "Ponti (or Mollino or Albini) will give you today a chair or a desk that stands on its own, complete and detached, ready to follow you from apartment to villa or, if called, across the sea. Indeed so free and adaptable are these independent designs that one almost suspects them of automotive power."[12] The message on the merits of Italian design was indeed heard across the Atlantic, and the exhibition was critical in making America aware of the revival of Italian craft and design after the war.

Merchandising good design
Edgar Kaufmann was an important ally for the promotion of Italian art, given his position at the Museum of Modern Art in New York. In a small publication he wrote for the museum in 1950, entitled *What Is Modern Design*, Kaufmann illustrated a glass bowl by Venini, 1935, drinking glasses by Nason and Moretti, 1945, and a chandelier by Gino Sarfatti.[13] In that same year Kaufmann organized the first of a series of exhibitions on "Good Design" in collaboration with the large retailer, Merchandising Mart of Chicago. It was intended to raise awareness of contemporary design by showing the best new examples of home furnishings on the American market. These exhibitions focused primarily on American mass-produced products, but in the January 1951 presentation of "Good Design" at Chicago's Merchandising Mart, Franco Albini's glass-top desk produced by Knoll was included.[14]

Retailers and manufacturers responded to the new awareness

of Italian design in exhibitions and periodicals. Department stores like Lord & Taylor offered Italian wares, and Macy's in New York held its own "Italy-in-Macy's, U.S.A.," event for fifteen days from September 25, 1951.[15] This extravaganza of Italian draperies, lamps, carpets, housewares, ceramics, clothing, and food was highlighted by a 36-foot Venetian gondola parked in the centre aisle of the store and a three-ton model of Saint Peter's Church.

A more serious approach was taken by the M. Singer & Sons firm at 32–38 East Nineteenth Street, New York, which for over sixty-five years had made fine furniture in traditional styles. Joe Singer, the head of this family firm, decided to branch out into modern Italian design with the help of architect and designer Gio Ponti.[16] Ponti was an obvious contact because of his renown as an architect and designer, and his stature as editor of *Domus* magazine.[17] Joe Singer went to live in Italy for five months and worked with four architects whom he commissioned to design furniture for the firm: Carlo De Carli, Carlo Mollino, Ico Parisi, and Ponti. In November 1951, Singer & Sons launched their Modern Line, which they advertised as being sculptural and "neither boxy nor cold."[18] The wooden furniture with organic, tapered lines by Ico and Luisa Parisi and the easily disassembled designs of De Carli had frequently been featured in *Domus*, along with the work of Carlo Mollino. Typical of the Singer furniture was an elegant table by Gio Ponti with his characteristic tapered elements and two drawers, suspended from the top, as if floating within their frame (p. 72). The company did well with its modern line, because in March 1954, Singer illustrated its Italian furniture in an announcement of its new showrooms in San Francisco, Los Angeles and Miami.[19]

Even though Scandinavian design was popular in America after the war

and through the 1950s and early 1960s, firms specializing in European imported designs began to offer Italian furnishings; for example in New York, Lightolier Inc; Richards Morgenthau & Co., 225 Fifth Avenue; and Bonniers, which was a centre of Scandinavian design. By 1953, Altamira, at 18 East Fiftieth Street, was competing with Singer & Sons in the promotion of Italian furniture.[20] In 1955, Altamira advertised every month in *Interiors* promoting "the largest collection of fine Italian furniture, lamps and accessories in the United States," and the firm imported Marco Zanuso's aluminium and foam rubber chairs the *Lady* (cat. 351) and the *Martingala*.[21] In New York, Italian design was gradually supplanting the taste for Scandinavian furnishings.

The Triennali
America's new interest in Italian design on the part of manufacturers and retailers was stoked by its gradual recognition of Italy's Esposizione internazionale delle arti decorative e industriali moderne e dell'architettura moderna that had been held since 1923 and revived after the war. After the VIII Triennale in 1947, which examined Italy's housing problem, the IX Triennale focused on the integration of interior design, architecture, the fine and the decorative arts. Presented in Milan from May 5 until September 30, 1951, the American press gave it little advance publicity. So, even though there was a US pavilion, designed by Italian architects Belgiojoso, Peressutti and Rogers, Americans were not aware of the Triennale's importance. Walter Darwin Teague, however, did attend the fair and wrote in *Interiors* that it was the most stimulating show of its kind he had ever seen. He added that the settings for the displays—the use of materials, colour and lighting—were as interesting as the exhibits.[22] One of the most impressive

installations was Lucio Fontana's dramatic light sculpture in the grand staircase hall of the Palazzo dell'Arte, the central pavilion of the exhibition (p. 75). Teague described the thrill as you ascended the staircase, to see overhead "huge, three-dimensional swirls of hundreds of feet of white neon tube, floating apparently unsupported in a dark void."[23]

In contrast to the 1951 exhibition, the X Triennale in Milan (August 25–November 15, 1954) was well covered by the American press. *Interiors* editor, Olga Gueft, in her "Letter from Milan," wrote "the visiting reporter is bound to rub shoulders with more colleagues from the New York press than one could count on meeting at home during a month of press openings, not to mention hordes of designers—Americans visiting the Triennale, Italians, Britons, Scandinavians, and others participating in it. All of *our* world, in fact seems to be here."[24] *Interiors* devoted a large section of their November issue to the exhibition, acknowledging that in the field of interior design, Milan stood as one of the main world centres.[25]

A major theme of the X Triennale was industrial design, dramatically exhibited in galleries painted matte black and lit

Belgiojoso, Peressutti
and Rogers
Olivetti Corporation
Showroom at 584 Fifth
Avenue, New York
1954
From the magazine
Domus, September 1954

with enormous circular hanging lamps of white canvas like "sculptured clouds or flying saucers" that hovered over the 150 small industrial objects placed on low lying bases (p. 78). Such theatrical displays caught America's attention as did the Italian industrial design works. Olga Gueft acknowledged that even though the Americans were well ahead in the field of industrial design, the details in these mass-produced Italian wares were different and usually better. She commented with insight: "We may yet discover that the essential is craftsmanship in the broad sense, and not necessarily *hand*-craftsmanship. The plywood chairs of De Carli, Albini, and Gregotti, Meneghetti, and Stoppino, are sufficient proof that competence, precision and wit can exist in industrial design."[26]

Interior shop design
Another writer who was impressed by the individualist and experimental approach of Italian architects was Ada Louise Huxtable, a young assistant

curator at the Museum of Modern Art, New York.[27] She had followed developments in Italian architecture and design and organized a travelling exhibition of photographs and drawings entitled *The Modern Movement in Italy: Architecture and Design*, which was presented from August 17 to September 6, 1954 at MoMA. Huxtable wrote an article entitled "Post War Italy: Architecture and Design" for *Art Digest* to coincide with her exhibition.[28] She noted that although modern architecture had come late to Italy, the country was reaching its high point as a creative force, and she illustrated her article with Pier Luigi Nervi's feat of engineering, the airplane hangar in Rome—a spectacular structure of reinforced concrete that was breathtaking in its sculptural form. In the exhibition, Huxtable covered twenty-five years of Italian invention in architecture and design. She was especially impressed by Italian architects' exceptional flair in the interior design of shops and exhibitions—

"where much of the pure research, experimentation and transformation is done that translates the influences of the fine arts of painting and sculpture into terms of the practical arts of design . . ."[29]

This genius for display was readily evident in interiors for shops such as Scandale corset boutique designed by Paolo Chessa (*Interiors*, June 1950), Guglielmo Ulrich's design for the Società Ceramica Italiana Laveno in Milan (*Arts and Architecture*, June 1951), and the Olivetti Corporation's showroom in New York at 584 Fifth Avenue, which became the "talk of the town." Designed by the architects Belgiojoso, Peressutti and Rogers in 1954, it was a showcase for the vitality and imagination of postwar Italian design (p. 76). The Olivetti company, manufacturer of typewriters and business machines, had already been given the spotlight in an exhibition at the Museum of Modern Art in 1952, because the company had set a standard of modern design not only in its products, but also in its factories, stores, employee housing, and advertising (cat. 256).[30] *Domus* devoted seven pages to Olivetti's New York showroom, and the American magazine *Progressive Architecture* wrote that the new Olivetti interior and its merchandise reflected Olivetti's belief that good design was good business.[31]

Ada Louise Huxtable reviewed the Olivetti store for *Art Digest*, describing the sixteen-foot Italian walnut entrance door, the sea-like floor of malachite-green marble with white striations, a blue ceiling above and a sand-cast relief by Constantino Nivola along an entire wall. Rising out of the floor were tapered green marble supports upon which were perched Olivetti typewriters and calculators. Overhead hung cone-shaped Venini glass lamps in swirling colours (cat. 342). Other typewriters were displayed on pink marble-top tables and on a large, yellow rotating wheel, which conveyed the machines like a fairground Ferris wheel. In an understatement Huxtable wrote: "Visitors to the shop seem a bit dazzled by its unconventionality . . . So much expensive marble, so much rich color, so much drama do not fit readily into accepted standards and conventions."[32] The *Interiors* reviewer, Olga Gueft, was awed by "a great piece of showmanship, a stupendous display and wonderful theatre."[33] Gueft even published the architects' plans for the room and sketches of specific details of the supports and furniture. Unfortunately this masterwork of Italian showroom design from the 1950s was taken down a few years later.

Italian design: a distinctive look
Judging from American journals of the early 1950s, one is aware of a steadily increasing admiration for Italian design. Americans marvelled at the versatility of Italian designers who turned their attention just as easily to a glass vase as to the architecture of a building. They were equally impressed by the blend of new design with old traditions, the Italian love of decoration and colour, the adventurous breaking of old rules and codes of design, and above all, the distinctiveness Italians brought to industrial design in the face of uniform mass-production. North America began to import not only Italian products but the Italian architects and designers as well. In the field of car design, with the success of Italy's Cisitalia model (1949), by 1953 the Italians Pinin Farina, Mario Boano and Mario Revelli had been hired as consultants for the automobile manufacturers Nash, Chrysler and General Motors respectively.[34] Not only car designers, but Italian architects, graphic artists and furniture designers were being called upon by American firms for their talents and creative solutions.

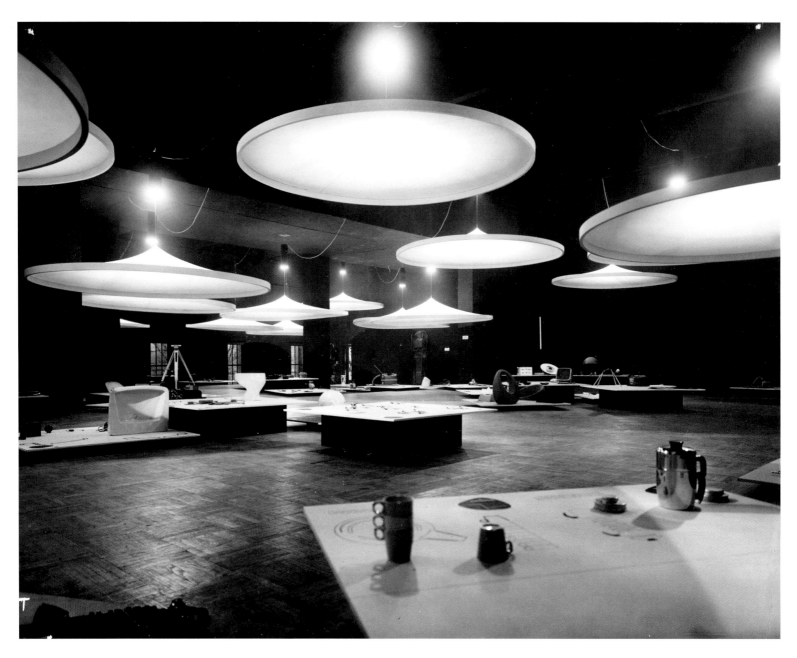

Achille and Pier Giacomo
Castiglioni
The Industrial Design
Gallery at the X Milan
Triennale (1954)
Triennale di Milano
In the foreground is the
Canadian presentation
from the Industrial Design
Division of the National
Gallery of Canada. An
aluminum coffee pot by
Jack Luck is prominently
displayed.

In the early 1950s, many Americans suddenly had the opportunity and financial means to travel to Italy, and they delighted in Italian films, food and fashion. A good example of Italy's "economic miracle" was the rise of Emilio Pucci who revolutionized casual fashion with his colourful sportswear (cat. 279) and silk jersey prints (cat. 280) that were embraced by America's fashion elite. Italian machines, appliances, accessories and architectural fittings began to invade the American office and the hearth of the American home—the kitchen. For Americans, what had started as a gesture of goodwill and business

sense in helping Italy recover from the war, became admiration for the unique character of Italian products and an acknowledgement of Italian leadership in international design.

[1] *Interiors*, vol. CVII, no. 12 (July 1948), pp. 71–118.
[2] Olga Gueft, "The Jests of Chessa," in *Interiors*, vol. CIX, no. 11 (June 1950), p. 86.
[3] W. D. Teague, "Italian Shopping Trip," in *Interiors*, vol. CX, no. 4 (November 1950), pp. 144–149, 194–201.
[4] Ibid., p. 201.
[5] After the Art Institute of Chicago, March 7–May 7, 1951, the show went to the following museums: M. H. de Young Memorial Museum, San Francisco; Portland Art Museum, Oregon; Minneapolis Institute of Fine Arts; Museum of Fine Arts, Houston; City Art Museum of St Louis; Toledo

Museum of Art; Albright Art Gallery, Buffalo; Carnegie Institute, Pittsburgh; Baltimore Museum of Art; Rhode Island School of Design, Providence.

[6] Meyric R. Rogers, *Italy at Work: Her Renaissance in Design Today* (Rome: The Compagnia Nazionale Artigiana, 1950), p. 15. Walter Dorwin Teague wrote the Foreword to the catalogue.

[7] This Finzi bowl was purchased by the New York dealer Julian Levy in 1954. (Brooklyn Museum of Art, Decorative Art Department Archives). At the end of the exhibition's tour, because custom duties had been waived, the exhibition items were given to the host museums or to Italian consulates around the country. Many were also returned to Italy, and smaller objects were finally sold through the Brooklyn Museum.

[8] *Magazine of Art*, vol. 44, 1 (January 1951), to accompany an article by Edgar Kaufmann, Jr., "Contemporary Italian Design: A Commedia dell'Arte," pp. 16–21.

[9] Rogers 1950, p. 49.

[10] Some examples are: *The New York Times*, August 11, 1950 and November 29, 1950; *Interior Design and Decoration*, November 1950; and *Art Journal*, vol. 10, 3 (1951). *Domus* gave a fully illustrated review of the exhibition in the November-December 1950 issue (nos. 252–253).

[11] Press release of *Italy at Work: Her Renaissance in Design Today*, Brooklyn Museum of Art, Decorative Art Department Archives.

[12] Kaufmann January 1951, pp. 19–20.

[13] Edgar Kaufmann, Jr., *What is Good Design* (New York: MoMA, 1950), pp. 23–24, 29.

[14] Edgar Kaufmann, Jr.,"Good Design '51, As Seen by its Director and by its Designer," in *Interiors*, vol. CX, no. 8 (March 1951), p. 103.

[15] "Italian Fair at Macy's," in *Interiors*, vol. CXI, no. 4 (November 1951), p. 14.

[16] "Across the Seas Collaboration for the New Singer Collection," in *Interiors*, vol. CXI, no. 5 (December 1951), pp. 120–129, 158. The "Modern by Singer" line of furniture was also featured in the February 1952 issue of *Domus*, 267, pp. 50–51.

[17] Ponti had founded *Domus*, an architecture and design magazine, in 1928 and was editor until 1977, except for a period from 1941 to 1947 when he set up the magazine *Stile*.

[18] Advertisement "Modern by Singer," in *Interiors*, vol. CXI, no. 3 (October 1951), p. 17. One American, Bertha Schaefer, was included in Singer's modern line.

[19] "Modern by Singer Now Spans the Nation," in *Interiors*, vol. CXIII, no. 8 (March 1954), pp. 6–7. In July 1955, Singer began to import Venini glass (*Interiors*, July 1955, p. 100).

[20] "Mobili italiani per l'America," in *Domus* (March 1954), pp. 57–72. See also Irene de Guttry and Maria Paola Maino, *Il Mobile Italiano Degli Anni '40 e '50* (Rome: Editori Laterza & Fidi, 1992), pp. 38–42.

[21] "Zanuso's Anthropomorphism in Foam," in *Interiors*, vol. CXIV, no. 12 (July 1955), p. 99.

[22] Walter Darwin Teague, "The Ninth Triennale: A Report on Milan's Great International Exhibition of Interior Design, Architecture and Industrial Design," in *Interiors*, vol. CXI, no. 2 (September 1951), p. 93.

[23] Ibid., p. 96.

[24] Olga Gueft, *Interiors*, vol. CXIV, no. 2 (September 1954), p. 61. The Industrial Design Division of the National Gallery of Canada, under the direction of Donald W. Buchanan sent a display of Canadian design objects to the X Triennale, (Industrial Design Division Report for April to October 1954, National Gallery of Canada Archives, 7.4 D, "Design in Industry," file 6, 1953–54.)

[25] Gueft, "Triennale: urbis et orbis," in *Interiors*, vol. CXIV, no. 4 (November 1954), p. 82.

[26] Ibid., p. 86.

[27] In 1963, Huxtable became the *New York Times* architecture critic. Lawrence Wodehouse, *Ada Louise Huxtable, An Annotated Bibliography* (New York; London: Garland Publishing, Inc., 1981).

[28] *Art Digest*, vol. 28, no. 18 (July 1954), pp. 6–8. There was no catalogue for her exhibition, only panel texts and photographs. The MoMA exhibition was presented in Ottawa beforehand, November 6–29, 1953, at the Design Centre run by Industrial Design Division of the National Gallery of Canada (National Gallery of Canada Archives). The architect, Enrico Peressutti, gave a conference on "Modern Design in Italy," on November 19, 1953, as part of the exhibition program. For the Canadian show, objects were added from Canadian stores such as Henry Birks & Sons and from private lenders in Canada and Italy.

[29] Quoted in "The Modern Movement in Italy: A Museum of Modern Art Travelling Show," in *Interiors*, vol. CXIII, no. 5 (December 1953), p. 153.

[30] The exhibition, "Olivetti: Design in Industry," was presented at MoMA October 22–November 30, 1952 and written up in the *Museum of Modern Art Bulletin*, vol. 20, no. 1 (Fall 1952), pp. 3–19.

[31] "Italia a New York," in *Domus*, no. 298 (September 1954), pp. 3–9. Page Beauchamp, "P/A Interior Design Data: Showrooms," in *Progressive Architecture* (November 1954), pp. 125–126.

[32] Huxtable, "Olivetti's Lavish Shop," in *Art Digest*, vol. 28, no. 18 (July 1, 1954), p. 15.

[33] Olga Gueft, "Olivetti New York," in *Interiors*, vol. CXIV, no. 4 (November 1954), pp. 124–131.

[34] "Italy's Bid on the World Market," in *Interiors*, vol. CXII, no. 9 (April 1953), p. 79. Also "Fiat to Ferrari, Those Fabulous Italian Cars," in *Industrial Design*, vol. 7 no. 4 (April 1960), pp. 78–95.

Diane Charbonneau

Touché! Italian Design Inspires Canada

In Canada, the shift to modernity in interior decoration came with the adoption of the Scandinavian style in the late 1950s. Informed consumers preferred this aesthetic, which was distinguished by its rational and simple solutions. It contrasted with the traditional forms of the past and of the postwar American model, which ran counter to the European temperament of the Canadians. The infatuation with this style was so great that it became the norm of Canadian taste in the 1960s, reflected not only in objects imported from Scandinavia but also in the design of local furniture and products.[1]

But this world in which teak predominated was shaken by the arrival of Italian design on the international scene in the mid-1960s. This period saw the globalization, rejuvenation and popularization of design. It was the influence of Pop art, as it had been assimilated by the Italians, that spread in the industrialized countries. Modern design, favouring perfection of form and rooted in the importance of function, found itself called into question. Tired of being told what was "morally" correct, consumers demanded objects that met their own needs and desires.

Canadian design was not immune to all this, and the most progressive of its practitioners followed suit. But it was the people of Quebec who were the most open to the Italian influence. The Latin roots of the Québécois may have been a contributing factor. Some thirty years later, Andrea Branzi would point out the propensity to adopt a European sensibility in a North American context. ". . . Quebec could become the mentor of North America in so far as it is a melting pot of ideas in which the European sensibility is mixed with American efficiency, but without its extreme pragmatism. Because they are familiar with the habits of the American consumer, designers from Quebec are well placed to collaborate with European enterprises on the creation of products aimed at the North American market."[2]

In the global village in which we live today, the fascination with the Italian look is far from fading. Indeed it has become a benchmark of excellence for many Canadian consumers, often to the detriment of the look of certain local products. Yet it remains hard to copy since, rooted in a humanistic approach, Italian design stems as much from intellectual considerations as from technological ones. In Canada, with just a few exceptions, it is technical expertise that attracts designers. Conceptual research is rarely encouraged.

Italian impetus
For over fifty years, Italian design has been admired, scrutinized and imitated all over the world by designers and companies who wish to present an image that is at once sophisticated, intelligent and fashionable. In Canada, two sectors of production stand out—furniture and lighting—as well as two major Italian influences—that of Pop design of the 1960s and the Postmodernism of the Memphis group in the 1980s.[3]

In the mid-1960s Pop art and plastic went hand in hand. If Pop freed the object from its dogmatic straitjacket through its distinctive aesthetic characteristics, the properties of plastic were necessary for this to be fully achieved. Italian designers and manufacturers were the first to recognize that the inherent qualities of plastic went beyond its capacity to imitate wood or other materials. Moreover, and in keeping with the new tastes of consumers, plastic objects were given an emotional charge while taking on simple and sensual forms in bright colours.

In Canada, plastic became fashionable in the manufacture of furniture. Designers and manufacturers produced inexpensive furniture that went down well with Canadians of all ages and income brackets. At the outset Plexiglas was

favoured, and then acrylic and polyurethane grew in appeal. However, output remained limited due to the modest level of the advanced technology required for effective mass production. Moreover, designers were far from innovative in their approach, imitating to a greater or lesser extent the style of furniture manufactured in other countries, including Italy.[4]

Lamp manufacturers also borrowed the vocabulary of Pop. They opted for coloured plastics, painted metal and chrome. Forms took on a playful air and were sometimes made out of combinations of more than one material. Among the lighting produced in this period, it is worth mentioning the *Glo-Up* collection of lamps designed in 1969 by Douglas Ball (Peterborough, 1935) in collaboration with

Jean-François Jacques
Circus Table
1982
Musée national des
beaux-arts du Québec

John Berezowsky. The forms (a question mark, the figure nine, and so on) were made out of a sheet of acrylic wrapped around a globular bulb. Produced for more than a dozen years by Danesco, the collection included bracket, table and floor lamps available in white, yellow or red.

If the aesthetic revolution engendered by Pop design faded for a while during the 1970s, it was to come back strongly in the early 1980s under the banner of Postmodernism. This time aestheticization and multiplicity—inherent characteristics of Pop design—were combined with historicism. This new form of anti-design developed under the aegis of the Memphis group, headed by Ettore Sottsass. Contesting the idea that household objects should stick to a traditional vocabulary of forms, colours, textures and motifs, the group's designers exploited unusual materials, unbridled forms, kitsch motifs and dazzling colours (cat. 112).

The repercussions on young designers were immediate. In Montreal, Météore Studio—made up of Pierre-Marc Pelletier, Jean-François Jacques, Jean-Yves Rouleau

and Hélène Benoît—took its inspiration from the Memphis approach in its eight original pieces of furniture produced for a studio of architectural design in December 1982. Even their manifesto was an echo of Memphis thinking: "Météore Studio offers an alternative to pure functionalism. Its aim is to show that furniture can be amusing and allusive and can join a host of images that have no relationship to function."[5]

Emancipated from its function and given an evocative name, the *Circus* table designed by Jean-François Jacques (Quebec City, 1957) exemplifies the creative effervescence of the moment. Exploring the possibilities of laminate and lacquered wood, the table is composed of simple geometrical shapes (square, triangle, sphere). Its structure and the repetition of the motifs are reminiscent of funfairs. Despite the enthusiasm shown by the media for Météore Studio's collection, however, manufacturers remained cautious, obliging designers like Jean-François Jacques to turn entrepreneur in order

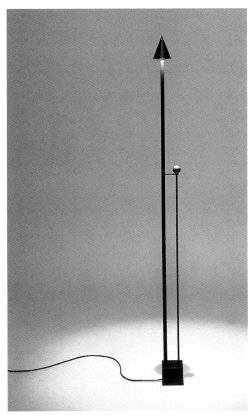

Scot Laughton
Strala Lamp
1986
Spun aluminum, epoxy-
coated steel, bronze
Produced by Portico,
Toronto
Courtesy Scot Laughton
Design

to bring out their objects in limited editions.

In Toronto, the pre-eminence of conceptual thinking over formal design was what motivated the establishment of Portico. In 1987 Scot Laughton, James Bruer and Scott Lyons set up this design studio, which also carries out production. It provided its founders with a means of ensuring that their furniture and lighting were produced in limited editions while maintaining a high level of quality. The *Strala* floor lamp is emblematic of their creations. Laughton (Ottawa, 1962) designed it in 1986 during his last year at the Ontario College of Art. At this time, Laughton was fascinated by Memphis, especially Sottsass's *Carlton* room divider (cat. 325).[6]

Strala, which means ray of light, took its inspiration from Memphis's lopsided geometry, but was much more minimalist and lacked its colours. In fact *Strala* is reminiscent of the *Holiday* floor lamp designed by Martine Bedin in 1983, both in its use of geometric forms and in its elongated and slender appearance. Forty signed and dated lamps were produced in collaboration with Tom Deacon, and Portico went on to manufacture several hundred of them. Arteluce, the Italian lighting manufacturer, showed some interest in the design, making a prototype but never bringing it into production.

Very few Canadian manufacturers embraced Italian Postmodernism at first. Baronet, the Quebec producer of household furniture, temporarily adopted the style when it came out with a new line of bedroom furniture in the 1980s. Its chief designer, Vell Hubel, claimed to be inspired by Memphis, but created sober furniture without embellishments. In the realm of lighting, it was a technological innovation from Italy that stimulated production. Two Quebec-based companies, Bazz and Sverige, adopted the halogen bulb in the mid-1980s. Rendered accessible by Richard Sapper's *Tizio* lamp

(cat. 293) in 1972, this new technology at last freed designers from the need for enormous lampshades. Michel Morelli, a designer working for Sverige, was one of the first to introduce the halogen lamp into Canada, and went for the trendy European look instead of the Scandinavian style.

Italian-style expertise

The excellence, sense of creativity and innovative character of Italian design constantly drew foreign designers to Italy. Among them were a number of Canadians who chose to live in the country, study there or simply take advantage of the expertise of its industrialists.

The most Italian of the Canadian designers is undoubtedly Albert Leclerc (1935), who has lived in the country for over thirty years. After completing his studies in Montreal, London and Paris, Leclerc put the finishing touches to his apprenticeship with Gio Ponti, for whom he designed in the 1960s. The following decade, he joined Sottsass's studio, where he worked on several designs, including the *Sistema 45* line of office furniture (1973), and the *A5* and *A7* (1974) and *Lexikon 90* typewriters (1975) for Olivetti. He also worked as a consultant for other Italian companies: Lorenz (clocks), Tecno and Planula (furniture), and Velca (office equipment).[7] He devoted himself to interior decoration as well, which gave him the opportunity to create one-of-a-kind pieces of furniture. For Leclerc, who now divides his time between Milan and Montreal, the influence of Italian design can be said to be an abiding feature. He favours an intellectual approach that takes technical factors into consideration, even though he has sometimes encountered a certain resistance in Canada.[8]

Nathalie Jean (Montreal, 1963) embarked on a career in Milan in 1988. She worked first for Sottsass Associati and then Aldo Cibic, before opening a studio of her own in 1993, where she specializes

Nathalie Jean
VS Vase
2002, 8/20
Produced by Design
Gallery Milano
The Montreal Museum
of Fine Arts
Liliane and David
M. Stewart Collection

mainly in interior design for the fashion world, articles for the home and more recently jewellery. In 2002, Jean produced a series of objects—furniture, boxes, vases, carpets—entitled *La ville nouvelle* for Design Gallery Milano. Taking her inspiration from the molecular world, she designed unique and elegant forms, at once angular and sharp. Typical of the Design Gallery's mission, the *VS* vase in polished metal was produced in a limited edition of twenty, with each vase signed and numbered. The following year Jean conceived, in the same vein, the *Atalashii Machi* series, made up of three ceramic vases for Driade's "Kosmo" collection.

A key Canadian figure on the international scene, Karim Rashid (Cairo, 1960) stands out for his fertile and innovative production. After receiving a degree in Canada, he continued his study of design in Naples, going on to work with Sottsass, Gaetano Pesce and Rodolfo Bonetto. He spent some time in Canada in the 1980s, and then opened a studio in New York in 1993, where he has specialized in interior decoration and the design of furniture and lighting, as well as fashion. Rashid works for an impressive range of clients, including several Italian manufacturers like Alessi, Artemide, Cappellini, Danese, Edra, Magis and Zeritalia.

Rashid's work is distinguished by a style that he describes as "sensual minimalism"[9] and a conceptual approach considered closer to that of the artist than that of the designer. It encompasses the use of new materials and the development of advanced technology and expressive forms. The *Aura* coffee table, designed for Zeritalia in 1990, epitomizes some of his ideas. The table is composed of three glass surfaces in different shapes (oval, rectangle, figure eight) and various colours inserted in a structure of steel rods. With the colours, Rashid broke new ground through the use of Color-Tint technology. Moreover, and despite the minimal appearance of the table, its structure allowed the position of the shelves to be changed to create a variety of permutations and colour effects.

Karim Rashid
Aura Coffee Table
1990
Produced by Zeritalia
The Montreal Museum
of Fine Arts
Liliane and David
M. Stewart Collection,
gift of Zeritalia

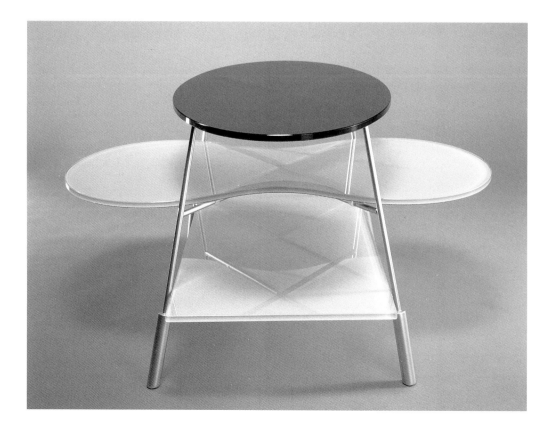

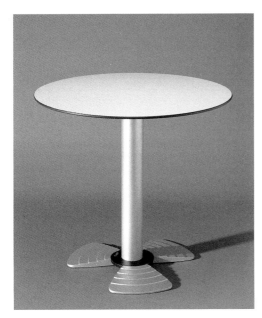

Charles Godbout
Margherita Table
1997
Produced by Plank
Musée national des
beaux-arts du Québec,
donated by Plank s.r.l.

Access to Italian know-how was a factor for Charles Godbout (Montreal, 1955) as well. His move from the Canadian scene to Italian production was made on behalf of Flou America, a Quebec company specializing in the manufacture of beds designed in Italy. Godbout created out of aluminium—his favourite material—a platform for a bed that attracted the attention of Flou Italia. Plank then brought out his *Margherita* table, launched at the Milan Furniture Show in 1997. Simple and cheap to manufacture, the table had an innovative base consisting of a single pillar and a system of modular feet in cast aluminium.[10] His more recent *Folder* table stands out for its concave fold moulded in the plywood of the top. The undulation gives the table its name while bestowing on it an unprecedented touch for an otherwise classic design. Although designed for the Canadian firm Arconas, Godbout acknowledges the Italian influence.[11]

With globalization, Canadian designers have begun to make a mark on the international scene and it matters little whether they work in major cities like Montreal, Toronto or Vancouver, or in Winnipeg, Ottawa or Hamilton. A wide variety of Canadian creations has been brought out in Italy, including lighting, household accessories and furniture. Of note are the *Tango* desk lamp (1989) designed by Stephan Copeland for Arteluce and the *Dragonfly* spotlight (1997) designed by Kirk Mosna from Hamilton, of which more than 10,000 have been produced by Egoluce. In 1999, the Bakery Group of Ottawa was approached by Prandina for its *Light Volumes* collection.

Make room for Italian design!
While the Italians remain masters at distributing their creations, foreigners are also keen to promote them. Italian design regularly stirs the curiosity of the cultural milieu in Canada. This has found expression in a series of events, including

exhibitions and conferences, that have taken place since the early 1980s.

As far as exhibitions of Italian design in museums of fine arts are concerned, the first was organized by the Contemporary Art Museum in La Jolla, California, and presented at the Musée d'art contemporain in Montreal in 1983. It was called *Italian Re-evolution: Design in Italian Society in the Eighties* and displayed some 600 contemporary objects from the spheres of the food industry, fashion, transport, work, the home and leisure. This was followed, in 1985, by *The European Iceberg. Creativity in Germany and Italy Today*, organized by the Art Gallery of Ontario under the direction of Germano Celant. The exhibition included a modest section on design: the Italians were represented by Achille Castiglioni, De Lucchi and Sottsass, among others.

In 1996, the Musée du Québec put on a show entitled *Masterworks: Italian Design, 1960–1994*, organized by the Denver Art Museum with pieces from its own collection. The exhibition comprised 145 objects, including furniture, glassware, ceramics and metalwork.

Institutions specializing in design have also regularly put on shows celebrating Italian creativity. At the Centre de design of the Université du Québec à Montréal (UQAM), three exhibitions, two of which were monographic, bear mentioning: *Enzo Mari, une démarche progressive* (1983), *Gaetano Pesce : produire industriellement la différence* (1989) and *Compasso d'Oro : les prix du design italien de 1954 à 1998* (2003).[12] The last of the three, organized by the Galleria del Design e dell'Arredamento in Cantù in concert with the ADI (Associazione per il Disegno Industriale), CLAC (Centro Legno Arredo Cantù) and the Milan Politecnico, was held at various venues in North America.

In Toronto, the Design Exchange put on the exhibition *Gusto: Italy Inspires Canada*, which was divided into three

sections: "Moda," "Macchina" and "Compasso d'Oro." Extolling the excellence of Italian *savoir-faire* in the realms of fashion, cars (Pininfarina) and industrial design (the Compasso d'Oro award, 1998), the organizers urged Canadians to take inspiration from this model. Then, in 2002, Design Exchange presented *iMade*, which examined the radical changes, in terms of both technology and materials, that affected the Italian furniture industry between 1991 and 2001.

This survey of Canadian shows would be incomplete without a mention of the international conferences held by the École de design industriel at Université de Montréal in the 1990s. Under the direction of Albert Leclerc,[13] students and aficionados of design have been introduced to the works of the following designers: Andrea Branzi, Clino Castelli, Achille Castiglioni, Antonio Citterio, Enzo Mari, Alessandro Mendini, Nanni Strada and Massimo Vignelli.[14] In addition, Leclerc permitted students in the design program to take advanced courses with Branzi, Citterio, Lissoni and Mendini, as well as to pay visits to Italian manufacturers (Pininfarina).[15]

Collecting Italian design is another matter that fascinates many, but nothing in Canada compares to the Liliane and David M. Stewart Collection[16] housed in the Montreal Museum of Fine Arts. Devoted essentially to the twentieth century, the collection highlights the postwar period and the leading exponents of contemporary design. Its first acquisitions include pieces from Scandinavia and the United States, but then it is Italian design that holds the limelight, to a great extent as a result of the relationship that the collection has established with Andrea Branzi, Alessandro Mendini, Gaetano Pesce and Ettore Sottsass.

It is the aim of the Liliane and David M. Stewart Collection to prize innovation— be it in terms of form, the use of materials or the choice of subject—in pieces that are often on the borderline between art object and functional object. Large-scale industrial production, limited editions and even handicrafts coexist harmoniously. This approach has led to the acquisition not only of the products of manufacturers (Cappellini, Edra, Zanotta, Kartell, Gufram, Artemide or Flos) but also of objects from galleries specializing in limited editions or one-of-a-kind pieces, like Design Gallery Milano (cats. 7, 49 and 50).

It is through exhibitions that the Liliane and David M. Stewart Collection defines its specific character and adds to its contents. In 1991 the exhibition *Design 1935–1965: What Modern Was* explored the different aspects of modernity and contributed to the inclusion of some eminent designers: Gio Ponti (cat. 273), the Castiglioni brothers (cat. 73), Joe Colombo, Carlo Mollino (cat. 220), Carlo Scarpa (cat. 304) and Lino Sabattini (cat. 288). Then, in 1997, *Designed for Delight: Alternative Aspects of Twentieth-century Decorative Arts* permitted the inclusion of a more diverse production corresponding to the Radical Design of the 1960s and the Postmodernism of the 1980s: Studio Tetrarch, Piero Gilardi, Alessandro Mendini (cat. 212), Matteo Thun (cat. 336) and Ettore Sottsass (cat. 326). Monographic exhibitions have enriched the collection with objects designed by Gaetano Pesce (cat. 254) and Andrea Branzi (cat. 50), and produced by Kartell (cat. 88).

Today it is in the galleries of the Montreal Museum of Fine Arts that visitors are treated to Italian expertise. The Museum's recent acquisition of a group of pieces produced by Memphis, of *La Poltrona di Proust* designed by Mendini (cat. 208) and of the *Corallo* armchair designed by the Campana brothers for Edra demonstrates an unwavering interest in Italian design. It is an interest that in and of itself warrants the staging of the major exhibition on 100 years of Italian creativity.

Fernando and
Humberto Campana
Corallo Armchair
2003–04
Produced by Edra
The Montreal Museum
of Fine Arts, gift of Edra

[1] This passage to modernity is described in Michael Prokopow, "Daigner être moderne. Le goût du Canada pour le style scandinave dans les années soixante," in Alan C. Elder (ed.), *Fabriqué au Canada. Métiers d'art et design dans les années soixante* (Montreal; Kingston: McGill–Queen's University Press, 2005), pp. 93–105.

[2] "Le design à Montréal. Entrevue de Myriam Gagnon avec Marie-Josée Lacroix," in Myriam Gagnon, *Montréal. Portraits de cinq designers montréalais* (Montreal: Centre de design de l'UQAM, 1998), p. 14.

[3] The different aspects of the impact of Italian design on Canadian creativity are discussed in a work devoted to Canadian design: Rachel Gotlieb and Cora Golden, *Design in Canada since 1945. Fifty Years from Teakettles to Task Chairs* (Toronto: Alfred A. Knopf Canada, 2001).

[4] For a discussion of the importance of plastic in Canada in the 1960s, see Brent Cordner, "Capsules. Plastique et utopie," in A. C. Elder (ed.), *Fabriqué au Canada. Métiers d'art et design dans les années soixante* (Montreal; Kingston: McGill–Queen's University Press, 2005), pp. 81–92.

[5] Paul Bourassa, "Design industriel," in Marc H. Choko, Paul Bourassa and Gérald Baril, *Le design au Québec* (Montreal: Les Éditions de l'homme, 2003), p. 91.

[6] David Hayes, "The Edge of Control," in *Azure*, vol. 18, no. 143 (September/October 2002), p. 82.

[7] Bourassa 2003, p. 68.

[8] "Four Questions: Italy Inspires Canada," in *Exchange*, vol. 8, no. 1 (Spring 1999), p. 31.

[9] Helen Delacretaz, *Habitat. Canadian Design Now / Le point sur le design canadien* (Winnipeg: The Winnipeg Art Gallery, 2002), p. 74.

[10] Bourassa 2003, pp. 96, 98.

[11] David Theodore, in "Cool Front Moves In. Hot Designs from the Near North," in *Azure*, vol. 19, no. 147 (May/June 2003), p. 80.

[12] Information taken from documents supplied by the Centre de design.

[13] Albert Leclerc was head of the École de design industriel from 1992 to 2004.

[14] Information supplied by the École de design industriel, Autumn 2005.

[15] Interview with Albert Leclerc, Spring 2005.

[16] A collection that led to the foundation of the Montreal Museum of Decorative Arts, which in 2000 entered in its entirety the Montreal Museum of Fine Arts.

Achille Bonito Oliva

Italian Ways
in Contemporary Art

Lucio Fontana
Soffitto al neon
For the exhibition *Italia '61*,
Turin (1961)

From the historical avant-garde to the neo-avant-garde movements, from Futurism to the Transavanguardia, in its representations of modernity Italian art has embodied a uniquely Mediterranean and cosmopolitan character distinct from its northern European and American counterparts. This innate cultural identity rests on a design-oriented process that has played a determining role in the linguistic strategy of Italian art from the fifteenth through the twentieth century.

The Renaissance perspective on the world gave symbolic form to an anthropocentric and logocentric ideology via spatial representations based on Euclidean geometry. The use of this geometry naturally meant that a sense of proportion was part and parcel of the iconographic essentiality of the images produced. As exemplified in Paolo Uccello's *Battle of San Romano*, whether abstract or figurative, the pictorial motif was filtered by an increasingly analytical eye, leading Leonardo da Vinci to affirm: "painting is a mental thing."

This "mentalism" would sustain the development of Italian art, marked by an expansion and refinement of form, through the spatial acceleration of the Baroque and the transition from the nineteenth to the twentieth century, and into the early decades of Futurism and Metaphysical painting. The sculptural work of Medardo Rosso, which predated these avant-garde movements, represents the manifestation of a desire for dematerialization, an attempt to bring a refinement to sculpture almost akin to that achieved in painting. The Metaphysics of De Chirico, Carrà and Morandi informs its iconography through deliberate attempts to disrupt the viewer's normal modes of perception within a well-defined perspective grid. And here again it is the sense of proportion that gives the image its simplicity and epiphanic clarity.

A uniquely Italian approach to the creative process informs twentieth-century Italian art. It is reflected in an interpretation of modularity imbued with an *esprit de géometrie*, a wide-ranging inspiration that influences both conventional and non-conventional works. The module becomes the structural element that makes form possible, a form that always embodies complexity and reproduces the surprises of geometry potentially ad infinitum. Convention has it that geometry is the field of pure evidence and cold demonstration, the locus of mechanical and wholly functional rationality. In this sense the module appears to favour the premise, and thus the conclusion is the inevitable outcome of a simple logical and deductive process.

The Italian artist on the other hand inaugurates a new use of geometry as fertile ground for getting "outside of the box," developing its principles on the basis of surprise and emotional impact. But these two elements are not in conflict with the principle of the design process; if anything they strengthen it through a pragmatic and non-confining use of descriptive geometry. The artist continually shifts from the two-dimensional realm of the design to the three-dimensional realm of the created form, from the black-and-white of the idea to its multicoloured expression, proving that the idea generates a creative process that is not purely demonstrative but also fruitful. The final form, whether two- or three-dimensional, offers concrete, non-abstract visual matter.

The principles of non-congruence sustain work that formalizes irregularity as a creative principle. In this sense form is not completely made clear in the idea; there is no absolute mirror image relationship between a design and its execution. The work embodies in its very design the possibility of non-congruence, because the design is informed by the

Alberto Burri
Rosso plastica
1964

mentality of modern art and the conception of the world that surrounds it, a world full of surprises and sudden turns.

The concept of design is thus imbued with a new meaning. It no longer refers to a process marked by superb precision, but rather to an open-ended exploration, albeit one piloted by a method derived from practice, from the execution. The method naturally relates to a need for consistent and progressive features grounded in a historical awareness of a context dominated by technology.

Technology forces production processes founded on standardization, objectivity and neutrality. These are the founding principles of a fecundity that differs from the one built on the traditional and hyper-subjective idea of difference. In this, the Italian artist is classically modern, a producer of differences via the creation of forms that use standardization, objectivity and neutrality in a fertile way, capable of penetrating the imagery of a mass society subject to the primacy of technology, which has emptied it of all subjectivity. Hence the strong relationship between art and architecture that would later triangulate with design.

For the Futurists (Balla, Marinetti, Boccioni), the city is the realm of random encounters, the place where the

unforeseen is rendered dynamic by the ability of technology to reproduce it endlessly. Art is the instrument for formalizing this hallucination by creating a visual field for it. The Futurist movement, in retrospect, was more balanced than it seemed at first glance or from readings of period documents. The works and the theoretical manifestos present the identity of a group of artists who combine the internationalist apologia for the machine with the rediscovery of their Mediterranean roots. The salient feature of even the first generation of Futurists is their adherence to the principle of art as a quest capable of embracing an "objectivity" of scientific scope. Balla works with an interdisciplinary impetus that sends him into linguistic solutions adhering faithfully to a philosophy of creative experience. A sort of phenomenological outlook guides the artist's hand; he does not project himself into or identify emotionally with the recovered materials. The characteristics of objectivity and concrete presence are reaffirmed through another assumed characteristic, one belonging not to the figurative arts but to theatre, to the event. The painted frame outlines a stage that circumscribes the happening. The image is fulfilled in its objective extraneousness to matter and form when the audience contemplates it. The audience is in some way incited to gauge its temporal dynamism, its plastic rearing of form. This dimension presupposes both the concrete weight of the material and its mental abstraction, the essence of the number and the biological evolution of the material, growth and stasis, volume and pure colour. One of Balla's works is titled *I numeri innamorati* [Enamoured Numbers].

In the architectural designs of Sant'Elia, everything moves in a circle along lines of flow that envelope the composition. The composition thus becomes a field for a system of mobile relations governed by the rules of an eternal engine that seems to lose the machine-oriented ardour typical of Futurist sermons and take on the peaceful lilt of a wise vision that goes even beyond modernity. Sant'Elia's architectural virtuality—pure non-built design—is successfully overturned in the built architecture of Albini, Baldessari and Terragni, which is opposed in painting by the Novecento movement of Sironi, Terrazzi and Donghi, and by the work of Muzio and Gio Ponti in architecture and design.

In the late 1940s and early 1950s, artists in Italy had to come to terms with the results of three different but parallel artistic lines, represented by Burri, Fontana and Capogrossi respectively, who took as their point of departure the concept of art (material, gesture and sign) as a total act of convergence between artwork and life. The work of art is where the artist takes refuge from the precarious nature of life.

The problem for Burri was to synthesize the space within a painting, the obscure fulcrum of existence, the traumatic flow of time, and the innate power of matter (jute, iron, wood, plastic). Capogrossi traced out an archaic and unvarying sign on the surface of the painting, the glaring alphabet of a language capable of articulating a stratified temporality within the instant of the image: symbol and decoration, substance and form. The problem for Fontana on the other hand was to throw himself upon the dimensions of space and time and reduce them to a single sign. The canvas is left with a scar, the symbolic trace of the artist's actions as an immediate experience of real space, which then opens up into architecture, for the observer a habitable place.

A generation later, in the late 1950s and early 1960s, other artists asserted the concept of art as a specific and

Jannis Kounellis
Senza titolo
1987
Galleria Sprovieri, Rome

autonomous activity. For Castellani, Manzoni, Agnetti, Lo Savio and Paolini, creative experience had to be expressed via specific techniques and with a clarity of action so as to render maximally explicit the "making" of the work, now seen as a reality unto itself, relieved of any subjective purpose. These artists opposed the "heteronomy" of art in favour of its autonomy; in opposition to the concept of art as a liberating and uncontrolled adventure, they imposed a kind of political awareness of their role, which led them to live their creative quest professionally.

These artists ceased to identify with the work and adopted an active detachment that allowed them to control the work via the analysis of language. They no longer believed in the absolute value of art, but only in its relative value arising from a "metalinguistic" awareness of it. This new attitude would inevitably lead to a reduction of art to zero, to the fundamental rules, to pure creative exploration, to the affirmation of a linguistic tautology. Art had to stop being generated by its own indeterminateness; it had to move into a controlled and verifiable cognitive field.

This new analytical protocol (which found more than inspiration in the gesture in Fontana's art as a measure of itself and of space) brought about a qualitative shift with an intentionally political emphasis. The artist no longer sought to conflate art and life, to resolve the antinomies of history through art, but only to probe more deeply and forge ahead in the artistic quest. The artist of the 1960s responded to the partial reality of the everyday with the relative totality of the work that now lost all its imitative allusions to the theatricality of life and instead acquired its own resplendent superficiality. Superficiality here is the awareness of the intrinsic ambiguity of the two-dimensional nature of the

language, of its being both created work and creative vehicle.

The work of art no longer expressed the urge to push towards life, but now sought to analyze the distance between itself and life and the peculiarity of artistic language with respect to the language of communication. The artist became dedicated to the exercise of a profession specialized in a well-identified object: language. Language exists prior to the work, and its realm is in the history of art. But the artist, embedded in history and subject to its repercussions, is lucidly aware that our precarious existence cannot be redeemed through imagery. Imagery is generated by language, it is always grounded in reality, but in order for it to be formulated in a work of art, a rigorously analytical procedure is required that can separate the disorder of life from the order of art.

The analytical processes of Castellani, Colombo, Dadamaino, Mauri, Nigro, Uncini, Manzoni, Agnetti, and in a certain sense Schifano, Lo Savio and Paolini, do not rely on previous conventions, but seek to establish their own method of verification simultaneous with the creation of the work, so that nothing exists before or after it. The metaphysical margin persisting in informal art is thus eclipsed, so that the work becomes the continuation of life, and life is the before and after of the work.

Castellani works within the sphere of modular experimentation to investigate the notion of space. The work is configured as a colourless surface, plotting out the spatial element as a two-dimensional expanse and the temporal element as a rhythmic depth-wise modification of the surface itself. Surface and rhythm are the two polarities that conjugate the work and define it in terms of proportion and experience, as also occurs in Mauri's Schermi [Screens],

Francesco Lo Savio
Articolazione totale
1962

whose naked object-ness highlights their tautological substance.

Manzoni's Achromes (cat. 177) are predominantly white surfaces, created out of various materials that organize a portion of space that has relevance only to itself. A metonymic conception dominates the work, replacing the metaphorical vision that underpinned the art of the 1950s. Yet the material and the cut were always metaphors for dynamic energy and traces of a possessed real space. The Achromes are only what is seen, a particular phenomenology of space reduced to a visual and concrete event. The painting is the result of a procedure in which all the elements are under the emotional control of the artist, who gives the work a separate and autonomous identity of its own. The works are concrete events that present diversified images of the intentionally colourless pictorial space containing no hint of subjectivity.

With these works and his subsequent identity cards, Manzoni anticipated themes regarding painting and the art of behaviour. While the Achromes consist in the annulment of painting as expression, his non-painted works sought to develop a comparison between art and life in order to create a fun experience, one that is not metaphorical and formal but authentic and real. The ninety tins of *Merda d'artista* [Artist's Shit (cat. 176)] are sealed specimens of organic waste of a body, the artist's, that have been preserved for future memory.

Agnetti worked against the specificity of languages by using them interchangeably: the mathematical code, with its succession of numbers, replaces literary language. The result was an initial annulment and a subsequent amplification, which derived its meaning from the universal character of the new language as a means of communication. Naturally, communication is accomplished through the objectivity of a language seeking its referents in science and philosophy, astronomy and algebra.

Lo Savio anticipated the primary creative pursuits of Minimal art with an analysis of the structural elements upon which the notion of painting and sculpture rests: light and space. His Filtri [Filters] and Metalli [Metals] highlight this analysis through an essential and phenomenal representation of light and space as concrete events. Light is not represented in geometrical rhythms as Balla did, rather it is underlined and rendered volumetric by a formal arrangement that concretely frames and encapsulates it.

Paolini pursued an analysis of art as an autonomous and self-referential system. His creative investigations followed a winding path through the labyrinths of the language and history of art. Artifice and mirror-image relations are the qualities he uses in representation: the former represents distinctions while the latter are the interlocutory action of language within the code of art. His analysis does not find its outlet in formal simplification, but rather brings out the ambiguous substance of the cognitive process through allusions to the double and to the labyrinth.

While these artists introduced the need for analytical process into the art of the 1960s, Ceroli, Schifano, Festa, Pascali and Kounellis worked via a synthetic process. Ceroli made wide use of wood as a compositional material for his abstract and figurative works. With formal rigour he constructed spaces and masses out of a material strongly associated with nature. In the age of the mechanical reproduction of images, he created a landscape of shapes, a metaphysical figurative standard, via a precise and balanced interweaving of the coldness of the concept and the warmth of memory: "nature–nature-generated" sequences in the forms of art.

Mario Merz
Triplo Igloo
Aluminum, steel,
broken glass, clay
Musée d'art contemporain
de Montréal

With his Monocromi Schifano negated the pictorial space, underlining its "superficialist" significance with bright and aggressive colours in a revival of urban iconography, a relic of the Futurist archives and the mass media. He subsequently inscribed on the surface details of natural and urban landscapes such as Incidenti d'auto [Car Accidents], an evident reference to the rhythmic figurativeness of Balla. Here too colour is accentuated in bright, artificial tones. The image is the product of a swift execution that elicits a Futurist idea of temporality in which the acceleration of processes and the deceleration of form incessantly feed into one another.

Tano Festa operated in the direction of neo-metaphysics, the dream of a cultured world that retains its roots even though shaken by the impact of voracious consumerism, which has transformed its myths into infinitely reproducible images. His painting conserves a literary aura and a humanistic memory of the regality of art. This produces a calibrated immobility in his images and singularly present figures growing out of a "universal" culture, over which there seems to loom the protective but absolutely non-metaphysical shadow

of De Chirico with his disquieting sense of classical proportion.

Pascali progressively developed an oeuvre that falls somewhere between painting and sculpture, a kind of final objectivism in which an equilibrium is established between the transparency of form and the depth of elements: *32 mq. di mare* [32 sqm of Sea] and *Confluenze* [Confluences] represent the successful products of a Mediterranean current that unites a repetition of the supporting structure with the fluid movements of water. In this case the "aura" of the work manages to protect the complex depth of the subject precisely through the use of modular elements (water or shaped stone) and the absolutely non-phenomenological use of materials. At the same time the simulation of a real object—be it machine gun or cannon—is the result of a combinatory system that both assembles and transfigures industrially produced elements.

Analytical and synthetic processes underpinned the artistic pursuits of the late 1960s and early 1970s in the conceptual and behavioural modes of art, architecture, and design. The conceptual mode arose from the need to shift the aims of art away from its traditional objects and materials. Whether focusing

97

on the process, the concept, or behaviour, Italian art of the 1960s stayed clear of the notion of poetics, understood as an obsessive faith in the same material or in a fixed image.

Poetics is a sort of symbol functioning as an autograph, a distinctive mark, the datum that attributes paternity of the work to its creator. It always arises from the need of artists to be consistent and true to themselves. Artists in those years eschewed paralyzing attributions, adhering instead to a programmatic unfaithfulness that enabled them to create apparently contradictory works. They thus placed themselves in synchrony with the closely woven web of real events that take form and evolve under the sign of uncertainty. They rather systematically incorporated this uncertainty into their own work, challenging consumer society and transgressing the limits of linguistic orthodoxy. The radical thought of the 1960s also swept through architecture and design, bringing with it a comprehensive analysis of their language and functions. The result was an analytical work whose outcomes were not only critically valid but also a creative success. A network of young architects and groups of architects developed in Britain who expressed their analyses via an initial materialization of the product. The British Archigram group was answered in Italy by the radical architecture groups concentrated around Milan and Florence: Memphis, led by Ettore Sottsass; Alchimia, headed by Alessandro Mendini; Superstudio; Archizoom; and UFO.

Each of these individuals or collectives produced conceptual works that often took the form of drawing boards, photos, maps, or objects stripped of their function. As a whole, these works opened up new horizons for architecture and design. Some groups were prevalently serious and composed in their works,

while others ventured into an ironic and mocking approach fuelled by a healthy nihilism, through which they highlighted the reduction of architecture, design and programmatic art to pure gadgetry.

Pistoletto intentionally went through various phases, with works that upended and displaced his entire early oeuvre with mirrors. With these mirrors he has portrayed the art–life enigma as a *trompe l'œil*. His *Lamiere specolari* [Reflective Steel Surfaces] contain superimposed images of everyday objects or figures of people, fixed in some random instant. Standing before the work, the observer is reflected and thus assumes a dual position: reflected object and beholding subject. Time is the element that attributes a historical quality to the work; its form belongs to the interactive present time of the spectator.

With a sidestep worthy of the deftest torero, and as theorized in his 1967 booklet *Le ultime parole famose* [Famous Last Words], Pistoletto abruptly abandoned his work with reflective surfaces and set out to consolidate a linguistic system in which the concept prevails over the object. Participants in this overall process included artists such as Anselmo, Fabro and Boetti.

Anselmo intended to ensnare the spatial and temporal relationships contained within abstract categories of thought, exemplified for instance in the terms "whole," "detail" and "infinite." Detail is represented by an area on the wall or the floor of the gallery illuminated by a projector. The area is rendered as a self-fulfilling space. Thus the linguistic term is identified with its physical manifestation, in its spatial and temporal presence.

Fabro's work sought to be an exercise of discovery in which the material exhibition of the object became an incitement to new formulations of thought. The use of incongruous materials in startling juxtapositions

Francesco Clemente
Due porte
1982

Enzo Cucchi
La guerra delle regioni
1981

generated unprecedented schemes that do not admit a straightforward, passive reading. The apparent linguistic tautology is counterposed with a true mental contradiction, a displacement of the image that packages art as an ideological practice.

Boetti proposed a different focus and a system of ambivalent relationships within the sphere of given experiences that existed prior to his work. Art became a language imbued with virtuality as compared to the slumbering rigidity of other languages. It took on the attitude of an intelligence capable of revealing hidden currents, the intrinsic qualities perceivable in the creative act. The combinatory system becomes the medium between the artist-client and the executors. The work (map or tapestry) is nevertheless the result of a design process dictated by the artist and enriched by the manual work of those who bring it into form.

Also working in the conceptual circle were Lombardo and artists such as Prini, Isgrò and Mulas. Kounellis worked on the poetic recovery of myth, on the use of primary elements such as fire, and original languages such as dance and music. He shifted the processes of painting to the physicality of real space, which took on the composed fixity proper to a square. His performance art and installations tended to highlight sensitivity as the capacity to perceive the world at the point of intersection between nature and culture. This complexity finds its representation in an image inspired by a powerful and intense classicality, one that is not neutral but severely objective. Art becomes the visible phenomenon that gives form to the conflicts of history in an exemplary manner, and resolves them via the catharsis of the creative event.

Operating in the decidedly post-conceptual sphere were Mochetti, Spalletti, Bagnoli, Salvadori and Piacentino.

Piacentino accepted the idea of art as the rigorous redesigning of forms, creating three-dimensional objects presented in a manner far removed aesthetically from the traditional colours of painting and sculpture. He obtained the chromatic splendour of his objectivism from the mechanical register of the technological universe, emphasizing its metaphysical geometry.

The work of Bagnoli was an investigation into the physical and mental quality of space and time, in their virtuality and the open-ended dialectics of their multiplicative product. It is an analysis of the concept of limit, of the interstice as a location for the germination of differences and oppositions. The principle of centrality is violated in favour of oblique and mobile relationships.

Salvadori conducted an investigation mainly into the theme of the doubling of unity and the simultaneous presence of two opposing polarities, such as male versus female, top versus bottom. The line is the diaphragm separating and differentiating identity and similarity, which can be placed at the median to generate the two faces of symmetry on two opposite and irreconcilable planes.

In the mid-1970s, a more disabused and cultured art overturned the purely grammatical presentation of elementary materials. The prevailing tendency became that of representation, reintroducing references to nature. This act of recovery was filtered through the historical memory of the languages of art and became part of the culture. It was an act of revival arising from the need to go beyond the threshold of the pure presentation of materials, in favour of a representation capable of greater autonomy with respect to the strong words of the political that conditioned artists in the 1960s to the point where they abandoned complexity in their work. Artists thus launched a healthy process

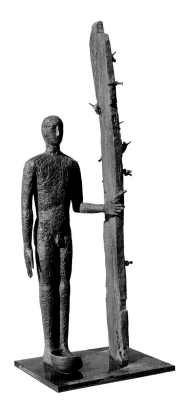

Mimmo Paladino
Untitled
2002
Bronze, 3/3
The Montreal Museum
of Fine Arts, purchase,
gift of International
Friends of The Montreal
Museum of Fine Arts

of de-ideologization. They transcended the euphoric idea of the creative experience as an eternally experimental movement and compulsion for the new through a more meditated manner, as in Spalletti.

The energy crisis and its political and cultural counterparts in the first half of the 1970s had the beneficial effect of smoothing out the fabric of art, worn out by overwrought experimentalism driven by the productive optimism of the economic system of the decade.

Experimentalism had taken on an impersonal, objective character focusing not only on communication, but also on the information contained in the linguistic structure of the work. An analytical tension unquestionably pervaded the artistic pursuits of the 1960s and 1970s, a kind of antagonism towards reflective scientific thought yet also imitative of it. The abstract and dematerializing work of the experimental testing ground coincided with the destructuring and dematerialized work of art, as in the case of Mochetti.

The Transavanguardia movement responded immediately to the general crisis of history and culture, embracing a deviation from outdated pure experimentalism. Instead it reversed the outdatedness of painting in order to imbue the creative process with new vitality and images that did not shy away from the pleasures of knowledge and cultural memory. In architecture and design, the response arose from the anti-dogmatic Postmodern attitude that questioned the value of the design-oriented approach and the continuity of the Modern movement. The Memphis group under Sottsass produced a series of objects exalting characteristics that went beyond function. The architecture of Aldo Rossi re-established a continuity with fifteenth-century linguistic values and a neo-metaphysical idea of history.

The art of the 1980s responded to the linguistic standardization of the 1960s and 1970s with the revival of citation, using the history of art as a "ready-made" and the styles of the past as *objets trouvés*. It thus represented a synthesis of the mindset of Picasso and Duchamp, with a conceptual implication that accepted Leonardo's statement that "painting is a mental thing," especially as seen in Clemente and Paladino with their adoption of the combinatory system, and in De Maria in his assumption of the relational notion of "field."

Clemente's works drove a progressive shift of style, the undifferentiated use of a variety of techniques. His work was characterized and sustained by a completely non-dramatic idea of art, a nomadic lightness fostering an image where repetition and difference merge together. Repetition arose from the deliberate use of stereotypes, references and stylizations that also reintroduced conventional elements into works. But it is this conventionality that opened the way for subtle and unpredictable variations that created in the reproduced image a shift within the Oriental idea of circular space. The realm of the "portrayable" was attenuated by the conceptual presence of ornamentation.

De Maria's work sought to transgress the picture frame and move out into the surrounding space. A visual field is thereby created where a host of references can intersect. His painting was the instrument of representation for a progressive shift towards dematerialization. Mental and psychological state merge into an image based on the fragmentation of visual data. The result is a kind of internal architecture that contains within it all the vibrations inherent in the designs for the work. Each fragment is caught up in a system of mobile relations; there are no centres or favoured points. De Maria replaced the notion of space with that

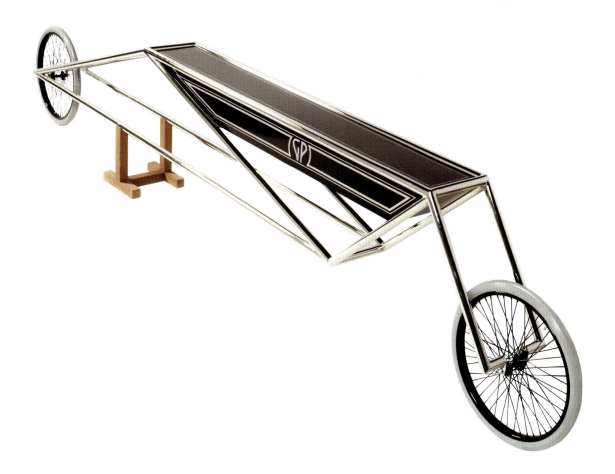

of a field, a dynamic and potential network of relationships that find their visual constant in abstraction and in the idea of total art.

Paladino created a painting and sculpture of surfaces. He practised an idea of surface as the only possible depth. Thus all the data of cultural memory and personal sensitivity emerge visually, held together in the perimeter of a painting that approaches sculpture and a formal system recalling the spiritual order of Malevich. The work becomes the place where subtle, impalpable motifs are translated into images. Elements from the abstract tradition and the more evident figurative elements accept geometrical coexistence in the built work.

In short, the Italian art of recent decades has progressively accepted an idea of art as a reality independent of its creator, oscillating back and forth between the neutrality of analytical procedure and the partiality of synthetic procedure. In any case, the artists stoically accept the awareness of their somewhat marginal role, stepping back from the directness of a positive head-on approach that now seems to have become the purview of politics and no longer that of the creative process. Art is now relegated to a position on the sidelines, a reflective and critical position that takes refuge in language and its metaphors from an unacceptable world. From this arises the awareness of a role that, albeit exercised, cannot resolve problems outside of art. In its production of visual, architectural or object forms, it seems to have revived an idea of "soft project" that avoids the design-oriented arrogance of the past avant-garde elements of the Modern movement, and finds a meeting of the ways between the unpredictability of the present and the possibility of containing it in a form that may not be definitive, but that nevertheless ensures its stability for future memory.

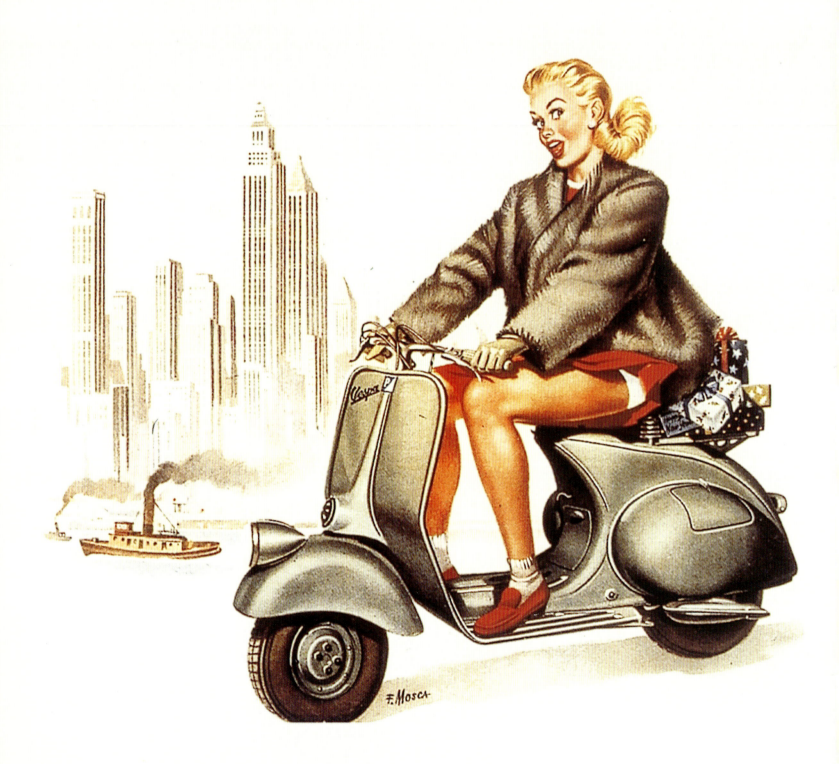

Paola Antonelli

A l'italienne . . .

On page 102:
Franco Mosca
Drawing for a Piaggio
Calendar
1950s

Gio Ponti
Espresso Coffee Machine
1949
Produced by La Pavoni

In the culminating scene of Campbell Scott's and Stanley Tucci's 1996 movie *Big Night*, two Italian brothers, the proud owners of a restaurant on the New Jersey shore, gently extract their edible masterpiece, the *timpano*, from its mould as if they were delivering a baby. They observe it, smell it, lightly tap it to test its perfection, and carry it on a throne to the dinner table, where an explosion of applause greets them. At the end of the monumental dinner, people are in tears. Isabella Rossellini is among them. Italian beauty comes in many sensuous forms. It is deeply moving, and its appreciation dramatic, at times verging on caricature.

Most foreigners endearingly consider Italy the quintessence of style and elegance in all the categories that represent the Good Life, from clothing and household objects to food, bicycles, furniture and fancy cars. Italy's powerful manual of style contains a whole set of cultural references and positive stereotypes for the use and consumption of worldly buyers. The passionate admiration for Italian aesthetics and quality is matched by a puzzled curiosity for the country's political, business and cultural tendencies. Italians are perceived as slightly amoral, politically and economically unpredictable, fun-loving, and, in spite of everything, enviable. Americans have a romantic notion of Italy that is crystallized in a fantasy of beauty and vulnerability, borrowed from movies like *Cinema Paradiso*. A Vespa, a Valentino gown, a leather sofa, or a Cinelli bike look great, are manufactured impeccably, and promise a cinematic dream—Sofia Loren leaning to one side in the back seat, a slow descent into Piazza di Spagna on a warm summer night, a sophisticated after-dinner conversation in an attic in Milan, a lazy ride in the hills near Siena with frequent stops for pecorino and good wine.

Just like any dream, however, the power of Italian design lies in its unattainability. In the minds of consumers on the American continent, the bits of Italian culture that one can buy are exquisite, eccentric, and expensive, certainly not the stuff of every day. For this reason, while food and clothing have enjoyed better market penetration, Italian design objects have had a hard time gaining wide distribution. While a white-truffle dinner and a Fendi coat, albeit extravagant, can still be found in a city like New York or Montreal, a Cappellini or Poltrona Frau sofa represents a far greater and daunting commitment. Several Italian manufacturers distributing in North America cannot shed this elitist label and count on the particular dynamic of the American Dream, in which quality products are viewed as symbols of economic and therefore social prestige. They have chosen to remain confined to the high-design ghettoes of, for instance, SoHo in New York, the Design District in Miami, or Melrose Avenue in Los Angeles. Others, like Kartell and Alessi, have chosen a more diffused route and distribute not only through their own stores, but also in many other outlets spread all over cities and states. They advertise in the mass media, solicit wide editorial coverage, and learn the rules of the game for the American market, which are very different in philosophy from those of Europe.

Despite these exceptions, much praised Italian industrial and furniture design remains outside of the real international market, or better, levitates above it with a nonchalant air of superiority. Automobiles and lighting fixtures are often considered incompatible with technical standards outside of Europe. Production is not boosted to reach competitive retail prices. Most iconic cars, furniture, tabletop objects, and appliances are either difficult

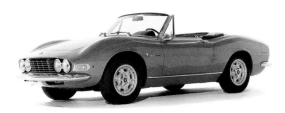

Carrozzeria Pininfarina
Dino Convertible
1966
Produced by Fiat

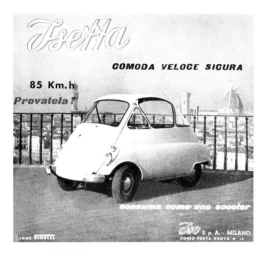

Ermenegildo Preti
Isetta Micro-car
1953
Produced by ISO

to maintain or just too expensive because of the small size of the companies, research costs, and inadequate distribution. Popular international outreach does not seem to be most Italian manufacturers' worry or responsibility. The Italian legend is made of a series of dream-objects, most of which remain among people's desires and can never really penetrate their daily lives.

There exists nonetheless a field of Italian design that proves to be really successful, at all cultural levels and in all countries: food. Food is the most universal stereotype of Italian design, for better or for worse. Several years ago, this author received from the office of then New York Mayor Rudolph Giuliani an invitation to an Italian celebration, illustrated with a cut salami and a flask of wine—no mandolin, thank heavens. The universal symbols of choice for Italy are not an Armani suit or a Vespa, but rather pasta, amaretti, pizza and Campari. All in all, Italians have been masters at designing evocative symbols. And nowadays, even in a country as disorganized in its corporate image communication as Italy, the best examples of furniture and industrial design have managed to team up with the food and fashion industry to project a national image of outstanding manufacture and unfailing design quality, the good design of a nation.

Above and beyond any romantic declaration about Italians and their secret recipe to success stands the exceptional effectiveness of Italy as a twentieth-century design case study. Nowhere in the world can one find so many varied examples, both in terms of conception and of formal outcome; so many applications of diverse technologies; such a complete representation of all applied design forms, from fashion and graphics, to product and set design; such an extensive and multifaceted documentation recorded

in literature; and such an international resonance as in Italy. By engaging the best industrial and cultural forces of the country in a single-minded and spontaneous operation of national image building, Italian Design has become an icon in itself, almost independent of its products.

Thanks to the typically Italian lack of boundaries between the various spheres of human activity, from art and politics to science, technology and religion, Italian artists, architects, designers and intellectuals have yielded a remarkable synthesis of history in their production. In Italy, probably more than in any other country in the world, design is an all-encompassing noun. From architecture to product design, from graphics to fashion, from gastronomy to glass blowing, any form of controlled and targeted creativity is considered part of the design sphere. And when bona fide artists decide to address human factors, they seamlessly become designers, without feeling any loss of pride or stature. Art and industry, in particular, came together in exceptional harmony in the second half of the twentieth century, in objects of everyday and once-in-a-lifetime use alike. In a sweeping timeline of design history of the last century, different nations seem to have reached their creative and productive zenith in different decades, each one becoming the temporary beacon of international design. Naturally, this dynamic has followed closely the peaks and valleys of history, and after Great Britain and Austria's primacy at the turn of the century, it was France's turn in the second and third decades, Germany's in the 1930s and 1940s, while the United States and Scandinavia shared the stage in the 1950s. Italian design dominated the 1960s and early 1970s.

In those intensely emotional years, when so many political, economic, technological and cultural explosions

Achille and Pier Giacomo
Castiglioni
Sleek Mayonnaise Spoon
1962
Produced by Kraft

Giorgio Armani
Design from the *Giorgio
Armani Women's Wear*
advertising campaign
Spring–Summer 1987

steered history toward an unexpected course, Italy was able to mirror all those bouts of exhilaration and anxiety in the objects it produced. In fact, the talent had been there for centuries. Most Italian products, even among those designed before 1950, are strangely able to take a direct shortcut to the soul of the international public and flaunt the expressionistic capabilities of character actors. Yet the international dimension of the market in the post-World War II era brought a stronger resonance. Two among the most successful and exemplary products are Corradino d'Ascanio's Vespa (cat. 106)—which, though first produced in 1945, was really the embodiment of the 1950s—and Ettore Sottsass' *Valentine* typewriter of 1968 (cat. 322). These two icons, like many others—think of a Ferrari, a Bialetti coffee machine, or a *Tizio* lamp (cat. 293)—exude the romantic narrative and the timeliness that the international public seems to crave, and that only Italians seem to be able to provide consistently, at least in design.

Before World War II, only a few companies, especially in the food and mechanical industries, like Campari, Pirelli, and Olivetti, stood out. The case of Olivetti is exemplary. Adriano Olivetti, a typewriter manufacturer whose company was founded in 1908 by his father Camillo, was able to create a design paradise and a strong corporate image by hiring the best designers for his company's products; the best artists, from painters to poets, for its advertising campaigns; and the best architects for the company's buildings and showrooms. The Olivetti company produced at least two typewriters that became Italian icons, the *Lettera 22* of 1950 (cat. 239), and the *Valentine* of 1968 (cat. 322). Sometimes transcending immediate corporate interests, Adriano Olivetti nonetheless also made the company into a patron of the arts of the past and

present, and a manufacturer not only of products, but also of culture.

In the 1950s the model became contagious. Legend has it that at the time some talented but unemployed architects fortuitously met enlightened industrial manufacturers in search of products, while, in the background, the mechanical and chemical industries were bubbling with innovations waiting to be seized and applied. Together, they established the collaborative formula, based on sharing technical knowledge, dreams and goals, that became a model and bore them fruit in the 1960s. The best examples of Italian design reflect this close-knit collaboration, a relationship that to this day provides designers from all over the world with exceptional support for experimentation.

Although they are all design geniuses, Achille and Pier Giacomo Castiglioni, Vico Magistretti and Marco Zanuso, to name just a few, could possibly never have achieved their success without the unusual receptiveness and complete trust of the manufacturers. Likewise, many pre-existing companies that relied on big contract commissions, yet also on trite imitation of eclectic styles, like Cassina, would have never become pioneers of design without them. These family-based companies—located especially in northern Italy, in the region north of Milan and Veneto, and in pockets of central Italy—reacted positively both to these architects' sophisticated culture and to the technology transfers provided by the idle war industries.

The economic boom provided enough fuel for numerous new start-up companies. Some of them were created from the ground up to take advantage of the new technologies, like Kartell, founded in 1948 by engineer Giulio Castelli to exploit the invention of polypropylene. Designers who wanted to manufacture their ideas in more than

one piece, and who therefore approached technology in a more pondered and instrumental fashion, initiated others, like Arteluce. Meanwhile, to add to the interdisciplinary effervescence of the national scene, the architecture and design community sparked a lively dialogue with the rest of the world and sharpened the spectacular edge of Italian design through its many international publications and events, like the Furniture Fair in Milan, established in 1961, and the Triennali.

The golden age of Italian design culminated in the 1972 *Italy: The New Domestic Landscape* exhibition at the Museum of Modern Art in New York, which is considered by some also its swan song. The oil crisis and the "leaden years" of terrorism indeed took a heavy toll, not only on the economy, but also on the design world's optimism. Yet they also provided the spark for a deep reflection and further evolution that kept Italian design at the technological and cultural forefront. In the 1970s designers like Ettore Sottsass, Alessandro Mendini and Gaetano Pesce, movements like Radical Design, Memphis and Alchimia, publications like *Casabella*, *Domus* and *Abitare* all collaborated to draw the new intellectual and technical landscape of Italian design in the post-industrial era.

Thanks to these efforts, Italian designers and companies were in the 1980s once again ready to experiment. The new paradigm was another area of product design in which Italy excels, prêt-à-porter fashion. The Memphis phenomenon and the activity of companies like Alessi, to name one of the most influential and groundbreaking, exemplified the new way, more attuned to the fashion industry's rhythms and idiom. Design companies started using the word "collection" in their production catalogues and focusing on the designers' signatures, supported by a creative

director's—in Alessi's case, Mendini— sharp work on the company's image. Italian design manufacturers have been able to maintain their status and their traditional experimental verve to this day and are attracting the best talents from all over the world. What is Italian design today, after all? In strict accordance with geographic definition, the Italian element of the formula is represented by the entrepreneurs, manufacturers, technicians, and their intellectual and physical real estate.

The design component could be British, Spanish, American, French or Indian.

Yet when designers from these countries move to Italy, some for long periods, others permanently, they truly enjoy the whole experience and get a lot of inspiration from it; therefore, in my biased political geography, they become Italian.

But Italy's success lies in the golden media: in fashion and in domestic interiors alike. Rather than shocking the bourgeoisie, most Italian architects and designers of this century have sought the highest common denominator and attempted to make elegance and style available to a wider audience. Gio Ponti is the most luminous example: he was able to standardize certain steps in the design of domestic interiors, especially the decorative elements—tiles, cutlery, knobs—and yet maintain the handcrafted exclusivity of composition that was in the 1940s and 1950s the first requirement of an upper-class domestic interior. Neoclassical with several twists, his homes are elegant, inventive, reassuring in their undeniable style, and non-threatening, as their cultural references fly at average height. They are subtly luxurious and stylistically durable, much like an Armani jacket or today's homes by Antonio Citterio. They cannot possibly go out of fashion.

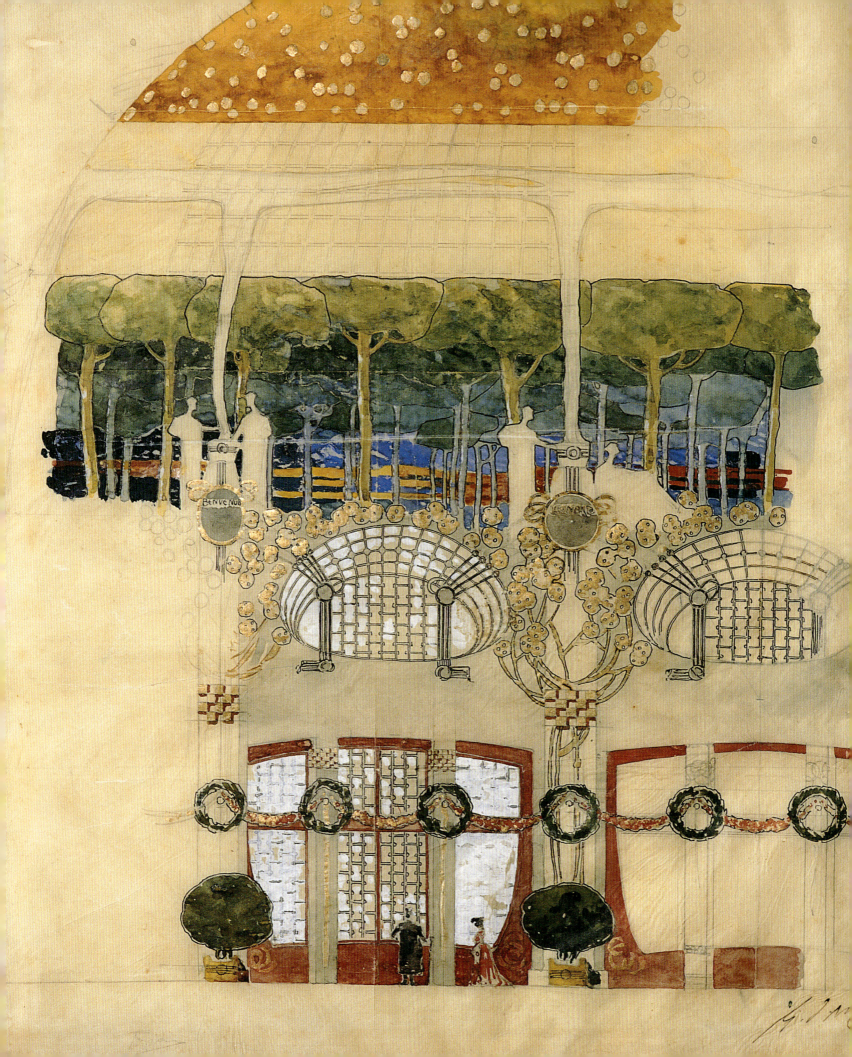

Boundless Optimism

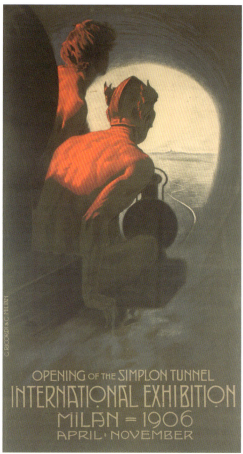

215
Leopoldo Metlicovitz
*Opening of the Simplon
Tunnel. International
Exhibition. Milan, 1906*
1906
Ricordi, Milan
Civica Raccolta delle
Stampe A. Bertarelli –
Castello Sforzesco, Milan

The first decade of the twentieth century in Europe was a time of great anxiety but also great hopes. Lagging economically and socially behind the countries at the forefront of the Industrial Revolution, Italy found itself at the threshold of the new century with a new and powerful yet contradictory impetus generated by the failure of the previous century's sporadic and uncertain attempts to achieve a middle-class revolution.

Post-unification (1861) Italy still bore the marks—and would for some time— of its long and intricate history of dominations, cultural influxes and regionalisms. Its hard-won unity, flying the colours of a middle-class revolution, had only achieved a partial victory. The country was still shackled by the closed monarchic world of Piedmont with its king and the Savoy court, by widespread clericalism, and by the dominating power of landed estates, all of which tended to suffocate the intermittent sparks of a nascent middle-class culture seeking to respond to the international climate.

During the Giolittiana (an age named after Giolitti, the three-term prime minister, 1903–05, 1906–09, 1911–13), Italy witnessed an economic boom accompanied by a strong surge in the production of consumer goods. This naturally had a deep impact on the way artisanal and proto-industrial products were conceived and designed, in response to needs for greater quantities and especially in order to create aesthetic differentiation. But this scenario was still under the sway of a culture in the grip of a deeply rooted biased discrimination between humanism and science, that is to say, between art and science, with its technological applications.

While the most ambitious attempt to organize a culture of technology in Italy was initially represented by the establishment of the Milan Politecnico in 1863 (which had a significant impact on a new technological aesthetics), followed by other similar technological universities, it is important to recognize the very important contribution of vocational schools for "arts and trades." These would play a fundamental role in training the professionals of intermediate industrial production (workshop heads, supervisors, production designers) and more generally in creating a culture of industrial labour. This process would transform a large group of people, mainly of rural origins, into an urban working class. But the need for highly qualified manpower found its principal source in Italy's artisan culture. This very rich tradition was in crisis after the dismantling of the guilds in the late eighteenth and early nineteenth centuries. The tradition of apprenticeships (assistant, journeyman, master) remained alive, but no longer benefited from the security offered by the trade associations. Nevertheless, the desire to innovate, so often hobbled by the conservative system of privileges associated with the guilds, found new opportunities for development in this period.

It was not until 1907, however, when many of these vocational schools had already assumed great importance, that three categories of school were officially codified: "industrial schools" (elementary, secondary, university, as in the Regio Museo Industriale of Turin united with the Politecnico); "industrial arts schools" (drafting for labourers, drafting and product design for the higher echelons, art applied to industry); and "vocational schools for women."

A special contribution to the development of technical vocational instruction was made by humanitarian welfare associations such as the mutual aid societies. A pre-eminent role was

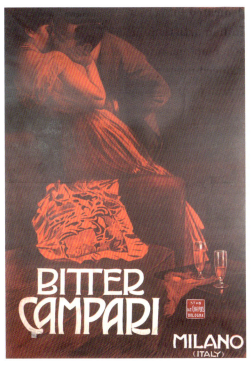

133
Marcello Dudovich
Bitter Campari
1904
Civica Raccolta delle
Stampe A. Bertarelli –
Castello Sforzesco, Milan

assumed by the Società Umanitaria (Milan, 1893), founded with the purpose of combatting unemployment and raising the living standards of the working class both economically and intellectually.

A pioneer on the path of Socialist egalitarianism, in 1903 this institution would establish the first school-workshops for industrial arts that would do much to develop the culture of design in Milan.

The much less numerous academies of fine arts took a rather haughty view of the ferment in the "minor arts." But this protectionist attitude toward privilege would meet with increasingly sharp attacks from such pre-eminent critics as Melani and Boito, who were troubled by anachronistic teaching methods founded entirely on copying classic "models." However, while some critics (Melani, Boito, Pica, Thovez) urged artists to seek a relationship between the creative quest and serial production methods, this low-key and at times ambiguous aesthetic reformism was countered with great tenacity in the 1900s by the influential philosopher Croce, who considered the concept of technology to be entirely extraneous to that of art. Branzi would comment: "Benedetto Croce, self-described Neapolitan intellectual, who lived in a nation where industrial reality was more a theoretical than a practical phenomenon, sundered that relationship, affirming that art and industry were two separate realities, and that if anything it was the task of industry (which he never directly named), that champion of utility and logic, to elevate itself to the level of art. In other words, the problem is not to strip art of its aura so it can descend into practicality; it is up to industry to rise above its own limits and interests and achieve the universal stature of art."

"In this sense the advantage of Italy's backwardness consisted precisely, as we will see later, in never calling into question—partially thanks to Benedetto Croce's idealism—the existence of a substantial difference between art and utilitarianism. Instead Italy worked within the context of that difference to seek an alliance between culture and industry, one that would be expressed in each individual project, plan, catalogue or enterprise that brought together different positions, and not take the form of a mutual loss of features in order to conform to a unitary technical-artistic system that had no real existence. [It was] an imperfect alliance based on reciprocal weaknesses and incompleteness."[1] Yet it is clear enough that it was not in large-scale industry (heavy industry, infrastructure, mass-produced products), nor in standard or specialized design that the roots of the Italian adventure in design would be found, but rather in the characteristic flexibility proper to the Italian polytechnical culture.

In effect, technology in Italy also has its own characteristic and perhaps anomalous approach, one influenced by its widespread humanistic culture, but also oriented by a more powerful scientific culture and strongly stimulated by "creative" and empirical explorations. Giuseppe Colombo, president of the Milan Politecnico in 1908, championed a "more general than specialized" education in European technical universities, stating that "schools have to limit themselves to doing a good job of teaching those subjects that serve as a foundation for or initiation to applied arts. If we were to divide [education] into as many specialties as there are branches of engineering, this specialization would be nothing but harmful to the general and technical education of young people." The consequences of this position on

31
Ernesto Basile
Perspective of the Florio
Pavilion at the Milan
Exhibition (1906)
1906
Donazione Basile, Facoltà
di Architettura, Università
degli Studi di Palermo

culture, as De Giorgi reminds us, led directly to the still current keywords of the Italian approach to design: flexibility, design as investigation, application as compositional event.

The shift to industrial production occurred in England and elsewhere via the mechanization of the production of traditional artisanal products (ceramics, glassware, metal tools). Italian furniture production, in all its ambiguity, greatly helps in interpreting the transformations in the Italian design process. While on the one hand furniture production in some cases witnessed important and innovative developments both at the technical and the formal level, we must not forget that until 1930 furniture production remained strongly bound by regional traditions, deeply rooted popular tastes, and construction techniques. The development of a national style began not only to be an issue of renewal of form, but also a defence of the Italian identity without attempting to reawaken the idealized splendour of the golden age of Italian art.

Triggered by ferment in Europe and finding fertile terrain in the economic recovery of the Giolitti period, there was a sudden explosion of interest in the decorative arts, which took on very precise social and cultural meanings. Stile Floreale, the Italian version of European Art Nouveau, would become the only aesthetic movement capable of immediately establishing an identity for the new industrial and bureaucratic class throughout the Italian peninsula.

But the factors at play were many and the fragmented and jumbled faces of this new middle class stimulated a search for new languages that could respond to many contradictory demands and thereby give voice to various cultural aspirations and anxieties.

While on the one hand a more strongly aesthetics-driven vein was dedicated to recreating an idealized Italian artistic pre-eminence, on the other, an emerging social conscience induced many product designers and manufacturers to carry this new language, conveyor of a renewed synthesis among the arts, to a larger audience, to a proletariat with strong rural roots who also wanted a new, simpler, and more communicative language.

Hence we find under the umbrella term Stile Floreale a broad spectrum extending from the symbolism of Previati and Segantini to the alluring naturalism of decorative artists such as Zen, Valabrega, Chini and Spertini, a number of important experiments by Basile and Quarti, and the more crafted works of Mazzucotelli and Bellotto. Each in his own way represents Stile Floreale inspired by the models of the various European Art Nouveau movements. This expression of vitality would evolve during the early years of World War I into a rather complex, open-minded yet decadent model of the "aesthetic life," bearing the stamp of D'Annunzio or characterized by the *decadentista* current of the Crepuscolari. Opposing Pascoli's "rustic object" were two sides: one, the decadentist idea of "inimitable life," aesthetic and sensual, beyond the current morality; and the other, the Crepuscolari's melancholic nostalgia, aversion to rhetoric, and love of the provincial. But Stile Floreale also embraced expressions ranging from the rebellion of the Scapigliatura movement to certain social aspirations of Pellizza da Volpedo, Morbelli, early Boccioni or Balla, Cambellotti's Roman secession, Basile's Morris-influenced vein, Ars Aemilia and Cometti.

An innovative and disorienting factor alongside all this was the eclectic and decidedly heterodox quest of certain artists who wanted to free themselves from the dominant European models

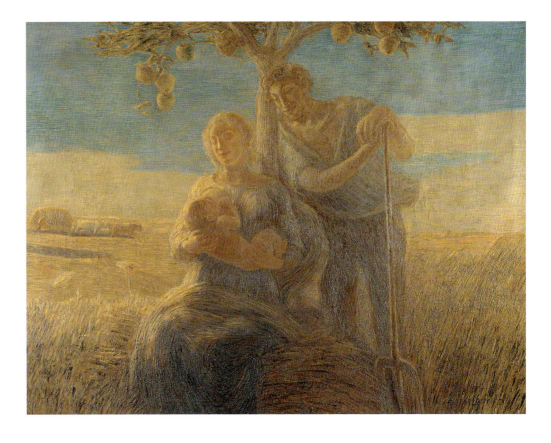

and regenerate inner historicity or autonomous forms of expression that aspired to a sort of "re-foundational" metalanguage typical of avant-garde movements. Examples of this are the quasi-abstract and informal art of Medardo Rosso (often cited by the Futurists), the formal and material inventions of Wildt (much loved teacher of fundamental modern artists such as Fontana and Melotti seeking forms of abstract lyricism), and, from the realm of the decorative arts, the Byzantine visions of Zecchin, the romantic aspect of technology of Fortuny, or the pre-Futurist brilliance of Bugatti. It is no coincidence that the birth of Europe's first artistic avant-garde movement, Futurism (Marinetti, Balla, Boccioni, Sant'Elia, Russolo and others), occurred precisely in this period. It embodied an intolerance for the "good things in poor taste" of the washed-out model represented by Umberto and Giolitti, while drawing inspiration from those bold eclectic and autonomous forms expressed by a certain part of the Italian artistic and decorative arts community at the dawn of the twentieth century. But alongside the irreverent language of the Futurists, another surprising expressive language would attempt to reveal the "unconscious optimism" in all its agonizing tension, presenting itself as a sort of rival project to Futuristic exaltations: the Metaphysics of De Chirico, Carrà, Savinio and Morandi, which would leave a deep impression on Italian art.

Giampiero Bosoni

[1] A. Branzi, *Introduzione al design italiano. Una modernità incompleta* (Milan: Baldini & Castoldi, 1999), p. 67.

30
Ernesto Basile
Secretary
1903
Execution: V. Ducrot
Metalwork: A. Ugo
Painting: E. De Maria-
Bergler
The Mitchell Wolfson,
Jr. Collection – The
Wolfsonian-Florida

International University,
Miami Beach, Florida

The integration of art and
design in this secretary
becomes even more
apparent once the doors
are opened to reveal the
paintings of Ettore De
Maria-Bergler. They depict
young women in a

landscape of stylized,
linear tree and plant
forms, inspired by
international Art Nouveau
and Symbolist art.
Italy's traditional expertise
in metalwork is seen
in the decorative cast-
bronze mounts by
sculptor Antonio Ugo.
R. P.

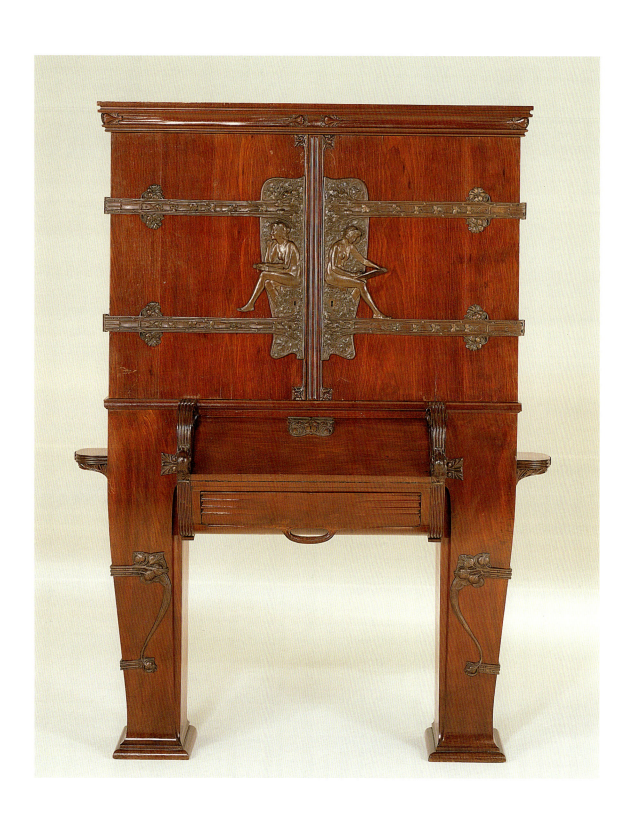

309
Giovanni Segantini
Primavera sulle Alpi
1897
French & Company,
New York

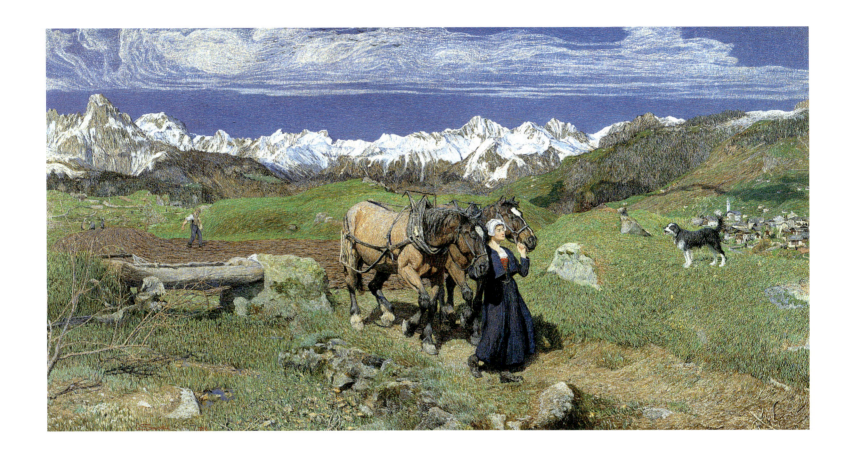

46
Luigi Bonazza
La leggenda di Orfeo
1905
Museo d'Arte Moderna e
Contemporanea di Trento
e Rovereto
Deposit of Società
SOSAT

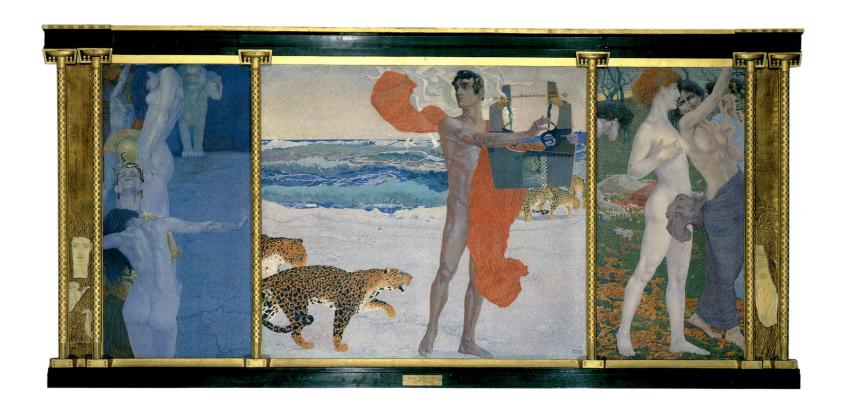

51
Carlo Bugatti
Armchair
About 1895
The Montreal Museum
of Fine Arts

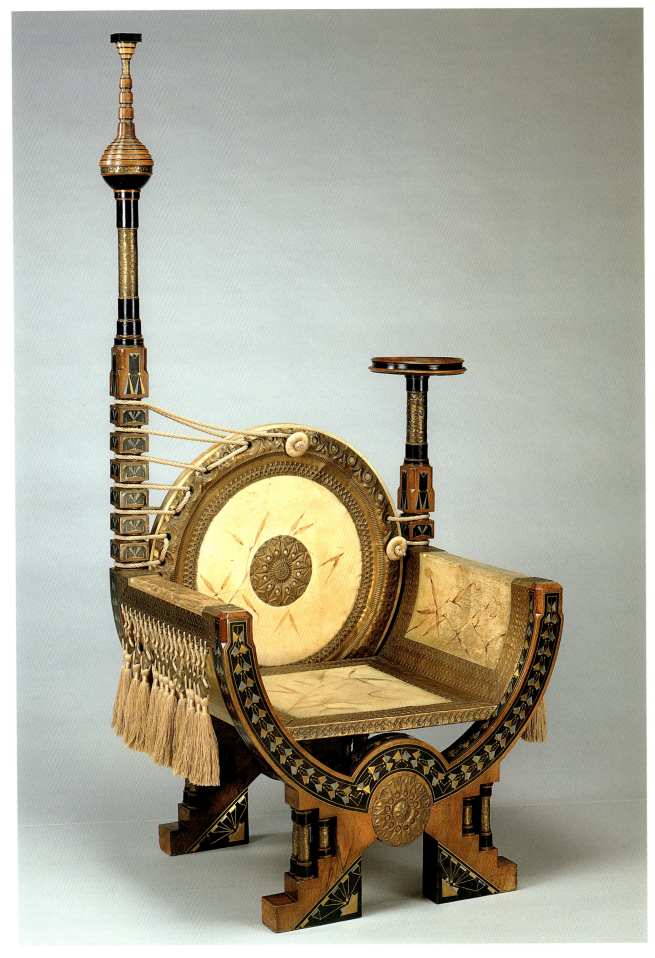

214
Leopoldo Metlicovitz
Poster for the opera
Madama Butterfly
1904
Civica Raccolta delle
Stampe A. Bertarelli –
Castello Sforzesco, Milan

86
Galileo Chini
Vase
About 1903–04
Produced by Arte della
Ceramica
Bardelli Casa, Tuscany

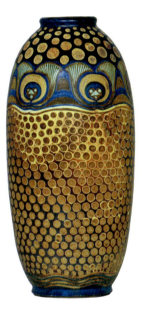

85
Galileo Chini
Vase
1901
Produced by Arte della Ceramica
Bardelli Casa, Tuscany

87
Galileo Chini
Vase
1910
Produced by Manifattura Chini
del Mugello
Bardelli Casa, Tuscany

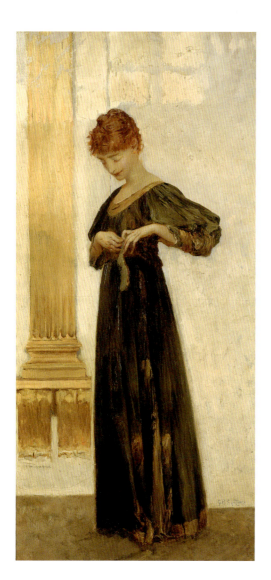

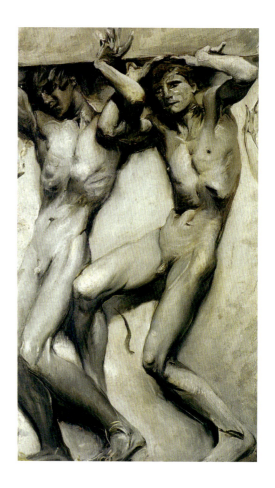

297
Giulio Aristide Sartorio
*Maria Hardouin
D'Annunzio*
1926
Galleria Nazionale d'Arte
Moderna, Rome

296
Giulio Aristide Sartorio
*Frammento del Fregio
del Lazio*
1906
Private collection

295
Giulio Aristide Sartorio
Abisso verde
1892
Private collection

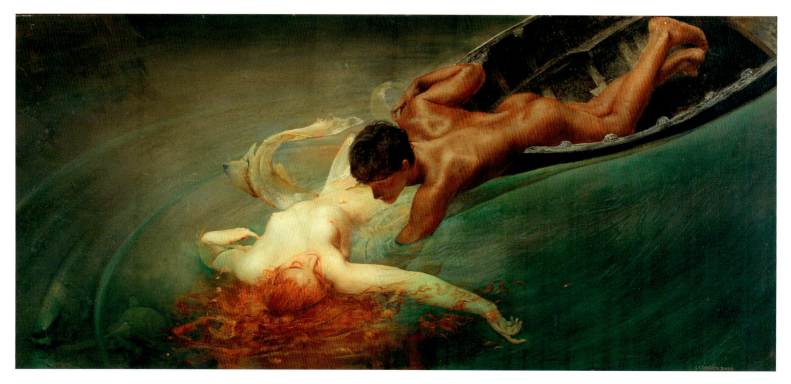

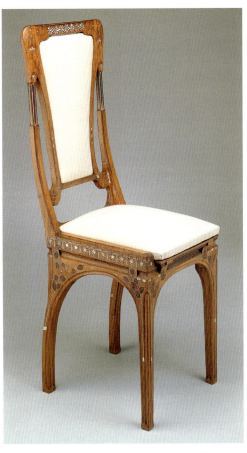

282
Eugenio Quarti
Chair
About 1900
The Mitchell Wolfson, Jr.
collection – The
Wolfsonian-Florida
International University,
Miami Beach, Florida

Eugenio Quarti was one
of Italy's most highly
regarded cabinetmakers
of the Stile Floreale, and
this chair was part of his
display at the Paris
Exposition universelle of
1900. At this fair Quarti
received a major award
from an international jury,
which increased
his recognition at home
in Milan. The chair
is distinguished
by the fine quality of
the cabinetmaking and
the technical perfection
of the metal wire and
mother-of-pearl inlay
for which Quarti was
especially noted.
R. P.

360-361
Carlo Zen
Writing Desk and Chair
About 1900
Cooper-Hewitt National
Design Museum,
Smithsonian Institution

The Milan furniture
manufacturer, Carlo Zen,
offered his clients the
most up-to-date furniture
reflecting the Art Nouveau
designs current in
France and Belgium.
Characteristic of Zen's
work (and of other Italian
designers such as Quarti
and Bugatti) are the
intricate inlays in silver,
brass and mother-of-pearl
that showcase the high
quality of Italian

craftsmanship. The
meandering filaments of
metal follow the curving,
attenuated forms of the
furniture. These delicate
draftsman-like lines are in
keeping with the restless,
flowing, organic lines
of Art Nouveau. The
emphasis on nature
as a source of decorative
inspiration is also a key
element in Art Nouveau
design. The same model
of writing desk (with a
different chair) was
exhibited by Zen at the
Turin Esposizione
internazionale delle arti
decorative e moderne
in 1902.
R. P.

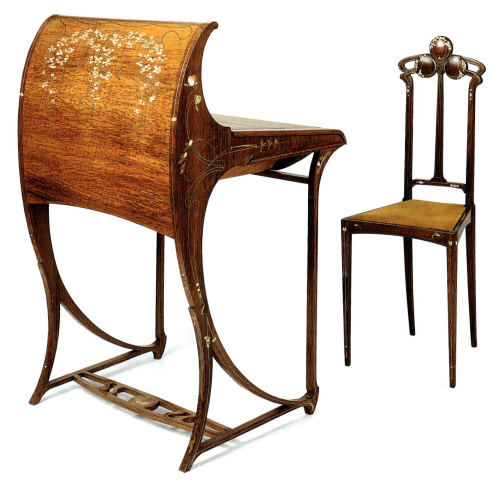

52
Carlo Bugatti
Chair
1902
Carnegie Museum of Art,
Pittsburgh

In 1902 at the Turin Esposizione internazionale delle arti decorative e moderne, Carlo Bugatti, one of Italy's most inventive designers of the period, created an extraordinary *camera a chiocciola* or "Snail Room" which featured four sculptural chairs like this one. The curvilinear movement of lines and the organic form of the chair were unique but in keeping with Art Nouveau tendencies of the time. The wooden frame of the chair is completely covered in parchment, a material Bugatti favoured. Its cream colour serves as a perfect ground for his painted stylized geometric motifs in black and red. With his unrivalled imagination Bugatti launched Italy's pursuit of new and individual means of expression in design in the twentieth century.
R. P.

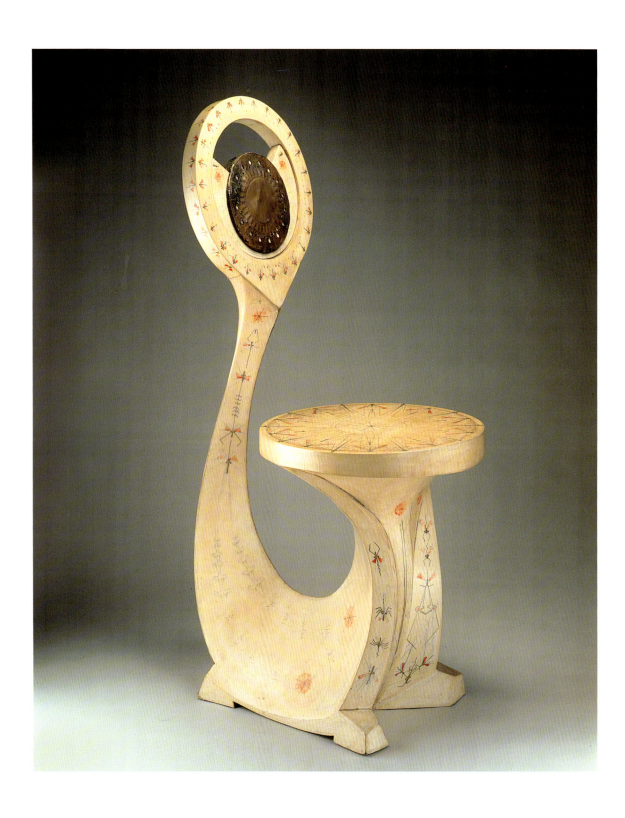

53
Carlo Bugatti
Lady's Writing Desk
1904
Brooklyn Museum,
New York

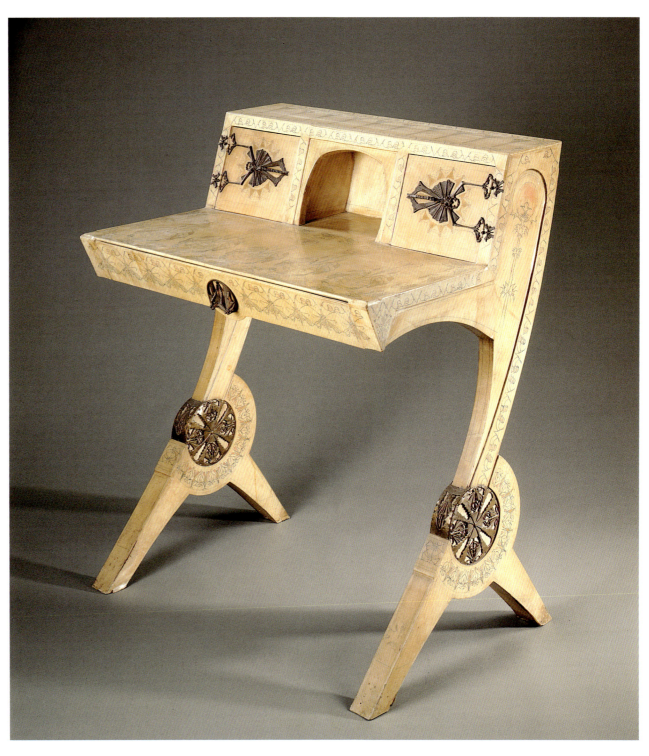

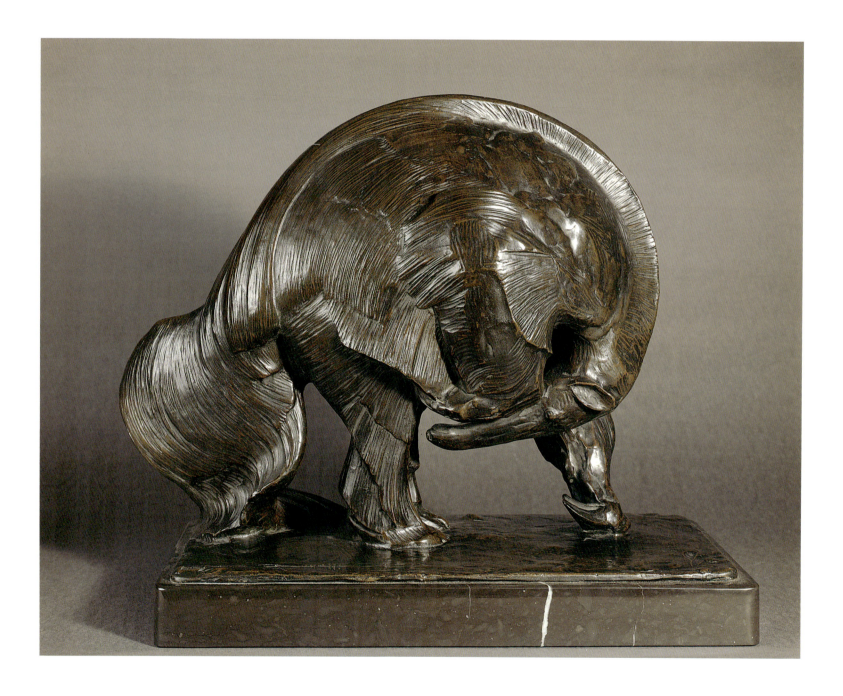

199
Alessandro Mazzucotelli
Hanging Lamp
1902
Fondazione Cavallini
Sgarbi

200
Alessandro Mazzucotelli
Le serpi
Early 20th century
Chiara and Francesco
Carraro collection

The artisan Mazzucotelli revitalized the art of wrought iron in Italy at the beginning of the twentieth century. Noted primarily for his architectural ironwork inspired by the Stile Floreale, Mazzucotelli created curvilinear, naturalistic plant and animal forms in his designs for balustrades, grilles, lamps and stair railings. In this sculptural work, Mazzucotelli has selected one of the recurring images in Symbolist art and literature of the period—the serpent, or in this case three serpents rising like a Medusa head, representing the forces of evil in their combat with the forces of good. With his mastery of the iron medium, Mazzucotelli has wrought and stretched the metal into fluid, organic forms so characteristic of the Art Nouveau style.
R. P.

155
Vittorio Grassi
Table
1907
The Mitchell Wolfson Jr.
Collection – Fondazione
Regionale C. Colombo,
Genoa

249
Giuseppe Pellizza
da Volpedo
Fiumana
1895
Private collection

221
Angelo Morbelli
In risaia
1901
Private collection

58
Duilio Cambellotti
La falsa civiltà
1905
Private collection

128

59
Duilio Cambellotti
Curule Chair
1907–08
Archivio Cambellotti
Collection

57
Duilio Cambellotti
Bowl
1903–06
Private collection

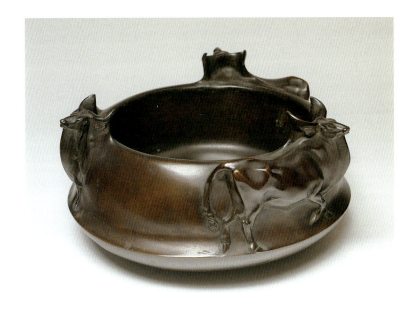

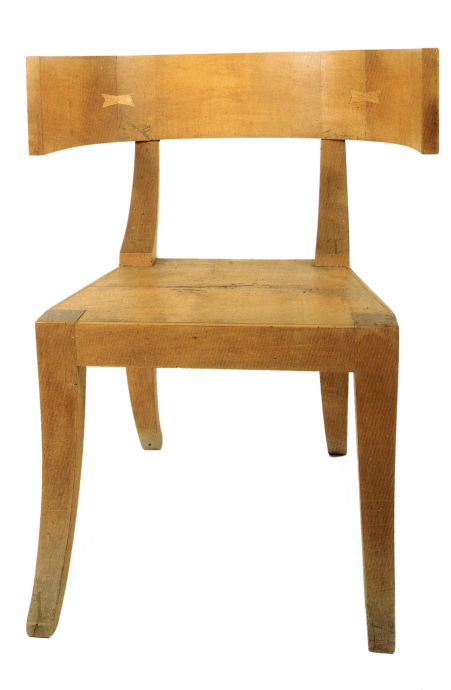

29
Ernesto Basile
Armchair
1902
Execution: V. Ducrot
Private collection

105
Raimondo D'Aronco
Decoration for the
Rotunda of Honour at the
Esposizione Internazionale
d'Arte Decorativa
Moderna, Turin (1902)
1902
Galleria d'Arte Moderna,
Udine

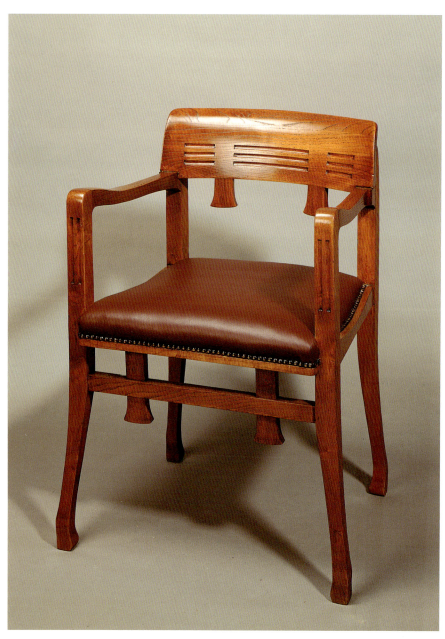

362
Carlo Zen
Cabinet
1902
The Montreal Museum
of Fine Arts

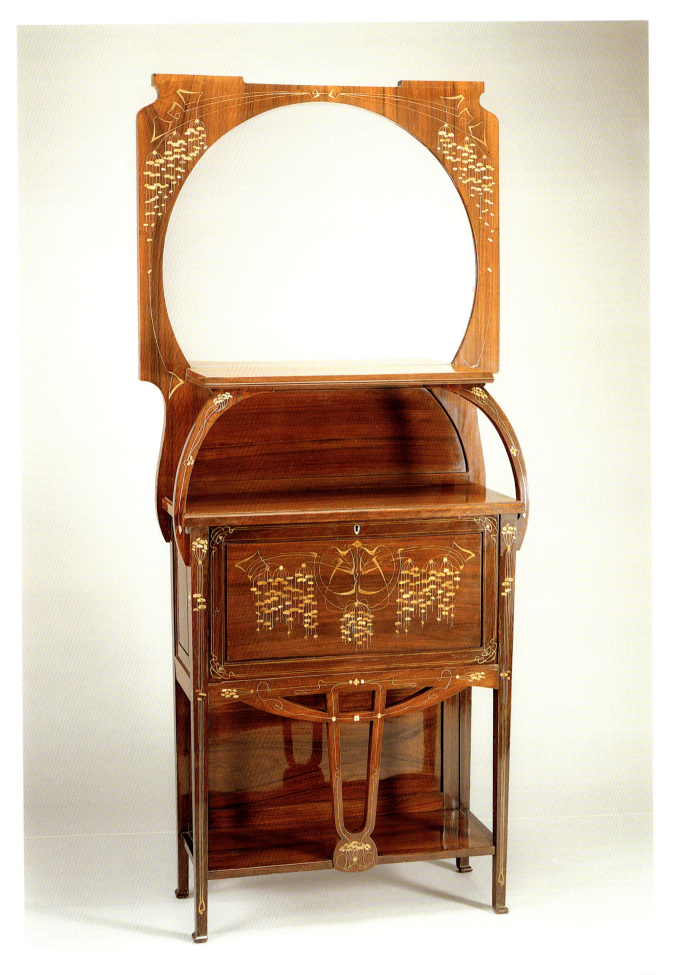

150-151

Mariano Fortuny
Delphos Dresses
About 1907
The Metropolitan Museum
of Art, New York

The *Delphos* dress is
Mariano Fortuny's most
famous creation. He
designed it about 1907,
and it continued to be
created in a range of rich
colours well into the
1930s. Each dress was
individually handmade
from coloured silk
permanently pleated by
means of a technique that
was secretly guarded
during the designer's
lifetime. In reaction to the
tight-fitting, restrictive
clothes of the period, the
dress was loose and
comfortable, sensuously
following the human form.
The folds of silk
cascaded straight down
and spread over the
feet, and the colour of the
silk changed with the
effects of movement and
light. Tiny Venetian glass
beads edged the borders
of sleeves and skirt
to provide ornamentation
but also to weigh down
and maintain the shape
of the lightweight silk
material. The simplicity
and form of the dress,
inspired by classical
Greek design, was
timeless in style.
R. P.

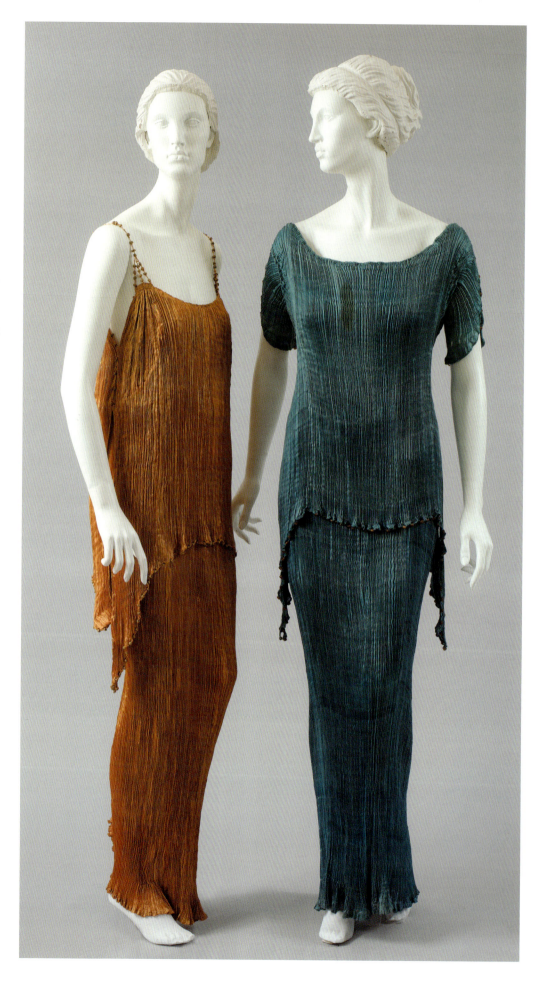

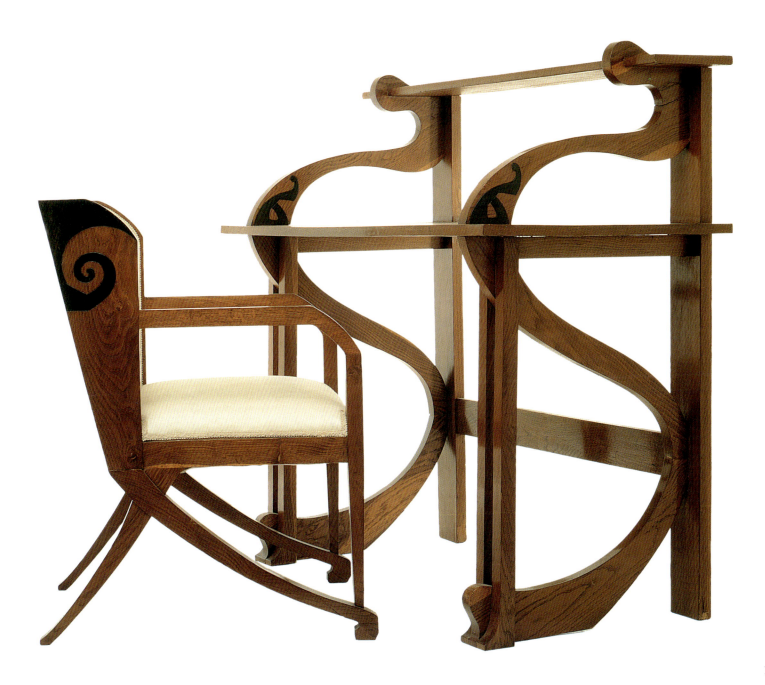

346
Adolfo Wildt
I Puri
1913
Private collection

348
Adolfo Wildt
La famiglia. Testa della madre
1922
Franco Maria Ricci collection

347
Adolfo Wildt
Holy Water Stoup
1921
Private collection

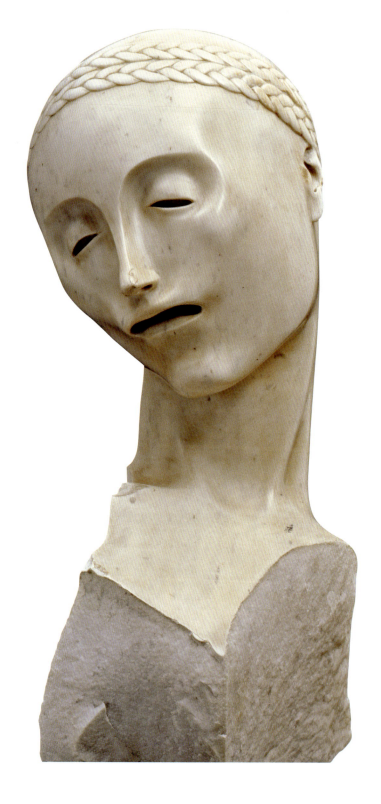

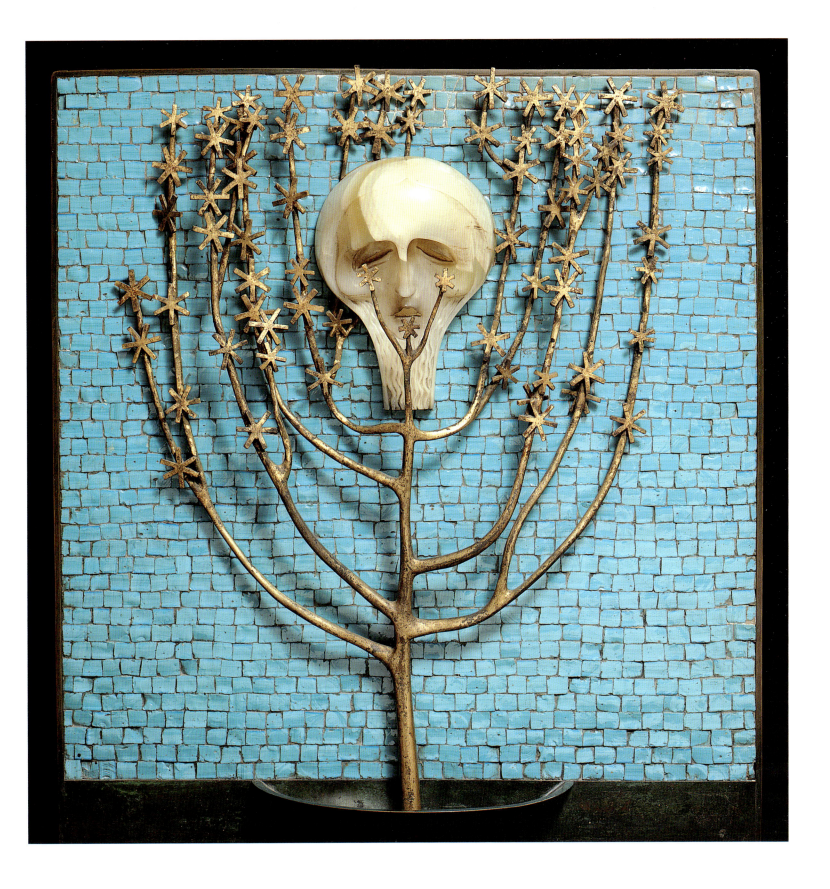

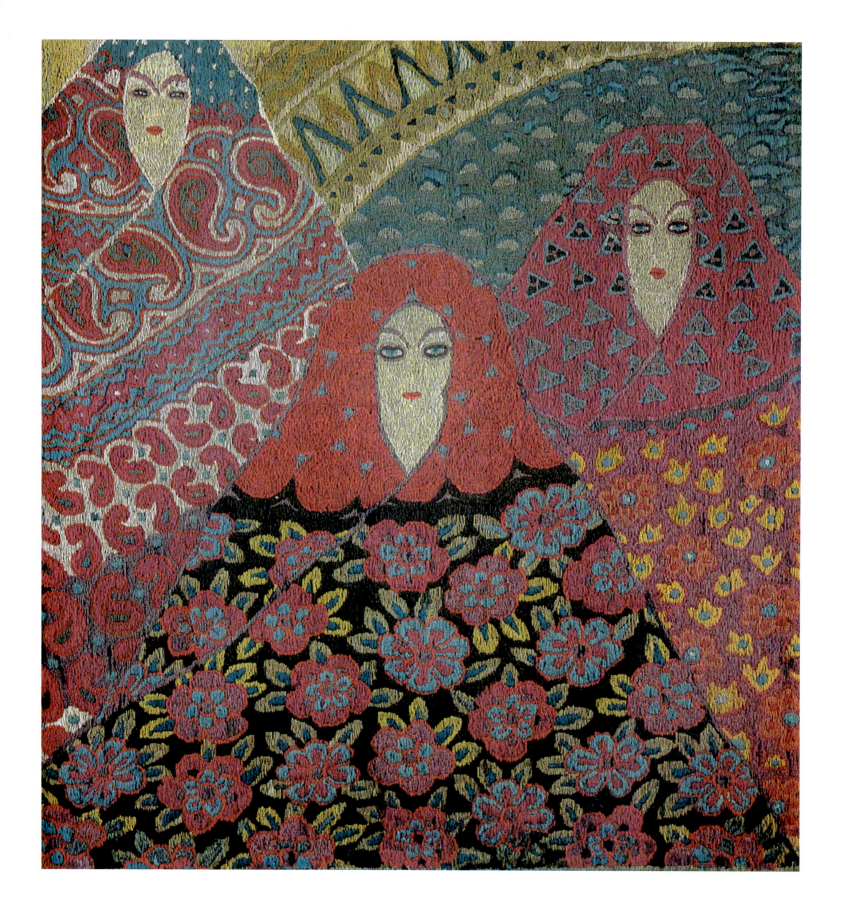

358
Vittorio Zecchin
Donne in scialle
About 1920
Execution: Laboratorio di
Vittorio Zecchin, Murano
Private collection

357
Vittorio Zecchin
Vase
About 1914
Produced by Vetreria
Artistica Barovier, Murano
The Mitchell Wolfson Jr.
Collection – Fondazione
Regionale C. Colombo,
Genoa

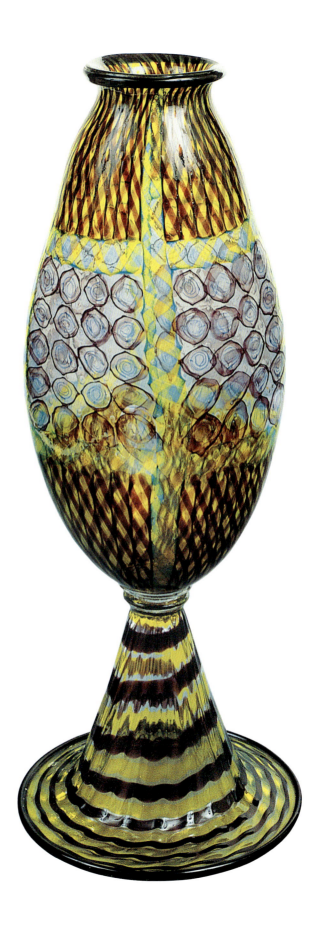

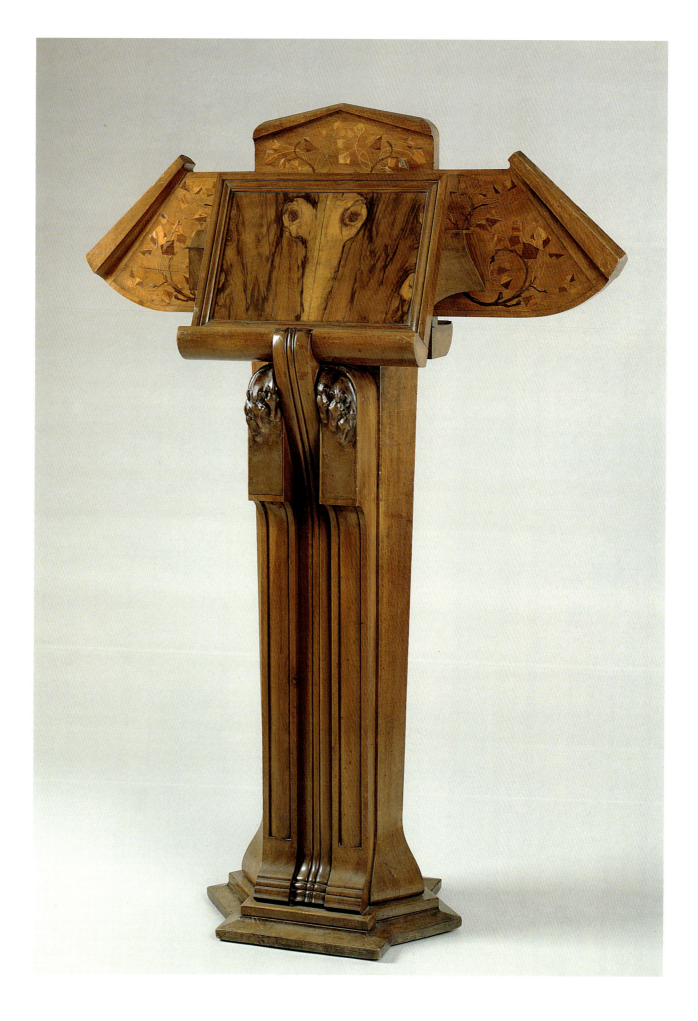

61

Duilio Cambellotti
La notte Chest
1925
The Mitchell Wolfson Jr.
Collection – Fondazione
Regionale C. Colombo,
Genoa

The simplicity of form in this chest, respect for natural wood and traditional craftsmanship are all characteristics of the furniture designed by Cambellotti. Inspired by vernacular Italian tradition, he drew his decorative motifs from the life of his beloved Roman countryside. The front panel is decorated with the forms of sleeping sheep inlaid in ivory and ebony and placed in horizontal lines. Around the front and sides are architecturally rendered figures of shepherdesses standing like sentinels, watching over the flocks. Exhibited in 1925 at the Monza exhibition, the straight lines, ordered composition and clear geometry reflected the current trend away from the curvilinear rhythms of the Stile Floreale to the pure, more rectilinear shapes of the Novecento.
R. P.

Monumentality
and Rationalism

The horrors of war had extinguished early Futurism's grand revelry (Sant'Elia was killed in battle; Boccioni died during cavalry exercises). The "subtle and fecund years" at the origins of Metaphysical painting (Giorgio De Chirico) had been left hanging in a cathartic dimension. After 1919 the Italian aesthetic pursuit, in lockstep with the ideological and social ferment of the day, entered into a regressive and restorative phase. After the painfully won victory on the battlefields, a propitiatory idea of a "return to order" both in art and politics appeared in Italian society as a dutiful atonement for the suffering of the war and its political and economic repercussions.

The period between the two wars, sadly known in Europe as the age of totalitarianism, was characterized in Italy almost exclusively by the Fascist regime (1922–1943). Among the various regimes that came to power in Europe, Italian Fascism was distinguished by a number of features that were incongruent with a dictatorship, among them its complex and ambiguous relationship to planning and to art.

An accumulation of tensions and retractions characterized the particular cultural amalgam held together by the skilful rhetorical politics of Benito Mussolini. This was also apparent in the concerns within the variegated society under his rule to fit everyday objects into different and opposing ideas on culture: conservatism versus modernity; rationalism versus monumentality; moderate neo-avant-garde versus neo-bourgeois anti-romanticism; stylistic-historical or stylistic-rustic inspiration versus new international avant-garde. The troubling question became more urgent than ever: classicism or modernity? But what made this juxtaposition particularly interesting is the dialectical process it initiated, giving birth to a modern classicism that contrasted with, yet also stood in close relation to, a classical modernity.

These two antithetical (yet in the Italian case also paradoxically convergent) modes were the response to the profound malaise pervading late-nineteenth-century Italian culture, which was in its death throes and which was highlighted by an uncertain and fragile spirit of modernity and development. The two modes of response represented, after World War I, two future-oriented focuses for a radical

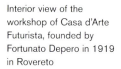

Interior view of the workshop of Casa d'Arte Futurista, founded by Fortunato Depero in 1919 in Rovereto

38
Renato Bertelli
*Testa di Mussolini
(Profilo continuo)*
1933
Museo d'Arte Moderna e
Contemporanea di Trento
e Rovereto

questioning of the high-flown rhetorical and institutional certainties of the still dominant late Classicalesque and decidedly backward culture of Umberto I. It is interesting to note how the Fascist regime, through its various historical phases, managed to stay astride this unstable equilibrium, leaning first toward one and then the other of these re-elaborations of classicism and modernity. From the advent of the Fascist regime in 1922 to its fall in 1943, art and architecture (and consequently decorative arts, the early ventures into proto-design, and the new communications technologies) initially found themselves enveloped in a cultural climate where representations of the regime were steered, especially with respect to the younger generations, toward an anti-historical and revolutionary stance similar to that of the Futurists (well represented for many at that time by the more straightforward artistic forms of the European avant-garde movements). Then later, in the tragic progression of the final years of the Fascist regime, these representations acquired a strongly monumental and rhetorical character imposed with a stubborn and increasingly pompous and self-referential arrogance.

Over the course of two decades, the initial revolutionary and vanguardist vision of the Fascist pursuit was transformed into the joyless, imperial monumentalism of the dictatorship with its symbolic lictorian fasces. The dialectical impetus in art would remain vital and alive for a good part of this period (up to approximately 1936), constituting an interesting anomaly within a totalitarian system, which thus revealed itself in certain ways to be favourably "imperfect," at least regarding the somehow still protected territory of art. The Mussolini regime would long maintain an ambiguous and contradictory—or as Piacentini would say, a "loose knit"—relationship with art. Art and design managed to conserve a

rather significant degree of autonomy that allowed the many various movements to continue developing themes, some even with international impact, with great sensitivity and acuity.

This apparently monolithic political and cultural context, which in reality was many faceted and rich in bias, provided the space for the different languages and philosophies of the various artistic and design movements to develop and intertwine.

The figurative artistic current known as Novecento adhered to the purest spirit of a "return to order." Over the course of its development it embraced the creative minds of Mario Sironi, Achille Funi, Piero Marussig, Leonardo Dudreville, Anselmo Bucci, Gian Emilio Malerba, Ubaldo Oppi, Adolfo Wildt, Carlo Carrà, Gigiotti Zanini, Arturo Martini, Felice Casorati and Massimo Campigli. Coordinated by the influential art critic Margherita Sarfatti, the Novecento group postulated a new synthesis to be pursued in classicism through a purist simplification of composition, linear precision and chromatic sobriety. It was a synthesis that Sarfatti simply called *lo stile*, the expression of a modern classicism seeking a return to the classic rules of drawing and composition. And it was this same spirit that witnessed the birth of so-called Milanese architectural Neoclassicism, the heir of certain ventures of Metaphysical painting. It united the hieratic metaphysical monumentalism of Muzio with the visionary modernistic composition developed by Piero Portaluppi, the ironic rereading of Palladio elaborated by Zanini with the sub-Neoclassicism of Mino Fiocchi and Giuseppe Pizzigoni, and the stylistic revisitation of the Viennese Secession and Parisian Art Deco by Gio Ponti, Vincenzo Lancia, Tomaso Buzzi and G. Greppi with the school of Adolf Loos imported by Giuseppe De Finetti. In this vein, but in a decidedly more compromising and earthy manner with respect to the rhetoric of the

Fascist regime, we find the vast monumental work of the Roman school with Marcello Piacentini at the head. He was flanked by others showing significantly different linguistic approaches, including Arnaldo Foschini, Mario de Renzi, Enrico del Debbio, Mario Paniconi and Giulio Pediconi, Ernesto Angelo La Padula, Pietro Aschieri, G. Calza Bini and G. Busiri Vici.

A different approach was represented by the modernist and international current expressed by the early Italian Rationalists appearing on the scene in 1926 as the Gruppo 7 (Luigi Figini and Gino Pollini, Giuseppe Terragni, Sebastiano Larco, Guido Frette, Carlo Rava and Ugo Castagnoli, later replaced by Adalberto Libera), whose work would intertwine with the first geometrical-rationalist projects of Ivo Pannaggi, Alberto Sartoris, Pietro Lingeri, Giuseppe Pagano, Gino Levi Montalcini, Gabriele Mucchi and Luciano Baldessari.

While historians have established that Italian design has its roots in the Rationalist movement, it is equally well substantiated that these roots draw their sustenance equally from the exploration of classical forms reinterpreted in metaphysical terms by certain artists in the Novecento group (Sironi above all, who would often work both with Muzio and with Terragni), and from the pursuits of a part of the Secondo Futurismo movement, as expressed by such disruptive and multifaceted personalities as Fortunato Depero (a native of Rovereto like the architects Baldessari and Pollini, and like the artist Fausto Melotti, whom he introduced into the salons of the Milanese Futurists), Ivo Pannaggi, Enrico Prampolini, Fillia, Nicola Mosso, Bruno Munari and Tullio D'Albisola, who are conceptually akin to Giacomo Balla in his intense work in the realm of art-furnishings-environment in the 1920s. This variegated tapestry of creative minds explains the wealth of ideas developed

within this climate of modernity as a continual dialectical antithesis to history: from Edoardo Persico, M. Zizzoli and Cesare Cattaneo to Ignazio Gardella and Franco Albini, from Luigi Vietti, Luigi Moretti and Carlo Mollino to BBPR (Gian Luigi Banfi, Lodovico Belgiojoso, Enrico Peressutti, Ernesto Rogers) and Piero Bottoni, from Giovanni Michelucci, Mario Ridolfi and Ludovico Quaroni to Pier Luigi Nervi and G. Fiorini, from Gigi Chessa and Carlo Scarpa to M. Asnago and C. Vender.

Regarding artistic explorations more closely attuned to the Abstract-Rationalist vein, we find, on the one hand, the various expressions of Futurism extending from the epicentre of the still very active Giacomo Balla out to the ventures of the Turinese Nicolai Diulgheroff, Pippo Oriani, Fillia and Mino Rosso, and to the aerial painting of Tullio Crali and Gerardo Dottori. On the other hand, we find for some an abstract-geometrical tendency expressed to varied effect by Bruno Munari, Enrico Prampolini, Marcello Nizzoli, Lucio Fontana, Virginio Ghiringhelli, Mauro Reggiani, Osvaldo Licini, Alberto Magnelli, Atanasio Soldati, Luigi Veronesi and Fausto Melotti, and in a more programmatic form by the group from Como composed of Mario Radice, Manlio Rho and Carla Badiali. In particular, we may cite the ideal encounter among these artistic and architectural quests in the fountain for the VI Triennale (1936) created by Cesare Cattaneo and Mario Radice, and in the celebrated Casa del Fascio [Fascist Party Headquarters] in Como designed by Giuseppe Terragni with artistic contributions from Marcello Nizzoli and Mario Radice.

In the decorative and applied arts we observe an interesting effort to get in step with the times by a number of important, recently established schools and institutions. Two schools stand out in an uncertain and changing context that witnessed the decline of drafting in the polytechnical design schools in favour

237
Marcello Nizzoli
Campari. l'aperitivo
1925–26
Centro Studi e Archivio della Comunicazione, Università degli Studi di Parma

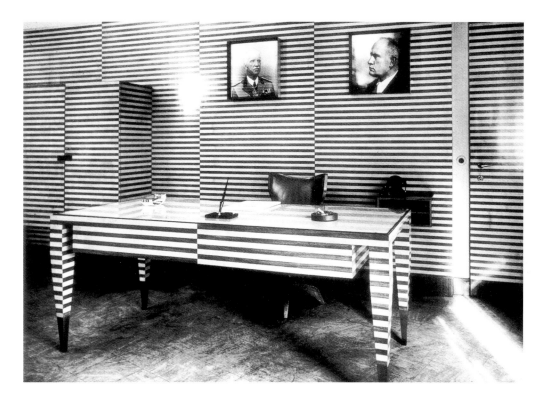

of mathematical methods and new techniques of reproduction, such as the blueprint (the direct relationship with the physical reality of the object, and its material execution thus becoming more distant and abstract). There was also the retrogression of the varied and complex world of the schools of applied art, after the vitalizing phase brought about by the advent of Art Nouveau, into regional styles or more traditional and popular expressions. These schools would exert a growing influence on applied and industrial arts in Italy, at least until 1930: the Scuola Umanitaria of Milan, founded in 1893 as part of strong Socialist-inspired community support efforts; and the Istituto Superiore per le Industrie Artistiche (ISIA) of Monza established in 1922 via an initiative of the Scuola Umanitaria to create a "decorative arts unit" in Monza.

The histories of these two schools are still more significant in their relationship with the "Triennale" exhibitions, which would have a great importance in framing the debate on decorative arts in the period between the two world wars. The Scuola Umanitaria was the organizer of the *Prima esposizione regionale lombarda di arte decorativa* held in 1919 in the school. This was the forerunner of the first *Esposizione internazionale delle Arti decorative* held in 1923 at the Palazzo Reale of Monza in close collaboration with ISIA. The organizational committee of the 1919 event included such eminences in the culture of decorative arts as Mazzucotelli, Marangoni, Melani and Moretti, as well as a younger generation of art critics interested in industrial issues such as Margherita Sarfatti and Raffaello Giolli. The ISIA would adopt an even more modern and ambitious approach right from its inception with an important position given to painting for advertising, and to posters. Among the luminaries working at the school were Depero followed by Nizzoli, Sironi and Persico, and later by Pagano and Marino Marini. There were also celebrated blacksmiths like Vercellini, goldsmiths like Nicolatti, and tinsmiths like Conoletti. Guido Balsamo Stella was the first director, and the first generation of students included future artists such as Mirko, Nivola and Fancello.
Giampiero Bosoni

64
Carlo Carrà
*Piazza del duomo
a Milano*
1909
Private collection,
courtesy Claudia Gian
Ferrari, Milan

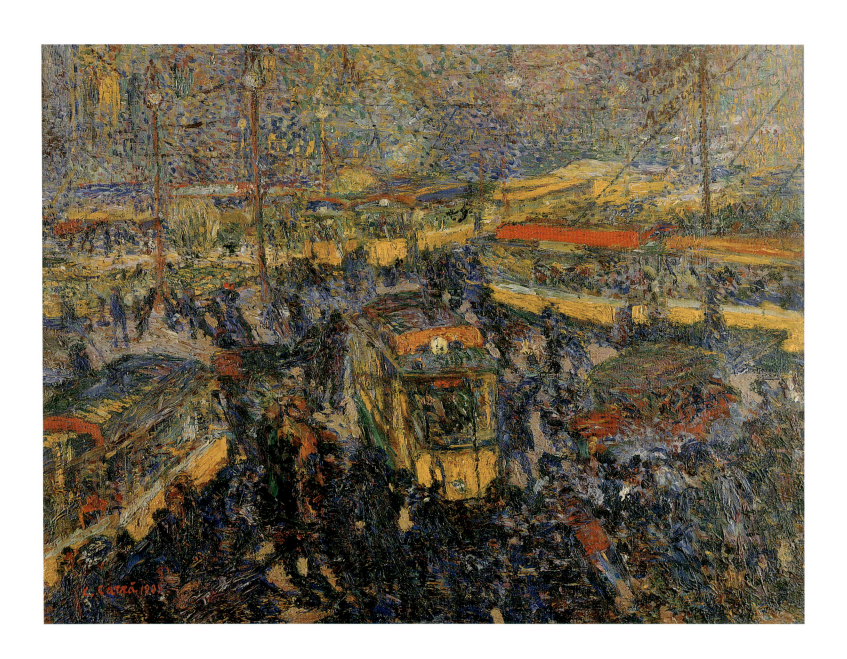

146

Umberto Boccioni
*Forme uniche di
continuità nello spazio*
1913
The Metropolitan Museum
of Art, New York

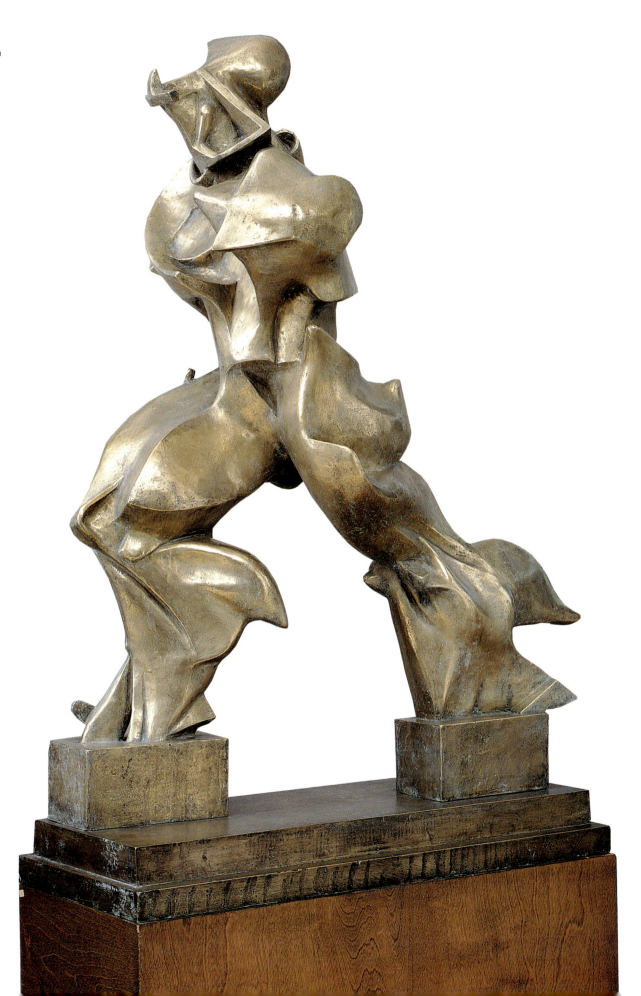

189
Filippo Tommaso Marinetti
*Les mots en liberté
futuristes*
Milan, Edizioni Futuriste di
"Poesia," 1919
The Mitchell Wolfson Jr.
Collection – Fondazione
Regionale C. Colombo,
Genoa

188
Filippo Tommaso Marinetti
*Guido Guidi. Parole in
libertà*
1916
Private collection

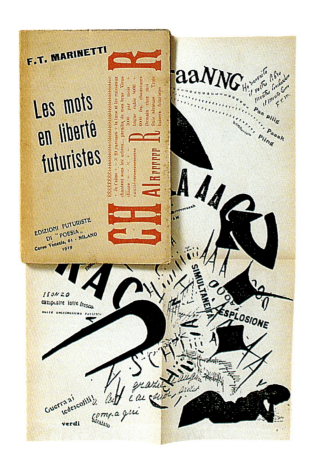

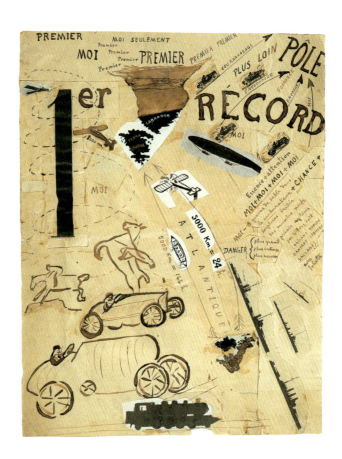

66
Carrozzeria Castagna
Integral Aerodynamics on
an Alfa Romeo 40/60 HP
Chassis
Reduced-size model for a
car commissioned by
Count Marco Ricotti and
built in 1914
1913
Museo Alfa Romeo,
Arese, Milano

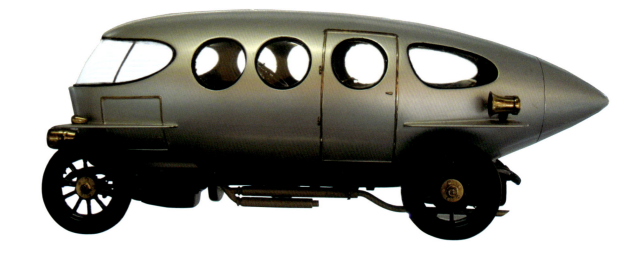

17
Giacomo Balla
Rumoristica plastica
BALTRR
1914
Private collection

62
Francesco Cangiullo
Crowd on the Piazza del
Popolo, Rome (Tavola
parolibera)
1914
Private collection

14
Giacomo Balla
Ciac-Ciac Musical
Instrument
1910–15
Museo Nazionale degli
Strumenti Musicali, Rome

16
Giacomo Balla
*Compenetrazione
iridescente n. 5
(Eucaliptus)*
1914
Yves Saint Laurent –
Pierre Bergé collection

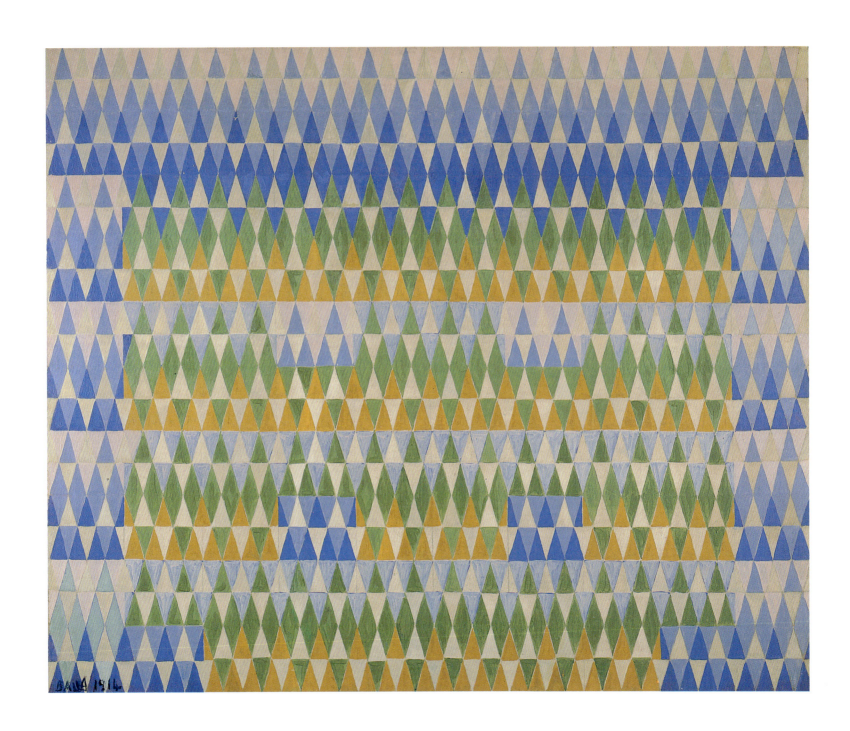

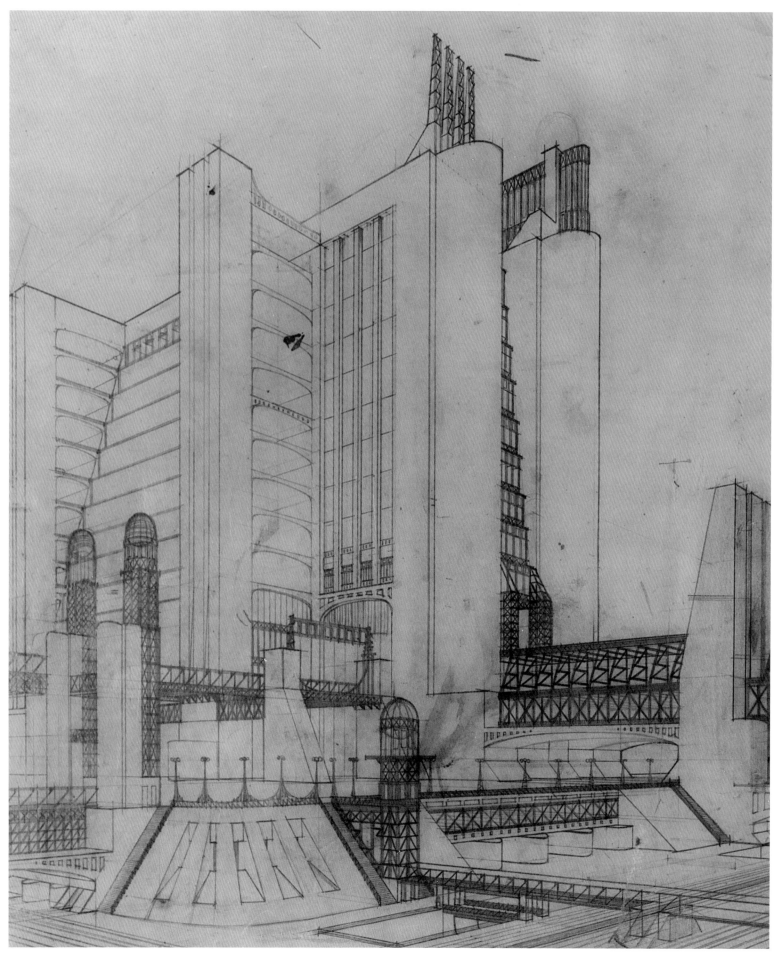

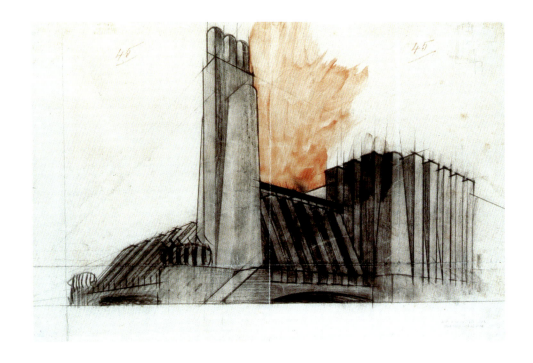

292
Antonio Sant'Elia
Casamento su tre piani stradali per città nuova
1914
Musei Civici, Como

291
Antonio Sant'Elia
Edificio industriale o stazione ferroviaria
1913
Musei Civici, Como

138
Arrigo Finzi
Antonio Sant'Elia
Futurismo "Navette"
1919
Execution: S. A. Arrigo
Finzi e C.
Olga Finzi Baldi collection

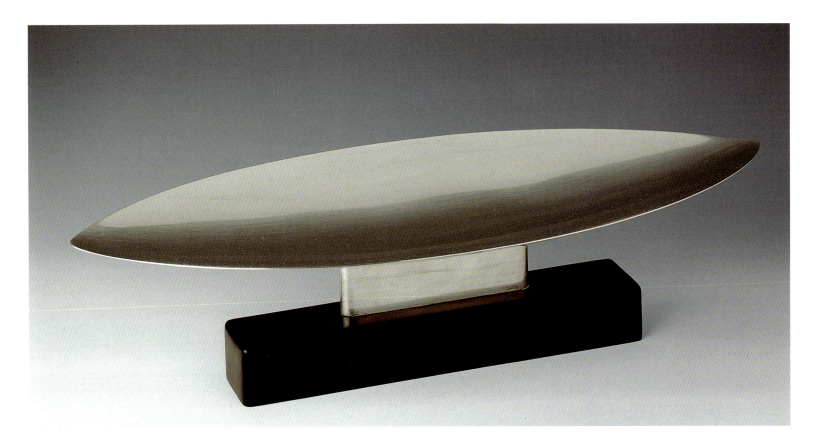

153

18
Giacomo Balla
Painted Screen
(both sides shown)
About 1917
Private collection

20
Giacomo Balla
Progetto per arredamento
di salone
1918
Private collection

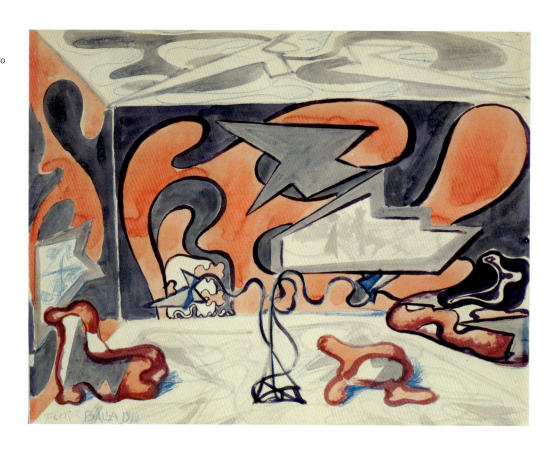

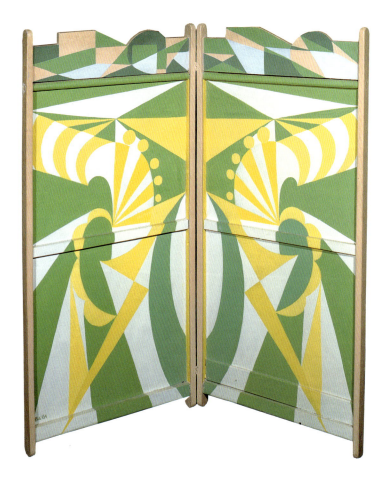

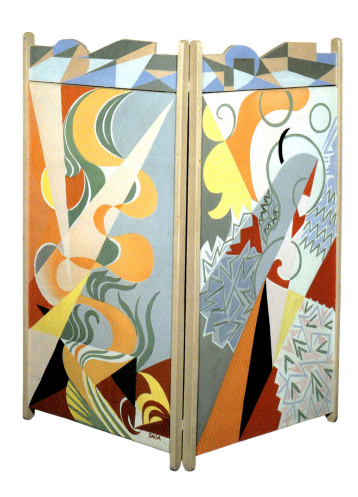

154

19
Giacomo Balla
*Linee forza di
paesaggio + giardino*
1918
Museo d'Arte Moderna e
Contemporanea di Trento
e Rovereto
Deposit of Società
SOSAT

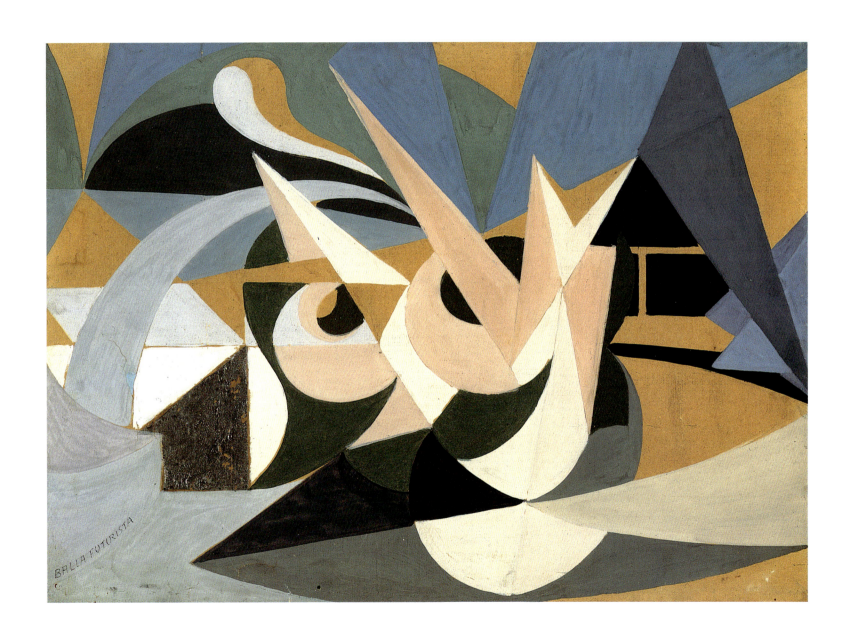

22
Giacomo Balla
Chair
1920s
Private collection

21
Giacomo Balla
Box
1919
Private collection

23
Giacomo Balla
Magazine Rack
1920s
Private collection

Giacomo Balla was among the most ardent of the Futurist artists in bringing everyday furnishings and even fashion into the sphere of Futurist art. He designed cupboards, tables, chairs and shelves like this one in non-traditional shapes. The construction material was unimportant because he would decorate his furniture with abstract geometric motifs in bright colours in the belief that each object would interact with its environment and user. The interpenetration of lines, solid masses of bold colour, and the combination of angular geometric shapes with curved forms recall elements of Balla's non-objective paintings, which focused on dynamic movement and the effects of light and colour. His unusual furniture designs and decoration foretell the humour and joyfulness of postmodern Italian design.
R. P.

24
Giacomo Balla
Futurist Vest
1924–25
Fondazione Biagiotti
Cigna

15
Giacomo Balla
Velocità e vortice
1913
Robert and Alice Landau,
Montreal

118
Fortunato Depero
Costruzione di donna
1917
Museo d'Arte Moderna e
Contemporanea di Trento
e Rovereto

117
Fortunato Depero
Costruzione di bambina
1917
Museo d'Arte Moderna e
Contemporanea di Trento
e Rovereto

120
Fortunato Depero
Meccanica di ballerini
1917
Museo d'Arte Moderna e
Contemporanea di Trento
e Rovereto

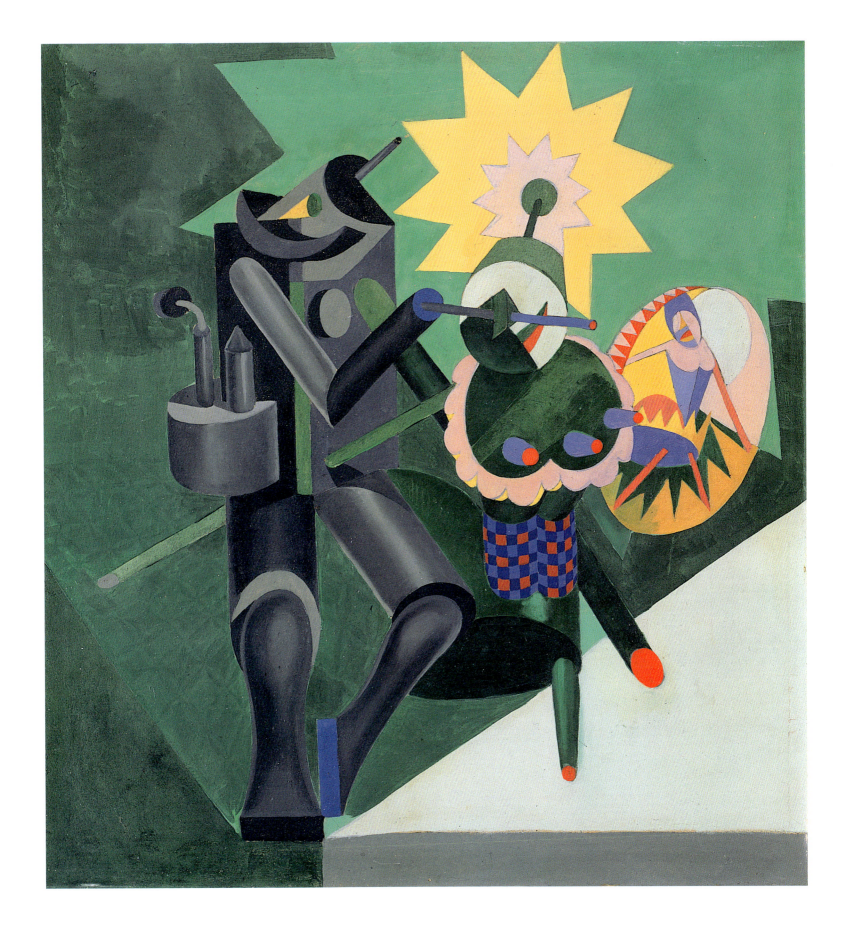

121
Fortunato Depero
Study for a Lamp
1920–22
Museo d'Arte Moderna e
Contemporanea di Trento
e Rovereto

125
Fortunato Depero
Depero futurista
Dinamo-Azari Album,
Milan, 1927
Private collection,
courtesy Museo d'Arte
Moderna e Contemporanea
di Trento e Rovereto

116
Fortunato Depero
Vaso futurista
1913
Museo d'Arte Moderna e
Contemporanea di Trento
e Rovereto

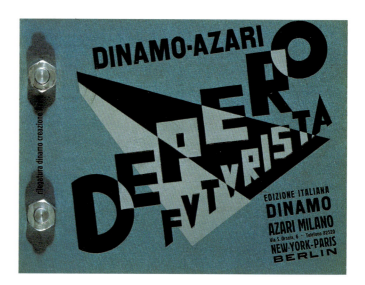

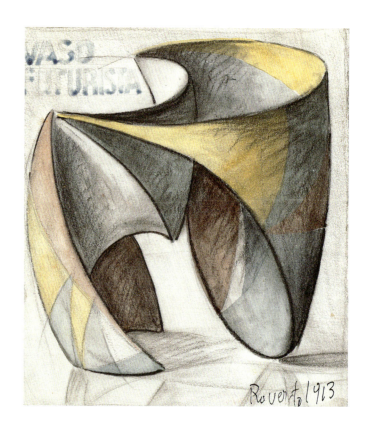

119
Fortunato Depero
Il gobbo e la sua ombra
1917
Museo d'Arte Moderna e
Contemporanea di Trento
e Rovereto

122
Fortunato Depero
Chiosco pubblicitario
1924
Museo d'Arte Moderna e
Contemporanea di Trento
e Rovereto

124
Fortunato Depero
Design for the Book
Pavilion of Treves
Tumminelli, Monza
III Triennale (1927)
1926–27
Museo d'Arte Moderna e
Contemporanea di Trento
e Rovereto

130
Fortunato Depero
Design for Davide
Campari & C. Publicity
Pavilion
1933
Collezione Campari, Milan

162

127

Fortunato Depero
Festa della sedia
1927
Museo d'Arte Moderna e
Contemporanea di Trento
e Rovereto

Fortunato Depero was devoted to the Futurist ideal that art and design were an essential part of a continuously changing environment. Like his colleague, Balla, with whom he wrote the manifesto *Futurist Reconstruction of the Universe* in 1915, Depero turned his imagination to all aspects of art including theatre design, typography, costume, graphic design, and the applied arts. In 1919 he founded the "Casa d'Arte" in Rovereto where he produced designs for household objects, especially wall hangings such as this one, in collaboration with his wife. The repetitive rhythms and the jagged, vibrant colours and shapes of Futurist design are evident in this wall hanging entitled "Festival of the Chair." A joyous celebration of Depero's characteristic mechanical figures forms a procession marching towards an unconventional looking chair. In the background stand two Cubist architectural fantasies. One, a montage of alphabet letters, recalls Depero's famous book pavilion he created for the Monza exhibition of 1927.
R. P.

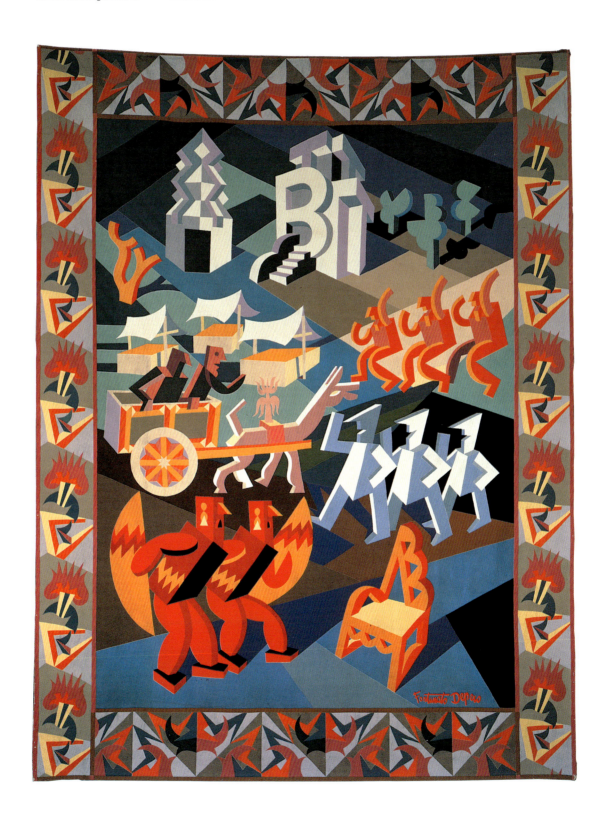

65

Carlo Carrà
Composizione TA
(Natura morta metafisica)
1916–18
Museo d'Arte Moderna e
Contemporanea di Trento
e Rovereto

230
Giovanni Muzio
Ca' Brütta, Milan.
Facade on the Via Turati
1922
Archivio Muzio

310
Mario Sironi
*Paesaggio urbano
con taxi*
1920
Museo d'Arte Moderna e
Contemporanea di Trento
e Rovereto

68
Felice Casorati
Una donna (L'attesa)
1918–19
Private collection

71
Felice Casorati
Seat for the Music Room
in Casa Casorati, Turin
1925
Execution: Giacomo
Cometti
Private collection, Turin

298
Alberto Sartoris
Felice Casorati
Private Theatre for
Riccardo Gualino, Turin.
Version B, Perspective
from the Stage
1924–25
Archives de la
construction moderne
EPFL, Fonds Alberto
Sartoris

69
Felice Casorati
Sculpture "Chair" for
Casa Casorati, Turin
1925
Execution: Giacomo
Cometti
Fondazione Guido ed
Ettore de Fornaris,
Galleria d'Arte Moderna
e Contemporanea, Turin

70
Felice Casorati
Sculpture Pedestal for
Casa Casorati, Turin
1925
Execution: Giacomo
Cometti
Fondazione Guido ed
Ettore de Fornaris,
Galleria d'Arte Moderna
e Contemporanea, Turin

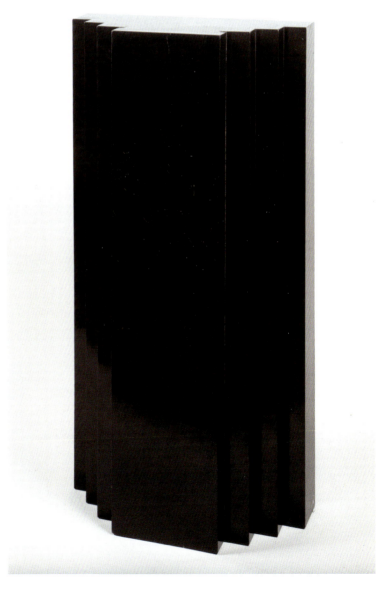

260
Gio Ponti
Prospettica Bowl
1923–30
Produced by Richard-
Ginori
Museo Richard-Ginori
della Manifattura di
Doccia, Sesto Fiorentino,
Firenze

350
Gigiotti Zanini
La città
1922
Private collection,
courtesy Claudia Gian
Ferrari, Milan

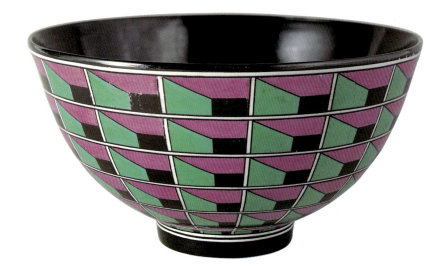

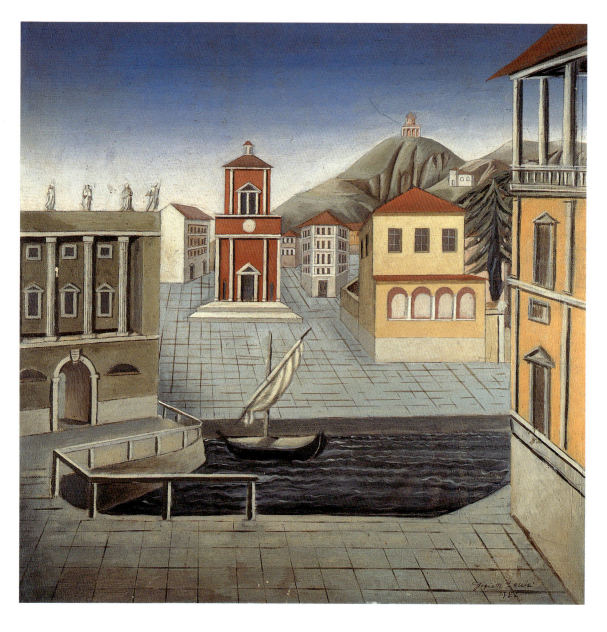

243
Ubaldo Oppi
La giovane sposa
1922–24
Musei Civici, Museo
d'Arte Medievale e
Moderna, Padua

231
Giovanni Muzio
The Marble Room of the
IV Mostra delle Arti
Decorative, Monza Triennale
(1930). Elevation and Floor
1929
Archivio Muzio

232
Giovanni Muzio
The Marble Room of the
IV Mostra delle Arti
Decorative, Monza Triennale
(1930). Elevation
About 1929
Archivio Muzio

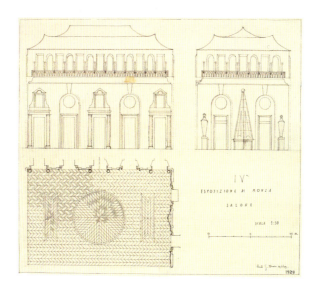
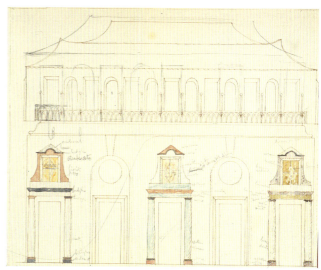

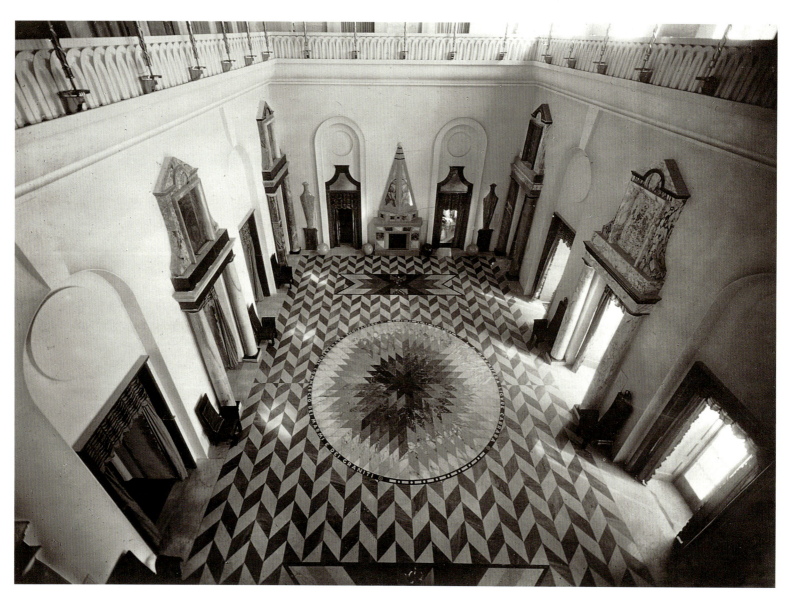

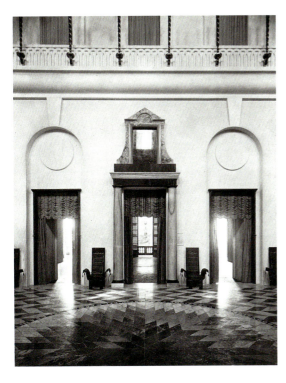

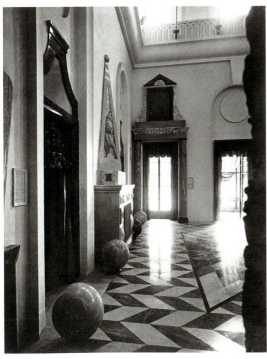

234
Giovanni Muzio
The Marble Room of the
IV Mostra delle Arti
Decorative, Monza
Triennale (1930)
1930
Archivio Muzio

235
Giovanni Muzio
The Marble Room of the
IV Mostra delle Arti
Decorative, Monza
Triennale (1930)
1930
Archivio Muzio

236
Giovanni Muzio
The Marble Room of the
IV Mostra delle Arti
Decorative, Monza
Triennale (1930)
1930
Archivio Muzio

233
Giovanni Muzio
Ceremonial Armchair for
the Hall of Honour, known
as the "Marble Room," IV
Monza Triennale (1930)
1930
Galleria Daniela Balzaretti

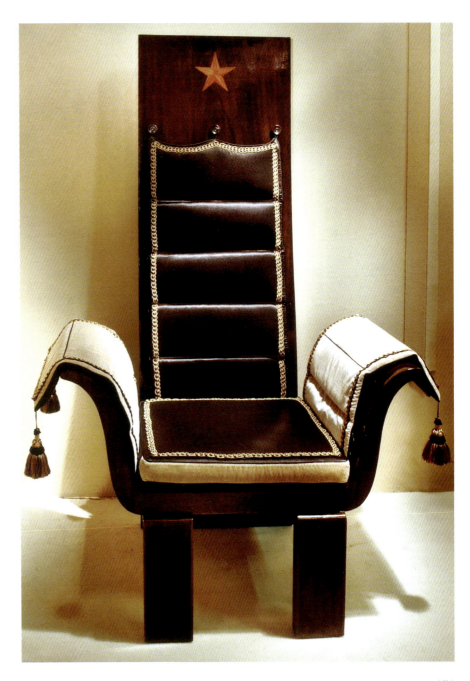

196
Napoleone Martinuzzi
"Pulegoso" Vase
1930
Produced by Venini
Roberto Navarro

193
Napoleone Martinuzzi
Pianta
1930
Produced by Venini
Roberto Navarro

194
Napoleone Martinuzzi
Pianta
1930
Produced by Venini
Roberto Navarro

25
Ercole Barovier
Covered Urn
About 1910
The Mitchell Wolfson, Jr.
Collection – The
Wolfsonian-Florida
International University,
Miami Beach, Florida

172

301
Carlo Scarpa
"Trasparente" Vase
1926
Produced by MVM
Cappellin
Roberto Navarro

The glassware designed
by Carlo Scarpa is a
good example of the
attention given by Italian
architects to the
production and
development of the
applied arts in the
twentieth century. Scarpa
was first associated with
the glassworks of MVM
Cappellin & Co. from
1926 until 1932, and
then became artistic
director for Venini & C.
until 1947. His forms and
decoration for Venini are
among the company's
best and rarest pieces.
This simple spherical
vase is one of the series
of "Trasparenti" designs
in thin, blown, and lightly
coloured glass, which
Scarpa created for MVM
Cappellin & Co. in 1926.
The pure geometry of its
form and the emphasis
on the qualities of the
glass medium reflected
his interest in the
Rationalist ideals of such
architects as Mies van
der Rohe.
R. P.

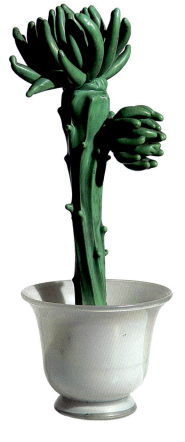

195
Napoleone Martinuzzi
Pianta grassa
1933
Produced by
Zecchin/Martinuzzi – Vetri
Artistici e Mosaici
Nicoletta Fiorucci collection

359
Vittorio Zecchin
Libellula Vase
1922–26
Produced by MVM Cappellin
Galleria Marina Barovier,
Venice

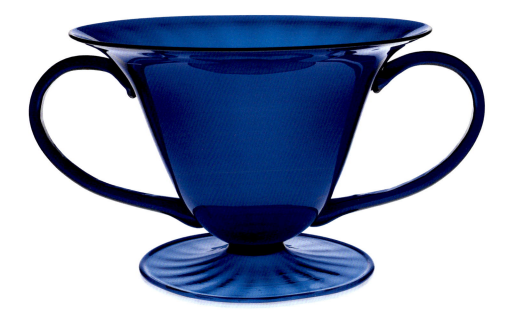

173

261
Gio Ponti
*La passeggiata
archaeologica* Urn
1925
Produced by Richard-
Ginori
The Metropolitan Museum
of Art, New York

Although trained as an architect, Gio Ponti spent the years from 1923 to 1930 as artistic director for the Richard-Ginori porcelain factory. He designed one-of-a-kind pieces and smaller works that could be industrially produced. This urn is characteristic of the classically inspired wares he created in the 1920s, which brought international attention and awards to Ponti and the Ginori firm. It is decorated with motifs from his series entitled "La passeggiata archeologica" [An Archaeological Stroll], first exhibited in 1923. The decoration, similar to that of his better known series, "La conversazione classica" [Classical Conversation], consists of two-dimensional figures, each identified by an attribute or specific pose, and columns supporting classical, archaeological artefacts, all set against a rectangular grid or flooring pattern.
The limited use of colour— red and grey outlined in gold—against the white porcelain give a modern look to the urn's elegant form.
R. P.

262
Gio Ponti
*La conversazione
classica* Vase
1926–about 1927
Produced by Richard-
Ginori
The Montreal Museum
of Fine Arts

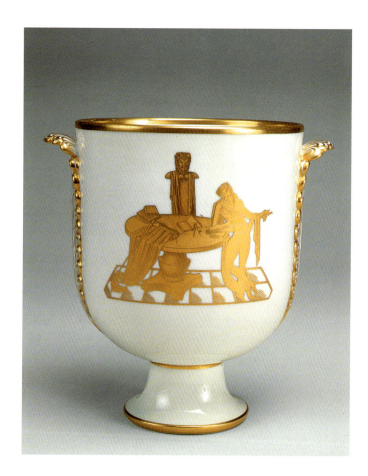

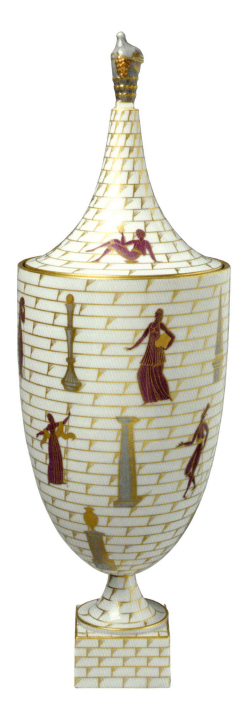

174

109
Giorgio De Chirico
Tebe
1928
Museo d'Arte Moderna e
Contemporanea di Trento
e Rovereto

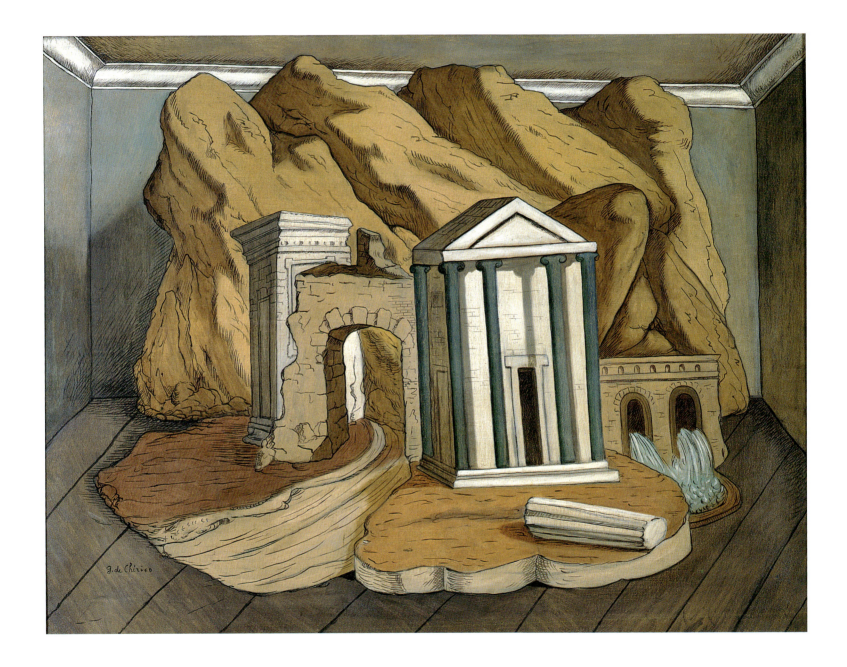

170
Elio Luxardo
Torso di uomo
About 1940
Archivio fotografico
Fondazione 3M

169
Elio Luxardo
Torso di donna
About 1940
Archivio fotografico
Fondazione 3M

168
Elio Luxardo
L'Italica bellezza
About 1940
Archivio fotografico
Fondazione 3M

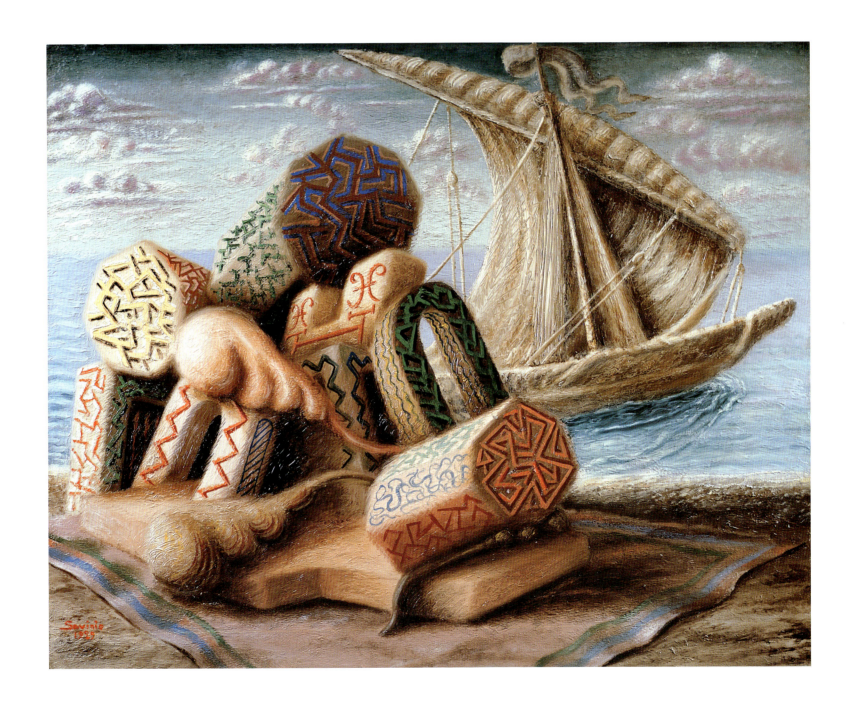

299
Alberto Savinio
Les Rois Mages
1929
Museo d'Arte Moderna e
Contemporanea di Trento
e Rovereto

216
Carlo Mollino
Interior View of Casa
Miller, Turin, Showing
a Table Designed
by C. Mollino
1938 or later
Canadian Centre for
Architecture, Montreal

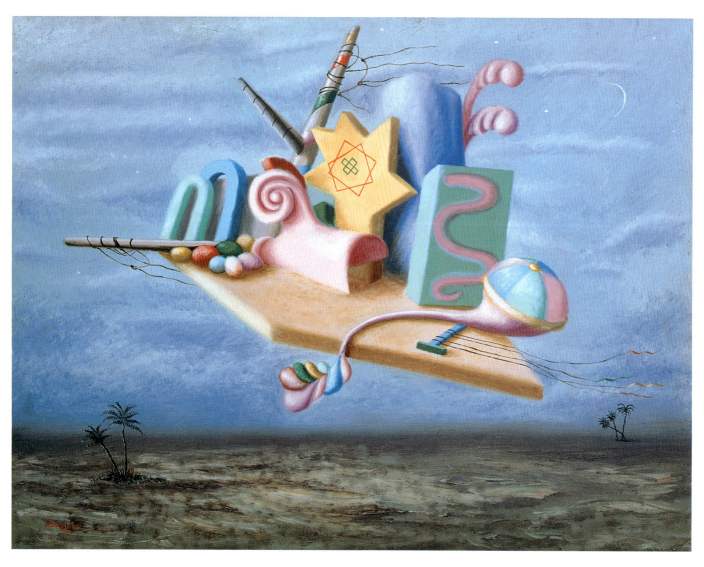

217
Carlo Mollino
View of the Living Room
of Casa Devalle, Turin
1940 or later
Canadian Centre for
Architecture, Montreal

264
Gio Ponti
Le mani
About 1935
Produced by
Richard-Ginori
Museo Richard-Ginori
della manifattura di
Doccia, Sesto Fiorentino,
Firenze

179

349
Adolfo Wildt
Portrait of Cesare Sarfatti
1927
Private collection

178
Giacomo Manzù
Giuseppe Pizzigoni
Eva Floor Lamp
About 1929
Pizzigoni collection

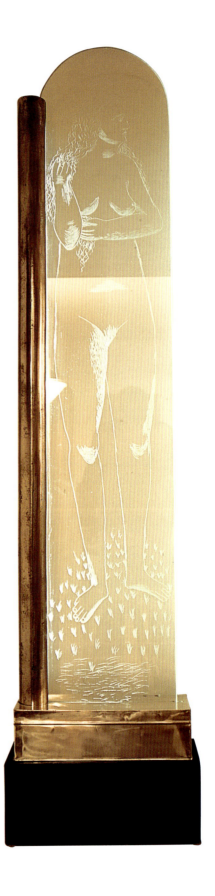

192
Arturo Martini
Il pastorello
1928–29
Private collection,
courtesy Claudia Gian
Ferrari, Milan

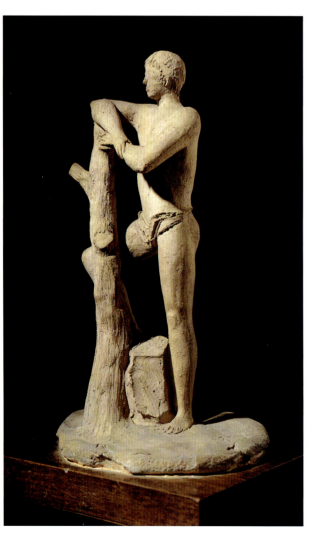

258
Giuseppe Pizzigoni
Armchair for Casa
Pizzigoni
1928–29
Pizzigoni collection

274
Piero Portaluppi
Sconce for Casa
Corbellini-Wassermann,
17 Viale Lombardia, Milan
1934–37
Rosanna Monzini
collection

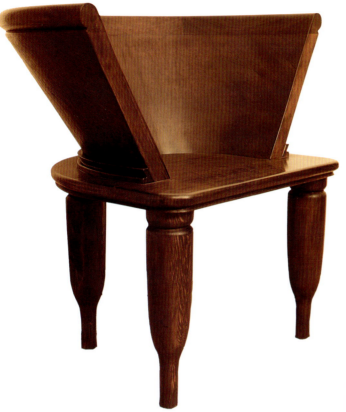

275
Piero Portaluppi
Console for Casa
Corbellini-Wassermann,
17 Viale Lombardia, Milan
1934–37
Cristina Luisa Cappa
Legora collection

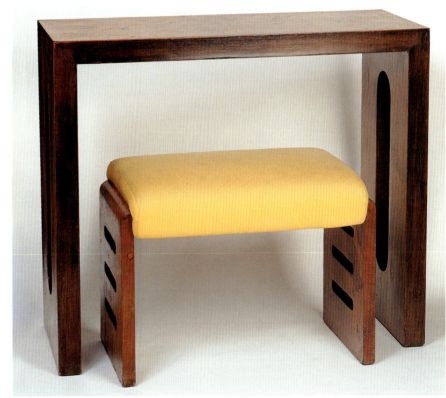

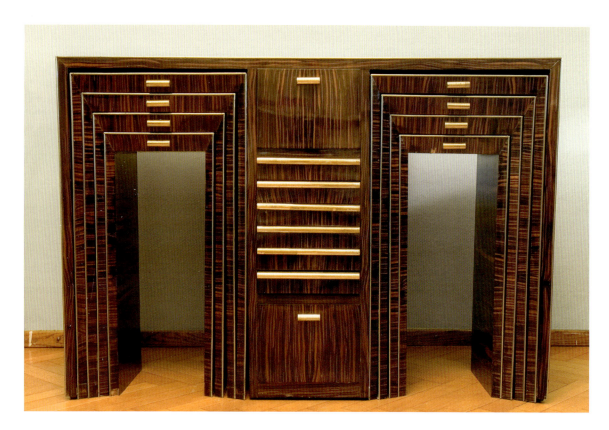

1
Franco Albini
Sideboard with Nesting
Tables for the Dining
Room of Casa Ferrarin,
Milan
1931
Private collection

255
Marcello Piacentini
Chair for the Entrance
Hall of Fiammetta
Sarfatti's House, Rome
1933
The Mitchell Wolfson Jr.
Collection – Fondazione
Regionale C. Colombo,
Genoa

281
Ernesto Puppo
Gate
1933
The Mitchell Wolfson, Jr.
Collection – The
Wolfsonian-Florida
International University,
Miami Beach, Florida

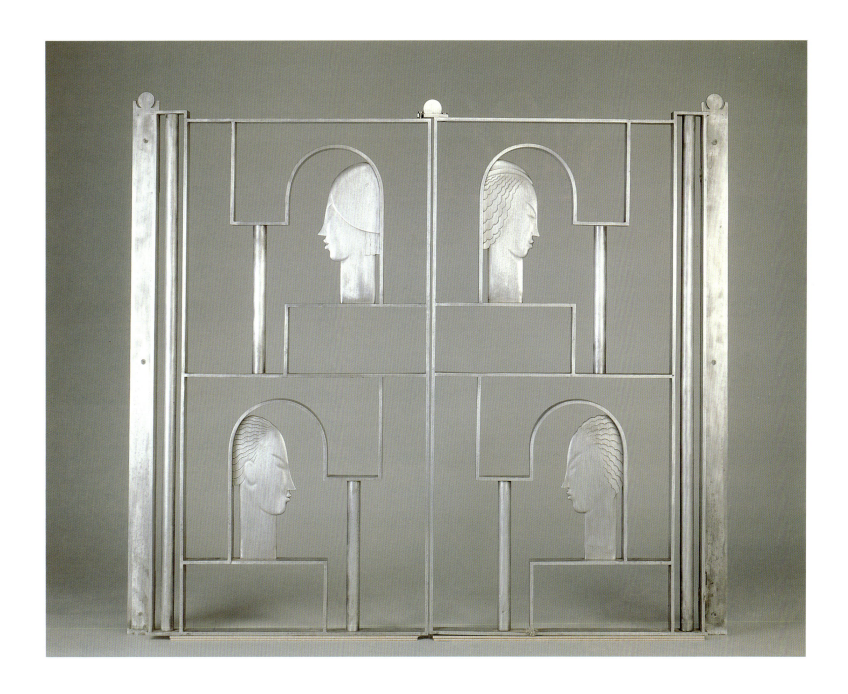

131
Piero De Vecchi
Vase
1938
Collezione De Vecchi
Milano 1935

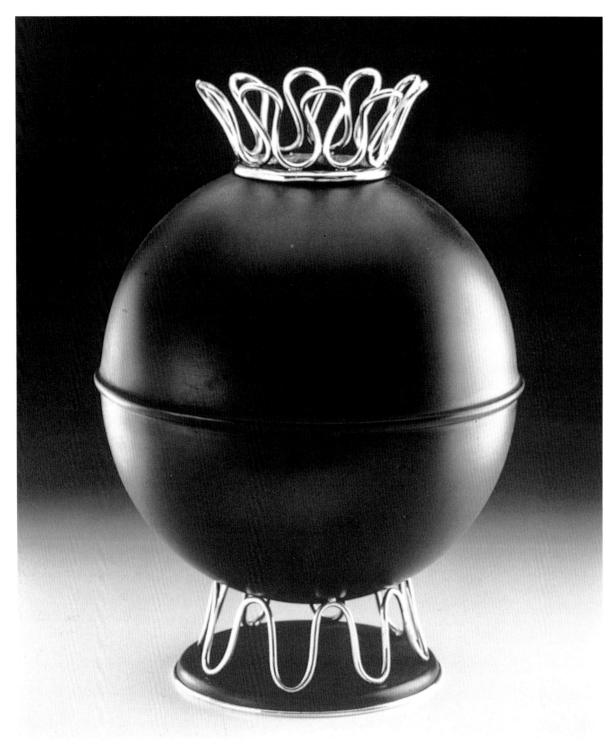

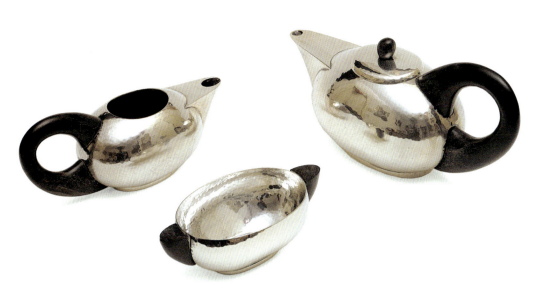

338
Guglielmo Ulrich
Tea Service
About 1930–35
Giancorrado Ulrich
collection

339
Guglielmo Ulrich
Chair
About 1936
Giancorrado Ulrich
collection

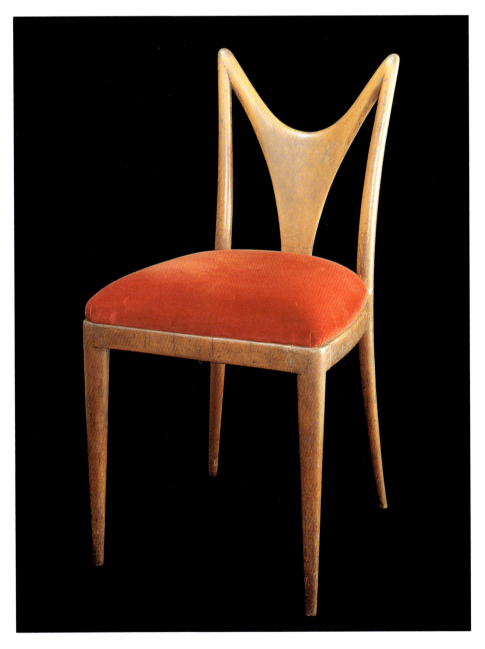

185

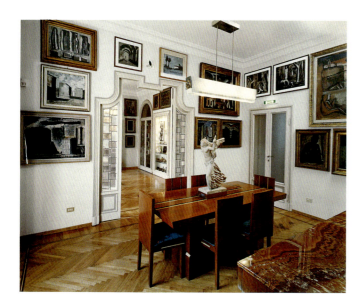

312
Mario Sironi
Dining Room Set
of Casa Aimetti, Milan
About 1936
Fondazione Casa Museo
Boschi Di Stefano –
Musei Civici Milanesi,
Milan

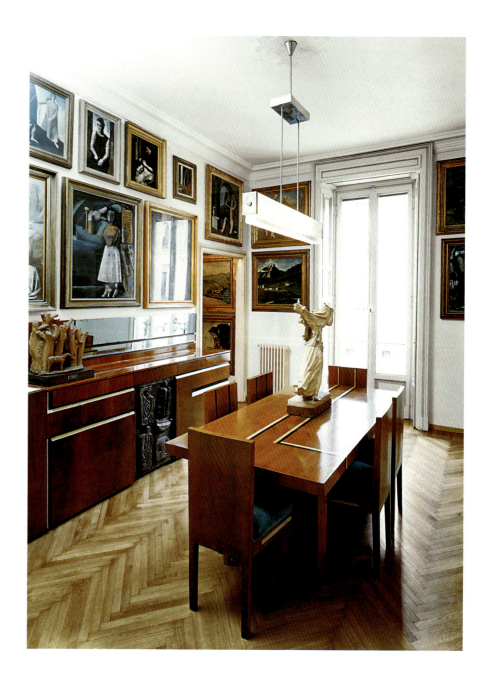

311
Mario Sironi
I costruttori
1930
Casa Museo Boschi
Di Stefano, Milan

102
Tullio D'Albisola
Nino Strada
Mural Study for *Le forze
fasciste*, for the
Architecture Pavilion, VI
Triennale, Milan (1936)
About 1935
Execution: Casa
Giuseppe Mazzotti,
Albisola Marina, Savona
The Mitchell Wolfson, Jr.
Collection – The
Wolfsonian-Florida
International University,
Miami Beach, Florida

56
Corrado Cagli
Dante Baldelli
Marcia su Roma Vase
1930–31
Johannes Von
Wackerbarth collection,
Rome

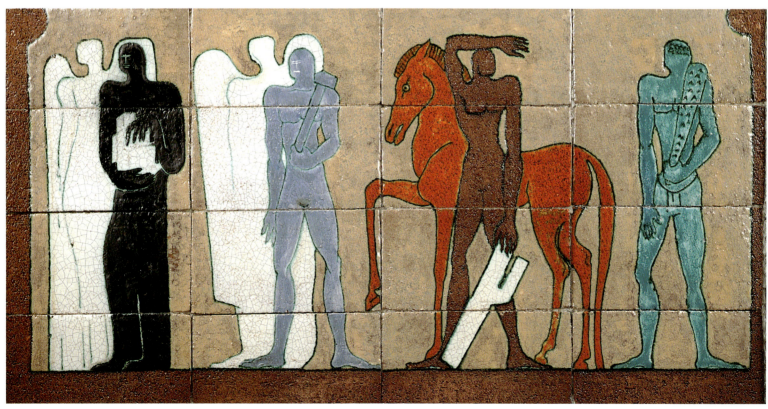

162
Ernesto Angelo La Padula
with G. Guerrini and
M. Romano
Perspective of the Palace
of Italian Civilization,
Esposizione Universale
di Roma, 1942
1939
The Museum of Modern
Art, New York

265
Gio Ponti
with R. Angeli,
C. De Carli, L. Olivieri
and G. Ulrich
Design for the Ministry
of Foreign Affairs, Rome
1939
Centro Studi e Archivio
della Comunicazione,
Università degli Studi di
Parma

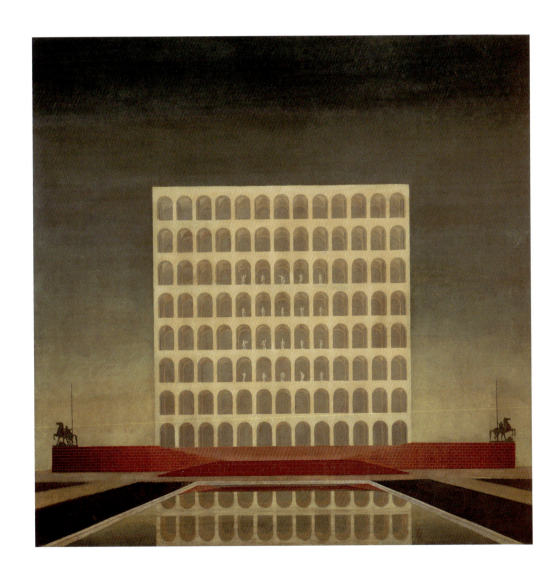

189

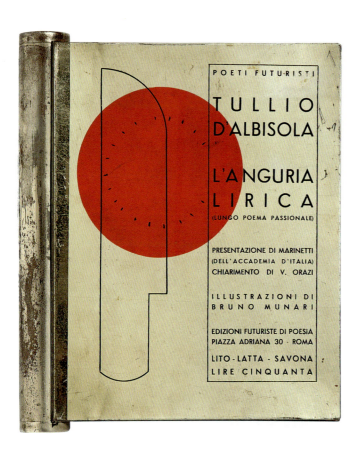

POETI FUTURISTI

TULLIO
D'ALBISOLA

L'ANGURIA
LIRICA
(LUNGO POEMA PASSIONALE)

PRESENTAZIONE DI MARINETTI
(DELL'ACCADEMIA D'ITALIA)
CHIARIMENTO DI V. ORAZI

ILLUSTRAZIONI DI
BRUNO MUNARI

EDIZIONI FUTURISTE DI POESIA
PIAZZA ADRIANA 30 - ROMA

LITO - LATTA - SAVONA
LIRE CINQUANTA

224
Bruno Munari
Cover and Illustrations
for *L'anguria lirica* (*Lungo
poema passionale*)
by Tullio D'Albisola
Rome, Edizioni Futuriste
di "Poesia," undated
[1934]
The Mitchell Wolfson Jr.
Collection – Fondazione
Regionale C. Colombo,
Genoa

101
Tullio D'Albisola
Vase
About 1930
Luigi and Grazia Gilli
collection, Milan

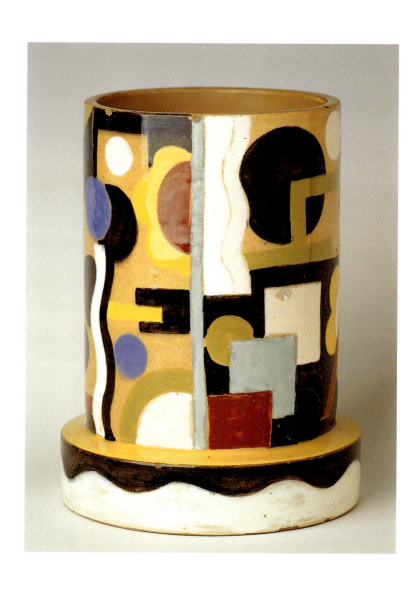

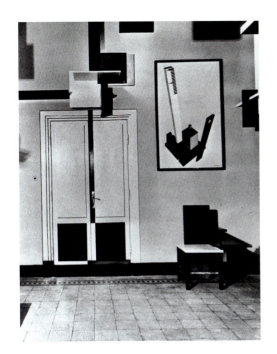

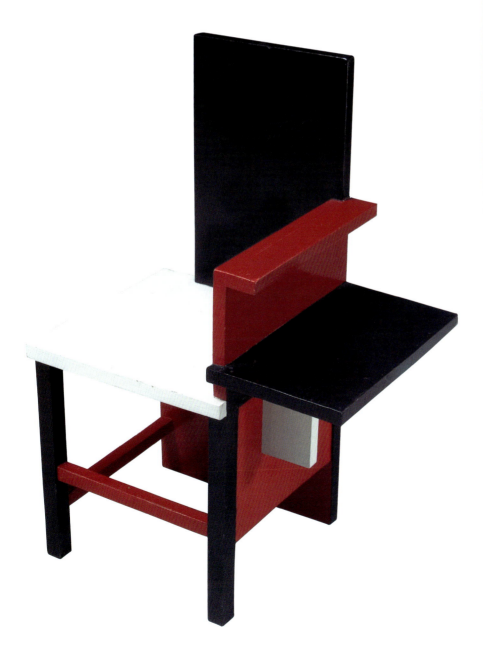

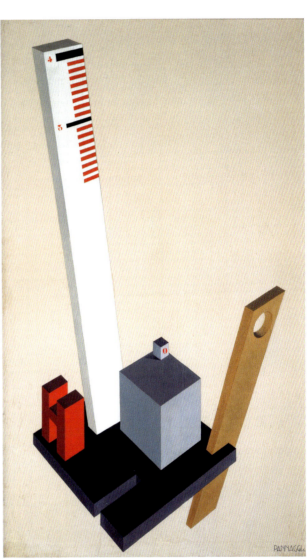

245
Ivo Pannaggi
Chair for the Entrance
Hall of Casa Zampini,
Esanatoglia
1925–26
Pinacoteca Comunale,
Macerata

246
Ivo Pannaggi
*Funzione architettonica
H-03*
Painting made for the
entrance hall of Casa
Zampini, Esanatoglia
1926
Galleria Nazionale d'Arte
Moderna, Rome

123
Fortunato Depero
Armchair
1926
Museo d'Arte Moderna e
Contemporanea di Trento
e Rovereto

126
Fortunato Depero
Campari Tray
1927
Private collection, Italy

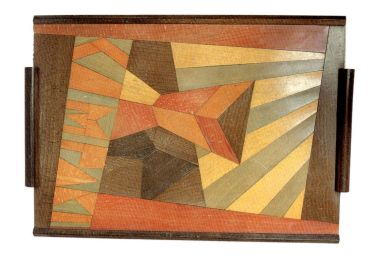

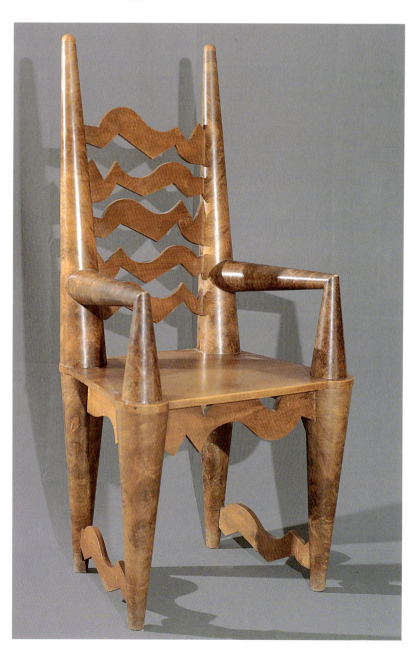

128
Fortunato Depero
Futurist Beret
1929
Ugo Nespolo collection

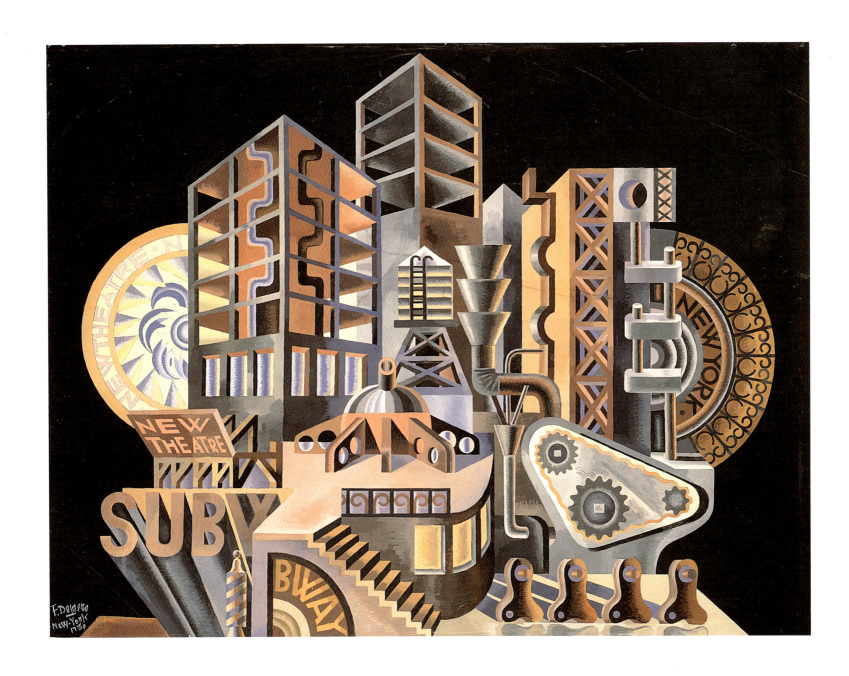

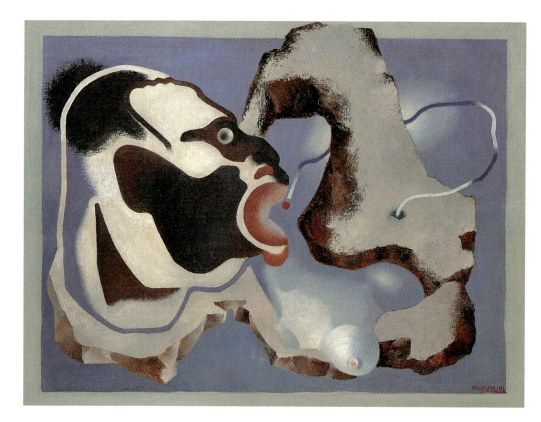

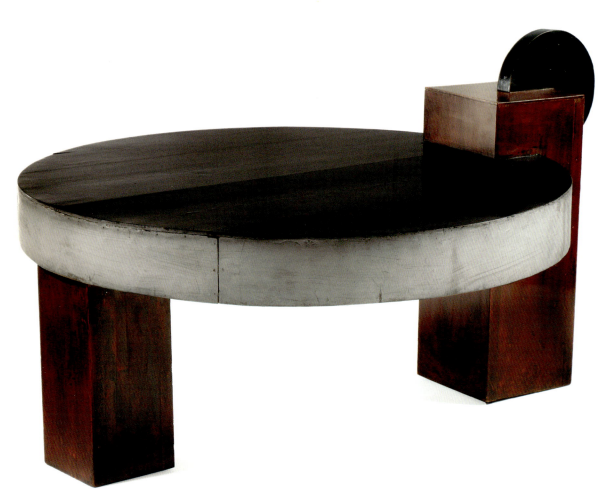

Tullio Crali
*Incuneandosi nell'abitato
(Dalla carlinga)*
1939
Private collection,
courtesy Paolo Curti /
Annamaria Gambuzzi
& Co., Milan

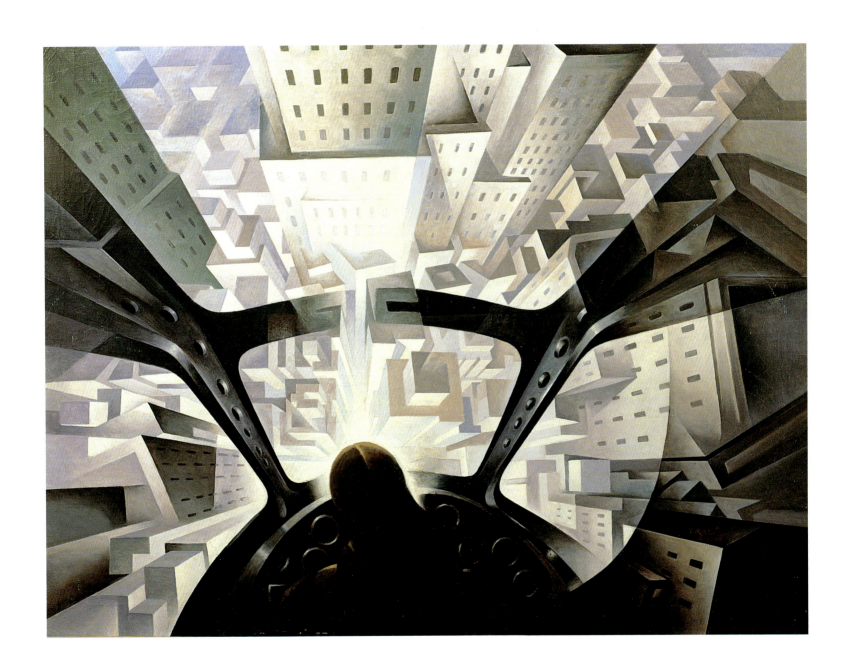

313
Mario Sironi
Il gasometro
1943
Museo d'Arte Moderna e
Contemporanea di Trento
e Rovereto
Deposit of Società
SOSAT

90
Plinio Codognato
Fiat 514
1930
Arti Grafiche Bertarelli,
Milan (for Fiat)
Archivio Storico Fiat

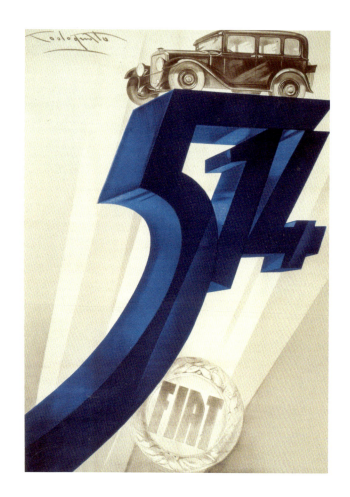

67
Carrozzeria Touring
Alfa Romeo 6C 2500
Freccia d'Oro
1947
Private collection

134
Marcello Dudovich
Fiat. La nuova Balilla per tutti, eleganza della Signora
1934
Massimo and Sonia Cirulli Archive, New York

12
Luciano Baldessari
Luminator Floor Lamp
1929
Centro di Alti Studi sulle
Arti Visive, Comune di
Milan

Baldessari's lamp
developed from an
imaginative solution for a
tailor's dummy over which
to drape cloth, combined
with display lighting for
the Italian textile pavilion
at the Barcelona
Exposición Internacional
of 1929. The lamp's tall
cylindrical metal shaft,
the conical metal shade
to reflect light towards
the ceiling and the metal
tube curving up and
around the lamp give it a
machine-like appearance.

The emphasis on
geometry, mechanics and
light were all issues of the
Futurist artists. At the
same time, the lamp's
pure form, use of
materials and functional
design were in keeping
with the ideals of the
modern movement in
architecture and design.
This form of "light
sculpture" led the way in
Italy's eventual leadership
in domestic lighting and
display design.
R. P.

263
Gio Ponti
Bilia Lamp
1931
Produced by FontanaArte
FontanaArte SpA,
Corsico, Milano

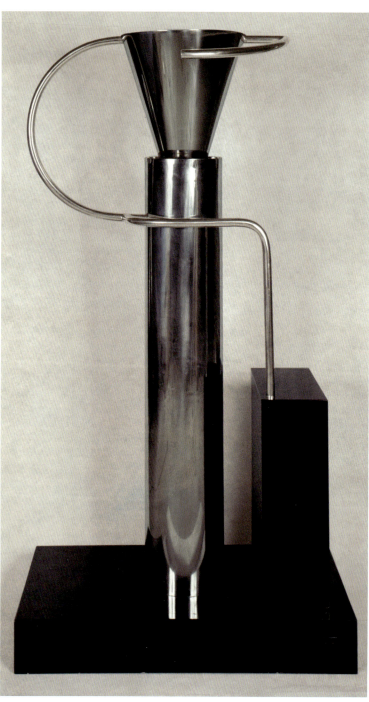

141
Lucio Fontana
Abstract Sculpture
1934
Fondazione Lucio
Fontana, Milan

165
Osvaldo Licini
Composizione
1933
Museo d'Arte Moderna e
Contemporanea di Trento
e Rovereto

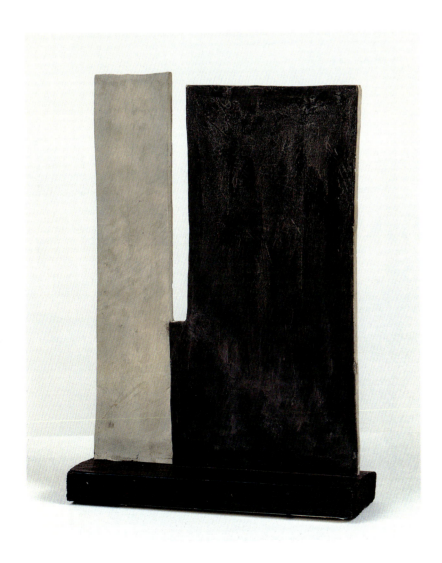

332
Giuseppe Terragni
Casa del Fascio, Como
(1932–36). Perspective
of the Back Facade
1933
Archivio Centro Studi
Giuseppe Terragni

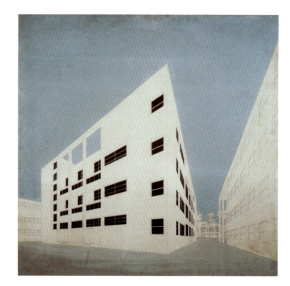

283
Mario Radice
Study for a Large Fresco
in the Board Room of
Casa del Fascio, Como
1932–34
Musei Civici di Como,
Palazzo Volpi

333
Giuseppe Terragni
Sant'Elia Armchair for the
Board Room, Casa del
Fascio, Como (1935–36)
1933
Archivio Centro Studi
Giuseppe Terragni

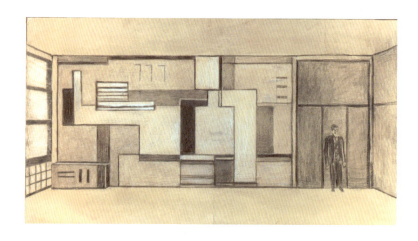

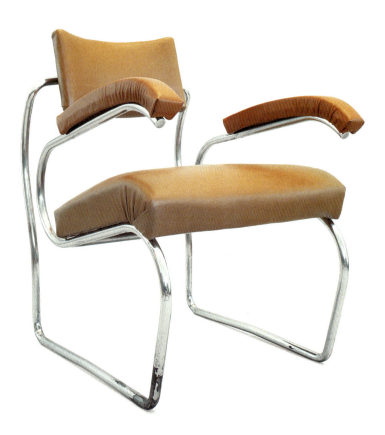

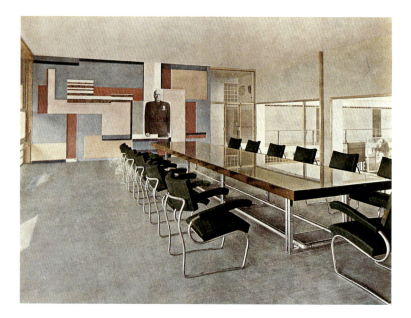

Giuseppe Terragni
Board Room for the Casa
del Fascio, Como,
with mural decoration
by Mario Radice
1936

Pietro Lingeri
Display Case for the
"Fitting Room of a
Modern Dressmaker's
Shop," IV Monza
Triennale (1930)
1930
Archivio di disegni e
documenti dell'architetto
Pietro Lingeri, Milan

135
Luigi Figini
Gino Pollini
Desk for the Manusardi
Apartment, Milan
1935
Private collection

344
Luigi Vietti
Armchair
About 1936
The Mitchell Wolfson Jr.
Collection – Fondazione
Regionale C. Colombo,
Genoa

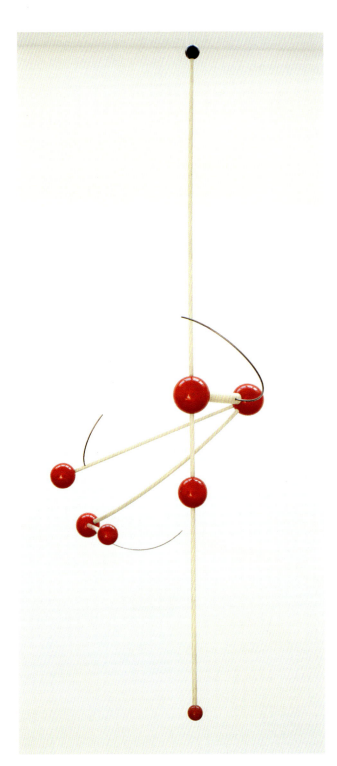

223
Bruno Munari
Macchina aerea
1930
(1971 reconstruction
by Danese)
Private collection

202
Fausto Melotti
Sculpture 23
1935
Museo d'Arte Moderna e
Contemporanea di Trento
e Rovereto

2
Franco Albini
Radio
1938
Studio Albini Associati,
Milan
Archivio del Moderno,
Mendrisio

3
Franco Albini
Mitragliera Lamp
1938–40
Studio Albini Associati,
Milan
Archivio del Moderno,
Mendrisio

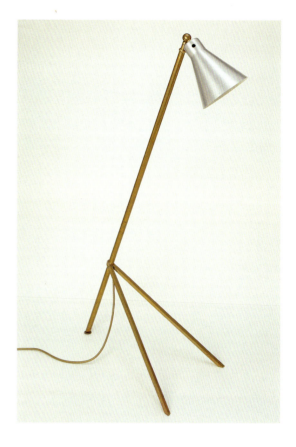

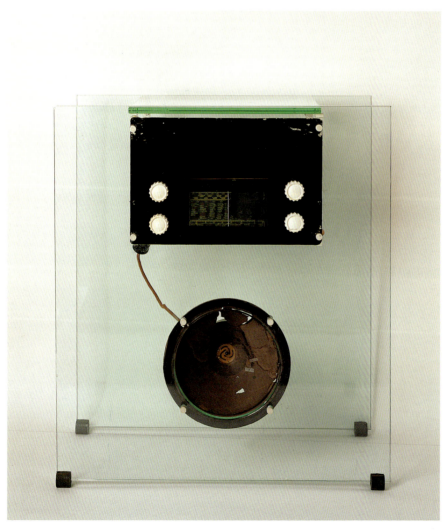

4
Franco Albini
Swing Armchair for the
"Living Room of a Villa,"
VII Milan Triennale (1940)
1940, recent
reconstruction
Cosmit collection

Franco Albini was one
of Italy's most prominent
Rationalist architects.
His minimalist furniture
designs and his inventive
use of materials placed
him ahead of his time.
This chair was part of
Albini's highly acclaimed
display at the VII
Triennale (1940) for a
"Living Room of a Villa,"
in which the interior and
exterior spaces of the
house intermingled.
The room included two
floors and had a tree
growing up through
the second floor from
a glass-covered garden
floor below. A pair of
chairs such as this one,
upholstered in bright blue
and white stripes like
the sails of a boat, were
suspended between
the outdoor and indoor
spaces of the room
like swings.
The lightweight furniture,
openness of plan and
the fluidity of space
defined the modernity
of Albini's project.
R. P.

305
Carlo Scarpa
"Murrina" Plate
1940
Produced by Venini
Venini SpA, Murano,
Venezia

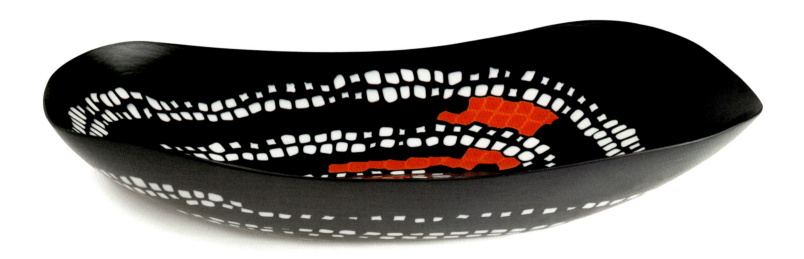

302
Carlo Scarpa
"Corroso" Vase
1936
Produced by Venini
Roberto Navarro

304
Carlo Scarpa
"Tessuto" Vase
1939
Produced by Venini
The Montreal Museum
of Fine Arts
Liliane and David
M. Stewart Collection

303
Carlo Scarpa
"Corroso" Vase
1936
Produced by Venini
Roberto Navarro

207

307
Xanti Schawinsky
Poster for the
Olivetti MP 1 Typewriter
1935
Private collection

172
Aldo Magnelli
Olivetti MP 1 Typewriter
1932
Produced by Olivetti
Lisa Licitra Ponti
collection

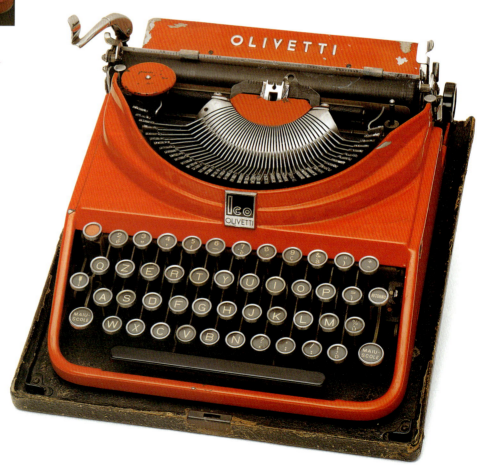

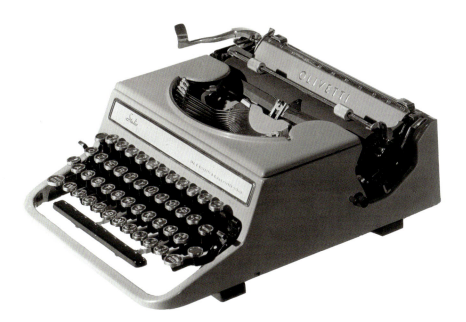

136
Luigi Figini
Gino Pollini
Xanti Schawinsky
Olivetti Studio 42
Typewriter
1935
Produced by Olivetti
Archivio Storico Olivetti,
Ivrea, Torino

55
Luigi Caccia Dominioni
Livio Castiglioni
Pier Giacomo Castiglioni
Five-valve Radio Receiver
1940
Produced by
Fimi-Phonola Radio
Museo Casa Mollino

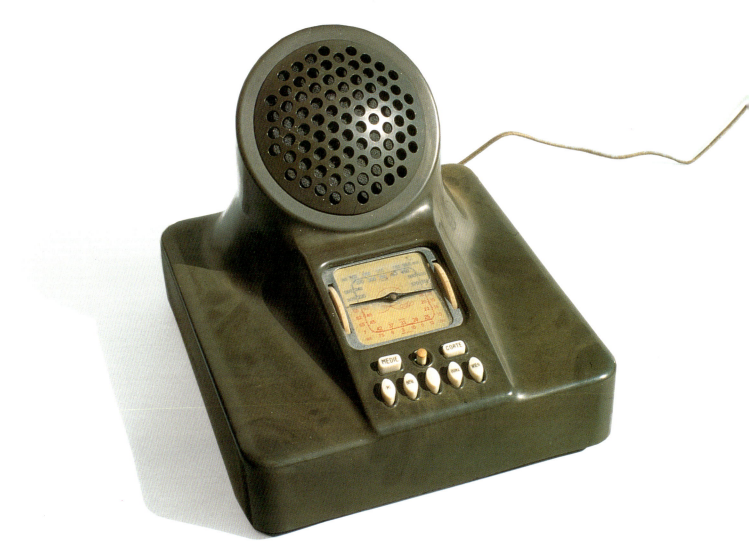

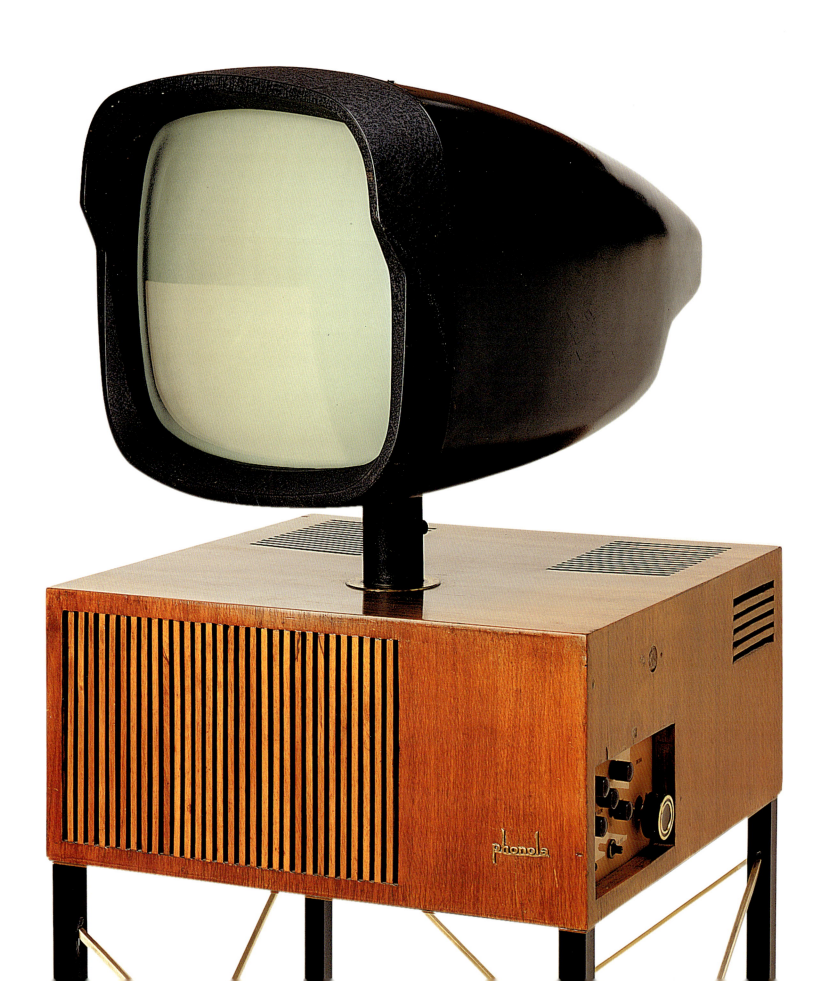

Reconstruction and the Economic Miracle

Gio Ponti
Upholstery designed
by Lucio Fontana
Dismountable Chair
(model 852)
1954
Produced by Cassina

With the end of World War II and the tragic conclusion of a dictatorship lasting over twenty years, the English word "design" entered the Italian lexicon. It referred to a perspective, a type of know-how that excited the new generations of planners and designers involved in the reconstruction of an industrious and free civil society. The first challenge was the rebuilding of the cities and their physical and conceptual "interiors." At the end of the conflict, the urban fabric and its architecture were left with dreadful gashes. Many buildings were gutted or completely destroyed. "Practicality" was imperative. Since there was virtually no furniture industry and much of the artisanal base had been destroyed, the only possible solution was rational planning (supported by the extensive work done in the 1930s). Above all a practical, flexible and adaptable plan was needed, but one that was also joyous, reassuring, some would say valuable, and in any case, well suited to an industrial model. This state of emergency was the scenario in which the Castiglioni brothers (Achille, Pier Giacomo and Livio), Marco Zanuso, Angelo Mangiarotti, Alberto Rosselli, Vico Magistretti, Ico and Luisa Parisi, Gino Sarfatti, Ettore Sottsass, Vittoriano Viganò and Osvaldo Borsani made their first moves, while the masters Gio Ponti, Franco Albini, Guglielmo Ulrich, Carlo Mollino, Ignazio Gardella, BBPR, Pietro Chiesa and Luigi Caccia Dominioni dusted off their tools and prepared for the work ahead.

Beyond the specific historical situation, the overall Italian scenario was very complex and characterized by the re-emergence of alarming shortcomings in the process of modernization. On the one hand, the Rationalist architecture of the 1930s, mainly in Milan, resumed its intense and multifaceted course with the contributions of a number of artistic groups. But on the other, the reactivated industrial culture, almost exclusively confined to northern Italy, exhibited an endemic and nearly general state of backwardness. Somewhere in the middle, a highly segmented workforce rooted in artisanal traditions was seeking its own space. It was rather evenly distributed throughout Italy and its contribution of ideas and creations had not yet been sufficiently explored.

These were the forces of design and production on which Italian industry, engaged in the exhausting process of recovery and modernization, could rely in the spirit of democratic renewal driving national reconstruction between 1946 and 1948. This brief period was marked by an intensely creative and highly participatory rapid growth that was suddenly thwarted by the new political conditions ushered in with the first free elections in 1948. For all the various forces involved in genuine efforts for social, cultural and industrial rebirth, this marked the end of the dream to instil immediately and fully a modern culture into Italy's organizational structure.

But the enthusiasm—we might even say the euphoria—that pervaded the country in this period was strong and well represented by a host of ornamental models and practical articles patented in those years. At this point in history, the thrust behind productive efforts was not consumption, but rather the search for a social utopia that could identify and satisfy its own needs from the bottom up. This positively charged atmosphere would unknowingly generate the premises for a process that would mark Italy's rebirth: the economic boom.

Two cases from 1946 to 1950 are emblematic of the different components in the industrial product planning and design process deriving from this new spirit and from the forces in the field cited above: the scooter, with the first Vespas and Lambrettas designed by the aeronautical engineers Corradino d'Ascanio and Cesare Pallavicino; and the Olivetti typewriters and calculators

190
Marino Marini
Cavaliere
1952
Robert and Alice Landau,
Montreal

designed by Marcello Nizzoli. The latter began as an artist in the spirit of early Futurism (1920s) and moved into product design under the influence of Rationalism (1930s) to become the prototype of the modern industrial designer.

The propulsive but also critical years of growth and organization of the nascent Italian design culture began after 1948. A new culture of planning, a new approach to design work, took form in those years within a narrow circle of "enlightened" architects, graphic designers, artists, intellectuals and industrialists. They were all keenly involved in this process of cultural renewal but had quite a struggle finding governmental institutions capable of recognizing the cultural and economic added value of their ideas.

Two different ways of expressing the physical and conceptual reconstruction of the country through art arose in Italy in those years: Arte Concreta and Neorealismo. However, there was also a geographical component to the distinction. Milan was the home of the Rationalist movement and for much of abstract art, and a particular relationship developed there between the planning process and the work of artists who were close to the northern European currents inspired by Bauhaus and the Concrete of the De Stijl group. Rome, liberated by the Americans in 1944, fostered a more humanized and communicative relationship between planning, art and society, one that was completely anti-rhetorical and neo-realist.

Much of Italian design work may be ascribed more or less directly to one of these two currents. In some cases there is an exercise in formal synthesis and purity inspired by the ethic of "minimum cost, maximum function, mass production," which constituted the credo of the Rationalist faith. In other cases there is special attention paid to popular forms, often decorated, certainly inspired by the grand tradition of Italian artisanship, but also emerging in the

design of the new means of transportation (scooters, mopeds, microcars), which were based on simple and expressive languages, precisely as in neorealist works. And among these works, the great Italian cinematic cycle (De Sica, Rossellini, Fellini, Visconti, Antonioni) remains one of the world's greatest artistic achievements of the period.

These years also witnessed the development and refinement of a number of exploratory paths in interior design. In addition to offering interesting interpretations of neorealist expression for the task of reconstruction, they also manifested a need to expand their own horizons by resuming their interrupted dialogue with the international scene (Charles Eames, Alvar Aalto) and with the historical roots of the Italian culture of housing. The reference points for these new perspectives were the American and especially the Scandinavian experiences on the one hand, and on the other the creation of an enlightened middle class, which represented the ideal model of a refined and advanced society honouring the precepts of its cultural and building traditions.

The housing issue became the locus of a sophisticated exploration of the planning and design process on more than one level. While interior design focused on the development of new housing types to better meet the urgent needs of postwar reconstruction, the same architects were also engaging in intense experimentation with new types of furniture and furnishings innovative enough to match the revolution in culture and customs that was shaking up Italy as it moved into the 1960s. But apart from a number of fundamental and clearly industrial projects, for a great many years a constant pattern in Italian furniture making was the production of individual pieces conceived for and "tested" in specific living spaces before being put into small- or medium-scale production.

36
Gianni Berengo Gardin
*Venezia, acqua alta
a San Marco*
1955–60
Centro Studi e Archivio
della Comunicazione,
Università degli Studi
di Parma

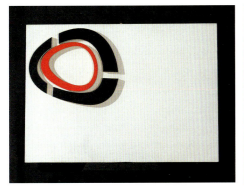

91
Ettore Colla
Triptych: *Assedio,*
Svolgimento, Rilievo
1951
Museo d'Arte Moderna e
Contemporanea di Trento
e Rovereto

The exhibition *Colori e forme nella casa d'oggi* [Colours and Forms in Today's Home] at the Villa Olmo in Como in 1957 marked a crucial turning point. Achille and Pier Giacomo Castiglioni participated in the show, "providing the furnishings for a sort of leftover space, an Italian storage-space-under-the-stairs dwelling, an inhabited closet, where modernity," commented A. Branzi, "is defined as freedom, the temporary and the accidental, a sort of ingenious bricolage of great elegance and nimbleness that is completely disorienting with respect to the rigour of European Rationalism, yet capable of rendering explicit that permanent state of uncertainty underlying Italian design ever since its inception within the Futurist avant-garde."[1] The Castiglioni brothers' project for Villa Olmo also highlighted the great experimental value of exhibition design, whether culturally or economically oriented. And almost all the creative minds of the period who were engaged in orchestrating the thrust toward modernization demonstrated a strong and original exploratory spirit with regards to exhibition design.

With economic recovery, what had previously been emergency planning in the early postwar years became a true industrial matter in which a host of planners and designers were the driving force behind a major renewal of models and forms of consumer items, especially for the home. Once Italian society, still fatigued from the reconstruction effort, began to regain its dignity and courage, other needs that had been momentarily set aside re-arose with urgency. New materials and new formal solutions contributed to the aesthetic pleasure of form and its representation. The upholstered furniture industry emerged in the early years of the 1950s with the technology-based sofas of Arflex, Tecno and RIMA; the industry of plastic household products was born with Kartell and the Smalterie Meridionali; and the electrical appliance industry took its first steps. The years of the Triennali design exhibitions (1951, 1954, 1957) marked the beginning of the recognition of the economic and social role of design. The first Compasso d'Oro was awarded in 1954, and the Associazione per il Disegno Industriale (ADI) was founded in 1956.

Along with the household products industry, the transportation sector also developed in response to the different levels—or perhaps we should say "classes"—of the market: mass market products (the Vespa and Lambretta scooters and all their interesting affiliations; the microcars, including the

Fiat 600 and the new Fiat 500 designed by Dante Giacosa, the Fiat Bianchina, and the BMW Isetta), limited production or customized products, and research prototypes exhibiting strong technological, typological or morphological innovation (especially the work of the great car designers such as Pininfarina, Bianchi Anderloni for Touring, Vignale, Bertone and Zagato).

In January 1954, television entered Italian homes, providing a decisive contribution to unification throughout the Italian peninsula in terms of styles of life, language and behaviour. Television triggered a bottomless and unprecedented need for communication. February 3, 1957 marked the first television broadcast of the program *Carosello*. Its unique formula, unlike anything else in the world, of offering entertainment with an advertising message, freed products from the fixity of the poster or printed page, and gave them voice, life and a great power of suggestion.

The beginnings of an advanced exploratory program in electronic technology saw Olivetti taking giant steps in 1959 when they introduced their first large computer conceived for a new market and as an alternative to the American monopoly. The Elea 9003 was designed by Ettore Sottsass, who brought innovative principles to the sector.

Toward the late 1950s, with Italy's entrance into the Common Market in 1957 and the start, in the opinion of many scholars, of the economic boom in 1958, we see the rise of a certain culture of images and the final fall, in much of the country, of the peasant culture, a shift that favoured the development of production, consumption, and the economy that underpinned the successes of the following decade.

In the early 1960s the culture of design, increasingly associated with a rise in goods production, acquired an unquestionably pre-eminent role within the broad arena of urban design to the point of coming into conflict with its natural sister disciplines: architecture and urban planning. The gradual migration of many architects in those years from architecture to design was certainly emblematic. Industrial planning, the emergence of an irrepressibly vital small- and medium-sized business community, and a basic sensitivity for interpreting transformations in lifestyle became constant characteristics of the new Italian way of designing household objects and accessories. New creative minds such as Joe Colombo, Enzo Mari, Mario Bellini, Afra and Tobia Scarpa, Rodolfo Bonetto,

Giulio Colombini
Carpet-beaters
(model KS 1476)
1960
Produced by Kartell

Carrozzeria Bertone
designed by Franco
Scaglione with Giorgetto
Giugiaro
Giulietta Sprint
1954
Produced by Alfa Romeo

Giotto Stoppino, Gino Colombini, Gino Valle, Anna Castelli Ferrieri, Gae Aulenti, Sergio Asti, Cini Boeri, Gianfranco Frattini, Gruppo 14, Giancarlo Piretti and Roberto Sambonet took their places alongside the ongoing work of the first and second generations, Ponti, Zanuso, Magistretti, Caccia Dominioni, BBPR, Sottsass, Mangiarotti and Morassutti, the Castiglioni brothers, Rosselli, Munari, Gardella and Albini. Urban design became, in a certain ideological reinterpretation, the central theme of an artistic current very close to the world of the design process: Arte Programmata (Bruno Munari, Enzo Mari) intertwined with Kinetic art (Gianni Colombo, Gruppo T), and Op art (Getulio Alviani, Franco Grignani). And in less direct ways it connected to some of the early experiments in environmental art in Fontana's Spazialismo, the "object-oriented" art of Castellani, and the provocative explorations into Dadaism and Conceptual art of Manzoni. But rampant industrial planning drew out another important response from the art world: the trend of Art Informel, which found original and intense interpretations

in Italy in the works of Vedova, in the material painting of Burri, the sign-art of Capogrossi, and in the Arte Nucleare of Baj and Joe Colombo. Of particular interest in this climate is the design-focused relationship between the brothers Joe and Gianni Colombo (the former one of the foremost designers, and the latter one of the pre-eminent artists of the period), who together would create the celebrated *Acrilica* lamp.

In the mid-1960s a subtle malaise began to take hold and seep into what was becoming the soft underbelly of the economic boom. Design also went through a troubled period, although one not lacking in stimuli, in which its role within the machine of consumption was put into question. While the young disciples of the Rationalist school triggered an interesting reaction to the dogmatism of the new International Style and gave rise to a brief but meaningful creative outburst known in Italy as Neo-Liberty (Gregotti, Aulenti, Asti, Portoghesi, Rossi, Gabetti and Isola, and Riva), on another level some designers closer to the art world dedicated themselves to an

increasingly minimalist and stark aesthetic.

In the climate of a revolution in customs, which swept over the entire world in the mid-1960s, unsparing criticism began to be directed at what was seen as the failure of the classic theory of design. In response, some groups of very young designers (Archizoom, Superstudio, Gruppo Strum, Gianni Pettena and Gaetano Pesce) launched utopian provocations under the title of Radical Design. In 1972 a major exhibition at the MoMA in New York, titled *Italy: The New Domestic Landscape*, sanctioned the international success of Italian design, also giving a place of honour to the emerging radical proposals.
Giampiero Bosoni

[1] Andrea Branzi, "Un paese senza casa, modelli sperimentali per lo spazio domestico," in Giampiero Bosoni (ed.), *La cultura dell'abitare, Il design in Italia 1945-2001* (Milan: Skira, 2002).

308
Ferdinando Scianna
Ciminna: Venerdì Santo
1962
Ferdinando Scianna
collection, Milan

179
Giacomo Manzù
La morte del partigiano
About 1958
The Montreal Museum
of Fine Arts

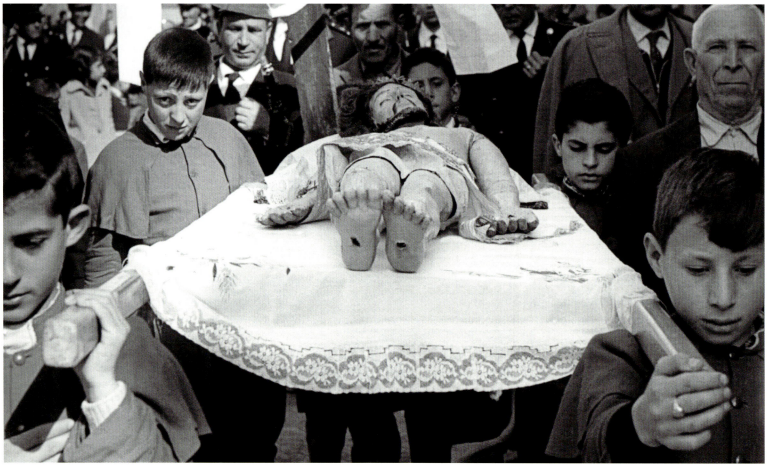

218

159
Renato Guttuso
Boogie-Woogie
1953
Museo d'Arte Moderna e
Contemporanea di Trento
e Rovereto

108
Mario De Biasi
Gli italiani si voltano
1953
Mario De Biasi collection,
Milan

222
Ugo Mulas
Bar Giamaica
1953–56
Archivio Ugo Mulas

107
Mario De Biasi
*Il sagrato del Duomo,
Milano*
1951
Mario De Biasi collection,
Milan

106
Corradino D'Ascanio
Vespa 125
1955
Produced by Piaggio
Scootart, Montreal

152
Dante Giacosa
Fiat *Nuova 500*
1957
Richard Petit collection

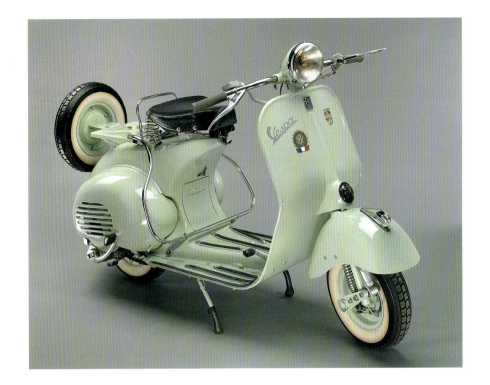

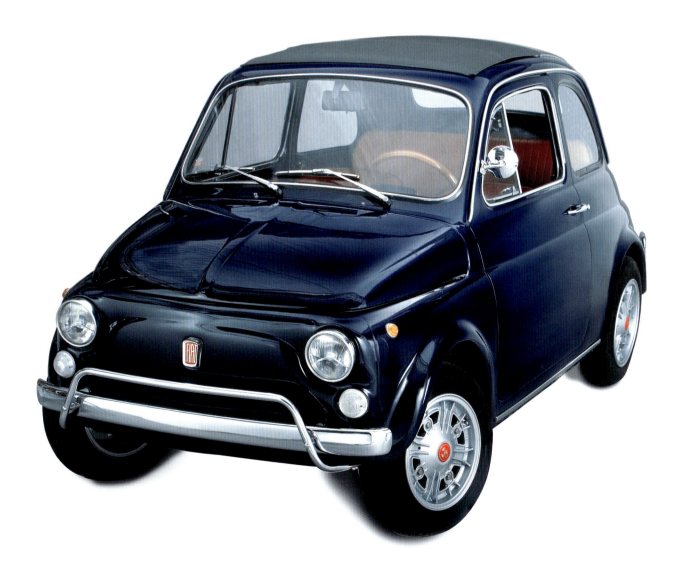

256
Giovanni Pintori
Poster for *Olivetti*
1949
Archivio Storico Olivetti,
Ivrea, Turin

238
Marcello Nizzoli
Giuseppe Beccio, Eng.
Lexikon 80 Typewriter
1948
Produced by Olivetti
The Montreal Museum
of Fine Arts
Liliane and David
M. Stewart Collection

239
Marcello Nizzoli
Giuseppe Beccio, Eng.
Lettera 22 Portable
Typewriter
1950
Produced by Olivetti
The Montreal Museum
of Fine Arts
Liliane and David
M. Stewart Collection

341
Gino Valle
with J. Meyer, M.
Provinciali and N. Valle
Cifra 5 Clock
1955
Produced by Solari
Alessandro Pedretti
collection, Milan

240
Marcello Nizzoli
Mirella Portable Sewing
Machine
1957
Produced by Necchi
Fondazione ADI per il
design italiano –
Collezione Compasso
d'Oro

226
Bruno Munari
Cubo Ashtrays
1957
Produced by Danese
Fondo Jacqueline Vodoz
e Bruno Danese

228
Bruno Munari
Maldive Bowls
1960
Produced by Danese
Fondo Jacqueline Vodoz
e Bruno Danese

225
Bruno Munari
Giallo-rosso
From the series
"Negativo-positivo"
1951
Banca Intesa collection

227
Bruno Munari
Scultura da viaggio
1958, 1994 edition, 3/8
Miroslava Hajek – Antonio
Zucconi collection, Italy

227

73
Achille Castiglioni
Pier Giacomo Castiglioni
Luminator Floor Lamp
1955
Produced by Gilardi
& Barzaghi (1955),
Arform (1957),
and Flos (1994)
The Montreal Museum
of Fine Arts
Liliane and David
M. Stewart Collection

Two words spring to mind
in relation to *Luminator*—
functionalism and
minimalism. With its body
made of a thin steel tube
set upright on a tripod of
steel rods, the lamp is
distinguished by its light
bulb fitted with a reflector
on top. Respecting the
individual characteristics
of each component, the
Castiglioni brothers
exploit the position of the
bulb to project the light
onto the ceiling.
D. C.

314
Ettore Sottsass
UFO Lamp
1957
Produced by Arredoluce
Galleria Colombari, Milan

37
Sergio Berizzi
Cesare Butté
Dario Montagni
Television Set with
Adjustable Screen
(model 17/18)
1956
Produced by Phonola
Private collection

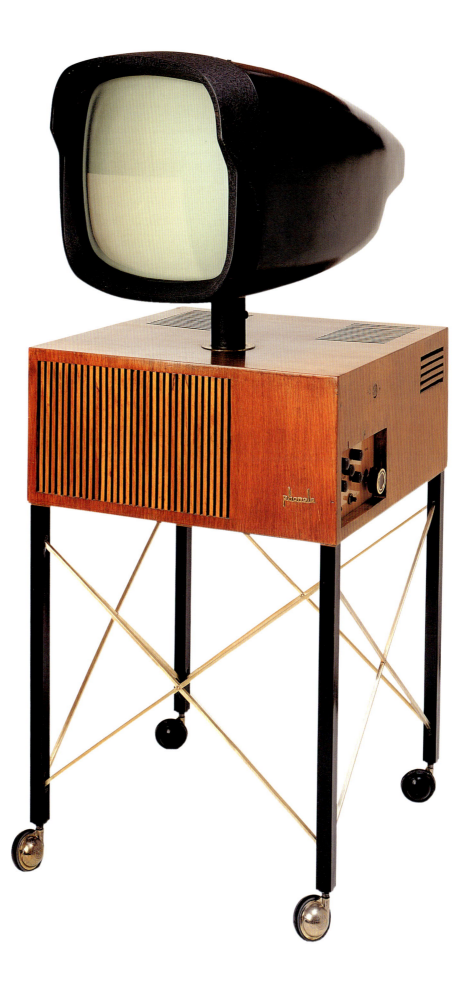

351
Marco Zanuso
Lady Armchair
1951
Produced by Arflex
The Metropolitan Museum
of Art, New York

Building upon the postwar experiments of the Pirelli rubber company in the use of foam rubber and elastic webbing for car upholstery, Marco Zanuso designed the *Lady* armchair, which introduced these industrial materials for the manufacture of household furniture. For easy production, the armrests, seat and back were each upholstered separately before they were assembled.

The elastic straps (Nastrocord) supporting the seat and back varied in width, and the firmness of the upholstery foam rubber also varied in density, according to the support needed to cushion a seated body. Produced by Arflex, the *Lady* chair was first introduced in 1951 at the IX Triennale in Milan, where Zanuso won a gold medal for this design.
R. P.

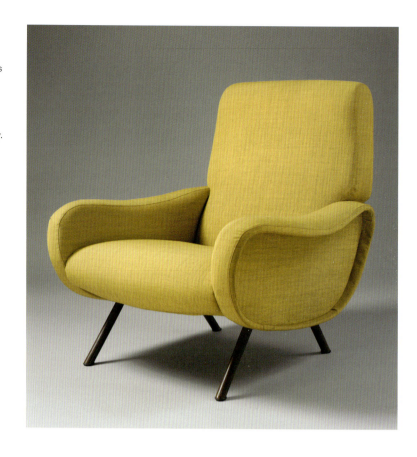

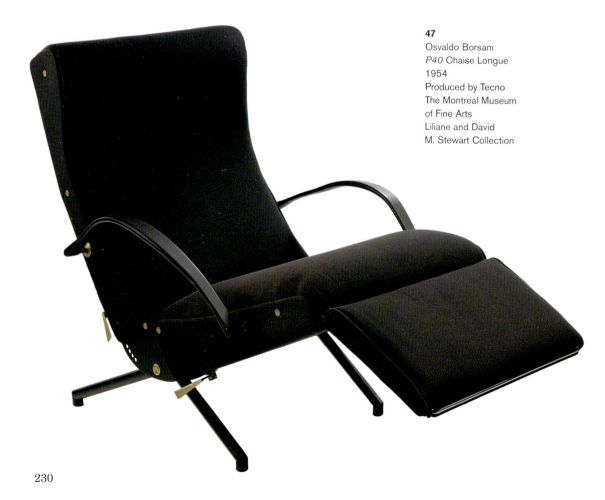

47
Osvaldo Borsani
P40 Chaise Longue
1954
Produced by Tecno
The Montreal Museum
of Fine Arts
Liliane and David
M. Stewart Collection

230

98
Sergio Conti
Luciano Grassi
Marisa Forlani
Armchair
1962
Produced by Emilio Paoli
The Montreal Museum
of Fine Arts
Liliane and David
M. Stewart Collection

5
Franco Albini
Gino Colombini
Margherita Armchair
1950
Produced by Vittorio
Bonacina
The Montreal Museum
of Fine Arts
Liliane and David
M. Stewart Collection

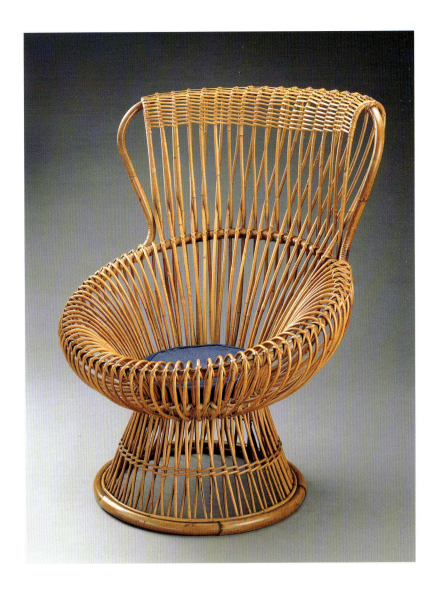

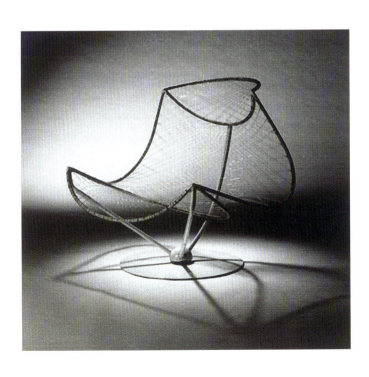

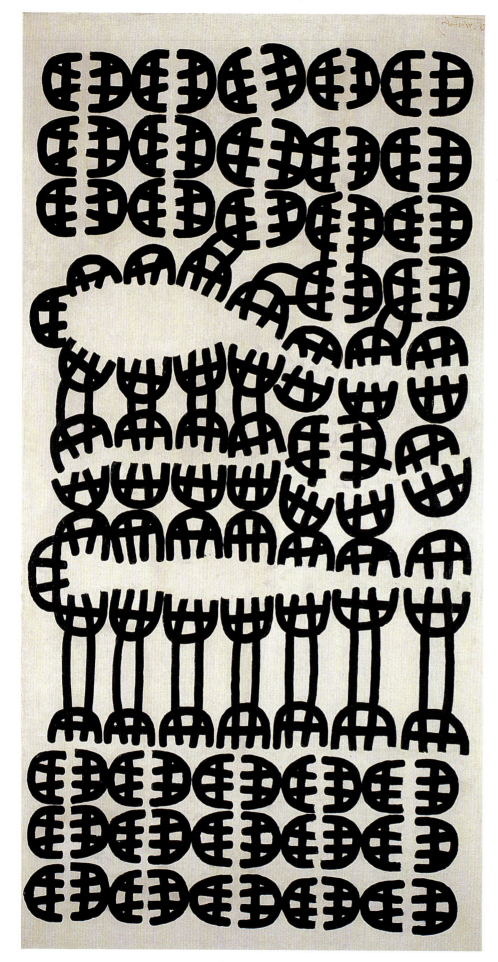

63
Giuseppe Capogrossi
Cartagine = Superficie 027
1956
Museo d'Arte Moderna
e Contemporanea
di Trento e Rovereto
Deposit of Collezione
Torinese

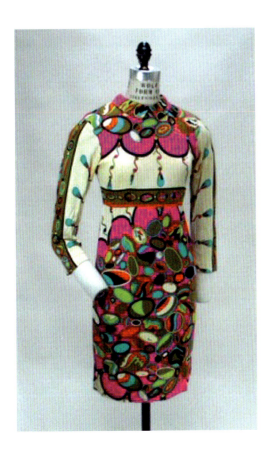

280
Emilio Pucci
Dress
1962
The Museum at the
Fashion Institute
of Technology

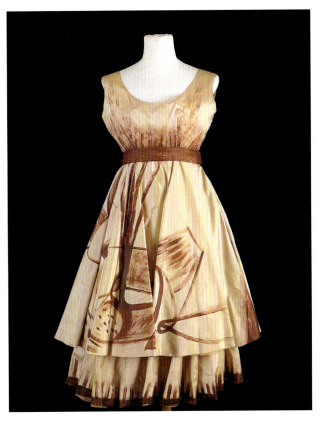

197
Germana Marucelli
Giuseppe Capogrossi
Dress
Early 1950s
Archivio Marucelli

279
Emilio Pucci
Playsuits
1957
The Museum at the
Fashion Institute
of Technology

An example of Italy's
postwar recovery was the
enormous success of
clothing designer Emilio
Pucci, who developed a
small local company into
a leading international
business of ready-to-wear
fashions that were
uniquely Italian. Pucci
made his reputation in the
1950s with elegant but
casual sportswear,
suitable for the modern,
active woman. He
became known for his

boldly coloured,
unconventional patterns
and for his unusual
fabrics such as
lightweight silk jersey,
which was easy to care
for. His informal designs
were greatly admired by
the jet-set society both in
Europe and in America.
These two playsuits were
formerly owned by
actress Lauren Bacall.
R. P.

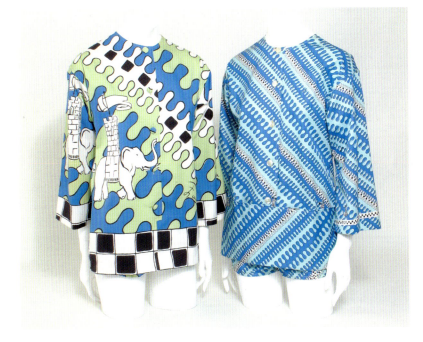

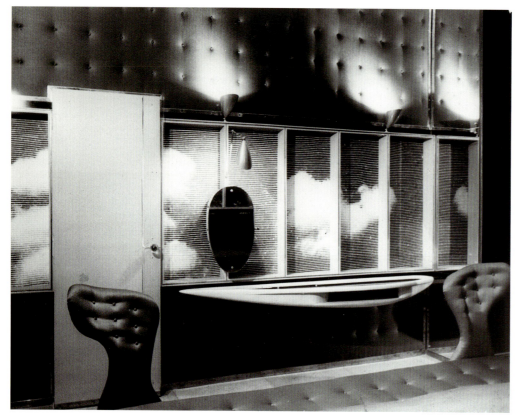

219
Carlo Mollino
View of the Bedroom of
Casa Rivetti, Turin
1949–50
Canadian Centre for
Architecture, Montreal

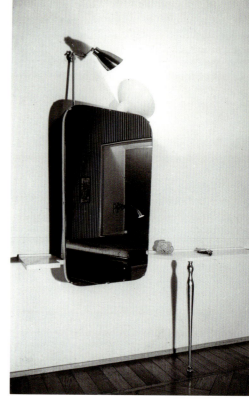

218
Carlo Mollino
View of the Bedroom of
Casa Minola, Turin, with
an Adjustable Mirror and
Lamp by C. Mollino
1944–46
Canadian Centre for
Architecture, Montreal

13
Luciano Baldessari
Model of the Breda
Pavilion, XXX World's
Fair, Milan (1952)
1952 (later reconstruction
by L. Baldessari)
Centro di Alti Studi sulle
Arte Visive, Comune
di Milano

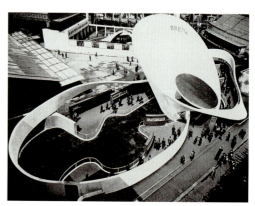

220
Carlo Mollino
Arabesco Table
1950
Produced by Apelli
e Varesio
The Montreal Museum
of Fine Arts
Liliane and David
M. Stewart Collection

Architect Carlo Mollino's organic designs for plywood furniture were among the most original and unconventional works to emerge right after World War II. Denying the rational functionalism of the Modern Movement's architects who, Mollino felt, left no room for fantasy, he created evocative, sculptural furniture like this table, with its undulating plywood support, its shaped glass shelves inspired by the female torso, and its brass bolts left visible as part of the design. A similar model of table was sent to the Brooklyn Museum in 1950 as part of Mollino's display in the promotional exhibition of Italian design, which travelled to twelve American museums.
R. P.

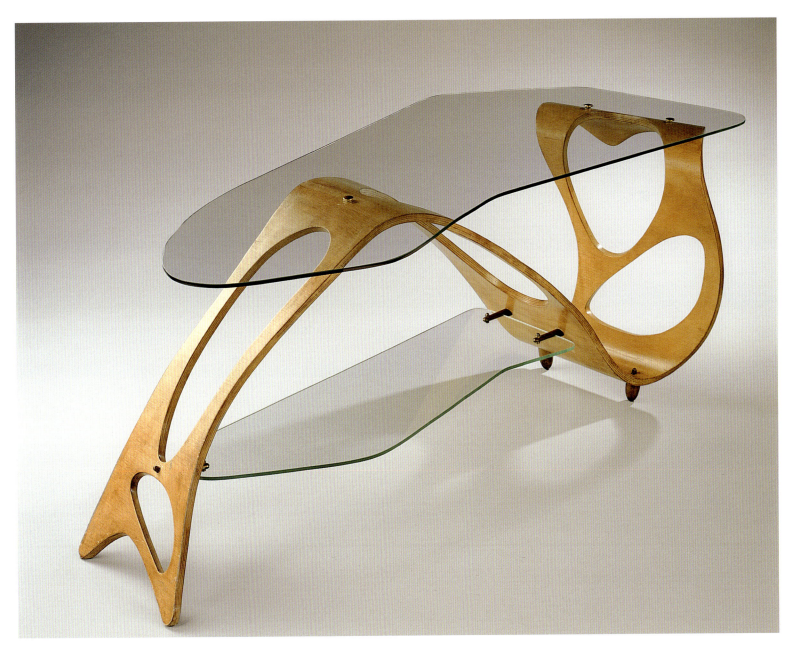

235

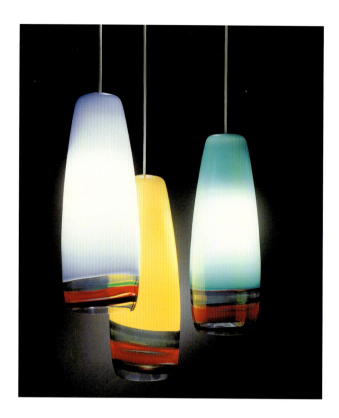

345
Massimo Vignelli
Suspensions
1953
Produced by Venini
The Montreal Museum
of Fine Arts
Liliane and David
M. Stewart Collection

342
Venini & C.
Hanging Lamp for the
Olivetti Showroom by
L. Belgiojoso, E. Peressutti
and E. N. Rogers, New York
1954
Produced by Venini
Roberto Navarro

Olivetti's New York
Showroom on Fifth
Avenue by the BBPR firm
1954

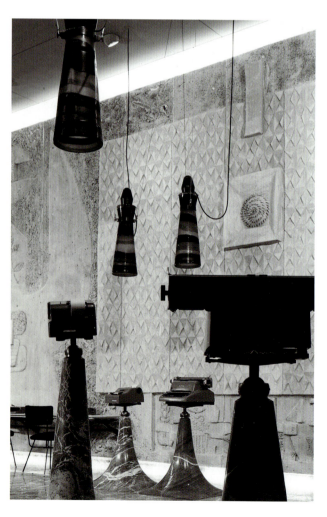

26
Ercole Barovier
"Tessere" Vase
1950s
Produced by Barovier
& Toso
Royal Ontario Museum,
Toronto

27
Ercole Barovier
"Tessere" Vase
1950s
Produced by Barovier
& Toso
Royal Ontario Museum,
Toronto

271
Gio Ponti
Fulvio Bianconi
Paolo Venini
"Canna" Decanter
1950s
Produced by Venini
Royal Ontario Museum,
Toronto

343
Paolo Venini
Fulvio Bianconi
Morandiane Bottle
About 1950–55
Produced by Venini
The Montreal Museum
of Fine Arts
Liliane and David
M. Stewart Collection

39
Fulvio Bianconi
Bottle
About 1950
Produced by Venini
The Montreal Museum
of Fine Arts
Liliane and David
M. Stewart Collection

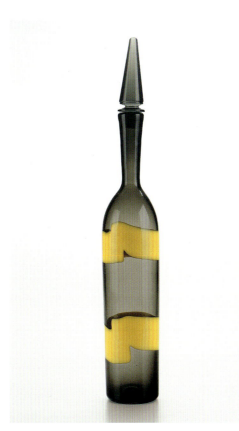

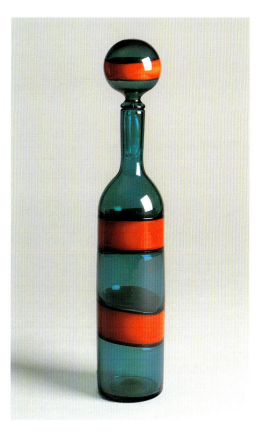

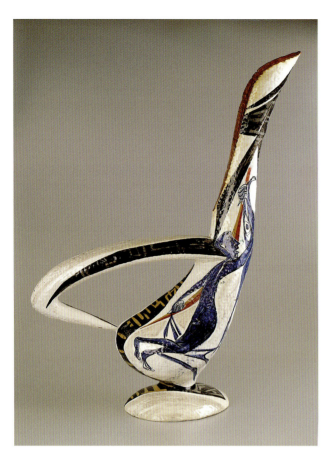

201
Salvatore Meli
Ewer
1956
The Montreal Museum
of Fine Arts
Liliane and David
M. Stewart Collection

266
Gio Ponti
Paolo De Poli
Table
1941
Private collection

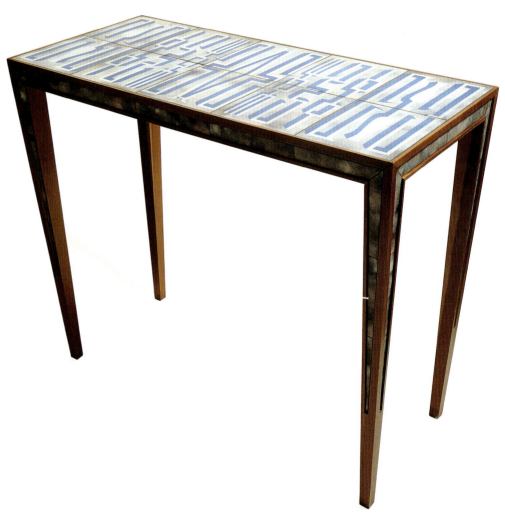

270
Gio Ponti
Piero Fornasetti
Architecture Secretary
1950
Produced by Piero
Fornasetti and
Immaginazione
The Montreal Museum
of Fine Arts
Liliane and David
M. Stewart Collection

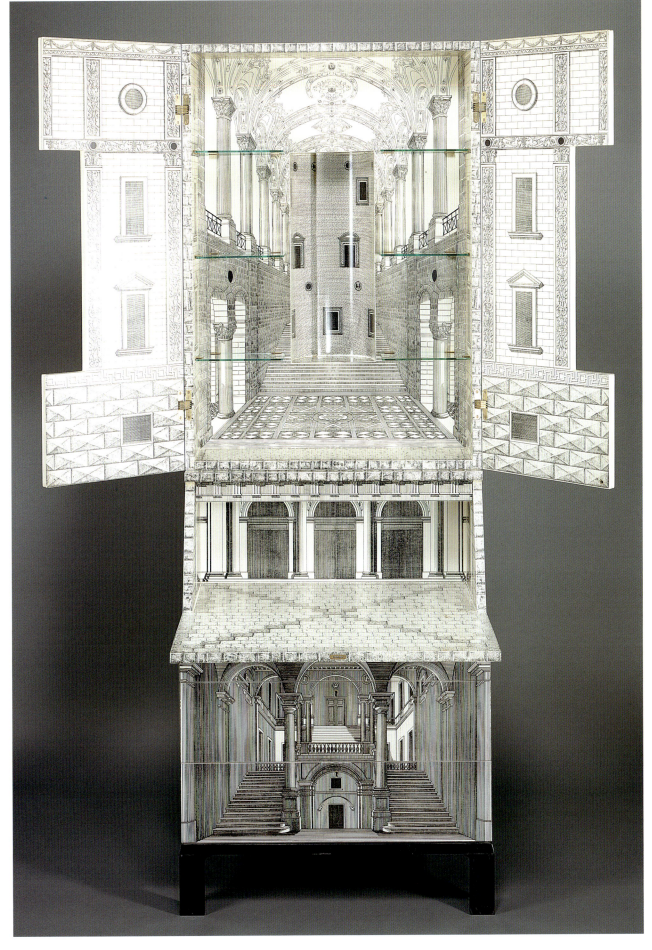

204
Fausto Melotti
Coppa blu
1954
Museo d'Arte Moderna e
Contemporanea di Trento
e Rovereto

205
Fausto Melotti
Sonno di Wotan
1958
Museo d'Arte Moderna e
Contemporanea di Trento
e Rovereto

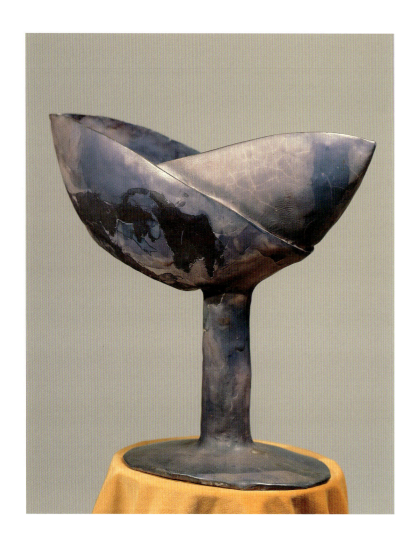

203
Fausto Melotti
Vase
About 1950
Galleria Christian Stein,
Milan; Archivio Melotti,
Milan

In the postwar period,
when the cost of materials
was high, many artists
turned to clay, a traditional
and easily available
material, and this brought
about a flourishing
renewal of the ceramic art
in the 1950s. The sculptor
Fausto Melotti was
awarded the Gran Premio
at the IX Triennale (1951)
in Milan for his thin-walled
vases like this one. The

form is pure, unadorned
geometry, but the vase
has not lost the imprint of
the manual working with
clay. The conical base
tapers up to a cup from
which rises another cone,
set slightly at an angle,
emphasizing the
handcrafted nature of the
vessel and the lack of
concern for its functional
aspect.
R. P.

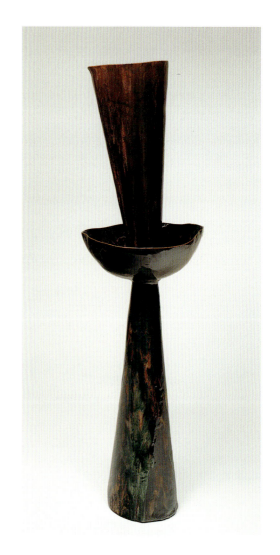

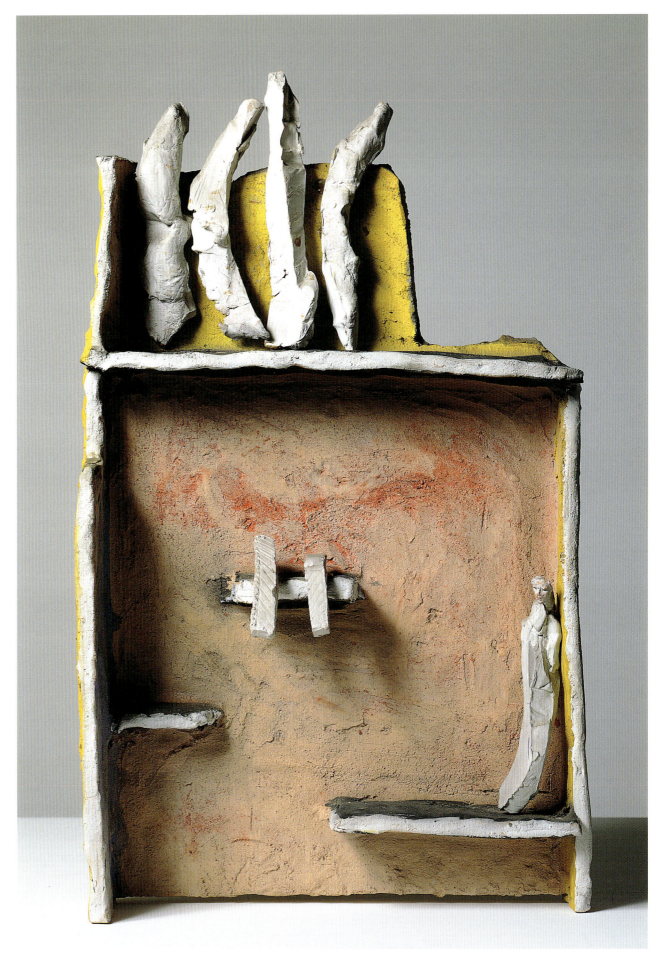

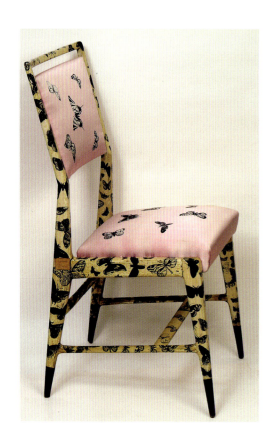

268
Gio Ponti
Piero Fornasetti
Farfalle Chair for the
Lucano Residence, Milan
1949
Produced by Fornasetti
Barnaba Fornasetti
collection

147, 148, 149
Piero Fornasetti
Plates
About 1950–about 1955
Produced by Piero
Fornasetti
The Montreal Museum
of Fine Arts
Liliane and David
M. Stewart Collection

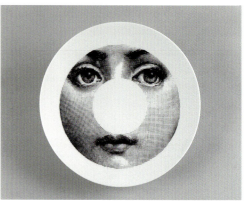

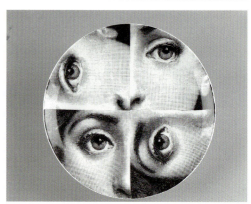

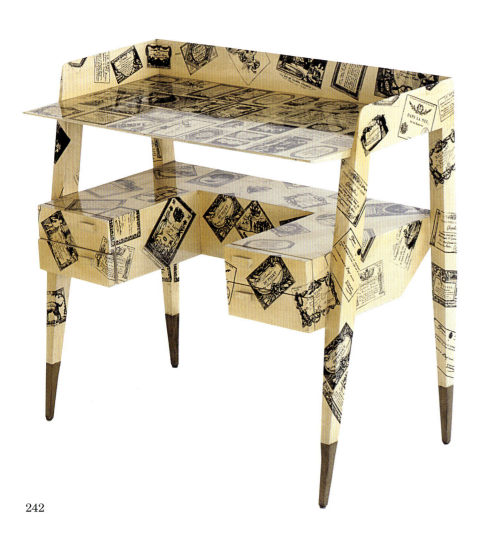

269
Gio Ponti
Piero Fornasetti
Biglietti da visita Desk
1950
Produced by Piero
Fornasetti
Barnaba Fornasetti
collection

267
Gio Ponti
Paolo De Poli
Il mercato Cabinet
1942
Giovanni and Evelina
De Poli collection, Padua

Gio Ponti's support of
Italian craft traditions is
evident in the furniture he
produced in collaboration
with artists like Paolo De
Poli and Piero Fornasetti.
Ponti designed the form
of this cabinet, which was
then decorated with
enamel tiles by De Poli, a
master in the technique of
enamelling on copper.
The architectural
presence of the cabinet

and its elegance of form,
emphasized by tall
tapered legs, were
characteristic of Ponti's
furniture of the period.
Like a small theatre set,
the doors of the cabinet
open to reveal a tableau
of shelves on which to
arrange small treasures.
Ponti delighted in surprise
elements and the playful
nature of niches and
peek-through openings.
De Poli's enamel
decoration on the face of
this piece of furniture,
entitled *Il mercato*,
depicts vibrantly coloured
display stands of street
merchants.
R. P.

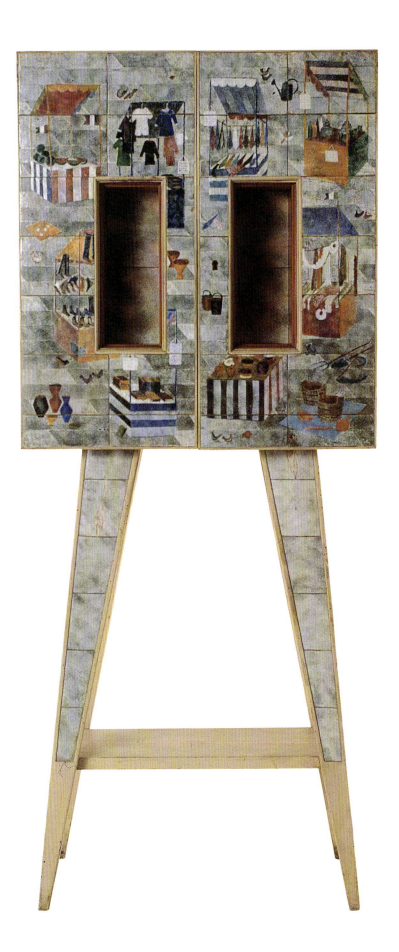

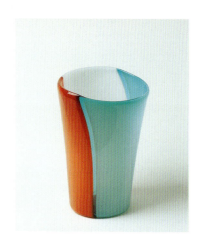

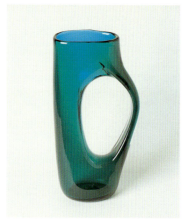

41
Fulvio Bianconi
Vase
1952
Produced by Venini
Roberto Navarro

40
Fulvio Bianconi
Moore Vase
1951–52
Produced by Venini
Roberto Navarro

272
Gio Ponti
Silverware
About 1951
Produced by Argenteria
Krupp
The Montreal Museum
of Fine Arts
Liliane and David
M. Stewart Collection

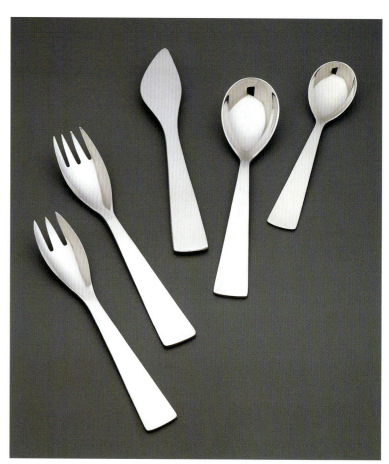

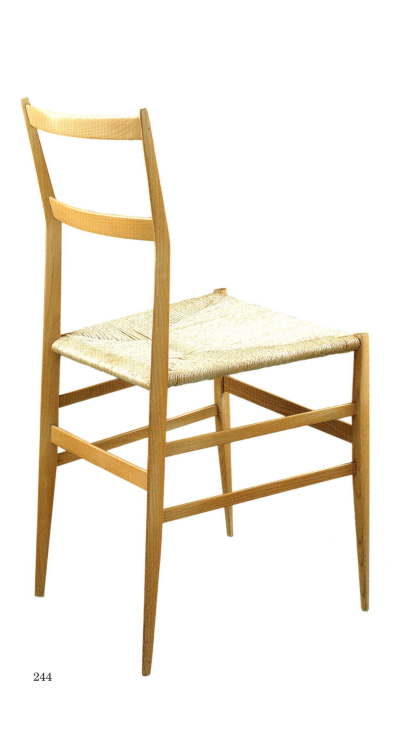

273
Gio Ponti
Superleggera Chair
1955
Produced by Cassina
The Montreal Museum
of Fine Arts
Liliane and David
M. Stewart Collection

139
Olga Finzi
Manhattan Stackable
Tea Service
1957
Produced by Finzi Arte
Olga Finzi Baldi collection

288
Lino Sabattini
Como Tea and Coffee
Service
1957
Produced by Christofle
The Montreal Museum
of Fine Arts
Liliane and David
M. Stewart Collection

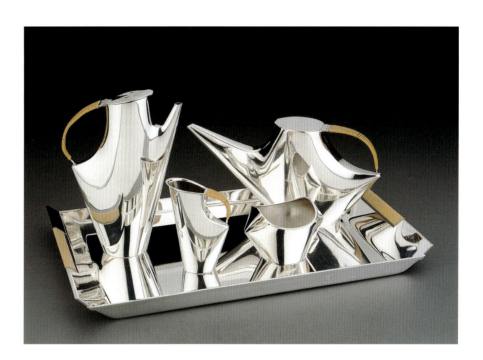

289
Roberto Sambonet
Fish Kettle/Serving Dish
1955
Produced by Sambonet
Centro Studi e Archivio
della Comunicazione,
Università degli Studi di
Parma

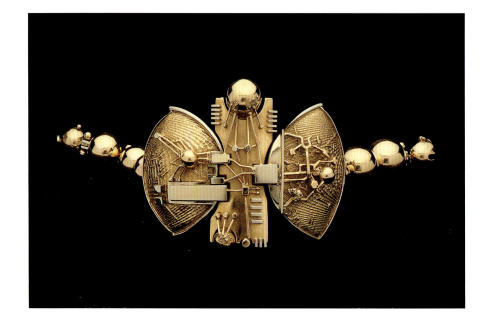

140
Olga Finzi Baldi
Continuità di Pensiero
Necklace
1972
Olga Finzi Baldi collection

92
Ettore Colla
Brooch
1964, based on a 1953
relief
Private collection

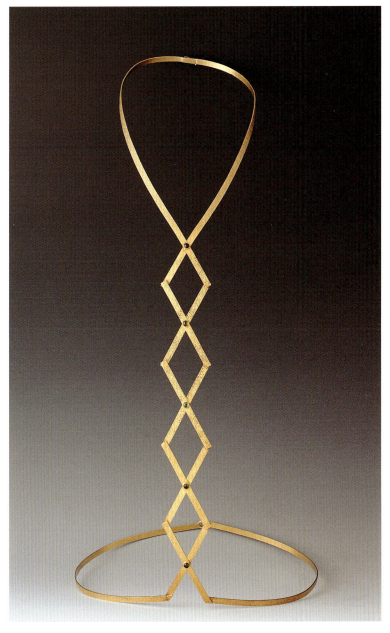

145
Lucio Fontana
Concetto spaziale.
La fine di Dio
1963
Fondazione Lucio
Fontana, Milan

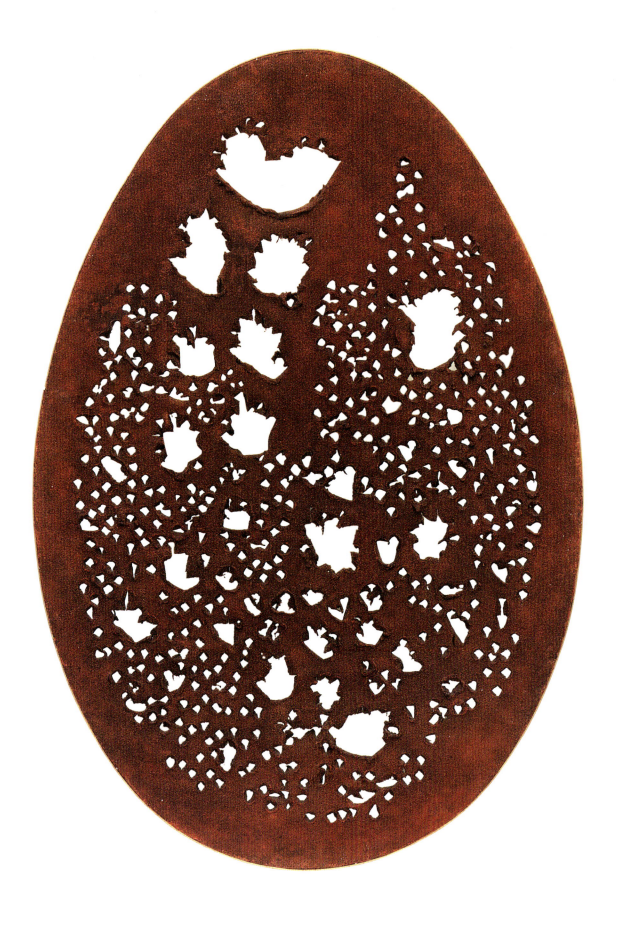

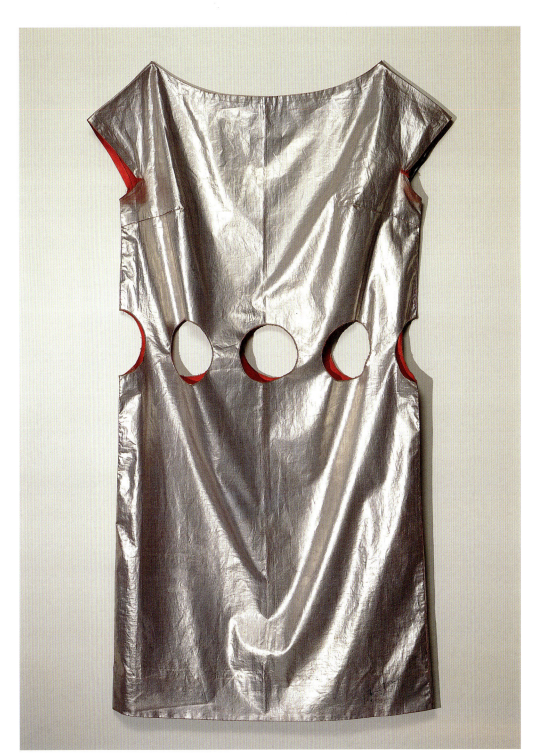

144
Bruna Bini
"Divertissement" for
a fashion show attended
by Lucio Fontana
Dress
1961
Produced by Bini-Telese
Gentucca Bini collection,
Milan

198
Germana Marucelli
Getulio Alviani
Armour Outfit
"Aluminum" Collection
1968–69
Archivio Marucelli

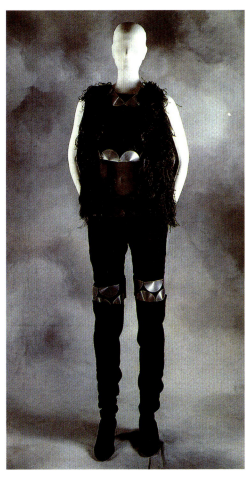

340
Giuseppe Uncini
Cementarmato del Bob
1960
Museo d'Arte Moderna e
Contemporanea di Trento
e Rovereto

294
Gino Sarfatti
Lamp (model 559)
1953
Produced by Arteluce
Flos SpA, Bovezzo,
Brescia

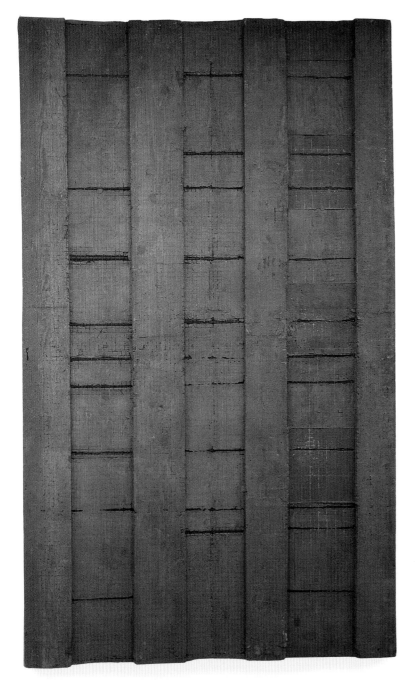

143
Lucio Fontana
Concetto spaziale.
Attese 1 + 1419
1959–60
The Montreal Museum
of Fine Arts
Loan, Société de la Place
des Arts de Montréal

142
Lucio Fontana
Concetto spaziale. Attese
1959
Museo d'Arte Moderna e
Contemporanea di Trento
e Rovereto

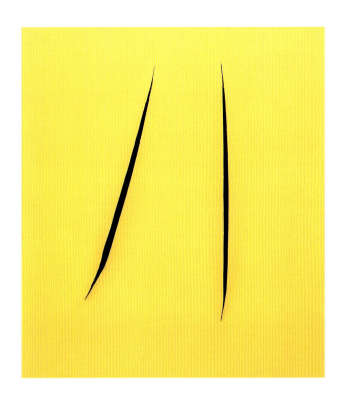

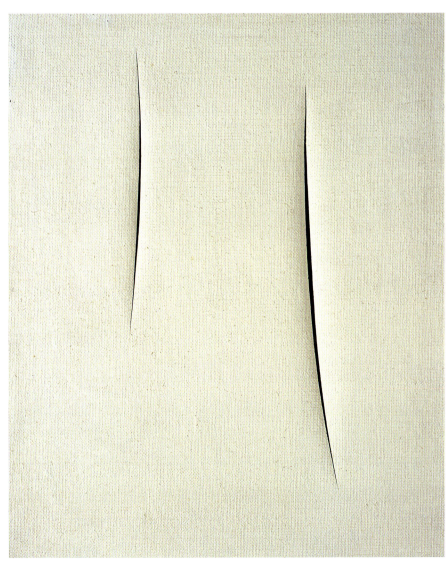

175
Piero Manzoni
Uovo scultura, No. 11
1960
Archivio Opera Piero
Manzoni, Milan

176
Piero Manzoni
Merda d'artista
1961
Archivio Opera Piero
Manzoni, Milan

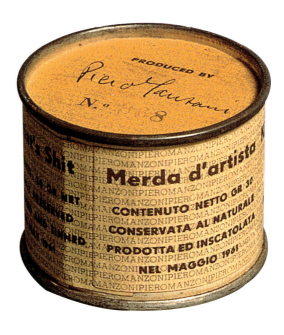

74
Achille Castiglioni
Pier Giacomo Castiglioni
Mezzadro Stool
1957
Produced by Zanotta
The Montreal Museum
of Fine Arts
Liliane and David
M. Stewart Collection

79
Achille Castiglioni
Pier Giacomo Castiglioni
Toio Floor Lamp
1962
Produced by Flos
The Metropolitan Museum
of Art, New York

253

Piero Manzoni
Achrome
About 1962
Archivio Opera Piero Manzoni,
Milan

94
Joe Colombo
Gianni Colombo
Acrilica Lamp
1962
Produced by O-Luce
The Montreal Museum
of Fine Arts
Liliane et David
M. Stewart Collection

Both a sculpture and
a functional object,
Acrilica is a product of
the combination of the
areas of knowledge
shared by the Colombo
brothers. On the one
hand, we recognize the

interest in three-
dimensional art and
understanding of forms
that placed Joe Colombo
in the avant-garde
of Italian design; on the
other, the lamp also
reflects the research
carried out by Gianni
Colombo into kinetic art.
Simple in form, the object
consists of a metal base
that conceals a
fluorescent tube and
is topped by a C-shaped
piece of transparent
acrylic from which
light radiates.
D. C.

93
Gianni Colombo
Strutturazione fluida
1960
Museo d'Arte Moderna e
Contemporanea di Trento
e Rovereto

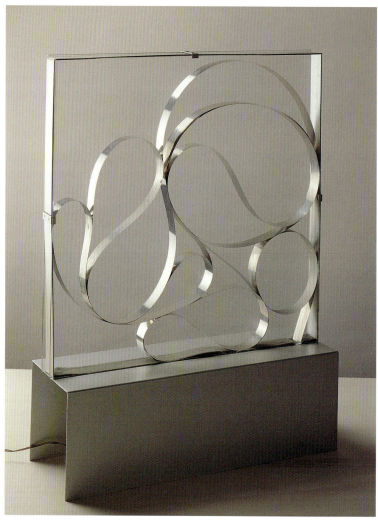

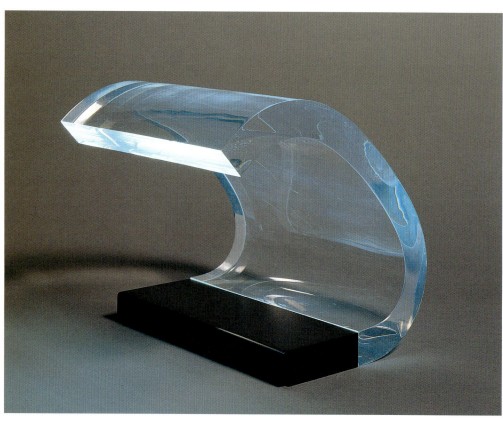

256

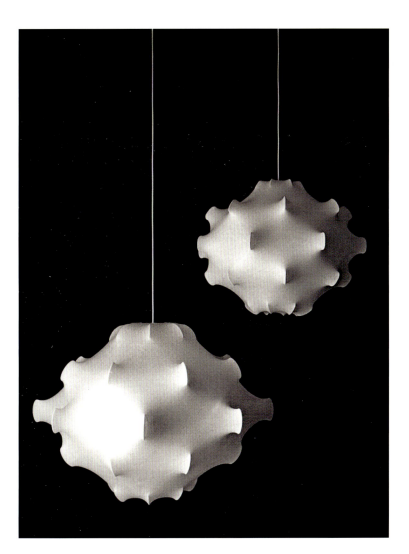

76
Achille Castiglioni
Pier Giacomo Castiglioni
Taraxacum Hanging Lamps
1960
Produced by Flos
Flos SpA, Bovezzo,
Brescia

72
Enrico Castellani
Superficie sagomata
1962
Private collection,
courtesy Galleria dello
Scudo, Verona

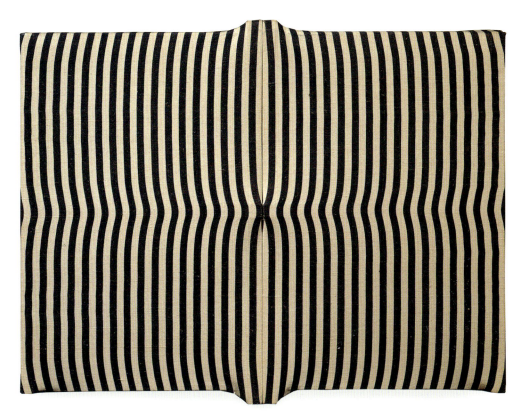

Enzo Mari
Struttura 1059
1964 (1970 piece)
Enzo Mari collection

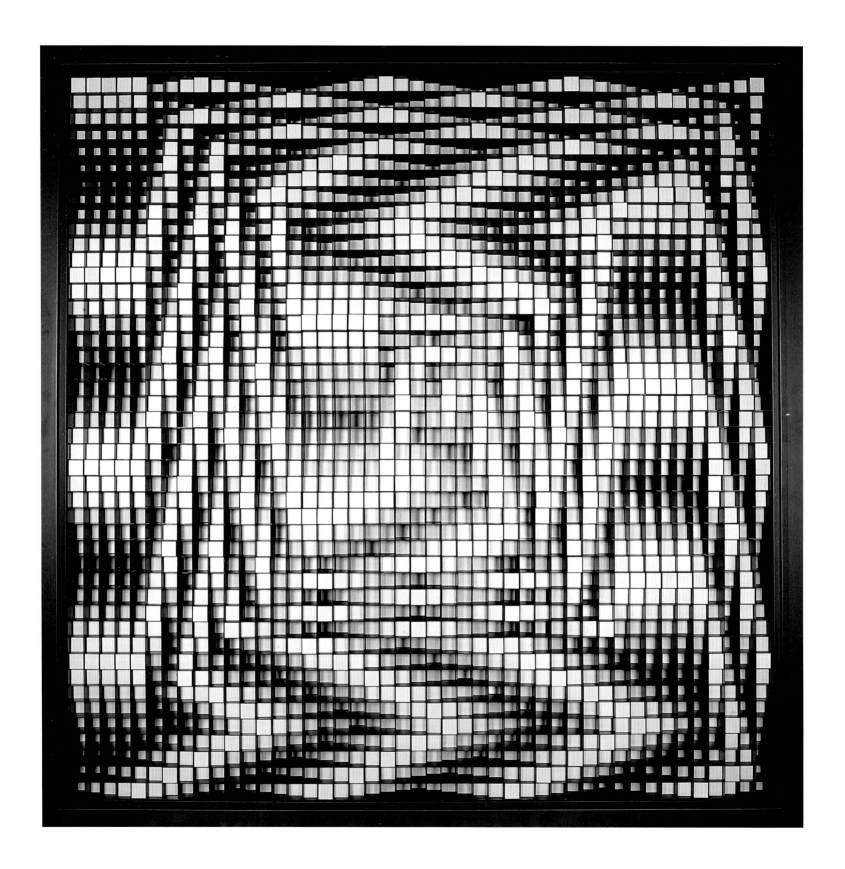

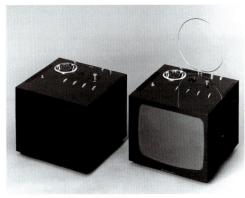

356
Marco Zanuso
Richard Sapper
Black ST 201
Television Set
1969
Produced by Brionvega
Andrea Rosetti collection

80
Achille Castiglioni
Pier Giacomo Castiglioni
RR 126
Radio-gramophone
Stereo System
1966
Produced by Brionvega
Centro Studi e Archivio
della Comunicazione,
Università degli Studi
di Parma

75
Achille Castiglioni
Pier Giacomo Castiglioni
Sanluca Armchair
1959
Produced by Gavina
(1960), Knoll International
(1969), Bernini (1990)
and Poltrona Frau (2005)
Pierre Bouvrette, Montreal

6
Franco Albini
Franca Helg
PL 19 Armchair
1957
Produced by Poggi
Studio Albini Associati,
Milan
Archivio del Moderno,
Mendrisio

78
Achille Castiglioni
Pier Giacomo Castiglioni
Taccia Lamp
1962
Produced by Flos
The Montreal Museum
of Fine Arts

77
Achille Castiglioni
Pier Giacomo Castiglioni
Arco Floor Lamp
1962
Produced by Flos
The Montreal Museum
of Fine Arts
Liliane and David
M. Stewart Collection

Postmodern
Testing Ground

335
Armando Testa
Poster for the Vermouth
Punt e Mes
1960
Centro Studi e Archivio
della Comunicazione,
Università degli Studi
di Parma

287
Mimmo Rotella
Marilyn
1963
Private collection

The household objects put forward by members of the new generation of designers in the 1970s (the Jonathan de Pas–Donato d'Urbino–Paolo Lomazzi group, Gaetano Pesce, Paolo Deganello, Massimo Morozzi, Michele De Lucchi, Gruppo Strum, Alessandro Mendini and Studio Alchimia, over which hovered the spirit of the older and charismatic Ettore Sottsass) were almost unrecognizable with respect to their traditional use. In a manner of speaking, many of these items were turned into something else: a game, a sculpture, a vehicle for messages, provocation, in short the destruction and monumentalization of the object and of the very idea of the home. In this way a new, informal way of living took shape. Artistic investigations in Italy were influenced on the one hand by some elements of international pop culture (on very different planes, in the work of Piero Gilardi, Mimmo Rotella, Gino Marotta, Michelangelo Pistoletto, Alighiero Boetti and Mario Ceroli). On the other a distinctive Italian artistic vein known as Arte Povera (Luciano Fabro, Giulio Paolini, Mario Merz and Jannis Kounellis) stood out for its originality and character. Material, essence, symbols and concepts were the ingredients of this vein, which focused on the physical and cultural wreckage left by consumer society.

The furniture industry kept a watchful eye on the changes that were taking place, paradoxically operating under the same system of cause and effect of the model of consumption that had re-created the myth of the middle-class home in the previous decade. In the darkest time of the terrorist period known as the *anni di piombo*, in the late 1970s, the informal driving force of Radical Design weakened and was transformed into the more elegant concept of the "casual." On the other hand the idea of an aseptic and efficient "high-tech" took hold of the rational

aspects of design, pushing it towards a hedonism of the mechanical and simple form that offered the prospect of a lucid and transparent future. Faced with the contraction brought by a phase of economic and political austerity, design too went for a sort of historic compromise, sanctioned by the revival of the Compasso d'Oro in 1979 after a break of about a decade.

In the early 1980s a wind of economic recovery arose under the banner of political and cultural restoration, bringing a certain idea of industrial design back to the fore. A breach in this model was made (once again under the protective wing of the guru, Ettore Sottsass) by the groundbreaking Memphis collection, presented in 1981. This phenomenon of objects with asymmetrical, disjointed and totemic forms, in vivid and decorative colours, was also associated with the shockwave of a new aesthetics called the Postmodern, which had been consecrated in 1980 at the Architecture Biennale organized by Paolo Portoghesi. These two impulses in the field of design and architecture were linked with the artistic phenomenon known as the Transavanguardia (Enzo Cucchi, Mimmo Paladino, Nicola De Maria, Francesco Clemente and Sandro Chia), champion of a new figurative expressionism that appeared on the scene in perfect synchronicity with Memphis and the Biennale that introduced the wave of so-called Postmodernism.

As far as the design of objects was concerned, the 1980s and early 1990s were marked, on the one hand, by the dominance of a certain formalism connected with the more decorative conception of the varied poetics of Postmodernism, often associated with an idea of "creative" revival of the stylistic models of the past. On the other, however, they showed another, vaguely neo-Modern face, in many ways also eclectic,

Gianni Pettena
Wearable Chairs
1971

well represented by the emergence of the phenomenon of fashion in all its most evanescent aspects. In both cases, in market terms, a new industriousness was at work, occupying an area somewhere between the flexibility of the crafts and industrial production. The concept of prêt-à-porter, one of the keys to the success of Italian fashion, was rooted in a process that had already been set in motion in the world of Italian furniture design, and that grew increasingly sophisticated in the recesses of a market with myriad facets that was now beginning to reflect the emergence of globalism in culture, manufacturing and commerce.

The closing years of the last millennium constituted a period of transition characterized by forms that were tight and compact, as though seeking an emotional dimension of the symbolic value of the individual object. Hybrid languages combined in a natural blend of different ways of being according to chance and necessity. No longer was there the dualism that to varying degrees had accompanied the encounter-collision between ancient and modern, classical and innovative, institutional and revolutionary, model and counter-model, for almost the whole of the century. In art, as well as design, reference models proliferated and were often crossbred.

Different trends coexisted freely without apparent conflict in a "democratic eclecticism," a condition in which more than ever before it was the individual artist (Maurizio Cattelan, Vanessa Beecroft, Luigi Ontani) or designer (Michele De Lucchi, Antonio Citterio, Denis Santachiara, Fabio Novembre, Matteo Thun, Jacopo Foggini, Andrea Anastasio, Marco Ferreri, Giovanni Levanti, among others) who became the only and original bearer of poetics. Many foreign designers (Philippe Starck, Marc Newson, Ross Lovegrove, Jean Nouvel, Tom Dixon, the Campana

brothers, Karim Raschid, Ron Arad, and others) have contributed to this recent phase in Italian design, finding in this cultural and industrial testing ground (manufacturers assumed an important role as a repository of culture during this period) a great opportunity to give tangible expression to their own investigations.

In the case of design in particular, there was an exploration of familiar forms and expressions, as has happened in all times of transition, when, in expectation of an epoch-making transformation, people either practise the ritual of rebirth of form (polished and natural like a pebble in the sea, or pure and abstract like a rock crystal), or hark back, following the already familiar script of eclecticism and historicism, to the "styles" of a recent as well as distant past: multiform signs as suspended and reflective emotions in a precarious equilibrium. An eclectic and heterodox production (and in the view of some, one that has also been paradoxically ironed into a uniformity of the "different at any cost"), which nevertheless presented a fully developed dimension grounded in the awareness of its being at the centre of the merchandising system. In a more constructive and ideal projection, however, it can be recognized that the DNA of Italian design has survived in a sort of increasingly sophisticated and advanced experimental testing ground (in tune with what is now described as the third Industrial Revolution), capable of keeping in step with a new commercial globalism, and above all with changes in customs and ways of living: changes that are naturally seen and interpreted through that distinctive and still recognizable Italian way of giving form and meaning to the use of things.
Giampiero Bosoni

315
Ettore Sottsass
Vase
1957
Produced by Cav.
G. Bitossi & Figli
The Montreal Museum
of Fine Arts
Liliane and David
M. Stewart Collection

316
Ettore Sottsass
Vase
1957
Produced by Cav.
G. Bitossi & Figli
The Montreal Museum
of Fine Arts
Liliane and David
M. Stewart Collection

317
Ettore Sottsass
Vase
1958
Produced by Bucci
for Il Sestante
The Montreal Museum
of Fine Arts
Liliane and David
M. Stewart Collection

318
Ettore Sottsass
Plate
1958–59
Produced by Bucci
for Il Sestante
The Montreal Museum
of Fine Arts
Liliane and David
M. Stewart Collection

319
Ettore Sottsass
Vase
1959
Produced by Cav.
G. Bitossi & Figli
The Montreal Museum
of Fine Arts
Liliane and David
M. Stewart Collection

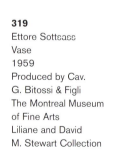

320
Ettore Sottsass
Cabinet
1964
Produced by Renzo
Brugola
The Montreal Museum
of Fine Arts
Liliane and David
M. Stewart Collection

Despite the Rationalist
training he received
at the Turin Politecnico,
Sottsass prefers a
spontaneous creativity.
He takes his inspiration
from sculpture and
painting, in particular from
certain forms of abstract
art such as Mondrian's
geometry and Jean Arp's
biomorphism, as well as
American Abstract
Expressionism and Pop
art. His objets are freed
from functionalist rigidity
while questioning their
relationship with the user.
This cabinet is one of his
more fanciful, with its
enormous proportions
and anthropomorphic
appearance. The mixture
of colours, patterns and
forms is another
characteristic of his
design.
D. C.

186
Enzo Mari
Proposal for "Self-design"
Furniture
1973
Variable dimensions
Produced by Simon
International and Cassina
Triennale di Milano

180
Enzo Mari
Ashtray
From the series "Putrella"
1958
Produced by Danese
The Montreal Museum
of Fine Arts
Liliane and David
M. Stewart Collection

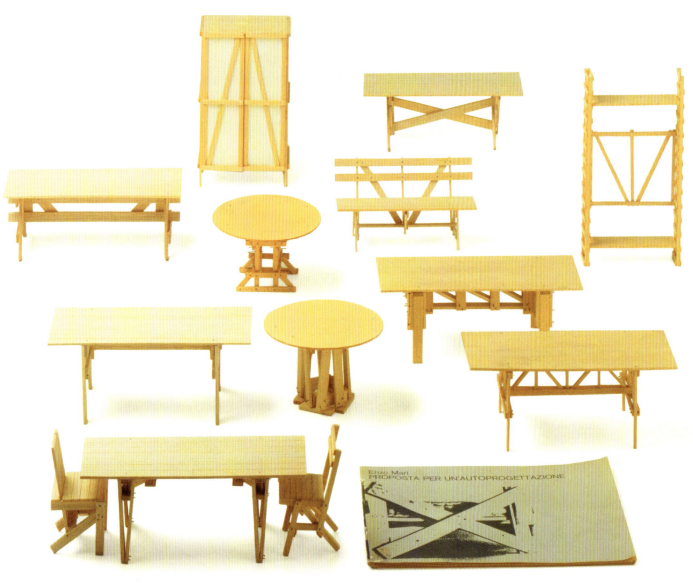

Ettore Sottsass
Wardrobe
1966
Produced by Renzo
Brugola
The Montreal Museum
of Fine Arts
Liliane and David
M. Stewart Collection

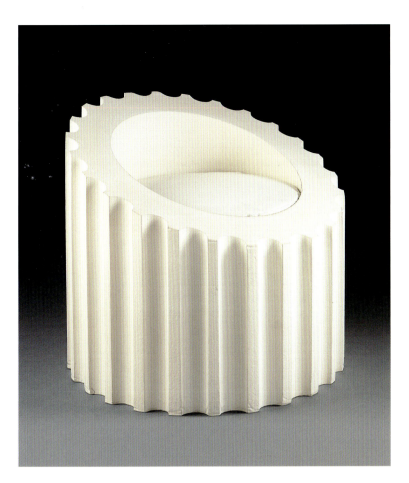

330
Studio 65
Attica Chair
1972
Produced by Gufram
The Montreal Museum
of Fine Arts
Liliane and David
M. Stewart Collection

158
Gruppo Strum
Pratone Seating
1966, 50/200
Produced by Gufram
The Montreal Museum
of Fine Arts

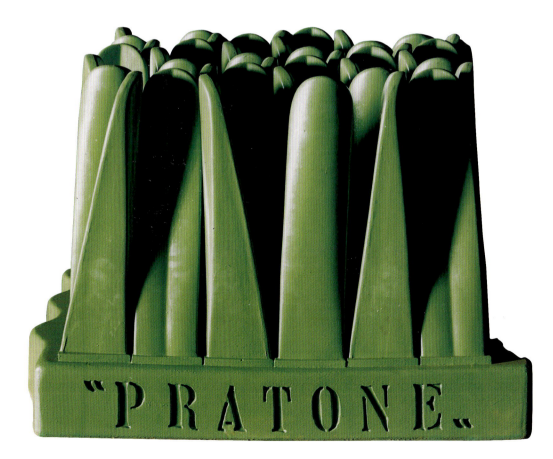

8
Archizoom Associati
Safari Sectional Couch
1967–68
Produced by Poltronova
The Montreal Museum
of Fine Arts
Liliane and David
M. Stewart Collection

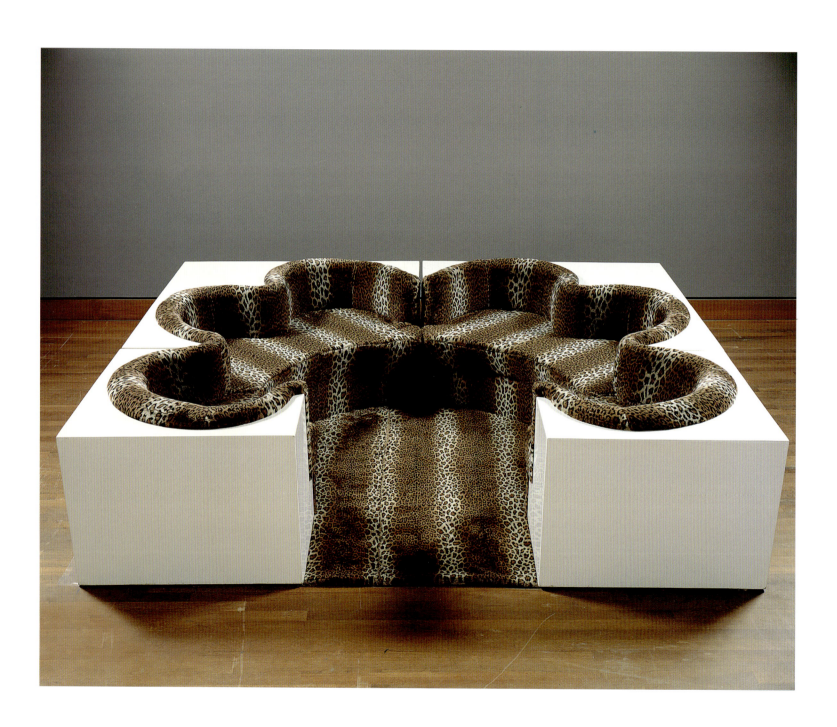

191
Gino Marotta
*Albero rinascimentale
artificiale*
1966
Private collection

28
Dario Bartolini
Archizoom Associati
Sanremo Floor Lamp
1967
Produced by Poltronova
for Archizoom Associati
The Montreal Museum
of Fine Arts
Liliane and David
M. Stewart Collection

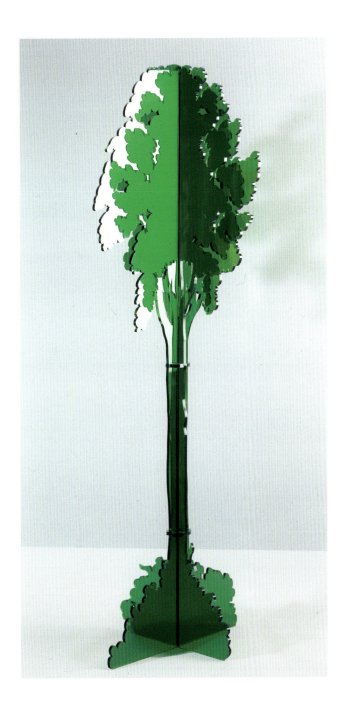

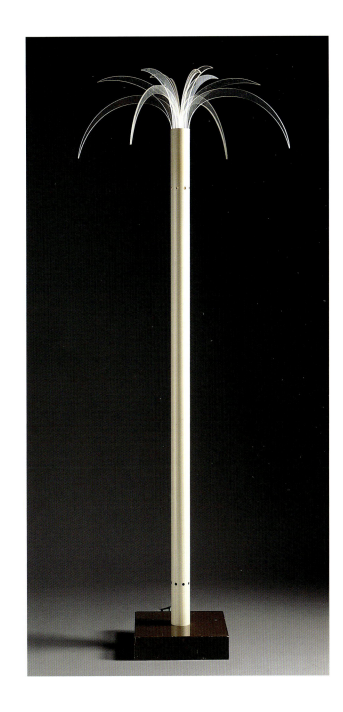

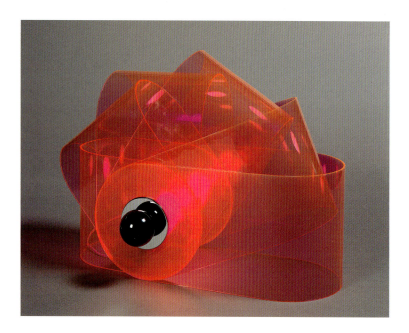

331
Superstudio
Gherpe Lamp
1967
Produced by Poltronova
The Montreal Museum
of Fine Arts
Liliane and David
M. Stewart Collection

156
Gruppo Architetti
Urbanisti Città Nuova
Nesso Lamp
1962
Produced by Artemide
The Montreal Museum
of Fine Arts
Liliane and David
M. Stewart Collection

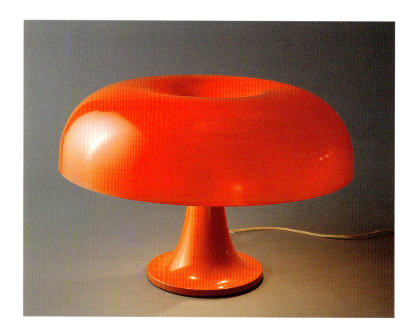

82
Livio Castiglioni
Gianfranco Frattini
Boalum Lamp
1969
Produced by Artemide
The Montreal Museum
of Fine Arts
Liliane and David
M. Stewart Collection

137
Gianfranco Fini
Quanta Lamp
About 1970
Produced by New Lamp
The Montreal Museum
of Fine Arts
Liliane and David
M. Stewart Collection

The *Quanta* lamp is one of those objects designed by Fini that defy any attempt at categorization. Its steel casing and rods of frosted methacrylate produce an impression of light rather than that of a suitable source of illumination. Its sculptural form is reminiscent of the "lumino-dynamic" Kinetic artworks of the early 1960s: interactive works combining light and movement that revolutionized wall space. *Quanta* sets out to create a kind of optical illusion. The observer animates the light by his or her movement in the space.
D. C.

324

Ettore Sottsass
T. Taiteshi
Giant Works. Panoramic Road to See the Irrawaddy River and the Jungle along its Banks
From the series
"The Planet as Festival"
n. d. [1972]
Centro Studi e Archivio della Comunicazione, Università degli Studi di Parma

This panoramic road with a view of the Irrawaddy River and its banks belongs to a series of lithographs made by Sottsass in the early 1970s. Responding to the growing pessimism of the time, Sottsass turned from the creation of objects to critical reflection on the role of design in contemporary culture. The motifs of his utopian visions of the environment of the future are steeped in both American popular culture and the mysticism of Eastern religions. *The Planet as Festival* celebrates an ideal society in which people are free to live without constraints and to enjoy their leisure in an exotic setting.
D. C.

323

Ettore Sottsass
Ambiente sperimentale
For the exhibition *Italy: The New Domestic Landscape*, the Museum of Modern Art, New York (1972)
n. d. [1972]
Centro Studi e Archivio della Comunicazione, Università degli Studi di Parma

278

115
Jonathan De Pas
Donato D'Urbino
Paolo Lomazzi
Carla Scolari
Blow Armchair
1967
Produced by Zanotta
The Montreal Museum
of Fine Arts
Liliane and David
M. Stewart Collection

95
Joe Colombo
Tube Chair
1969–70
Produced by Flexform
The Metropolitan Museum
of Art, New York

Mastering new technologies and innovative materials, especially plastic, Colombo created a series of products for the "environment of the future." His multiple interests reflected the lifestyle of the late 1960s, at a time when the demand for mobility and flexibility prevailed. Among other things, he revolutionized seating with his *Tube* chair made up of four upholstered semi-rigid cylinders that could be put together in any shape the user desired. He was fascinated by the problem of storage and produced several different storage units. One was the *Boby* caddy made in ABS plastic (cat. 96) with revolving drawers, a model that is still in production today.
D. C.

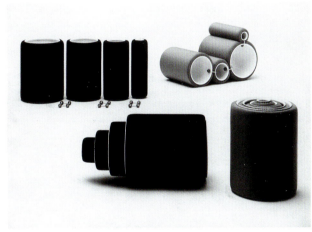

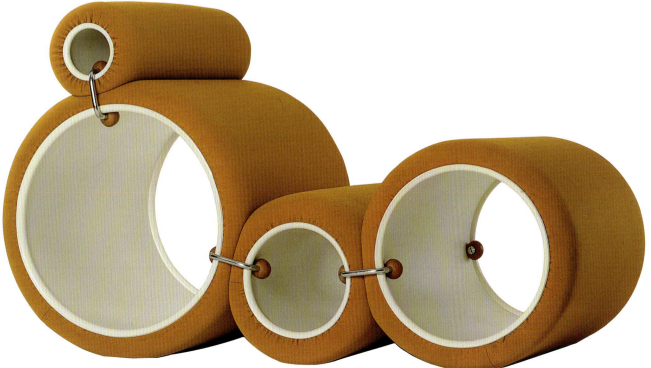

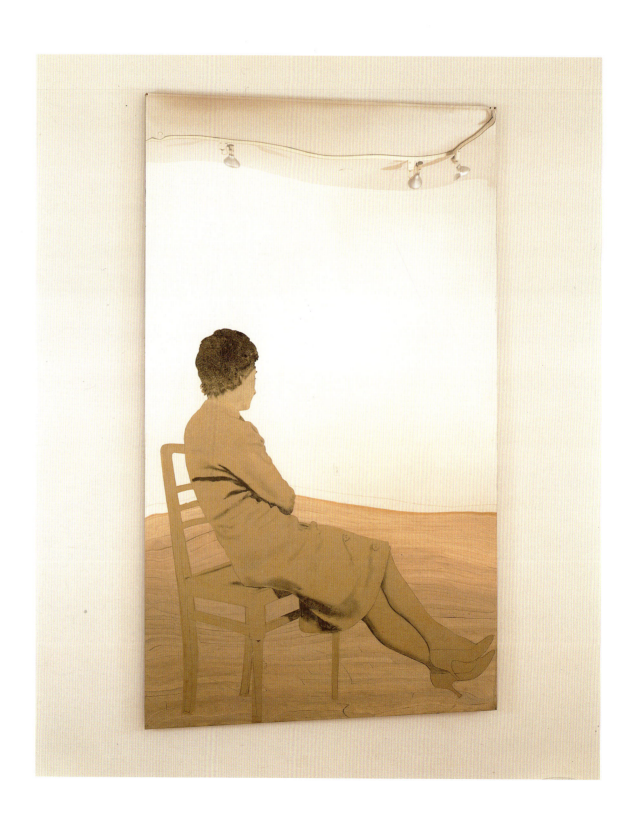

9

Archizoom Associati
Mies Armchair and
Footrest
1969
Produced by Poltronova
Carnegie Museum of Art,
Pittsburgh

Irony and provocation are the words that come to mind looking at the *Mies* armchair with footrest. It is intended as a comment on modernist rhetoric, which was seriously questioned in the late 1960s. Favouring the materials and geometry the functionalists drew from the group created a chair that is more sculptural than functional in appearance. The user temporarily shatters this formal balance by sitting on the band of latex that serves as both back and seat. The pony-skin cushions used as a headrest and footrest are a parody of Le Corbusier's chaise longue (1929), covered with the same type of material.
D. C.

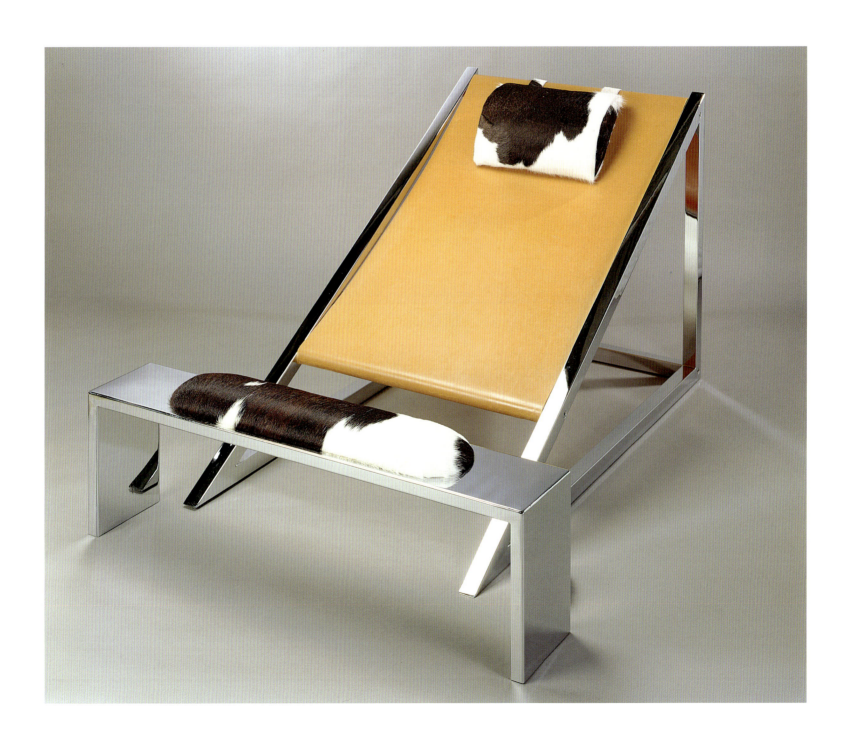

281

187
Enzo Mari
Box Chair
1976
Produced by Anonima
Castelli
The Montreal Museum
of Fine Arts
Liliane and David
M. Stewart Collection

182
Enzo Mari
Atollo Fruit Bowl
1965
Produced by Danese
Fondo Jacqueline Vodoz
e Bruno Danese

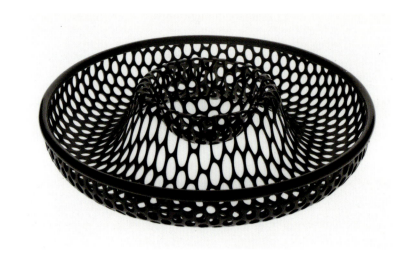

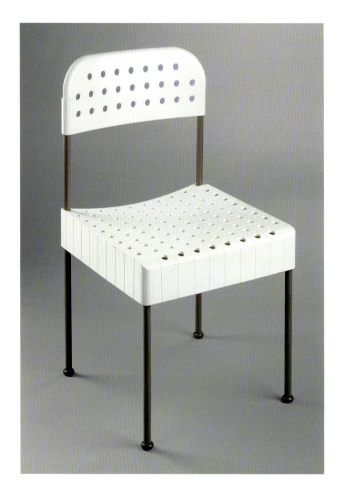

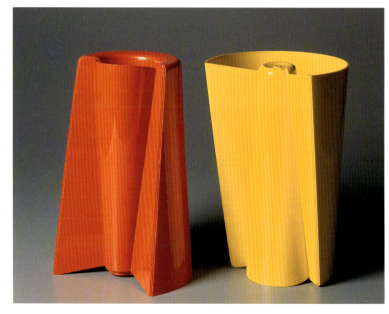

183
Enzo Mari
Pago-Pago Vases
1968
Produced by Danese
The Montreal Museum
of Fine Arts
Liliane and David
M. Stewart Collection

171
Vico Magistretti
Vicario Armchair
1970
Produced by Artemide
The Montreal Museum
of Fine Arts
Liliane and David
M. Stewart Collection

352
Marco Zanuso
Richard Sapper
Child's Stackable Chair
(model K 4999)
1959
Produced by Kartell
The Kartell Foundation
Museum

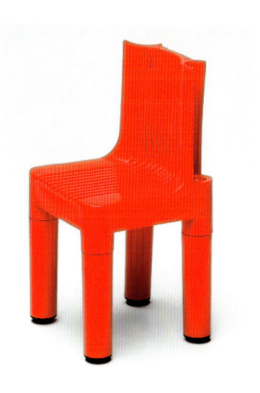

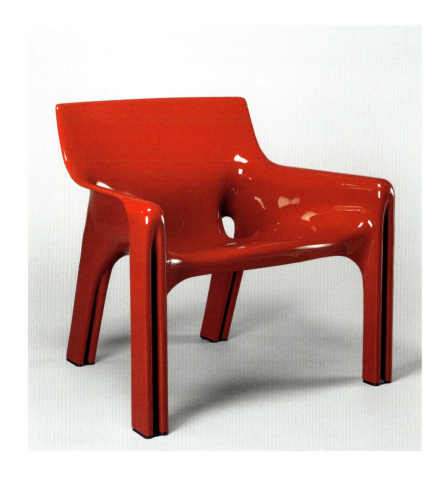

132
Guido Drocco
Franco Mello
Cactus Coat Rack
1972
Produced by Gufram
The Montreal Museum
of Fine Arts
Liliane and David
M. Stewart Collection

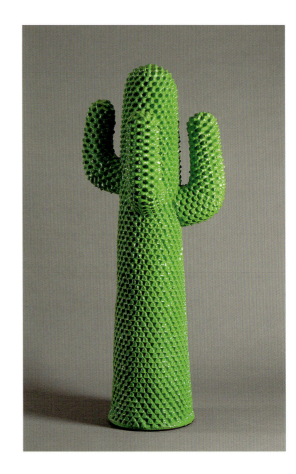

250
Gaetano Pesce
La Mamma Armchair
and Footrest
Up 5 and *Up 6* from
the series "Up"
1969, 1984 edition
Produced by C & B Italia
and B & B Italia
The Montreal Museum
of Fine Arts
Liliane and David
M. Stewart Collection

Pesce has exploited the
properties of polyurethane
foam to make this
anthropomorphic seat
with a double meaning:
it is both an homage
to a prehistoric goddess
of fertility and a comment
on the female condition.
Thanks to the material's
high density, there is
no need for an internal
framework; it is just
covered with jersey-knit
synthetic fabric. To
minimize the pair's volume
during transport, they
are squashed flat between
two sheets of vinyl that
are then heat sealed.
When the package is
opened, the two pieces
regain their original shape
on exposure to air.
D. C.

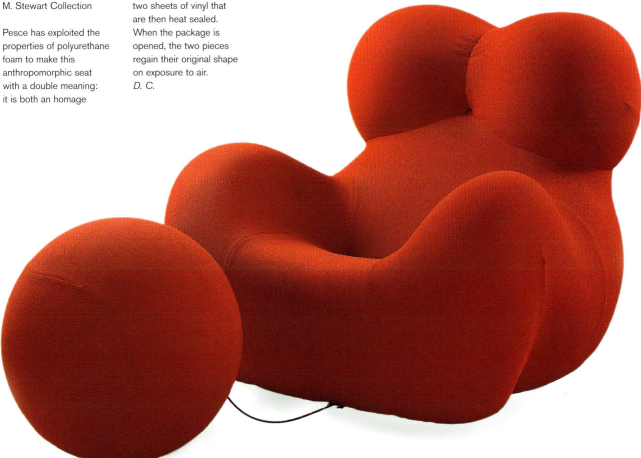

45
Alighiero Boetti
Afghanistan
1988–89
Museo d'Arte Moderna e
Contemporanea di Trento
e Rovereto

153
Piero Gilardi
Zuccaia
1966
Fondazione Guido ed
Ettore de Fornaris,
Galleria d'Arte Moderna e
Contemporanea, Turin

96
Joe Colombo
Boby Caddy
1970
Produced by Bieffeplast
The Montreal Museum
of Fine Arts
Liliane and David
M. Stewart Collection

322
Ettore Sottsass
Perry Alan King
Valentine Typewriter
1969
Produced by Olivetti
The Montreal Museum
of Fine Arts
Liliane and David
M. Stewart Collection

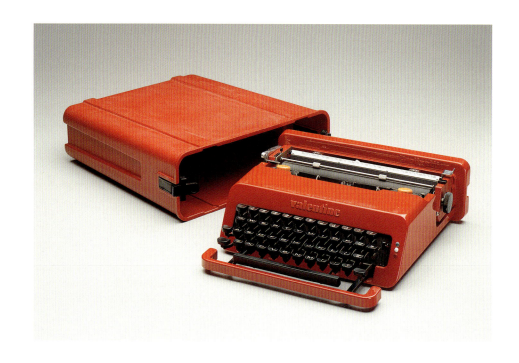

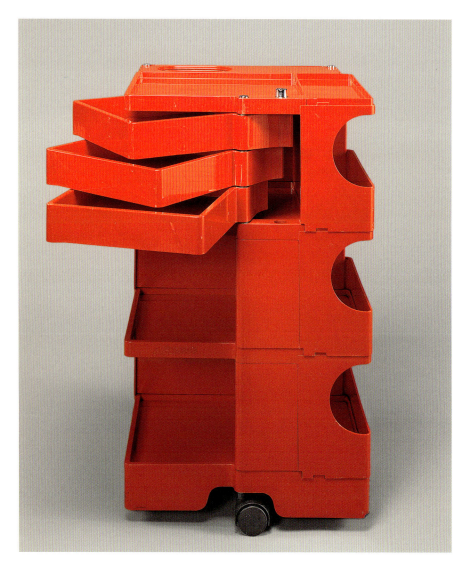

184
Enzo Mari
"Phytomorphic" Vases
1969
Produced by Danese
Fondo Jacqueline Vodoz e
Bruno Danese

163
Leonardi-Stagi Architetti
Dondolo Rocking Chair
1967
Produced by Elco
The Montreal Museum
of Fine Arts
Liliane and David
M. Stewart Collection

287

34
Mario Bellini
Divisumma 18 Calculator
1972
Produced by Olivetti
The Montreal Museum
of Fine Arts
Liliane and David
M. Stewart Collection

33
Mario Bellini
TVC 250 Terminal
1966
Produced by Olivetti
Triennale di Milano

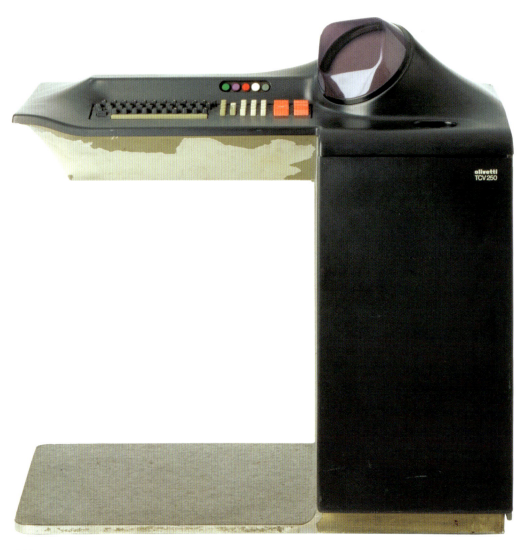

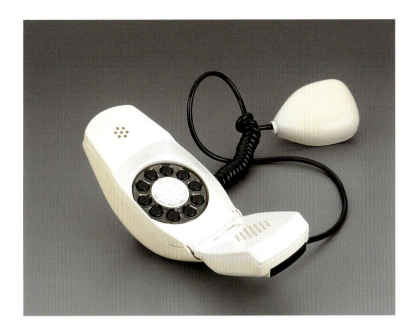

353
Marco Zanuso
Richard Sapper
Brionvega TS 502
Portable Radio
1964
Produced by Brionvega
The Montreal Museum
of Fine Arts
Liliane and David
M. Stewart Collection

355
Marco Zanuso
Richard Sapper
Grillo Telephone
1966
Produced by Sit-Siemens /
Italtel
The Montreal Museum
of Fine Arts
Liliane and David
M. Stewart Collection

354
Marco Zanuso
Richard Sapper
Algol 3 Television Set
1964
Produced by Brionvega
The Montreal Museum
of Fine Arts

In the 1960s Zanuso and Sapper often collaborated to create industrial objects for Brionvega, a renowned company specializing in sound and image products since 1945. They designed a series of reductionistic television sets such as the *Algol 3* in 1963–64. This television with its angled screen moved one step further towards the more geometric forms that were to characterize Brionvega's production in the 1970s. This design was periodically updated and a third generation of Algol was in production at the end of the 1980s. Another project was the *TS 502* portable radio (1964) (cat. 353).
D. C.

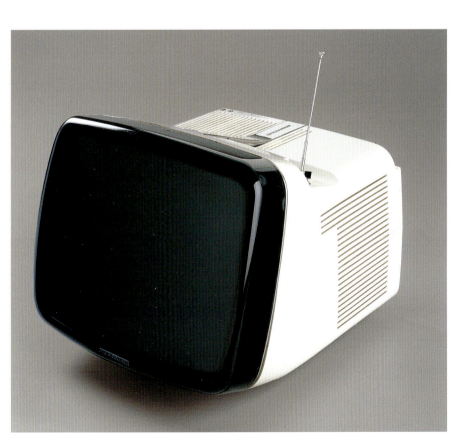

185
Enzo Mari
Sof Sof Chair
1971
Produced by Driade
(1973), Robots
Centro Studi e Archivio
della Comunicazione,
Università degli Studi di
Parma

81
Achille Castiglioni
Pio Manzù
Parentesi Lamp
1970
Produced by Flos
Flos SpA, Bovezzo,
Brescia

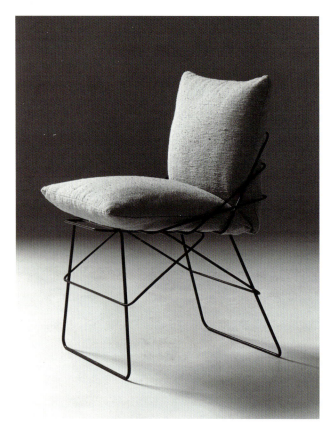

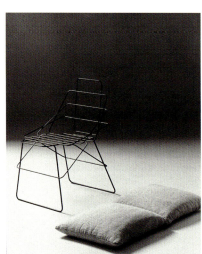

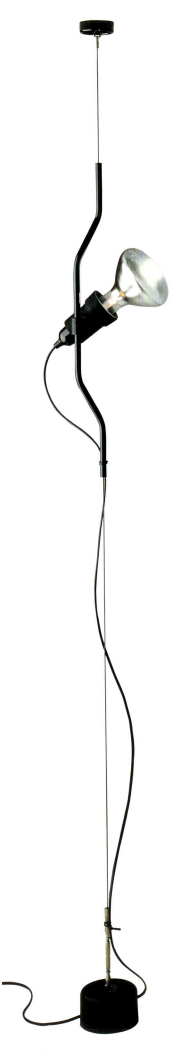

157
Gruppo G 14
Fiocco Armchair
1970
Produced by Busnelli
The Museum of Modern
Art, New York

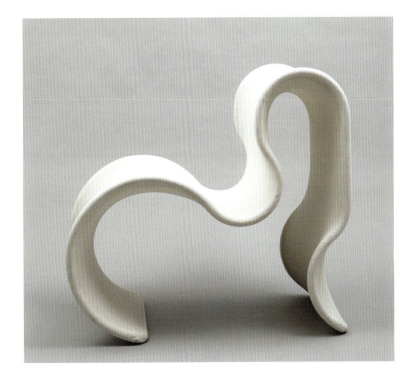

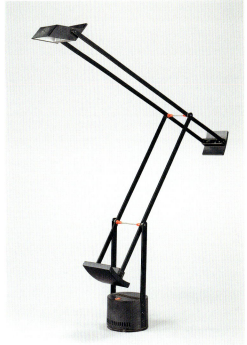

35
Mario Bellini
Cab Chair
1976
Produced by Cassina
The Montreal Museum
of Fine Arts
Liliane and David
M. Stewart Collection

Reductionist in its
composition and
conception, the *Cab* chair
stands out for its
upholstery in saddlery
leather that zips up the
legs like a pair of boots.
Bellini broke new ground
with this way of covering
the welded-steel frame:
zip fasteners had
generally only been used
in furnishing for fabric
covers. The leather
camouflaging the frame
adds a certain sensuality
to the chair.
D. C.

293
Richard Sapper
Tizio Lamp
1972
Produced by Artemide
The Montreal Museum
of Fine Arts
Liliane and David
M. Stewart Collection

The *Tizio* lamp is
distinguished by its
revolving cylindrical base,
cantilevered construction
and use of a halogen
bulb. Minimalist in form
and easily adjustable, it
takes up little space. The
well-balanced arm pivots
by means of an internal
balancing mechanism.
The small shade holds the
tiny halogen bulb that
gives off as much light as
an incandescent bulb.
The *Tizio* popularized the
use of halogen in lighting
for the home. Made of
aluminium lacquered in
matte black, it has
touches of red that bring
out the hinges and
switch.
D. C.

209
Alessandro Mendini
Il mobile infinito
1981
Produced by Studio
Alchimia
Private collection

244
Mimmo Paladino
Cuore di Russia
1984
Museo d'Arte Moderna e
Contemporanea di Trento
e Rovereto

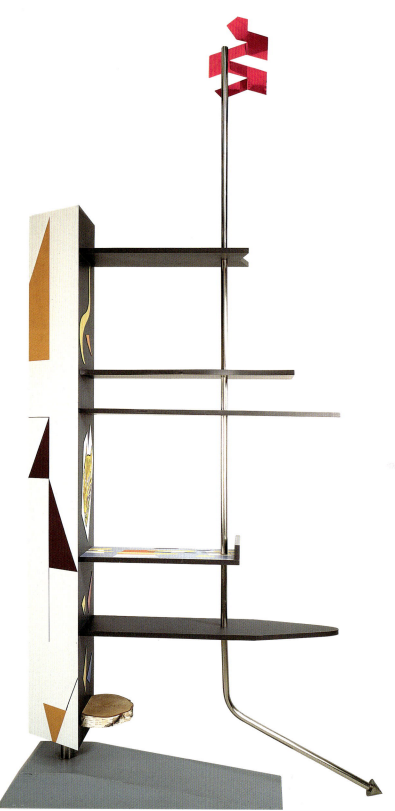

208
Alessandro Mendini
La poltrona di Proust
"Bau.Haus" collection
1978, example of 2001
Painting by Claudia
Mendini
Produced by Studio
Alchimia (1978–87)
and Atelier Mendini
(since 1989)
The Montreal Museum
of Fine Arts

A member of the
Alchimia group, Mendini
developed his concept of
Re-Design (1978) out of
the idea that everything
has already been invented
and that all that can now
be done is to revise or
alter existing objects. *La
Poltrona di Proust* is one
of his reinterpreted
"classics," modified by the
addition of structural or

decorative elements that
change the dynamics of
the original. In an allusion
to the descriptions of time
and space in Marcel
Proust's writings, the old-
style armchair is painted
in the Divisionist manner
after a detail of a picture
by Paul Signac.
D. C.

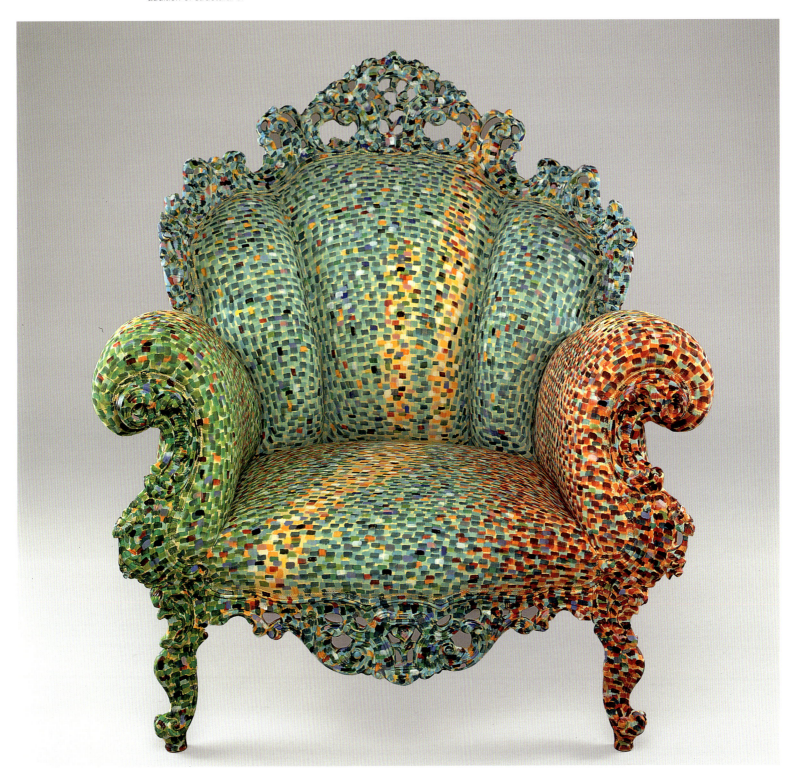

Sandro Chia
La rastrellatrice
1979
Museo d'Arte Moderna e
Contemporanea di Trento
e Rovereto

327
Ettore Sottsass
Murmansk Fruit Dish
1982
Produced by Rossi
e Arcandi for Memphis
The Montreal Museum
of Fine Arts
Liliane and David
M. Stewart Collection

Perched on six zigzag
feet, the *Murmansk* fruit
dish was one of the first
luxury objects designed
by Ettore Sottsass for
Memphis. In line with the
pluralistic aesthetics of
the group, which allowed
all styles to coexist,
Sottsass here combines
his interest in popular
culture and the traditions

of the East and
developing world with his
love of unspoiled nature.
Elegant and functional,
the vessel conjures up
the cold climate and
isolation of the Russian
city after which it is
named.
D. C.

336
Matteo Thun
Volga Bud Vase
1981
Made by Porcellane
d'Arte San Marco for
Memphis
The Montreal Museum
of Fine Arts
Liliane and David
M. Stewart Collection

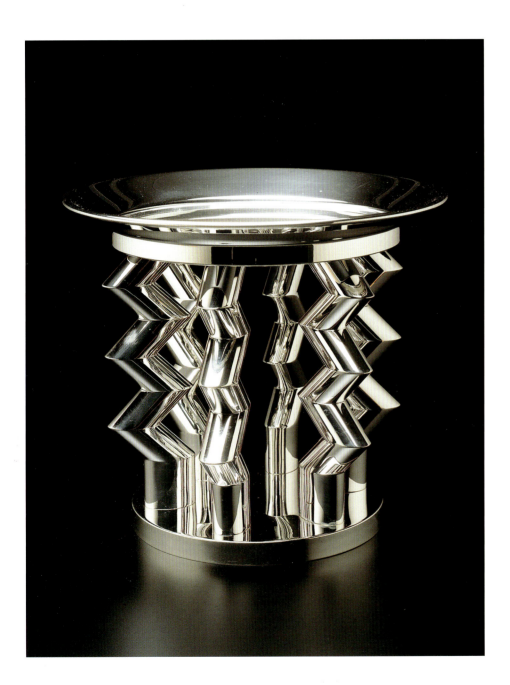

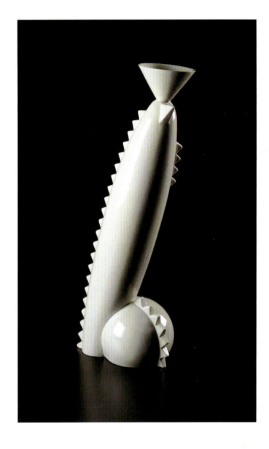

100
Enzo Cucchi
Eroe del mare Adriatico centrale
1977–80
Museo d'Arte Moderna e Contemporanea di Trento e Rovereto

326
Ettore Sottsass
Mizar Vase
1982
Made by Compagnia Vetraria Muranese for Memphis
The Montreal Museum of Fine Arts
Liliane and David M. Stewart Collection

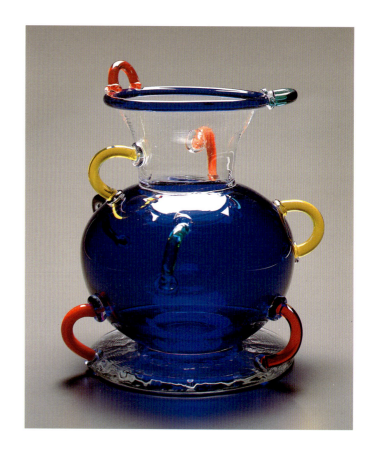

89
Francesco Clemente
Semi
1978
Museo d'Arte Moderna e
Contemporanea di Trento
e Rovereto

329
Ettore Sottsass
Clesitera Vase
1986
Made by Toso Vetri d'Arte
for Memphis
The Montreal Museum
of Fine Arts
Liliane and David
M. Stewart Collection

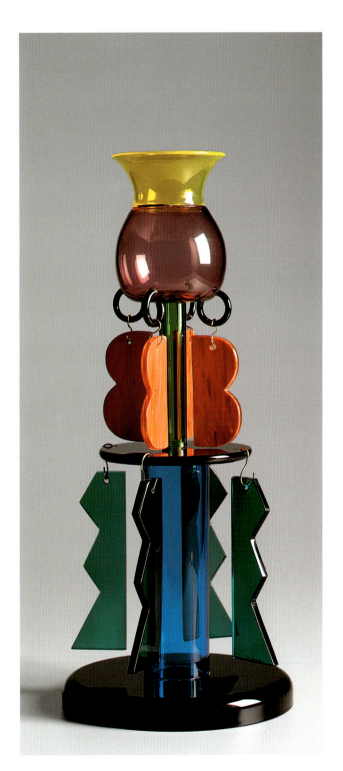

328
Ettore Sottsass
Sirio Vase
1982
Made by Toso Vetri d'Arte
for Memphis
The Montreal Museum
of Fine Arts
Liliane and David
M. Stewart Collection

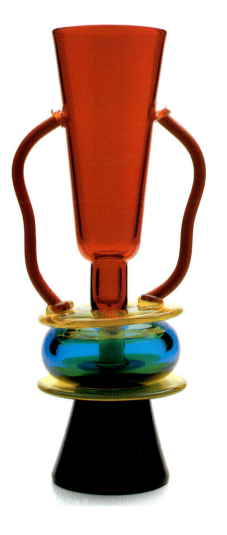

A.D. ITALO LUPI. MASCHERE DI STEVEN GUARNACCIA. *Stuart* LITOGRAFIA 1988

domus
RIVISTA MENSILE DI ARCHITETTURA, INTERNI, DESIGN, ARTE.

NEL RITRATTO: ALVAR AALTO

DOMUS SVELA IL DESIGN

167
Italo Lupi
Mask by Steven
Guarnaccia on a
Photograph of Alvar Aalto
Poster for the periodical
Domus
1988
Private collection

213
Alessandro Mendini
Nigritella Nigra Chest
of Drawers
1993
Painting by Lucio Giudici
Produced by Design
Gallery Milano
The Montreal Museum
of Fine Arts
Liliane and David
M. Stewart Collection

337
Matteo Thun
Andrea Lera
Chicago Tribune
Floor Lamp
"Still-light" collection
About 1984
Produced by Bieffeplast
The Montreal Museum
of Fine Arts
Liliane and David
M. Stewart Collection

The *Chicago Tribune*
lamp anticipated the
appropriation of
decorative styles of the
past into the design of
contemporary objects.
Thun took his inspiration
from the famous
architectural competition
for the construction of a
new building for the

Chicago Daily Tribune
(1922). The designs
submitted reflected the
interest in the dynamic
verticality of American
skyscrapers at the time.
Thun alludes to them, and
in doing so fits in with the
postmodern thinking of
the 1980s, when
designers drew on
architectural models,
often with a sense of
humour. Here, the
skyscraper is reduced to
a cylinder and cubic
forms that are almost
childish, perhaps evoking
Loos' proposal in
particular. The high-tech
aesthetic is complemented
by the diamond patterns
created with the laser.
D. C.

301

114
Nicola De Maria
Poesia notturna dentro
il regno dei fiori
1990
Museo d'Arte Moderna e
Contemporanea di Trento
e Rovereto

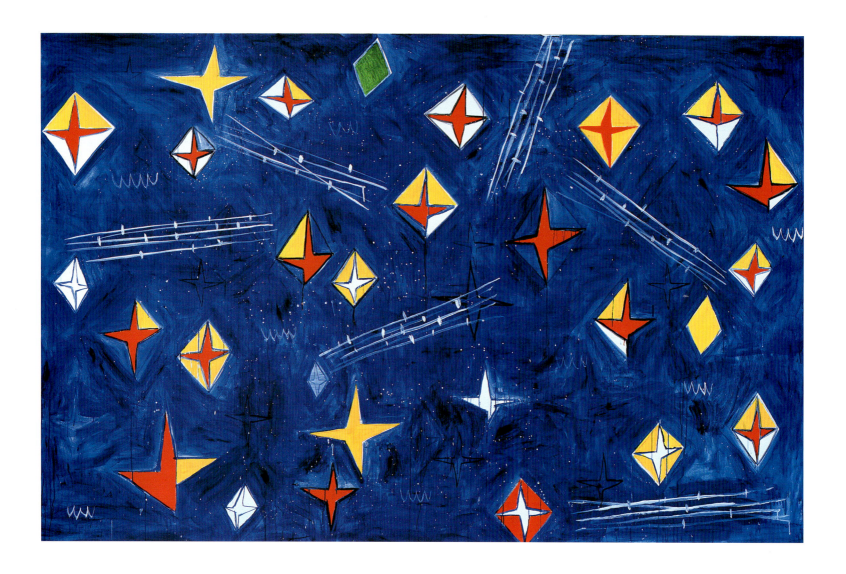

212
Alessandro Mendini
Godezia Jewellery Box
Stellaria Vase
1993
Produced by Design
Gallery Milano
The Montreal Museum
of Fine Arts
Liliane and David
M. Stewart Collection

Alessandro Mendini
Tea & Coffee Service
"Tea and Coffee Piazza"
Collection
1983
Produced by Alessi
Museo Alessi

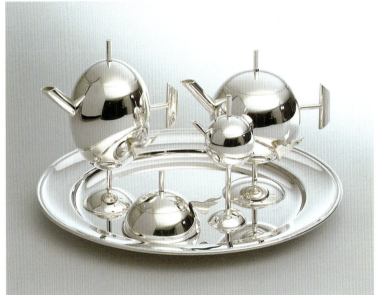

211
Alessandro Mendini
Peyrano Bonbon Dish
1988
Produced by Alessi for
Cioccolato Peyrano
The Montreal Museum
of Fine Arts
Liliane and David
M. Stewart Collection

104
Riccardo Dalisi
Neapolitan Coffee Maker
(model 90018)
1988
Produced by Alessi
The Montreal Museum
of Fine Arts
Liliane and David
M. Stewart Collection

286
Aldo Rossi
La cupola Coffee Maker
1988
Produced by Alessi
Museo Alessi

103
Riccardo Dalisi
a. *Totò*
b. *The King*
c. *Waving Coffee Maker*
Research on the
Neapolitan Coffee Maker
1987
Produced by Alessi
The Montreal Museum
of Fine Arts
Liliane and David
M. Stewart Collection

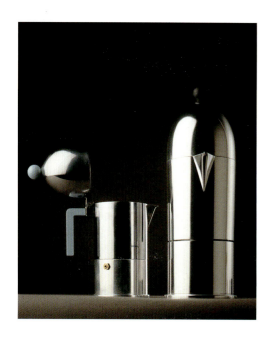

285
Aldo Rossi
Tea & Coffee Service
"Tea and Coffee Piazza"
collection
1983
Produced by Alessi
Museo Alessi

Under the direction of Alessandro Mendini and the Alessi company, eleven architects reinvented the tea and coffee service. The silver services were made in a limited edition of ninety-nine pieces and bore the label of Alessi and the monograms of their designers. Known for his use of simple shapes and geometric motifs, Aldo Rossi gives the tea and coffee pots a conical form. In addition, dispensing with the traditional tray, he places the service under a glass case.
D. C.

160
Mimmo Jodice
Pompeii
1983
Mimmo Jodice collection

154
Paolo Gioli
Omaggio a Bayard
1982
Fondo Paolo Gioli –
Museo di Fotografia
Contemporanea

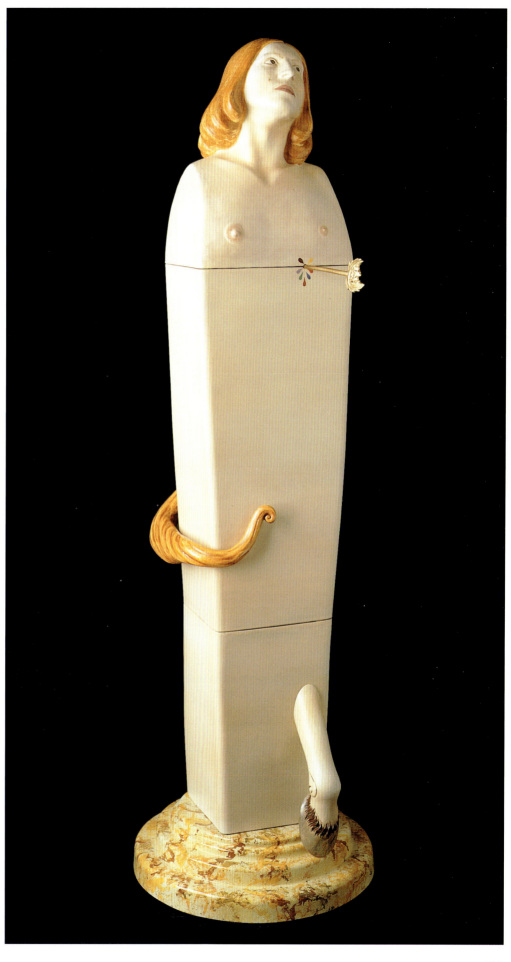

254
Gaetano Pesce
Tutti Frutti Basket
1997
Produced by Fish Design,
New York
The Montreal Museum
of Fine Arts
Liliane and David
M. Stewart Collection

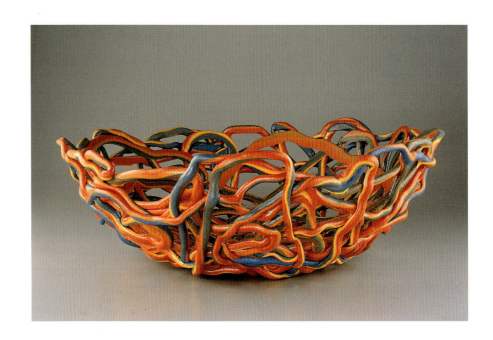

251
Gaetano Pesce
Sansone Table
1980
Produced by Cassina
The Montreal Museum
of Fine Arts
Liliane and David
M. Stewart Collection

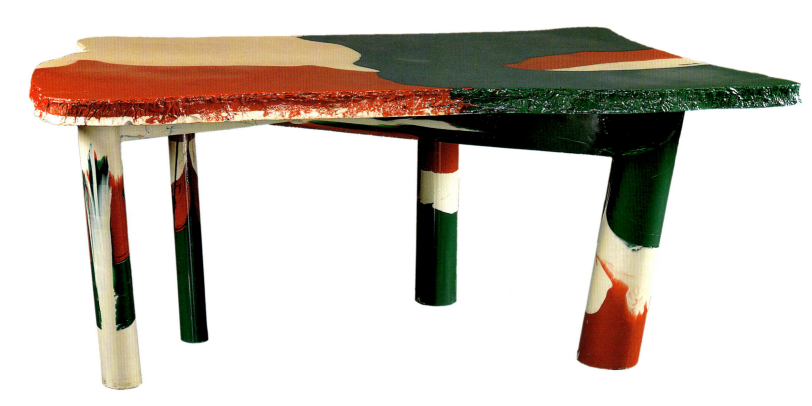

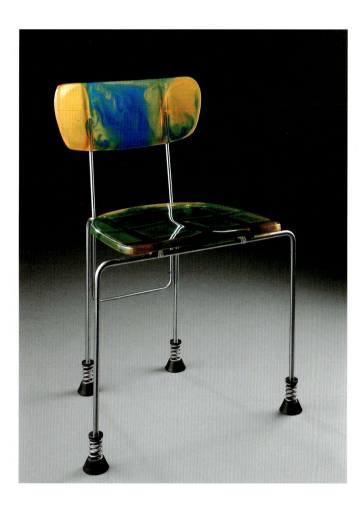

252
Gaetano Pesce
I Feltri Armchair
1986
Produced by Cassina
The Montreal Museum
of Fine Arts
Liliane and David
M. Stewart Collection

The *I Feltri* armchair consists of a large semicircle cut out of industrial felt. After impregnation with polyester resin, the felt is placed in a mould and heated to a high temperature. This hardens it and turns it into a solid base surmounted by a flexible upper part.

Hemp stitching is used to create the impression that it is made by hand, and the padded fabric is attached by means of snaps. The back of the armchair can be folded down like a giant collar or wrapped around the sitter like a cloak.
D. C.

253
Gaetano Pesce
543 Broadway Chair
1992–95
Produced by Bernini
The Montreal Museum
of Fine Arts
Liliane and David
M. Stewart Collection

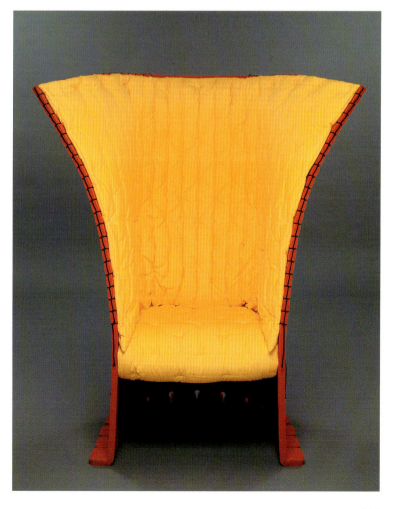

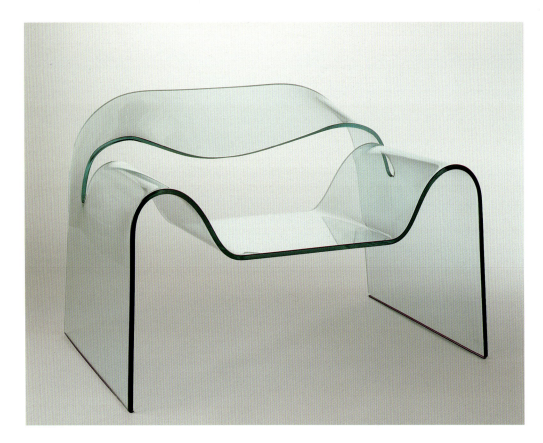

44
Cini Boeri
Tomu Katayanagi
Ghost Armchair
1987
Produced by Fiam
The Montreal Museum
of Fine Arts
Liliane and David
M. Stewart Collection

11
Gae Aulenti
Coffee Table
(model 2744/55)
1980
Produced by FontanaArte
FontanaArte SpA,
Corsico, Milano

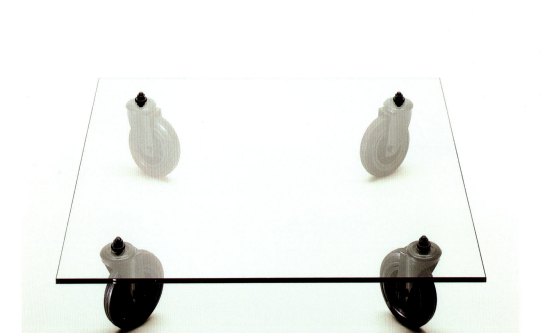

310

88
Antonio Citterio
Glen Oliver Löw
Mobil Storage Unit
1993
Produced by Kartell
The Montreal Museum
of Fine Arts
Liliane and David
M. Stewart Collection

83
Pierluigi Cerri
Thieme/Schafft/Wissen
1886-1986
1986
Pierluigi Cerri

311

306
Tobia Scarpa
Afra Scarpa
Pierrot Lamp
1990
Produced by Flos
Flos SpA, Bovezzo,
Brescia

146
Carlo Forcolini
Apocalypse Now
Coffee Table
1984
Produced by Alias
The Montreal Museum
of Fine Arts
Liliane and David
M. Stewart Collection

The table represents
Forcolini's interest in
creating forms from
industrial materials,
something that fascinated
a number of Italian
designers in the 1980s.
Its unorthodox design
emphasizes the
communicative dimension
of the object. The table is
made of Cor-Ten, a type
of steel that rusts only on

the surface, and whoever
uses the table leaves
marks on it. Its title is also
of interest as it refers to
the famous 1979 movie
directed by Francis Ford
Coppola, and suggests,
perhaps, the metal war
machines of the film, such
as the omnipresent
helicopters with their
angled struts and wheels.
D. C.

49
Andrea Branzi
Vases from the Series
"Amnesie e Altri Luoghi"
1991
Produced by Design
Gallery Milano
The Montreal Museum
of Fine Arts
Liliane and David
M. Stewart Collection

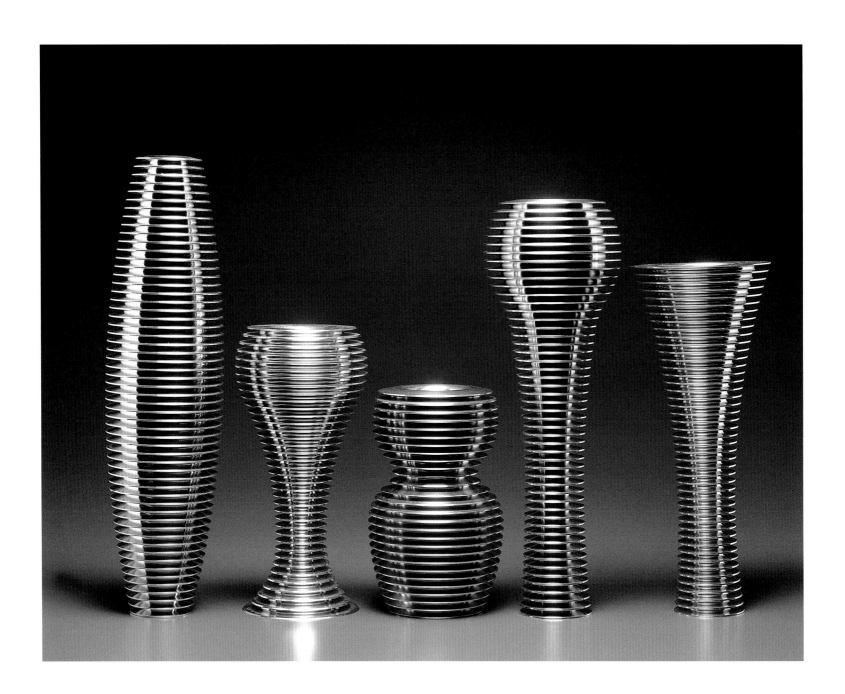

50
Andrea Branzi
Wireless Light Bookshelf
1996
Produced by Design
Gallery Milano
The Montreal Museum
of Fine Arts
Liliane and David
M. Stewart Collection

113
Michele De Lucchi
Basequadra Vase
1997
Produced by Produzione
Privata
The Montreal Museum
of Fine Arts
Liliane and David
M. Stewart Collection

7
Andrea Anastasio
Alba Chest of Drawers
1991
Produced by Design
Gallery Milano
The Montreal Museum
of Fine Arts
Liliane and David
M. Stewart Collection

The simplicity of form of
this chest of drawers with
an almost square front, of
which only twelve were
produced, contrasts with
the impression of spatial
confusion that it creates.
The interior and exterior
surfaces of the piece of
furniture, including the
three drawers, are faced
with a sheet of aluminium
that reflects its
surroundings. Because
their supports are hidden
in the back, the drawers
seem to float in space, an
effect that is accentuated
by the rose-tinted
aluminium facing.
D. C.

48
Andrea Branzi
Foglia Lamp
1988
Produced by Memphis
Memphis Srl

290
Denis Santachiara
Santavase Flowerpot
2000
Produced by Serralunga
The Montreal Museum
of Fine Arts

319

164
Giovanni Levanti
Xito Chaise Longue
1999
Produced by Campeggi
Campeggi Srl, Producer

241
Fabio Novembre
Org Table
2001
Produced by Cappellini
The Montreal Museum
of Fine Arts
Liliane and David
M. Stewart Collection

Fabio Novembre is a member of the new generation of Italian designers who openly take their inspiration from their country's legendary joie de vivre. Indifferent to fashion, his primary concern is to give an innovative plastic form to raw emotions. Whimsical in character, the *Org* table consists of a glass top set on a large number of flexible legs, only a few of which are rigid enough to provide support. Available in a variety of shapes (square, round, rectangular) and colours (red, white or black), this intriguing and appealing table leaves it to the guest to decide whether to sit down at it . . . or not.
D. C.

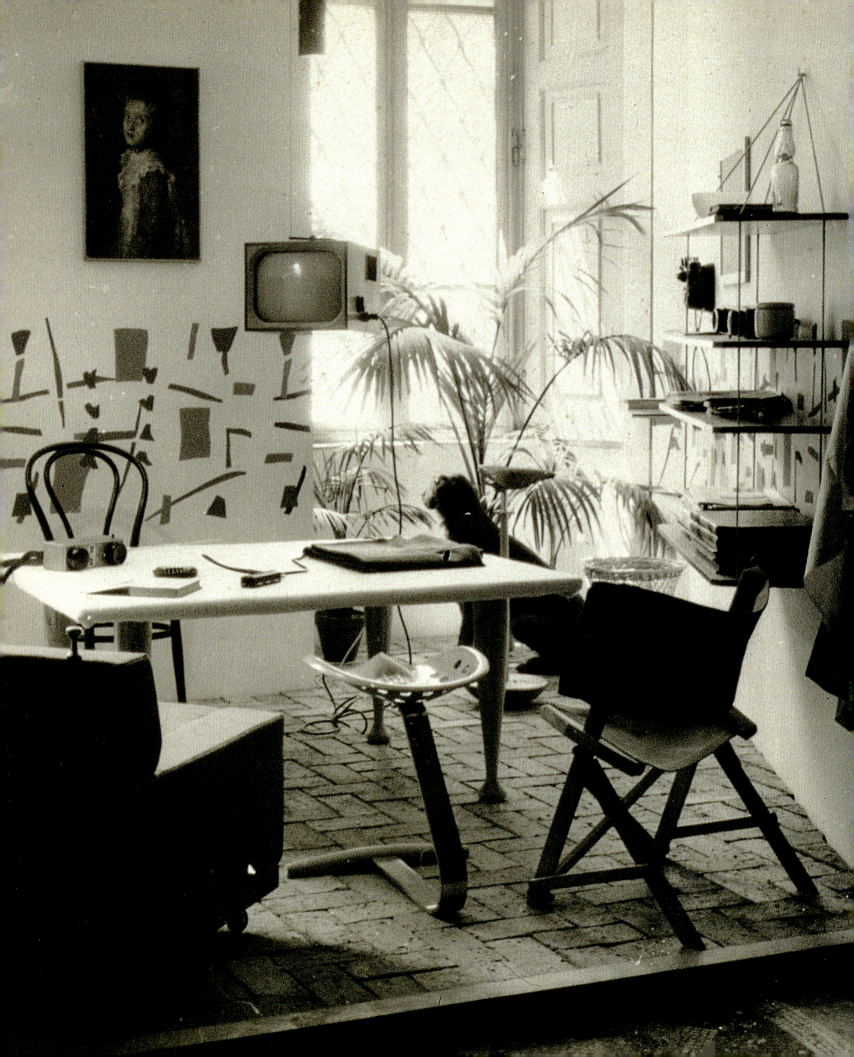

Conversation with Gillo Dorfles

Achille and Pier Giacomo
Castiglioni
Design for a Living Space
at the Exhibition *Colori
e forme della casa d'oggi*,
Villa Olmo, Como (1957)
For this occasion the
Castiglioni brothers
designed the *Mezzadro*
stool and the *Sella* chair,
among other things. The
Luminator floor lamp was
also presented.

Giampiero Bosoni: In the section entitled "Art, Technology and Industrial Aesthetics" of your book *Il divenire delle Arti* [Milan 1959] you said that "the art of today is not that of yesterday, and it will not be that of tomorrow, neither as "form" nor—what matters more—as "function." Starting out from this axiom you went on to propose design as an art in the process of becoming, an art that through its sensitivity to the continual mutability of fashions and tastes would be able to perform a "premonitory" function, in other words, to predict and anticipate the formal data that "great art" has not yet mastered. After almost fifty years, in light of the great changes that have taken place in the world of art as well, do you think that design can at this point be considered an expression of contemporary art, or do you see it as entailing some "limit"—even taking into consideration its evolution of "form" and "function"— that means it cannot be equated with art?

Gillo Dorfles: I believe that design— after the period of uncertainty and, how shall I put it, gestation with William Morris's Arts and Crafts, the School of Glasgow, etcetera, that is to say, after the differentiation between craft and "mass-produced art" had been to some extent accepted and stabilized—has come to play a full part in the sector to which it belongs, architecture on the one hand and the plastic arts on the other. So, in this sense, it seems to me that design at every level can be regarded as belonging to the world of the arts. Of course, we are well aware that in design as in architecture, there is a functional, practical, factual aspect that is missing from painting and sculpture. Thus in design there will always be this utilitarian element, which in a certain sense can appear a factor of conflict from the formal point of view, but in fact unifies the work designed.

G.B.: In this sense Italian design has the peculiar characteristic of having often been a lively testing ground of typological and formal explorations, with peaks of innovation even in the technological field, but decidedly less strong, compared with other countries, from the viewpoint of mass production. Quite a few of the most famous objects of Italian design have been produced in limited editions, some have remained one-of-a-kind pieces for a long time, and others still are today. Should this condition of Italian design, more interested in developing prototypes than in mass production, be considered a limitation or a resource?

G.D.: I think it has certainly been important, because right from the early

323

Luciano Baldessari
Design for a Bedroom
and Living Room in a
Bachelor's Apartment,
Milan
1933–34

prototypes, like the Phonola radio [1940] by the Castiglioni brothers, we were already seeing in these models produced in small runs the same stylistic characteristics that would then find full expression in the industrial products by Castiglioni, Mari, Gae Aulenti or Zanuso.

G.B.: I'm thinking too of the investigations carried out by Albini in the late 1930s that gave rise to some celebrated models that have nevertheless remained one-of-a-kind pieces, like the *Veliero* bookcase, a "legendary" object that has always been considered one of the milestones of the history of Italian design. This is also true of other famous designs, covered extensively in the literature, but which have in fact remained one-of-a-kind pieces, like several of the models by Viganò and Mollino. What value, in your view, have these studies, these prototypes had, with regard to the question of aesthetic research?

G.D.: I believe they have been of very great importance, and proof of this comes from the parallel between the world of art and the world of furniture, considering the remarkable development of this sector in Italy over the following decades, which underwent its first development at the time of Futurism. I remember I often went to see Mario Sironi's mother, Giulia Sironi, an extraordinarily intelligent woman who had been a friend of all the members of the Roman group of Futurists, and therefore of Marinetti, Balla and so on. And I went with her to visit some of the homes of these old Futurists where there were pieces of furniture designed, for example, by Balla. But even then, that furniture, very primitive in its design, showed how the relationship between Futurism and furniture design was very real. Something that then had its subsequent development in the evolution of Italian furniture, which, after the interlude of "subjugation" to the

Scandinavian model in the early 1950s, became independent.

G.B.: In this general discourse, do you think that there is a relationship of cause and effect, in both directions, between artistic explorations and explorations in design, in the technical as well as the methodological sense?

G.D.: At this point there is a fact that we must be careful to take into account, the fact that a true awareness of design, in Italy, did not come until after World War II, because the earlier experiences of design were in a way more closely linked to industrial production, automobiles and technological objects, which were still in a phase of proto-design. It was immediately after World War II, through big companies like Olivetti and Necchi, to mention just two names, that industry finally realized the necessity of a designer who would not just be a technician, but also an inventor of form. This is why real Italian design did not emerge until after the war. Before there was still this mixture of craftsmanship, plastic arts and visual arts, which did not permit a clear vision of what Italian design was.

G.B.: We often refer to what are now legendary names in the history of Italian design, like Olivetti, but we should remember that in those same years many equally important objects were born in much more uncertain situations from the industrial point of view, and this is surely one of the most interesting facets of the culture of design in Italy. Small- and middle-sized companies have been the real force in Italian economic history, offering a highly original alternative to what have been the themes of international design: it was with these companies that a highly inventive industrial situation was created.

G.D.: And that's not all. It is also interesting to note that in that period [the 1950s] there was still a considerable discrepancy between the situations in the

Bruno Munari
Falkland Lamp
(suspended and collapsed)
1964
Produced by Danese

arts and design. Many of the designers who had been precocious in the adoption of certain forms and certain materials, like those at Sambonet, had on the other hand remained very backward as far as art was concerned. In Italy we had on the one hand progress and advance in the field of design and on the other the persistence of a backwardness in the field of the arts. A case in point was Nuova Corrente—with Treccani and many others of this trend—which was an anti-Fascist movement, but reactionary from the artistic point of view, during a period in which design was already experimenting with very advanced forms. Later on things continued to be highly differentiated, since we had artistic movements, like Concrete art, known as MAC [Movimento Arte Concreta] and Fontana's Spatialism, which corresponded in temporal terms to what appeared, for example, to be the backwardness of certain forms of craftsmanship.

G.B.: Sometimes it is hard to explain to outsiders the tortuous paths taken by the Italian culture of design and art in the twentieth century, in that there have often been deviations or distinct areas. Some may consider these simply eclectic or at least compromising lines of exploration, but I think it would be more correct to define them as the product of a heterodox culture that tried to react to the dominant forms of certain orthodox formulas that pertained more to the culture of other countries. I'm thinking above all of what happened in Italy in the 1950s, when in a climate of great fervour and excitement certain fossilized principles of Rationalism were brought into question. I think the confrontation and interaction between two figures like Rogers and Ponti are an obvious example.

G.D.: That is undoubtedly a typical example of the contrasts that permeate not just the culture of design, but Italian culture in general. Another is Gio Ponti,

who created ceramics in the 1920s and 1930s that were even then extremely nineteenth-century, not even Art Nouveau but actually belonging to the time of Umberto I, but who then turned himself into an avant-garde architect with the construction of the Pirelli skyscraper in the 1950s, and even before that with Palazzo Montecatini in the 1930s. Moreover, in Ponti's circle we find Lancia, Fornasetti and others, all creators of decidedly reactionary artistic forms. I would say that this contrast, to which not enough attention is usually paid, is present in the whole of Italian production, especially since the middle of the last century.

G.B.: In this sense Gio Ponti also had the luck to spend a long time as a central and leading figure. From 1923, when he was put in charge of the image of the Richard-Ginori company, and to an even greater extent from 1928, when he became editor of *Domus*, until his death at the end of the 1970s, he was involved in the most productive and important periods in design. But do you think that this figure of Ponti as a leader in the history of modernity, and vice versa, has been a positive one, a figure who contributed in the best possible way, as some argue, to the rich and complex evolution of Italian design, or did he create some problems over which, as others claim, the history of Italian design has stumbled?

G.D.: Well, I think that he has been fairly dangerous. In my view, for example, even though the two things are very different, many of the radical groups [UFO, Superstudio, Archizoom and Radical Design in general] were at bottom a revival of that emphasis on decoration that then degenerated into the Studio Alchimia and Memphis. So the main road of a rationalism, but not a rigorous one—which when all is said and done was the right way for Italian design, the one followed by Zanuso, by Mangiarotti,

etcetera—then degenerated into a predominance of decoration that was in a way second-rate, precisely because it harked back to the decorative styles of the first half of the century. Which then all link up naturally with Stile Liberty, with the difference that in Liberty the decoration had resulted in a substantial transformation of architectural construction, as in the cases of Basile, Sommaruga, Campanini and Aronco. All of them had also sought to make structural innovations through form, and so their use of decoration was acceptable, as was Sullivan's. Whereas the emphasis on decoration in the 1970s by the designers I mentioned earlier was not acceptable because it did not correspond to any real innovation in design.

G.B.: But thirty years after the appearance of Radical Design, the last avant-garde movement of Italian design, do you think that only the decorative aspect has survived, or has it led to what they, and I'm thinking mainly of Andrea Branzi, claim has been a revolutionary strategy of design, one that has offered a new way of interpreting the relationship between design and post-industrial society ahead of its time, perhaps even too far ahead of its time?

G.D.: Well yes, that's partly true. Many of these movements, let us lump them all under the "radical" label, have also been positive, in the sense that they emancipated Italian design from its subjection to Central European design, represented at that time by the Braun line and by Dieter Rams. In this way Italy showed that it was not a slave to Calvinist rationalism. In this sense it can be said that there has been a positive side, because it then led Italy to open up to collaborations like the ones that have seen figures like Ron Arad or Philippe Starck take possession of a part of Italian design.

G.B.: Every so often I like to quote, with a small modification, the famous phrase of Alessandro Manzoni [celebrated Italian writer of the nineteenth century, regarded as the founder of the modern Italian language], who before starting work on his famous book *I promessi sposi* [The Betrothed] went to Florence, as he put it, "to rinse his clothes in the Arno": well I say that the international world of design has come and continues to come "to rinse its clothes in Milan." The city remains a centre of great energy as far as the culture of design is concerned, in part thanks to a series of courageous, open-minded and in some cases enlightened entrepreneurs, who put their faith in and

Archizoom Associati
Picture from the series
"Parcheggio residenziale"
1971

to some extent invented this world of Italian design.

G.D.: Zaha Hadid, for instance, with that beautiful sofa of hers, produced by Moroso, is a typical example of how a very avant-garde type of architecture, and if you like a debatable one, has found here the way to create an excellent piece of furniture.

No, I think that design in Italy still has a great deal to say. As I was saying, the fact that many foreigners, from Starck to Tusquets, to take two completely different examples, are working for Italian companies is a positive sign, clearly a very positive sign.

It's as if there were a special soil here that permits the growth of forms that might not develop with such harmony anywhere else. What is strange is that in Italy what happens with design does not

happen with the other arts: we haven't had the same development in the other arts as they have abroad.

G.B.: Could it be that design in Italy has gained the upper hand over artistic explorations and represents, at least in our country, the main force in contemporary aesthetics?

G.D.: I would say so, because if we look at the art scene elsewhere, especially America and to some extent Germany, we see that there has been a much greater and much more differentiated development than there has been in Italy. Whereas this did not happen before, in the years immediately after the war when Spatialism, the Arte Nucleare, the MAC and later Arte Povera took on forms in Italy that were very independent of what was going on abroad.

5. Diagramma fallico. 6. Diagramma clitorideo. 7. Diagramma cosmico. 8. Diagramma della realtà, detto misticamente Shiva o Yoruba o anche chiamato misticamente con altri nomi.

Conversation with Ettore Sottsass

Giampiero Bosoni: At a previous meeting you expressed doubts about this parallel between art and design. While recognizing the importance of the artistic experience, you argued that you had not developed as a designer by regarding art as your main problem.

Ettore Sottsass: I have clarified this position of mine a little since then. I think that there is some hazy terminology in this discussion. First of all: what is art? Which is where we start. There are different ways of interpreting this term. One says art is anything you know how to do well: so a surgeon is an artist too, a baker is an artist. In this case it's a technical ability to be picture-perfect, *a regola d'arte* as they say in Italian. I don't think that's the meaning that interests us here. But I have another one: art is what you look at, not what you use. There is a profound difference between art, architecture and industrial design. Because industrial design produces objects that are used. People look at them as well, but above all they use them. If we don't get this clear we end up in quite another place. In fact when I hold an exhibition of ceramics they call me an artist, but I say, okay, but if you look carefully, you can put a flower or something else in each of my pots.

I don't do art! I get pissed off when they tell me I'm an artist. Let's not talk about architecture . . . I'm more interested in the interior of the architecture than the exterior. Because the exterior is used as a symbol of power, a hidden use but an obvious one. So much so that in the history of architecture you find nothing but stories of temples, of great palaces. You don't see stories of little houses. The real reason for the grand definition of architecture is that it has to be something immense: it's frightening, fatuous or a gigantic spectacle. But for me architecture is when you are able to design an artificial environment that you can live in with your body, with the warmth and the cold, with light or shade, with your children and your wife: that is architecture.

The other part of the discourse, which I notice people talk about in a really incorrect way, is design. The English word design has the same meaning as the Italian word *progetto*. It means *disegno* and *progetto*. But when people say design today they mean design for industry, industrial design. But it would be good to make a distinction, because you and I designed ourselves this morning, you with a blue jacket and striped shirt, me all in white. We are

329

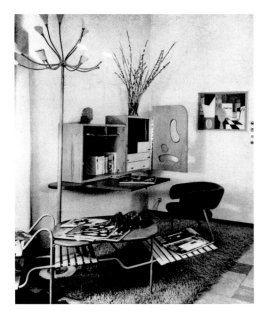

Ettore Sottsass
Furnishings designed for
the exhibition *Arredatori
Contemporanei* for Fede
Cheti, Milan (1949)

always designing ourselves. I think it would be interesting, at this moment in time, not to make a linguistic confusion, which after all is a confusion of concepts.
G.B.: Can I remind you, though, that this confusion around the terms "minor art" or "design" has roots in the distant past?
E.S.: Certainly, but let's be clear, not everything that is literature is called poetry. So let's see: in literature there is lyric poetry, prose. What else is there? The newspaper article, the report and then, finally, there is poetry. In literature there are these distinctions, we use them all the time. We don't call one of Mayakovsky's poems literature; no, we say it's a poem. And then we say that there is good journalism, but we have a name with which to distinguish it. Today, in the world of art, we don't have these distinguishing words anymore. When people used to say minor art, that "minor" was already a distinction.
G.B.: In fact it then became decorative art, applied art, industrial art and some thought what could also have been the space of industrial design.
E.S.: Yes, but I prefer to call it industrial design, and not industrial art. Art has got nothing to do with it. Whether industrial design is interesting or not, poetic or not, we can talk about afterwards, at a later stage. But let's not get things muddled up: it is industrial design and that's all. I am an architect, for example. Being an architect I have one constant attitude: the things I design are to be used.
G.B.: But for a long time architecture has been considered the greatest art.
E.S.: They were right to apply the title of greatest art to certain constructions of particular value, because today everything is architecture. I, for instance, make a distinction between architecture and building. Because there are millions of houses that are buildings and there is one every so often, if we're lucky, that is a work of architecture. For example the great geniuses of modern architecture,

in their moment of history, achieved excellent results because they had a profoundly ethical attitude. They thought that architecture could be used by people, and not just by corporations, banks or deities. For example there is the great distinction that I make between the ancient architecture of power and the modern architecture of power. For the ancient architecture of power, the power was God, it was the supernatural: even the pharaoh who built himself a pyramid was dealing with eternity. Contemporary works of architecture on the other hand only deal with banks.
G.B.: You think that designing for the human being is a great value, but also designing for . . .
E.S.: . . . society . . .
G.B.: . . . or even God, in the sense of a higher being.
E.S.: . . . but I agree totally.
G.B.: Art has often had this traditional role of being dedicated in its highest moments . . .
E.S.: . . . to the supernatural, the unknown, let's call it. I'll tell you, perhaps in minor architecture this relationship with the unknown, if you think about it carefully, is more intense than in major works of architecture. Because we all have anxieties, we all have troubles, and if we design for ourselves a place where we can sit down, I won't say to pray, but to meditate on this darkness that surrounds us, on the fragility of life, on what will be and what will not, etcetera, it's at home that we do it.
G.B.: It seems to me that at a certain point you decided that the design of objects was the most interesting way of entering the domestic dimension that you were looking for.
E.S.: There was that aspect too, yes . . . But first there was another and more banal aspect, that I was broke, when for example Olivetti, I don't know why, asked me to design for him. That's another strange story. At the time . . . I was

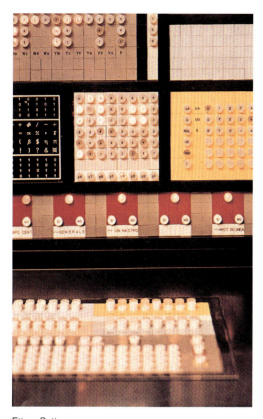

Ettore Sottsass
Detail of the control panel
and keyboard of the
Elea 9003 computer
Produced by Olivetti
1958

making objects at home out of wire, out of sheets of metal that I cut up, because I didn't really know what to do. I went through a truly disastrous period for four or five years right after the war. However, as soon as Gio Ponti, who was the editor of *Domus*, saw these works of mine he wanted to publish them. This was a stroke of luck, because it allowed me to communicate. Adriano [Olivetti] must have seen something in them, and through Mario Soavi [a well-known intellectual and art critic], who at that time was married to one of Adriano's daughters, asked me if I wanted to do a book with my works . . . I felt like a model . . . But I don't have anything I told him . . . No, no, he replied, you do whatever you want. Well, I did and Adriano chose me as the designer for the new electronics division. You can imagine how scared I was, as I was quite unprepared, and for a few months, terrified, I did nothing. Finally Adriano called me up and asked: "So Sottsass, when are we going to see something?" . . . In two weeks, I said, to play for time. Under pressure I designed the first ELEA [one of the most advanced computers of the time, 1959]. But that in reality was an architectural design, since it was a whole room, with cabinets and so on . . . It was the design of a place, not just an object: the object was in the place, but it generated the place, you can say.
But to go back to the original subject, you wanted to know what effect painting has had on me. Well, you know, then you're going to have to ask me other questions: why I took an interest in archaeology, for example, why I took an interest in literature. When I was a student I read all the Russian literature I could get my hands on. Then I read books in German, which I could barely understand, including, I recall, a magnificent text on African sculpture, perhaps the first book on the subject. So it is not that painting has influenced me more than any other

source of information or area of curiosity. I have been more influenced, if you like, by India. But what has influenced me most, I repeat, is ancient archaeology, the archaeology of the very ancient past. Do you know why? Because I was looking— and am still looking—for an existential state, I don't want to say something pure, but a simple, primitive thing, to set me free of all the intellectual structures that surrounded the world of the architecture, let's say . . . You know, people have talked a lot of crap. For example in that book on the work of the pre-Socratics of which I spoke in the interview for the exhibition on the 1960s in Montreal, there is almost nothing, just a few fragments. And the fragment is a mental stimulus that induces you to think about something, and to imagine something romantically as well. The fragment is like the ruin . . . I am very fond of ruins. Because, again, they're what's left, all that is granted us by the unknown . . . of thoughts, of plans, of hopes.

G.B.: Can we say that all the things you have mentioned are humanistic interests?

E.S.: I think so. You can say that.

G.B.: Vico Magistretti, who is about your age, often declared with a certain taste for provocation: "We became good designers because we went to secondary schools where they taught us Greek and Latin."

E.S.: I think it's true. But I'll go further, you know why we became good at it? Because we added to all these things a political hope.

G.B.: A passion for design that, after the war, was fused with a political impulse full of great enthusiasm and great hope for the future . . .

E.S.: . . . you can call it ethical or political. In any case it declared loudly: let's remake the world. Every country where an authoritarian rule or a war comes to an end for at least five years goes through a period of great hope,

of great activity, of great—how to put it?—light.

G.B.: And yet while on the one hand you say "I became an artist because I had no job," you also speak of a continuous quest . . .

E.S.: . . . certainly, but I did it primarily because I was and am curious about everything. But I have always gone to the bottom of these "curiosities" of mine. When I was curious about India I went to India. When I was curious about photography, I worked my ass off with the camera . . . I've never been a superficial dabbler, I'm a deep dabbler.

G.B.: Don't you think that there have been situations in the world of Italian architecture—which is the same one that felt the need to evolve in the direction of the system of objects of everyday use—a relationship with and a sensitivity to the world of artists that has rarely existed with this sort of continuity in other countries?

E.S.: I agree. That here in Italy, because of other impossibilities . . . let's say . . . But I don't even know if you can say . . . For example, an architect has to know how to draw, in my opinion. So what is drawing? When I was a boy I went to look at all the great draftsmen, from Rodin to all the rest, to understand what the differences were. Then there was the relationship I had with the artist Spazapan. He, for example, taught me that there are different kinds of paper: absorbent paper, smooth paper, etcetera, and that the way you draw on each kind of paper has a different "tone."

G.B.: I find it very interesting that you are talking about how you are interested in exploring the technical side of the artistic experience, which can be used in its turn to seek an expressive quality.

E.S.: That's clear too, because you have to understand the means that you use to express yourself. The columns of the Parthenon were carved by Phidias, someone called Phidias, okay . . . who knew what a column was because he was a sculptor. For him a column was an important object.

G.B.: But is a chair designed in the mid-nineteenth century, like the model 14 Thonet that you have behind there, one of those objects that has the dignity to be representative of a higher form?

E.S.: I believe so, but there are different situations that have to be appraised. For example in the letterhead of your exhibition I see that you have put images of various objects: well, among these in my view the Vespa scooter is the only real one, in the sense that I described to you before. If we are talking about implements for a ritual, that archetypal model of the scooter is a primitive implement: it is the stone tool, the flint, if you like; today we have gone much further . . . Lately I have been taking photographs of these contemporary contraptions . . . Today the flint has become, what shall I say, a bronze arrowhead.

But it is the engine that counts more than its design. You see, the logic that has designed the inside of these machines—as well as the wheels, the brakes, the handlebars and all the rest—has always been dictated by necessities of production, by mechanical needs. So at this point I don't know whether the world will become all this: we will learn about the aesthetics of the machine, the aesthetics of the engine, the design of aerodynamics, rather than all the rest. Even the colour of these objects is an extra-human colour because it is applied by machines. It is not the hand that paints. Here we are in another field. I call it extra-human because it is not done with the human hand. For this reason we have to change the language too, because we cannot judge this vase designed by Gio Ponti in the 1920s in the same way as we judge this scooter of the 1950s. It's another thing. So there are two possibilities: either you accept this novelty of a world of extra-human

Ettore Sottsass
Design for Glass Vase
1998

production where everything is mechanized, a world of mass production, which is very beautiful, or you are lost and spend your whole day complaining. I have always been very struck by something Pier Paolo Pasolini wrote in an article published in the *Corriere*, where he was talking about the centre of the city and its outskirts. New ideas always come from the periphery. They always come from hobos, from truck drivers, from young people who go to the disco, etcetera. The centre protects something: the centre always has something to lose, the outskirts are always looking for something. So if this idea is of any use to you, I'll tell you: I'm on the side . . . or rather I'm interested in the periphery in general, not the centre. Established culture doesn't interest me at all. What interests me is that mysterious aspect of culture that germinates at the moment in which you don't even know if it is culture. Think of graffiti, for instance, think of so many other things, of contemporary music, electronic and non-electronic, and so on. Then you go somewhere else, but you also have to use another language. We have to change the language.

I would like it if the design of objects were to have the unknown as a theme. I mean the ritual, or any higher form of approach to the object or the use of the object. But let's drop it for now, because there is not even a shadow of this sort of thing here. Listen, I have a suggestion for you. Everything they call African art is not art. The Africans have had no galleries in which to exhibit art, there is no commerce in art. Why? Because all the things they have made were implements for a certain ritual: masks for ritual dances, or gods to be prayed to, to be imagined, or something of the kind. In the sense that there is no concept of art there, it doesn't exist. I feel I can say that, to some extent, I have this obsession: imagining the design of objects as the design of instruments for domestic rituals.

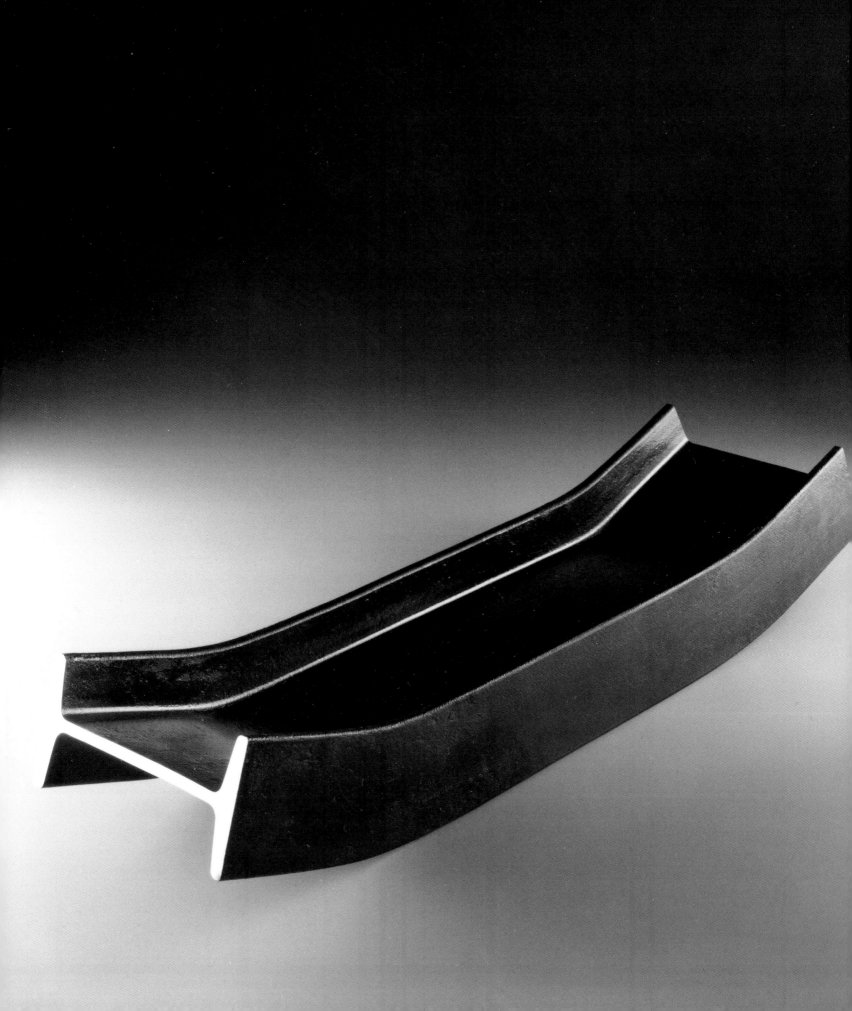

Conversation with Enzo Mari

Giampiero Bosoni: In the chapter entitled "Tre Orizzonti" of your recent book *Progetto e passione* [Turin: Bollati Boringhieri editore, 2001] you describe what you see as the three cultural horizons to which the discipline of design must necessarily look. In the first place you cite that of the relationship with production, then that of the natural sciences and finally the horizon of expression, which you explain regards all the arts, including the plastic, music and literature. To what extent and above all in what way do you think that design should look to the horizon of "expression"?

Enzo Mari: I believe there are several factors that go beyond the needs of the "market": design has to do with "standards," it has to do with quantity. Note that I am not emphasizing the concept of standard from the viewpoint of the quantity of pieces manufactured, but using it rather in its philosophical sense of *étendard*, that is to say a particular unit of measurement: the standard that allows us to recognize one another in battle by virtue of common rules. So quantity implies rules. In this sense I hold that the task of design is to define rules. Thus design has as its objective the problem of the "standard" as banner. That

is to say, as rule, and above all as collective rule. This has been a central problem from prehistoric times to the present. Religions are nothing but political mechanisms, above and beyond the folktales of the gods, created to provide rules for a civilized way of living. Rules based on ethical and not subjective values. So the consequence of this point is that even when responding to a real need, design has first of all to deal with its component of a symbolic nature. If there is something worth fighting for in a society that no longer has any rules, or where the rules are dictated by the culture of ignorance and the total domination of kitsch, it is to make the most of the fundamental character of design, which is its symbolic component. Be careful though, not symbolic in the sense of the expression of an individuality or of the subjective difference of an artist, which is why I get irritated by the presence of certain individuals, but in that of the rule to be proposed in the despair, in the meaninglessness of society. The early avant-garde movements took this upon themselves, the decent intellectuals of the last hundred years have taken this upon themselves: what is the rule? So design has to deal with the standard and in this

Enzo Mari
Models and prototypes
of *Java* tabletop containers
Moulded melamine
1968
Proj. 907 for Danese,
re-produced by Alessi
in 1997

sense, implicitly, in brackets, with uniformity. Thus art, the art of the past, let us say up to Manet, is a symbol, it tends to define a rule for society. It is the only mechanism that humanity knows for speaking about transcendence: about what transcends needs. Looking at all the most important examples from the past it is clear that the aim was always to give a signal, to provide a collective model that was able to speak of what went beyond immediate and banal needs. What symbols did the old art produce? It produced symbols of rhetoric: the Seven Muses, the Eternal Father, the Crucifixion and so on. Symbols always have something to do with the transcendent, they speak of absolute, all-embracing values. In today's design how can I speak of God in a society that tends to "forget" or transfigure him, whereas in my view he can only be placed at the centre, especially for someone who is secular? I am profoundly secular and I say that God has to be there: the only question that I ask myself with regard to God is whether he knows he is there or not . . . And if he doesn't know he's there, then our responsibility is even greater. In this respect artists had an advantage: it was taken for granted that they used the symbols of rhetoric. There is total degradation. In this context modern art can only be understood as a dialectical element with respect to ancient art. As an element of despair when compared with ancient art.

Design cannot use the symbols of rhetoric and is faced with a world of total superfluity, of merchandise and kitsch. Any symbol I use has already been used by others in the opposite sense. So at this point I go back to what was the real school, that of Zanuso and the Castiglioni brothers, and I say, Okay, if the problem is making a chair, the chair has to be made with these techniques. And I try to make it with those techniques while removing any component of imitation.

This is the case, and it is one that crops up constantly, which leads me to assert: a form is beautiful when it "is," and it's always wrong when it "seems to be." It can be said at this point that design reduces function to true essentiality. So where does the problem of art lie? If art signifies a system of symbols, what art can we speak of in the case of design? Certainly not the one that we are generally familiar with. Instead it is necessary to reflect on what it can be in a specific way for this new context. When I make my things, which I do by elimination, I try to make them with the same intensity as Brancusi or Manet when they produced their masterpieces, only I take care not to use their icons. That's why I can't stand all those designers who without any understanding of art say "I am an artist," or who declare "design is art." My comment on this is very simple: "at the most what you are doing is decorative art."

You see Giampiero, this is the point. When the people who came up with the scooter [the Lambretta or Vespa]—who were pure engineers and knew nothing about design, if by "design" is meant what we see today in shops as well as in exhibitions put on by self-styled critics—saw the strange lightweight and portable motorcycle that American paratroops were equipped with, it made them think. They worked on the idea and eventually designed the scooter—in exactly the same way as a real artist, who looks at the world, and sees what it needs, not the immediate needs of the shopkeeper on the corner, but looking at future prospects—as a response to the fact that the roads in Italy, just after the war, were filled with mules and donkeys and that 90%, 95% of them were dirt roads. So in that situation they had the intelligence— they were pure engineers coming out of the world of aircraft, where the purity of the form of an aeroplane is a matter of science, that's how it is and it doesn't

Enzo Mari
16 animali
1957
Made in wood in 1959 by
Danese and subsequently
in polyurethane
Proj. 351 for La
Rinascente, re-produced
by Alessi in 1997

have to look like anything—to make what historians today unanimously recognize as one of the most important products of design in Italy and the world.

Well, this is the other pure form. So I try to do my work like D'Ascanio [designer of the Vespa scooter] . . . to the extent to which I am able to defend myself against the demands of the market. And in this respect I admit that it is not always possible to be clear-eyed.

G.B.: Like D'Ascanio, but like Brancusi and Manet too.

E.M.: Yes! But knowing that they are two different things. You know, Giampiero, that I have created some works of art, both those of a long time ago [the works of Arte Programmata between the late 1950s and the early 1970s] and the later ones [the Allegories of the 1980s and 1990s], but I've never kept up with them and I've put them aside.

And then I go along with the other perverse, crazy discourse, which is that of saying: since the mannerism of the avant-garde is the matrix of merchandise, then "the new has to be made obsessively for the new." And when I speak of merchandise I'm not talking about an Alessi object—some objects can be fun . . . but what can we say when the whole of design is obsessively nothing but fun?—I'm talking about people turned into merchandise. When a designer sets himself the goal of proposing something different, cost what it may, he's certainly not a criminal, but the fact remains that he has become a cog in the mechanism of merchandise, perverted, a damn fool. And there's the problem again. I, personally, and a few others—in their own way, even without having the experience of being an artist, for example Castiglioni and Zanuso in some way did it, and some others, for example Mart Stam—try to give the dignity of art to this object of everyday use. I try to give it the dignity of art, but distancing myself from the icons of art. I know the artistic avant-

garde very well: for instance I was a friend of the very talented [body artist] Gina Pane, but it has never occurred to me to make the leg of a table look "wounded" . . . with a drop of blood. What is needed instead is to understand what quality an object of design should have to approach the quality of art, but without having to ape it.

G.B.: What significance has your intense artistic investigations of the 1950s and 1960s had for your work as a designer, investigations that saw you emerge as one of the leading figures of the Italian art of that period with the current of so-called Arte Programmata?

E.M.: What was the discourse of the Arte Programmata of the 1950s and 1960s? I started to do those works as a snub to the academic world. The issue at stake for me at that time was that I wanted to understand what aesthetic quality is. I wanted to understand it in rational terms, that was the naïveté of the time. I was ingenuous then, ignorant, unprepared, in short I wasn't surrounded by intellectual points of reference: fathers, friends, etcetera. Then I understood, twenty years later, that art is much more subtle and cannot be caged in a set of simple rules. I carried out this investigation in total ignorance of what had been going on in Germany especially. In the beginning they were investigations, inquiries, that I did for myself, but gradually, at a time when it seemed to me I was coming up with interesting findings, in an operation that was almost statistical in character, the problem arose of how to communicate them to others. In that period I was, in quotes, a "communist," but didn't belong to any party. Let's say I was deeply concerned about the problem of *égalité* and tried to make a contribution that was fundamental, or at least I thought it was. Then a few more people stumbled across this line of investigation, and at a certain point I even found myself, for about two

Enzo Mari
Marble Vase
From the series "Paros"
*New Proposals for the
Working of Marble and
Glass*
1964
Proj. 745 for Danese

years, acting as co-ordinating secretary of all the European groups of artistic investigations that were devoting themselves to what from a certain moment on came to be known as Arte Programmata and Kinetic art. On the one hand, today I feel like saying it was a very naive thing, but on the other it has to be admitted that much of that investigation actually anticipated or interpreted computer-based processes: the program, the rationality, how a form is arrived at. As you know, in those years my naïveté led me to think straightaway that what I had discovered about the importance of form could be communicated to workers and, contemporaneously with my research, I started to design objects of everyday use, not for the market, but as models . . . allegories of a different society in which labour would no longer be a source of alienation. Even today I am still pursuing this conscious folly . . . but it is a question of dignity.

I went on doing these things, almost from force of habit, up until 1968. Then, at a certain point, I made the ideological decision to refuse to take part in the joint exhibitions. In 1968 I wrote a sort of manifesto entitled *Un rifiuto possibile* [A Possible Refusal], in which I involved Castellani, Le Parc and others, and on that occasion I set out to challenge the adverse effects of the art market by deciding not to participate any longer in what I considered to be its most compromised manifestations, joint exhibitions.

But you see Giampiero, I think that today I'm the only one from that group of artists who is still seeking the values of those poetics [Arte Programmata] in the multitude of occasions for doing something. I raise the same old problem: where does quality lie? How can these matters be discussed with people? How can we get them out of the mire of apathy into which they have been thrown?

G.B.: Is there, in your view, a two-way relationship of cause and effect between artistic explorations and explorations into what is called design?

E.M.: I'll take as a reference the catalogue of works assembled for your exhibition. On the one hand we find the poetics of art. Then from the poetics of art derive, with different degrees of interest and coherence, the decorative arts. That is to say there are people we can define as "decorators," who take, for example, the Arte Floreale style, the "goodness-knows-what style" and then make a little vase. I'm well aware that you can't say simply that they've made a vase, but let's just say that at that moment there was the Arte Floreale style and these decorators "used" it. Up until 1800, or at the most, with a whole series of contradictions, up until the mid-twentieth century, this was all quite clear. That's how things had always been. History reminds us that there are works of art that shape the poetics, that determine the course, that set the tone for things, and then all the rest are decorative arts. But even today—I mean the last fifty years—on the one hand there are works of art, that is significant works of art and not the bedlam we see around us, and then on the other there is a large component of decorative art. I'm talking about from 1950 to today. To be clear, even in the 1950s, traditional components of the decorative arts could be found in the work of some artists who presented themselves as representatives of the new aspirations of modernity. This is obvious in the work of Gio Ponti for instance. So in the 1950s and 1960s the question was still fairly confused. But then in 1970 we began to see—and this continued in 1980, in 1990 and in 2000— let's say, at a rough estimate, to be optimistic, in somewhere around 50% of products [unfortunately I think the real figure is actually much lower], the signs of a new culture called "design," whatever

Enzo Mari
Tonietta Chair
Die-cast aluminum and
injection-moulded
polyamide
1980–85
Proj. 1318 for Zanotta
The elements that make
up the disassembled
chair show a parallel
with the historic structural
system of the model 14
Thonet chair, to which
the *Tonietta* clearly pays
tribute.

its poetics may be, that wanted and had to be something different from the other 50%, which are just products of decorative art. I'm unhappy that here these two values get mixed up. These two values shouldn't be confused. I'm talking about design as it has always been understood in the community of designers. For example I have always contested the limited nature of the expression industrial design, but it is fairly clear. For example in the case of Castiglioni, if you ask me to position him in one of these two worlds, that of design and that of the decorative arts, there can be no doubt that his place is in the world of design. Zanuso's place has never been in the decorative arts. The early Sottsass, when he was working for Olivetti, was certainly in the world of design, but when the later Sottsass, in rebellion against the banalities, not to mention the rest, of the industrial world, produced a "different" kind of design, he was actually placing himself in the panorama of the decorative arts. I understand his rebellion, it's mine too. But my craziness

has made me choose to remain in design, fighting against everything I don't agree with in the world of industry. Always raising with determined passion ethical arguments . . . which should also be understood as technical arguments. If the word design implies quality of form, anyone can see that the form of great works of art is the only possible materialization of ethics . . . What else can I say? The same is true for Mendini and Pesce: they put themselves in the decorative arts.

I can conclude by observing that the exhibition you are helping to put on ought to be divided into Art . . . Design . . . Decorative Arts, independently of their respective degrees of quality.

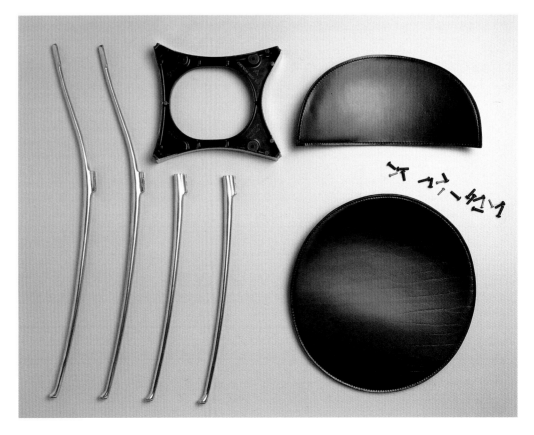

Conversation with Alessandro Mendini

Giampiero Bosoni: As I was looking through the recent collection of your complete writings I came across an interesting "open letter" to Achille Bonito Oliva written in 1988, where you talked about "pictorial" design and "designed" painting. This is a topic you had already addressed in a 1977 conversation with Pierre Restany. In light of your specific interest in this regard, do you feel there has ever been, and still is, a cause and effect relationship—one that works both ways—between the artistic quest and what is pursued in design?

Alessandro Mendini: Yes, certainly. Talking about this, creative adventures such as Constructivism, and Futurism in Italy, immediately come to mind. Futurism was very important for someone like me. It was a sort of coming together of alphabetical signs and utopian intentions that could be transposed onto two or three dimensions, on a small or a large scale, and that generated architecture, stage design, interiors, furniture, graphics, and objects as well. And as I see it, this all has a further value since I tend to see an object almost as if it were a sort of still life; so I like to design an object and then paint it so that I get a result along the lines of a still life.

G.B.: At the beginning you said that a fundamental reference point for your creative pursuit is the Futurist movement, but as you continued, you revealed a more, shall we say, interior aspect of it, in some ways falling between the playful and the dramatic, a more static aspect, the still life, typical of metaphysical thinking, and something that seems to surface in your work with renewed emotional power.

A.M.: Exactly. Those two components are there. For example, if you look at the work of the painter Savinio, you will see that he created still lifes containing accumulations of objects that look like they were recent creations of the designer Giovannoni—playful, pink, azure, or beige objects. Or else, those pictures by Casorati where you see a table with a bowl and three eggs on it, which are practically works of design in their own right, or at least, Casorati has interpreted the objects in a quasi design-oriented way.

G.B.: Along those lines, we have a few furnishings by Casorati in the exhibition that he designed and had someone build as objects to be reproduced in still-life paintings, to use as decorations in the painted settings—it is an interesting transposition of the conceptual model of

Alberto Savinio
The Annunciation
1932
Casa-Museo Boschi
Di Stefano, Milan

the metaphysical world into daily reality.

A.M.: Indeed. But also the photographs of Morandi's jars, the bowls that were made opaque, perhaps by coating them with plaster, in such a way that they should inspire an idea of missing gloss—how to put it?—showing in Morandi too the relationship that exists between the real object and what he designed as the setting for his painting. This relationship between reality and how things are seen is very interesting to me. On the other hand, when I speak of Futurism, I am talking about a general utopia, of a sort of "stylematic" occupation of the world. Because as I see it, in Italy, after Verrocchio's workshop, to cite an important Renaissance model—meaning by that an infra-artistic place where they did everything from sculpture to architecture to decoration and so on—we move on to the workshop of Futurism, the workshop of the wizardry of Depero, where we now have sounds, noises, and the whole theme of dynamics. Then there was the workshop of the "*bel design italiano*," which began to develop after World War II. And I think that the studio of the Castiglioni brothers, their studio, for example, represents very well that happy period that the Americans took to calling Italian "good design" in the 1960s. Then, on the actual level of movements, I would associate Studio Alchimia, and later Memphis, with this guiding theme. They also represent models of workshops dedicated to infra-artistic research. These are all specific entities united by the idea of synthesizing the function of the object into its emotional extreme: a "subspecies of art."

G.B.: In fact, in that 1988 letter to Achille Bonito Oliva, which you published among your writings, you talk about your desire to undertake the "subspecies of art" design project.

A.M.: (smiles)

G.B.: Then you associated with this definition your hypothesis that there is both "designed" painting and "pictorial" design. Can you explain a bit better what you mean by these definitions, and what interrelationships have been created between them? Because it seems to me that you don't see it just in your own work, but you also read it in a context that particularly regards Italy.

A.M.: Yes, I think so. Because, for example, a facade like that of the Palazzo della Stampa in Piazza Cavour in Milan, designed by Muzio with the painter Sironi, with a large bas-relief by Sironi right in the middle of the facade, is a facade-sculpture. It is a bas-relief facade with an extremely intimate integration between the two disciplines: architecture and sculpture. In certain cases the facade of a palazzo or its overall architecture—even in Terragni's Fascist party headquarters—is a sort of grossly enlarged maquette, or else a sort of painting on an architectural scale. Naturally, I realize full well that this is a tendentious reading.

G.B.: The relationship between Muzio and Sironi is even more interesting when we recall that Sironi also worked closely with Terragni. Here it is interesting to observe how the historical dualism represented by the Novecento movement in Milan and Rationalism had been deeply characterized by a relationship of encounter-collision through figures like Sironi, who actually constituted within it an important aesthetic and cultural link.

A.M.: But then this characteristic has extended to our times: Sironi, in a certain sense, became Aldo Rossi. By this I mean that Aldo Rossi's architectural designs, so charged with emotion or with a sort of metaphysics of a very Sironian sort, are practically a sort of superimposition over the facades of the architecture itself. If you look at the facade of the hotel he designed in Japan, or the Teatro del Mondo in Venice, which is a macro-sculpture, you can't figure out what kind of objects they are, what three-

Alessandro Mendini
Kandissone Carpet
"Bau.Haus" Collection
1980
Studio Alchimia

dimensional form they have. They are an ideal abstraction that strongly coincides with his initial pictorial design.

G.B.: In your opinion, has this relationship between architecture, the design of household implements, and the art world in Italy remained constant, disappeared, or been affirmed only in certain periods?

A.M.: Well, if I think about Munari, who in my opinion is an artist in all respects, a complete artist, he conceived and designed objects from the 1930s to the 1980s. Then I think of Enzo Mari, who began with some very interesting works in the realm of planned art. If I think of the Castiglioni brothers as well, what immediately springs to mind is their way of playing with Dadaism. But there are certain creators who are much more strictly designers, even though they naturally have a typically Italian aesthetic style. In this sense you couldn't say Magistretti behaved like an artist; his is an example of a complete designer. If anything, we have to recall that he is an architect and belongs to the first cultural phase of the Italian architectural quest led by E. N. Rogers, editor in chief of the magazine *Casabella* in the second half of the 1950s.

G.B.: Certainly, but [Magistretti] had a deeply humanistic background.

A.M.: Very, for those times.

G.B.: [He is] a designer with roots, as Magistretti has often stated, in Greek and Latin, a grounding in classical studies, rather than having—as it were—practised the science of building or [precepts of] the school in Ulm. In this regard certain creators considered to be classic examples of what you call Rationalist "*bel design italiano*," show a different attitude in their relations with the arts and aesthetic quests in general. For example, what do you think of Franco Albini and Marco Zanuso in this regard?

A.M.: I see them more as technology-oriented designers. Among other things,

both of them are strongly linked, in the classic sense, to architecture, and you can never figure out what it is that interests us most about their work. And their relations with artists do not seem to me to be dedicated to a specific interest in integrating their respective pursuits; it is more a collaborative relationship. True integration, as I see it, is seen in the early works of Vittoriano Viganò. When he did those small art galleries in the early 1950s, you can see how he tried to get in tune with Fontana on the one hand, and with Munari on the other. His home, for example, his apartment in Milan, is truly extraordinary!

G.B.: Regarding cultural intermixings, in one of your texts dedicated to the 1970s, you describe the path of your cultural development and speak often of your interest—one might say your "fatal attraction"—more for the works of contemporary artists than of designers. In particular, I was struck by the reference to your encounter with Joe and Gianni Colombo where you say, "I admired in my university friend Joe Colombo his ability to be at once a designer and a hard-core painter." This quality of Joe's was further amplified by the natural bond he had with his brother, Gianni, one of the most interesting artists in the Italian art scene of those years, with whom he designed one of his most famous pieces, the *Acrilica* lamp.

A.M.: Both of them were friends of mine, but separately, and I don't actually know how often they spent time together. Their paths were really quite different. Of Joe Colombo I remember his extreme exuberance, somewhat like Starck. He was an extrovert in his sports car, and clearly had a zone in his brain that was informal and thus a sort of "hard core." There was a sort of overflowing of freeborn, material images, and then his ability to grasp the substance of any object and to cultivate it with new materials: the works for Bayer and all.

343

Gianni was much more analytical, much more rational. Joe was all instinct.

G.B.: Your professional career began as a collaborator in the Nizzoli studio, and I imagine the figure of this designer, with his impressive artistic background, was a point of reference for your subsequent design-oriented development.

A.M.: Let us say he was a virtual point of reference, because I joined the Nizzoli studio after he was already gone and so I never actually met him. But his legendary name hovered there in the air. I found myself in the Nizzoli Studio on Via Rossini, where Nizzoli had worked with Persico in the 1930s. Sure, I can say that perhaps I got some of my sense of decoration, my sense of embroidery, my sense of "defuturized" design from the air I breathed there. As for architecture, that was the formula within which I developed—although I have to say that even before that there was the architecture of Portaluppi, who designed the house on Via Jan where I grew up with my uncle, Antonio Boschi, and my aunt, Marieda Di Stefano. My strong attraction to Portaluppi had nothing to do with the paintings in my aunt and uncle's celebrated collection of art. I could have designed the decorations of that architecture myself—not that I lean towards plagiarism—but for example in the Boschi house there is a painting by Severini that is very symmetrical, it is a sort of stellar, clear architecture. Then there is the post-Futurist aspect of Portaluppi with all the pointed elements in his decorations.

G.B.: So, your youth spent in the house designed by Portaluppi on Via Jan, filled with your aunt and uncle's extraordinary collection of twentieth-century Italian art evidently represented for you the crucible for your first—shall we say—alchemic experiments with the figurative elements and materials of your poetics, of your design language.

A.M.: It certainly was something important. By the way, I have to tell you that my aunt and uncle didn't frequent the world of architects. Design never entered that house on Via Jan, except for a few pseudo-Zanuso armchairs, or the furniture designed by Portaluppi. I was always struck by my aunt and uncle's total lack of sensitivity to architecture and to design. I didn't actually discover design until later when I was at the university and then afterwards when I encountered Nizzoli's thinking.

G.B.: But in the years of your early development, I mean, when you were in school in the 1950s and 1960s, what sort of relationship of attraction or repulsion did you feel between the world of design that you were beginning to be exposed to, and the world of the art collected in your aunt and uncle's house? Did you feel any conflicts emerging at the time that were difficult to sort through, or were the relationships among the arts still close and established and something you could communicate immediately?

A.M.: No, there was a sort of gradual wearing away, a sort of friction, in the sense that while I was going to university I was living in that apartment on Via Jan, where I had paintings by Savinio and Virgilio Guidi in my room. I didn't know what sort of things went on in the architecture department. I was fresh from the country, from around Verona. I was very young, seventeen years old, and I enrolled in the engineering department at the Milan Polytechnic because my grandfather had a construction business and ever since I had been born I was told that I would be an engineer. At the Polytechnic I discovered the architecture department and it immediately struck me as being— how shall I say it?—more pleasant. I crossed paths occasionally with Portaluppi, who was a sort of hard-core Fascist. And later I also caught a glimpse of Gio Ponti. And so I asked my parents

Alessandro Mendini and
Francesco Migliaccio
shown painting a
Poltrona di Proust
"Bau.Haus" Collection
1980
Studio Alchimia

to let me transfer to the other
department. Back then I really loved to
draw, albeit in an unrefined sort of way.
My goal was to become a caricaturist.
I liked caricature, I liked humour and
satire. Later, after I'd been a student for a
number of years, I also made my
contribution, as secretarial aide to Gio
Ponti, to the idea of creating the Museum
of Modern Architecture. Ponti was totally
dedicated to this. He wrote dozens of
letters every day to all the industrialists
he knew to get some funding. Then he
put together a scientific committee that
included all kinds of people such as the
architectural historian Argan and the
enlightened businessman Roberto
Olivetti. I remember that Ponti would
call me at 6:30 in the morning, or else on
a Sunday evening, completely enamoured
of his project, which in the end led to
nothing. Ah! This thing really gave me a
lot in terms of culture. Because driven by
this practical idea of creating a museum
you get down and study, you really try to
understand. I don't know whether
I should consider Ponti my teacher, but
I certainly admire his full spectrum
genius, his energy to do the work of fifty
people.
I have to admit that when I was spending
time with Ponti, his image had been a bit
denigrated by modern culture: there was
Rogers, for example, who "smirked"
[at his work], and as the Pirelli
skyscraper was being built, many
compared it to a giant nightstand.
Anyway, in regard to all this, my start in
design went like this: I joined the Nizzoli
studio in 1968. A small community took
form there and I was part of it. We
thought mainly about the importance of a
democratic design process in the studio
rather than about the quality of what
would come of it. We lived a sort of myth
of the dynamic design collective. And
right about then I started working with
Casabella and came into close contact
with artists like Paolo Scheggi, Getulio

Alviani, Gianni Colombo, Davide Boriani,
Toni Trotta, and others like them.
When I became editor-in-chief of
Casabella I started drawing in
Archizoom, Superstudio, Ettore Sottsass,
Gaetano Pesce, Gianni Pettena . . . you
know, all the trendy players in Radical
Design. The first objects I made were
objects to be used on the covers of
Casabella: the chair made of bales of
straw, the burnt chair, the bronze
suitcase, which I called spiritual objects,
object-ideas born of a religious spirit.

Conversation with Gaetano Pesce

Giampiero Bosoni: Is there, in your opinion, a cause and effect relationship— one that works both ways—between artistic explorations and explorations into what is called design? And what has been, in this regard, your relationship with artistic investigations?

Gaetano Pesce: In the late 1950s and early 1960s, when I was engaged in artistic expression through Arte Programmata, I frequented the studios of both architects and artists who more or less fell into the humanistic tradition. For me the turning point came in 1964 when I met two people who opened my eyes to a world I had never known: industrial design, that is, creativity expressed in accordance with the needs of industry. One of them was Milena Vettore, at that time a student at the Venice Istituto superiore di Disegno Industriale, a school that no longer exists. The other was the industrialist Cesare Cassina.

And I realized that if I followed the romantic artistic legacy of those times I would inevitably end up on a limited path that marked the life of every artist of the time, a path that led from the workshop to the art gallery. Vettore and Cassina helped me understand that contemporary creativity was associated with the new reality of our times. It did not subscribe to the romantic ideal of art, but rather to industrial production. It was all clear enough if I just looked around me: the clothes I was wearing, the books I was reading, the music I listened to, and the car I drove were all industrial products.

And hence the traditional artistic pursuit per se lost all interest for me. Setting aside the romantic notion of art meant picking up the development of what art had been in the previous era: a set of products designed to meet the needs of a select clientele, an applied art where the portrait, the landscape or the nude corresponded to a well-defined demand. But even then, however, mastery and art were two distinct concepts. Among the quality products, some were distinguished by being exceptionally innovative in terms of themes and language, something that we would term, then as now, artistic.

G.B.: In 1975, in *Marcel Duchamp est mort*, you wrote: "The sculptor should work in the field of 'design,' which, once it has been freed of functionalist-rationalist pressure, is a language like any other." Today, in 2005, to what degree may we consider "design" to have been freed of functionalist-rationalist pressure,

347

Gaetano Pesce
Model for the design
of a "Vertical Loft"
1982

and to what extent is "design" to be defined as a language like any other?

G.P.: In the shift from romantic art to industrial art, Marcel Duchamp's works touched me the most profoundly. The works he had been exhibiting in art galleries way back at the beginning of the century, his ready-mades, were industrial products. But there was still something confining about the new perspective I was exploring, impersonal elements that limited subjective expression both in terms of production based on the form–function dyad, and regarding the clientele, an indistinct and amorphous entity.

Would an industrial product have allowed me to express myself with the same subjective freedom as traditional art? Because if so, if, that is, the producer were able to instil in the product his or her life experience, his or her political, philosophical and religious credo, then there would no longer be any difference between art and design.

Today the answer is clear. Design has become an expression of creativity that is much closer to our contemporary reality than the traditional fine arts, which seem to be irremediably marked by academicism.

A spoon is a spoon, but not all spoons are created equal. The thing that distinguishes one industrial product from another is not its function, but the innovation of its language. That's where the artistry is, the cultural element. This added value does not appeal to all clients. Part of the public appreciates creativity while another is solely interested in function.

G.B.: In his famous 1959 text *Il divenire delle arti* [The Future of the Arts], Gillo Dorfles wrote in the section "Art, engineering, and industrial aesthetics" that "today's art is different from yesterday's and unlike that of tomorrow, both in terms of 'form' and—what matters most—in terms of 'function.'"

Starting from this premise, Dorfles ended up hailing design as an emerging art form with characteristics that at that time were premonitory, closer to the epiphenomena of style and fashion. Almost fifty years later, in light of the great transformations that have occurred in the art world and elsewhere, do you feel that design could be considered at this point a form of contemporary art?

G.P.: Gillo Dorfles is right. Time is the ever-present factor in the lives of all generations of human beings since the beginning of our world. Time is not merely a system of measurement, it is also a judge that constantly redefines values, stripping them of their absolutism.

What Benjamin said in his time in no way applies when the cultural characteristics of an epoch change. The musical expression of Mozart no longer mirrors the times in which it was conceived. Likewise, today's art is no longer the academic art of yesterday, but an expression associated with the idea of production, I mean, a creative project that becomes a product.

Design kept the promise we glimpsed in the late 1950s. It has become full-fledged creative expression.

Let us just think of the recent past. In the nineteenth century, when the Impressionist movement had already been in swing for twenty years or so, the critics continued to exclude it from official exhibitions and to consider the so-called *pompiers* to be artists. Time has shown that it was precisely the excluded ones who were expressing the art of their times and opening up new horizons.

Two hundred years from now, someone looking at my *Up* armchair from 1969 will have to try to see it within the context of our times in order to understand the creative motivations of its creator, otherwise it will just appear to be a purely functional and decorative object.

Gaetano Pesce
Amazonia Vase
1995
Produced by Fish Design,
New York

But we still have to wonder if this awareness is really so widespread. Are we not still experiencing the same phenomenon that excluded the Impressionists from the major exhibitions of their time? Are we not perhaps still considering art the imitator of an academic creativity, while marginalizing the true artistic expression of our times—design?

G.B.: In Italy since the beginning of the twentieth century, I am thinking especially of the explosion of the Futurist movement, but going farther back still we might also recall some eclectic movements at the end of the nineteenth century, art and the design of everyday objects have had frequent points of contact. So much so that in certain cases we might speak of an exchange inspiring experimentation, whether aesthetic or technical, across various fields of activity, leading to inevitable overlaps. As you see it, has this relationship been a determining factor in the development of a certain way of doing design in Italy?

G.P.: Unquestionably in Italy in the first half of the twentieth century there was a true revolution in the way of conceiving and developing the great Italian art of previous centuries. The great luminaries of Romanticism, Gothicism, the Renaissance, the Baroque and Neoclassicism were made into the creators who express themselves in ways that have something to do with the idea of industrial production. In the twentieth century, the equivalents of Duccio da Boninsegna, Michelangelo, Caravaggio, Guardi and such are the big names in fashion, automobile design and Italian cuisine; they are the artists and industrialists associated with Italian design.

Traditional art is not going to disappear, but it is relegated to the world of a small intellectual elite, while artistic expression linked to industrial production allows Italian creativity to fulfill the needs of the world, and continues to possess the characteristics of universal communication that marked the great art of the past.

Industrial art has succeeded in overcoming the limitations of origins, the impersonality of the function, and the abstraction of the client, shifting from the serial production of copies to the production of originals, in which every piece may be different from the next. Flexible, deformable and elastic, moulds admit a degree of randomness, products that allow error. The quality is in the anomaly.

Now I am working for someone who chooses. And he or she can choose because the products are all different from one another. The client is no longer abstract.

In our era, the hope for industrial creativity is to create more limited series targeted to economic and cultural minorities: not a spoon for everyone, but an infinite series of spoons to satisfy infinite individual demands. In this new world of artistic expression, creators and thus also designers would be intellectual "traitors," experimenters who are capable of contradicting and betraying even themselves.

Conversation with Mario Bellini

Mario Bellini
Model of the Control
Console of the *TCV 250*
Computer
Produced by Olivetti
1967

Giampiero Bosoni: You were trained as an architect, and then you had a long period of great success as a designer. Over the last ten years you have devoted your attention chiefly to architecture again, with prestigious results. In light of this experience, what is your view today of the relationship between design and other fields that have historically been closely linked to the origins of design, such as the decorative arts, artistic experimentation and the world of architecture? Do you regard them as separate, associated or in some way reconciled?

Mario Bellini: First of all I want to say that what is fundamental in all this for me is a short essay I wrote for *Domus*, when I had been editing the magazine for four months, in which I presented just this argument, establishing a connection between technique, architecture, art and so-called design. In that article I also tried to question the use made of the term design: a word that is syncretistic, vague, meaning everything and nothing at the same time, and one where any attempt to define it according to the various schools always brings you to a crisis point. If design is one thing, then, I don't know, it turns out that what Branzi does is not design; or if design is another thing, then it turns out that everyone does design. Then there are expressions that make me cringe when I hear them, such as: so and so is a company of design, or such and such is an object of design. When I hear these expressions my spirit, somewhere between the lay and the rational, shudders, because I know that it's an imbroglio. And I'm immediately tempted to respond in an irreverent way: and so all the theory from which this word "design" pretends to derive, you're negating it, rendering it ridiculous, because it means that you're using it in the sense of a "style." Saying this is a "chair of design" is like saying this is a Biedermeier chair. Something that, in any case, does not scandalize me, and I have to admit at once to being sure that in a few decades the word **"design"** will be remembered as a label for a particular cultural period. The word style, moreover, was demonized during the early years of Modernist enthusiasm in which the concept of design was born, precisely because the aesthetic theory on which it was based and defined started out from the rejection of styles. People said that's enough, the new way of designing should be based on the relationship between needs, function, technology and

materials, and styles have to vanish. Something that, I have to admit, makes no sense.

G.B.: The famous motto "form follows function."

M.B.: A statement of a monstrous, crude naïveté. Every age expresses its culture, its way of being, its vision of the world, through its style. It is ridiculous to think that two thousand years after the birth of Christ, at a certain moment, nothing was true any longer, and a new thing was born because we are, who knows, more intelligent. It's a very stupid idea.

G.B.: But this noble word style is transposed or wrongly interpreted by some, who associate it with the idea of decoration, in the sense that decoration has become a synonym for style.

M.B.: I'm well aware of it. In fact it's even worse than that: in the early days of the ADI [Associazione per il Disegno Industriale, late 1950s], I was very young, and I remember clearly that a distinction used to be made between "design" and "styling". Styling was something disgusting, it was sin, it was the immoral decadence of a commercial activity, and design was the noble thing.

I find this to be yet another enormous stupidity. In the past, moreover, there were the *Centri Stile* in the world of cars, and people used to pronounce the word with their lips curled, with a sneer. Now the problem has been solved by calling them *Centri Design*.

G.B.: Yet it has to be remembered that in that moment something happened that was wonderful in its linguistic ambiguity, and that has meant a great deal to the awareness of Italian design, Alberto Rosselli's magazine *Stile industria*.

M.B.: That was, unlike others, an educated definition.

G.B.: Do you think there is a relationship of cause and effect, in both directions, between artistic exploration and exploration into what is called design? Do you think there is an Italian way, in contrast to foreign models, in which this type of relationship is particularly manifest?

M.B.: There certainly is. I'm more and more convinced of it and I become increasingly aware, the older I get, and the more experienced I am, of just how much we owe—and perhaps to some extent the other way round as well—to

Mario Bellini
GA 45 Pop Portable
Record Player
1968
Produced by Minerva

Mario Bellini
Model of *Teneride* Office
Chair
1970

"artists," in the broad sense of the term, who, and it's a mystery as to how or why, have always seen, sensed and opened up new directions. And I'm not saying this because I feel I belong to a second-class tribe, but in great pleasure at benefiting from the fact that there is a circularity, a permeability, a porosity between all the activities of experimentation, of design, etcetera, that turn around the notion of the "visual." After all, we shouldn't forget that they are all called "visual arts."

G.B.: In fact the Bauhaus was one of the highest moments in the history of exploring into design, bringing together painters, glassworkers, ironworkers, potters, weavers, architects, colour theorists and so on.

M.B.: That's right, and that was also the very moment of birth, in my view, of an ossified theory, the German one, which was not so much that of the early Bauhaus as that of the school of Ulm in the early 1960s: an "objective" theory that, partly with the unconscious aid of our highly poetic artist Bruno Munari, denied the possibility of art having any value in design. Paradoxically this new discipline, this new way of doing things, was based precisely on the opposite to what had been the poetic work of that artist, Munari, who nevertheless went on saying things like "art doesn't interest me," "design is not art," "design is exactly this balance between form and function" and so on. These are pathetically and extraordinarily ingenuous statements to make, perhaps because the person who made them felt the need to defend himself with declarations of faith. Like saying: I believe in the One and Triune God . . . and the more you embroider on it and the more you explain it, the madder you get over something that cannot be explained; something that on the one hand is very noble, and on the other is completely up in the air. So the more Munari insisted on claiming "there's an enormous difference between art and

design," "I reject and deny art because my way of doing things is linked to design," the more in reality he, like someone trying to get going in the snow, went deeper into it. And in the end he found himself, now that he's not there anymore, in a situation that to us, his heirs, looks exactly like the work of a great artist. Isn't that so?

G.B.: It certainly is, and perhaps that explains better what he did in the years in which he worked, from the late 1920s to the late 1980s. Because the aim of Concrete art, which set out to undermine not just the concept of traditional figurative art, but also that of Abstract art still tied to the traditional canons of "painting," was probably to sweep away those systems by putting certain models in a critical position.

M.B.: In reality his art coincided with his declaration that "art doesn't interest me, there is no art." How many artists have based their entire work on the premise that "art is dead"? When you're an artist and start proclaiming the death of art, you go on being an artist, you can't get out of it.

G.B.: Well, you've put forward an argument, using the ADI and Munari as examples, that various attempts have been made in Italy to separate art from design in every way, only to discover that in many cases it has been a process, as with Munari, that led to the reconstruction of a new relationship between design and artistic quests, perhaps in a new humanistic perspective. On the other hand, along with Munari, for whom it is right to acknowledge an interesting artistic value to his overall project, we have to remember that other important designers have drawn on the themes of art, though undoubtedly in different ways. I'm thinking of Enzo Mari, Joe Colombo, Max Huber, Alessandro Mendini and Ettore Sottsass.

M.B.: Ettore Sottsass is another one, and perhaps it would be hard to find anyone

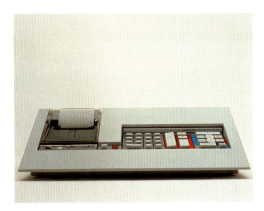

Studies with polystyrene
models and final version
of the Logos 50/60
calculator
Produced by Olivetti
1973

354

more of an artist than him, as in reality he's an architect/designer or designer/architect. I remember, when I was very young, that I was in quite close contact with him at the beginning, through Olivetti. I remember with what conviction, the conviction of a neophyte, a preacher, he used to talk about modules, concepts, series, about situations in which all the space was colonized with the "module 17 cm," for which there were the dedicated supports, tops and volumes. All this rampant "Ulmism" elaborated by someone who, in reality, has always been the opposite of all that, who did what we know he did. But because often, without realizing it, we are two-faced; we have a talent, an aptitude of whose dangers we are unconsciously aware, and we ward them off with these disciplinary declarations, standing up in defence of principles and theories that we think can shield us from temptation. Because in a way some people see this yielding to artistic inclination, to talent, to take pleasure in making something, to the uncontrollable movement and growth and rise of artistic talent, as sinful since it is something that you can't define with reason. How can you? It eludes you, you see. Then there has to be an instinctive sense of protection, and it's a thing that Mari feels, that Munari felt, that Sottsass has felt, in very different ways, this need to arm yourself, to defend yourself with the armour of a kind of "scientific" method [the so-called "design methodology"], and so on. And the same can be said for the whole beginning of the theories of design.

G.B.: But in the Italian case we have figures, including yourself, who have communicated and expressed points of view that are very different from one another. Sometimes they have been brought back to a common denominator, but in any case they are dialectically open to a debate that is continually bringing the system into question. This is something that in the world of international design, after the experience of the avant-gardes, doesn't happen any longer. Do you think there is an Italian way that actually characterizes design and artistic investigations in Italy?

M.B.: In some ways yes, but we have to step back a little. We need to let cool off all this heat generated by the continual talk of design. I, for example, have decided not to use the English word "design" any longer when speaking Italian. I would like to suspend the use of the term for three years and try to say everything we have to say without using it. I think this would be of extraordinary benefit: let's use the Italian word *disegno* instead, for furniture, for cars, for machinery, for lamps: *disegno* . . . it's so simple! Then nobody is going to say: this is an object of design. They will say this is a well-designed coffee pot, but designed in a way that reminds me of this or that. Why on earth should there be a "design coffee pot"? And if something is not "design," then what is it? It's rubbish! But who says so? But we're not going to be able to get away from it, because now it's on the television, in the newspapers, the comics, the weeklies, all the popular media: design, design, design, design . . . It's now spread so far that we can't control it any longer. No one is going to take this word back. And unfortunately we are worse off than English speakers, because in the English language none of this has happened, they have always said design. In fact, even today they call the architect who draws up the architectural concept—not the one who organizes how it's going to be put into effect, nor the one who oversees the work—the "design architect." If you said, here in Italy, about a given building "I am a *design architect*," people would think you were the decorator. And so we have this curse; it's terrible this thing.

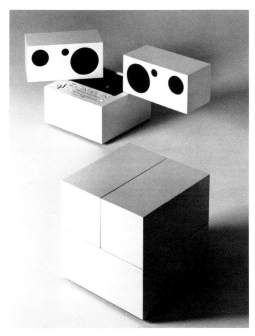

Mario Bellini
Totem Stereo System
1970
Produced by Brionvega

In England design is an ordinary word, for us it's a kind of jargon, a magic word.
G.B.: But I have the impression that by now it's spreading to the rest of the world.
M.B.: Because, in a way, it is we this time who are giving it this new connotation. But it lives with the two systems.
G.B.: What they would once have defined as "industrial design" . . .
M.B.: Well, the complete expression "industrial design" isn't used any more.
G.B.: Even in the English-speaking world by now they use, for the most part, the word design indiscriminately. So that, in this sense, they too are ready to call Branzi or Mendini designers, even when they produce one-of-a-kind pieces or just a few examples, in the same way as someone like Sapper rather than Meda designs pieces for mass production. Indeed a situation is being created in which the designer . . .
M.B.: . . . the less designer you are, the more you're a designer. Perhaps because some magazines have decided that Branzi is more of one than Bellini is.
G.B.: A world seems to have been created that is separate from the traditional industrial design of cars, cameras, etcetera, which is almost a world apart . . .
M.B.: Design has gone back into the companies. Mind you, I've already said all these things. Once I wrote an editorial in which I said: design will go back into the factories, into the companies, and the external industrial designer will no longer exist.
G.B.: It is no accident that there is a whole category that is looking with new interest at this question of design, I mean the world of art that is more attracted by the phenomena of decoration, or at any rate the operations that are, according to a certain tradition of the object, not just the decoration but also the aspect of magnificence and imagination, which has always been seen in art as the capacity to give expression to the emotion of a "gesture."

M.B.: Well, for me design has always been that. You'll never have heard me saying these monastic-sermonizing things. Not even once in my life. When I was younger, in 1960–61, I gave that famous interview to Gregotti for the monographic issue on "Design" in the magazine *Edilizia Moderna*. I laid out the terms of my way of thinking right there. In essence, I still subscribe today to 90% of what I said then.
G.B.: What, in your view, is the most distinctive feature of Italian design, understood as that broad "way," with different voices, of exploring the meanings, the uses and the different values of objects?
M.B.: What is Italian design? What makes this phenomenon different—if it is—from the rest? Basically, I think that there is a sort of Italian instinct to have, for example, little respect for authorities. To put it in a positive way: if technology, capital and the corporate pyramid are authorities, I, like many others—each in his own way—have always acted toward these structures with irreverent and positive freedom; something that—and this too is very Italian—was appreciated by our craftsman-industrialist clients. It made them feel straightaway that you had taken the reins of the carriage in your hand and weren't sitting behind like a lackey.

List of Exhibited Works

Franco Albini
Robbiate, Lecco, 1905 – Milan, 1977
1
Sideboard with Nesting Tables for the
Dining Room of Casa Ferrarin, Milan
1931
Macassar ebony, nickel trim
81 × 120 × 45 cm
Private collection
2
Radio
1938
Radio device, Securit glass
70 × 64 × 29 cm
Studio Albini Associati (arch. Marco
Albini, arch. Francesco Albini), Milan
Archivio del Moderno, Mendrisio
3
Mitragliera Lamp
1938–40
Brass, aluminum
108 cm
Studio Albini Associati
(arch. Marco Albini,
arch. Francesco Albini), Milan
Archivio del Moderno, Mendrisio
4
Swing Armchair for the "Living Room
of a Villa," VII Milan Triennale (1940)
1940 (recent reconstruction by Cosmit)
Enamelled metal, upholstery
222 × 75 × 95 cm (including bar)
Cosmit Collection

Franco Albini
Robbiate, Lecco, 1905 – Milan, 1977
Gino Colombini
Born in Milan in 1915
5
Margherita Armchair
1950
Malacca and Indian cane, viscose
rayon, foam rubber
99.1 × 78.8 × 78.8 cm

Produced by Vittorio Bonacina, since
1951
The Montreal Museum of Fine Arts
Liliane and David M. Stewart
Collection, gift of the American
Friends of Canada through the
generosity of Jay Spectre
Inv. D84.177.1a-b

Franco Albini
Robbiate, Lecco, 1905 – Milan, 1977
Franca Helg
Milan, 1920 – Milan, 1989
6
PL, 19 Armchair
1957
Metal, foam rubber, leather
93.5 × 81.5 × 76.5 cm
Produced by Poggi
Studio Albini Associati (arch. Marco
Albini, arch. Francesco Albini), Milan
Archivio del Moderno, Mendrisio

Andrea Anastasio
Born in Rome in 1961
7
Alba Chest of Drawers
1991 (example of 1999)
Lacquered wood, aluminum laminate,
methacrylic resin
121 × 126 × 50 cm
Produced by Design Gallery Milano
The Montreal Museum of Fine Arts
Liliane and David M. Stewart
Collection
Inv. D99.163.1

Archizoom Associati
Florence then Milan, 1966–74
(Dario Bartolini, born in Trieste in
1943; Andrea Branzi, born in Florence
in 1938; Gilberto Corretti, born in
Florence in 1941; Paolo Deganello,
born in Este, Padua, in 1940; Lucia

Morozzi, born in Florence in 1944;
Massimo Morozzi, born in Florence
in 1941)
8
Safari Sectional Couch
1967–68
Fibreglass, latex foam, cotton,
synthetic leopard-print upholstery
64 × 261 × 216 cm
Produced by Poltronova, 1967–68
The Montreal Museum of Fine Arts
Liliane and David M. Stewart
Collection
Inv. 2004.20.1-5
9
Mies Armchair and Footrest
1969
Chromed steel, latex sheet, pony skin
80 × 73.7 × 130.8 cm
Produced by Poltronova
Carnegie Museum of Art, Pittsburgh;
Second Century Acquisition Fund
Inv. 2001.8.1.A-B
10
*No Stop City, Parcheggio residenziale
Sistema Universale, paesaggi interni*
[No Stop City: Residential Parking
Universal System, Interior
Landscapes]
n. d. [1969–72]
Wood, plastic, metal, paper, cardboard,
tempera, acrylic, mirror and light
183 × 70 × 43 cm
Centro Studi e Archivio della
Comunicazione, Università degli Studi
di Parma
Inv. B007450 S

Gae (Gaetana) Aulenti
Born in Palazzolo della Stella, Udine,
in 1927
11
Coffee Table (model 2744/55)
1980

Glass, castors
25 × 110 × 110 cm
Produced by FontanaArte
FontanaArte SpA, Corsico, Milano

Luciano Baldessari
Rovereto, Trento, 1896 – Milan, 1982
12
Luminator Floor Lamp
1929 (prototype for the X Triennale,
Milan, 1954)
Chromed steel, wood base
184 × 100 × 53 cm (with base)
C.A.S.V.A. – Centro di Alti Studi sulle
Arti Visive, Comune di Milano
Inv. Collezione Mosca-Baldessari
I.C.7b
13
Model of the Breda Pavilion,
XXX World's Fair, Milan (1952)
1952 (later reconstruction
by L. Baldessari)
Plastic, bristol board, wood
17 × 85 × 30 cm
C.A.S.V.A. – Centro di Alti Studi sulle
Arte Visive, Comune di Milano
Inv. Collezione Musca – Baldessari,
Architectura, 3e

Giacomo Balla
Turin, 1871 – Rome, 1958
14
Ciac-Ciac Musical Instrument
1910–15
Painted wood, tin discs
58 × 8 × 6 cm
Museo Nazionale degli Strumenti
Musicali, Rome
15
Velocità e vortice
[Speed and Spin]
1913
Pastel on paper
49.3 × 69.5 cm
Robert and Alice Landau, Montreal
16
*Compenetrazione iridescente n. 5
(Eucaliptus)*
[Iridescent Interpenetration, No. 5
(Eucalyptus)]
1914
Oil on canvas
102 × 120 cm
Collection Yves Saint Laurent –
Pierre Bergé
17
Rumoristica plastica BALTRR
[Plastic Rumour BALTRR]
1914
Mixed media, watercolour, colour ink,
collage on cloth-lined paper
112.5 × 98 cm
Private collection
18
Painted Screen
About 1917

Oil on wood
124 × 58 × 9 cm
Private collection
19
Linee forza di paesaggio + giardino
[Force Lines of Landscape + Garden]
1918
Tempera on paper
54 × 76.5 cm
Mart – Museo d'Arte Moderna e
Contemporanea di Trento e Rovereto
Deposit of Società SOSAT
Inv. Mart 1119
20
Progetto per arredamento di salone
[Design for an Interior]
1918
Ink on paper
44.5 × 56 cm
Private collection
21
Box
1919
Painted cardboard
10.5 × 60.5 × 21 cm
Private collection
22
Chair
1920s
Painted wood
90 × 32 × 36 cm
Private collection
23
Magazine Rack
1920s
Painted wood
66 × 44 × 32 cm
Private collection
24
Futurist Vest
1924–25
Four-colour embroidered wool
61 × 56 cm
Fondazione Biagiotti Cigna

Ercole Barovier
Murano, Venezia, 1889 – Murano, 1974
25
Covered Urn
About 1910
Black amethyst glass, white fillets
40.3 × 23.8 × 21.6 cm
The Mitchell Wolfson, Jr. Collection –
The Wolfsonian-Florida International
University, Miami Beach, Florida
Inv. 84.8.21
26
"Tessere" Vase
1950s
Glass
H. 21 cm, D. 18 cm
Produced by Barovier & Toso
Royal Ontario Museum, Toronto
Inv. 957.102.1
27
"Tessere" Vase

1950s
Glass
H. 28.5 cm, D. 15.9 cm
Produced by Barovier & Toso
Royal Ontario Museum, Toronto
Inv. 957.103.2

Dario Bartolini
Born in Trieste in 1943
28
Sanremo Floor Lamp
1967
Enamelled steel and aluminum,
acrylic plastic
238.7 × 89 × 89 cm
Produced by Poltronova for Archizoom
Associati, 1968–72
The Montreal Museum of Fine Arts
Liliane and David M. Stewart
Collection
Inv. D90.192.1a-l

Ernesto Basile
Palermo, 1857 – Palermo, 1932
29
Armchair
1902
Oak, leather
77 × 54 × 62 cm
Execution: Vittorio Ducrot (1867–1942)
Private collection
30
Secretary
1903
Carved, painted and gilt mahogany,
leather blotter, bronze
170.2 × 132.1 × 49.5 cm
Execution: Vittorio Ducrot (1867–1942)
Metalwork: Antonio Ugo (1870–1956)
Painting: Ettore De Maria-Bergler
(1850–1938)
The Mitchell Wolfson, Jr. Collection –
The Wolfsonian-Florida International
University, Miami Beach, Florida
Inv. 84.11.17
31
Perspective of the Florio Pavilion
at the Milan Exhibition (1906)
1906
India ink on tracing paper
50.4 × 34 cm
Dotazione Basile, Facoltà di
Architettura, Università degli Studi
di Palermo

Vanessa Beecroft
Born in Genoa in 1969
32
The Ponti Sisters
Performance at the exhibition *Camera
Italia* (Associazione culturale Vista
Mare, Pescara) June 30, 2001
2 colour photographs, 1/3
177.8 × 218.4 cm (each)
Courtesy Deitch Projects
and the artist

Mario Bellini
Born in Milan in 1935
33
TVC 250 Terminal
1966
Steel, ABS
91.6 × 93.5 × 55.8 cm
Produced by Olivetti
Triennale di Milano
34
Divisumma 18 Calculator
1972
ABS, synthetic rubber
4.5 × 30.5 × 11.5 cm
Produced by Olivetti
The Montreal Museum of Fine Arts
Liliane and David M. Stewart
Collection, gift of Geoffrey N. Bradfield
Inv. D87.185.1
35
Cab Chair (model 412)
1976
Enamelled steel, polyurethane
foam, leather
80 × 47 × 42 cm
Produced by Cassina, since 1976
The Montreal Museum of Fine Arts
Liliane and David M. Stewart
Collection, by exchange
Inv. D93.254.1a-b

Gianni Berengo Gardin
Born in Santa Margherita Ligure,
Genova, in 1930
36
Venezia, aqua alta a San Marco
[Venice, High Tide in St Mark's]
n. d. [1955–60]
Gelatin silver print
40.5 × 30 cm
Centro Studi e Archivio della
Comunicazione, Università degli Studi
di Parma
Inv. C011978 S

Sergio Berizzi
Milan, 1930 – Boston, 1976
Cesare Butté
Born in Milan in 1930
Dario Montagni
Born in Trento in 1929
37
Television Set with Adjustable Screen
(model 17/18)
1956
Wood, iron, brass
120 × 50 × 50 cm
Produced by Phonola
Private collection

Renato Bertelli
Lastra a Signa, Firenze, 1900 –
Lastra a Signa, 1974
38
Testa di Mussolini (Profilo continuo)
[Head of Mussolini

(Continuous Profile)]
1933
Patinated terracotta
H. 34 cm, D. 27 cm
Mart – Museo d'Arte Moderna e
Contemporanea di Trento e Rovereto
Inv. 1396

Fulvio Bianconi
Padua, 1915 – Milan, 1996
39
Bottle
About 1950
Glass
40.7 × 8.2 × 8.2 cm
Produced by Venini, 1951–55
The Montreal Museum of Fine Arts
Liliane and David M. Stewart
Collection
Inv. D95.106.1a-b
40
Moore Vase
1951–52
Glass
H. 29 cm
Produced by Venini
Roberto Navarro
41
Vase
1952
Glass
H. 19 cm
Produced by Venini
Roberto Navarro

Umberto Boccioni
Reggio Calabria, 1882 – Verona, 1916
42
Io-noi-Boccioni
[I-We-Boccioni]
1907
Vintage photograph
9 × 13.5 cm
Private collection
43
*Forme uniche di continuità
nello spazio*
[Unique Forms of Continuity
in Space]
1913
Bronze
121.9 × 39.4 × 91.4 cm
The Metropolitan Museum of Art,
New York
Bequest of Lydia Winston Malbin,
1989
Inv. 1990.38.3

Cini Boeri (Maria Cristina Mariani)
Born in Milan in 1924
Tomu Katayanagi
Born in Japan in 1950
44
Ghost Armchair
1987
Sheet glass

61 × 93.5 × 63 cm
Produced by Fiam, 1987–98
The Montreal Museum of Fine Arts
Liliane and David M. Stewart
Collection, gift of Fiam Italia SpA
Inv. D98.121.1

Alighiero Boetti
Turin, 1940 – Rome, 1994
45
Afghanistan
1988–89
Embroidery on canvas mounted
on panel
106 × 114 cm
Mart – Museo d'Arte Moderna e
Contemporanea di Trento e Rovereto
Inv. Mart-Fiz 2305

Luigi Bonazza
Arco, Trento, 1877 – Trento, 1965
46
La leggenda di Orfeo
[The Legend of Orpheus]
1905
Oil on canvas (triptych)
Central panel: 146 × 166. 5 cm
Side panels: 145 × 76 cm
Mart – Museo d'Arte Moderna e
Contemporanea di Trento e Rovereto
Deposit of Società SOSAT
Inv. Mart 5

Osvaldo Borsani
Varedo, Milano, 1911 – Milan, 1985
47
P40 Chaise Longue
1954 (example of 1959–60)
Steel, paint, rubber, polyfoam, cotton
86.7 × 72.7 × 115 cm
Produced by Tecno, since 1955
The Montreal Museum of Fine Arts
Liliane and David M. Stewart
Collection
Inv. D83.116.1

Andrea Branzi
Born in Florence in 1938
48
Foglia Lamp
1988
Electroluminescent glass
25 × 45 cm
Produced by Memphis
Memphis Srl
49
A 56, A 38, A 28, A 51, A 46 Vases
From the series
"Amnesie e Altri Luoghi"
1991, 22/50, 11/50, 11/50, 14/50,
18/50
Aluminum
H. 44.2 cm, D. 11.4 cm; H. 28.2 cm,
D. 13.6 cm; H. 22 cm, D. 13.7 cm;
H. 40.3 cm, D. 13.6 cm; H. 34 cm,
D. 14 cm

Produced by Design Gallery Milano
The Montreal Museum of Fine Arts
Liliane and David M. Stewart
Collection, gift of Paul Leblanc
Inv. D93.297.5, 2, 1, 4, 3
50
Wireless Light Bookshelf
1996
Walnut, rice paper, metal
137.2 × 95.2 × 29.8 cm
Produced by Design Gallery Milano
The Montreal Museum of Fine Arts
Liliane and David M. Stewart
Collection
Inv. D97.100.1a-m

Carlo Bugatti
Milan, 1856 – Molsheim, Alsace, 1940
51
Armchair
About 1895
Wood, painted parchment, brass,
white metal, silk
149 × 75 × 58 cm
The Montreal Museum of Fine Arts
Purchase, Deutsche Bank Fund
Inv. 2002.9.1-2
52
Chair
Similar model to the chair for the
"Snail Room," Turin Exhibition (1902)
1902
Wood, painted parchment, copper
97.8 × 53.3 × 37.2 cm
Carnegie Museum of Art, Pittsburgh
Berdan Memorial Trust Fund, Helen
Johnston Acquisition Fund, and
Decorative Arts Purchase Fund, 1995
Inv. 95.16
53
Lady's Writing Desk
1904
Beech, painted parchment, copper
95.5 × 89.5 × 58 cm
Brooklyn Museum, New York
Frank L. Babbott Fund, Henry
L. Batterman Fund, Frank Sherman
Benson Fund, Carll H. de Silver Fund,
Frederick Loeser Fund
Inv. 71.74

Rembrandt Bugatti
Milan, 1884 – Paris, 1916
54
Le grand fourmilier
[Great Anteater]
1909
Bronze, 2/4
34.5 × 47.5 × 21.5 cm
Courtesy Galerie Cazeau-Béraudière,
Paris

Luigi Caccia Dominioni
Born in Milan in 1913
Livio Castiglioni
Milan, 1911 – Milan, 1979

Pier Giacomo Castiglioni
Milan, 1913 – Milan, 1968
55
Five-valve Radio Receiver
1940
Bakelite
24.5 × 25 × 27 cm
Produced by Fimi-Phonola Radio
Museo Casa Mollino

Corrado Cagli
Ancona, 1910 – Rome, 1976
Dante Baldelli
Città di Castello, Perugia, 1904 –
Città di Castello, 1953
56
Marcia su Roma Vase
[March on Rome]
1930–31
Ceramic
45 × 24 cm
Private collection

Duilio Cambellotti
Rome, 1876 – Rome, 1960
57
Bowl
1903–06
Bronze
H. 17 cm, D. 33.5 cm
Private collection
58
La falsa civiltà
[The False Civilization]
1905
Charcoal, tempera on paper
55.4 × 51.3 cm
Private collection
59
Curule Chair
1907–08
Maple
84 × 74 × 71 cm
Archivio Cambellotti
Collection
60
Lectern
1923
Walnut, maple marquetry, copper
plaques
166 × 118 × 45 cm
Metalwork: Alberto Gerardi
(1889–1995)
The Montreal Museum of Fine Arts
Purchase, The Museum Campaign,
1988–1993 Fund
Inv. 2004.143
61
La notte Chest
1925
Walnut, ebony, ivory
54 × 80 × 40 cm
The Mitchell Wolfson, Jr. Collection –
Fondazione Regionale C. Colombo,
Genoa
Inv. GX1993.209

Francesco Cangiullo
Naples, 1888 – Livorno, 1977
62
Crowd on the Piazza del Popolo,
Rome (Tavola parolibera)
1914
Watercolour on paper
74 × 58 cm
Private collection

Giuseppe Capogrossi
Rome, 1900 – Rome, 1972
63
Cartagine = Superficie 027
[Carthage = Surface 027]
1956
Oil on paper mounted on canvas
169 × 88 cm
Mart – Museo d'Arte Moderna e
Contemporanea di Trento e Rovereto
Deposit of Collezione Torinese
Inv. Mart-Fiz 2308

Carlo Carrà
Quargnento, Alessandria, 1881 –
Milan, 1966
64
Piazza del duomo a Milano
[Piazza del Duomo, Milan]
1909
Oil on canvas
45 × 60 cm
Private collection
Courtesy Claudia Gian Ferrari, Milan
65
Composizione TA (Natura morta
metafisica)
[TA Composition (Metaphysical
Still-life)]
1916–18
Oil on canvas
70 × 54 cm
Mart – Museo d'Arte Moderna e
Contemporanea di Trento e Rovereto
Inv. Vaf-Mart 970

Carrozzeria Castagna
Founded in Milan in 1906
66
Integral Aerodynamics on an Alfa
Romeo 40/60 HP Chassis
Reduced-size model for a car
commissioned by Count Marco Ricotti
and built in 1914
1913
21 × 57 × 18 cm
Execution: Conti
Museo Alfa Romeo, Arese, Milano

Carrozzeria Touring
Milan 1926–1966
67
Alfa Romeo *6C 2500 Freccia*
d'Oro
1947
Private collection

Felice Casorati
Novara, 1883 – Turin, 1963
68
Una donna (L'attesa)
[A Woman (Waiting)]
1918–19
Tempera on canvas
137 × 127 cm
Private collection

Felice Casorati
Novara, 1883 – Turin, 1963
Giacomo Cometti
Turin, 1863 – Turin, 1938
69
Sculpture "Chair" for Casa Casorati,
Turin
1925
Maple and spruce
72.5 × 56.3 × 54 cm
Execution: Giacomo Cometti
Fondazione Guido ed Ettore
de Fornaris, Galleria d'Arte Moderna
e Contemporanea, Turin
Inv. FD/109
70
Sculpture Pedestal for Casa Casorati,
Turin
1925
Applewood
125.5 × 65 × 29.5 cm
Execution: Giacomo Cometti
Fondazione Guido ed Ettore
de Fornaris, Galleria d'Arte Moderna
e Contemporanea, Turin
Inv. FD/111
71
Seat for the Music Room
in Casa Casorati, Turin
1925
Wood
40 × 40 × 45 cm
Execution: Giacomo Cometti
Private collection, Turin

Enrico Castellani
Born in Castelmassa, Rovigo, in 1930
72
Superficie sagomata
[Shaped Surface]
1962
Shaped striped fabric
70 × 50 cm
Private collection
Courtesy Galleria dello Scudo, Verona

Achille Castiglioni
Milan, 1918 – Milan, 2002
Pier Giacomo Castiglioni
Milan, 1913 – Milan, 1968
73
Luminator Floor Lamp
(model B9)
1955
Steel
180.3 × 48.3 × 40.6 cm

Produced by Gilardi & Barzaghi,
1955; Arform, 1957; Flos, 1994
The Montreal Museum of Fine Arts
Liliane and David M. Stewart
Collection
Inv. D85.171.1
74
Mezzadro Stool
1957
Chromed steel, enamelled metal,
beech
51.4 × 48.8 × 50.8 cm
Produced by Zanotta, since 1970
The Montreal Museum of Fine Arts
Liliane and David M. Stewart
Collection
Inv. D90.201.1
75
Sanluca Armchair
1959
Wood, leather, brass
96 × 87 × 100 cm
Produced by Gavina (1960–69);
Knoll International, 1969; Bernini,
1990; Poltrona Frau, 2005
Collection Pierre Bouvrette, Montreal
76
Taraxacum Hanging Lamp
1960
Cocoon (plastic over nylon thread),
metal frame
H. 51 cm, D. 84 cm
Produced by Flos
Flos SpA, Bovezzo, Brescia
77
Arco Floor Lamp
1962
Marble, stainless steel, aluminum
241.4 × 213.4 × 30.6 cm
Produced by Flos, since 1962
The Montreal Museum of Fine Arts
Liliane and David M. Stewart
Collection, gift of the American
Friends of Canada through the
generosity of Barbara Jakobson
Inv. D82.104.1a-c
78
Taccia Lamp
1962
Aluminum, glass, chromed steel
H. 53.5 cm, D. 49.5 cm
Produced by Flos, since 1962
The Montreal Museum of Fine Arts
Gift of Mimi and Jacques Laurent
Inv. 2004.29.1-3
79
Toio Floor Lamp
1962
Automobile headlight bulb,
enamelled steel
165.1 × 21 × 19.7 cm
Produced by Flos
The Metropolitan Museum of Art,
New York
Gift of Dr. Michael Sze, 2002
Inv. 2002.582.5

80
RR 126 Radio-gramophone
Stereo System
1966
Lacquered wood, aluminum
92 × 62 × 36 cm (closed)
70 × 124 × 36 cm (open)
Produced by Brionvega
Centro Studi e Archivio della
Comunicazione, Università degli Studi
di Parma
Inv. B007004 S

Achille Castiglioni
Milan, 1918 – Milan, 2002
Pio Manzù (Pio Manzoni)
Bergamo, 1939 – Brandizzo,
Torino, 1969
81
Parentesi Lamp
1970
Stainless steel, rubber, metal tube,
resin
H. 400 cm (max.); foot: D. 10 cm
Produced by Flos, since 1971
Flos SpA, Bovezzo, Brescia

Livio Castiglioni
Milan, 1911 – Milan, 1979
Gianfranco Frattini
Born in Padua in 1926
82
Boalum Lamp
1969
PVC, metal
L. 190 cm, D. 7 cm
Produced by Artemide, 1970–84
and since 1999
The Montreal Museum of Fine Arts
Liliane and David M. Stewart
Collection
Inv. D97.161.1

Pierluigi Cerri
Born in Orta San Giulio, Novara,
in 1939
83
Thieme / Schafft / Wissen 1886-1986
Poster
1986
Lithograph
100 × 70 cm
Pierluigi Cerri

Sandro Chia
Born in Florence in 1946
84
La rastrellatrice
[The Raker]
1979
Oil on canvas
140 × 210 cm
Mart – Museo d'Arte Moderna
e Contemporanea di Trento
e Rovereto
Inv. C. Grassi Mart 1480

Galileo Chini
Florence, 1873 – Florence, 1956
85
Vase
1901
Earthenware, lustre glaze
H. 40 cm
Produced by Arte della Ceramica
Bardelli Casa, Tuscany
86
Vase
About 1903–04
Earthenware, lustre glaze
H. 42 cm
Produced by Arte della Ceramica
Bardelli Casa, Tuscany
87
Vase
1910
Earthenware, lustre glaze
H. 28 cm
Produced by Manifattura Chini
del Mugello
Bardelli Casa, Tuscany

Antonio Citterio
Born in Meda, Milano,
in 1950
Glen Oliver Löw
Born in Leverkusen, Germany,
in 1959
88
Mobil Storage Unit
1993
Thermoplastic polymer, chromed
steel, plastic
98.1 × 60.5 × 47 cm
Produced by Kartell, 1993–96
The Montreal Museum of Fine Arts
Liliane and David M. Stewart
Collection
Inv. D95.190.1

Francesco Clemente
Born in Naples in 1952
89
Semi
[Seeds]
1978
Tempera on paper
179.5 × 189.5 cm
Mart – Museo d'Arte Moderna
e Contemporanea di Trento e Rovereto
Inv. C. Grassi Mart 1471

Plinio Codognato
Verona, 1878 – Milan, 1940
90
Fiat 514
Poster
1930
Lithograph
195 × 140 cm
Arti Grafiche Bertarelli, Milan
(for Fiat)
Archivio Storico Fiat

Ettore Colla
Parma, 1896 – Rome, 1968
91
Triptych:
Assedio
[Siege]
Svolgimento
[Development]
Rilievo
[Relief]
1951
Painted wood relief
65 × 100 cm
70 × 100 cm
70 × 100 cm
Mart – Museo d'Arte Moderna e
Contemporanea di Trento e Rovereto
Inv. Mart 399, 400, 401
92
Brooch
1964 (based on a 1953 relief)
Yellow gold
7 × 5 cm
Private collection

Gianni Colombo
Milan, 1937 – Milan, 1993
93
Strutturazione fluida
[Fluid Structuring]
1960
Steel, glass
60 × 45 × 15 cm
Mart – Museo d'Arte Moderna e
Contemporanea di Trento e Rovereto

Joe (Cesare) Colombo
Milan, 1930 – Milan, 1971
Gianni Colombo
Milan, 1937 – Milan, 1993
94
Acrilica Lamp
1962
Perspex acrylic, lacquered steel
23 × 23.7 × 24.7 cm
Produced by O-Luce, since 1962
The Montreal Museum of Fine Arts
Liliane and David M. Stewart
Collection, gift of Guy Alexandre
Miller
Inv. D91.322.1

Joe (Cesare) Colombo
Milan, 1930 – Milan, 1971
95
Tube Chair
1969–70
PVC telescopic tubes, polyurethane
foam, synthetic fabric, rubber and
metal joints
W. 64.1 cm, D. 49.2 cm (nested)
Produced by Flexform, 1970
The Metropolitan Museum of Art,
New York
Purchase, Theodore R. Gamble,
Jr. Gift, in honour of his mother,

Mrs. Theodore Robert Gamble,
1987
Inv. 1987.98.1a-d
96
Boby Caddy
1970
ABS, steel
73.5 × 43.4 × 42.7 cm
Produced by Bieffeplast, since 1970
The Montreal Museum of Fine Arts
Liliane and David M. Stewart
Collection
Inv. D99.136.1a-d

Pietro Consagra
Mazara del Vallo, Trapani, 1920 –
Milan, 2005
97
Brooch
About 1959–60
Yellow gold, silver
6 × 4.8 cm
Agnese De Donato collection,
Rome

Sergio Conti
Florence, 1927–2001
Luciano Grassi
Born in Bologna in 1928
Marisa Forlani
Active in Florence
98
Armchair
1962
Enamelled tubular iron, nylon netting
87 × 110 × 85 cm
Produced by Emilio Paoli, Florence
The Montreal Museum of Fine Arts
Liliane and David M. Stewart
Collection

Tullio Crali
Igalo, Dalmatia, 1910 – Milan, 2000
99
*Incuneandosi nell'abitato
(Dalla carlinga)*
[Nose Dive into the City
(the Fuselage)]
1939
Oil on canvas
60 × 80 cm
Private collection
Courtesy Paolo Curti / Annamaria
Gambuzzi & Co., Milan

Enzo Cucchi
Born in Morro d'Alba, Ancona, in 1949
100
Eroe del mare Adriatico centrale
[Hero of the Central Adriatic Sea]
1977–80
Oil on canvas
130 × 205 cm
Mart – Museo d'Arte Moderna e
Contemporanea di Trento e Rovereto
Inv. C. Grassi-Mart 1462

Tullio D'Albisola (Tullio Mazzotti)
Albisola Marina, Savona, 1899 –
Albisola Marina, 1971
101
Vase
About 1930
Ceramic
H. 17 cm, D. 13 cm
Luigi and Grazia Gilli collection,
Milan
Tullio D'Albisola (Tullio Mazzotti)
Albisola Marina, Savona, 1899 –
Albisola Marina, 1971
Nino Strada
Milan, 1904–(?), 1971
102
Mural Study for *Le forze fasciste*
[The Fascist Forces], for the
Architecture Pavilion, VI Triennale,
Milan (1936)
About 1935
Glazed earthenware
46.1 × 88.8 × 3.8 cm
Execution: Casa Giuseppe Mazzotti,
Albisola Marina, Savona
The Mitchell Wolfson, Jr. Collection –
The Wolfsonian-Florida International
University, Miami Beach,
Florida
Inv. 84.7.82

Riccardo Dalisi
Born in Potenza in 1931
103
a. *Totò*
b. *The King*
c. *Waving Coffee Maker*
(Research on the Neapolitan
Coffee Maker)
1987
a. Tin, brass, copper;
32.4 × 21 × 12.1 cm
b. Tin, copper, brass, paint;
33 × 24.2 × 12.7 cm
c. Copper, tin, plastic;
15.5 × 22.6 × 8.3 cm
Produced by Alessi
The Montreal Museum of Fine Arts
Liliane and David M. Stewart
Collection, gift of Vivian and David
Campbell
Inv. D88.229.1a-c, D88.236.1a-c,
D88.244.1a-c
104
Neapolitan Coffee Maker
(model 90018)
1988
Stainless steel, wood
25.4 × 27.4 × 9.5 cm
Produced by Alessi
The Montreal Museum of
Fine Arts
Liliane and David M. Stewart
Collection, gift of Vivian and David
Campbell
Inv. D88.241.1a-d

Raimondo D'Aronco
Gemona del Friuli, Udine, 1857 –
San Remo, Imperia, 1932
105
Interior Decoration for the Rotunda
of Honour at the Esposizione
Internazionale d'Arte Decorativa
Moderna, Turin (1902)
1902
Pencil, India ink, watercolour,
bronze powder on paper
62.2 × 47.5 cm
Galleria d'Arte Moderna, Udine
Inv. Sch.24UD7

Corradino D'Ascanio
Popoli, Pescara, 1891 – Pisa, 1981
106
Vespa 125
1955
Pressed steel monocoque
Produced by Piaggio
Scootart, Montreal

Mario De Biasi
Born in Sois, Belluno, in 1923
107
Il sagrato del Duomo, Milano
[The Parvis of the Duomo, Milan]
1951
Gelatin silver print
39.8 × 30.4 cm
Mario De Biasi Collection, Milan
108
Gli italiani si voltano
[The Italians Turn Around]
1953
Gelatin silver print
30.5 × 40 cm
Mario De Biasi Collection, Milan

Giorgio De Chirico
Volos, Greece, 1888 – Rome, 1978
109
Tebe
[Thebes]
1928
Oil on canvas
90.5 × 116.5 cm
Mart – Museo d'Arte Moderna
e Contemporanea di Trento
e Rovereto
Inv. Vaf-Mart 974

Michele De Lucchi
Born in Ferrara in 1951
110
Hairdryer Prototype for Girmi
1979 (Milan Triennale)
Lacquered wood, metal, plastic
49.2 × 49.2 × 12.4 cm
The Montreal Museum
of Fine Arts
Liliane and David M. Stewart
Collection
Inv. D98.128.1

111
Fan Prototype for Girmi
1979 (Milan Triennale)
Lacquered wood, metal, plastic
33.2 × 23.5 × 20.5 cm
The Montreal Museum of Fine Arts
Liliane and David M. Stewart
Collection
Inv. D98.130.1
112
Kristall Side Table
1981
Lacquered wood, tubular steel
61 × 55 × 53 cm
Produced by Memphis, since 1981
The Montreal Museum of Fine Arts
Liliane and David M. Stewart
Collection, gift of The Lake St. Louis
Historical Society
Inv. 2002.86
113
Basequadra Vase
1997
Glass, steel
H. 32.3 cm, D. 17.8 cm
Made for Produzione Privata,
since 1997
The Montreal Museum of Fine Arts
Liliane and David M. Stewart
Collection, gift of The Lake St. Louis
Historical Society
Inv. 2002.346

Nicola De Maria
Born in Foglianise, Benevento, in 1954
114
Poesia notturna dentro il regno dei fiori
[Night Poetry in the Realm of Flowers]
1990
Oil on canvas
200 × 300 cm
Mart – Museo d'Arte Moderna e
Contemporanea di Trento e Rovereto
Inv. C. Grassi-Mart 2477

Jonathan De Pas
Milan, 1932 Florence, 1991
Donato D'Urbino
Born in Milan in 1935
Paolo Lomazzi
Born in Milan in 1936
Carla Scolari
Born in Marchirolo, Varese,
in 1937
115
Blow Armchair
1967
Clear PVC
76 × 83 × 98 cm
Produced by Zanotta, 1968–69,
1988–92
The Montreal Museum
of Fine Arts
Liliane and David M. Stewart
Collection
Inv. D99.134.1a-c

Fortunato Depero
Fondo, Trento, 1892 – Rovereto,
Trento, 1960
116
Vaso futurista
[Futurist Vase]
1913
Pencil, charcoal on paper
19.2 × 17 cm
Mart – Museo d'Arte Moderna e
Contemporanea di Trento e Rovereto
Inv. 0035-b
117
Costruzione di bambina
[Construction of a Little Girl]
1917
Painted wood
41 × 21 × 14 cm
Mart – Museo d'Arte Moderna e
Contemporanea di Trento e Rovereto
Inv. Md 0011-f
118
Costruzione di donna
[Construction of a Woman]
1917
Painted wood
41 × 21 × 17 cm
Mart – Museo d'Arte Moderna e
Contemporanea di Trento e Rovereto
Inv. Mart 473
119
Il gobbo e la sua ombra
[The Hunchback and His Shadow]
1917
Painted wood, mirrors
30.5 × 43 × 43 cm
Mart – Museo d'Arte Moderna e
Contemporanea di Trento e Rovereto
Inv. Vaf-Mart 976
120
Meccanica di ballerini
1917
Oil on canvas
75 × 71.3 cm
Mart – Museo d'Arte Moderna e
Contemporanea di Trento e Rovereto
Inv. Pat 021608
121
Study for a Lamp
1920–22
Pencil on paper
27.1 × 20.5 cm
Mart – Museo d'Arte Moderna
e Contemporanea di Trento
e Rovereto
Inv. 0541-a
122
Chiosco pubblicitario
[Publicity Stand]
1924
Collage
58 × 39 cm
Mart – Museo d'Arte Moderna
e Contemporanea di Trento
e Rovereto
Inv. Md 0002-C

123
Armchair
1926
Wood
120 × 62 × 45 cm
Mart – Museo d'Arte Moderna e
Contemporanea di Trento e Rovereto
Inv. Md 0041-f
124
Design for the Book Pavilion of Treves
Tumminelli, Monza III Triennale (1927)
1926–27
Pencil, India ink on paper
42.2 × 51 cm
Mart – Museo d'Arte Moderna e
Contemporanea di Trento e Rovereto
Inv. Md 0102-a
125
Depero futurista
Dinamo-Azari Album, Milan, 1927
Printed sheets, aluminum bolts
24.4 × 32.2 cm
Private collection
Courtesy Mart – Museo d'Arte
Moderna e Contemporanea di Trento
e Rovereto
Inv. Mart u/2b
126
Campari Tray
1927
Coloured wood
40.5 × 29 × 1.5 cm
Private collection, Italy
127
Festa della sedia
[Chair Festival]
1927
Wool cloth on cotton canvas
wall hanging
330 × 257 cm
Mart – Museo d'Arte Moderna e
Contemporanea di Trento e Rovereto
Inv. Md 0003-d
128
Futurist Beret
1929
Wool fabric
D. 28 cm
Ugo Nespolo collection
129
3-D Mobile Stage Design for
The New Babel
1930
Tempera on paper
70 × 93 cm
Mart – Museo d'Arte Moderna
e Contemporanea di Trento
e Rovereto
Inv. Md 0087-b
130
Design for Davide Campari & C.
Publicity Pavilion
1933
Tempera, collage on fine cardboard
46.3 × 41.5 cm
Collezione Campari, Milan

Piero De Vecchi
Milan, 1908 – Milan, 1991
131
Vase
1938
Iron, silver
H. 26.5, D. 19.5 cm
Collezione De Vecchi Milano,
1935

Guido Drocco
Born in San Benedetto Belbo, Cuneo,
in 1942
Franco Mello
Born in Genoa in 1945
132
Cactus Coat Rack
1972
Painted polyurethane foam, steel
167.7 × 66.1 × 70.8 cm
Produced by Gufram, since 1972
The Montreal Museum of Fine Arts
Liliane and David M. Stewart
Collection
Inv. D95.185.1

Marcello Dudovich
Trieste, 1878 – Milan, 1962
133
Bitter Campari
Poster
1904
Lithograph
141.8 × 103 cm
Chappuis, Bologna
Civica Raccolta delle Stampe
A. Bertarelli – Castello Sforzesco,
Milan
Inv. B 250
134
*Fiat. La nuova Balilla per tutti,
eleganza della Signora*
[Fiat. The New Balilla for Everyone,
the Elegance of the Signora]
Poster
1934
Lithograph
200 × 140 cm
Star, Officine I.G.A.P. Milan, Rome
(for Fiat)
Massimo and Sonia Cirulli Archive,
New York

Luigi Figini
Milan, 1903 – Milan, 1984
Gino Pollini
Rovereto, Trento, 1903 – Milan,
1991
135
Desk for the Manusardi Apartment,
Milan
1935
Glass, aluminum, chromed brass,
wood
85 × 150 × 60 cm
Private collection

Luigi Figini
Milan, 1903 – Milan, 1984
Gino Pollini
Rovereto, Trento, 1903 – Milan, 1991
Xanti (Alexander) Schawinsky
Basel, 1904 – Locarno, 1979
136
Olivetti Studio 42 Typewriter
1935
Metal
15 × 30 × 34 cm
Produced by Olivetti
Archivio Storico Olivetti, Ivrea, Torino

Gianfranco Fini
Born in Rome in 1936
137
Quanta Lamp
About 1970
Methacrylate, steel
92.7 × 92.7 × 21 cm
Produced by New Lamp
The Montreal Museum of Fine Arts
Liliane and David M. Stewart
Collection
Inv. 2004.93

Arrigo Finzi
Venice, 1890 – Milan, 1973
Antonio Sant'Elia
Como, 1888 – Monte Hermada,
Quota 77, Gorizia, 1916
138
Futurismo "Navette"
1919
Silver, ebony base
11.5 × 47.5 × 21 cm
Execution: S. A. Arrigo Finzi e C.
Olga Finzi Baldi Collection

Olga Finzi
Born in Milan in 1932
139
Manhattan Stackable
Tea Service
1957
Silver
H. 52 cm, D. 13–8 cm
Produced by Finzi Arte
Olga Finzi Baldi Collection

Olga Finzi Baldi
Born in Milan in 1932
140
Continuità di Pensiero Necklace
[Continuity of Thought]
1972
Gold necklace-waistcoat, tourmaline
cabochons
48 × 23 × 18.5 cm
Made by Studio Olga Finzi
Olga Finzi Baldi Collection

Lucio Fontana
Rosario, Argentina, 1899 – Comabbio,
Varese, 1968

141
Abstract Sculpture
1934
Coloured plaster
28 × 18 × 7.5 cm
Fondazione Lucio Fontana,
Milan
Inv. 34SG26
142
Concetto spaziale. Attese
[Spatial Concept. Expectations]
1959
Water-based paint on canvas
100 × 81 cm
Mart – Museo d'Arte Moderna e
Contemporanea di Trento e Rovereto
Inv. Mart-Fiz 2317
143
Concetto spaziale. Attese 1 + 1419
[Spatial Concept. Expectations
1 + 1419]
1959–60
Oil on canvas
90 × 80 × 2 cm
The Montreal Museum of Fine Arts
Loan, Société de la Place des Arts
de Montréal, gift of Mr. and Mrs.
Guy de Repentigny
Inv. 253.2001

Bruna Bini
"Divertissement" for a fashion
show attended by **Lucio Fontana**
144
Dress
1961
Silver chintz
90 × 48 cm
Produced by Bini-Telese
Gentucca Bini Collection, Milan

Lucio Fontana
Rosario Argentina, 1899 – Comabbio,
Varese, 1968
145
Concetto spaziale. La fine di Dio
[Spatial Concept. The End of God]
1963
Oil and graffiti on canvas with slashes
and holes
178 × 123 cm
Fondazione Lucio Fontana, Milan
Inv. 63FD28

Carlo Forcolini
Born in Como in 1947
146
Apocalypse Now Coffee Table
1984
Cor-Ten steel, galvanized steel,
chrome, rubber
118 × 120 × 120 cm
Produced by Alias, since 1984
The Montreal Museum of Fine Arts
Liliane and David M. Stewart
Collection, gift of the American Friends

of Canada through the generosity
of Nannette and Eric Brill
Inv. 2004.30.1-2

Piero Fornasetti
Milan, 1913 – Milan, 1988
147
Plate
About 1950–about 1955
Transfer-printed porcelain
(lithograph)
D. 26 cm
Produced by Piero Fornasetti
The Montreal Museum of Fine Arts
Liliane and David M. Stewart
Collection
Inv. D89.180.1
148
Plate
About 1950–about 1955
Transfer-printed porcelain (lithograph)
D. 26 cm
Produced by Piero Fornasetti
The Montreal Museum of Fine Arts
Liliane and David M. Stewart
Collection
Inv. D89.184.1
149
Plate
About 1950–about 1955
Transfer-printed porcelain
(lithograph)
D. 26 cm
Produced by Piero Fornasetti
The Montreal Museum of Fine Arts
Liliane and David M. Stewart
Collection
Inv. D89.186.1

Mariano Fortuny y Madrazo
Granada, Spain, 1871 – Venice, 1949
150
Delphos Dress
About 1907 (1920s model)
Silk, glass beads
L. 159.4 cm
The Metropolitan Museum of Art,
New York
Gift of Gloria Barggiotti, 1980
Inv. 1980.170
151
Delphos Dress
About 1907 (1930s model)
Silk, glass beads
L. 144.8 cm
The Metropolitan Museum of Art,
New York
Gift of the Estate of Agnes Miles
Carpenter, 1958
Inv. C.I.58.61.4

Dante Giacosa
Rome, 1905 – Turin, 1996
152
Fiat *Nuova 500*
1957

Manufactured by Fiat, 1957–60
Richard Petit collection

Piero Gilardi
Born in Turin in 1942
153
Zuccaia
[Pumpkin Patch]
1966
Polyurethane foam
40 × 155 × 155 cm
Fondazione Guido ed Ettore
de Fornaris, Galleria d'Arte Moderna
e Contemporanea, Turin
Inv. FD/60

Paolo Gioli
Born in Sarzano di Rovigo, in 1942
154
Omaggio a Bayard
[Tribute to Bayard]
1982
Pinhole photograph transferred
to drawing paper
70 × 50 cm
Fondo Paolo Gioli – Museo
di Fotografia Contemporanea

Vittorio Grassi
Rome, 1878 – Rome, 1958
155
Table
1907
Solid wood
80 × 110 × 108 cm
The Mitchell Wolfson, Jr. Collection –
Fondazione Regionale C. Colombo,
Genoa
Inv. 87.620.11.1

**Gruppo Architetti Urbanisti
Città Nuova**
Bologna, 1961–98
(Pier Luigi Cervellati, Umberto
Maccaferri, Giancarlo Mattioli, Gian
Paolo Mazzucato, Franco Morelli,
Giorgio Villa, and Mario Zaffagnini)
156
Nesso Lamp
1962
ABS, cellulose acetate
H. 34.3 cm, D. 53.6 cm
Produced by Artemide, 1965–87
and since 1999
The Montreal Museum of Fine Arts
Liliane and David M. Stewart
Collection, gift of Louise Lalonde
Inv. D94.123.1

Gruppo G 14
Founded in Milan in 1967
(Gianfranco Facchetti, born in Milan
in 1939; Umberto Orsoni, born in
Milan in 1940; Gianni Pareschi,
born in Milan in 1940; Pino Pensotti,
born in Lecco in 1939; Marcello Pozzi,

born in Como in 1950; Roberto Ubaldi,
born in Milan in 1940)
157
Fiocco Armchair
1970
Tubular metal, elastic fabric
108.6 × 73.3 × 118.1 cm
Produced by Busnelli, 1972
The Museum of Modern Art,
New York
Gift of the manufacturer, 1972
Inv. 410.1972

Gruppo Strum
Turin, 1966–75
(Giorgio Ceretti, born in Domodossola,
Verbano-Cusio-Ossola, in 1932;
Pietro Derossi, born in Turin in 1933;
Carlo Giammarco, born in Pescara
in 1940; Riccardo Rosso, born in Turin
in 1941; Maurizio Vogliazzo, born
in Turin in 1943)
158
Pratone Seating
1966, 50/200
Polyurethane foam, Guflac paint,
95 × 140 × 140 cm
Produced by Gufram, since 1971
The Montreal Museum of Fine Arts
Liliane and David M. Stewart
Collection

Renato Guttuso
Bagheria, Palermo, 1912 – Rome,
1987
159
Boogie-Woogie
1953
Oil on canvas
169.5 × 205 cm
Mart – Museo d'Arte Moderna
e Contemporanea di Trento
e Rovereto
Inv. VAF 827

Mimmo Jodice
Born in Naples in 1934
160
Pompeii
1983
Gelatin silver print, 2/3
35 × 50 cm
Mimmo Jodice Collection

Jannis Kounellis
Born in Piraiévs, Greece, in 1936
161
Untitled
1989
Iron, mixed media
180 × 200 cm
Mart – Museo d'Arte Moderna
e Contemporanea di Trento
e Rovereto
Deposit of Società SOSAT
Inv. Vaf-Mart 738

Ernesto Angelo La Padula
Pisticci, Matera, 1902 – Rome, 1968
with **Giovanni Guerrini** (1887–1972)
Mario Romano (1887–1972)
162
Perspective of the Palace of Italian
Civilization, Esposizione Universale
di Roma, 1942
1939
Tempera on wood
90 × 89.9 cm
The Museum of Modern Art,
New York
Purchase, 1984
Inv. 309.1984

Leonardi-Stagi Architetti
Founded in Modena, 1962
(Cesare Leonardi, born in Modena
in 1935; Franca Stagi, born in Modena
in 1937)
163
Dondolo Rocking Chair
1967
Fibreglass-reinforced polyester
76.8 × 174.9 × 40 cm
Produced by Elco, 1967–70
The Montreal Museum of Fine Arts
Liliane and David M. Stewart
Collection, gift of the American
Friends of Canada through the
generosity of Geoffrey N. Bradfield
Inv. D87.154.1

Giovanni Levanti
Born in Palermo in 1956
164
Xito Chaise Longue
1999
Polyurethane foam, fabric
H. 65 cm (back raised) / 13 cm (flat),
L. 212 cm (max.)
Produced by Campeggi
Campeggi Srl, Producer

Osvaldo Licini
Monte Vidon Corrado, Ascoli Piceno,
1894 – Monte Vidon Corrado, 1958
165
Composizione
[Composition]
1933
Oil on canvas
64 × 48 cm
Mart – Museo d'Arte Moderna e
Contemporanea di Trento e Rovereto
Inv. Pat 040550

Pietro Lingeri
Tremezzo, Como, 1894 – Tremezzo,
1968
166
Display Case for the "Fitting Room
of a Modern Dressmaker's Shop,"
IV Monza Triennale (1930)
1930

Burl walnut, glass, brass
175 × 70 × 35 cm
Archivio di disegni e documenti
dell'architetto Pietro Lingeri,
Milan

Italo Lupi
Born in Cagliari in 1934
167
Mask by Steven Guarnaccia
on a Photograph of Alvar Aalto
Poster for the periodical *Domus*
1988
Lithograph
96 × 67.5 cm
Produced by Litorama
Private collection

Elio Luxardo
Sorocaba, Brazil, 1908 – Sperlonga,
Latina, 1969
168
L'Italica bellezza
[Italianate Beauty]
About 1940
Gelatin silver print
39.7 × 29.7 cm
Archivio fotografico Fondazione 3M
169
Torso di donna
[Woman's Torso]
About 1940
Gelatin silver print
39 × 29.5 cm
Archivio fotografico Fondazione 3M
170
Torso di uomo
[Man's Torso]
About 1940
Gelatin silver print
38 × 28.5 cm
Archivio fotografico Fondazione 3M

Vico (Ludovico) Magistretti
Born in Milan in 1920
171
Vicario Armchair
1970 (example of about 1990)
Fibreglass-reinforced polyester
68.5 × 71.1 × 65 cm
Produced by Artemide, 1971–93
The Montreal Museum of Fine Arts
Liliane and David M. Stewart
Collection, gift of Artemide Ltée
Inv. D91.379.1

Aldo Magnelli
Florence, 1903 – São Paulo, 1980
172
Olivetti MP 1 Typewriter
1932
Metal
11.7 × 29.2 × 30 cm
Case: 15 × 32 × 34 cm
Produced by Olivetti
Lisa Licitra Ponti Collection

Piero Manzoni
Soncino, Cremona, 1933 – Milan, 1963
173
Alfabeto
[Alphabet]
1959
Ink, kaolin on canvas
25 × 18 cm
Private collection
174
1-30 Settembre, 1959
[September 1–30, 1959]
1959
Calendar pages on paper
65 × 48 cm
Private collection
175
Uovo scultura, No. 11
[Egg Sculpture]
1960
Egg, ink, wood box
5.6 × 8.2 × 6.8 cm
Archivio Opera Piero Manzoni,
Milan
176
Merda d'artista, No. 68
[Artist's Shit]
1961
Metal can
H. 4.8 cm, D. 6.5 cm
Archivio Opera Piero Manzoni,
Milan
177
Achrome
About 1962
Kaolin-coated bread rolls
49.5 × 49.5 × 9.5 cm
Archivio Opera Piero Manzoni,
Milan

**Giacomo Manzù
(Giacomo Manzoni)**
Bergamo, 1908 – Rome, 1991
Lamp design:
Giuseppe Pizzigoni
Bergamo, 1901 – Bergamo, 1967
178
Eva Floor Lamp
About 1929
Engraved crystal
201 × 48 × 20 cm
Pizzigoni collection

**Giacomo Manzù
(Giacomo Manzoni)**
Bergamo, 1908 – Rome, 1991
179
La morte del partigiano
[Death of a Partisan]
About 1958
Bronze
61 × 48 × 3.1 cm
The Montreal Museum
of Fine Arts
Gift of Mrs. Wilson G. McConnell
Inv. 1966.1547

Enzo Mari
Born in Novara in 1932
180
Ashtray (model 3012)
From the Series "Putrella"
1958
Iron
10.8 × 12.9 × 9.8 cm
Produced by Danese
The Montreal Museum of Fine Arts
Liliane and David M. Stewart
Collection, gift of Eleanore and
Charles Stendig in memory of Eve
Brustein and Rose Stendig
Inv. D94.132.1
181
Struttura 1059
1964 (1970 piece)
Anodized aluminum
138 × 138 × 12 cm
Enzo Mari collection
182
Atollo Fruit Bowl
1965
PVC
H. 10 cm, D. 45 cm
Produced by Danese
Fondo Jacqueline Vodoz e Bruno
Danese
Inv. 3071 A
183
Pago-Pago Vases
1968
ABS
30.2 × 20 × 15.5 cm (each)
Produced by Danese, 1969–88
The Montreal Museum of Fine Arts
Liliane and David M. Stewart
Collection
Gift of Wistar Morris, by exchange
Inv. D88.125.1
Gift of the American Friends
of Canada through the generosity
of Geoffrey N. Bradfield
Inv. D87.216.1
184
"Phytomorphic" Vases:
Bambù
Tortiglione
Trifoglio
1969
PVC
H. 42 cm, D. 12.5 cm
H. 34 cm, D. 12.5 cm
H. 37 cm, D. 12.5 cm
Produced by Danese
Fondo Jacqueline Vodoz
e Bruno Danese
Inv. 3085 A, 3084 B, 3084 C
185
Sof Sof Chair
1971
Iron rod frame, cushions
85 × 48 × 70 cm
Produced by Driade, 1973;
Robots, 2003

Centro Studi e Archivio della
Comunicazione, Università
degli Studi di Parma
Inv. B001276 S
186
Proposal for "Self-design" Furniture
1973
Wood
Variable dimensions
Produced by Simon International,
then Cassina
Triennale di Milano
187
Box Chair
1976
Polypropylene, PVC-covered
tubular steel
85 × 44 × 44.5 cm
Produced by Anonima Castelli,
since 1976
The Montreal Museum of Fine Arts
Liliane and David M. Stewart
Collection, gift of David A. Hanks
Inv. D97.123.1a-h

Filippo Tommaso Marinetti
Alexandria, 1876 – Bellagio,
Como, 1944
188
Guido Guidi. Parole in libertà
1916
India ink on paper
35 × 26.5 cm
Private collection
189
Les mots en liberté futuristes
[Futurist Words in Freedom]
Milan, Edizioni Futuriste di "Poesia,"
1919
19.2 × 12.8 cm
The Mitchell Wolfson, Jr. Collection –
Fondazione Regionale C. Colombo,
Genoa
Inv. GF1993.1.16

Marino Marini
Pistoia, 1901 – Viareggio, Lucca,
1980
190
Cavaliere
[Horse Rider]
1952
Bronze, edition of 6, one artist's proof
H. 110 cm
Robert and Alice Landau,
Montreal

Gino (Luigi) Marotta
Born in Campobasso in 1935
191
Albero rinascimentale artificiale
[Artificial Renaissance Tree]
1966
Transparent coloured methacrylate
195 × 73 × 72 cm
Private collection

Arturo Martini
Treviso, 1889 – Milan, 1947
192
Il pastorello
[Shepherd Boy]
1928–29
Terracotta
34 × 17 × 20 cm
Private collection
Courtesy Claudia Gian Ferrari, Milan

Napoleone Martinuzzi
Murano, Venezia, 1892 – Venice, 1977
193
Pianta
[Plant]
1930
"Pulegoso" glass
H. 11 cm, D. 10 cm
Produced by Venini
Roberto Navarro
194
Pianta
[Plant]
1930
"Pulegoso" glass
H. 9 cm, D. 16 cm
Produced by Venini
Roberto Navarro
195
Pianta grassa
[Succulent Plant]
1933
Glass
H. 28 cm
Produced by Zecchin/Martinuzzi –
Vetri Artistici e Mosaici
Nicoletta Fiorucci Collection
196
"Pulegoso" Vase
1930
Glass
H. 39 cm
Produced by Venini
Roberto Navarro

Germana Marucelli
Florence, 1905 – Milan, 1983
Hand-painted designs:
Giuseppe Capogrossi
Rome, 1900 – Rome, 1972
197
Dress
Early 1950s
Painted taffeta
Archivio Marucelli

Germana Marucelli
Florence, 1905 – Milan, 1983
Getulio Alviani
Born in Udine in 1939
198
Armour Outfit
1968–69 ("Aluminum" Fall-winter
Collection)
Leather and aluminum bodice, wool

shorts with aluminum disks, ostrich-feather vest
Archivio Marucelli

Alessandro Mazzucotelli
Lodi, 1865 – Milan, 1938
199
Hanging Lamp
1902
Wrought iron, glass
H. 35 cm, D. 30 cm
Fondazione Cavallini Sgarbi
200
Le serpi
[The Snakes]
Early 20th century
Wrought iron, marble base
85 × 61 × 19 cm
Chiara and Francesco Carraro
collection

Salvatore Meli
Born in Comiso, Ragusa, in 1929
201
Ewer
1956
Painted and glazed earthenware
96.3 × 73 × 24.7 cm
The Montreal Museum of Fine Arts
Liliane and David M. Stewart
Collection, gift of the American
Friends of Canada through the
generosity of Mrs. William H. Fish
Inv. D88.101.1

Fausto Melotti
Rovereto, Trento, 1901 – Milan, 1986
202
Sculpture 23
1935
Plaster
90 × 90 × 6.5 cm
Mart – Museo d'Arte Moderna e
Contemporanea di Trento e Rovereto
Inv. Pat 037200
203
Vase
About 1950
Glazed ceramic
99 × 26 × 19 cm
Galleria Christian Stein, Milan;
Archivio Melotti, Milan
Inv. VA 093
204
Coppa blu
[Blue Glass]
1954
Glazed ceramic
45 × 35 × 20 cm
Mart – Museo d'Arte Moderna e
Contemporanea di Trento e Rovereto
Inv. Mart 25
205
Sonno di Wotan
[Wotan's Sleep]
1958

Terracotta, brass
52 × 37 × 11 cm
Mart – Museo d'Arte Moderna e
Contemporanea di Trento e Rovereto
Inv. Pat 074935
206
Teatrino angoscia
[Toy Theatre of Anguish]
1961
Terracotta
55 × 33 × 10 cm
Mart – Museo d'Arte Moderna e
Contemporanea di Trento e Rovereto
Inv. Mart 201
207
Necklace
About 1966 (prototype)
Brass
9 × 14 cm
Galleria Christian Stein, Milan;
Archivio Melotti, Milan

Alessandro Mendini
Born in Milan in 1931
208
La poltrona di Proust
[Proust's Armchair]
"Bau.Haus" Collection
1978 (example of 2001)
Painted wood and fabric, polyurethane
foam, passementerie
106 × 102 × 92.5 cm
Painting: Claudia Mendini
Produced by Studio Alchimia,
1978–87; Atelier Mendini, from 1989
The Montreal Museum of Fine Arts
Purchase, the Museum Campaign,
1988-1993 Fund
Inv. 2005.88
209
Il mobile infinito
[Infinite Furniture]
Furniture made up of pieces designed
by various designers, which can be
assembled in countless ways
1981
Wood, metal, plastic
360 × 82 × 82 cm
Produced by Studio Alchimia
Private collection
210
Tea & Coffee Service
"Tea and Coffee Piazza" Collection
1983
Silver, 925/1000
Teapot: 24 × 21.5 × 12.5 cm
Coffee pot: 24.1 × 19.7 × 13.4 cm
Creamer: 21.5 × 23 × 13.5 cm
Sugar bowl: 18 × 9 × 7 cm
Teaspoon: L. 11 cm
Tray: H. 3 cm, D. 45 cm
Produced by Alessi
Museo Alessi
211
Peyrano Bonbon Dish
1988

Stainless steel, plastic
12 × 26.5 × 17 cm
Produced by Alessi for
Cioccolato Peyrano
The Montreal Museum of Fine Arts
Liliane and David M. Stewart
Collection, gift of Paola and Rossella
Colombari
Inv. D92.124.1a-c
212
Godezia Jewellery Box
Stellaria Vase
1993
Partially enamelled aluminum, 4/24
Box: H. 46.5 cm, D. 19 cm
Vase: H. 41.5 cm, D. 19 cm
Produced by Design Gallery Milano
The Montreal Museum of Fine Arts
Liliane and David M. Stewart
Collection, gift of Paul Leblanc
Inv. D93.293.1a-b, D93.294.1
213
Nigritella Nigra Chest of Drawers
1993
Stained and lacquered mahogany,
Abet plastic laminate, ceramic, gold
leaf, hand-cut glass mosaic tile
110 × 97 × 50 cm
Painting: Lucio Giudici
Produced by Design Gallery Milano,
1993
The Montreal Museum of Fine Arts
Liliane and David M. Stewart
Collection, gift of Caroline Moreau
Inv. D94.318.1

Leopoldo Metlicovitz
Trieste, 1868 – Pontelambro, Como,
1944
214
Madama Butterfly
Poster for Giacomo Puccini's opera
1904
Lithograph
143.4 × 102 cm
Ricordi, Milan
Civica Raccolta delle Stampe
A. Bertarelli – Castello Sforzesco,
Milan
215
Opening of the Simplon Tunnel.
International Exhibition. Milan, 1906
Poster
1906
Lithograph
90 × 50 cm
Ricordi, Milan
Civica Raccolta delle Stampe
A. Bertarelli – Castello Sforzesco,
Milan

Carlo Mollino
Turin, 1905 – Turin, 1973
216
Interior View of Casa Miller,
Turin, Showing a Table Designed

by C. Mollino
1938 or later
Gelatin silver print
16.3 × 22.4 cm
Collection Centre Canadien
d'Architecture / Canadian Centre
for Architecture, Montreal
Inv. PH, 1999:0096
217
View of the Living Room of Casa
Devalle, Turin
1940 or later
Gelatin silver print
19.1 × 29.2
Collection Centre Canadien
d'Architecture / Canadian Centre
for Architecture, Montreal
Inv. PH, 1999:0097
218
View of the Bedroom of Casa Minola,
Turin, with an Adjustable Mirror
and Lamp by C. Mollino
1944–46
Gelatin silver print
17.9 × 11.5 cm
Collection Centre Canadien
d'Architecture / Canadian Centre
for Architecture, Montreal
Inv. PH, 1999:0100
219
View of the Bedroom of Casa Rivetti,
Turin
1949–50
Gelatin silver print
17.2 × 23.3 cm
Collection Centre Canadien
d'Architecture / Canadian Centre
for Architecture, Montreal
Inv. PH, 1999:0108
220
Arabesco Table
1950
Maple-faced plywood, glass, brass
50.2 × 122 × 49.5 cm
Produced by Apelli e Varesio, 1951
The Montreal Museum of Fine Arts
Liliane and David M. Stewart
Collection
Inv. D88.128.1a-c

Angelo Morbelli
Alessandria, 1853 – Milan, 1919
221
In risaia
[The Rice Field]
1901
Oil on canvas
183 × 130 cm
Private collection

Ugo Mulas
Pozzolengo, Brescia, 1928 –
Milan, 1973
222
Bar Giamaica
1953–56

Gelatin silver print
53 × 40.5 cm
Archivio Ugo Mulas

Bruno Munari
Milan, 1907 – Milan, 1998
223
Macchina aerea
[Aerial Machine]
1930 (1971 reconstruction by Danese)
Wood, enamelled metal
180 × 30 × 60 cm
Private collection
224
Cover and illustrations for *L'anguria lirica (Lungo poema passionale)*
by Tullio D'Albisola
Rome, Edizioni Futuriste di "Poesia,"
undated [1934]
15.5 × 19.5 cm
The Mitchell Wolfson, Jr. Collection –
Fondazione Regionale C. Colombo,
Genoa
Inv. GF1993.1.25
225
Giallo-rosso
[Yellow-red]
From the series "Negativo-positivo"
1951
Oil on canvas
100 × 100 cm
Banca Intesa Collection
Inv. A.D-73448A-L/BI
226
Cubo Ashtray
1957
Anodized aluminum, melamine
8 × 8 × 8 cm; 6 × 6 × 6 cm
Produced by Danese
Fondo Jacqueline Vodoz
e Bruno Danese
227
Scultura da viaggio
[Travel Sculpture]
1958 (1994 edition, 3/8)
Balsa wood, canvas, pearwood
base
96 × 21.5 × 21 cm
Miroslava Hajek – Antonio Zucconi
collection, Italy
228
Maldive Bowl
1960
Satin-finish nickel silver
20 × 20 cm
Produced by Danese
Fondo Jacqueline Vodoz
e Bruno Danese
229
Prelibri
Series of 12 children's books
1979
Various materials
10 × 10 cm (each)
Danese Edizioni per bambini
Private collection

Giovanni Muzio
Milan, 1893 – Milan, 1982
230
Ca' Brütta, Milan.
Facade on the Via Turati
1922
India ink, coloured pencil
on tracing paper
70 × 125 cm
Archivio Muzio
231
The Marble Room of the IV Mostra
delle Arti Decorative, Monza Triennale
(1930). Elevation and Floor
1929
Pencil on tracing paper
60 × 68 cm
Archivio Muzio
232
The Marble Room of the IV Mostra
delle Arti Decorative, Monza
Triennale (1930). Elevation
About 1929
Pencil, watercolour on tracing paper
30.5 × 37.6 cm
Archivio Muzio
233
Ceremonial Armchair for the Hall of
Honour, known as the "Marble Room,"
IV Monza Triennale (1930)
1930
Rosewood, upholstery
168.5 × 94 × 58 cm
Execution: Mario Quarti
Galleria Daniela Balzaretti
234
The Marble Room of the IV Mostra
delle Arti Decorative, Monza
Triennale (1930)
1930
Vintage photograph
28 × 22 cm
Archivio Muzio
235
The Marble Room of the IV Mostra
delle Arti Decorative, Monza
Triennale (1930)
1930
Vintage photograph
28 × 21.5 cm
Archivio Muzio
236
The Marble Room of the IV Mostra
delle Arti Decorative, Monza
Triennale (1930)
1930
Vintage photograph
19 × 26 cm
Archivio Muzio

Marcello Nizzoli
Boretto, Reggio nell'Emilia, 1887 –
Camogli, Genova, 1969
237
Campari. l'aperitivo
[Campari. The Aperitif]

Poster
1925–26
Lithograph
140 × 100 cm
Star, Officine I.G.A.P. Milan
Centro Studi e Archivio della
Comunicazione, Università degli Studi
di Parma
Inv. BO22133 S

Marcello Nizzoli
Boretto, Reggio nell'Emilia, 1887 –
Camogli, Genova, 1969
Giuseppe Beccio, Eng.
238
Lexikon 80 Typewriter
1948
Metal, plastic
44 × 23 × 38 cm
Produced by Olivetti
The Montreal Museum of Fine Arts
Liliane and David M. Stewart
Collection, gift of the Geoffrion family
in memory of the notary Claude
Geoffrion
Inv. D96.110.1a-e
239
Lettera 22 Portable Typewriter
1950
Enamelled metal, plastic
11.5 × 30.1 × 31.4 cm
Produced by Olivetti
The Montreal Museum of Fine Arts
Liliane and David M. Stewart
Collection, gift of the American
Friends of Canada through the
generosity of Barry Friedman and
Patricia Pastor
Inv. D86.198.1

Marcello Nizzoli
Boretto, Reggio nell'Emilia, 1887 –
Camogli, Genova, 1969
240
Mirella Portable Sewing Machine
1957
Cast iron, steel
30 × 45 × 20 cm
Produced by Necchi
Fondazione ADI per il design italiano –
Collezione Compasso d'Oro

Fabio Novembre
Born in Lecce in 1966
241
Org Table (model OG/4)
2001 (example of 2002)
Glass, polypropylene, steel, cord,
brushed stainless steel
73.2 × 100 × 200 cm
Produced by Cappellini, since 2001
The Montreal Museum of
Fine Arts
Liliane and David M. Stewart
Collection
Inv. 2002.57.1-172

Luigi Ontani
Born in Montovolo di Grizzana
Morandi, Bologna, in 1943
in collaboration with Ceramica
Gatti di Faenza
242
San SebastianSagittario
1995
Glazed earthenware
H. 176 cm, D. 52 cm (base)
Private collection
Courtesy Galleria dello Scudo, Verona

Ubaldo Oppi
Bologna, 1889 – Vicenza, 1942
243
La giovane sposa
[The Young Bride]
1922–24
Oil on canvas
99 × 69.8 cm
Musei Civici, Museo d'Arte Medievale
e Moderna, Padua
Inv. 2760

Mimmo (Domenico) Paladino
Born in Paduli, Benevento, in 1948
244
Cuore di Russia
[Heart of Russia]
1984
Mixed media on canvas
68 × 59 × 10 cm
Mart – Museo d'Arte Moderna e
Contemporanea di Trento e Rovereto
Inv. C. Grassi-Mart 1440

Ivo Pannaggi
Macerata, 1901 – Macerata, 1981
245
Chair for the Entrance Hall of Casa
Zampini, Esanatoglia
1925–26
Painted wood
99.8 × 70 × 45.8 cm
Pinacoteca Comunale, Macerata
246
Funzione architettonica H-03
[Architectural Function H-03]
Painting made for the entrance hall
of Casa Zampini, Esanatoglia
1926
Oil on canvas
151 × 90 cm
Galleria Nazionale d'Arte Moderna,
Rome
Inv. 5584

Giulio Paolini
Born in Genoa in 1940
247
Untitled
1962–63
Three overturned canvases
50 × 60 cm
Anne and Wolfgang Titze Collection

Federico Patellani
Monza, Milano, 1911 – Milan, 1977
248
Acquapendente (Viterbo)
1945 (2005 print)
Gelatin silver print
40 × 50 cm
Fondo Federico Patellani (Regione Lombardia), Museo di Fotografia Contemporanea

Giuseppe Pellizza da Volpedo
Volpedo, Alessandria, 1868 – Volpedo, 1907
249
Fiumana
[Multitude]
1895
Oil on canvas (sketch)
44.2 × 77.8 cm
Private collection

Gaetano Pesce
Born in La Spezia in 1939
250
La Mamma Armchair and Footrest
Up 5 and *Up 6* from the series "Up"
1969 (example of 1984)
Polyurethane foam, viscose, nylon, Lycra knitted fabric
Armchair: 100 × 113.7 × 125.1 cm
Footrest: D. 59.1 cm
Produced by C & B Italia, 1970–72; B & B Italia, 1973–81, 1984, since 1994
The Montreal Museum of Fine Arts
Liliane and David M. Stewart Collection, gift of B & B Italia
Inv. D84.179.1-2
251
Sansone Table
1980
Polyester resin
77.5 × 190.8 × 117.5 cm
Produced by Cassina
The Montreal Museum of Fine Arts
Liliane and David M. Stewart Collection, by exchange
Inv. D91.416.1
252
I Feltri Armchair
1986
Wool felt impregnated with polyester resin, hemp, stainless steel, cotton
127.6 × 105.4 × 67.3 cm
Produced by Cassina, 1987
The Montreal Museum of Fine Arts
Liliane and David M. Stewart Collection, gift of Cassina
Inv. D98.159.1a-b
253
543 Broadway Chair
1992–95
Polyurethane resin, stainless steel, nylon
74 × 55 × 38.5 cm

Produced by Bernini
The Montreal Museum of Fine Arts
Liliane and David M. Stewart Collection
Inv. D98.160.4
254
Tutti Frutti Basket
1997
Flexible polyurethane resin
Produced by Fish Design, New York, 1997
28.5 × 77 × 77 cm
The Montreal Museum of Fine Arts
Liliane and David M. Stewart Collection
Inv. D97.133.1

Marcello Piacentini
Rome, 1881 – Rome, 1960
255
Chair for the Entrance Hall of Fiammetta Sarfatti's House, Rome
1933
Aniline-painted spruce and plywood
H. 90 cm, D. 44 cm
The Mitchell Wolfson, Jr. Collection – Fondazione Regionale C. Colombo, Genoa
Inv. GD1993.6

Giovanni Pintori
Tresnuraghes, Oristano, 1912 – Milan, 1999
256
Poster for *Olivetti*
1949
Lithograph
85 × 60 cm
Produced by Olivetti
Archivio Storico Olivetti, Ivrea, Torino

Michelangelo Pistoletto
Born in Biella in 1933
257
Donna seduta di spalle
[Seated Woman Facing Away]
1962 63
Painted tissue paper on chromed steel
199 × 120 cm
Private collection
Courtesy Sonnabend Gallery, New York
Inv. MP-05

Giuseppe Pizzigoni
Bergamo, 1901 – Bergamo, 1967
258
Armchair for Casa Pizzigoni, Bergamo
1928–29
Mahogany
80 × 65 × 85 cm
Pizzigoni Collection

Giò Pomodoro
Orciano di Pesaro, Pesaro e Urbino, 1930 – Milan 2002

259
Bracelet
1965
Gold
D. 8 cm
The Montreal Museum of Fine Arts
Gift of Cécile and Gérard Baillargeon
Inv. 1995.Ds.10

Gio (Giovanni) Ponti
Milan, 1891 – Milan, 1979
260
Prospettica Bowl
1923–30
Porcelain
H. 11 cm
Produced by Richard-Ginori
Museo Richard-Ginori della Manifattura di Doccia, Sesto Fiorentino, Firenze
Inv. 5354
261
Covered Urn:
La passeggiata archaeologica
[An Archaeological Stroll]
1925
Porcelain
H. 50.2 cm, D. 16.8 cm
Produced by Richard-Ginori
The Metropolitan Museum of Art
Purchase, Edward C. Moore Jr. Gift, 1931
Inv. 31.83ab
262
Vase:
La conversazione classica
[The Classical Conversation]
1926 (form), about 1927 (decoration)
Hard paste porcelain, gold underglaze decoration
19.5 × 19.6 × 15.3 cm
Produced by Richard-Ginori
The Montreal Museum of Fine Arts
Purchase
Inv. 1933.Dp.4
263
Bilia Lamp
1931
Metal, glass
H. 43 cm, D. 20 cm
Produced by FontanaArte
FontanaArte SpA, Corsico, Milano
264
Le mani
[Hands]
About 1935
Porcelain
H. (1) 34.5 cm, (2, 3) 33.8 cm
Produced by Richard-Ginori
Museo Richard-Ginori della manifattura di Doccia, Sesto Fiorentino, Firenze
Inv. (1) 3204, (2) 3206, (3) 3208

Gio (Giovanni) Ponti
Milan, 1891 – Milan, 1979

with **R. Angeli**, **Carlo De Carli**, **L. Olivieri** and **G. Ulrich**
265
Design for the Ministry of Foreign Affairs, Rome
n. d. [1939]
Pencil on fine parchment paper
49 × 65 cm
Centro Studi e Archivio della Comunicazione, Università degli Studi di Parma
Inv. B008590 S

Gio (Giovanni) Ponti
Milan, 1891 – Milan, 1979
Decoration:
Paolo De Poli
Padua, 1905 – Padua, 1996
266
Table
1941
Walnut, enamel on copper
76 × 94 × 43 cm
Private collection
267
Il mercato Cabinet
1942
Wood, enamel on copper
164 × 70 × 35 cm
Giovanni and Evelina De Poli collection, Padua

Gio (Giovanni) Ponti
Milan, 1891 – Milan, 1979
Piero Fornasetti
Milan, 1913 – Milan, 1988
268
Farfalle Chair for the Lucano Residence, Milan
1949 (prototype)
Wood, silk upholstery, lithograph prints
80 × 50 × 50 cm
Produced by Fornasetti
Barnaba Fornasetti collection
269
Biglietti da visita Desk
1950
Wood, lithograph prints
Produced by Fornasetti
Barnaba Fornasetti collection
270
Architecture Secretary
1950
Lithographs mounted on hardboard, lacquered wood, sheet metal, glass, brass, felt, neon
218 × 80 × 40.5 cm
Produced by Piero Fornasetti
1951–97, Immaginazione, since 1989
The Montreal Museum of Fine Arts
Liliane and David M. Stewart Collection, gift of Senator Alan A. Macnaughton, Sr. / Inv. D97.172.1a-k

Gio (Giovanni) Ponti
Milan, 1891 – Milan, 1979
Fulvio Bianconi
Padua, 1915 – Milan, 1996
Paolo Venini
Milan, 1895 – Venice, 1959
271
"Canna" Decanter
1950s
Glass
H. 33.2 cm, D. 8.5 cm
Produced by Venini
Royal Ontario Museum,
Toronto
Inv. 957.123.3a-b

Gio (Giovanni) Ponti
Milan, 1891 – Milan, 1979
272
Silverware
About 1951
Stainless steel
Salad fork: 16.8 × 2.5 cm
Dinner fork: 18.1 × 3.2 cm
Knife: 18.5 × 3.2 cm
Soup spoon: 17.7 × 4.2 cm
Teaspoon: 15.2 × 3.5 cm
Produced by Argenteria Krupp,
1951–57
The Montreal Museum
 of Fine Arts
Liliane and David M. Stewart
Collection
Inv. D84.101.1–5

Gio (Giovanni) Ponti
Milan, 1891 – Milan, 1979
273
Superleggera Chair (model 699)
1955
Ash, cellophane cane
85.3 × 40.4 × 44.9 cm
Produced by Cassina, since 1957
The Montreal Museum
of Fine Arts
Liliane and David M. Stewart
Collection
Inv. D83.115.1

Piero Portaluppi
Milan, 1888 – Milan, 1967
274
Sconce for Casa Corbellini-
Wassermann, Milan
1934–37
Brass, mirrors, wood
56 × 30 cm
Rosanna Monzini collection
275
Console for Casa Corbellini-
Wassermann, Milan
1934–37
Burl walnut
90 × 100 cm
Cristina Cappa Legora Collection,
Milan

Enrico Prampolini
Modena, 1894 – Rome, 1956
276
Table for the Artist's Home
1925–26
Painted wood
42 × 107 × 87 cm
Private collection
277
Apparizione magica (Visione magica)
[Magical Apparition (Magical Vision)]
1931
Oil on canvas mounted on Masonite
89 × 116 cm
Mart – Museo d'Arte Moderna
e Contemporanea di Trento
e Rovereto
Inv. Vaf-Mart 982

Gaetano Previati
Ferrara, 1852 – Lavagna,
Genova, 1920
278
Georgica
[Georgic]
1905
Oil on canvas
169.5 × 216 cm
Vatican Museums – Pinacoteca
Inv. 43354

Emilio Pucci
Naples, 1914 – Florence, 1992
279
Playsuits (2)
1957
Printed cotton
Size 12 (US)
The Museum at the Fashion Institute
of Technology
Gift of Lauren Bacall
Inv. 71.254.42, 74.017.39
280
Dress
1962
Printed silk jersey
Size 8 (US)
The Museum at the Fashion Institute
of Technology
Gift of Helen O'Hagan
Inv. 78.189.11

Ernesto Puppo
Genoa, 1904 – Barcelona, 1987
281
Gate
1933
Aluminum
62.8 × 117.8 × 6.4 cm (each leaf)
Execution: Officina Matteucci,
Faenza
The Mitchell Wolfson, Jr. Collection –
The Wolfsonian-Florida International
University, Miami Beach,
Florida
Inv. 87.1569.17.2.1–.2.

Eugenio Quarti
Villa d'Almè, Bergamo, 1867 –
Milan, 1929
282
Chair
About 1900
Mahogany, inlay of mother-of-pearl,
brass, copper and silver, upholstery
92.7 × 33 × 43.2 cm
Execution: Eugenio Quarti workshop,
Milan
The Mitchell Wolfson, Jr. Collection –
The Wolfsonian-Florida International
University, Miami Beach, Florida
Inv. 84.11.10.2

Mario Radice
Como, 1898 – Milan, 1987
283
Study for a Large Fresco in the
Board Room of Casa del Fascio, Como
1932–34
Charcoal
56 × 102 cm
Musei Civici di Como, Palazzo Volpi
Inv. P699

Paolo Rizzatto
Born in Milan in 1941
Alberto Meda
Born in Lenno Tremezzina, Como,
in 1945
284
Titania Hanging Lamp
1989
Anodized aluminum blades,
polycarbonate filters, steel cable
8 × 70 × 27 cm
Produced by Luceplan, since 1991
The Montreal Museum of Fine Arts
Liliane and David M. Stewart
Collection
Inv. D91.401.1

Aldo Rossi
Milan, 1931 – Milan, 1997
285
Tea & Coffee Service
"Tea and Coffee Piazza" Collection
1983, 925/1000
Silver, baked enamel (blue band),
quartz
Coffee pot: 26 × 13.5 × 12 cm
Teapot: 22.5 × 17 × 15 cm
Creamer: 8.5 × 13.5 × 7.5 cm
Sugar bowl: H. 22.5 cm, D. 6.5 cm
Teaspoon: L. 17 cm
Small case:
Iron, glass, quartz, copper, blue
enamel plate, with clock
64 × 43.5 × 29 cm
Produced by Alessi
Museo Alessi
286
La cupola Coffee Maker
1988

Cast aluminum
H. 28.5 cm, D. 10 cm
Produced by Alessi
Museo Alessi

Mimmo Rotella
Catanzaro, 1918 – Milan 2006
287
Marilyn
1963
Collage
188 × 134 cm
Private collection

Lino Sabattini
Born in Correggio, Reggio nell'Emilia,
in 1925
288
Como Tea and Coffee Service
1957
Plated silver brass, plastic,
raffia
Teapot: 14.5 × 30 cm
Coffee pot: 22 × 16.5 cm
Sugar bowl: 8 × 15 cm
Creamer: 12 × 7.5 cm
Tray: 48.2 × 31.2 × 3.8 cm
Produced by Christofle, 1959–70
The Montreal Museum of Fine Arts
Liliane and David M. Stewart
Collection
Inv. D86.164.1–4; D89.174.1

Roberto Sambonet
Vercelli, 1924 – Milan, 1995
289
Fish Kettle/Serving Dish
1955
Stainless steel
7 × 16 × 54 cm
Produced by Sambonet, 1957
Centro Studi e Archivio della
Comunicazione, Università degli Studi
di Parma
Inv. B001929 S

Denis Santachiara
Born in Campagnola,
Reggio nell'Emilia, in 1951
290
Santavase Flowerpot
2000
Polyethylene, steel tip
H. 85 cm, D. 40 cm
Produced by Serralunga
The Montreal Museum of Fine Arts

Antonio Sant'Elia
Como, 1888 – Monte Hermada,
Quota 77, Gorizia, 1916
291
*Edificio industriale o stazione
ferroviaria*
[Industrial Building or Railway
Station]
1913

369

Pencil, black ink, red watercolour
on paper
17.4 × 41.5 cm
Musei Civici, Como
Inv. A 279

292
*Casamento su tre piani stradali
per città nuova*
[Building on Three Street Levels
for the New City]
1914
Black ink, black-blue pencil
on yellow paper
52.5 × 51.5 cm
Musei Civici, Como
Inv. A 357

Richard Sapper
Born in Munich in 1932
293
Tizio Lamp
1972
Enamelled aluminum, ABS,
thermoplastic resin
119 × 11 × 11 cm (extended)
Produced by Artemide, since 1972
The Montreal Museum of Fine Arts
Liliane and David M. Stewart
Collection
Inv. D93.232.1

Gino Sarfatti
Venice, 1912 – Gravellona Toce,
Verbano-Cusio-Ossola, 1985
294
Lamp (model 559)
1953
Plexiglas, painted metal
Produced by Arteluce
Flos SpA, Bovezzo, Brescia

Giulio Aristide Sartorio
Rome, 1860 – Rome, 1932
295
Abisso verde
[Green Abyss]
1892
Oil on canvas mounted on panel
58 × 128 cm
Private collection
296
Frammento del Fregio del Lazio
[Fragment from the Latium
Frieze]
1906
Oil on canvas
98 × 54 cm
Private collection
297
Maria Hardouin D'Annunzio
1926
Oil on canvas
80 × 40 cm
Galleria Nazionale d'Arte Moderna,
Rome
Inv. 5645

Alberto Sartoris
Turin, 1901 – Cossonay, Switzerland,
1998
Felice Casorati
Novara, 1883 – Turin, 1963
298
Private Theatre for Riccardo Gualino,
Turin. Version B, Perspective from the
Stage
1924–25
India ink on tracing paper
27.5 × 34.8 cm
Archives de la construction moderne
EPFL, Fonds Alberto Sartoris

**Alberto Savinio
(Andrea De Chirico)**
Athens, 1891 – Rome, 1952
299
Les Rois Mages
[The Magi]
1929
Oil on canvas
89 × 116 cm
Mart – Museo d'Arte Moderna e
Contemporanea di Trento e Rovereto
Inv. Pat 052939
300
Ulysse et Polyphème
[Ulysses and Polyphemus]
1929
Oil on canvas
65 × 81 cm
Mart – Museo d'Arte Moderna e
Contemporanea di Trento e Rovereto
Inv. Vaf-Mart 989

Carlo Scarpa
Venice, 1906 – Sendai, Japan, 1978
301
"Trasparente" Vase
1926
Glass
H. 34 cm
Produced by MVM Cappellin
Roberto Navarro
302
"Corroso" Vase
1936
Glass
H. 19 cm
Produced by Venini
Roberto Navarro
303
"Corroso" Vase
1936
Glass
H. 31 cm
Produced by Venini
Roberto Navarro
304
"Tessuto" Vase
1939 (piece about 1950–70)
Glass
H. 33.3 cm, D. 14 cm
Produced by Venini, 1940–90

The Montreal Museum of Fine Arts
Liliane and David M. Stewart
Collection
Inv. D88.109.1
305
"Murrina" Plate
1940
Glass
7.5 × 35 × 24 cm
Produced by Venini
Venini SpA, Murano, Venezia

Tobia Scarpa
Born in Venice in 1935
Afra Scarpa (Afra Bianchin)
Born in Montebelluna, Treviso, in
1937
306
Pierrot Lamp
1990
Polycarbonate, nylon, Pebax
elastomer, thermoplastic
H. 254 / 94 cm (max./min.)
Produced by Flos
Flos SpA, Bovezzo, Brescia

Xanti (Alexander) Schawinsky
Basel, 1904 – Locarno, 1979
307
Poster for the *Olivetti MP 1*
Typewriter
1935
Lithograph
33 × 22 cm
Studio Boggeri, Milan (for Olivetti)
Private collection

Ferdinando Scianna
Born in Bagheria, Palermo, in 1943
308
Ciminna: Venerdì Santo
[Ciminna: Good Friday]
1962
Gelatin silver print
13.2 × 24 cm
Ferdinando Scianna collection, Milan

Giovanni Segantini
Arco, Trento, 1858 – Schafberg,
Switzerland**,** 1899
309
Primavera sulle Alpi
[Springtime in the Alps]
1897
Oil on canvas
116 × 227 cm
French & Company, New York

Mario Sironi
Sassari, 1885 – Milan, 1961
310
Paesaggio urbano con taxi
[Urban Landscape with Taxi]
1920
Oil on canvas
72 × 52 cm

Mart – Museo d'Arte Moderna
e Contemporanea di Trento
e Rovereto
Inv. Vaf-Mart 988
311
I costruttori
[The Builders]
1930
Oil on canvas
100 × 70 cm
Casa Museo Boschi Di Stefano, Milan
Inv. 1023
312
Dining Room Set of Casa Aimetti,
Milan
1936 (exhibited)
Walnut, ivory, ebony
Table: 76 × 204 × 104 cm
Chair (4): 76 × 46 × 43 cm
Sideboard: 99 × 16 × 264 cm
Mirror: 36 × 182 cm
Fondazione Casa Museo Boschi
Di Stefano – Musei Civici Milanesi,
Milan
313
Il gasometro
[The Gasometer]
1943
Oil on canvas
38 × 51.5 cm
Mart – Museo d'Arte Moderna e
Contemporanea di Trento e Rovereto
Deposit of Società SOSAT
Inv. C. Giovanardi-Mart 284

Ettore Sottsass
Born in Innsbruck, Austria, in 1917
314
UFO Lamp
1957
Plastic, painted metal, Lucite
34.9 × 27.9 × 27.9 cm
Produced by Arredoluce
Galleria Colombari, Milan
315
Vase
1957
Partially glazed earthenware
H. 46.8 cm, D. 17.8 cm
Produced by Cav. G. Bitossi & Figli,
1957
The Montreal Museum of Fine Arts
Liliane and David M. Stewart
Collection
Inv. D87.159.1
316
Vase
1957
Partially glazed earthenware
H. 13.4 cm, D. 16.8 cm
Produced by Cav. G. Bitossi & Figli,
1957
The Montreal Museum of Fine Arts
Liliane and David M. Stewart
Collection
Inv. D87.160.1

317
Vase
1958
Copper enamel, satinwood
H. 47.5 cm, D. 9.4 cm
Produced by Bucci for Il Sestante,
1958–59
The Montreal Museum of Fine Arts
Liliane and David M. Stewart
Collection
Inv. D87.158.1

318
Plate
1958–59
Copper enamel
D. 29.8 cm
Produced by Bucci for Il Sestante,
1958–59
The Montreal Museum of Fine Arts
Liliane and David M. Stewart
Collection, anonymous gift
Inv. D91.424.1

319
Vase
1959
Glazed earthenware
H. 46.8 cm, D. 17.8 cm
Produced by Cav. G. Bitossi & Figli,
1959
The Montreal Museum of Fine Arts
Liliane and David M. Stewart
Collection
Inv. D87.240.1

320
Cabinet
1964 (example of 1988)
Walnut, cherry veneer, lacquered wood
251 × 152.5 × 61 cm
Produced by Renzo Brugola
The Montreal Museum of Fine Arts
Liliane and David M. Stewart
Collection, gift of Vivian and David
Campbell
Inv. D88.132.1a-k

321
Wardrobe
1966 (made in 1988)
Plywood, plastic laminate,
chromed steel
215.3 × 83.8 × 83.8 cm
Produced by Renzo Brugola
The Montreal Museum of Fine Arts
Liliane and David M. Stewart
Collection, gift of Paul Leblanc
Inv. D90.207.1a-b

Ettore Sottsass
Born in Innsbruck, Austria, in 1917
Perry Alan King
Born in London in 1938
322
Valentine Typewriter
1969
ABS, metal
11.4 × 34.3 × 35 cm
Produced by Olivetti

The Montreal Museum of Fine Arts
Liliane and David M. Stewart
Collection
Inv. D87.218.1-2

Ettore Sottsass
Born in Innsbruck, Austria, in 1917
323
Ambiente sperimentale
[Experimental Environment]
For the exhibition *Italy: The New
Domestic Landscape*, the Museum
of Modern Art, New York (1972)
n. d. [1972]
Pencil, India ink on fine cardboard
41.6 × 48.5 cm
Centro Studi e Archivio della
Comunicazione, Università degli Studi
di Parma
Inv. B004707 S

Ettore Sottsass
Born in Innsbruck, Austria, in 1917
with the collaboration of **T. Taiteshi**
324
*Opera gigantesca. Strada panoramica
per l'osservazione del fiume Irrawaddy
e della giungla lungo le sue rive*
[Giant Works. Panoramic Road for
Observation of the Irrawaddy River
and the Jungle along its Banks]
From the series "Il pianeta come
festival" [The Planet as Festival]
n. d. [1972]
Pencil, watercolour, pastel on fine
cardboard
37.4 × 29.1
Centro Studi e Archivio della
Comunicazione, Università degli Studi
di Parma
Inv. B004718 S

Ettore Sottsass
Born in Innsbruck, Austria, in 1917
325
Carlton Room Divider
1981
Wood, plastic laminate
194.9 × 189.9 × 40 cm
Produced by Memphis
The Metropolitan Museum of Art,
New York
John C. Waddell Collection.
Gift of John C. Waddell, 1997
Inv. 1997.460.1a-d
326
Mizar Vase
1982
Glass
34 × 32.8 × 30 cm
Made by Compagnia Vetraria
Muranese for Memphis
The Montreal Museum of Fine Arts
Liliane and David M. Stewart
Collection
Inv. D96.103.1

327
Murmansk Fruit Dish
1982
Silver-plated brass
H. 29.9 cm, D. 35.5 cm
Produced by Rossi e Arcandi for
Memphis, 1986–about 1996
The Montreal Museum of Fine Arts
Liliane and David M. Stewart
Collection, anonymous gift
Inv. D91.423.1

328
Sirio Vase
1982
Glass
36.2 × 15.9 × 12.1 cm
Made by Toso Vetri d'Arte
for Memphis
The Montreal Museum of Fine Arts
Liliane and David M. Stewart
Collection
Inv. D89.129.1

329
Clesitera Vase
1986
Glass
49.5 × 21.9 × 21.9 cm
Made by Toso Vetri d'Arte
for Memphis
The Montreal Museum of Fine Arts
Liliane and David M. Stewart
Collection, gift of Vivian and David
Campbell
Inv. D91.405.1a-q

Studio 65
Founded in Turin in 1968
330
Attica Chair
1972
Polyurethane, polyurethane foam,
cotton
H. 64.4 cm, D. 70.8 cm
Produced by Gufram, 1986
The Montreal Museum of Fine Arts
Liliane and David M. Stewart
Collection, gift of the American
Friends of Canada through the
generosity of Eleanore and Charles
Stendig in memory of Eve Brustein
and Rose Stendig
Inv. D94.144.1a-d

Superstudio
Florence, 1966–78
(Cristiano Toraldo Di Francia, born in
Florence in 1941; Piero Frassinelli, born
in Florence in 1939; Alessandro Magris,
born in Florence in 1941; Roberto
Magris, Florence, 1935 – Florence, 2003;
Adolfo Natalini, born in Pistoia in 1941;
Alessandro Poli, born in Florence in
1941)
331
Gherpe Lamp
1967

Perspex acrylic, chromed steel
20 × 42.9 × 20.3 cm (closed)
Produced by Poltronova, 1967–72
The Montreal Museum of Fine Arts
Liliane and David M. Stewart
Collection, gift of Eleanore and
Charles Stendig in memory of Eve
Brustein and Rose Stendig
Inv. D94.139.1a-e

Giuseppe Terragni
Meda, Milano, 1904 – Como, 1943
332
Casa del Fascio, Como (1932–36).
Perspective of the Back Facade
1933
Tempera, pencil on paper
100 × 100 cm
Archivio Centro Studi Giuseppe
Terragni
Inv. 23/021/D
333
Sant'Elia Armchair for the Board
Room, Casa del Fascio, Como
(1935–36)
1933
Tubular stainless steel, upholstery
89 × 61.5 × 80 cm
Archivio Centro Studi Giuseppe
Terragni

Federico Tesio
Turin, 1869 – Milan, 1954
334
Desk and Armchair
About 1898
Chestnut oak, aniline-stained
wood inlay
Desk: 115 × 120 × 60 cm
Armchair: 86 × 58 × 50 cm
Galleria Daniela Balzaretti

Armando Testa
Turin, 1917 – Turin, 1992
335
Punt e Mes
Poster for the Vermouth Punt e Mes
n. d. [1960]
Lithograph
200 × 140 cm
Centro Studi e Archivio della
Comunicazione, Università degli Studi
di Parma
Inv. B009677 S

Matteo Thun
Born in Bolzano in 1952
336
Volga Bud Vase
1981
Glazed porcelain
H. 54 cm, D. 15 cm
Made by Porcellane d'Arte
San Marco for Memphis,
1983–94
The Montreal Museum of Fine Arts

Liliane and David M. Stewart
Collection, anonymous gift
Inv. D91.425.1

Matteo Thun
Born in Bolzano in 1952
Andrea Lera
Born in Piombino, Livorno, in 1959
337
Chicago Tribune Floor Lamp
"Still-light" Collection
About 1984
Steel
$191.5 \times 30 \times 30$ cm
Produced by Bieffeplast, 1984–88
The Montreal Museum of Fine Arts
Liliane and David M. Stewart
Collection, gift of The Lake St. Louis
Historical Society
Inv. 2002.342

Guglielmo Ulrich
Milan, 1904 – Milan, 1977
338
Tea Service
About 1930–35
Silver, ebony
Teapot: $14 \times 32 \times 12$ cm
Creamer: $8 \times 22 \times 10$ cm
Sugar bowl: $6 \times 17 \times 10$ cm
Giancorrado Ulrich collection
339
Chair
About 1936
Mahogany
$81.3 \times 43.2 \times 47$ cm
Giancorrado Ulrich collection

Giuseppe Uncini
Born in Fabriano, Ancona, in 1929
340
Cementarmato del Bob
[Bob Reinforced Concrete]
1960
Reinforced concrete, iron rods
$190 \times 116 \times 5$ cm
Mart – Museo d'Arte Moderna
e Contemporanea di Trento
e Rovereto
Inv. Vaf-Mart 1799

Gino Valle
Udine, 1923 – Udine, 2003
with **John Meyer**, **Michele Provinciali**
and **Nani Valle**
341
Cifra 5 Clock
1955
Methyl polyacrylate, ABS
$17 \times 27 \times 11$ cm
Produced by Solari
Alessandro Pedretti Collection,
Milan

Venini & C.
Founded in Murano in 1925

342
Hanging Lamp for the Olivetti
Showroom, New York, by
L. Belgiojoso, E. Peressutti
and E. N. Rogers
1954
Glass
H. 67 cm
Produced by Venini
Roberto Navarro

Paolo Venini
Milan, 1895 – Venice, 1959
Fulvio Bianconi
Padua, 1915 – Milan, 1996
343
Morandiane Bottle (model 526.15)
About 1950–55 (example from
between 1950–70)
Glass
H. 49.2 cm, D. 7.3 cm
Produced by Venini, 1955–90
The Montreal Museum of Fine Arts
Liliane and David M. Stewart
Collection
Inv. D88.111.1a-b

Luigi Vietti
Novara, 1903 – Milan, 1998
344
Armchair
About 1936
Chromed tubular steel, leather straps
$83 \times 60 \times 69$ cm
The Mitchell Wolfson, Jr. Collection –
Fondazione Regionale C. Colombo,
Genoa
Inv. GG1999.3

Massimo Vignelli
Born in Milan in 1931
345
Suspensions (model 4035L)
1953
Glass
$50 \times 18 \times 18$ cm
Produced by Venini, about 1954–
about 1970, 1986
The Montreal Museum of Fine Arts
Liliane and David M. Stewart
Collection
Inv. D85.151.1-3

Adolfo Wildt
Milan, 1868 – Milan, 1931
346
I Puri
[The Pure]
1913
Ink, gold on parchment
23.5×18 cm
Private collection
347
Holy Water Stoup
1921
Mosaic, gilt bronze, onyx

$47 \times 44 \times 11$ cm
Private collection
348
La famiglia. Testa della madre
[The Family. Head of the Mother]
1922
Marble
H. 61.2 cm
Franco Maria Ricci collection
349
Portrait of Cesare Sarfatti
1927
Marble, bronze plaque
$48 \times 37.5 \times 23$ cm
Private collection

Gigiotti (Luigi) Zanini
Vigo di Fassa, Trento, 1893 –
Gargnano del Garda, Brescia,
1962
350
La città
[The City]
1922
Oil on canvas
59.8×59.8 cm
Private collection
Courtesy Claudia Gian Ferrari, Milan

Marco Zanuso
Milan, 1916 – Milan, 2001
351
Lady Armchair
1951
Wood, metal, foam rubber, fabric
$82 \times 77 \times 77$ cm
Produced by Arflex, 1951
The Metropolitan Museum of Art
Purchase, Theodore R. Gamble Jr.
Gift, in honour of his mother, Mrs.
Theodore Robert Gamble, 1986
Inv. 1986.287

Marco Zanuso
Milan, 1916 – Milan, 2001
Richard Sapper
Born in Munich in 1932
352
Child's Stackable Chair
(model K 4999)
1959
Polyethylene, removable legs
$50 \times 28 \times 28$ cm
Produced by Kartell, 1964–79
The Kartell Foundation Museum
353
Brionvega TS 502 Portable Radio
1964
ABS, Zamak chrome
$13 \times 22 \times 13.4$ cm
Produced by Brionvega
The Montreal Museum of Fine Arts
Liliane and David M. Stewart
Collection, gift of the American
Friends of Canada through the
generosity of Eleanore and Charles

Stendig in memory of Eve Brustein
and Rose Stendig
Inv. D94.147.1a-b
354
Algol 3 Television Set
1964
Plastic
$25.5 \times 29.5 \times 32.5$ cm
Produced by Brionvega, 1964–
about 1989
The Montreal Museum of Fine Arts
Gift of Huguette and Vittorio Ferrero
Inv. 2000.62.1-3
355
Grillo Telephone
1966
ABS
$7 \times 16 \times 8$ cm
Produced by Sit-Siemens / Italtel
The Montreal Museum of Fine Arts
Liliane and David M. Stewart
Collection, gift of Priscilla
Cunningham
Inv. D87.210.1
356
Black ST 201 Television Set
1969
Acrylic
$30.5 \times 30.5 \times 30.5$ cm
Produced by Brionvega
Andrea Rosetti Collection

Vittorio Zecchin
Murano, Venezia, 1878 – Venice, 1947
357
Vase
About 1914
Glass
H. 50 cm, D. 21 cm
Produced by Vetreria Artistica
Barovier, Murano
Execution: Benvenuto Barovier
(1855–1932) or Giuseppe Barovier
(1853–1942)
The Mitchell Wolfson, Jr. Collection –
Fondazione Regionale C. Colombo,
Genoa
Inv. GX1993.271
358
Donne in scialle
[Women in Shawls]
About 1920
Tapestry of embroidered wool
on jute
113×108 cm
Execution: Laboratorio di Vittorio
Zecchin, Murano
Private collection
359
Libellula Vase
1922–26
Glass
19.5 cm $\times 50.5$ cm
Produced by MVM Cappellin
Galleria Marina Barovier,
Venice

Carlo Zen
Verona, 1851 – Lanzo d'Intelvi,
Como, 1918
360
Chair
About 1900
Fruitwood, inlay of brass, white metal
and mother-of-pearl, cotton velvet
upholstery
97.7 × 36.2 × 36.5 cm
Cooper-Hewitt National Design
Museum, Smithsonian Institution
Gift of Donald Vlack
Inv. 1971-49-1
361
Writing Desk
About 1902
Fruitwood, inlay of brass, white metal
and mother-of-pearl, leather
104.1 × 64.8 × 63.5 cm
Cooper-Hewitt National Design
Museum, Smithsonian Institution
Gift of John Goodwin
Inv. 1963-29-1
362
Cabinet
1902
Mahogany, inlay of mother-of-pearl,
silver and brass
198 × 94.5 × 31.8 cm
The Montreal Museum of Fine Arts
Purchase, estates of Serge Desroches,
Hermina Thau, David R. Morrice,
Mary Eccles, Jean Agnes Reid
Fleming, G. C. Chisholm, Margaret
A. Reid, F. Eleanore Morrice
Inv. 2001.73.1-5

Biographies

Albini, Franco

(Robbiate, Lecco, 1905 – Milan, 1977)
Architect, designer. He graduated
from the Milan Politecnico in 1929.
After working for a short time in the
Ponti and Lancia studio, he opened a
studio in Milan with Camus and
Palanti in 1930, taking part in the
Triennali and other exhibitions.
Editor with Palanti of the magazine
Costruzioni Casabella (1945–46) and
one of the exponents of the Rationalist
movement before the war, he
afterwards turned his attention to
urban planning (he was one of those
who drew up the AR urban
development scheme for Milan in
1945), architecture (La Rinascente
department store, Rome, 1957–61;
Olivetti store, Paris, 1960), design
(winning two Compassi d'Oro) and
museology (Museo del Tesoro di San
Lorenzo, Genoa, 1952–56). In 1952
F. Helg became a partner in the studio.
A member of the CIAM and founding
member of the MSA, he taught at the
universities of Turin (1954–55), Venice
(1955–64) and Milan (1964–77).

Anastasio, Andrea

(Rome, 1961)
Designer. In 1993 he went to India
and worked at the Krishnamurti
Foundation. He graduated in
philosophy in Venice and his interest
in this area, and in art, religion,
music, theatre and history, opened the
doors of the Memphis Group to him.
Particularly active in the design of
glassware, he collaborates with Rahul
Mehrotra Associates in Mumbai on
the design of private houses and holds
workshops at the National Institute of
Design in Ahmedabad.

Archizoom Associati

(Active in Florence then Milan,
1966–74)
Dario Bartolini (Trieste, 1943),
Andrea Branzi (Florence, 1938),
Gilberto Corretti (Florence, 1941),
Paolo Deganello (Este, Padova, 1940),
Lucia Morozzi (Florence, 1944),
Massimo Morozzi (Florence, 1941).
Group of architects founded by
Branzi, Corretti, Deganello and
Morozzi. Taking its inspiration from
Pop art and Archigram, it made its
debut in the field of urban research,
laying the foundations of Radical
Design (*No Stop City*, 1969–72), and
then went on to concentrate on the
design of objects and settings,
producing displays and articles as
well as their projects of Design
Dressing. With Superstudio it
organized the exhibition
Superarchitettura in Pistoia and
Modena (1966–67). Present at the
Milan Triennale of 1968 with its
Centro di Cospirazione Eclettica
[Centre of Eclectic Conspiracy], it
showed an experimental domestic
living unit at the exhibition *Italy: The
New Domestic Landscape* (MoMA,
New York) in 1972. In 1973 the group
moved to Milan.

Aulenti, Gae (Gaetana)

(Palazzolo della Stella, Udine, 1927)
Architect, designer, set designer. She
graduated from the Milan Politecnico
in 1954 and then began to design,
working in parallel on the page layout
of *Casabella-Continuità* (1954–62).
Involved in the neo-Stile Liberty
experience, she was particularly
active in the design of domestic and
commercial interiors (Olivetti

Showroom, Paris, 1967–68). From the
1970s onwards she devoted a lot of
energy to set design, collaborating
with the director Luca Ronconi.
She showed an experimental domestic
living unit at the exhibition *Italy:
The New Domestic Landscape* (MoMA,
New York) in 1972. Since the 1980s
she has designed numerous exhibition
spaces (Musée d'Orsay in Paris;
Palazzo Grassi, Venice; Asian Art
Museum, San Francisco), and won the
Praemium Imperiale for Architecture
(Tokyo, 1991).

Baldelli, Dante

(Città di Castello, Perugia, 1904–53)
Ceramicist. He graduated in sculpture
from the Accademia di Belle Arti in
Rome. Related to one of the founders
of the Ceramiche d'Arte Rometti in
Umbertide, he became its art director
until it closed down (1928–42). He
exhibited his own work on various
occasions, and held a solo show
in Città di Castello (1932). Thanks to
the high quality of its creations, the
Rometti firm was invited to show at
the Milan Triennale of 1933.

Baldessari, Luciano

(Rovereto, Trento, 1896 – Milan, 1982)
Architect, set designer, artist. He was
introduced to Futurism by Depero in
1913, and graduated in architecture
in Milan in 1922. In 1923 he moved to
Berlin where, in touch with the
Bauhaus and the principal exponents
of European culture, he devoted
himself to architecture, painting,
sculpture and set design. After
returning to Italy (1926), he played an
active part in the Rationalist
movement and worked on some

significant projects (Bar Craja, with Figini and Pollini, Milan, 1930; Press Pavilion, Milan Triennale, 1933), set designs and ballets. After working as a painter and set designer in New York (1940–48), he went back to Milan, staging exhibitions and designing important works of architecture (atrium and grand staircase, Milan Triennale; Breda Pavilion, Milan Trade Fair, 1952).

Balla, Giacomo
(Turin, 1871 – Rome, 1958)
Painter, designer. He attended the Accademia Albertina for a few months and then moved to Rome in 1895. Drawn to Divisionism and its social concerns, he took part in the literacy campaign of the Scuola per la Campagna Romana and taught painting to young artists like Boccioni and Severini. In 1903 he exhibited at the Venice Biennale, and in 1909 at the Salon d'Automne in Paris. After signing the *Manifesto of the Futurist Painters* and the *Technical Manifesto of Futurist Painting* (1910), he wrote *The Antineutral Suit* (1914), signed the *Futurist Reconstruction of the Universe* (1915), the *Manifesto of Futurist Cinematography* (1916) and the *Manifesto of Colour* (1918). Showing at the main Futurist exhibitions in different parts of the world from 1912 to the 1930s, he was active in various fields (painting, cinema, set design, interior design, applied arts, fashion). In 1931 he signed the *Manifesto of Aeropainting*, and in 1937 left the Futurist movement.

Barovier, Ercole
(Murano, Venezia, 1889–1974)
Designer of glassware. In 1919 he entered the family firm of Artisti Barovier, which he renamed Vetreria Artistica Barovier & C. He remained its art director until 1972, contributing to the renewal of the art of glassmaking. In 1942 the firm became Barovier & Toso (following its merger with Saiar Ferro-Toso in 1936). In 1929, after years of study and experimentation with forms and materials, he developed a new kind of glass and produced an innovative series of glassware called "Primavera." In 1935–36 he discovered the technique of colouring the material while hot but without melting it, thus creating new types of glass. From 1948 to 1972 he experimented with the possibilities of mosaic glass.

Bartolini, Dario
(Trieste, 1943)
Architect, designer, artist.
He graduated in architecture from the university of Florence in 1972. A member of the Archizoom group (1968–73) with his wife Lucia, he took part in several exhibitions (Milan Triennale, 1968; *Italy: The New Domestic Landscape,* MoMA, New York, 1972; *Vestirsi è facile*, Milan Triennale, 1973). He has produced interactive sound machines and installations (1967–70), been a consultant in the field of clothing design for companies in the textile and fashion industry (1973–96), illustrated and written books for children and designed teaching aids (1973–89). Since 1989 he has devoted himself exclusively to art (painting, sculpture, Land Art).

Basile, Ernesto
(Palermo, 1857–1932)
Architect, designer. A leading exponent of Stile Liberty, he graduated in architecture in 1878. He designed public buildings and numerous villas in Rome and Palermo. It was with the Villino Florio and Villa Igiea in Palermo (1899) that he demonstrated his enthusiasm for the modern spirit of Art Nouveau. One of the principal authors and promoters of the renewal of the applied arts in Italy, from 1899 he designed various types of avant-garde furniture for the Golia company, later Ducrot, which were published in Italian and foreign magazines. He took part in the Esposizione internazionale d'Arte decorativa in Turin (1902), the Esposizione internazionale in Milan (1906) and the Venice Biennale (1903). He designed majolica ware for Ceramica Florio and taught at the universities of Rome and Palermo.

BBPR
(Founded in Milan in 1932).
Gian Luigi Banfi (Milan, 1910 – Mauthausen, Austria, 1945), Lodovico Barbiano di Belgiojoso (Milan, 1909–2004), Enrico Peressutti (Pinzano di Tagliamento, Pordenone, 1908 – Milan 1976), Ernesto Nathan Rogers (Trieste, 1909 – Gardone Riviera, Brescia, 1969)
Studio of architects, urban planners and designers. Its members, after graduating in Milan in 1932, were among the protagonists of Italian Rationalism before the war. They participated after the war in the

Milan Triennali, the MSA and the CIAM (they organized the one held in Bergamo, 1949) and produced a number of important designs (Torre Velasca, Milan, 1950–58; Musei del Castello Sforzesco, Milano, 1952–56). As designers they worked with various companies (including Olivetti), winning a Compasso d'Oro. Rogers, the theorist of the group and a decisive figure in Italian architectural culture, wrote influential essays and criticism, edited *Domus* (1946–47) and *Casabella-Continuità* (1953–64) and taught in Switzerland during the war and at the Milan Politecnico (from 1953). Peressutti taught in London and at important American institutions in the 1950s. Barbiano di Belgiojoso, who was involved in planning the reconstruction of Milan after the war, kept the studio going even after the death of his partners. He taught at the universities of Venice (1954–63) and Milan (from 1963).

Beecroft, Vanessa
(Genoa, 1969)
Artist. She studied painting at the Accademia Ligustica di Belle Arti in Genoa (1987–88) and set design at the Accademia di Brera in Milan (1988–93). Since 1993 she has staged performances that involve groups of young women or, more recently, sailors in the US Navy, rapidly gaining an international reputation that was crowned in 1998 by a solo show at the Guggenheim Museum in New York. Her work has been exhibited at numerous group and solo exhibitions all over the world. She lives and works in New York.

Bellini, Mario
(Milan, 1935)
Architect, designer. He graduated from the Milan Politecnico in 1959. In charge of design at La Rinascente (1961–63), he set up a studio of architecture and design in 1963 that is now called Mario Bellini Associates. He has worked for various companies, especially in the field of electronics, and has been in charge of Olivetti design since 1963. He contributed an experimental domestic living unit to the exhibition *Italy: The New Domestic Landscape* at the MoMA in 1972, and became an adviser on research and design at Renault in 1978. Since the 1980s he has devoted himself chiefly to architecture (Tokyo Design Center, 1988–92; National Gallery of Victoria, Melbourne,

1996–2003). Very active in the field of exhibition design at an international level, he has taught at the universities of Venice, Vienna and Genoa. Editor of *Domus* (1986–91), he has won eight Compassi d'Oro.

Berengo Gardin, Gianni
(Santa Margherita Ligure, Genova, 1930)
Photographer. He made his debut in 1954, publishing his first photographs in *Il Mondo*. Close to the neorealist current, he has contributed to major magazines and newspapers in Italy and abroad (*Domus, Epoca, L'Espresso, Time, Stern, Harper's Bazaar, Vogue, Du, Le Figaro*) and around 200 volumes of his photographs have been brought out by Italian (Touring Club Italiano, Istituto Geografico de Agostini) and foreign publishers. He has also worked extensively in advertising and architectural photography. He has been a member of Contrasto since 1990, and his work has been presented at numerous group exhibitions and solo shows in various parts of the world, and he has received important international awards.

Berizzi, Sergio
(Milan, 1930 – Boston, 1976)
Butté, Cesare
(Milan, 1930)
Montagni, Dario
(Trento, 1929)
Architects. They graduated from the Milan Politecnico (1955–56). In 1956 Alex Poss, executive of the Phonola company, invited them to design a television set. Out of this came the television with an adjustable screen (model 17/18). Once the commission had been fulfilled they pursued separate careers.

Bertelli, Renato
(Lastra a Signa, Firenze, 1900–74)
Sculptor. He was trained at the school of the sculptor D. Trentacoste. He made his debut at the Esposizione Primaverile in Florence in 1922. In 1928 he exhibited at the Venice Biennale. In the 1930s he became involved with the Futurists, taking part in their cultural initiatives (organizing the Nuovo Gruppo Indipendente in Linea in Signa). His most famous work, *Testa di Mussolini* [Head of Mussolini], 1933, was patented and reproduced in various materials and was present in almost all the local branches of the Italian Fascist Party (the Casa del Fascio).

Bianconi, Fulvio
(Padua, 1915 – Milan, 1996)
Artist, designer. After graduating from the Accademia di Belle Arti in Venice, he moved to Milan where, in the late 1930s, he worked as a graphic artist and illustrator for various companies (HMV, Pathé, Fiat, Pirelli, Motta, Mondadori, Garzanti) and manufacturers. He went to learn glassmaking in Murano where he worked for Venini from 1948 onwards, showing several works at the Venice Biennale of that year and his famous *pezzati* [flecked] and *a spicchi* [segmented] vases at the Milan Triennale (1951). From 1951 onwards he did freelance work for companies like Venini & C., Vetreria Cenedese and Vetreria Vistosi.

Boccioni, Umberto
(Reggio Calabria, 1882 – Verona, 1916)
Artist, illustrator. After moving to Rome in 1899, he frequented the studio of a poster artist, the Scuola Libera del Nudo and Balla's studio, learning the trades of illustrator and painter. Moving on to Milan in 1907, he got to know Marinetti and in 1910 promoted the birth of Futurist painting, signing with others the *Manifesto of Futurist Painters* and the *Technical Manifesto of Futurist Painting*, organizing the group's exhibitions and holding his first solo show in Venice (Ca' Pesaro). In 1912 he wrote the *Technical Manifesto of Futurist Sculpture* and took part in the first travelling exhibition of Futurist painters in Europe.
He showed at all the movement's exhibitions in Italy and abroad until 1914, the year he published *Futurist Sculpture Painting – Plastic Dynamism*. He took part in various international debates in the magazines *Der Sturm* and *Lacerba*.

Boeri, Cini (Maria Cristina Mariani)
(Milan, 1924)
Architect, designer. She graduated in Milan in 1951. After a period in Ponti's studio she worked with Zanuso (1952–63). Since 1963 she has worked freelance in the fields of architecture and design. Her research is focused chiefly on the study of functionality in homes with limited space. In 1967 she began to collaborate with Arflex. In 1979 she set up the Cini Boeri Associati studio, producing numerous designs for stores in Italy and abroad (Venini, Arflex, Knoll International). She has taught at the Milan

Politecnico (1980–83) and won a Compasso d'Oro.

Boetti, Alighiero
(Turin, 1940–Rome, 1994)
Artist. Self-taught, he commenced his career in the circle of Arte Povera, holding his first solo shows in 1967 (Galleria Christian Stein, Turin; Galleria La Bertesca, Genoa). In 1968 he began to present himself as two different personalities, signing his works "Alighiero e Boetti." From 1971 to 1979 he made a series of journeys to Afghanistan, inaugurating a series of coloured embroideries made by local women. Using letters, maps and numbers, he devised new mechanisms founded on mathematical rules and infinite possibilities of combination. From 1972 onwards he exhibited frequently at the Venice Biennale and the Documenta in Kassel. He held numerous solo shows in various parts of the world.

Boggeri, Antonio
(Pavia, 1900 – Santa Margherita Ligure, Genoa, 1989)
Graphic artist, photographer. Director of the Milanese printing works Alfieri & Lacroix (1924–32). In 1933 he founded the Studio Boggeri in Milan, the first agency in Italy capable of providing clients with a complete service of graphic design and advertising. Influenced by the European avant-gardes, he experimented with advanced techniques like photography and photomontage, drawing on the services of graphic artists like Bernhardt, Schawinsky, Nizzoli, Carboni, Muratore, Munari, Huber, Vivarelli, Ballmer, Grignani, Calabresi, Noorda, Steiner and Monguzzi. He won the Gran Premio and the Medaglia d'Oro at the IX and XI Milan Triennali.

Bonazza, Luigi
(Arco, Trento, 1877 – Trento, 1965)
Painter, engraver. After moving to Vienna (1897–1912) and coming into contact with the Secession, he graduated from the Kunstgewerbeschule (1901). Devoting himself to painting and engraving, he took part in the Esposizione internazionale in Milan (1906), the exhibition of the Secession (1907) and the Venice Biennale (1912). Returning to Trento, he taught at the Scuola Reale Superiore and began the decoration of his house (1914). A designer of airplanes for Caproni,

he exhibited with success on several occasions (Venice Biennale, 1920–22) and executed a number of mural decorations (Trento post office, 1932–33).

Borsani, Osvaldo
(Varedo, Milano, 1911 – Milan, 1985)
Architect, designer. He graduated in architecture in Milan in 1937. While still a student, he worked as a designer in his father's furniture company. In 1933 he took part in the Milan Triennale, along with Cairoli and Varisco, with the project for the Casa Minima. In 1953, with his brother Fulgenzio, he founded Tecno (a company mass-producing furniture that he designed), combining his enthusiasm for technology with his passion for art (he collaborated with artists like Fontana, Melotti and Pomodoro). One of the founders of the magazine *Ottagono* (1966), he created the Ufficio Progettazione e Studi in 1970 to carry out research into design and new technology.

Branzi, Andrea
(Florence, 1938)
Architect, designer, theorist. He graduated in Florence in 1967. One of the founders of Archizoom Associati (1966–74), he moved to Milan, setting up the Consulenti Design Milano (CDM) company and carrying out the first research into Design Primario (1973–82). Art director of Fiorucci (1975–79), he joined Studio Alchimia (1977) and Memphis (1981–87). A theorist and essayist, he contributed to *Casabella* (1972–76), edited *Modo* (1983–87) and works in the fields of design, architecture, urban installations, theatre design and installations. Founder and cultural director of the Domus Academy (1983–96), he has taught at the Milan Politecnico since 1994. He organizes exhibitions on design and on themes related to the home, winning international prizes for his design and theoretical work (two Compassi d'Oro).

Bugatti, Carlo
(Milan, 1856–Molsheim, Alsace, 1940)
Cabinetmaker, artist. He left the Accademia di Brera to devote himself to cabinetmaking at the Mentasti workshop, where he made his first furniture. Awarded the Diploma of Honour at the *Italian Exhibition* in London, he opened his own workshop in Milan in 1888. He sold some of his furniture at Liberty & Co. (London,

Paris). At the height of his success, in 1898, he founded Carlo Bugatti & C. His furniture impressed the critics with its unusual materials and shapes and Japanese and Moorish decorative motifs, winning prizes and awards at the most important exhibitions of the time. In 1900 he designed furniture for the palace of the khedive in Istanbul and in 1902 presented his famous "Snail Room" at the Esposizione internazionale in Turin, winning the Gran Diploma d'Onore. After moving to Paris in 1904, he produced small objects and sculptures at the Hébrard foundry and devoted himself to painting. In 1937 he retired to live with his son Ettore in Molsheim.

Bugatti, Rembrandt
(Milan, 1884 – Paris 1916)
Sculptor. Carlo's son and a pupil of Troubetzkoy, he studied at the Accademia di Brera. In 1903 he moved to Paris, where he frequented the zoo, the source of inspiration for his sculptures. In 1905 he gave the exclusive rights to sell his works to the gallery owner Hébrard, who was also the proprietor of a bronze foundry. He exhibited at the Venice Biennale from 1903 and the Salon d'Automne from 1905 onwards and won the Gran Premio at the Esposizione internazionale in Milan (1906). He moved to Antwerp in 1907. He was made a Chevalier of the Légion d'Honneur, and held a solo show in Antwerp's famous zoo in 1911. In 1915 he returned to Paris and committed suicide a year later.

Caccia Dominioni, Luigi
(Milan, 1913)
Architect, designer. He graduated in Milan in 1936 and began his career as a designer with L. and P. G. Castiglioni (1938–40), carrying out innovative research in the field and participating in the Triennale of 1940. In 1947 he opened a studio of architecture and design and was one of the founders of the furniture manufacturer Azucena, which would produce many of his pieces. A leading member of the group of architects gathered around *Casabella-Continuità*, he created housing models for a new middle class, reinventing the "Milanese style" (house on Piazza Sant'Ambrogio, 1949–50; residential building on Piazza Carbonari, 1960–61). He won a Compasso d'Oro.

Cagli, Corrado

(Ancona, 1910 – Rome, 1976)
Artist. He studied at the Accademia di Belle Arti in Rome. He made his debut in 1927 with mural painting. From 1928 to 1931 he lived in Umbertide and worked with D. Baldelli at the Ceramiche d'Arte Rometti pottery. In 1932, the year of his first solo show in Rome, he formed the group known as the École de Rome with Capogrossi and Cavalli, exhibiting with them in Milan (Galleria del Milione), Rome and Paris. In the 1930s he painted important murals (Milan Triennale, 1933) and wrote as theorist and critic. After living in Paris and New York (1938–48), he went back to Rome where he devoted himself to painting and theatre design, providing inspiration to young artists.

Cambellotti, Duilio

(Rome, 1876–1960)
Artist, designer. He graduated from the Museo Artistico Industriale. Initially drawn to Art Nouveau, he designed lamps and small objects for foreign firms. A sculptor, graphic artist and illustrator, he also began to work as a set designer in 1905. Principal architect of the renewal of the applied arts in Rome, he set up a school of ceramics at the Museo Artistico Industriale in 1917. Socially engaged, he devoted his energies, along with Cena, Marcucci and Balla, to the creation of schools in the Roman countryside to promote literacy among peasants and staged the *Mostra delle scuole dell'Agro Romano* (1911). He showed his own creations (furniture, stained glass, tapestries, pottery, bronzes) at the Monza Biennali (Diploma d'Onore, 1923). He designed the interiors of the Palazzo dell'Acquedotto Pugliese, Bari (1931–34). From 1908 onwards he taught at the Accademia di Belle Arti in Rome.

Cangiullo, Francesco

(Naples, 1884 – Livorno, 1977)
Poet, writer, artist. He debuted as a poet in 1912. Until the mid-1920s he worked with *Lacerba*, *Vela Latina*, *L'Italia Futurista* and *Roma Futurista*, and composed the Futurist poems *Piedigrotta*, *Caffè-concerto*. *Alfabeto a sorpresa* and *Poesia pentagrammata*. His debut as an artist was at the *Esposizione Libera Futurista internazionale* held at the Galleria Sprovieri in Rome (1914). He co-authored the manifestos

Il mobilio futurista (1920), and with Marinetti, *Il Teatro della sorpresa* (1921). Author of Futurist theatrical summaries, Futurist pictorial works and poetic and literary texts, in 1924 he abandoned Futurism.

Capogrossi, Giuseppe

(Rome, 1900–1972)
Painter. After graduating in law in 1922, he studied at the Scuola di Nudo and decided to devote himself to painting. He travelled often to Paris (1927–31). In 1930 he exhibited at the Venice Biennale. A prominent exponent of the École de Rome (1931–33) along with Cavalli and Cagli, he showed with the group in Milan (Galleria del Milione), Rome and Paris. In 1949 he turned from figurative painting to the language of signs (with his Surfaces). He founded Gruppo Origine with Burri and others and signed the *Fourth Spatialist Manifesto* (1953) with Fontana, Crippa and Dova, establishing an international reputation.

Carrà, Carlo

(Quargnento, Alessandria, 1881 – Milan, 1966)
Painter, art critic. He started his career as a mural decorator, going on to decorate pavilions at the Exposition universelle in Paris (1900). In 1901 he went to study at the Accademia di Brera in Milan. An interest in Divisionism brought him into contact with Boccioni and Russolo. In 1910 he joined the Futurist movement, signing the *Manifesto of Futurist Painters* and the *Technical Manifesto of Futurist Painting* and taking part in the main Futurist exhibitions. Repeated stays in Paris drew him towards Cubism, which he fused with the tradition of Italian art, leading to the development of Metaphysical painting. Hospitalized in Ferrara during the war, he met De Chirico, Savinio and De Pisis in 1917. After returning to Milan, he was one of the founders of the magazine *Valori Plastici* (1919). This was followed by important group exhibitions (*I Mostra del Novecento Italiano*, 1926) and solo shows (Galleria del Milione, Milan, 1935; Venice Biennale, 1928, 1940).

Carrozzeria Castagna

(Milan, 1906 – Venegono Superiore, Varese, 1954)
In 1894 Carlo Castagna took over the management of the Ferrari & Orsaniga group, which brought together several Milanese

coachbuilders, steering them towards the production of car bodies and gradually assuming control. The Carrozzeria C. Castagna & C. (1906) built innovative and famous chassis for Alfa Romeo, Fiat, Isotta Fraschini, Lancia, Mercedes and Duesenberg. From 1914 onwards his son Ercole ran the company with his brother Emilio (in charge of the design department from 1920) and it reached the peak of its success. The company was transferred to Venegono Superiore and closed down in 1954.

Carrozzeria Touring

(Milan, 1926–1966)
In 1926 Felice Bianchi Anderloni and Gaetano Ponzoni took over the Carrozzeria Falco and founded the Carrozzeria Touring. Bianchi Anderloni took charge of the design side, drawing on the services of talented collaborators (Seregni, Betti, Formenti). He produced innovative chassis for Isotta Fraschini, Alfa Romeo and Ferrari that were characterized by a remarkable lightness (Weymann system, Superleggera system) and devised the model of the light sports saloon (Gran Turismo). On his death in 1948, his son Carlo Felice became director of the company, which was renamed Carrozzeria Touring Superleggera.

Casorati, Felice

(Novara, 1883 – Turin, 1963)
Painter. He made his debut at the Venice Biennale in 1907. In the second decade of the century he exhibited with the young Secessionists at the Ca' Pesaro, Venice. After moving to Turin in 1918, he made friends with the industrialist and patron of the arts Riccardo Gualino, for whom he created a small theatre (1925) for his house, entrusting its architectural design to the young Alberto Sartoris. In 1927 he designed a model butcher's shop for the Monza Biennale. An active designer of scenery and costumes (1930s), he staged the *Mostra collettiva di Arte astratta italiana* in his studio in 1935. He promoted young artists, exhibited frequently in Italy and abroad and held two solo shows at the Venice Biennale (1924, 1952). He taught at the Accademia Albertina in Turin (1928–30), and became its principal in 1952.

Castellani, Enrico

(Castelmassa, Rovigo, 1930)
Artist. After moving to Brussels in 1952, he attended the Académie

Royale des Beaux Arts and the École Nationale Supérieure, graduating in architecture in 1956. He settled in Milan, founded the magazine *Azimut* and the gallery of the same name with Manzoni, Bonalumi and Agnetti in 1959, and exhibited his first monochrome surface with punctures and reliefs. In 1960 he showed at the exhibition *Monochrome Malerei* at the Kunstmuseum, Leverkusen. This was followed by other important exhibitions in Italy and abroad, including the Venice Biennale (1964, 1968) and Documenta, Kassel (1968). He lives and works in Celleno.

Castiglioni, Achille

(Milan, 1918–2002)
Architect, designer. From 1938 onwards he and his brothers devoted themselves to experimentation with industrial products. In 1944 he graduated from the Milan Politecnico and after the war shared a studio with his brother Pier Giacomo. Together they designed a wide range of objects and exhibition designs (Villa Olmo, Como, 1957; Montecatini Pavilion, Milan Trade Fair, 1962) and several works of architecture, combining rationality, a sense of irony, assemblage, technological minimalism and functionality with masterly skill. On the death of his brother, he continued to work as a designer. Present at all the Milan Triennali from 1947 onwards (winning major prizes), he was also active as a critic (*Stile Industria*, 1950–60). One of the founders of the ADI (he sat on its board of directors), he taught at the Politecnicos of Turin (1969–80) and Milan (1981–93), where he received an honorary degree in industrial design (2001). He won nine Compassi d'Oro (one for lifetime achievement).

Castiglioni, Livio

(Milan, 1911–1979)
Architect, designer. He graduated from the Milan Politecnico in 1936. In 1938 he opened a studio with his brother Pier Giacomo, carrying out innovative research in collaboration with Caccia Dominioni, especially in designing radio sets, and took part in the Milan Triennale of 1940. After the war he struck out on his own. Consultant for design at Phonola (1940–60) and Brionvega (1960–64), he devoted his attention chiefly to lighting from 1952 onwards. President of the ADI (1959–60), he created audiovisual installations in the 1960s, collaborating with famous artists and

designers (Expo '67, Montreal; Venice Biennale, 1970). From 1973 onwards he collaborated with his son Piero.

Castiglioni, Pier Giacomo

(Milan, 1913–1968)
Architect, designer. He graduated from the Milan Politecnico in 1937. In 1938 he opened a studio with his brother Livio, carrying out innovative research in the field of design in collaboration with Caccia Dominioni. After the war he shared a studio with his brother Achille. Together they designed a wide range of objects and exhibition designs (Villa Olmo, Como, 1957; Montecatini Pavilion, Milan Trade Fair, 1962; Palazzo Reale, Milan, 1963) as well as several works of architecture, combining rationality, a sense of irony, assemblage, technological minimalism and functionality with masterly skill. Present at all the Milan Triennali from 1947 onwards (winning major prizes), he was one of the founders of the ADI (he sat on its board of directors). He taught at Milan Politecnico (1946–68) and won five Compassi d'Oro.

Cerri, Pierluigi

(Orta San Giulio, Novara, 1939)
Architect, graphic artist, designer. He graduated from the Milan Politecnico in 1962. Particularly active in the fields of graphics and publishing, he was responsible for the image of Palazzo Grassi in Venice and the Venice Biennale (1976). He was art director of the Electa publishing house (1978–84) and the magazines *Rassegna* and *Casabella*, and has designed some important installations (*Identité Italienne*, Centre Georges Pompidou, Paris, 1981). He was a founding member of the Gregotti Associati studio in Milan (1974–98), where he worked in communications, industrial design and interior design. In 1998 he set up Studio Cerri & Associati. A member of the Alliance Graphique Internationale (AGI), he won three Compassi d'Oro.

Chia, Sandro

(Florence, 1946)
Artist. He graduated from the Accademia di Belle Arti in Florence in 1969. In 1970 he settled in Rome, exhibiting frequently and staging happenings in the city (Galleria La Salita, 1971) and elsewhere in Europe, as well as making numerous trips to the East. In the 1980s he was one of the exponents of the Transavanguardia. He worked in Mönchengladbach (1980–81) and New York (1981–82). He has exhibited several times at the Venice Biennale since 1980. His work has been presented at numerous solo shows (The Metropolitan Museum of Art, New York, 1984) and group exhibitions (Guggenheim Museum, New York, 1983). He lives and works in New York and Montalcino.

Chini, Galileo

(Florence, 1873–1956)
Artist, decorator, set designer. He worked with his uncle, a decorator and restorer, and attended the Accademia di Belle Arti in Florence. Active throughout his life as a painter, he was also a successful set designer from 1908 onwards. In 1896 he founded the Arte della Ceramica pottery with others, becoming its art director. An exponent of Italian Stile Liberty, he received a triumphal reception at major international exhibitions (Paris, 1900; Saint Petersburg, 1901; Turin, 1902). In 1906 he set up the Fornaci di San Lorenzo pottery. He showed his paintings frequently and decorated many rooms at the Venice Biennale (1901–36). Invited to Bangkok by the king of Siam, he decorated the Palace of the Throne (1911–14).

Citterio, Antonio

(Meda, Milano, 1950)
Architect, designer. He graduated from the Milan Politecnico in 1972. Since then he has worked as a designer for numerous companies, winning two Compassi d'Oro and collaborating with G. O. Löw since 1987. Since 1981 he has also designed buildings and interiors with T. Dwan since 1987 (Esprit European headquarters, 1987). In 1999 he set up the Antonio Citterio and Partners studio with P. Viel in Milan (opening a branch in Hamburg in 2000) with emphasis on product design, urban planning, architecture (Edel Music head office, Hamburg, 2002) and commercial interiors (B & B Italy). He has taught at the Accademia di Architettura in Mendrisio since 1999.

Clemente, Francesco

(Naples, 1952)
Artist. After moving to Rome, he gave up studying architecture to devote himself to art, holding a solo show at the Galleria Valle Giulia (1971). Since 1972 he has travelled extensively. Interested in Hindu spirituality and folk culture, he collaborates with Indian painters and miniaturists. One of the leading figures of the Transavanguardia, he was a great international success at the Venice Biennale of 1980. After moving to New York, he produced books (with Allen Ginsberg) and murals, collaborating with Warhol and Basquiat (1983). Many solo shows of his work have been staged in various parts of the world (Guggenheim Museum, New York, 1999). He lives and works in New York, Rome and Madras.

Codognato, Plinio

(Verona, 1878 – Milan, 1940)
Painter, illustrator, graphic artist. He attended the Accademia Cignoroli in Verona. He soon gave up painting for commercial art. He illustrated various magazines (*Il Secolo XX*, *Emporium*, *L'Auto italiana*) and designed numerous posters for advertisements and sporting events. He worked for Arti Grafiche Coen, Officine Ricordi, Gros Monti and important companies like Fiat, where he was also responsible for the illustration and graphics of *Rivista Fiat* from 1920.

Colla, Ettore

(Parma, 1896 – Rome, 1968)
Artist. After graduating from the Scuola di Belle Arti in Parma (1923), he travelled widely in Europe before settling in Rome (1926), where he produced works for public buildings and took part in several group exhibitions. He showed at the Venice Biennali of 1930 and 1932 (and returned in 1964). In 1951 he was one of the signatories of the *Manifesto of the Gruppo Origine*, going on to become the director of its foundation. In 1952 he founded the magazine *Arti Visive*, devoted to abstract art. In 1955 he joined the MAC, creating abstract sculptures out of salvaged materials. In 1957 he held his first solo show (Galleria la Tartaruga, Rome).

Colombini, Gino (Luigi)

(Milan, 1915)
Designer, architect. He received a diploma as a building surveyor, and worked as a designer alongside F. Albini for twenty years (1933–53), creating several products (*Margherita* armchair, Bonacina, 1951) and works of architecture (Pirovano Mountain Refuge, Cervinia, 1948–52) with him. Director of the Kartell technical department (1954–64), he ennobled plastic as a material, designing pieces of high quality and winning four Compassi d'Oro. From 1964 to 2000 he was the proprietor and technologist of Polifiber, a company manufacturing monofilaments in plastic.

Colombo, Gianni

(Milan, 1937–1993)
Artist. In 1959 he founded Gruppo T (with Anceschi, Boriani and De Vecchi) and joined the international movement Nuove Tendenze. A leading exponent of experiments with Kinetic art and Arte Programmata, he held his first solo show at the Galleria Pater (Milan, 1960). In the 1960s he made experimental films, kinetic objects and environments. Since the 1980s he has designed avant-garde theatrical scenery (Operntheater, Frankfurt, 1986) and virtual works of architecture. He has exhibited on numerous occasions in Italy and abroad (First prize for painting, Venice Biennale, 1968). He directs and teaches at the Accademia di Brera (1985).

Colombo, Joe (Cesare)

(Milan, 1930–1971)
Artist, architect, designer. He attended the Accademia di Brera and the Milan Politecnico (1950–54), working in parallel as a painter, sculptor and designer. A member of the Movimento Nucleare (from 1951) and the MAC (1952–55), he was director of the family company, which produced electrical materials (1959). From 1960 onwards he devoted his energies exclusively to design, winning two Compassi d'Oro and a gold medal at the Milan Triennale (1964). In 1961 he opened a studio of architecture and industrial, interior, installation and graphic design. His experimental Total Furnishing Units are famous: Milan Triennale (1968), Visiona '69, Cologne (1969), MoMA, New York (1972).

Cometti, Giacomo

(Turin, 1863–1938)
Sculptor, designer. In 1891 he graduated in sculpture from the Accademia Albertina and went on to become Leonardo Bistolfi's principal collaborator. At the end of the century he embarked on an independent career as a cabinetmaker, creating furniture with lavish floral decorations. Receiving an honourable mention at the Exposition universelle

in Paris (1900) and praised by the critics at the Esposizione in Turin (1902) for the rigour and coherence of his modern style, he showed at the main exhibitions of the time (Milan, 1906) and was awarded the Gran Premio d'Onore at the Monza Biennale (1923).

Consagra, Pietro
(Mazara del Vallo, Trapani, 1920 – Milan 2005)
Sculptor. He studied at the Accademia di Belle Arti in Palermo. After moving to Rome (1944), he worked in the studios of Mazzacurati and Guttuso. One of the founders of the group of abstractionists called Forma 1 (1947), he created sculptural reliefs of variable thickness and sculptures that were on a monumental scale (Gibellina, 1981; Rome, 1998) or as light as air (*Frontal City*, scenery of *Oedipus Rex*, Gibellina, 1988). From 1950 onwards he exhibited several times at the Venice Biennale (three solo shows), Documenta in Kassel and other major international exhibitions. A critic and essayist, he taught at the School of Arts in Minneapolis in 1967.

Crali, Tullio
(Igalo, Dalmatia, 1910 – Milan 2000)
Painter, set designer. In 1929 he joined the Futurist movement, of which he would always be a great champion. From 1931 he took part regularly in exhibitions of Aeropainting in Italy and Europe. He graduated from the Accademia di Belle Arti in Venice (1932) and produced theatrical scenery, fashion sketches, architectural designs and advertising posters. In 1940 he had a solo show at the Venice Biennale. IIe drew up the manifestos *Plastic Illusionism of War and Perfecting of the Earth* with Marinetti (1942) and *Musical Words – Alphabet in Freedom* (1944). After the war he taught in Paris, Cairo and Milan.

Cucchi, Enzo
(Morro d'Alba, Ancona, 1949)
Artist. After moving to Ancona, he began to paint and write poetry around 1970. In 1977 he held his first solo show in Rome (Palazzo Taverna). One of the exponents of the Transavanguardia, in the 1980s he exhibited at the Venice Biennale, Documenta in Kassel and numerous group and solo exhibitions in various parts of the world (Guggenheim Museum, New York; Centre Georges Pompidou, Paris, 1986). He created various outdoor sculptures (Basel, 1984), architectural decorations, theatrical sets and costumes and artists' books (with poets, writers and designers). He lives and works in Ancona and Rome.

D'Albisola, Tullio (Tullio Mazzotti)
(Albisola Marina, Savona, 1899–1971)
Ceramicist, sculptor, poet. The most gifted of the Futurist ceramicists, he was trained in his father's pottery. A follower of Futurism, he created objects of his own and made them for other artists. He exhibited ceramics and sculptures in Italy and abroad (Paris Exposition internationale, 1925; Galleria Pesaro, Milan, 1931; Galerie Bernheim-Jeune, Paris, 1935). Active as a critic and poet, in 1932–33 he published *litolatta* books (with metal pages) with his own texts and those of F. T. Marinetti. In 1938 he published the manifesto *Futurist Ceramics* with Marinetti.

Dalisi, Riccardo
(Potenza, 1931)
Architect, designer, artist. In 1957 he graduated in architecture at Naples. In 1968 he involved students and local residents in the creation of objects and performances with salvaged materials from rundown districts of the city. He repeated the experience in the Rione Traiano (1970s) and the Rua Catalana (1993). Active in the debate over Radical Architecture and one of the founders of Global Tools, he worked with various companies, winning a Compasso d'Oro. Since 1995 he has devoted himself to sculpture. Invited several times to the Venice Biennale and the Milan Triennale, he taught at the Faculty of Architecture in Naples from 1969 and since 2000 has directed the Scuola di Specializzazione in Disegno Industriale. He has written extensively.

D'Aronco, Raimondo
(Gemona del Friuli, Udine, 1857 – San Remo, Imperia, 1932)
Architect. His father, a building contractor, took him to Graz to learn the trade (1871–74). After graduating from the Accademia di Belle Arti in Venice (1880), he went to Istanbul in 1893 to design the national Ottoman Exhibition, staying to work as architect to the sultan until 1909. A representative of Stile Liberty, he had an intense teaching program at various institutions up until the early 1920s. He won many competitions with his temporary structures for major exhibitions (Venice, 1887; Turin, 1902) and received several awards (gold medal at the Monza Biennale, 1923).

D'Ascanio, Corradino
(Popoli, Pescara, 1891 – Pisa, 1981)
Engineer. In 1914 he graduated from the Turin Politecnico. In 1917 he entered the technical department of the Società d'Aviazione Pomilio, and was sent by the company to the United States in 1918. In 1925 he set up a company for the design of helicopters in Popoli: the third D.A.T.3 prototype set three flying records in 1930. In 1932 he joined Piaggio as a specialist in rotors. He remained there until 1961, designing the Vespa scooter (1946) and building several helicopters (after 1949). Later he became a consultant to Piaggio and the Agusta Group. Author of scientific publications and holder of numerous patents, he taught at the university of Pisa (1937–61).

De Biasi, Mario
(Sois, Belluno, 1923)
Photographer. He began his career in 1945 in Germany, where he had been deported during the war. In 1948 he held his first solo show in Milan, the city where he had chosen to live. Linked for over thirty years to the magazine *Epoca*, from 1953 onwards he produced famous reportages all over the world. The author of over seventy photographic books and recipient of numerous international prizes (Erich Salomon Preis, Cologne, 1964; Prix Saint Vincent, 1982; Prize for Lifetime Achievement, Arles, 1994), he has presented his work at numerous solo and group exhibitions in Italy and abroad (Guggenheim Museum, New York, 1994). Today he is active as a photographer, draftsman and teacher.

De Chirico, Giorgio
(Volos, Greece, 1888–Rome, 1978)
Artist. He studied at the Athens Polytechnic and the Munich Academy (1906), where he was greatly impressed by Böcklin and Klinger. In Paris from 1911, he showed at the Salons d'Automne (1912–13) and, invited by Apollinaire, the Salons des Indépendants (1913–14). Settling in Ferrara in 1915, he initiated the movement known as "Metaphysical" painting, which would be joined by Carrà and Morandi. After moving to Rome in 1918, he collaborated with the *Valori Plastici* magazine and group, as well as Futurist and Dada groups. In 1919 he held his first solo show at the Casa d'Arte Bragaglia. After returning to Paris (1924–32), he exhibited with the Surrealists at the Galerie Pierre (1925). From 1926 onwards he showed with the Novecento group in Italy and abroad. He held a series of major exhibitions in the United States (1936–38). In 1944 he went to live in Rome, devoting himself to sculpture, graphics and set design. He was present at numerous Venice Biennali from 1924 and the Milan Triennale of 1933 (with a large mural), and his work has been shown at important retrospective exhibitions in various parts of the world.

De Lucchi, Michele
(Ferrara, 1951)
Architect, designer. In 1975 he graduated in architecture in Florence. An exponent of Radical Architecture, he belonged to the Cavart (1973), Alchimia (1978–80) and Memphis (1981–90) groups, collaborating with Sottsass. In 1984 he opened a studio and in 1990 founded the design collection Produzione Privata. Head of Olivetti design from 1990 to 2002, he also works on architectural and exhibition design and global projects for companies (ENEL, the Italian Post Office). Recently he has worked on designs for several museum buildings (Museo del Design, Milan; Neues Museum, Berlin). He has won two Compassi d'Oro. Since 2001 he has taught at the IUAV in Venice.

De Maria, Nicola
(Foglianise, Benevento, 1954)
Artist. After moving to Turin, he graduated in medicine. Since 1975 he has devoted himself exclusively to art. He began his career with a prolific output of drawings, but soon moved on to painting on walls and canvas. He uses a highly lyrical and spiritual language couched in brilliant colours. One of the leading exponents of the Transavanguardia, he began to exhibit more frequently in the 1980s. Since the 1990s he has concentrated on pure abstraction. He has exhibited at the Venice Biennale (1980, 1988 and 1990) and at Documenta in Kassel (1982). He has held various solo exhibitions (MACRO, Rome, 2004).

De Pas, Jonathan

(Milan, 1932–Florence 1991)

D'Urbino, Donato

(Milan, 1935)

Lomazzi, Paolo

(Milan, 1936)

Architects, designers. After graduating from the Milan Politecnico, they founded the DDL studio in 1966. In the 1960s they experimented with inflatable modular furniture in PVC and created a series of pneumatic structures for the XIV Milan Triennale and the World Exposition in Osaka (1970). Present at the MoMA exhibition *Italy: The New Domestic Landscape* in New York (1972), they turned their attention to the design of flexible furniture in the 1970s, winning a Compasso d'Oro. They have worked with important companies in the field of design, and designed buildings, interiors and installations (*Italienische Möbel Design 1950/80*, Cologne, 1980), even after the death of De Pas. Members of the board of directors of the ADI, they have also taught (De Pas at the ISIA in Florence; D'Urbino and Lomazzi at the Milan Politecnico).

Depero, Fortunato

(Fondo, Trento, 1892 – Rovereto, Trento, 1960)

Artist, decorator, graphic and set designer. He was trained at the Scuola Reale Elisabettiana in Rovereto. In 1913 he moved to Rome and joined the Futurists, exhibiting with the group from 1914 (Galleria Sprovieri) until the late 1930s. In 1915 he signed the manifesto *Futurist Reconstruction of the Universe* with Balla (which would be followed by *Futurist Aeropainting* and the *Manifesto of Futurist Commercial Art*, 1931–32). In contact with Diaghilev and Russian Cubo-Constructivism, he staged the *Balli plastici* [Plastic Dances] at the Teatro dei Piccoli in 1917. In 1919 he set up the Casa d'Arte Futurista in Rovereto, where he produced tapestries, furniture and toys. He also designed advertising pavilions. After moving to New York (1928–30), he devoted himself to the theatre and commercial art and design (*Vanity Fair*, *Vogue*). In Italy he worked for several magazines (*Emporium*) and devised the Campari advertising campaign (*Numero Unico Futurista Campari*, 1931). He showed at the Monza Biennali (1923, 1925), the Exposition internationale in Paris (1925), the Venice Biennali (solo show, 1926, 1932) and the Milan Triennale (1933).

De Poli, Paolo

(Padua, 1905–1996)

Artist, craftsman. He studied painting and embossing, holding several exhibitions in the early 1930s. From 1933 onwards he devoted himself to the art of high-fired enamel on copper, renewing its technique and expressive potential and extending its use to numerous applications (sculptures, decorative panels, furniture, objects of everyday use), for which he received various awards. In the 1950s and 1960s he contributed to the revitalization of Italian taste with his works, which found a home on ocean liners, in public buildings and in museums in various parts of the world, and collaborated with many artists and designers, including Ponti.

De Vecchi, Piero

(Milan, 1908–1991)

Silversmith. Apprentice painter and engraver, he studied sculpture at the Scuola Superiore d'Arte Applicata all'Industria del Castello. Foreman at the Argenteria Merlo (1932–34), he showed at the *I Mostra Nazionale Futurista* (1934) and opened a workshop with P. Cattaneo (1935). During the period Italy was under international sanctions he applied his technical and aesthetic know-how in the working of silver to Alcor aluminium. After the war he founded the Metallarte workshop with others, and in 1949 set up his own successful business, going back to work with silver. Often present at the Milan Triennali, he received numerous awards. In 1962 the firm was taken over by his son Gabriele.

Drocco, Guido

(San Benedetto Belbo, Cuneo, 1942)

Architect, designer. After moving to Turin, he graduated from the Politecnico (1974), where he has taught since 1996. Since 1962 he has collaborated with the Gabetti & Isola studio, taking responsibility for many projects of architecture and design. In parallel, he has been working independently since 1968. Since 1997 he has collaborated with V. Drocco. Together they founded the Fulful Design studio (2001), specializing in the in-house production or licensing of prototypes by young designers. He has won numerous prizes for architecture and design.

Ducrot, Vittorio

(Palermo, 1867–1942)

Entrepreneur, designer. He transformed the small furniture manufacturing company run by his stepfather Golia into a large industrial operation. In 1899 he formed a partnership with the architect Ernesto Basile. With the furniture designed by Basile, he took part in the Turin (1902) and Milan international exhibitions (1906) and the Venice Biennali (1903–09). The Ducrot company, specializing in prestigious furnishings for major hotels, ships and embassies, was still very active in the 1930s.

Dudovich, Marcello

(Trieste 1878 – Milan, 1962)

Painter, poster designer. He worked as a poster designer at the Officine Grafiche Ricordi in Milan (1897–99; 1906–15) and the Chappuis publishing house in Bologna (1899–1905). He also illustrated various magazines (*Italia Ride*, *Novissima*) and, after moving to Munich (1911–16), illustrated the society news column of the journal *Simplicissimus*. Returning to Milan, he collaborated for thirty years with La Rinascente and set up the Società Editrice Star, supervising the Pirelli and Michelin campaigns. He took part in the Paris (gold medal, 1900; 1925), Turin (1902) and Milan (1906) international exhibitions, as well as the Venice (1920–22) and Monza (1925) Biennali.

Figini, Luigi

(Milan, 1903–1984)

Pollini, Gino

(Rovereto, Trento, 1903 – Milan, 1991)

Architects, urban planners, designers. Figini graduated from the Milan Politecnico in 1926, followed in 1927 by Pollini, who was active on the cultural scene in Rovereto in the early 1920s (with Depero, Melotti, Belli and Baldessari). Among the founders of Gruppo 7, which gave rise to the Italian Rationalist movement, and members of the MIAR, they set up a studio in Milan in 1929. In the 1930s they designed buildings and interiors in a Rationalist mould: Electric House (with Bottoni, Libera and Frette), Monza Triennale, 1930; Bar Craja (with Baldessari), Milan, 1930; Villa-Studio for an artist, Milan Triennale, 1933; House at the Journalists' Village (Figini alone), Milan, 1933–34; Manusardi Apartment, Milan, 1935. With the design of the works at Ivrea (1934), they began a partnership with Olivetti that was to last until 1957 (daycare centre, cafeteria, housing,

social services complex). They were very active in the postwar period (with Ponti, Plan for the INA Residential District, Via Dessiè, Milan, 1951; church of the Madonna dei Poveri, Milan, 1952–54). Figini contributed to several magazines (*Metron*, *Chiesa e Quartiere*). One of the Italian delegates at the CIAM until 1946, Pollini taught at the universities of Milan (1959–69) and Palermo (1969–78).

Fini, Gianfranco

(Rome, 1936)

Painter, architect, designer. He made his debut as a painter in Paris (1955–57), exhibiting in Italy and abroad on various occasions (Venice Biennale). As a designer, he collaborated with Autovox and other companies in the 1970s. In 1976 he opened a studio in Rome, working on urban planning, architecture, interiors, design and painting. In 1978 he received a degree in architecture. From 1972 up to the present he has designed installations and scenery with M. Ceroli. He lives in Rome and the Dominican Republic, where he is overseeing the expansion of the Casa de Campo Marina (built in 2001).

Finzi, Arrigo

(Venice, 1890 – Milan, 1973)

Silversmith. His aim was to create silverware inspired by the Futurist movement. After moving to Milan, he met Sant'Elia in 1909 with whom he embarked on an important collaboration until the latter's death. In 1919 he set up the successful factory S.A. Arrigo Finzi e C. and in 1934 founded the Nova Argenteria, producing some pieces from designs by Sant'Elia as well as his own designs, continually evolving with the times. Relying on a futuristic production plant and prestigious shops in Milan and Rome, he served a distinguished international clientele.

Finzi Baldi, Olga

(Milan, 1932)

Designer. She dreamed of making a name for herself like her father, Arrigo, pioneer of modern silverware, but with the "architecture of jewellery." The first piece of jewellery she created (by melting down the necklace given to her on her 18th birthday) was so innovative that she was described on television as "the youngest jeweller in Europe": this was the prelude to a life devoted entirely to art. She embarked on a brilliant

career, receiving prestigious prizes and international awards right from the outset. Her creations are to be found in important museums and private collections.

Fontana, Lucio
(Rosario, Argentina, 1899 – Comabbio, Varese, 1968)
Artist. In 1924 he opened a studio of sculpture. In 1928 he studied under Wildt at the Accademia di Brera, Milan. In the early 1930s he took part in the exhibitions at the Galleria del Milione, getting to know the group of Italian abstractionists and supporting the Paris-based Abstraction-Création movement. After returning to Buenos Aires (1940), he founded an academy at Altamira in 1946 and laid out the theoretical principles of Spazialismo in the *White Manifesto*. After returning to Milan, he founded the *Movimento spaziale* in 1947 and published the *First Manifesto of Spatialism* (which would be followed by four more, 1948–52). After his first *Ambiente spaziale* [Spatial Environment] (Galleria del Naviglio, Milan, 1949), he went on in the 1950s to create the first *Concetti spaziali* [Spatial Concepts] (1952–53), ceramic works (Galleria dello Zodiaco, Rome, 1955) and his first works with cuts made in the canvas (1958), to which he returned in the 1960s in his series of *La fine di Dio* [The End of God], *Teatrini* [Toy Theatres] and *Ellissi* [Ellipses]. He often collaborated with architects (with Baldessari: Grand Staircase, Milan Triennale, 1951; Breda Pavilion, Milan Trade Fair, 1952). From 1930 onwards he showed frequently at the Venice Biennali (First prize, 1966) and Milan Triennali.

Forcolini, Carlo
(Como, 1947)
Designer. In 1969 he graduated from the Accademia di Brera in Milan, taking an interest in Kinetic art. He made his debut as a designer with R. Coizet and P. Vianello (1970–74). Since 1978 he has worked independently in Milan and London. In 1979 he was one of the founders of Alias, of which he is managing director and art director. Since 1980 he has collaborated with Artemide, setting up its subsidiary in Great Britain (1981). In 1993 he founded the Nemo lighting company and in 1999 the multidisciplinary studio Forcolini.lab. He has been president of the ADI since 2001.

Fornasetti, Piero
(Milan, 1913–1988)
Artist, designer. Expelled from the Accademia di Brera (1932), he studied at the Scuola Superiore di Arti Applicate all'Industria in Milan. In 1935 he commenced production of fabrics printed with surreal motifs for furnishings and clothing and invented a method of printing that allowed him to stamp his designs on furniture, furnishing accessories and pottery, achieving great success. Present at all the Milan Triennali from 1933 to 1951, he decorated numerous interiors (San Remo Casino, 1950). From 1940 onwards he collaborated intensely with Gio Ponti (Casa Lucano, Milan, 1951; *Andrea Doria* ocean liner, 1952).

Fortuny y Madrazo, Mariano
(Granada, Spain, 1871 – Venice, 1949)
Painter, photographer, set designer, textile and fashion designer, inventor. He studied painting and frequented the beau monde in Paris. In 1889 he settled in Venice. Dazzled by the theatre, from 1899 onwards he designed scenery and took an interest in lighting techniques. In 1901 he patented a system of theatrical illumination with indirect and diffuse light. In 1902 he experimented with the Fortuny dome (working on it until 1928) and in 1906 set up a company with AEG for the construction of cycloramas. He also experimented with various techniques for printing on raw fabrics imported from China and India. In 1909 he patented *Delphos* clothing. In 1919 he set up a textile factory, decorating buildings all over Europe and making clothes for the most celebrated women of the day (Duse, Duncan, Bernhardt). He took out twenty-two patents during his lifetime.

Frattini, Gianfranco
(Padua, 1926)
Architect, designer. He graduated from the Milan Politecnico in 1953. In 1954, after a collaboration with Gio Ponti (1952–54), he opened an architecture and design studio in Milan and worked for Cassina. He came to industrial design after doing a great deal of work in the field of interior design. One of the founders of the ADI and a member of the board of directors of the Milan Triennale since 1983, he has received numerous prizes and awards.

Giacosa, Dante
(Rome, 1905 – Turin, 1996)

Engineer, car designer. In 1927 he graduated in mechanical engineering from the Turin Politecnico (where he was to teach for several years). In 1928 he designed military vehicles at the SPA. In 1929 he went to work for Fiat as a designer (diesel engines for industrial vehicles, and then in the aero-engine section). In 1934–36 he designed the first economy car, the Fiat 500, known as the "Topolino," and became head of the Ufficio Tecnico Vetture. From 1946 he was in charge of all motor vehicles. Director of the Centro Stile Fiat (1958–70), he designed many successful cars (with Pininfarina, Cisitalia Tipo 202, 1947; Fiat 600, 1955; Fiat Nuova 500, 1957).

Gilardi, Piero
(Turin, 1942)
Artist, designer. Since 1965 he has been producing works in polyurethane foam (*Tappeti-natura* or "Nature-Carpets") that he has exhibited with success all over the world. From 1967 to 1980 he interrupted his artistic activity to devote his time to the theoretical analysis of new tendencies in art (Arte Povera, Land Art, Anti-form) and aesthetic and political activities in countries of the developing world. He belonged to the design group MultiGufram (1967–73), which was set up to produce prototypes and furniture in polyurethane foam. Since 1985 he has been creating interactive multimedia installations. With others, he founded the international association Ars Technica. He writes for *Flash Art Italia*.

Gioli, Paolo
(Sarzano di Rovigo, 1942)
Painter, photographer, filmmaker. He attended the Accademia di Belle Arti in Venice. In 1967 he moved to New York, where he developed an interest in cinema and photography. After moving to Rome (1969), be began to experiment with silkscreen printing, lithography, painting and design, and showed his first films at the FilmStudio. He has lived in Milan since 1976, continuing to devote himself to cinema and photography (Polaroid and Cibachrome) and exhibiting several times at the gallery Il Diaframma/Canon. Linked to the Galerie Michèle Chomette of Paris since 1982, he has held numerous solo shows in various countries.

Grassi, Vittorio
(Rome, 1878–1958)

Painter, set designer, designer. Close to Cambellotti and Balla, he joined the group known as the XXV della Campagna Romana (1905). He designed furniture that he illustrated in the magazine *La Casa* (to which he had contributed since 1908). In 1911 he staged an exhibition of Roman topography and designed scenes and costumes for *Macbeth* (Teatro Costanzi, Rome). His furniture, ceramics and stained glass were exhibited on many occasions (Venice Biennale, 1912; San Francisco International Exposition, 1915; Monza Biennale, 1923, Diploma d'Onore). He directed the illustration department of the *Enciclopedia Italiano Treccani* (1937). He founded the course of set design at the Accademia di Belle Arti in Rome, where he taught for about forty years.

Gruppo Architetti Urbanisti Città Nuova
(Bologna, 1961–98)
Pier Luigi Cervellati, Umberto Maccaferri, Giancarlo Mattioli, Gian Paolo Mazzucato, Franco Morelli, Giorgio Villa, Mario Zaffagnini
Group of architects, urban planners and designers, since 1970 made up solely of Maccaferri (Bologna, 1933) and Mazzucato (Bologna, 1937). In 1962 Villa (lecturer at the Faculty of Architecture in Florence) left the group. He was followed, in 1964, by Cervellati (lecturer at the IUAV in Venice), Mattioli (head of the major projects department of the municipality of Bologna), Morelli (head of the urban planning department of the municipality of Bologna) and, in 1970, Zaffagnini (lecturer at the Faculty of Architecture in Ferrara). They devoted themselves primarily to architecture. In 1963 they won first prize in the Artemide-*Domus* competition with the *Nesso* lamp, which was then brought into production.

Gruppo G14
(Founded in Milan, 1967)
Gianfranco Facchetti (Milan, 1939), Umberto Orsoni (Milan, 1940), Giovanni Pareschi (Milan, 1940), Pino Pensotti (Lecco, 1939), Roberto Ubaldi (Milan, 1940)
Studio of architects whose members graduated from the Milan Politecnico. In 1974 it became G14 Progettazione Srl, and was joined by M. Pozzi. Since 1985 the designers belonging to the G14 company have been organized into autonomous teams. They operate

in various sectors of design: industrial, communications, creative marketing (Pareschi), architecture (Pensotti, Ubaldi, Pozzi), interiors (Facchetti) and special projects for large-scale contracts (Orsoni).

Gruppo Strum
(Turin, 1966–1975)
Giorgio Ceretti (Domodossola, Verbano-Cusio-Ossola, 1932), Pietro Derossi (Turin, 1933), Carlo Giammarco (Pescara, 1940), Riccardo Rosso (Turin, 1941); Maurizio Vogliazzo (Turin, 1943) Founded by architects who had graduated from the Turin Politecnico, the Gruppo Strum (the name is abbreviated from the Italian *"architettura strumentale,"* meaning functional architecture) promoted seminars and theoretical studies that played a decisive part in the political development of Antidesign and Radical Architecture. Present at the exhibition *Italy: The New Domestic Landscape* (MoMA, New York) in 1972 (where they distributed free copies of the picture stories *Utopia*, *Le lotte per la casa* and *La città intermedia*), their aim was to carry out teaching, socio-political, design and cultural activities.

Guerrini, Giovanni
(Imola, Bologna, 1887 – Rome, 1972) Architect, painter, engraver. He studied at the Reale Istituto Artistico Industriale in Florence. He devoted himself to painting, interior decoration and lithography (*Eroica*, *Emporium*), showing at the exhibition of the Novecento Italiano (1926), the Rome Quadriennali and the Venice Biennali. Artistic director of the ENAPI (1927–49), he set out to bring about a renewal of the Italian crafts. Winner, with Romano and La Padula, of the competition for the Palazzo della Civiltà Italiana in Rome (1937), he designed numerous interiors. He taught at the Academies of Fine Arts in Bologna and Ravenna.

Guttuso, Renato
(Bagheria, Palermo, 1912 – Rome, 1987) Painter. He decided to devote himself to painting in 1930. Admitted to the first and second Rome Quadriennali, he settled in Rome in 1933. He exhibited at the Galleria del Milione, Milan (1932), with the Gruppo del Quattro. In 1938 he held his first solo show at the Galleria della Cometa. In 1940 he joined the Corrente group.

He played a fundamental role in the evolution of Italian painting in a "realist" direction. In 1947 he joined the Fronte Nuovo delle Arti. A member of the central committee of the Italian Communist Party, he represented the current of Socialist Realism. He showed at the Venice Biennale (1936; 1952–61) and many international exhibitions.

Helg, Franca
(Milan, 1920–1989) Architect, designer. She graduated from the Milan Politecnico in 1945. In 1952 she became F. Albini's partner and they worked together on many architectural projects (La Rinascente department store, Rome, 1957–61; Olivetti store, Paris, 1960), museology (Museo di Palazzo Rosso, Genoa, 1952–62) and design (with Albini, Piva and Noorda, system of signs for the Milanese subway system, 1963, Compasso d'Oro). She taught at the Milan Politecnico and gave lectures in various cities in Europe and Latin America.

Jodice, Mimmo
(Naples, 1934) Photographer. Since 1967 he has devoted himself to photography, showing a preference for experimentation. Collaborating with the gallery owner L. Amelio (1968–85), he came into contact with the main exponents of the international artistic avant-gardes. In the 1970s he focused on investigating the social problems of modern Naples. Since the 1990s he has participated in European projects in which he has been engaged in exploring the culture and places of the Mediterranean and antiquity as a subject. He has published many volumes (*Mediterraneo*, *Eden*, *Il Reale Albergo dei Poveri*) and shown at major international venues. He has taught at the Accademia di Belle Arti in Naples.

King, Perry Alan
(London, 1938) Architect, designer. He studied at the Birmingham College of Art. After working a short time, he moved to Italy in 1964, commencing a long collaboration with Olivetti, designing office equipment and taking charge of the corporate identity. In 1975 he founded the Studio King-Miranda Associati with S. Miranda in Milan. Active in the field of design, interiors and graphics, he works with numerous companies.

Kounellis, Jannis
(Piraiévs, Greece, 1936) Artist. After moving to Rome (1956), he studied at the Accademia di Belle Arti and held his first solo show in 1960 (Galleria La Tartaruga). One of the leading exponents of Arte Povera, he showed at the movement's main group exhibitions from 1967 onwards (Galleria La Bertesca, Genoa). In the late 1960s he introduced live animals into his works (Galleria L'Attico, Rome, 1969). Since 1972 he has shown at various Venice Biennali (solo show, 1988) and Documenta in Kassel. He has held solo shows in several countries (Museum of Contemporary Art, Chicago, 1986; Museo Nacional Centro de Arte Reina Sofía, Madrid, 1996–97). He also designs theatrical scenery. He taught at the Kunstakademie in Düsseldorf (1993–2001).

La Padula, Ernesto Angelo
(Pisticci, Matera, 1902 – Rome, 1968) Architect. He began his career in the field of graphic and interior design. After graduating from the Scuola Superiore di Architettura in Rome (1931), he joined the MIAR and collaborated with the architects G. Marletta and Mario Romano. In 1934 he took part in the competition for the Palazzo del Littorio in Rome (with Ridolfi, Cafiero and Rossi). In 1937 he won first prize, with Romano and Guerrini, in the national competition for the Palazzo della Civiltà Italiana at the EUR (architectural symbol of the twenty years of Fascist rule in Rome). Moving to Argentina (1949), he taught at the university of Córdoba and devoted himself to urban planning.

Leonardi-Stagi Architetti
(Modena, 1962) Cesare Leonardi (Modena, 1935), Franca Stagi (Modena, 1937) Architects, designers. They graduated in architecture in Florence (Leonardi in 1960) and Milan (Stagi in 1962). In 1961 Leonardi opened a studio in Modena, which Stagi joined in 1962. Together they worked on architecture, urban planning and design (Leonardi created and patented several pieces of furniture) and published *L'architettura degli alberi* (1982). Since the 1980s they have worked separately. Leonardi is also a successful photographer (since 1950), exhibiting in Italy and abroad, and has taught at the university of Florence (1981–82).

Lera, Andrea
(Piombino, Livorno, 1959) Designer. He graduated from the ISIA in Rome. After moving to Milan in 1985, he collaborated with M. Thun on a series of lamps (*Still-light*, produced by Bieffeplast). He is in charge of the production of Skipper lamps and is very active in the field of lighting techniques.

Levanti, Giovanni
(Palermo, 1956) Architect, designer. He graduated in architecture in Palermo in 1983 and received a master's degree in industrial design from the Domus Academy in Milan in 1985. From 1985 to 1990 he collaborated with A. Branzi and was active in the Memphis Group. In 1990 he opened his own studio in Milan, focusing chiefly on design. He has taught at the university of Palermo (1995–97), the Domus Academy in Milan (1997–2000), and the ISIA in Faenza (1998–2002).

Licini, Osvaldo
(Monte Vidon Corrado, Ascoli Piceno, 1894–1958) Painter. He attended the Accademia di Belle Arti in Bologna. After moving to Paris, he showed at the Salon d'Automne and the Salon des Indépendants in 1922. In 1926 he returned to Italy and showed at the *I Mostra del Novecento Italiano*. In the 1930s he joined the group of Italian abstractionists and was in contact with Abstraction-Création. In 1935 he held his first solo show at the Galleria del Milione in Milan and took part in the *I Mostra collettiva di arte astratta italiana* in Turin. In 1941 he signed the manifesto *Primordial Values Milan Como* with Munari and Nizzoli. In 1958 he won the international Gran Premio for painting at the Venice Biennale.

Lingeri, Pietro
(Tremezzo, Como, 1894–1968) Architect, designer. From 1906 onwards he worked in Milan as a decorator. He studied sculpture in Brera, and graduated in architectural design (1926). In 1927 he designed the "Rationalist" head office of Motonautica Amila in Tremezzo. A member of the MIAR and the CIAM, he participated with the group of architects from Como in the Monza Triennale (1930) and the Milan Triennale (1933), and was one of the founders of the magazines *Quadrante*

(1933) and *Valori Primordiali* (1937). In 1932 he opened a studio in Milan and began to collaborate with Terragni (Casa Rustici, Milan). He was president of the MSA (1946–47), and won the Gran Premio at the Milan Triennale (1951).

Löw, Glen Oliver
(Leverkusen, Germany, 1959)
Designer. He graduated from the Bergische Universität in Wuppertal and received a master's degree in industrial design from the Domus Academy of Milan. Since 1987 he has worked with A. Citterio in Milan, designing a wide range of products and interiors and winning several competitions for corporate design (branches of the Commerzbank, Berlin and Frankfurt, 1996; Smart Centres, 1998). In 2000 he opened his own design studio in Hamburg and taught at the Hochschule für Bildende Künste.

Lupi, Italo
(Cagliari, 1934)
Architect, graphic artist and exhibition designer. In 1961 he graduated from the Milan Politecnico. In 1962 he became graphics consultant of the development department of La Rinascente. Since 1972 he has designed graphics, signs and various exhibitions (Palazzo Grassi, Venice; Museum of Modern Art, Tokyo), collaborating frequently with A. Castiglioni. Responsible for the image of the XVI Milan Triennale and for communications at IBM Italia, he has been the art director of various magazines, including *Domus* (1986–92), *Abitare* (1974–84), of which he became the editor in 1992, and *If* (Compasso d'Oro, 1998). A member of the Alliance Graphique Internationale (AGI), he teaches at the ISIA in Urbino.

Luxardo, Elio
(Sorocaba, Brazil, 1908 – Sperlonga, Latina, 1969)
Photographer. A champion swimmer and cameraman at sporting events, he was taught to take photographs by his father. In 1930 he moved to Rome. He studied at the Centro Sperimentale di Cinematografia and opened a photography studio where he made features on fashion and the cinema for the most prestigious magazines. A successful photographer of the sets and stars of the Italian movie industry, he took pictures in the style of the Novecento movement,

linked to the cult of the body, and devoted himself to sculpture. After the war he moved to Milan, where he also worked for advertising agencies.

Magistretti, Vico
(Milan, 1920)
Architect, designer. After graduating from the Milan Politecnico in 1945, he entered his father's studio. One of the promoters of the MSA, he showed some furniture at the *RiMA* exhibition (Milan, 1946). In 1949 he was involved in the setting up of Azucena and showed at Fede Cheti's exhibition in Milan. Until the 1960s he devoted most of his attention to architecture and urban planning (Tower in Parco Sempione, Milan, 1953–56; Casa Arosio, Arenzano, 1958). Later he concentrated more on design. He showed at the Milan Triennali from 1948 onwards and was awarded four Compassi d'Oro (one for lifetime achievement) and an honorary degree in industrial design at the Milan Politecnico (2002). One of the founders of the ADI and a member of the CIAM (1959), he has taught in various parts of the world (at the Royal College of Art, London, since 1980).

Mangiarotti, Angelo
(Milan, 1921)
Architect, designer. He graduated from the Milan Politecnico in 1948. Visiting professor at the Institute of Design, Illinois Institute of Technology, Chicago (1953–54), he got to know the great masters of architecture (Wright, Mies van der Rohe, Gropius). In 1955 he opened a studio in Milan with Morassutti, his partner until 1960. In 1989 he set up the Mangiarotti & Associates Office in Tokyo. He has worked as an architect (church at Baranzate, 1956–57), town-planner, designer and sculptor. One of the founders of the ADI, he was awarded a Compasso d'Oro for lifetime achievement. Granted an honorary degree in engineering in Munich (1998) and in industrial design in Milan (2002), he has taught in Italy and abroad.

Mango, Roberto
(Naples, 1920–2003)
Architect, designer. After a period of teaching and working in the US (Princeton University, R. Loewy Corporation, Fuller Foundation), he went on in the 1950s to collaborate with Tecno (designing its logo among other things) and with the ceramicists of Vietri. Present at the Milan

Triennali of 1954 and 1957, he was one of the curators of the *Mostra internazionale dell'abitazione* [International Housing Exhibition] and worked at its *Centri Studio* from 1955–73. A lecturer at the Faculty of Architecture in Naples (Compasso d'Oro for the research into design he carried out there, 1964–67), he founded the Postgraduate School of Industrial Design (1988).

Manzoni, Piero
(Soncino, Cremona, 1933 – Milan, 1963)
Artist. He attended the Accademia di Brera for a period. In 1957 he joined the Movimento Nucleare, signing its manifestos, and produced the first *Achromes*. An engaged critic and theorist, in contact with the Gruppo Zero, he founded the magazine *Azimut* and the gallery of the same name with Castellani in 1959. In 1960 he signed the manifesto *Del nulla contro il nulla* [Nothing against Nothing], showed at the exhibition *Monochrome Malerei* (Kunstmuseum, Leverkusen) and organized the performance *Consumazione dell'arte dinamica del pubblico divorare l'arte* [Consumption of the Dynamic Art of the Public Devouring Art] (Galleria Azimut). From 1957 onwards he presented his own works *Linee* [Lines], *Corpi d'aria* [Bodies of Air], *Fiato d'artista* [Artist's Air], *Uova scultura* [Egg Sculpture], *Basi magiche* [Magic Bases], *Achromes*, *Sculture viventi* [Living Sculptures], *Merda d'artista* [Artist's Shit] at solo shows and joint exhibitions in numerous parts of the world, anticipating the tendencies of Arte Povera and Conceptual art.

Manzù, Giacomo (Giacomo Manzoni)
(Bergamo, 1908 – Rome, 1991)
Artist. He received his training in craft workshops and at the Scuola di Plastica Decorativa and the Accademia Cicognini in Verona. After moving to Milan to decorate the chapel of the Università Cattolica (1930), he exhibited at the Galleria del Milione (1932) and Triennale (1933). In 1938–39 he commenced his series of *Cardinali* [Cardinals], which was awarded a gold medal at the Venice Biennale of 1948. He produced some famous monumental sculptures (*Door of Death*, Saint Peter's Basilica, Rome, 1948–64; *Door of Love*, Salzburg Cathedral, 1955–58) as well as theatrical sets and costumes. He taught at the Accademia di Brera (1941–54) and in Salzburg (1954–60).

Manzù, Pio (Pio Manzoni)
(Bergamo, 1939 – Brandizzo, Torino, 1969)
Designer. Son of the sculptor Giacomo. He graduated from the Hochschule für Gestaltung in Ulm (where he would be appointed assistant lecturer). In 1962 he began to develop new types of cars and founded the design team Autonova to provide the industry with designs and working prototypes. He wrote articles on car design for newspapers and specialist magazines. In 1968 he collaborated with the Fiat Centro Stile (City Taxi, 1968; Fiat 127, 1971). He also worked on product design and won a Compasso d'Oro.

Mari, Enzo
(Novara, 1932)
Artist, graphic artist, designer. Moving to Milan, he attended the Accademia di Brera and held his first solo show at the Galleria San Fedele (1953). From 1954 onwards he pursued a successful career as a designer. As a graphic artist he collaborated with the Studio Boggeri and later with important manufacturers. In 1957 he turned his attention to children's toys. In 1958 he began a fruitful collaboration with Danese, going on to work for many other companies. In 1963 he coordinated the group Nuove Tendenze and took part in the exhibition *Arte programmata* (Olivetti Showroom). From 1964 onwards he showed at the Venice Biennali and Milan Triennali, and took part in the exhibition *Italy: The New Domestic Landscape* (MoMA, New York, 1972). President of the ADI (1976–79), he won three Compassi d'Oro. Author of writings on aesthetic research, he has taught at the Scuola Umanitaria and the Milan Politecnico (honorary degree in industrial design, 2002), as well as various other Italian and foreign institutions.

Marinetti, Filippo Tommaso
(Alexandria, Egypt, 1876 – Bellagio, Como, 1944)
Ideologist, writer, poet. He studied humanities in Paris and graduated in law in Genoa. After moving to Milan, he founded the international magazine *Poesia* in 1905. In 1909 he founded the Futurist movement, publishing the *Manifesto of Futurism* in the Parisian newspaper *Le Figaro*. Leader of the movement, he organized its main exhibitions and events in Italy and abroad, as well as the

I Congresso Futurista in Milan (1924). He signed many of the group's principal manifestos (*Let's Murder the Moonlight!*, 1909; *Technical Manifesto of Futurist Literature*, 1912; *The Variety Theatre*, 1913; *Tactilism*, 1921). In 1925 he moved to Rome. He wrote novels, political tracts, "free word" poems and theatre summaries.

Marini, Marino

(Pistoia, 1901 – Viareggio, 1980) Sculptor. He studied at the Accademia di Belle Arti in Florence and moved to Milan in the late 1920s where he joined the Novecento group, participating with them in exhibitions in Italy and abroad. He spent part of 1929 in Paris, where he took part in the *Exposition d'Art Italien Moderne*. He travelled extensively in Europe and established contacts with the major artists (he became close friends with Henry Moore). He exhibited at a number of Venice Biennali (Gran Premio in sculpture, 1952), Milan Triennali and Rome Quadriennali. He exhibited his works on numerous occasions both in Italy and abroad after his solo show at the Buchholz Gallery in New York (1950). He was a distinguished teacher at the ISIA in Monza and the Accademia di Brera in Milan.

Marotta, Gino (Luigi)

(Campobasso, 1935) Artist, set designer, designer. After moving to Rome, from 1957 onwards he created his famous Bandoni and Piombi, pictures made with a blowpipe on sheets of tin and lead, going on to use methacrylate in the 1960s. He exhibited them at solo shows (Rotonda della Besana, Milan, 1973; Venice Biennale, 1984) and group exhibitions (Arsenali, Amalfi, 1968; Louvre, Paris, 1969) in various parts of the world. He organized art exhibitions and collaborated on major film productions. Since 1959 he has designed important theatrical sets (*Salomé*, C. Bene, 1972), artist's books, furniture for Gavina and architectural projects. He has been the director of the Accademia di Belle Arti at L'Aquila and teaches at the academy in Rome.

Martini, Arturo

(Treviso, 1889 – Milan, 1947) Sculptor. He received his training in a pottery and with a series of sculptors (Treviso, Venice, Munich). He was given his own room at the Ca' Pesaro in Venice (1911) and exhibited at the Salon d'Automne in Paris (1912) and the first Roman Secession (1914). In 1919 he went to Milan, where he met Margharita Sarfatti and entered the Valori Plastici group (1921). He took part in the exhibition of the *Novecento Italiano* (1926), the Rome Quadriennale (First prize, 1931) and the Venice Biennale (solo show, 1932), creating many works that were destined to renew Italian sculpture. From 1942 onwards he taught at the Accademia di Belle Arti in Venice.

Martinuzzi, Napoleone

(Murano, Venezia, 1892 – Venice 1977) Sculptor, glassmaker. He studied at the Accademia di Belle Arti in Venice and exhibited with the Secessionist group at Ca' Pesaro (1908). Director of the Museo Vetrario (1922–31), he became a partner in and art director of Vetri Soffiati Muranesi Venini & C. in 1925, creating the opaque glass called *pulegoso* [air bubbles]. In 1932 he and V. Zecchin founded Zecchin-Martinuzzi Vetri Artistici e Mosaici. Art director of Arte Vetro di Seguso (1947–53), he collaborated with the Vetreria Cenedese (1953–58) and Pauly & C. (1960–75). He was often present at the Venice Biennale (solo show in 1942) and major exhibitions in Italy and abroad.

Marucelli, Germana

(Florence, 1905 – Milan, 1983) Dressmaker, stylist. She worked for a long time in her family's clothing business and became a fashion designer. After running the Gastaldi fashion house in Genoa, she opened one of her own in Milan in 1938. In the 1940s she anticipated the New Look and the Parisian "sack silhouette" and took over the historic Ventura fashion house. In the 1950s she was one of the few to grasp the need for a link between fashion and art. She created garments and fabrics in collaboration with artists (Capogrossi, Alviani) and designed collections that took their inspiration from art (the Impero, Fraticello, Optical, Vescovo and Abstract collections). In the 1970s she worked outside the prêt-à-porter industry.

Mazzucotelli, Alessandro

(Lodi, 1865 – Milan, 1938) Metalworker. In 1891 he took over the smithy of the blacksmith to whom he had been apprenticed, Defendente Oriani. He collaborated with famous architects, including Broggi (New Stock Exchange, Milan, 1898–1901), Pirovano (house on Via Spadari, Milan, 1902), Sommaruga (Palazzo Castiglioni, Milan, 1903). He made objects and sculptures out of iron, bronze and precious metals. He took part in international exhibitions in Paris (1900), Turin (1902, gold medal), Milan (1906), Brussels (1910) and Paris again (1925), as well as the Monza Biennali and Milan Triennali. In 1922 he was one of the founders of the ISIA and of the Monza Biennale. From 1903 onwards he taught at the Scuola Umanitaria in Milan.

Meda, Alberto

(Lenno Tremezzina, Como, 1945) Engineer, designer. After graduating in mechanical engineering from the Milan Politecnico (1969), he worked for Magneti Marelli. In 1973 he became technical manager and head of design at Kartell. In 1979 he started to work independently in Milan, experimenting with new materials. Consultant to Alfa Romeo (1981–85) and Italtel Telematica (1983–87), he collaborated with Luceplan, along with P. Rizzatto, from 1984, and with Alias, from 1987. He has taught at the Domus Academy (1983–87) and the Milan Politecnico (1995–97). He has won two Compassi d'Oro and a European Design Prize.

Meli, Salvatore

(Comiso, Ragusa, 1929) Sculptor, ceramicist. He taught at the Scuola Statale d'Arte della Ceramica in Civita Castellana and at the Accademia di Belle Arti in Rome, the city where he lives and works. He has shown his own creations at numerous group exhibitions and solo shows in Italy, Europe, the United States and Japan, winning various prizes and awards (Premio Faenza, 1953). He has produced many works of art for public and private buildings.

Mello, Franco

(Genoa, 1945) Designer. After settling in Turin, he produced books and catalogues for many artists and supervised the image of a series of exhibitions at the GAM in Turin (*Conceptual Art / Arte Povera / Land Art*, 1970). In the 1970s he developed children's television programs for the Italian broadcasting corporation (RAI) with Munari, Orengo and Luzzati, and designed objects and playgrounds. He showed at the MoMA exhibition *Italy:*

The New Domestic Landscape in New York (1972) and on other important occasions (CCI, Paris, 1970; Milan Triennale, 1973). In 2002 he organized the exhibition *The Rock Furniture – Il design della Gufram negli anni del Rock*, Castello di Rivoli.

Melotti, Fausto

(Rovereto, Trento, 1901 – Milan, 1986) Artist, decorator. Active on the cultural scene in Rovereto in the early 1920s (with Belli and Depero), he graduated in engineering in Milan (1924) and, a pupil of Wildt, received a diploma in sculpture from the Accademia di Brera (1928). In 1930 he worked for Richard-Ginori and exhibited at the Monza Triennale. He collaborated with the Rationalist architects Figini, Pollini and Baldessari (Bar Craja, Milan, 1930; Villa-Studio for an Artist, Milan Triennale, 1933). From 1932 onwards he taught at the Scuola Professionale del Mobile in Cantù. He joined the group of Italian abstractionists and Abstraction-Création. In 1936 he held his first solo show at the Galleria del Milione in Milan, took part in the *I Mostra collettiva di arte astratta* in Turin and signed the *Manifesto for Abstract Art*. After the war he went back to working with ceramics, creating various decorations for Gio Ponti. In 1966 he showed at the Venice Biennale.

Mendini, Alessandro

(Milan, 1931) Architect, designer. After graduating from the Milan Politecnico (1959), he worked in the Nizzoli Associati studio until 1970. Author of essays and articles, he edited the magazines *Casabella* (1970–76), *Modo* (1976–79, Compasso d'Oro) and *Domus* (1980–85). One of the founders of Global Tools, he was a leading member of the Studio Alchimia from 1979 onwards. One of the principal theorists and promoters of the renewal of Italian design in the 1980s, he organized the exhibition *L'oggetto banale* [The Banal Object] at the Venice Biennale (1980). In 1989 he and his brother founded the Atelier Mendini. A design and image consultant to many companies (Alessi, Swatch), he also devoted himself to art, architecture (Groninger Museum, 1988–93) and interior design. He has taught at the Hochschule für Angewandte Kunst in Vienna.

Metlicovitz, Leopoldo

(Trieste, 1868 – Pontelambro, Como, 1944)

Poster designer, set designer, illustrator. He trained as an assistant lithographer in Udine. In 1892 he was appointed head of the technical department at the Officine Grafiche Ricordi in Milan, becoming a poster designer in 1896. Attracted by the Jugendstil and then by French symbolism, he conducted advertising campaigns for important companies, designing some famous trademarks (Fernet-Branca). He also worked as a set and costume designer for La Scala. He designed playbills, covers and musical scores. From 1906 onwards he illustrated various magazines (*Ars et Labor*) and from 1915 onwards devoted himself to painting.

Mollino, Carlo

(Turin, 1905–1973)
Architect, designer. After graduating in architecture in Turin (1931), he worked with his engineer father until 1936. Later he devoted himself to architecture (Società Ippica, Turin, 1937–39; Upper Station of the Lago Nero Sledge-lift, Sauze d'Oulx, 1946–47), urban planning, set design, photography, aeronautics, motor racing and skiing. He designed aircraft, racing cars (Bisiluro Le Mans, 1955), furniture (one-of-a-kind pieces or limited editions), interiors (in Turin: Casa Miller, 1938; Casa Minola, 1944; Casa Orengo, 1949) and experimental models somewhere between the surreal and the organic. He lectured at the university of Turin (1953–70) and exhibited at the XI and XII Milan Triennali.

Morbelli, Angelo

(Alessandria, 1853 – Milan, 1919)
Painter. In 1876 he graduated from the Accademia di Brera in Milan and made his debut at the Promotrice in Turin (1879). Linked to the realist tradition, he developed an interest in Italian Divisionism in 1890. In 1891 he showed at the Brera Triennale and commenced a long correspondence with Pellizza. He won gold medals at exhibitions in Dresden (1897), Paris (1900) and Munich (1905), and took part in the Brera Triennali and the Venice Biennale (1903). From 1912 onwards he wrote notes on the technique of painting and aesthetics (*La Via Crucis del Divisionismo*).

Mulas, Ugo

(Pozzolengo, Brescia, 1928 – Milan, 1973)

Photographer. In 1952 he left the Faculty of Law to attend courses at the Accademia di Brera in Milan, where he frequented the Bar Giamaica, a haunt of artists and intellectuals. Choosing photography as his medium, he did his early work on the outskirts of Milan, going on to document the Venice Biennale (1954–70). In 1960 he began to work in advertising and fashion and produce reportages for various magazines (*Illustrazione Italiana, Novità, Domus, Du*), but his main interest was the world of art. He took portraits of artists and made some famous series (*Ossi di seppia, Marcel Duchamp, Lucio Fontana*). After discovering Pop art, he went to New York in 1964 to document the art scene there. He also began to work on scenery for Strehler and Puecher. In 1967 he held his first solo show at the Galleria il Diaframma, Milan.

Munari, Bruno

(Milan, 1907–1998)
Artist, graphic artist, designer, teacher. From the time of the exhibition at the Galleria Pesaro in Milan (1927), he showed with the Futurists on various occasions (Venice Biennali, Milan Triennali). In parallel he worked as a graphic artist and illustrator, and founded the Studio R+M with Ricas. In 1942 he commenced a long collaboration with Einaudi (going on to work for other manufacturers as well). One of the founders of the MAC (1948), he embarked on a fruitful collaboration with Danese in 1957. In 1962 he organized the exhibition *Arte Programmata* at the Olivetti Showroom in Milan. In 1967 he taught a course at Harvard (which would form the basis for the book *Design e Comunicazione Visiva*). From 1968 onwards he focused on children, with books (of which he had already published several in the 1940s), educational toys, furnishings, workshops (the first held at Brera in 1977) and training. Awarded an honorary degree in architecture from the university of Genoa, he won six Compassi d'Oro (one for lifetime achievement). He held many solo shows around the world (Tokyo, 1965).

Muzio, Giovanni

(Milan, 1893–1982)
Architect. He graduated from the Milan Politecnico in 1915. After returning from the war, he advocated a strict return to order, proposing a

"neo-classical" formula. A member of the Club degli Urbanisti Milanesi [Club of Milanese Urban Planners], he was one of the leading exponents of the Novecento movement in architecture (Ca' Brütta, Milan, 1919–23; Tennis Club, Milan, 1923–29; Palazzo dell'Arte, Milan Triennale, 1931–33). He designed important pavilions and installations with Sironi (Internationale Presse-Ausstellung, Cologne, 1928; Barcelona Exposición Internacional, 1929; Gallery of Graphic Arts and, by himself, Marble Room, Monza Triennale, 1930).

Nizzoli, Marcello

(Boretto, Reggio nell'Emilia, 1887 – Camogli, Genova, 1969)
Architect, designer, graphic artist, painter. After graduating from the Scuola di Belle Arti in Parma, he moved to Milan in 1914 and joined the group Nuove Tendenze. In the 1920s he devoted himself to the applied arts (decorations for buildings, hangings, fabrics), set design and commercial art (Campari posters). In 1923 he started to collaborate with the Piatti silk mills, exhibiting with them at the Monza Biennali and in Paris (1925). He collaborated with Terragni (Casa del Fascio, Como, 1932–36) and Persico (1934–36: *Sala delle Medaglie d'Oro, Mostra dell'aeronautica italiana*; publicity stand, Galleria Vittorio Emanuele; Parker Stores), who introduced him to the world of industrial design. From 1938 onwards he was head of the technical department of advertising at Olivetti, where he worked as a designer from 1940. He designed several buildings (housing for Olivetti employees, Ivrea, 1952–53). He was awarded an honorary degree in architecture (Milan Politecnico, 1966), and won four Compassi d'Oro.

Novembre, Fabio

(Lecce, 1966)
Architect, designer. After graduating from the Milan Politecnico (1992), he achieved success as an industrial and interior designer (restaurants, nightclubs, shops, hotels) in Italy and abroad, often working in the world of entertainment (Caffè L'Atlantique and Caffè Shu, Milan). He created a style defined as "narcissistic neo-baroque," associating sumptuous materials with sensual forms. Art director of Bisazza (2000–03), he has designed showrooms in several parts of the world.

Ontani, Luigi

(Montovolo di Grizzana Morandi, Bologna, 1943)
Artist. In 1965 he created his first "pleonastic objects." Later he experimented with photographic techniques (1971), worked with *tableaux vivants* (*Contemporanea*, Rome, 1974) in which he played the dual role of artist and model, and produced papier-mâché "hybridols," masks, polychrome ceramics and watercolours. An irreverent interpreter of cultural myths, he draws his inspiration from the iconographic traditions of the West and East. Since 1972 he has often taken part in the Venice Biennale and presented his work at numerous solo shows (SMAK, Ghent, 2003) and group exhibitions (Kunsthalle, Lucerne, 1974).

Oppi, Ubaldo

(Bologna 1889 – Vicenza 1942)
Painter. After moving to Vienna, he attended Klimt's courses in 1907. He made his debut with a solo show at the Ca' Pesaro, Venice (1910). In Paris (1911–15) he exhibited at the Galerie Guillaume (1913) and the Salon des Indépendants (1921). Returning to Italy, he was one of the founders of the Novecento group (1923). In 1924 he was given his own gallery at the Venice Biennale (where he would show until 1932). Present at the exhibition of the Novecento Italiano (Milan, 1926) and the Secession (Munich, 1928), he frescoed the chapel of San Francesco at the basilica of Il Santo in Padua (1927–28) and held a solo show at the Galleria del Milione (Milan, 1930).

Paladino, Mimmo (Domenico)

(Paduli, Benevento, 1948)
Artist. He attended art school. In 1969 he held his first solo show at Caserta. Since the late 1970s he has combined the profoundly conceptual basis of his works with a renewed interest in the figure, mixing up different techniques and forms of expression. One of the leading figures of the Transavanguardia, he exhibited at the Venice Biennale (1980) and Documenta in Kassel (1982), holding solo shows in various parts of the world (Lenbachhaus, Munich, 1985). Since 1985 he has created large sculptures in bronze and installations. Since 1990 he has also designed scenery (UBU prize 2004 for *Oedipus Rex*, directed by M. Martone). He lives and works in Paduli, Rome and Milan.

Pannaggi, Ivo
(Macerata, 1901–1981)
Architect, artist, set designer.
He studied at the Scuola di
Architettura in Rome. In 1920 he
joined the Futurist movement.
In 1922 he signed the *Manifesto of
Futurist Mechanical Art* with Paladini
and staged the *Ballo meccanico
futurista*. He created mechanical
scenery and costumes for the Teatro
degli Indipendenti and designed the
interiors and furnishings of Casa
Zampini, Esanatoglia (1925–26).
He contributed to several magazines
and illustrated Futurist books. He
took part in the Venice Biennale
(solo exhibition, 1926) and the
I Mostra di architettura futurista
(1928). In the early 1930s he attended
the last course held at the Bauhaus
in Berlin.

Paolini, Giulio
(Genoa, 1940)
Artist. After moving to Turin, he
graduated from the Istituto per le Arti
Grafiche e Fotografiche (1959). Master
of Italian conceptual art, he held his
first solo show at the Galleria
La Salita, Rome (1964). Part of the
founding group of Arte Povera, he
showed at its major joint exhibitions
from 1967 onwards. Since 1969 he has
also devoted himself to the theatre,
collaborating with various directors.
Since 1970 he has exhibited frequently
at the Venice Biennale and Documenta
in Kassel. He has held numerous solo
shows in various countries (Galleria
Sonnabend, New York, 1972; Stedelijk
Museum, Amsterdam, 1980) and
published several collections of
reflections on art. He lives in Turin
and Paris.

Patellani, Federico
(Monza, 1911 – Milan, 1977)
Photojournalist. Trained as a lawyer,
he nursed a passion for painting.
In 1935 he went to Ethiopia with the
Italian army as a press photographer.
In 1939 he gave up painting and the
legal profession, embarking on a long
collaboration (1939–52) with the
weekly magazine *Tempo*, published by
Mondadori, for which he invented
"phototexts." In 1952 he began to
contribute to important foreign and
Italian periodicals (*Epoca, La
Domenica del Corriere*). In parallel he
developed a passion for the cinema as
well. He collaborated as director and
still photographer with Soldati and
Lattuada and made several television
documentaries.

Pellizza da Volpedo, Giuseppe
(Volpedo, Alessandria, 1868–1907)
Painter. He studied painting in
Volpedo, the Accademia di Brera in
Milan (1884–86) and the Accademia
di Belle Arti in Florence (1888), where
he made friends with Nomellini.
One of the leading exponents of Italian
Divisionism, he became interested in
the themes of Social Realism in 1895,
adopting Divisionism as a technique
and Symbolism as a means of
expression. From 1891 onwards he
exhibited at the Brera Triennali,
Venice Biennali and Promotrice in
Turin, as well as elsewhere in Europe
(Munich) and the United States (Saint
Louis), maintaining an intense
correspondence with critics and
artists.

Pesce, Gaetano
(La Spezia, 1939)
Architect, designer, artist. He
graduated from the IUAV in Venice
(1965). In Padua (1959–67) he
experimented with *Arte Programmata*
(Gruppo N) and directing. In 1962
he began to work as a designer,
experimenting with innovative
materials. After contributing an
experimental domestic living unit
to the exhibition *Italy: The New
Domestic Landscape* (MoMA,
New York, 1972), he formulated the
concepts of "performance design" and
"diversified series" in the 1970s, later
extending them to architecture as well
(skyscraper for São Paulo, 1987; house
in Salvador de Bahia, 1998). In 2004
he set up the company Fish Design in
Milan. He taught at the School of
Architecture in Strasbourg for many
years. Since 1980 he has lived and
worked in New York.

Piacentini, Marcello
(Rome, 1881–1960)
Architect, urban planner.
He graduated from the Scuola di
Applicazione degli Ingegneri in Rome
(1912). His first work was the plan for
the redevelopment of the centre of
Bergamo (1907). Art director of the
Esposizione internazionale in Rome
(1911), he won the prize for
architecture at Brussels (1910) and
San Francisco (1915). Principal
architect of the Fascist regime, he
bestowed a neo-classical character on
the buildings representing the state,
derived from ancient Rome. He
designed numerous works of
architecture (Law Courts, Milan,
1933; Rectorate Building, university of
Rome, 1936), often collaborating with

artists. He supervised the drawing up
of the Urban Development Plan for
the EUR, Rome (1937). A lecturer at
the university of Rome, he published
many articles and edited the
magazines *Architettura e Arti
Decorative* and *Architettura*.

Pintori, Giovanni
(Tresnuraghes, Oristano, 1912 –
Milan, 1999)
Graphic artist, painter. After moving
to Milan in 1931, he graduated from
the ISIA in Monza (studying under
Persico and Nizzoli). In 1934 he
collaborated with Pagano on the
exhibition design of the *Mostra
dell'aeronautica italiana* and on the
VI Milan Triennale. In 1936 he went
to work at the publicity and
development department at the
Olivetti company. In 1940 he took part
with Sinisgalli in the design of the
Mostra d'Arte Grafica at the Milan
Triennale. In 1950 he became art
director at Olivetti, overseeing the
corporate image with Nizzoli until
1967. In 1968 he opened a graphics
studio in Milan and devoted himself
to painting.

Pistoletto, Michelangelo
(Biella, 1933)
Artist. He made his debut in the late
1950s with paintings centred on the
human figure, depicted in isolation on
uniform grounds that he covered with
reflective paint. He went on to replace
the canvas with reflective metal
surfaces to make what he called
Quadri specchianti [Mirror Pictures].
In 1964 he held a solo exhibition in
New York (Sonnabend Gallery).
In 1965–66 he created the *Oggetti
in meno* [Minus Objects]. One of the
protagonists of Arte Povera, he often
exhibited with the group (Galleria
La Bertesca, Genoa, 1967). In 1968
he founded Gruppo Zoo, with which
he staged happenings in the streets.
From 1968 onwards he showed
frequently at the Venice Biennale
(Golden Lion for career achievement
in 2003) and at Documenta in
Kassel.

Pizzigoni, Giuseppe
(Bergamo, 1901–1967)
Architect, designer, painter. In 1923
he graduated in architecture in Milan.
In 1924 he worked in Muzio's studio,
and the latter's influence is evident in
the projects of those years (Casa
Pizzigoni and Casa Traversi,
Bergamo, 1924). From the late 1920s
onwards, he was very active in

Bergamo as an architect (church at
Gorno, Vai del Riso, 1928; Villa
Ardiani, Selvino, 1935) and painter
(teaching at the Accademia Carrara
and painting scenery for the Teatro
Donizzetti).

Pomodoro, Giò
(Orciano di Pesaro, Pesaro e Urbino,
1930 – Milan 2002)
Sculptor. After moving to Milan in
1954, he was a member of the
Movimento Nucleare until 1957.
In 1959 he exhibited at Documenta
in Kassel and won first prize for
sculpture at the Biennale des Jeunes
in Paris. In 1961–62 he showed
frequently with Gruppo Continuità,
together with his brother Arnaldo.
He also devoted himself to set design
and goldwork and realized
monumental sculptures in several
parts of the world. From 1956
onwards he often exhibited
(sometimes with his own gallery) at
the Venice Biennale and held various
solo shows (Palais des Beaux-Arts,
Brussels, 1963; Luisiana Museum,
Copenhagen, 1965).

Ponti, Gio (Giovanni)
(Milan, 1891–1979)
Architect, designer. After graduating
from the Milan Politecnico in 1921,
he matured in the Milanese milieu
of the "neo-classical" group. Art
director of Richard-Ginori (1923–30),
he was one of the founders of the
company Il Labirinto in 1927 and
realized the Domus Nova project with
Emilio Lancia (Studio Ponti-Lancia,
1927–33). In 1928 he founded the
magazine *Domus*, which he edited,
except for brief intervals, until his
death. In 1933 he set up FontanaArte
and became its art director. He
exhibited at all the Monza Biennali
and several Milan Triennali (he was
its director for years), making a
fundamental contribution to the
renewal of the decorative arts.
He founded and edited the magazine
Stile (1941–47) and was one of the
founders of the Compasso d'Oro and
the ADI. In 1950 he set up the Studio
P.F.R. with Fornaroli and Rosselli.
A highly active architect (Montecatini
Offices, Milan, 1936; Pirelli
Skyscraper, Milan, 1955–60), he
wrote some famous books (*La casa
all'italiana*, 1933; *Amate
l'architettura*, 1957) and taught
at the Milan Politecnico (1936–61).

Portaluppi, Piero
(Milan, 1888–1967)

Architect. In 1910 he graduated in architecture from the Milan Politecnico, where he would become dean (1939–63). His early work was in a neo-medieval and Secessionist style. From 1922 onwards he constructed numerous hydroelectric power stations for Imprese Elettriche Conti. In 1926 he won the competition for the city plan of Milan with Marco Semenza. Very active in the fields of architecture (House on Via Aldrovandi, Milan, 1929; Hoepli Planetarium, Milan, 1929), restoration and interior decoration, he presented the Holiday Home for Newlyweds with BBPR at the Milan Triennale in 1933.

Prampolini, Enrico
(Modena, 1894 – Rome, 1956)
Painter, set designer. In 1912 he left the Accademia di Belle Arti in Rome and joined the Futurists. From 1914 onwards he took part in the main Futurist exhibitions, signing several manifestos (*Manifesto of Mechanical Art*, 1923), writing theoretical texts and devoting himself to architecture, applied art and set design (Bragaglia's film *Thais*, 1916). In 1915 he founded the Teatro Magnetico and signed the manifesto on *Futurist Set Design*. He founded the magazine *Noi* and the Casa d'Arte Italiana (1918). In contact with various exponents of the European avant-gardes (Dada, Bauhaus, De Stijl), he lived in Paris from 1925 onwards. He exhibited at the Venice Biennali, Rome Quadriennali and Milan Triennali, producing aeropaintings and, later, mixed-media canvases.

Previati, Gaetano
(Ferrara, 1852 – Lavagna, Genova, 1920)
Painter, illustrator. He studied at the Scuola di Belle Arti in Ferrara. After moving to Milan, he attended the Accademia di Brera (1877–80), developing an interest in historical Romanticism. In 1887 he turned to Symbolism. With *Maternità* [Motherhood] (1890) he became a leading exponent of Italian Divisionism, exhibiting at the Brera Triennale (1891) and the Salon de la Rose-Croix in Paris (1892). From 1895 onwards he showed at all the Venice Biennali (with his own gallery in 1901 and 1912). In 1899 he signed a contract with Grubicy, which guaranteed his participation in all major exhibitions (Berlin Secession, 1902; Munich Quadrennial, 1905; Salon des peintres divisionnistes italiens, Paris, 1907).

Provinciali, Michele
(Parma, 1923)
Graphic artist. He graduated in art history in Urbino in 1947. In 1951 he studied at the Institute of Design in Chicago. After returning to Italy, he contributed to the magazine *Spazio* in 1953. In 1954 he was the graphic designer and organizer of the "industrial design" section at the X Milan Triennale (gold medal and diploma d'onore). Art director for institutions and companies of great importance (Kartell, Pirelli, Arflex, the Italian broadcasting corporation RAI), he devoted a lot of energy to publishing and worked for magazines like *Stile industria*, *Domus*, *Abitare* and *Edilizia Moderna*. From 1966 onwards he supervised the corporate image of Zanotta and was its art director. He taught for years at the ISIA in Urbino. He won a Compasso d'Oro.

Pucci, Emilio (Marchese di Barsento)
(Naples, 1914 – Florence, 1992)
Stylist. He received a master's degree in social sciences from Reed College in Portland, Oregon (1937), and graduated in political sciences in Florence (1941). A pilot in the Italian air force, he became a stylist by chance. In 1947 *Harper's Bazaar* published a picture of an original ski outfit he had designed and worn on the slopes. White Stag and Lord & Taylor of New York commissioned the first collections from him. From that time onwards he dressed the international jet set in his lightweight and versatile dresses, with their unmistakable printed silk-jersey fabrics. He designed revolutionary uniforms for air hostesses for Braniff (1965–71) and the logo for the Apollo 15 space mission (1971). He won the Neiman Marcus Fashion Award and the Council of Fashion Designers of America Award.

Puppo, Ernesto
(Genoa, 1904 – Barcelona, 1987)
Architect, designer. He embarked on a career in design alongside V. Marchi and A. G. Bragaglia and graduated from the Real Scuola di Architettura in Rome. An active member of the MIAR, he worked from 1931 onwards as an architect, urban planner, designer and graphic artist.
As a designer he frequently took part in the competitions staged by the Ente Nazionale per l'Artigianato e le Piccole Industrie (ENAPI).
A lecturer at the Museo Artistico Industriale in Rome (and later its

deputy head), he moved to Latin America in 1947, devoting himself to urban planning and designing public and private buildings.

Quarti, Eugenio
(Villa d'Almè, Bergamo, 1867 – Milan, 1929)
Cabinetmaker. He served his apprenticeship in Paris (1881–87) and with Bugatti in Milan (1888), where he opened his own workshop. An exponent of Stile Liberty, he won prizes at the international exhibitions in Turin (1898), Paris (Grand Prix, 1900) and Milan (Gran Premio Reale, 1906) and took part in the Turin Esposizione internazionale (1902). In 1904 he opened a factory where he produced both refined and low-cost furniture, and furnishings for public and private spaces (Palazzo Castiglioni, Milan, 1903–04; Kursaal Casino and Grand Hotel, San Pellegrino Terme, 1907). From 1903 onwards he taught at the Scuola Umanitaria.

Radice, Mario
(Como, 1898 – Milan, 1987)
Painter. In 1930 he decided to devote himself to painting and came into contact with exponents of the European avant-garde. One of the founders of the magazine *Quadrante* (1933), he frequented the abstractionists of Como and Milan, organizing the *I Mostra di Arte Astratta* (Galleria del Milione, 1934), and the *Mostra di pittura moderna italiana* (Villa Olmo, 1936). In 1935 he moved to Milan and collaborated with Terragni (Casa del Fascio, Como, 1933–36), Cattaneo (fountain for the square of Camerlata, 1935), Rho (Gold Medals' Room, Colonial Exhibition, Como, 1937) and Parisi. In the 1950s he joined the MAC. He showed regularly at the Venice Biennali (his own gallery in 1958), Rome Quadriennali and Milan Triennali.

Rizzatto, Paolo
(Milan, 1941)
Architect, designer. In 1965 he graduated from the Milan Politecnico. He worked with the Arteluce lighting company (1969–77) and in 1978 founded the company Luceplan in Milan, with R. Sarfatti and S. Severi. He designed products for numerous companies (in addition to Luceplan), including several with A. Meda, and won three Compassi d'Oro. As an architect, he designed various

residential buildings and the factory and offices of Luceplan (1997).

Romano, Mario
(Rome, 1898 – Arona, Novara, 1987)
Architect. After graduating in architecture in Rome (1928), he took part with Ernesto La Padula in various competitions staged by the Fascist regime. From 1933 onwards he collaborated with the Ente Nazionale per l'Artigianato e le Piccole Industrie (ENAPI), exhibiting his objects in Italy and abroad (Milan Triennali, 1933–54; Venice Biennali, 1934, 1938). In 1937 he won, with La Padula and Guerrini, the competition for the Palazzo della Civiltà Italiana in Rome. He continued to collaborate with Guerrini (on various interiors) and the La Padula studio (projects for INA Casa) until 1962.

Rossi, Aldo
(Milan, 1931–1997)
Architect, designer. He graduated from the Milan Politecnico in 1959. An editor at *Casabella-continuità* (1955–64), he worked with Gardella in 1956, and then with Zanuso. He directed the international architecture section at the Milan Triennale in 1973 and at the Venice Biennale in 1983. He won many international competitions and designed many works of architecture (Modena Cemetery, 1971–84; Theatre of the World, Venice Biennale, 1979; Hotel Il Palazzo, Fukuoka, 1987–89; Schützenstraße housing district, Berlin, 1994–96) and successful products. He taught at the Milan Politecnico (1965–71), the ETH in Zurich (1972–74) and the IUAV in Venice (from 1975). A theorist of architecture, he published several treatises (*L'Architettura della città*, 1966). In 1990 he won the Pritzker Architecture Prize.

Rotella, Mimmo
(Catanzaro, 1918 – Milan, 2006)
Artist. He studied art in Naples. After moving to Rome, he devoted himself to phonetic poetry in 1949 and went to the United States (1951–53), where he held performances and made recordings of "epistaltic" poems. In 1953 he created his first *décollages*, culminating in the *Cinecittà* series (1958). In 1960 he joined the Nouveau Réalisme group, exhibiting at the Galerie J in Paris (1961). In 1964 he showed at the Venice Biennale and experimented with Mec-Art in Paris. Moving to Milan, he produced the

Art-Typo (1967–73) and *Plastiforms* (1975) series and then developed the *Coverings* (1981), shown at the Galerie Denis René in Paris. He presented his work in solo shows and group exhibitions in many parts of the world (Guggenheim Museum, New York, 1994).

Sabattini, Lino
(Correggio, Reggio nell'Emilia, 1925) Designer, entrepreneur. He worked silver and other metals in his youth and in 1955 moved to Milan. Invited by Ponti to show his works at an exhibition he had organized in Paris (1956), he attracted international attention. From then onwards he exhibited frequently at the Milan Triennale and became head of design at the Christofle Orfèvrerie in Paris (until 1963). In 1964 he founded the Argenteria Sabattini in Bregnano (which produced objects designed by Ponti himself), while continuing to work with other companies.

Sambonet, Roberto
(Vercelli, 1924 – Milan, 1995) Painter, designer, graphic artist. In 1946 he left the Milan Politecnico to devote himself to painting. In 1947 he held his first exhibition in Stockholm. He moved to São Paulo (1948–53), and exhibited at the Museu de Arte in 1949. Now a successful painter and draftsman, he decided to return to Milan and devote himself to graphics and design. In 1953 he worked with A. Aalto and in 1954 opened a studio. Graphic designer for La Rinascente and art director of the magazine *Zodiac* (1956–60), he worked as an industrial designer with Italian and foreign companies, helping to revive the Sambonet family business. He won four Compassi d'Oro (one for lifetime achievement).

Santachiara, Denis
(Campagnola, Reggio nell'Emilia, 1951) Designer, artist. In 1966 he made his debut in the field of car design. From 1975 onwards he devoted himself to research into soft technology, designing animated images and objects halfway between art and design. He has collaborated with various companies and founded Domodinamica in 1990. He has designed interiors and works of architecture (Magic Museum, Blois, 1988–92), organized exhibitions in several parts of the world and shown at the Venice Biennale (1980),

Documenta in Kassel (1986), the Milan Triennale (1973–86) and the National Museum of Modern Art in Tokyo (1985). He writes articles for various magazines in Italy and abroad (*Domus*, *Flash Art*).

Sant'Elia, Antonio
(Como, 1888 – Monte Hermada, Quota 77, Gorizia, 1916) Architect. He studied at the Scuola Comasca di Arti e Mestieri. In 1907 he attended the Accademia di Brera in Milan, taking an interest in the emerging artistic avant-garde. In those years he produced numerous plans, took part in competitions and constructed buildings in a style faithful to Wagnerian Secessionism and Lombard Stile Liberty. In 1913 he opened a studio in Milan. In 1914 he produced the utopian and prophetic drawings of the *Città Nuova* [New City], took part in the *I Mostra di architettura* in Milan, joined the Nuove Tendenze group and exhibited with it and finally published the *Manifesto of Futurist Architecture* in *Lacerba*, marking his joining of the Futurism movement.

Sapper, Richard
(Munich, 1932) Designer. After graduating in economics at Munich, he entered the styling department of Mercedes-Benz in Stuttgart in 1955. After moving to Milan, he worked for Ponti and Rosselli (1957–59), for La Rinascente and, until 1977, with Zanuso, with whom he produced several "classics" of Italian design and participated in the exhibition *Italy: The New Domestic Landscape* at the MoMA, New York (1972). Returning to Stuttgart, he worked as a consultant to Fiat and Pirelli (1970–76) and took charge of product design all over the world for IBM (since 1980). Since 1985 he has been heavily involved in teaching (Hochschule für Angewandte Kunst, Vienna; Kunstakademie, Stuttgart). He has won ten Compassi d'Oro.

Sarfatti, Gino
(Venice, 1912 – Gravellona Toce, Verbano-Cosio-Ossola, 1985) Designer, entrepreneur. He left the Faculty of Aeronautical Engineering at Genoa and moved to Milan, where he worked for the Lumen company. In 1939 he set up a small company (Arteluce) in a workshop for the production of lighting. In 1945 he resumed activity with the opening of a small workshop-store that was to become

the company Arteluce, inviting some of the best-known Italian designers to collaborate with him. Designing much of the production himself, he carried out constant research. In 1973 he sold the business to Flos. He won two Compassi d'Oro.

Sartorio, Giulio Aristide
(Rome, 1860–1932) Painter, illustrator. He made illustrations for the magazine *Il Convito* and for d'Annunzio (*Isaotta Guttadauro*, 1886). In 1899 he held a successful exhibition in Paris. A member of the group In Arte Libertas, he took his inspiration from the pre–Raphaelites and Central European Symbolism. After a stay in Weimar, where he taught at the Kunstakademie (1895–99), he painted landscapes and large decorative friezes (Milan Esposizione internazionale, 1906; Chamber of Deputies at Montecitorio, Rome, 1908–12). From 1899 onwards (solo show) he exhibited several times at the Venice Biennale. A critic and writer, he taught at the academy in Rome, took photographs and made films (*Il mistero di Galatea*, 1918).

Sartoris, Alberto
(Turin, 1901 – Cossonay, Switzerland, 1998) Architect. He graduated from the École des Beaux-Arts in Paris (1923) and returned to Turin, collaborating with Rigotti, d'Aronco and Casorati. He joined the Futurist movement, showing at the *I Mostra di architettura futurista* (1928). A member of the MIAR and founding member of the Comité International pour la Résolution des Problèmes de l'Architecture (CIRPAC), he attended the first CIAM in La Sarraz and took part in the first and second *Esposizione Italiana di Architettura Razionale* in Rome (1928, 1931). Theorist and propagandist of Rationalist Italian culture (*Elementi dell'architettura funzionale*, 1932), he was also an art critic and had close relations with the European Concrete art avant-garde. He exhibited several times at the Monza Biennale and Milan Triennale. He taught at Lausanne, Sion and in the United States.

Savinio, Alberto (Andrea De Chirico)
(Athens, 1891 – Rome, 1952) Painter, musician, writer. He graduated from the Athens conservatory (1903), and studied composition in Munich (1906). After

moving to Paris, from 1911 onwards he devoted himself to music and writing, contributing to the magazine *Les Soirées de Paris*. In 1917, in Ferrara, he founded the movement of Metaphysical Painting with De Pisis and Carrà: its premise can be traced back to his *Poema fantastico* (1907–10). In 1918 he founded Valori Plastici. He started to paint in Paris in 1926. He exhibited his work in a solo show at the Galerie Jacques Bernheim (1927) and at the Venice Biennale (1930). He settled in Rome, and he pursued a literary and journalistic career, starting to compose again in 1946 and working in the theatre (set designer, director).

Scarpa, Carlo
(Venice, 1906 – Sendai, Japan, 1978) Architect, designer. In 1926 he graduated from the Accademia di Belle Arti in Venice and in 1927 opened a studio. Art director of M.V.M. (1927–32) and Venini & C. (1933–47), he became chairman of Gavina SpA (1960). He designed numerous installations, commencing a long collaboration with the Venice Biennale (lasting from 1948, with the Klee Pavilion, until the 1970s). Awarded the Olivetti prize for architecture (1956), he designed museum installations (Museo di Castelvecchio, Verona, 1958–64), buildings and commercial and residential interiors (Olivetti shop, Venice, 1957–58; Casa Veritti, Udine, 1955–61). Lecturer until 1976 and rector from 1972 to 1974 at the IUAV in Venice, he was awarded an honorary degree in architecture (1955).

Scarpa, Tobia
(Venice, 1935)
Scarpa, Afra (Afra Bianchini)
(Montebelluna, Treviso, 1937) Architects, designers. They graduated in architecture in Venice in 1969. Tobia worked as a designer for Venini & C. (1957–61), Gavina (from 1960) and other companies (occasionally collaborating with his father Carlo as well). From 1958 onwards they worked together as designers for various firms. In 1960 they opened a studio in Montebelluna, devoting themselves chiefly to design and sporadically to architecture (Benetton factory and house in Treviso, 1964; C & B factory at Novedrate, 1966). In 1964 they were put in charge of the image of Benetton stores in Europe and the United States. They won a Compasso d'Oro.

Schawinsky, Xanti (Alexander)

(Basel, 1904 – Locarno, 1979)
Painter, graphic artist, set designer.
He studied painting and architecture
in Zurich, Cologne and Berlin. From
1924 to 1929 he studied and worked at
the Bauhaus in Weimar and Dessau,
teaching set design. As a set designer
and graphic artist he worked in
Zwickau and Magdeburg. From 1932
onwards he worked in Milan as a
freelance commercial artist, as well as
for the Studio Boggeri and several
companies (Olivetti, Motta).
In 1936 he went to the United States
to teach at Black Mountain College
in North Carolina. He designed
the North Carolina Pavilion
and collaborated with Gropius and
Breuer at the World's Fair, New York
(1939). He taught at New York
University (1939–44) and devoted
himself to painting until 1960.

Scianna, Ferdinando

(Bagheria, Palermo, 1943)
Photographer. He made his debut
in the 1960s, taking pictures that
explored Sicilian culture and
traditions, and in 1965 published the
volume *Feste religiose in Sicilia*
[Religious Festivals in Sicily], with an
essay by his friend Leonardo Sciascia,
that made him famous and won him
the Prix Nadar (1966). For ten years
from 1967, he was a journalist and
photographer for *L'Europeo* in Paris.
In 1982, at the behest of Cartier-
Bresson, he joined the Magnum
agency. After moving to Milan, he
started to work as a fashion
photographer as well in 1987. He has
worked with the biggest names in
the Italian and foreign press.

Segantini, Giovanni

(Arco, Trento, 1858 – Schafberg,
Switzerland, 1899)
Painter. He attended the Accademia
di Brera in Milan. At the
Esposizione Nazionale of Brera
(1879) he was noticed by the
Milanese critics and met Grubicy,
his future patron (1883–89).
At Savognino (1886–94) he
experimented with the technique
of Divisionism and painted some
of his most important works, moving
towards Symbolism from 1889
onwards. He contributed to various
Italian magazines and, in contact with
the Viennese Secession, to *Ver sacrum*.
Present at major exhibitions,
he received many awards
(Amsterdam, 1883, 1885; Paris, 1889,
1900; Munich, Turin, 1892).

Sironi, Mario

(Sassari, 1885 – Milan, 1961)
Artist. In 1903 he began to attend
the Accademia di Belle Arti in Rome
and frequent Balla's studio, where
he met Boccioni, who was then close
to Divisionism. He stayed in Paris
(1906–07) and Erfurt (1908) and, after
returning to Rome, joined the
Futurists. He exhibited at the Galleria
Sprovieri (1914) and held a solo show
at the Casa d'Arte Bragaglia (1919).
From 1915 onwards, in Milan, he
worked as an illustrator and critic for
various magazines (*Popolo d'Italia*).
In 1922 he joined the Novecento
group, showing at the first and second
exhibitions of the Novecento Italiano
(1926, 1929) and the Venice Biennale
(1924–32). In 1933 he signed the
Manifesto of Mural Painting. In the
1930s he carried out a series of
decorative projects (IV Monza
Triennale; *Mostra della Rivoluzione
Fascista*, Rome; V Milan Triennale;
universities of Rome and Venice;
Law Courts, Milan).

Sottsass, Ettore

(Innsbruck, Austria, 1917)
Architect, designer, artist. After
graduating from the Turin Politecnico
(1939), he collaborated with G. Pagano
while also devoting himself to
painting, sculpture and photography.
In 1947 he opened a studio in Milan
and took part in the IX Milan
Triennale and the Fede Cheti
exhibition (1949). Art director of
Poltronova from 1957 and a
consultant to Olivetti from 1958, he
was an exponent of Radical Design in
the 1970s. One of the founders of
Global Tools, he showed an
experimental domestic living unit at
the MoMA exhibition *Italy: The New
Domestic Landscape* in New York
(1972) and worked with Studio
Alchimia. In 1980 he founded Sottsass
Associati and in 1981 the Memphis
Group, of which he was the leader.
Awarded honorary degrees by the
Royal College of Art, London (1968),
and the Milan Politecnico (2001), he
won five Compassi d'Oro (one for
lifetime achievement). As an architect
he has worked all over the world
(Esprit Showrooms, 1980–86;
Olabuenaga House, Hawaii, 1989–97;
Malpensa Airport, Milan, 1994–98).

Studio 65

(founded in Turin, 1965)
Group of architects, designers, artists,
founded by the architect Franco
Audrito (Balangero, Torino, 1943) in a
climate of radical protest. From 1967
onwards, with the entry of A. Garizio,
A. Sampaniotou and F. Tartaglia, the
group devoted itself to design, making
a fundamental contribution to the
Radical movement and Antidesign.
Between 1969 and 1972 G. Arnaudo,
R. Gibello, G. Paci, P. Perotti, A. Pozzo,
A. M. Rachetta, A. Sampaniotis, M.
Schiappa, Y. Skoulas and A. Vanara
joined the group. While particularly
active in the field of industrial design
(*Studio 65 Multiples*), it also produced
works of architecture and interiors.
Today the group is made up of
F. Audrito and A. Sampaniotou.
It focuses chiefly on architecture,
with branches in Turin, Jeddah,
Abu Dhabi, Bali and Beijing.

Superstudio

(Florence, 1966–1978)
Cristiano Toraldo di Francia
(Florence, 1941), Piero Frassinelli
(Florence, 1939), Alessandro Magris
(Florence, 1941), Roberto Magris
(Florence, 1935–2003), Adolfo Natalini
(Pistoia, 1941), Alessandro Poli
(Florence, 1941)
Group of architects founded by
Natalini and Toraldo di Francia to
carry out theoretical and practical
research in the field of architecture
and Radical Design. Very active in
exhibition design, teaching and
journalism, it collaborated with
Archizoom on the exhibition
Superarchitettura in Pistoia and
Modena (1966–67), from which it took
its name. From 1973 onwards the
group devoted its attention to research
and teaching at the Faculty of
Architecture in Florence and promoted
the foundation of Global Tools
(1973–75). It took part in the
exhibition *Italy: The New Domestic
Landscape* at the MoMA, New York
(1972), the XV and XVI Milan Triennali
and the Venice Biennali (1978–80).

Terragni, Giuseppe

(Meda, Milano, 1904 – Como 1943)
Architect, designer, painter.
One of the leading exponents of
Italian Rationalism, he graduated
from the Milan Politecnico and helped
form Gruppo 7 in 1926. From 1927
onwards he worked in Como and
participated in the Monza Biennali,
the *Mostra della Rivoluzione Facista*
in Rome (1932) and the Milan
Triennale (1933). A member of the
MIAR, he showed at the first and
second *Esposizione Italiana di
Architettura* in Rome. One of the
founders of the magazine *Valori*
Primordiali (1938), he designed
important works of architecture (Casa
del Fascio, Como, 1932–36; Sant'Elia
Nursery School, Como, 1934–36), and
collaborated with P. Lingeri in Milan
(1932–35). As a painter he belonged to
the Novecento group.

Tesio, Federico

(Turin, 1869 – Milan, 1954)
Successful breeder of thoroughbred
horses. A lover of art, chemistry
and astronomy, he finished his studies
at the Real Collegio in Moncalieri
and set off on a long journey around
the world that also took him to Paris
(where he encountered the beau
monde and was dazzled by the
horses). In 1898 he set up a stud farm
at Dormello, on Lake Maggiore,
designing a highly original set of
furniture for his own villa. His horses
(Nearco, Ribot) became famous all
over the world, winning the most
important races.

Testa, Armando

(Turin, 1917–1992)
Painter, graphic designer, advertising
agent. The father of modern Italian
advertising, he devoted himself
to abstract painting and printing as
a young man. In 1946 he turned
his attention to graphic design.
In 1956 he set up the Studio Testa,
an advertising agency that worked
for important international brands,
achieving great success with
television commercials (Carosello).
Winner of the Poster Biennale in
Warsaw (1970), he opened branches
in Rome and Milan in 1978. In 1985
he handed over the agency to his son,
devoting himself to painting and
cultural communications.

Thun, Mattco

(Bolzano, 1952)
Architect, designer. He studied under
Kokoschka at the Academy for Visual
Arts in Salzburg (1968) and
graduated in architecture in Florence
(1975). In 1978 he moved to Milan
and worked with Sottsass. He was one
of the founders of Sottsass Associati
(1980) and Memphis (1981). In 1984
he founded the Studio Matteo Thun,
devoting himself to architecture,
design and communications. Creative
director of Swatch (1990–96), he has
received various international prizes
and awards for architecture and
design. A member of the Royal
Institute of British Architects (RIBA),
he taught at the Kunstgewerbeschule
in Vienna (1983–95).

Ulrich, Guglielmo
(Milan, 1904–1977)
Architect, designer. He attended the Accademia di Brera and graduated from the Milan Politecnico (1928). He designed objects and furniture characterized by their high quality of craftsmanship for various companies, including Ar.Ca., which he founded in 1930. He also designed a series of interiors (with Ponti, hotel in Venice, 1937) and took part in urban planning schemes in Italian East Africa (1936–40). After the war, he designed buildings (with Bottoni, high-rise, Milan, 1948; office building, Brussels, 1958), shops, interiors and fittings for ships, published books and took part in several Triennali.

Valle, Gino
(Udine, 1923–2003)
Painter, architect, designer. After graduating in architecture in Venice (1948), he attended the Harvard Graduate School of Design (1951–52). He worked with his father in Udine, founding the Studio di Architetti Valle (which his sister Nani joined in 1952). An adviser on product design to Solari (1950s) and Zanussi (1959–61), he collaborated with Olivetti (1978–90). As an architect he designed many industrial and commercial buildings (Zanussi Offices, Porcia, 1959–61; Olivetti Offices, Ivrea, 1979–86). He won three Compassi d'Oro (one for lifetime achievement). From 1977 onwards he was a lecturer at the IUAV in Venice.

Venini, Paolo
(Milan, 1895 – Venice 1959)
Entrepreneur, designer. A lawyer, he was one of the principal architects of the renewal of the art of glass in Italy. In 1921 he and G. Cappellin founded the Vetri Soffiati Muranesi Cappellin Venini & C in Murano, entrusting the artistic direction to V. Zecchin. In 1925 he set up his own glassworks, with N. Martinuzzi as art director. In the 1930s he experimented with innovative materials and techniques and entrusted the artistic direction of Venini & C. to Buzzi (1932–34) and Scarpa (1934–47). Later he called on other architects and artists (Ponti, Wirkkala, Bianconi), while designing many pieces himself.

Vietti, Luigi
(Novara, 1903 – Milan, 1998)
Architect, designer. In 1928 he graduated from the Scuola Superiore di Architettura in Rome. He devoted himself to theoretical studies and urban planning. In the 1930s he worked at the Fine Arts Service for Liguria (1930–33) and designed furniture that combined the technical aspects of new materials with a revival of traditions. Later on he focused on the design of famous holiday homes (Costa Smeralda, Portofino, Cortina). His style came to be known as the "Cortina style."

Vignelli, Massimo
(Milan, 1931)
Graphic artist, designer. He studied architecture in Milan and Venice and made his debut as a designer for Venini. He taught at the Institute of Design, Illinois, and Institute of Technology, Chicago (1958–60). He set up a studio of architecture and design in Milan with his wife in 1960 and the Unimark International Corporation with Noorda and Doblin in 1965. Since 1966 he has lived in New York, where he founded Vignelli Associates (1971) and Vignelli Designs (1978), devoting himself to graphic art, corporate identity and installations, interior and industrial design. Awarded an honorary degree in architecture in Venice (1994), he has been president of the Alliance Graphique Internationale (AGI). He has won the American Institute of Graphic Arts' gold medal and two Compassi d'Oro.

Wildt, Adolfo
(Milan, 1868–1931)
Artist. From 1888 onwards he worked as a finisher for the principal sculptors in Lombardy and studied at the Accademia di Brera. In 1894 he signed a contract with F. Rose, beginning to exhibit abroad and receiving various awards (Munich Secession, 1913; Venice Biennale, 1922; Paris Exposition internationale, 1925). Supported by critics like Giolli and Sarfatti (who got him to join the group of the Novecento Italiano), he set the seal on his success in 1919 with a solo show at the Galleria Pesaro in Milan. In 1921 he published *L'arte del marmo*. In 1922 he opened his own school of the art of marble, which the following year became part of the Accademia di Brera, where he would teach sculpture.

Zanini, Gigiotti (Luigi)
(Vigo di Fassa, Trento, 1893 – Gargnano del Garda, Brescia, 1962)
Painter, architect. He started out as a painter in Florence, where he attended the Accademia di Belle Arti in 1911 and joined the group centred on the magazine *Lacerba*. After settling in Milan, he worked in Muzio's studio (1919–23) and from then on worked as an architect (Erba factory, Dergano, 1927–29; building on Piazza Duse, Milan, 1933–34) and decorator. Close to the Metaphysical movement, he joined the Novecento group, exhibiting with it in Milan and abroad, and was present at the Venice Biennali in the 1930s.

Zanuso, Marco
(Milan, 1916–2001)
Architect, designer. In 1939 he graduated from the Milan Politecnico and in 1945 opened a studio. In 1948 he created his first pieces of furniture padded with foam rubber for Arflex. From 1957 to 1977 he designed numerous "classics" of Italian design in collaboration with R. Sapper. In 1972 he showed an experimental domestic living unit at the exhibition *Italy: The New Domestic Landscape* (MoMA, New York). He built several industrial (Olivetti factory, São Paulo, 1956–58) and residential buildings (house on the island of Cavallo, 1981–88), and designed stores and exhibitions. Active in the cultural debate over the Modern Movement, he was co-editor of *Domus* (1947–49), on the editorial staff of *Casabella* (1952–54) and a member of the MSA and CIAM. One of the founders of the ADI, he was also its director (1966–69). He taught at the Milan Politecnico (1961–91), where he was awarded an honorary degree in industrial design (1999). He won various gold medals and Gran Premi at the Milan Triennale and seven Compassi d'Oro (one for lifetime achievement).

Zecchin, Vittorio
(Murano, Venezia, 1878 – Venice 1947)
Painter, designer. He studied at the Accademia di Belle Arti in Venice. He started out as a painter, taking his inspiration from the Viennese Secession. From 1912 he devoted himself with success to the applied arts (glassware, mosaics, embroidery, tapestries, furniture, ceramics), exhibiting at the Venice Biennali (1914–38) and Monza Biennali (Gran Premio, 1923). He designed vases for Salviati and Barovier and in 1916 opened a tapestry and embroidery workshop. In 1921 he became the art director of Cappellin Venini & C. In 1925 he founded the Maestri Vetrai Muranesi Cappellin & C. with G. Cappellin. From 1932 onwards he collaborated with other glassworks.

Zen, Carlo
(Verona, 1851 – Lanzo d'Intelvi, Como, 1918)
Cabinetmaker, entrepreneur. In 1898 he became the proprietor of the Zara and Zen furniture manufacturer in Milan, renaming it Carlo Zen. At the Turin Esposizione internazionale of 1898, he presented his first Stile Liberty furniture alongside pieces in an eclectic style. He won the Grand Prix at the Esposition universelle in Paris in 1900, and from the time of the Turin Esposizione internazionale of 1902 onwards his name was associated with the Viennese manufacturer of carpets and fabrics Haas, with which he exhibited in Milan (1906). He continued to produce period furniture alongside modern designs. In 1905 the company, by this time operating on a large scale, changed its name to Fabbrica Italiana di Mobili.

Abbreviations
ADI = Associazione per il Disegno Industriale (Industrial Design Association)
CIAM = Congrès Internationaux d'Architecture Moderne (International Congresses of Modern Architecture)
ISIA = Istituto Superiore per le Industrie Artistiche (College of Artistic Industries)
IUAV = Istituto Universitario di Architettura di Venezia (University College of Architecture of Venice)
MAC = Movimento Arte Concreta (Concrete Art Movement)
MIAR = Movimento Italiano di Architettura Razionale (Italian Movement of Rational Architecture)
MSA = Movimento Studi Architettura (Architectural Studies Movement)

Bibliography

History of economics, politics and culture

Annicinquanta. La nascita della creatività italiana. Exhib. cat. Florence: ArtificioSkira, 2005.

Anni Trenta: arte e cultura in Italia. Exhib. cat. Milan: Mazzotta, 1982.

Asor Rosa, A. *Le due società: ipotesi sulla crisi italiana.* Turin: Einaudi, 1977.

Asor Rosa, A. *La repubblica immaginaria: idee e fatti dell'Italia contemporanea.* Milan: Mondadori, 1988.

Bagnasco, A. *Tre Italie: la problematica territoriale dello sviluppo italiano.* Bologna: Il Mulino, 1977.

Calabrese, O. (ed.). *Italia moderna: immagini e storia di un'identità nazionale. Dall'Unità al nuovo secolo. Dall'espansione alla seconda guerra mondiale. Guerra, dopoguerra, ricostruzione, decollo. La difficile democrazia. Il paese immaginato.* Milan: Electa, 1982.

Calabrese, O. (ed.). *L'Italie aujourd'hui: aspects de la creation italienne de 1970 a 1985.* Exhib. cat. Florence: La Casa Usher, 1985.

Castronovo, V., *L'industria italiana dall'Ottocento a oggi.* Milan: Mondadori, 1980.

Celant, G. (ed.). *The Italian Metamorphosis, 1943–1968.* Exhib. cat. New York: Guggenheim Museum; Rome: Progetti Museali Editore, 1994.

Cipolla, C. M. *Storia dell'economia italiana, saggi di storia economica.* Turin: Edizioni Scientifiche Einaudi, 1959.

D'Angelo, P. *L'estetica italiana del Novecento.* Bari: Laterza, 1997.

Fabris, G. and V. Mortara. *Le otto Italie. Dinamica e frammentazione della società italiana.* Milan: Mondadori, 1986.

Ginsborg, P. *L'Italia del tempo presente. Famiglia, società civile, Stato 1980-1996.* Turin: Einaudi, 1998.

Ginsborg, P. *Storia d'Italia dal dopoguerra a oggi. Società e politica 1943- 1988.* Turin: Einaudi, 1989 (Eng. trans. *History of Contemporary Italy: Society and Politics: 1943–1988.* London: Penguin, 1990).

Graziani, A. *Lo sviluppo dell'economia italiana. Dalla ricostruzione alla moneta europea.* Turin: Bollati e Boringhieri, 1998.

La grande svolta – Anni '60. Viaggio negli anni Sessanta in Italia. Exhib. cat. Geneva and Milan: Skira, 2003.

L'economia italiana tra le due guerre. 1919-1939. Milan: Ipsoa, 1984.

Perniola, M. *L'estetica del Novecento.* Bologna: Il Mulino, 1997.

Procacci, G. *Storia degli italiani.* Rome and Bari: Laterza, 1968 (Eng. trans. *History of the Italian People.* London: Penguin, 1968).

Romano, R. and C. Vivanti (eds.). *Storia d'Italia. 4. Dall'Unità a oggi (La storia economica, La cultura, La storia politica e sociale).* Turin: Einaudi, 1976.

Romeo, R. *Breve storia della grande industria in Italia, 1861-1961.* Bologna: Cappelli, 1961.

Vergani, G. and L. Settembrini (eds.). *Made in Italy? 1951–2001.* Exhib. cat. Milan: Skira, 2001.

History of the relationship between art and design

Bologna, F. *Dalle arti minori all'industrial design. Storia di una ideologia.* Bari: Laterza, 1972.

Castelli, C. T. *Transitive Design. A Design Language for the Zeroes.* Milan: Electa, 1999.

Celant, G. (ed.). *Arti & Architettura, 1900-2000.* Exhib. cat. Milan: Skira, 2004 (Eng. trans. *Architecture and Arts, 1900/2004. A Century of Creative Projects in Building, Design, Cinema, Painting, Sculpture.* Exhib. cat. Milan: Skira, 2004).

Dorfles, G. *Il disegno industriale e la sua estetica.* Bologna: Cappelli, 1963.

Dorfles, G. *Il divenire delle arti* (1959). Turin: Einaudi, 1975.

Dorfles, G. *Il kitsch: antologia del cattivo gusto.* Milan: Gabriele Mazzotta, 1968 (Eng. trans. *Kitsch: The World of Bad Taste.* New York: Universe Books, 1969).

Dorfles, G. *Le oscillazioni del gusto, l'arte d'oggi tra tecnocrazia e consumismo.* Turin: Einaudi, 1970.

Eco, U. *Opera aperta.* Milan: Bompiani, 1962 (Eng. trans. *The Open Work.* Cambridge: Harvard University Press, 1989).

Francastel, P. *Art et technique aux XIXe et XXe siècles.* Paris: Éditions de Minuit, 1956.

Giedion, S. *Mechanization Takes Command. A Contribution to Anonymous History.* Oxford: Oxford University Press, 1948.

Giedion, S. *Space, Time and Architecture, the Growth of a New Tradition.* Cambridge (Mass.): Harvard University Press;

393

H. Milford, London: Oxford University Press, 1941.

Kepes, G. (ed.). *Structure in Art and in Science*. New York: G. Braziller, 1965.

Klingender, F. D. *Art and the Industrial Revolution*. London: Noel Carrington, 1947.

Kubler, G. *The Shape of Time, Remarks on the History of Things*. New Haven (Conn.): Yale University Press, 1972.

Lux, S. *Arte e industria*. Florence: Sansoni, 1973.

Maldonado, T. *La speranza progettuale. Ambiente e società*. Turin: Einaudi, 1970 (Eng. trans. *Design, Nature and Revolution. Toward a Critical Ecology*. New York: Harper & Row, 1972).

Mari, E. *Progetto e passione*. Turin: Bollati e Boringhieri, 2001.

Menna, F. *Il progetto moderno dell'arte*. Milan: Giancarlo Politi Editore, 1988.

Molotch, H. *Where Stuff Comes From: How Toasters, Toilets, Cars, Computers, and Many Other Things Come to Be As They Are*. New York: Routledge, 2003.

Mumford, L. *Art and Technics*. New York: Columbia University Press, 1952.

Munari, B. *Arte come mestiere*. Bari: Laterza, 1966 (Eng. trans. *Munari. Design as Art*. Harmondsworth: Penguin, 1971).

Munari, B. *Artista e designer*. Bari: Laterza, 1971.

Pansera, A. *Storia e cronaca della Triennale*. Milan: Longanesi, 1978.

Read, H. *Art and Industry, The Principles of Industrial Design*. London: Faber and Faber, 1934.

History of the decorative arts

Alfieri, D. and L. Freddi (eds.). *Mostra della Rivoluzione Fascista, I° decennale della marcia su Roma*. Bergamo: Officine dell'Istituto Italiano d'Arti Grafiche; Rome: PNF, 1933.

Annicchiarico, S. (ed.). *Custom-built: The Concept of Unique in Italian Design*. Exhib. cat. Milan: Charta, Triennale di Milano, 2003.

Badas, R. and P. Frattani. *50 anni di arte decorativa e artigianato in Italia. L'Enapi dal 1925 al 1975*. Rome: Ente Nazionale Artigianato Piccole Industrie, 1976.

Bairati, E., R. Bossaglia and M. Rossi. *L'Italia liberty*. Milan: Görlich Editore, 1973.

Barovier, M. *Il vetro a Venezia dal moderno al contemporaneo*. Milan: Federico Motta Editore, 1999.

Bauer, R. *La Società Umanitaria. Fondazione P. M. Loria, Milano 1893-1963*. Milan: Società Umanitaria, 1964.

Bellati, N. *New Italian Design*. New York: Rizzoli, 1990.

Benzi, F. (ed.). *Il déco in Italia*. Exhib. cat. Milan: Electa, 2004.

Berri, G. and C. Hanau. *L'Esposizione Mondiale del 1900 in Parigi*. Milan: Casa Editrice Dottor Francesco Vallardi, 1900.

Bossaglia, R. *Il Liberty in Italia*. Milan: Il Saggiatore, 1968.

Bossaglia, R. (ed.). *L'ISIA a Monza: una scuola d'arte europea*. Monza: Associazione Pro Monza, 1986.

Bossaglia, R., C. Cresti and V. Savi, *Situazione degli studi sul Liberty*. Florence: Clusf, 1974.

Bossaglia, R., E. Godoli and M. Rosci (eds.). *Torino 1902. Le Arti Decorative Internazionali del nuovo secolo*. Exhib. cat. Milan: Fabbri Editori, 1994.

Branzi, A. and N. *Domestic Animals: The Neoprimitive Style*. Cambridge (Mass.): MIT Press, 1987.

Brunetti, F. *Architetti e fascismo*. Florence: Alinea Editrice, 1993.

Buzio Negri, F. and R. Zelatore (eds.). *Albisola futurista. La grande stagione degli anni venti e trenta*. Gallarate: Edizioni Civica Galleria d'Arte Moderna, 2003.

Cicolini, M. *Catalogo Bolaffi del manifesto Italiano. Dizionario degli illustratori*. Turin: Giulio Bolaffi Editore, 1995.

Deboni, F. *Murano '900. Vetri et Vetrai*. Milan: Bocca Editori, 1996.

Eidelberg, M. (ed.). *Design 1935–1965. What Modern Was: Selections from the Liliane and David M. Stewart Collection*. Exhib. cat. Montreal: The Montreal Museum of Decorative Arts; New York: Abrams, 1991.

Etlin, R. A. *Modernism in Italian Architecture, 1890–1940*. Cambridge (Mass.): MIT Press, 1991.

Felice, C. A. *Arte decorativa 1930 all'Esposizione di Monza*. Milan: Casa Editrice Ceschina, 1930.

Fitoussi, B. *Memphis*. Paris: Éditions Assouline, 1998.

Fuchs, G. "L'art industriel Italien à l'Exposition de Turin 1902," in *Deutsche Kunst und Dekoration*. Edition Française. Darmstadt: 1902.

Giacobone, T. F. (ed.). *Argenti italiani del 20° secolo: dalle arti decorative al design*. Milan: Electa, 1993.

Gregory, T. and A. Tartaro (eds.). *E 42. Utopia e scenario del regime*. Venice: Marsilio, 1987.

Guida ufficiale della esposizione internazionale: Torino 1911. Turin: G. Momo, 1911.

Guttry, I. de and M. P. Maino. *Il mobile déco italiano 1920-1940*. Bari: Laterza, 1988.

Guttry, I. de and M. P. Maino. *Il mobile italiano degli anni Quaranta e Cinquanta*. Bari: Laterza, 1992.

Guttry, I. de and M. P. Maino. *Il mobile liberty italiano*. Bari: Laterza, 1983.

Guttry, I. de, M. P. Maino and M. Quesada. *Le arti minori d'autore in Italia dal 1900 al 1930*. Bari: Laterza, 1985.

Heiremans, M. *Art Glass from Murano 1910–1970 (Glas-Kunst aus Murano 1910-1970)*. Stuttgart: Arnoldsche, 1993.

Heller, S. and L. Fili. *Italian Art Deco: Graphic Design Between the Wars*. San Francisco: Chronicle Books, 1993.

Kaplan, W. (ed.). *Designing Modernity: The Arts of Reform and Persuasion, 1885–1945: Selections from the Wolfsonian*. Exhib. cat. New York: Thames and Hudson, 1995.

La Pietra, U. (ed.). *Fatto ad arte: arti decorative e artigianato*. Milan: Triennale, 1997.

Marangoni, G. *La III Mostra Internazionale delle Arti decorative nella villa Reale di Monza, 1927: notizie, rilievi, risultati*. Exhib. cat. Bergamo: Istituto Italiano d'Arti Grafiche, 1927.

Marescotti, E. A. and E. Ximenes (eds.). *Milano e l'Esposizione Internazionale del Sempione, 1906: cronaca illustrata dell'esposizione*. Milan: Fratelli Treves Tip. Edit., 1906.

Massobrio, G. and P. Portoghesi. *Album del Liberty*. Bari: Laterza, 1975.

Monti, R. *La Manifattura Richard Ginori di Doccia*. Milan: Mondadori; Rome: De Luca, 1988.

Mostra internazionale delle arti decorative: Villa reale di Monza, 1925: opere scelte. Exhib. cat. Milan: Grandi edizioni Artistiche, 1925.

Palanti, G. *Mobili tipici moderni*, Milan: Editoriale Domus S.A., n.d. [1933].

Pansera, A. (ed.). *1923-1930: Monza, verso l'unità delle arti. Oggetti d'eccezione dalle esposizioni internazionali di arti decorative*. Cinisello Balsamo: Silvana, 2004.

Papini, R. *Le Arti a Monza nel MCMXXIII*. Bergamo: Istituto Italiano d'Arti Grafiche, 1923.

Papini, R. *Le Arti d'Oggi. Architettura e Arti Decorative in Europa*. Milan: Casa Editrice d'Arte Sestetti; Rome: Tumminelli, 1930.

Pica, A. *Storia della Triennale 1918-1957*. Milan: Edizioni del Milione, 1957.

Pica, V. *L'arte decorativa all'esposizione di Torino del 1902*. Bergamo: Istituto Italiano d'Arti Grafiche, 1903.

Prima esposizione internazionale d'arte decorativa moderna, Torino, 1902: catalogo generale ufficiale. Exhib. cat. Turin: 1902.

Raimondi, G. *Italian Living Design: Three Decades of Interior Decoration 1960–1990*. New York: Rizzoli, 1990.

Sartogo, P. *Italian Re evolution: Design in Italian Society in the Eighties*. Exhib. cat. La Jolla (Cal.): La Jolla Museum of Contemporary Art, 1982.

Terraroli, V. *Dizionario Skira delle arti decorative moderne: 1851-1942*. Milan: Skira, 2001.

Venetian Glass, 1920–1970. Exhib. cat. Toronto: Istituto italiano di cultura, 1997.

Venetian Glass. The Nancy Olnick and Giorgio Spanu Collection. Exhib. cat. Milan: Charta; New York: American Craft Museum, 2000.

Weisberg, G. P. *Stile Floreale: The Cult of Nature in Italian Design*. Exhib. cat. Miami: Wolfsonian Foundation, 1988.

History of industrial design

Ambasz, E. (ed.). *Italy: The New Domestic Landscape. Achievements and Problems of Italian Design*. Exhib. cat. New York: Museum of Modern Art; Florence: Centro Di, 1972.

Anselmi, A. T. (ed.). *Carrozzeria italiana: cultura e progetto*. Exhib. cat. Milan: Alfieri, 1978.

Bassi, A. *La luce italiana. Design delle lampade 1945-2000*. Milan: Electa, 2003 (Eng. trans. *Italian Lighting Design: 1945–2000*, Milan: Electa Architecture, 2004).

Bosoni, G. (ed.). *Italy: Contemporary Domestic Landscapes, 1945–2000*. Milan: Skira, 2001.

Bosoni, G. and F. G. Confalonieri. *Paesaggio del design italiano, 1972-1988*. Milan: Edizioni di Comunità, 1988.

Bosoni, G., F. Picchi, M. Strina and N. Zanardi (eds.). *Brevetti del design italiano: 1946-1965*. Milan: Electa, 2000.

Branzi, A. (ed.). *Il Design italiano 1964-1990: un museo del design italiano*. Exhib. cat. Milan: Electa, 1996.

Branzi, A. *Introduzione al design italiano. Una modernità incompleta*. Milan: Baldini & Castoldi, 1999.

Branzi, A. *La Casa Calda*. Milan: Idea Books, 1984 (Eng. trans. *The Hot House: Italian New Wave Design*. Cambridge [Mass.]: MIT Press, 1984).

Branzi, A. *Learning from Milan: Design and the Second Modernity*. Cambridge (Mass.): MIT Press, 1988.

Canella, G. and V. Gregotti (eds.). "Dibattito sulla cultura del Novecento," in *Edilizia Moderna*, no. 81 (December 1963).

Carboni, M. and B. Radice (eds.). *Ettore Sottsass. Scritti 1946-2001*. Vicenza: Neri Pozza, 2002.

Centrokappa (ed.). *Il design italiano degli anni '50*. Exhib. cat. Milan: Ricerche design Editrice, 1985.

Ciucci, G. and F. Dal Co. *Atlante dell'architettura italiana del Novecento*. Milan: Electa, 1991.

Craig Miller, R. *Masterworks: Italian Design, 1960–1994*. Exhib. cat. New York: American Federation of Arts, 1996.

De Fusco, R. *Storia del design*. Bari: Laterza, 1985.

De Giorni, M. (ed.). *45.63: un museo del disegno industriale in Italia. Progetto di una collezione*. Exhib. cat. Milan: Abitare Segesta, 1995.

Design Process Olivetti 1908-1983. Ivrea: Olivetti, 1983.

Donà, C. (ed.). *Mobili italiani: le varie età dei linguaggi 1961-1991*. Milan: Cosmit, 1992.

Dorfles, G. *Introduzione al disegno industriale. Linguaggio e storia della produzione di serie* (1963). Turin: Einaudi, 1972.

Ferrari, F. and N. *Luce. Lampade 1968-1973. Il nuovo design italiano*. Turin: Umberto Allemandi, 2002 (Eng. trans. *Light: Lamps 1968–1973: New Italian Design*. Turin: Allemandi, 2002).

Fioravanti, G., L. Passarelli and S. Sfligiotti. *La grafica in Italia*. Milan: Leonardo arte, 1997.

Fossati, P. *Il design in Italia: 1945-1972*. Turin: Einaudi, 1972.

Fratelli, E. *Continuità e trasformazione: una storia del disegno industriale italiano*. Milan: Alberto Greco, 1989.

Gramigna, G. and S. Mazza (eds.). *Repertorio del design italiano 1950-2000 per l'arredamento domestico*. Turin-London-Venice-New York: Allemandi, 2003.

Grassi, A. and A. Pansera. *Atlante del design italiano 1940-1980*. Milan: Fabbri, 1980.

Gregotti, V. (ed.) with G. Bosoni, M. De Giorgi and A. Nulli. *Il disegno del prodotto industriale. Italia 1860-1980*. Milan: Electa, 1982.

Hanks, D. A. *Design for Living. Furniture and Lighting 1950–2000: The Liliane and David M. Stewart Collection*. Exhib. cat. Paris: Flammarion; Montreal: The Montreal Museum of Decorative Arts, 2000.

"Il campo della grafica italiana," in *Rassegna*, no. 6 (April 1981).

"Il disegno del mobile razionale in Italia 1928-1948," in *Rassegna*, no. 4 (October 1980).

La moda italiana. Milan: Electa, 1987

Maldonado, T. *Il disegno industriale: un riesame*. Milan: Feltrinelli, 1976.

Mendini, A. and F. *La fabbrica estetica: la dernière génération du design italien: création, humanité, engagement*. Exhib. cat. Paris: Institut Italien pour le Commerce Extérieur; Milan: Assarredo, 1993.

Morini, E. *Storia della moda dal XVIII al XX secolo*. Milan: Skira, 2000.

Navone, P. and B. Orlandoni. *Architettura radicale*. Segrate: G. Milani, 1974.

Pansera, A. (ed.). *Dizionario del design italiano*. Milan: Cantini, 1995.

Pansera, A. *Storia del disegno industriale italiano*. Bari: Laterza, 1993.

Parmesani, L. (ed.). *Alessandro Mendini. Scritti*. Milan: Skira, 2004.

Polano, S. *Mostrare. L'allestimento in Italia dagli anni '20 agli anni '80*. Milan: Lybra, 1990.

Radice, B. *Memphis. Ricerche, esperienze, risultati, fallimenti e successi del nuovo design*. Milan: Electa, 1984 (Eng. trans. *Memphis. Research, Experiences, Results, Failures and Successes of New Design*. New York: Rizzoli, 1984).

Sparke, P. *Italian Design – 1870 to the Present*, London: Thames and Hudson, 1988.

Storia del disegno industriale, 1. *L'età della rivoluzione industriale. 1750-1850*; 2. *Il grande emporio del mondo. 1851-1918*; 3. *Il dominio del design. 1919-1990*. Milan: Electa, 1989–91.

Tafuri, M. *Storia dell'architettura italiana, 1944-1985*. Turin: Einaudi, 1986 (Eng. trans. *History of Italian Architecture 1944–1985*. Cambridge [Mass.]: MIT Press, 1989).

Tonelli Michail, M. C. *Il design in Italia 1925-43*. Bari: Laterza, 1987.

Vergani, G. *La sala bianca: The Birth of Italian Fashion*. Exhib. cat. Milan: Electa, 1992.

Visual Design. 50 anni di produzione in Italia. Exhib. cat. Milan: Idealibri, 1984.

Vitta, M. *Il progetto della bellezza. Il design fra arte e tecnica, 1851-2001*. Turin: Einaudi, 2001.

Waibl, H. *Alle radici della comunicazione visiva italiana*. Como: Centro di Cultura Grafica, 1988.

History of Art

Argan, G. C. *Salvezza e caduta nell'arte moderna: studi e note 2*. Milan: Il Saggiatore, 1964.

Ballo, G. *La linea dell'arte italiana: dal simbolismo alle opere moltiplicate*. Rome: Edizioni Mediterranee, 1964.

Barilli, R. and F. Solmi (eds.). *La Metafisica: gli Anni Venti*. Exhib. cat. Bologna: Grafis, 1980.

Bonito Oliva, A. *Artisti italiani contemporanei, 1950-1983*. Exhib. cat. Milan: Electa, 1983.

Bonito Oliva, A. (ed.). *Transavanguardia: Italia-America*. Exhib. cat. Modena: Cooptip, 1982.

Bonito Oliva, A. *Minimalia: An Italian Vision in 20th-Century Art*. Exhib. cat. Milan: Electa, 1999.

Bossaglia, R., *Il "Novecento italiano": storia, documenti, iconografia*. Milan: Feltrinelli, 1979.

Braun, E. (ed.). *Italian Art in the 20th Century: Painting and Sculpture, 1900–1988*. Exhib. cat. London: Royal Academy of Arts; Munich: Prestel-Verlag, 1989.

Brunetta, G. P. *Guida alla storia del cinema italiano: 1905-2003*. Turin: Einaudi, 2003.

Cachin-Nora, F. (ed.), *Le futurisme, 1909-1916*. Exhib. cat. Paris: Éditions des musées nationaux, 1973.

Caramel, L. (ed.). *M.A.C. Movimento Arte Concreta 1948-1958*. Exhib. cat. Milan: Electa, 1984.

Carrà, M. with E. Rathke and P. Waldberg. *Metafisica*. Milan: Mazzotta, 1968 (Eng. trans. *Metaphysical Art*. New York: Praeger Publishers; London: Thames and Hudson, 1971).

Celant, G. (ed.). *Arte povera*. Milan: Mazzotta, 1969 (Eng. trans. *Arte povera*. New York: Praeger Publishers, 1969).

Celant, G. (ed.). *Identitè italienne. L'art en Italie depuis 1959*. Exhib. cat. Paris: Centre Georges Pompidou, Musée national d'art moderne; Florence: Centro Di, 1981.

Celant, G. *Il modo italiano = The Italian Manner*. Exhib. cat. Regione Piemonte: LAICA, 1983; Los Angeles: 1984.

Celant, G. *L' inferno dell'arte italiana Materiali. 1946-1964*. Genoa: Costa&Nolan, 1990.

Celant, G. *The European Iceberg: Creativity in Germany and Italy Today*. Exhib. cat. Toronto: Art Gallery of Ontario; Milan: Mazzotta, 1985.

Celant, G. *The Knot: Arte Povera at P.S. 1: Giovanni Anselmo, Alighiero Boetti, Pier Paolo Calzolari, Luciano Fabro, Jannis Kounellis, Mario Merz, Marisa Merz, Giulio Paolini, Pino Pascali, Giuseppe Penone, Michelangelo Pistoletto, and Gilberto Zorio*. Exhib. cat. Long Island (NY): P.S. 1, Institute for Art and Urban Resources; Turin: Allemandi, 1985.

Christov-Bakargiev, C. (ed.). *Arte Povera*. London: Phaidon Press, 1999.

Colombo, C. and S. Sontag. *Italy: One Hundred Years of Photography*. Exhib. cat. Florence: Alinari, 1988.

Cortenova, G. and F. Menna (eds.). *Astratta. Secessioni astratte in Italia dal dopoguerra al 1990*. Exhib. cat. Milan: Mazzotta, 1988.

Costantini, P. and I. Zannier (eds.). *L'insistenza dello sguardo. Fotografie italiane 1839-1989*. Exhib. cat. Florence: Fratelli Alinari editore, 1989.

Crispolti, E. *L'informale. Storia e poetica*. Exhib. cat. Assisi and Rome: Carucci, 1971.

Crispolti, E. (ed.). *Ricostruzione futurista dell'universo*. Exhib. cat. Turin: Museo Civico, 1980.

Divisionismo italiano. Exhib. cat. Milan: Electa, 1990.

Dorfles, G. *Ultime tendenze nell'arte di oggi* (1961). Milan: Feltrinelli, 2004.

Ecole romaine, 1925-1945. Exhib. cat. Paris: Paris-Musées, 1997.

Fagiolo dell'Arco, M. (ed.). *Realismo magico: pittura e scultura in Italia, 1919-1925*. Exhib. cat. Milan: Mazzotta, 1988.

Flood, R. and F. Morris (eds.). *Zero to Infinity: Arte Povera, 1962–1972*. Exhib. cat. Minneapolis: Walker Art Center, 2001.

Godoli, E. (ed.). *Dizionario del futurismo*. Florence: Vallecchi, 2001.

Guadagnini, W. (ed.). *Pop Art Italia: 1958-1968*. Exhib. cat. Cinisello Balsamo: Silvana, 2005.

Hulten, P. (ed.). *Futurismo & Futurismi*. Exhib. cat. Milan: Bompiani, 1986 (Eng. trans. *Futurism & Futurisms*. New York: Abbeville Press, 1986).

Hulten, P. and G. Celant (eds.). *Arte italiana: presenze 1900-1945*. Exhib. cat. Milan: Bompiani, 1989.

Il Novecento italiano 1923/1933. Exhib. cat. Milan: Mazzotta, 1983.

Lista, G. (ed.), *Dynamisme plastique: peinture et sculpture futuristes. Umberto Boccioni*. Lausanne: L'Age d'homme, 1975.

Lista, G. *Le futurisme*. Paris: Hazan, 1985.

Marchiori, G. *Arte e artisti d'avanguardia in Italia*. Milan: Edizioni di Comunità, 1960.

Meneguzzo, M. (ed.). *La scultura italiana del XX secolo*. Exhib. cat. Milan: Skira, 2005.

Perloff, M. *The Futurist Moment: Avant-garde, Avant Guerre and the Language of Rupture*. Chicago: University of Chicago Press, 1986.

Pontiggia, E. (ed.). *Da Boccioni a Sironi. Il mondo di Margherita Sarfatti*. Exhib. cat. Milan: Skira, 1997.

Ritchie, A. C. (ed.). *The New Decade: 22 European Painters and Sculptors*. New York: The Museum of Modern Art, 1955.

Sauvage, T. *Pittura italiana del dopoguerra, 1945-1957*. Milan: Ed. Schwarz, 1957.

Storia dell'arte italiana, Il Novecento. Vol. VII. Turin: Einaudi, 1982.

Tazartes, M. *Guide du futurisme*. Paris: Canal Éditions, 1998.

Valtorta, R. *Pagine di fotografia italiana 1900-1998*. Exhib. cat. Milan: Charta, 1998.

Verdone, M. *Storia del cinema italiano*. Rome: TEN, 1995.

Vergine, L. (ed.). *Arte programmata e cinetica 1953-1963. L'ultima avanguardia*. Exhib. cat. Milan: Mazzotta, 1983.

Zannier, I. (ed.). *Segni di luce*. 1. *Alle origini della fotografia in Italia*; 2. *La fotografia italiana dall'età del collodio al pittorialismo*; 3. *La fotografia italiana contemporanea*. Ravenna: Longo, 1991–93.

Zannier, I. *Storia della fotografia italiana*. Bari: Laterza, 1986.

Monographs

(in alphabetical order of the artist's or designer's surname)

Piva, A. and V. Prina. *Franco Albini 1905-1977*. Milan: Electa, 1998.

Getulio Alviani. Exhib. cat. Milan: Skira, 2004.

Petranzan, M. *Gae Aulenti*. Milan: Skira, 2003.

Mosca Baldessari, Z. (ed.). *Luciano Baldessari*. Exhib. cat. Milan: Mondadori, 1985.

Crispolti, E. (ed.). *La ceramica futurista da Balla a Tullio D'Albisola*. Exhib. cat. Florence: Centro Di, 1982.

Fagiolo dell'Arco, M. *Futur-Balla. La vita e le opere*. Milan: Electa, 1990.

Lista, G. *Balla*. Modena: Edizioni Galleria Fonte d'Abisso, 1982.

Barovier, M. *L'arte dei Barovier vetrai di murano 1866-1972*. Exhib. cat. Venice: Arsenale Editrice, 1993.

Sessa, E. *Mobili e arredi di Ernesto Basile nella produzione Ducrot*. Palermo: Novecento, 1980.

Piva, A. (ed.), *BBPR a Milano*. Milan: Electa, 1982.

Beccarla, M. (ed.). *Vanessa Beecroft. Performances 1993-2003*. Exhib. cat. Milan: Skira, 2003 (Eng. trans. *Vanessa Beecroft. Performances 1993–2003*. London: Thames & Hudson, 2003).

McCarty, M. *Mario Bellini: Designer*. Exhib. cat. New York: Museum of Modern Art, 1987.

Berengo Gardin, G. *Gianni Berengo Gardin*. Milan: Contrasto, 2005.

Bossaglia, R., *I vetri di Fulvio Bianconi*. Turin: Allemandi, 1993.

Coen, E. *Umberto Boccioni*. Exhib. cat. New York: The Metropolitan Museum of Art, 1988.

Avogadro, C. (ed.). *Cini Boeri: architetto e designer*. Cinisello Balsamo: Silvana, 2004.

Di Pietrantonio, G. and C. Levi (eds.). *Alighiero Boetti: Quasi tutto*. Exhib. cat. Cinisello Balsamo: Silvana, 2004.

Studio Boggeri and B. Monguzzi (eds.). *Lo studio Boggeri, 1933-1981*. Milan: Electa, 1981.

Luigi Bonazza (1877-1965). Exhib. cat. Trent: Provincia autonoma di Trento, Servizio beni culturali, 1985.

Gramigna, G. and F. Irace (eds.). *Osvaldo Borsani*. Rome: Leonardo De Luca, 1992.

Burkhardt, F. and C. Morozzi. *Andrea Branzi*, Paris: Dis voir, 1997.

Dejean, P. *Carlo, Rembrandt, Ettore, Jean Bugatti*. Paris: Editions du Regard, 1981 (Eng. trans. *Carlo,*

Rembrandt, Ettore, Jean Bugatti. New York: Rizzoli, 1982).

Lamarche-Vadel, B. and H. Obalk (eds.). *Bugatti, les meubles, Bugatti, les sculptures, Bugatti, les autos*. Exhib. cat. Vence, Galerie Beaubourg; Paris: La Différence, 1995.

Massé, M-M. *Carl Bugatti au Musée d'Orsay. Catalogue sommaire illustré du fonds d'archives et des collections*. Paris: Réunion des Musées Nationaux, 2001.

Irace, F. and P. Marini (eds.). *Luigi Caccia Dominioni - Case e cose da abitare - Stile di caccia*. Exhib. cat. Venice: Marsilio, 2002.

Troisi, S. (ed.). *Corrado Cagli: i percorsi del mito: opere 1929-1976*. Exhib. cat. Milan: Charta, 1999.

Bonasegale, G., A. M. Damigella and B. Matura (eds.). *Cambellotti (1876-1960)*. Exhib. cat. Rome: De Luca, 1999.

Caruso, L. *Francesco Cangiullo e il futurismo a Napoli*. Florence: SPES-Salimbeni, 1979.

Rosazza Ferraris, P. and R. Camerlingo Pittorino (eds.). *Capogrossi: i segni del secolo*. Exhib. cat. Turin: Allemandi, 1999.

Monferini, A. (ed.). *Carlo Carrà 1881-1966*. Exhib. cat. Milan: Electa, 1994.

Bianchi Anderloni, C. F. and A. T. Anselmi. *Carrozzeria Touring*. Rome: Autocritica, 1982.

Bertolino, G., A. Fiz and F. Poli (eds.). *Felice Casorati. La strategia della composizione*. Exhib. cat. Cinisello Balsamo: Silvana, 2003.

Celant, G. (ed.). *Enrico Castellani: 1958-1970*. Exhib. cat. Milan: Fondazione Prada, 2001.

Polano, S. (ed.). *Achille Castiglioni: tutte le opere, 1938-2000*. Milan: Electa, 2001 (Eng. trans. *Achille Castiglioni: Complete Works*. Milan: Electa, 2002).

Scodeller, D. *Livio e Piero Castiglioni. Il progetto della luce*. Milan: Electa, 2003.

Coen, V. (ed.). *Sandro Chia*. Exhib. cat. Turin: Hopefulmonster, 2000.

Monti, R. (ed.). *La manifattura Chini*. Rome: De Luca Edizioni d'Arte; Milan: Leonardo, 1989.

Bassi, A. *Antonio Citterio: industrial design*. Milan: Electa, 2004.

Percy, A. and R. Foye. *Francesco Clemente: Three Worlds*. Exhib. cat. Philadelphia: Philadelphia Museum of Art, 1990.

Lambarelli, R. and E. Mascelloni (eds.). *Ettore Colla: opere, 1950-1968*. Exhib. cat. Milan: Skira, 1995.

Fagone, V., H. Teshigahara and G. Usicco. *Gianni Colombo. L'artista e il suo mondo*. Exhib. cat. Milan: Reggiani, 1999.

Kries, M. (ed.). *Joe Colombo. Inventare il futuro*. Exhib. cat. Milan: Skira, 2005.

Accame, G.M. and G. Di Milia (eds.). *Pietro Consagra: scultura e architettura*. Exhib. cat. Milan: Mazzotta, 1996.

Rebeschini, C. (ed.). *Crali futurista / Crali aeropittore*. Exhib. cat. Milan: Electa, 1994.

Mercurio, G. (ed.). *Enzo Cucchi*. Exhib. cat. Milan: Electa, 2002.

Trimarco, A. (ed.). *Sculture: Riccardo Dalisi*. Naples: Electa, 1997.

Nicoletti, M. *D'Aronco e l'architettura liberty*. Bari: Laterza, 1982.

Bassi, A. and M. Mulazzani (eds.). *Le macchine volanti di Corradino d'Ascanio*. Exhib. cat. Milan: Giorgetti and Electa, 1999.

Colombo, A. *Mario De Biasi: fotografia, professione e passione*. Milan: Motta, 1999.

Baldacci, P. *De Chirico: The Metaphysical Period, 1888–1919*. Boston and Toronto: Little, Brown and Co., 1997.

Fagiolo dell'Arco, M. (et al.), *De Chirico: Essays*. New York: Museum of Modern Art, 1982.

Schmied, W. *Giorgio de Chirico: The Endless Journey*. Munich and New York: Prestel Verlag, 2002.

Bulegato, F. and S. Polano. *Michele De Lucchi. Comincia qui e finisce là*. Milan: Electa, 2004.

Bonito Oliva, A. and D. Eccher (eds.). *Nicola De Maria*. Exhib. cat. Milan: Electa, 2004.

Conti, F. *I progettisti italiani: De Pas, D'Urbino, Lomazzi*. Milan: Rima, 1989.

Comune di Padova e dell'Ordine provinciale Artigiani (ed.). *L'arte dello smalto. Paolo De Poli*. Exhib. cat. Padua: Artegrafica Bolzonella, 1984.

Belli, G. (ed.). *Depero. Dal Futurismo alla Casa d'Arte*. Exhib. cat. Milan: Charta, 1994.

Sessa, E. *Ducrot: mobili e arti decorative*. Palermo: Novecento, 1989.

Marcello Dudovich. Oltre il manifesto. Exhib. cat. Milan: Charta, 2002.

Gregotti, V. and G. Marzari (eds.). *Luigi Figini, Gino Pollini: opera completa*. Exhib. cat. Milan: Electa, 1996.

Grenier, C. (et al.), *Lucio Fontana*. Exhib. cat. Paris: Centre Georges Pompidou, Musée national d'art moderne, 1987.

Crispolti, E. and R. Siligato (eds.). *Lucio Fontana*. Exhib. cat. Milan: Electa, 1998.

Carlo Forcolini: immaginare le cose. Milan: Electa, 1990.

Mauriès, P. *Fornasetti, Designer of Dreams*. London: Thames & Hudson, 1991.

De Osma, G. *Fortuny. Mariano Fortuny, His Life and Work*. New York: Rizzoli, 1985.

Giacosa, D. *Forty Years of Design at Fiat*. Milan: Automobilia, 1979.

Spadoni, C. (ed.). *Piero Gilardi*. Exhib. cat. Milan: Mazzotta, 1999.

Valtorta, R. (ed.). *Paolo Gioli. Fotografie, dipinti, grafica, film*. Udine: Art&, 1995.

Maino, M. P., M. Quesada and F. Tetro (eds.). *Vittorio Grassi 1878-1958*. Rome: Galleria dell'Emporio Floreale, 1984.

Colao, P. and G. Vragnaz (eds.). *Gregotti Associati: 1973-1988*. Milan: Electa, 1990.

Scatasta, R. (ed.). *Gruppo Architetti Urbanisti "Città Nuova": progetti e architetture, 1961-1991*. Exhib. cat. Milan: Electa, 1992.

Bertoni, F. and O. Ghetti Baldi. *Giovanni Guerrini, 1887-1972*. Exhib. cat. Faenza: Assessorato alla Cultura, 1990.

Guttuso. Milan: Rizzoli, 1999.

Mimmo Jodice. Retrospettiva 1965-2000. Exhib. cat. Turin: GAM, 2001.

Corà, B. (ed.). *Kounellis*. Exhib. cat. Prato: Gli Ori, 2001.

Casavecchia, M. (ed.). *Ernesto Angelo La Padula. Opere e scritti 1930-49*. Venice: Cluva Editrice, 1986.

Lorenzelli, B. and M. (eds.). *Osvaldo Licini, secondo noi*. Exhib. cat. Milan: Skira, 2001.

Baglione, C. and E. Susani (eds.). *Pietro Lingeri (1894-1968)*. Milan: Electa, 2004.

Violo, L. (ed.). *Luxardo*. Milan: Motta, 2000.

Irace, F. and V. Pasca. *Vico Magistretti: architetto e designer*. Milan: Electa, 1999.

Celant, G. (ed.). *Piero Manzoni: catalogo generale*. Milan: Skira, 2004.

Strinati, C. and L. Velani (eds.). *Manzù: l'uomo e l'artista*. Exhib. cat. Rome: De Luca, 2002.

D'Avossa, D. and F. Picchi. *Enzo Mari, il lavoro al centro*. Exhib. cat. Milan: Electa, 1999.

Lemaire, G.-G. (et al.) *F. T. Marinetti*. Exhib. cat. Paris: Centre Georges Pompidou, 1984.

Carandente, G. (introductory essay). *Marino Marini. Catalogo ragionato della scultura*. Milan: Skira, 1998.

Riposati, M. (ed.) *Gino Marotta – Natura e Artificio*. Exhib. cat. Rome: Carte Segrete, 2005.

Vianello, G., N. Stringa and C. Gian Ferrari (eds.). *Arturo Martini: catalogo ragionato delle sculture*. Vicenza: Neri Pozza, 1998.

Barovier, M. (ed.). *Napoleone Martinuzzi. Maestro vetraio del Novecento*. Venice: Franco Martella Editore, 2001.

Gruppo Architettura Storia dell'Arte (ed.). *Ferro e liberty. Alessandro Mazzucotelli. Architettura. Fabbri di oggi*. Exhib. cat. Milan: Magma, 1979.

Picchi, F. *Alberto Meda*. Milan: Abitare Segesta, 2003.

Celant, G. *Melotti. Catalogo generale*. Milan: Electa, 1994.

Weiß, P. (ed.). *Alessandro Mendini. Cose, progetti, architetture*. Milan: Electa, 2001.

Eccher, D. (ed.). *Mario Merz*. Exhib. cat. Turin: Hopefulmonster, 2003.

Ginex, G. (ed.). *Metlicovitz, Dudovich: grandi cartellonisti triestini: manifesti dalla raccolta "Achille Bertarelli" del Castello Sforzesco di Milano*. Exhib. cat. Milan: Skira, 2001.

Irace, F. (ed.). *Carlo Mollino 1905-1973*. Exhib. cat. Milan: Electa, 1989.

Angelo Morbelli, tra realismo e divisionismo. Exhib. cat. Turin: GAM, 2001.

Grazioli, E. (ed.). *Ugo Mulas. Dentro la fotografia*. Exhib. cat. Nuoro: MAN, 2004.

Meneguzzo, M. *Bruno Munari*. Bari: Laterza, 1993.

Irace, F. *Giovanni Muzio 1893-1982: opere*. Milan: Electa, 1994.

Quintavalle, A. C. (ed.). *Marcello Nizzoli*. Exhib. cat. Milan: Electa, 1989.

Gullbring, L. *Fabio Novembre*. Basle: Birkhäuser, 2001.

Galasso, A. (ed.). *Luigi Ontani: OntanElegia*. Turin: Allemandi, 2004.

Pontiggia, E. (ed.). *Ubaldo Oppi, 1919-1930. La stagione classica*. Exhib. cat. Milan: Skira, 2002.

Sallis, J. and D. Eccher. *Paladino: una monografia*. Milan: Charta, 2001.

Crispolti, E. (ed.). *Pannaggi e l'arte meccanica futurista*. Exhib. cat. Milan: Mazzotta, 1995.

Giulio Paolini. Exhib. cat. Villeurbanne: Le Nouveau Musée, 1984.

Bolognesi, K., Calvenzi, G. (eds.). *Federico Patellani. Fotografie per i giornali*. Exhib. cat. Udine: Art&, 1995.

Scotti, A. *Pellizza da Volpedo. Catalogo generale*. Milan: Electa, 1986.

Gaetano Pesce: le temps des questions. Exhib. cat. Paris: Centre Georges Pompidou, 1996.

Bartolucci, M. *Gaetano Pesce*. San Francisco: Chronicle Books, 2003.

Lupano, M. *Marcello Piacentini*. Bari: Laterza, 1991.

Branzaglia, C. *Pintori*. Exhib. cat. Nuoro: MAN, 2003.

Farano, M., M. Mundici and M. Roberto. *Michelangelo Pistoletto. Il varco dello specchio: azioni e collaborazioni 1967/2004*. Turin: Fondazione Torino Musei, 2005.

Pizzigoni, A. (ed.). *Pizzigoni. Invito allo spazio, progetti e architetture 1923-1967*. Exhib. cat. Milan: Electa, 1982.

Fagone, V. (ed.). *Giò Pomodoro, 1930-2002. Un omaggio della Fondazione Ragghianti*. Exhib. cat. Lucca: Fondazione Ragghianti, 2003.

Falconi, L. *Gio Ponti. Interni Oggetti Disegni 1920-1976*. Milan: Electa, 2004.

Licitra Ponti, L. *Gio Ponti. L'opera*. Milan: Leonardo, 1990 (Eng. trans. *Gio Ponti: The Complete Work: 1923–1978*. Cambridge [Mass.]: MIT Press, 1990).

Romanelli, M. (ed.). *Gio Ponti: A World*. Exhib. cat. Milan: Abitare Segesta, 2002.

Molinari, L. and Fondazione Piero Portaluppi (eds.). *Piero Portaluppi: linea errante nell'architettura del Novecento*. Exhib. cat. Milan: Skira, 2003.

Crispolti, E. (ed.). *Prampolini. Dal Futurismo all'Informale*. Exhib. cat. Rome: Edizioni Carte Segrete, 1992.

Mazzocca, F. (ed.) *Gaetano Previati 1852-1920: un protagonista del simbolismo europeo*. Exhib. cat. Milan: Electa, 1999.

Dorfles, G. (ed.). *Provinciali: sentimento del tempo*. Bologna: Grafis, 1986.

Le Bourhis, K., S. Ricci and L. Settembrini (eds.). *Emilio Pucci*. Milan: Skira, 1996.

Bossaglia, R. (ed.). *Eugenio e Mario Quarti. Dall'ebanisteria liberty all'arredamento moderno*. Exhib. cat. Milan: Arti Grafiche A. Cordani, 1980.

Caramel, L. *Radice: catalogo generale*. Milan: Electa, 2002.

Ferlenga, A. (ed.). *Aldo Rossi. Tutte le opere*. Milan: Electa, 1999 (Eng. trans. *Aldo Rossi: The Life and Works of an Architect*. Cologne: Könemann, 2001).

Celant, G. (ed.). *Rotella*. Milan: Skira, 2006.

Marelli, E. *Lino Sabattini: suggestione e funzione: Intimations and Craftsmanship*. Mariano Comense: Metron, 1979.

Quintavalle, A. C. (ed.). *Roberto Sambonet*. Milan: Motta, 1993.

Briatore, V. *Denis Santachiara*. Milan: Editrice Abitare Segesta, 2002.

Antonio Sant'Elia. L'architettura disegnata. Exhib. cat. Venice: Marsilio, 1991.

Webb, M. *Richard Sapper*. San Francisco: Chronicle Books, 2001.

De Rosa, P. A. and P. E. Trastulli (eds.). *Giulio Aristide Sartorio: Il Realismo Plastico tra Sentimento ed Intelletto*. Exhib. cat. Orvieto: Fondazione Cassa di Risparmio di Orvieto, 2005.

Abriani, A. and J. Gubler. *Alberto Sartoris. Dall'autobiografia alla critica*. Milan: Electa, 1990.

Vivarelli, P. and P. Baldacci (eds.). *Alberto Savinio*. Exhib. cat. Milan: Mazzotta, 2002.

Masiero, R. (ed.). *Afra e Tobia Scarpa: architetture*. Milan: Electa, 1996.

Barovier, M. (ed.), *Carlo Scarpa. I vetri di un architetto*. Exhib. cat. Milan: Skira, 1998 (Eng. trans. *Carlo Scarpa: Glass of an Architect*. Exhib. cat.. Milan: Skira, 1998).

Dal Co, F. and G. Mazzariol (eds.). *Carlo Scarpa. Opera completa*. Milan: Electa, 1984 (Eng. trans. *Carlo Scarpa: The Complete Works*. New York: Electa/Rizzoli, 1984).

Ferdinando Scianna. Altre forme del caos. Exhib. cat. Rome: Contrasto, 1999.

Belli, G. and A.-P. Quinsac (eds.). *Segantini: la vita, la natura, la morte: disegni e dipinti*. Exhib. cat. Milan: Skira, 1999.

Benzi F. (ed.). *Mario Sironi, 1885-1961*. Exhib. cat. Milan: Electa, 1993.

Höger, H. *Ettore Sottsass, Jr.: Designer, Artist, Architect*. Tübingen: Wasmuth, 1993.

Radice, B. *Ettore Sottsass*. Milan: Electa, 1993 (Eng. trans. *Ettore Sottsass: A Critical Biography*. New York: Rizzoli, 1993).

Audrito, F. *Lo Studio 65: architettura e design*. Milan: Arcaedizioni, 1995.

Lang, P. and W. Menking (eds.). *Superstudio. Life without Objects*. Milan: Skira, 2003.

Illustrations

Ciucci, G. (ed.). *Giuseppe Terragni. 1904-1943*. Milan: Electa, 2003.

Bassani, R. (ed.). *Federico Tesio. Un grande proprietario e allevatore italiano*. Venice: Marsilio, 1997.

Gianelli, I., G. Verzotti and G. De Angelis Testa (eds.). *Armando Testa*. Exhib. cat. Milan: Charta, 2001.

Buck, A. and M. Vogt (eds.). *Matteo Thun – Designer*. Berlin: Ernst & Sohn, 1993.

La Pietra, U. (ed.). *Ulrich: gli oggetti fatti ad arte*. Milan: Electa, 1994.

Accame, G. M. and M. Saponaro (eds.). *Giuseppe Uncini*. Exhib. cat. Novara: De Agostini, 1996.

Croset, P.-A. *Gino Valle: progetti e architetture*. Milan: Electa, 1989.

Bettagno, A. (ed.). *Gli artisti di Venini. Per una storia del vetro d'arte veneziano*. Exhib. cat. Milan: Electa, 1996.

Gramigni, M. *Luigi Vietti architetto*. Milan: Galleria Orti d'arte, 2001.

Vignelli, L. and M. *Lella and Massimo Vignelli: Design is One*. Mulgrave: Images Pub. Group, 2004.

Mola, P. (ed.). *Adolfo Wildt, 1868-1931*. Exhib. cat. Milan: Mondadori Arte, 1989.

Ciucci, G. (ed.). *Gigiotti Zanini. Pittore e architetto*. Exhib. cat. Milan: Charta, 1992.

De Giorgi, M. (ed.). *Marco Zanuso. Architetto*. Exhib. cat. Milan: Skira, 1999.

Barovier, M., M. Mondi and C. Sonego, (eds.). *Vittorio Zecchin, 1878-1947: pittura, vetro, arti decorative*. Exhib. cat. Venice: Marsilio, 2002.

Every effort has been made to locate copyright holders for the photographs used in this book. Any omissions will be corrected in subsequent editions.

Archivi delle arti applicate italiane del XX secolo, Rome

Marino Barovier, Marino Barovier Archives

Archivio Albini, Milan

Archivio Giampiero Bosoni, Milan

Archivio Giampiero Bosoni, Milan. Photo Aldo Ballo

Archivio Giampiero Bosoni, Milan. Photo Archivio Albini

Archivio Giampiero Bosoni, Milan. Photo Archivio Bialetti

Archivio Giampiero Bosoni, Milan. Photo Studio Casali

Archivio Giampiero Bosoni, Milan. Photo Studio Castiglioni

Archivio Giampiero Bosoni, Milan. Photo (above) Jacqueline Vodoz (below) Clari

Archivio Fotografico Collezione Permanente del Design italiano La Triennale di Milano. Photo Amendolagine-Barracchia

Archivio Fotografico Fondazione 3M, Milan

Archivio Fotografico Mart, Rovereto

Archivio Fotografico Museo Kartell, Milan

Roberto Marossi, 1996 © Roberto Marossi

Archivio Mendini

Archivio del Moderno, Mendrisio

© 2006 Eredi Archivio Ugo Mulas. Tutti i diritti riservati

Archivio Muzio, Milan

Archivio Attilio Pizzigoni, Bergamo

Archivio Storico Fiat

Archivio Storico Olivetti

Archivio Studio Alchimia

Archivio Studio Alchimia. Photo Giuseppe Ragusa

Brooklyn Museum of Art

Brooklyn Museum of Art / Central Photo Archive

Carnegie Museum of Art / Pittsburgh. Photo Peter Harholdt

Carnegie Museum of Art / Pittsburgh. Photo Tom Little

Centrocolore industriale

Centro Studi e Archivio della Comunicazione, Università degli Studi di Parma

Centro Studi Giuseppe Terragni, Milan

Christophe Chauchat

Civica Raccolta delle Stampe "Achille Bertarelli", Milano - Saporetti, immagini d'arte s.n.c., Milan

Civico Museo di Arte Contemporanea, Milan

Fotografo Davide Clari, 1965 © Archivio storico Fondazione J. Vodoz e B. Danese

Massimo e Sonia Cirulli Archive, New York

Collection Centre Canadien d'Architecture / Canadian Centre for Architecture, Montréal

Collection Guntis Brands

Collection Anne et Wolfgang Titze

Collezione Alessandro Pedretti, Milan

Collezione Privata Cosmit, Milan. Photo Luciano Soave

Collezione Bardelli Casa, Pistoia

Collezione Privata, Rome

Cooper-Hewitt National Design Museum, Smithsonian Institution. Photo Matt Flynn

Courtesy Deitch Projects and the artist

Courtesy Douglas Ball Inc.

Courtesy of Gufram

Courtesy Scot Laughton Design

Courtesy Archivio Fausto Melotti

Courtesy of Morozzi & Partners s.a.s.

Giacomo D'Aguanno, Palermo

Pino Dell'Aquila Fotografo

Esso Gallery, New York

Photo Aldo Fallai (for Giorgio Armani, Paris)

Roberto Ferrarin Architetto, Milan

Fondazione Biagiotti Cigna, Guidonia

Fondazione Cavallini Sgarbi, Ferrara

Photograph Archive, Fondazione La Triennale di Milano

Photograph Archive, Fondazione La Triennale di Milano. Photo Fototecnica Fortunati

Fondazione J. Vodoz e B. Danese

Fondo Paolo Gioli – Museo di